A Dictionary of
modern design

Jonathan Woodham is Professor of the History of Design and Director of the Centre for Research Development (Arts & Architecture) at the University of Brighton. He also serves on the editorial boards of *Design Issues*, MIT, and the *Journal of Design History* (OUP). He is the author of *The Industrial Designer and the Public* (1983), *Twentieth Century Ornament* (1990), and the hugely successful *Twentieth Century Design* (OUP, 1997)

Oxford Paperback Reference

The most authoritative and up-to-date reference books for both students and the general reader.

ABC of Music
Accounting
Allusions
Animal Behaviour*
Archaeology
Architecture
Art and Artists
Art Terms
Astronomy
Better Wordpower
Bible
Biology
British History
British Place-Names
Buddhism
Business
Card Games
Catchphrases
Celtic Mythology
Chemistry
Christian Art
Christian Church
Chronology of English
 Literature*
Classical Literature
Classical Myth and Religion
Computing
Contemporary World History
Countries of the World
Dance
Dates
Dynasties of the World
Earth Sciences
Ecology
Economics
Encyclopedia
Engineering*
English Etymology
English Folklore
English Grammar
English Language
English Literature
English Surnames*
Euphemisms
Everyday Grammar
Finance and Banking
First Names
Food and Drink
Food and Nutrition
Foreign Words and Phrases
Geography
Humorous Quotations
Idioms
Internet
Islam

Kings and Queens of Britain
Language Toolkit
Law
Linguistics
Literary Quotations
Literary Terms
Local and Family History
London Place-Names
Mathematics
Medical
Medicinal Drugs
Modern Design*
Modern Quotations
Modern Slang
Music
Musical Terms
Musical Works
Nicknames*
Nursing
Ologies and Isms
Philosophy
Phrase and Fable
Physics
Plant Sciences
Plays*
Pocket Fowler's Modern
 English Usage
Political Quotations
Politics
Popes
Proverbs
Psychology
Quotations
Quotations by Subject
Reverse Dictionary
Rhyming Slang
Saints
Science
Shakespeare
Slang
Sociology
Space Exploration*
Statistics
Superstitions*
Synonyms and Antonyms
Weather
Weights, Measures, and Units
Word Histories
World History
World Mythology
World Place-Names*
World Religions
Zoology

*forthcoming

A Dictionary of

modern design

Jonathan M. Woodham

OXFORD
UNIVERSITY PRESS

OXFORD
UNIVERSITY PRESS

Great Clarendon Street, Oxford OX2 6DP

Oxford University Press is a department of the University of Oxford.
It furthers the University's objective of excellence in research, scholarship,
and education by publishing worldwide in

Oxford New York

Auckland Cape Town Dar es Salaam Hong Kong Karachi
Kuala Lumpur Madrid Melbourne Mexico City Nairobi
New Delhi Shanghai Taipei Toronto

With offices in

Argentina Austria Brazil Chile Czech Republic France Greece
Guatemala Hungary Italy Japan Poland Portugal Singapore
South Korea Switzerland Thailand Turkey Ukraine Vietnam

Oxford is a registered trade mark of Oxford University Press
in the UK and in certain other countries

Published in the United States
by Oxford University Press Inc., New York

© Oxford University Press, 2004, 2006

British Library Cataloguing in Publication Data
Data available

Library of Congress Cataloging in Publication Data
Data available

Typeset by SPI Publisher Services, Pondicherry, India
Printed in Great Britain by
Clays Ltd, St Ives plc

ISBN 0-19-280639-4 978-0-19-280639-0

10 9 8 7 6 5 4 3 2 1

For Amanda, Jeremy and Zachary

Acknowledgements

Having been involved in design history for nearly 30 years I would like to thank colleagues in Britain and around the world who have offered advice, friendly criticism, and comradeship during that time. Over that period I have taught countless students, many of whom have made a strong impression, offered interesting ideas, and asked awkward but important questions. Some now chair committees on which I sit; others have become successful academics, researchers, and writers from whom I have learnt a great deal. I would also like to thank friends at the University of Brighton who have done more than most to shape, develop, and support design historical studies. I hope they will all be interested in this dictionary and see it as a useful addition to the literature of design.

JMW

Brighton, 2004

Contents

List of illustrations xi

Introduction xiii

A Dictionary of Modern Design **1**

Bibliography 471

Timelines 489

Index 507

List of illustrations

A Otl Aicher pictogram figure for Munich
 Olympics 1
 Courtesy of ERCO

B Beck's Underground map 33
 © London Transport Museum

C Cadillac poster
 National Motor Museum, Beaulieu. 67
 © 2003 Scala/HIP

D Dyson vacuum cleaner 105
 Courtesy of Dyson Ltd.

E Ergonomic 'City' cutlery by David Mellor 135
 © David Mellor Design Ltd. Photo: Pete Hill

F Fiskars classic scissors 145
 Fiskars Brands UK Ltd.

G A Sort from the Gill typeface 161
 © The Type Museum. Photo: Andra Nelki

H Harley Davidson logo 193
 LP Pictures

I.1 Ikea catalogue covers 205
 LP Pictures (1990, 1997); Courtesy of Ikea (2002, 2004)

J Arne Jacobsen chair 221
 Courtesy of Dansk Mobelkunst (left);
 Fiell International (right)

K Kelmscott Press work 233
 LP Pictures

L Lego helicopter figure 249
 Fiell International

M Charles Rennie Mackintosh stained glass 265
 Mark Golding, The Arts and Crafts Home,
 www.achome.co.uk

N Nokia mobile phone 305
 Courtesy of Nokia

O Olivetti typewriter 321
 © Bettmann/Corbis

P Panton pendant light 327
 Courtesy of Dansk Mobelkunst

Q Mary Quant logo and Grace Codrington wearing
 'Banana Split' dress 357
 © Mary Quant. The ❀ logo is a trademark
 of the Mary Quant group of companies throughout
 the world and is reproduced with their permission.

R Rubik Cube 359

S Ettore Sottsass's 'Casablanca' sideboard 377
 © Philadelphia Museum of Art/Corbis

T Tiffany lamp 413
 © Christie's Images/Corbis

U Shigeru Uchida's 'Miss Achida' boutique 427
 Courtesy of the Uchida Design Institute,
 Tokyo

V GNER railroad identity by Vignelli 435
 © Vignelli Associates

W Frank Lloyd Wright's Guggenheim Museum 451
 © G. E. Kidder Smith/Corbis

XYZ Zanussi 'Oz' fridge 463
 Courtesy of Electrolux Home Products

Introduction

Writing a dictionary of modern design has been a challenging enterprise, given the changing nuances of the words 'design' and 'designer' over the past century and a half, the period covered by this volume. Now, in the early 21st century, even these words have become so pervasive in everyday language that their meanings have become dissipated. In addition to terms such as 'designer labels' and 'designer clothes' that emerged in the 1960s, other descriptors that entered common parlance in the 1980s, such as 'designer water', 'designer drugs', and 'designer stubble', began to render the word 'designer' less meaningful.

So how do we find a definition of design? Design is present in all aspects of daily life. It is involved with the world of work, in terms of environment, dress codes, equipment, and furnishing, even the processes and sequencing of work itself. It pervades every aspect of the domestic landscape, in decor, furniture, fittings, and appliances. In the world of leisure, too, design may relate to clothing, accessories, and equipment—whether skis, skateboards, tennis racquets, toys, theme park rides, or even outboard motors—as well as to the wider environment of cinemas, restaurants, fitness centres, or shopping malls. Design is also an integral ingredient in the form, function, and appearance of all kinds of transport, public, or private. It influences the appearance of everything encountered during the course of a day, ranging from the layout of newspapers, books, and magazines to the allure of advertising, packaging, and other ephemera.

Such a focus on 'design' in the vocabulary is evident also in the media—advertising, the increasing range of design-oriented publications and awards, television programmes, and the emerging prevalence of designer celebrities—and reinforced by the growing number of museums and collections devoted to design. That most major museums that collect and exhibit modern design present a very similar narrative reflects the fact that design has become an increasingly global commodity. The late 20th-century industry of museum and collection making gave rise to the establishment in 1989 of the Design Museum, London; in 1991 of the permanent collection of the Centre de Création Industrielle (CCI), Paris; and in 1999 of the Museu do Design, Lisbon.

Corporate enterprises have also been part of this, for example the Vitra Museum, inaugurated in 1989, and the Piaggio Museum, in 2000. In their own ways all of these collections perpetuate certain design mythologies, endorsing particular views of the ways in which design may be predicated upon celebrated designers, notable objects, or the singular aesthetic and cultural contributions that the individual corporations have made.

Although many collections of 19th-century design offer a richer diet of national perspectives and complexities than many of their 20th-century counterparts, in the 19th century itself many museums of design and the decorative arts were concerned with ideas of improving taste. Highly influential on the formation of a number of other major European and Scandinavian museums in the second half of the 19th century, the Victoria and Albert Museum in London had its mid-century origins in the Museum of Manufactures established by Henry Cole. The core collection of the latter was centred on objects purchased from the Great Exhibition of 1851 with the aid of a government grant. There was a gallery devoted to the display of 'Examples of False Principles in Decoration' that epitomized the outlook of the design reform movement, seeking to improve the taste of artisans, manufacturers, and the public. Notions of 'improvement' and 'false principles' of design also underpinned Nikolaus Pevsner's *Pioneers of the Modern Movement: From William Morris to Walter Gropius*, first published in 1936 but later substantially revised and enlarged and retitled *Pioneers of Modern Design*. This line of thinking was what informed the 'Good Design' philosophy of a number of organizations and awards. Such ideas were embodied in the aims of the Council of Industrial Design in Britain (established 1944), the Rat für Formgebung (Design Council, established in 1953) in Germany, and the Industrial Design Council of Australia (established 1960). This ethos also pervaded the outlook of the Rinascente and Bijenkorf department stores in Italy and Holland respectively, and the Museum of Modern Art, New York (established 1929).

Like many contemporary museum displays much of the writing and exhibiting of design over the past two decades in particular has centred on narratives of design success, divorced from many of the wider social, political, cultural, economic, and technological circumstances in which it is manufactured, marketed, and consumed. The design press often played a leading role in generating such an outlook, generally acting both as shop window and information exchange for the design

profession. Its attitude to views that deviated from an orthodoxy emphasizing the significance of individual designers, design movements, and organizations was often hostile. For example, when Adrian Forty published his seminal *Objects of Desire: Design and Society 1750–1930* in 1986 it received a number of harsh reviews in the design press, including one in the often more open-minded British periodical *Blueprint*, whose reviewer was not only unhappy with Forty's dismissal of the 'widespread assumption that individuals are the masters of their own will and destiny' but also with the fact that 'Le Corbusier is scarcely mentioned; Loos, Voysey, the Werkbund and Art Nouveau not at all'. Such a view seemed to suggest that a history of design that had at its core social, economic, technological, and cultural change as constituent elements of the world in which design is conceived, manufactured, marketed, and, most importantly, consumed was not appropriate unless liberally populated with 'names'.

The history of design as an academic discipline recognized by the establishment of specialist degree courses and the publication of significant scholarly research has had a comparatively short life. This may be compared to many other disciplines in the arts and humanities, even in relation to one of the history of design's closest family disciplines, art history. The impetus for the emergence of the history of design in Britain in the 1960s stemmed from a national requirement that all courses in practical design disciplines in higher education should devote 20 per cent of their time to historical and complementary studies. Those involved in teaching the history of design as part of this new curriculum structure had few readily available texts to call upon and were themselves often either graduates in the history of art or other arts and humanities disciplines with little training in the visual arts. Traditional art history at the time was still largely rooted in the principles of artistic 'pioneers' from Giotto to Cézanne, masters and pupils, styles and their transmission, art movements and, to a lesser extent, wider concerns such as patronage. Many of the available publications relating to the historical fields of design activity were written by connoisseurs or specialist museum curators, and were neither accessible nor appropriate for study in schools of art and design. Furthermore, they rarely focused upon the immediate past and were thus generally less appealing to students immersed in contemporary practice. As a result Pevsner's well-illustrated and well-written *Pioneers of Modern Design* seemed an attractive starting point. However, despite a degree

of contextualization of social and technological change, his account centred on the artistic creativity of well-known designers or 'pioneers' in the shift away from the 'false principles' of ornament, so derided by the design reformers of the latter half of the 19th century. This led inevitably towards the establishment of Modernism, an outlook firmly rooted in the spirit of the 20th century, its new technologies, materials, and abstract forms. By the 1960s, when the seeds of design history were being sown in British higher education, many of the tenets of Modernism were also being challenged on several fronts.

In the later 1950s, for example, the influential Hochschule für Gestaltung (College of Design, HfG) at Ulm, a post-Second World War German counterbalance to the Bauhaus of the interwar years directed by Walter Gropius from 1919 to 1928, marked a shift away from prevalent notions of the primacy of the individual creative designer or 'pioneer'. Furthermore, the extent to which individual designers were able to resolve problems in a period of increasing complexity and rapid social and technological change was being questioned. At the HfG, under the influence of Tomás Maldonado and others, there was a distinct move away from the traditional curricular emphasis on *making* towards a more scientific and analytical approach to design. Students would spend up to 50 per cent of their time studying other, design-related, subjects, such as social anthropology, cultural history, and statistical analysis. The implications of the 'scientific operationalism' of the HfG were taken up by the emerging Design Methods movement and also reflected in design management approaches in the 1960s.

Modernism came under siege through the writings of the French sociologist Roland Barthes, writer and academic Umberto Eco, historian and cultural theorist Gillo Dorfles, and architect designer Robert Venturi, all of whom looked to explore the realities of a richer visual syntax that drew upon popular culture as one of the major ingredients of Postmodernism. In Italy those associated with the progressive Anti-Design and Radical Design movements also sought to energize what its participants saw as the increasing social and cultural impoverishment of design, whilst in Britain the sheer exuberance and ephemeral nature of Pop did much to undermine the orthodoxy of Modernism. Fordism, a mainstay of capitalist enterprise since the early years of the 20th century when Henry Ford introduced moving assembly lines, was also in decline as many industrial, production-based economies inclined towards more service-based, post-industrial alternatives.

Large-scale Fordist production runs for homogeneous mass-consumer markets were replaced by more flexible modes of manufacture that catered more effectively for the increasingly varied demands of a pluralist, Postmodern society where consumer choice, rather than manufacturing dictate, became increasingly significant. Against such a backcloth it is perhaps understandable that in the period following the establishment of the first specialist free-standing degree courses in design history in Britain in the mid-1970s there was a tendency to contest substance, ingredients, and methods relating to the history of design. However, by 1987, when the *Journal of Design History* was launched, potential links were seen with other disciplines that explored material culture. These included anthropology, architectural history, art history, business history, craft history, cultural studies, design management studies, economic and social history, history of science and technology, and sociology.

Although the discipline of design history became more adventurous in its range of interdisciplinary thinking and exploration of the ways in which it could afford rich insights into other fields, one of its other characteristics in the later 20th and early 21st centuries was its comparatively limited geographical embrace. Given that much of mainstream history of design has been centred on the products of the industrial process (and thus focused on the industrialized world) this is understandable, although there is still much to be learnt about design in many of the under-represented subcontinents, regions, and countries such as South America, India, China, and the Pacific Rim. The heavy European and North American concentration of much design historical publication and research has given impetus to a number of international initiatives that set out to redress the balance. This began in 1999 with an international conference in Barcelona entitled *Historíar desde la periféria, historia i historias del disseny* that sought to develop the profile of the subject in the Spanish-speaking world. A second conference was held in Havana, Cuba, in the following year, with a third in Istanbul in 2002. The latter, entitled *Mind the Map: Design History beyond Boundaries*, attracted contributions from many other countries not generally included in design historical and design studies. Papers relating to design activity and history in 27 countries were presented at this conference. In October 2003 the Design History Workshop Japan and its journal *Design History Japan* was launched, further disseminating design

historical research, pedagogy, and publication in new geographical arenas.

It is clearly impossible to include all facets of design over the 150 years that this dictionary addresses, although a considerable effort has been made to reflect the disciplinary richness of the history of design. The vast majority of entries relate to mass-produced goods, designers and manufacturers, critics and theorists, although key entries relating to fields such as graphics and clothing design have also been included. Given the way in which design impinges on all aspects of everyday life, as indicated at the beginning of this introduction, it is inevitable that hard choices have been made, with some entries included at the expense of others. A balance has been struck between the various constituencies outlined in this essay. These range from the generally linear narratives of museum collections and the cultural celebration inherent in the majority of media representations of design to the more inclusive coverage in contemporary design historical thinking and practice. This volume's scope is broader than that customarily attempted in previous dictionaries of design. The profile of design as a significant reflection of popular culture has been considered alongside other aspects of the discipline that have impacted upon, and continue to impact upon, everyday life, as well as to cover adequately 'designer culture'.

Something of this may be indicated by reference to the coverage of a number of letters of the alphabet. 'M', for example, includes such entries as Charles Rennie Mackintosh, William Morris, Jasper Morrison, and Alphonse Mucha, but also McDonald's, Mercedes-Benz, Moskovitch, Marimekko, Matsushita, Meccano, and the Munich Vereinigte Werkstätten für Kunst im Handwerk. Other aspects are reflected in the inclusion of the Mainichi Design Prize, Modernism, the Museum of Modern Art, New York, Tomás Maldonado, and Marshall McLuhan. I have made considerable efforts to extend the geographical, as well as the subject, range of the dictionary although this has proved difficult given the paucity of available material in several fields. However, there are optimistic signs for the future. Indications are that the position will change as the history of design is taken up positively as a subject for research, publication, and curriculum development in an increasing number of countries. I hope that this dictionary will help further to stimulate such work.

Aalto, Aino Aalto, Alvar A&E Design Aar
Abramtsevo Art Colony ABS Action Man
Mikhail Mikhailovich Adhocism ADI Adi
Aesthetic Movement Ahlström, Tom Aicl
Ajeto Akaba Albers, Anni Albers, Josef ,
Alchymia Alessi Alfa Romeo Allgemeine
Gesellschaft Alliance Graphique Internati
alternative design Ambasz, Emilio Ameri
Industrial Designers American System of
American Union of Decorative Artists and
Amsterdam School Andrews, Gordon an
Anti-Design Apple Macintosh Computer
Archer, L. Bruce Archigram Architectural
Archizoom Arkady Armani, Giorgio Art l
Artel Cooperative Arteluce Artemide Ar
Art Moderne Art Nouveau Art pour Tous
Exhibition Society Arts & Crafts Moveme
Art Workers' Guild Arzberg Ashbee, Cha
Ashley, Laura Aspen Design Conference
Disegno Industriale Aston Martin Atelier
AUDAC Audi Aulenti, Gae Australian De
A&E Design Aarnio, Ee
ony ABS Action Man
Adhocism ADI Adi
tröm, Tom Aicl
Albers, Josef ,
Alessi Alfa Romeo Allgemeine
naft Alliance Graphique Internati
alternative design Am Ameri
Industrial Designers System of
American Union of Decorative Artists and
Amsterdam School Andrews, Gordon an
Anti-Design Apple Macintosh Computer
Archer, L. Bruce Archigram Architectural
Archizoom Arkady Armani, Giorgio Art l
Artel Cooperative Arteluce Artemide Ar
Art Moderne Art Nouveau Art pour Tous
Exhibition Society Arts & Crafts Moveme
Art Workers' Guild Arzberg Ashbee, Cha
Ashley, Laura Aspen Design Conference
Disegno Industriale Aston Martin Atelier
AUDAC Audi Aulenti, Gae Australian De
Aalto, Aino Aalto, Alvar A&E Design Aar
Abramtsevo Art Colony ABS Action Man
Mikhail Mikhailovich Adhocism ADI Adi
Aesthetic Movement Ahlström, Tom Aicl
Ajeto Akaba Albers, Anni Albers, Josef ,
Alchymia Alessi Alfa Romeo Allgemeine
Gesellschaft Alliance Graphique Internati
alternative design Ambasz, Emilio Ameri
Industrial Designers American System of
American Union of Decorative Artists and
Amsterdam School Andrews, Gordon an

Aalto, Aino (1894–1949) The work of the Finnish designer Aino Aalto (née Marsio), like the American designer Ray *Eames, has tended to be overshadowed by the work of her husband, a process in which historians have colluded. In fact she collaborated with Alvar across many aspects of design practice, from furniture to glass, following their marriage in 1924. A qualified architect and interior and glass designer, she and Alvar designed for many companies including the *Iittala glass company (which made her 1932 pressed glass *Bölgeblick* range, in production until the 1950s). As production supervisor, she also played an active role in the *Artek Company (established in Helsinki in 1935) which manufactured and sold Aalto furniture as well as promoting modern Scandinavian art and design. She and Alvar were jointly awarded the commission for the Finnish Pavilion at the *New York World's Fair of 1939–40.

Aalto, Alvar (1898–1976) Alvar Aalto is the most celebrated Finnish architect and designer working in furniture, lighting, glass, and textiles. His work is characterized by the use of organic forms and natural materials allied to the emphatically contemporary aesthetic tenets of *Modernism. Alvar Aalto trained as an architect at the Helsinki University of Technology, completing his studies in 1921. From 1923 to 1927 he established an office in Jvaslaka, in Turku from 1927 to 1933, and then in Helsinki until his death. In 1924 he married architect-designer Aino Marsio, who collaborated with him on many designs until her early death in 1949 (*see* AALTO, AINO). Amongst Aalto's best-known buildings were the Paimio Sanatorium (1929–33) and the Municipal Library at Viipuri. His use of organic forms and natural materials blended with the Modernist aesthetic, which was evident at Viipuri, was also embraced in his design for the Finnish Pavilion at the *New York World's Fair of 1939–40, which did much to establish his reputation in the United States. After the war he was appointed Professor of Architecture at the Massachussets Institute of Technology (1946–8) and in 1949 won a competition for design of the village centre of Säynätsälo, one of his most significant projects.

From the mid-1920s, in common with many other avant-garde designers in Germany, France, and elsewhere, Aalto designed tubular steel furniture. However, his reputation was founded on the use of moulded plywood, with which he began to experiment from 1929, working closely with Otto Korhonen, a factory manager at Huonekalu-ja Rakennustyotehdas. He found his *métier* in the sweeping organic forms of the *Paimio* armchair (1930–3) and the bentwood stacking stool (1933) for the Viipuri Library. The former was specially designed for the Sanatorium, its flowing, scroll-like form and laminated birch and plywood elements embodying practicality and functionalism—it could be easily cleaned and was able to be moved quietly, thus suiting its context. He was also well-known for glass designs, winning several competitions, resulting in designs such as the *Riihimaki Flower* set of stacking vases (1932) and the *Savoy* vase (1936) manufactured by *Iittala.

During the 1930s Aalto's work attracted increasing recognition outside Scandinavia, his furniture being shown in an exhibition sponsored by the *Architectural Review* and at the *Milan Triennale in 1933, the same year that the Aaltos moved their office to Helsinki. Many of his designs were manufactured and sold through the *Artek Company, established in Helsinki in 1935 and sales at home and abroad radically increased. Aalto's international reputation was consolidated by the showing of many of his and Aino's designs in the Finnish Pavilion at the 1937 *Paris Exposition and the mounting of a solo exhibition at the *Museum of Modern Art, New York, in 1938. After the war Aalto's principal furniture designs were produced in 1946-7 and 1954-6, including the elegant *Armchair 406* for the Villa Mairea (1946) and the ash veneer *Stool X601* (1954).

A&E Design (established 1968) This Swedish design consultancy was established in Stockholm by Tom Ahlström and Hans Ehrich (1942–　), who had worked in Italy earlier in the 1960s. The company gained a reputation for functional, durable, and ergonomically sound everyday products and also developed a particular cachet for design for the disabled. The clean undecorated forms that characterized many of their design solutions are well suited to plastics, a medium with which they have been often associated. Amongst their well-known products are the *AB Turnomatic* ticket machine for supermarket and other queuing systems (replacing the old model with 46 parts with six injection moulded components), the *Jordan* scouring brush (1975), and the *Stockholm* folding stool (1995) designed for weary museum visitors. They have won many government commissions and received many Swedish design awards.

Aarnio, Eerio (1932–　) A leading Finnish architect and designer who emerged as an international figure in the 1960s, Aarnio trained at the School of Industrial Design in Helsinki from 1954 to 1957. He established his design practice in Helsinki in 1962, specializing in furniture and interior design, but also worked in graphics and photography. Although his earlier furniture designs respected vernacular traditions and materials, he began working with plastics in the early 1960s, producing such strikingly futuristic designs as the spherical 1963 *Ball* easy chair for the Helsinki company Asko Finnternational. Available in red, black, white, and orange it brought Aarnio to international notice and was followed by other innovative designs such as the bulbous *Pastilli* chair of 1967 and the red, *Pop-influenced *Tomato* easy chair of 1971. In the early 1980s he began designing furniture on the computer screen. His design work was recognized through the award of the Design Prize of the American Institute of Interior Design (1969), his inclusion in the *Masters of Modern Design* in New York (1991), and the reissuing of his 1960s designs in 1997.

Abramtsevo Art Colony (1870–c.1917) Located about 40 miles from Moscow, this Russian artists' colony was for much of its history involved with the revival of Russian folk art and national culture and was at its most dynamic in the later 19th century. Originally a private estate purchased in 1843 by the Slavophile Russian writer Sergei Aksakov, who met regularly with like-minded Muscovite intellectuals, Abramtsevo was given further nationalistic impetus following its acquisition in 1870 by the Russian industrialist and art patron Savva Mamontov. He brought together many leading artists and designers, cultivating a strong interest in national traditions and Russian cultural heritage, as evidenced

by the estate's buildings and their decorations. Many of those associated with the colony went on to become leading figures in Russian art, their imaginations fuelled by Mamontov's collection of traditional Russian folk arts. Amongst those living in Abramtsevo during this period were the painters Il'ya Repin and Mikhail Vrubel, both of whom also worked with ceramics. In addition to ceramic figures, Vrubel also designed the traditional tiled stove in the church of Christ the Saviour in Abramatsevo, built in medieval style by members of the colony. Abramtsevo's artists and designers also built the Teremok, a traditional pitched-roof Russian cottage that contained traditional carved wooden furniture. Mamontov also built the first private opera in Russia, with set designs by the colony's artists. Other artists associated with Abramtsevo included Apollinarius and Viktor Vasnetsov, Mikhail Nesterov, Valentin Serov, Vasily Poleno, and Yelena Polenova.

ABS (acrylontrile-butadiene-styrene, 1940s–) ABS was one of many of the new breed of plastics that emerged in the post-Second World War period. It is a strong material that can be injection moulded and blow moulded as well as thermoformed or vacuum formed from ABS sheets. It is able to be produced in a wide variety of colours and is often used in the production of the casings of a wide variety of household goods from hairdryers to vacuum cleaners, and from telephones to toys such as *Lego. From the 1960s companies such as *Kartell and *Cassina produced many exciting design solutions for ABS furniture.

Action Man (1966–84) Toy manufacturer Hessenfeld Brothers originally launched this 12-inch (30 cm) tall figure in 1964 in the USA as GI Joe. Following a company takeover by the General Mills Corporation in 1966 it was renamed and marketed under the British Palitoy brand label competing with Pedigree Toys' British combatant launched at the same time, Tommy Gunn. Action Man lived up to his name with highly flexible joints, soft gripping hands (1973), moving eyes (1976), and a radically enhanced physique (1979). Action Man's commitment to combat and militarism attracted considerable criticism in many quarters, a stereotypical male counterpart to the glamour and consumption lifestyle of *Barbie and her more fashion-conscious boyfriend Ken. Like Barbie, Action Man also boasted many guises, from member of the armed forces to astronaut. However, by the mid-1980s Action Man was finding it increasingly difficult to compete with sophisticated computer games and Star Wars toys and so he was taken off the market in 1984. A series was launched in 1993.

Adamovich, Mikhail Mikhailovich (1884–1947) After attending the Strogonov School of Art and Industrial Design in Moscow, Adamovich travelled to Italy to study decorative painting in 1907. He returned to Russia in 1909, painting murals in St Petersburg and Moscow. After the First World War he worked in the art department of the State Porcelain Factory (known as the Imperial Porcelain Factory before the Russian Revolution and, after 1925, the Lomonosov State Porcelain factory). This was followed by service in the Red Army from 1919 to 1921, after which he returned to work in the State Porcelain Factory (1921–3), where he drew on revolutionary agitprop subject matter, including the head of Lenin, the Soviet Red Star, the hammer and sickle, and other emblems of the Soviet regime. He was subsequently awarded a medal at the 1925 *Paris Exposition des Arts Décoratifs and worked at other major porcelain works such as the Volkhov Factory (1924–7) and the Dulevo Works (1927–33).

ADHOCISM

Notions of 'Adhocism' were coined by architectural designer, theorist, and sometime designer Charles *Jencks and Nathan Silver in their book *Adhocism: The Case for Improvisation* (1972). They considered the ways in which designers could take immediate action through the use of readily available components in ways that had never been conceived in their original design. Hippy communities in the United States had explored some of these ideas in the 1960s, as in Drop City, where dome dwellings were constructed from car roofs bought cheaply from scrapyards, reusing materials abandoned by the consumer society. Some positive aspects of this outlook were to be found in *The Whole Earth Catalogue* of 1968, an encyclopaedia of alternative ways of living and suppliers of the means of doing so.

Adhocism *See* box on this page.

ADI (Associazione per il Disegno Industriale, established 1956) ADI, the Association for Industrial Design, has exerted a powerful voice in the promotion of the design profession in Italy for almost half a century, a period in which Italian design has enjoyed a significant international reputation for style, iconoclasm, and innovation. The organization has brought together a wide range of professionals in the promotion of design including designers, publishers, researchers, academics, critics, and journalists. It has also sought to foster recognition of the social, economic, and cultural significance of design and to act as a persuasive intermediary between the worlds of design and business. Since 1962 ADI has also managed the prestigious *Compasso d'Oro design award scheme (established in 1954 through La *Rinascente department store), the longest established and most important industrial design award in Italy. Four decades later, in 2001, ADI updated the competition's rules and regulations relating to selection and participation, including the opportunity for qualifying products to be given the ADI Design Index Quality Award and to be published in the annual publication, the *ADI Design Index*.

Manufacturers are also able to use the Quality Award in publicity and advertising. Also in 2001 the *Fondazione ADI per il Disegno Industriale (the ADI Foundation for Italian Industrial Design) was established with the aim of promoting the historic patrimony of Italian design and its future possibilities, whether in terms of culture, research, publishing, or funding.

ADI's activities devolve around three major departments: designers, enterprises, and general affairs, with regional hubs in Pesaro, Udine, Turin, Verona, and Rome. There are also focus groups that centre on design for disability and computing for design. The organization is represented on the Consiglio Nazionale dell'Economia e dei Lavoro (the National Economic and Labour Council) and works closely with Confidustria (the Confederation of Italian Industry). It was also a founding member of ICSID (the *International Council of Societies of Industrial Design, established in 1957), of BEDA (Bureau of European Design Associations), and is a member of ICOGRADA (the *International Council of Graphic Design Associations, established 1963).

Adidas (established 1920) This leading global producer of sports footwear, equipment, and leisure wear is widely recognized

by its trefoil logo, launched in 1972, the more geometric performance logo introduced in 1991, as well as the three stripes that run across many of its products. However the company's origins were modest, with the first handmade training shoe being made by the company's German founder Adolf ('Adi') Dassler in the family home in 1920. The company's first shoe-making factory was established in 1927 and Adidas shoes were seen at the Olympic Games in Amsterdam in the following year. Tennis shoes were added to the range in the early 1930s and a second factory opened in 1938. However, it was confiscated by the Nazis in the following year and taken over by the US army after the end of the Second World War. Although Adi Dassler quarrelled with his brother Rudolf, who went on to create the Puma brand in 1948, the Adidas company developed a strong presence in the post-war years with effective publicity campaigns. Its products were successfully promoted at succeeding football World Cup competitions and Olympic Games, including those at Melbourne in 1956, Rome in 1960, and Tokyo in 1964, where a significant percentage of athletes wore Adidas shoes. The company began manufacturing in France and, in the early 1960s, began to diversify into the production of footballs (1961) and tracksuits (1962), the first tracksuits with the characteristic three stripes being marketed in 1964. The company was also concerned to innovate, producing a number of key designs such as the *Achille* jogging shoe (1968), the revolutionary *Torsion* sole system (1998), and the *Predator* (1995). Association of the company's products with leading sporting figures continued to be a key part of its marketing strategy. Both Mohamed Ali and Joe Frazier wore Adidas boots for their world heavyweight boxing bout in 1971, the German World Cup football

champions all wore Adidas products in 1990, and the French World Cup winning team of 1998 was also sponsored by the company. In the early 1990s the company was radically restructured, in 1997 taking over the French Salomon Group, a leading manufacturer of winter sports equipment. The company's success is highly visible today in the large number of people around the world who carry its logo on leisure wear, sporting goods, and equipment, whether or not they are highly active participants in such activities.

AEG (Allgemeine Elektrizitäts Gesellschaft, established 1883) AEG was originally founded as the Deutsche Edison Gesellschaft für angewandte Elektrizitäts (DEG) by engineer Emil Rathenau two years after he had seen Edison's lighting at the 1881 Paris Exposition Internationale de l'Electricité. In 1887 the company was renamed as the Allgemeine Elektrizitäts Gesellschaft (General Electric Company), rapidly expanding its activities from the manufacture of light bulbs to the production of electric motors, domestic appliances, transformers, and other electrical equipment and the building of power stations at home and abroad. Industrial expansion continued in many fields of industrial production and transportation, making the company highly visible by the early years of the 20th century. The company also placed a high premium on design with the employment of leading architects and designers as an important underpinning of its *Corporate identity. These included Otto Eckmann, who executed many publicity and typographical designs, including the company's presentation at the Paris 1900 Exhibition. Perhaps most significant was the appointment of Peter *Behrens as artistic adviser to AEG in 1907, taking on the responsibility for the corporate identity of all dimensions

AESTHETIC MOVEMENT

This artistically self-conscious and highly fashionable British movement of the late 1860s, 1870s, and 1880s drew on a variety of sources. These included the work of artists associated with the Pre-Raphaelite Brotherhood, designers linked to the *Arts and Crafts Movement and the work of Japanese artists and designers whose work became increasingly influential from the 1850s onwards. Oriental sources also provided British artists and designers such as James McNeil Whistler and E. W. *Godwin with sources of inspiration that provided an alternative to the prevailing historicism characterizing much contemporary Victorian work. In fact, 'Art Furniture' was a term frequently adopted in design periodicals, signalling an alternative contemporary 'artistic' outlook to the prevalent commercialization of the past favoured by many contemporary Victorian manufacturers and consumers. The terms 'Art Industries' and 'Art Potteries' were also indicative of the preoccupations of a style that was satirized by George Du Maurier in the periodical *Punch* and W. S. Gilbert in the operetta *Patience*. The latter, subtitled an 'Aesthetic Opera', was first staged by D'Oyly Carte in 1881 with costumes supplied by *Liberty & Co. Arthur Liberty's store opened in Regent Street, London, in 1875. Liberty's played a leading role in the commercialization of Aesthetic, especially oriental, goods, although a number of other London stores such as Swan & Edgar and William Whiteley also opened their own oriental departments in order to capture the attention of fashion-conscious metropolitan consumers. Amongst the purveyors of 'art industry' products were Howell & James, W. B. Simpson & Sons, and Christopher *Dresser's short-lived Art Furniture Alliance which opened in London in 1880 for the sale of furniture, metalware, and other decorative artefacts with attendants wearing Aesthetic dress. In addition to those characteristics already identified, other ingredients of the Aesthetic sensibility included the literary, 'art for art's sake' outlook of the poet and writer Oscar Wilde and the sensual illustrations of Aubrey *Beardsley. Typical stylistic motifs included the sunflower, the lily, the peacock, and the stork as well as all kinds of oriental birds and fish. Many of the ways in which such motifs permeated the lives and possessions of fashionable society may be seen in the book illustration of artists such as Kate Greenaway and Walter *Crane.

of the company. These ranged from commercially successful arc lamps, clocks, kettles, and fans to publicity materials, exhibition pavilions, showrooms, factory buildings (including the famous Turbine Hall in Berlin 1909), and workers' housing and furniture. Such designs, which often incorporated standardized elements, embraced an efficient, contemporary aesthetic symbolizing the modernity of the industry that produced them, an outlook that was compatible with the modernizing tendencies of the *Deutscher Werkbund, established in 1907. He also redesigned the company's AEG logotype, which had first been introduced in abbreviated form in 1898. After Behrens's departure in 1914 the company did not employ such high-profile designers although it continued to play an important economic role. In the post-Second World War period the company redefined its activities. In the late 1970s it gave up its role in electricity generation, concentrating on such fields as microelectronics, domestic electrical appliances, and business-oriented electronic communications technology.

Aesthetic Movement *See* box on p. 7.

Ahlström, Tom *See* A&E DESIGN.

Aicher, Otl (1922–91) A German graphic designer and educator, Aicher studied at the Munich Academy of Fine Arts from 1946 to 1947. Having established a studio in Ulm in the following year, he later became closely associated with the highly influential and radical Hochschule für Gestaltung at *Ulm. In fact he was a co-founder and lecturer in visual communication from 1954 to 1965. He was also vice-chancellor from 1962 to 1964. He was strongly influenced by Max *Bill, the institution's first director and a graduate of the *Bauhaus. His graphic design work is characterized by a sense of structure, geometric organization, and discipline and communicates an ethos of functionalism. Whilst at Ulm he collaborated on the design and display of *Braun products with Hans *Gugelot, another key figure at the institution. However, Aicher is perhaps best known for his graphic design programme for the 1972 Munich Olympics, which embraced all the visual dimensions of the event, ranging from uniforms and interiors, to maps, street signs, and pictograms denoting individual sporting activities. He also worked on *Corporate identity graphics for a number of major clients including Lufthansa (1962–4), Frankfurt Airport (1967–70), König Pilsner (1975–6), and Erco (1975–7).

Airbrush The airbrush is a tool, powered by compressed air, which can spray ink or paint in a highly controlled manner and, before the advent of digital technology, was widely used by artists and designers to produce realistic two-dimensional representations of three-dimensional objects. Widely favoured by automobile stylists and industrial designers such as Raymond *Loewy, it was able to convey product ideas in an immediate and striking manner.

Ajeto (established 1989) After collaborating artistically for some years the celebrated Czech designer Borek *Sípek and talented young glass blower Petr Novotny founded this glass company in 1989, building up a specialist team of technicians and artists in order to explore the possibilities of innovation in the field. With Sípek as artistic director, and Novotny and Fafala as co-directors, the company specializes in handmade, limited edition pieces that extend the technical possibilities of the medium. It has produced work for *Driade in Italy, Maletti in Italy, lighting for Prague Castle, the Steltman Galleries in the Netherlands and the USA, and the Karl Lagerfeld shop in Paris.

Akaba (established 1986) This progressive Spanish furniture company was founded on four major principles: a commitment to design, an international outlook, a distinctive corporate identity, and the creation of new jobs. Many of its designs were avantgarde and conceived by prestigious designers such as Javier *Mariscal and Santiago Miranda (*see* KING-MIRANDA ASSOCIATI). From the 1990s the company began to concentrate on the contract market and its success was marked by a considerable expansion in scale: it grew from three employees in 1986 to 85 in 2000. More than 50 per cent of its output is exported around the world. Many of Akaba's designs have been geared to transportation. In Spain these have included seating by Rafael Moneo for Seville Airport, furniture for the new Airport Terminal at Bilbao, and benches for the Bilbao Underground and in Germany the architect Helmut Jahn designed the *Nomad* seating for the new Köln-Bonn Airport Terminal. The company's designs have featured widely in the design press as well as a number of prestigious exhibitions, including the *Nouvelles Tendances* exhibition at the Pompidou Centre, Paris

in 1987, where the complete Mariscal Furniture collection was shown. The company has also received a number of leading Spanish design prizes including the Delta de Ora award for the *Hola* chair in 1997 and the National Award for the company's professional development in 2000.

Albers, Anni (1899–1994) Textile designer and weaver Anni Albers (née Fleischmann) was born in Berlin, studying at the School of Applied Art, Hamburg, from 1919 to 1920. From 1922 to 1925 she studied in the Weaving Workshop at the Weimar *Bauhaus. In 1925, the year in which the Bauhaus moved to its new buildings in Dessau, she married Josef *Albers, a leading tutor at the school. She wove fabrics and wall hangings for the new buildings and, in 1929, made the transition from student to assistant in the Weaving Workshops. She moved to Berlin in 1932 when the Dessau Bauhaus was closed down as a result of its Socialist leanings. However, in the following year the Berlin Bauhaus was also closed down and the Albers found it necessary to leave Germany because Anni was Jewish and they were associated with a 'Bolshevik' cultural institution. Philip *Johnson, the American architect and curator, helped them to leave with the offer of teaching posts at the new and progressive Black Mountain College in North Carolina in the United States. Josef was appointed Professor of Painting and Anni Assistant Professor of Art, posts they held until 1949 when Anni became the first weaver to have a solo exhibition at the *Museum of Modern Art, New York. Whilst teaching at Black Mountain Anni had worked on industrial prototypes for textiles and, from 1950, when she and her husband moved to New Connecticut, she began work as a freelance, designing textiles for *Knoll International. She became increasingly interested in printmaking and, from 1970, when she gave up weaving completely, she worked with graphics and design for printed textiles. She also wrote a number of books including *On Designing* (1959) and *On Weaving* (1965), receiving for the latter a Decorative Arts Book Award citation. In addition to a number of honorary doctorates she was also awarded the Gold Medal of the American Crafts Council for 'uncompromising excellence.'

Albers, Josef (1888–1976) An influential German designer, artist, teacher, and writer, Albers was closely associated with the *Bauhaus, where he studied between 1920 and 1923, before joining the staff as an assistant to László *Moholy-Nagy on the Foundation Course (*Vorkurs*) and technician to the glass workshop. His teaching was based on a sound knowledge of physical properties and visual characteristics, involving structural explorations in paper and card, as well visual communication and perception. Much experimental structural work conducted on the Foundation Course involved the use of scissors and paper. In 1925 Albers became the first Bauhaus student to become a full master at the Bauhaus and, in the same year, married a Bauhaus weave and textile design student Anni Fleischmann (*see* ALBERS, ANNI). In 1928 he succeeded Marcel *Breuer as head of the furniture workshops until 1929, during which period he designed bentwood and tubular steel furniture. During his period at the Bauhaus he worked across a number of design disciplines, including church seating and a wood and glass display cabinet at the Bauhaus exhibition of 1923, a tea glass (1924), and a bentwood armchair (1929). In the mid-1920s he experimented with designs for stencil lettering for advertising, built on the principles of basic geometry. The resulting letterforms, like

those of a number of others at the time such as Herbert *Bayer, were intended to be easily legible, visual metaphors of a modern industrial society. Following the closure of the Bauhaus by the National Socialists in 1933 and further exacerbated by the climate of political repression in Germany, Albers emigrated to the United States with his wife Anni. There, with the help of Philip *Johnson, he was appointed as Professor of Painting (and Anni as an assistant professor) at the influential and experimental Black Mountain College in North Carolina (1933–49). He also taught at the Graduate School of Design at Harvard from 1936 to 1940 and at the Yale University School of Art from 1950 to 1960, where he established the graphic design programme and became the chairman of the Department of Design. He was also a visiting professor at the Hochschule für Gestaltung at *Ulm from 1953 to 1954 while it still remained close to the ideals of the Bauhaus. In the 1940s, building on his analyses of form and perception as a teacher at the Bauhaus and at Black Mountain College, he continued to study colour and perception. The results of such thinking were published in his book *Interaction of Colour* (1963), Albers often being said to have been an important influence on Op Art.

Albini, Franco (1905–77) Albini's design activities covered many spheres, from furniture, interior, and product design to architecture, planning, and museum design. He graduated in architecture from Milan Polytechnic in 1929, setting up his own practice in the following year. Although he had gained experience working with the architect, designer, and writer Gio *Ponti he became associated with the *Rationalist movement in 1930s Italy, a modernizing outlook which often informed the clean, articulate forms of his products and build-

ings. He often experimented with radical solutions, as in his radio design of 1938, where he set the loudspeaker between two sheets of glass, and an experimental shelving system of 1940. He participated in the *Milan Triennali, showcases for progressive Italian design from the 1930s onwards, showing furniture at the IV Triennale and designing interiors for the VI Triennale of 1936. At the IX Milan Triennale of 1951, although not typical of his work as a whole, he designed the *Margherita* cane armchair for La *Rinascente's garden terrace display, for which he was awarded a Gold Medal. From the 1930s to the 1960s he was commissioned to design furniture, products, and lighting for many other companies such as Poggi, with which he had a close working relationship from 1950 to 1968. Amongst the designs for Poggi were his knockdown table of 1951, the *Luisa* armchair (awarded a *Compasso d'Oro in 1955) and the *PS16* rocking chair of 1956. His designs for Arflex included the *Fiorenza* chair (1952–5); other companies he worked for included Bonacina, Knoll, and Fontana Arte. From 1952 he also worked closely with the architect Franca Helg on a number of important projects including the Rinascente department store in Rome (1957–61) and stations and signage for the Milan subway (1962–9). He had been co-editor of the design periodical *Casabella* for a year immediately after the Second World War and taught at the University Institute of Architecture in Venice from 1949 to 1964 and also at Milan Polytechnic. As well as playing a significant role in Italian debates about architecture, planning, design, and museology he was a member of the Associazione per il Disegno Industriale (*see* ADI) and *CIAM and won many awards including the Olivetti Architectural Prize in 1958.

Alchimia *See* STUDIO ALCHIMIA.

Alessi (established 1921) Founded in northern Italy by Giovanni Alessi Anghini as a manufacturer of metal components, the company began to produce everyday domestic and catering products in the late 1920s. From 1932 it developed an independent design policy under the direction of Carlo Alessi, Giovanni's son. From the 1980s the company has become widely recognized internationally for its technical and stylistic innovations and often slightly idiosyncratic, yet highly fashionable, *Postmodern products by leading designers such as Michael *Graves, Alessandro *Mendini, Ettore *Sottsass, Matteo *Thun, and Philippe *Starck. In Italy itself Alessi products generally cater for everyday purposes, whereas in the valuable export markets its more design-conscious products are seen to represent the stylishness and fashionability of Italian design.

Alessi designs were produced on an in-house basis (often by Carlo Alessi himself) until 1954 when designers such as Anselmo Vitale and Luigi Massoni began to be employed on a consultancy basis. After the Second World War the company increasingly turned to stainless steel instead of the nickel silver and brass that had characterized its earlier products. Though still respecting the craft traditions that were such a key aspect of design innovation and practice in post-war Italian consumer goods, the company also expanded its scale of production to what may be seen as medium-sized. In 1970 Alberto Alessi Anghini became general manager of the company and has been responsible for the company's increasing commercial and stylistic prominence for more than 30 years. An important landmark in the company's profile was the *Tea and Coffee Piazza* limited edition project initiated by Alessandro Mendini as part of a strategy to promote the company's profile internationally and to situate Italian design within an international context. A number of designers from different countries were commissioned including Mendini himself, Paolo Portoghesi, the Americans Robert *Venturi, Michael Graves, Charles *Jencks, and Stanley Tigerman, the Austrian Hans *Hollein, and the Japanese Kazuma Yamashita. These and subsequent experimental designs were produced under the trademark of the company's experimental division, Officina Alessi. Ironically, perhaps, amongst the best-known designs produced by the company are those by non-Italians such as Michael Graves's *Kettle with Bird Shaped Whistle* or Philippe Starck's *Juicy Salif* lemon squeezer. The company has also produced a number of designs that seek to underline its sophistication and awareness of design heritage, reflecting a cultural promotion strategy similar to that of the furniture company *Cassina and office equipment manufacturer *Olivetti. These include designs by the 19th-century industrial designer Christopher *Dresser, the Bauhaus metalware designer Marianne *Brandt, and the Finnish designer Eliel Saarinen.

Alessi has been highly adept at marketing its products through books and publishing ventures, multilingual catalogues, exhibitions, and the establishment of the Alessi Museum. Books have included *Alessi: The Design Factory* (1994) with essays by a number of people associated with the company and Alessandro Alessi's *The Dream Factory: Alessi since 1921* (1998). Amongst the exhibitions promoting the Alessi idea has been *L'Atelier Alessi. Alberto Alessi et Alessandro Mendini: dix ans de design 1980–1990*.

Alfa Romeo (established 1910) Founded as ALFA (Anonimo Lombarda Fabbrica Automobili) in Milan the company began its life producing vehicles and aircraft engines. The engineer Niccolò Romeo was employed

a

ALTERNATIVE DESIGN

In the late 1960s and early 1970s there were many writers and thinkers who looked towards alternative ways of living and consuming. These ranged from hippy communities that sought to reject the materialistic values of consumer society to those who adopted a more design-oriented moralizing approach, as in Victor Papanek's *Design for the Real World: Human Ecology and Social Change* (1971), or a more philosophical approach arguing for a decentralization of the design process, as in Eugene Schumacher's *Small is Beautiful: A Study of Economics as if People Mattered* (1973) and Ivan Illich's *Tools for Conviviality* (1973). American hippies rejected what they saw as the restrictions of consumer society, reacting against the clean cut looks and cosmetically enhanced appearance of mainstream Americans in favour of long hair, beards, and wearing brightly coloured and 'style-less' clothing rather than the tailored, branded outfits of the majority (*see* ADHOCISM). There were also many underground magazines such as *Fritz the Cat* and *Mr Natural*, illustrated by Robert Crumb, and *Fat Freddy's Cat* and *The Fabulous Furry Freak Brothers*, illustrated by Gilbert Shelton. In Britain magazines such as *International Times* (later retitled *IT*) and *Oz*, launched respectively in 1966 and 1967, expressed similar values.

from 1914, although his surname was not added to the company's name until after the Second World War. However, Alfa's involvement with automobile racing from the outset did much to establish its reputation and capture public interest. In the 1930s it employed the Italian car body stylists Touring for the *BC 2900 B Superleggera* (1937) and the *BC 2500 SS Duxia* (1939) and *Pininfarina for the *6C 2300 Pescara Coupé* (1939). In the 1950s the company moved into mass production, again employing Pininfarina for a number of designs, including the *Giulietta Spider* (1956) and iconic *Spider 1600 Duetto* (1966). *Bertone also contributed some notable designs including the *Giulietta Sprint* (1954) and *Montreal Coupé* (1967). Another celebrated designer, Giorgio Giugaro, styled the front-wheel drive, four-seater *Alfasud* (1972), for the production of which a new manufacturing plant had been established a few years earlier. However, in the 1970s and 1980s the company experienced a number of economic difficulties culminating in its take-over by *Fiat in 1987. The firm's reputation for style and performance has been continued with the Alfa Romeo *156* (1998).

Allgemeine Elektrizitäts Gesellschaft
See AEG.

Alliance Graphique Internationale
(AGI, established 1951) This was founded in Paris in 1951 by five French and Swiss graphic designers, but was extended to become an association of 200 leading graphic designers drawn from across the world. The original founders were Donald Brun and Fritz Bühler from Switzerland and Jean Colin, Jacques Garamond, and Jean Picart Le Doux from France. Membership of AGI is by invitation and is only extended to the most distinguished of practitioners. It is based in Zurich and congresses are held annually as well as regular exhibitions of members' work. AGI is a member of the *International Council of Graphic Design Associations (ICOGRADA) and seeks to promote graphic design as a means of commu-

nication, information, and education. In the early 21st century AGI sought to develop a website presence as a strategic means enhancing knowledge for the graphic design profession as a whole as well as providing the home for an AGI magazine, an information centre, data bank, and general archive that will eventually provide a historical reference for information about the body's aims and achievements since its inception in the mid-20th century.

Alternative Design, *See* box on p. 12.

Ambasz, Emilio (1943–) Having studied architecture at Princeton University from 1960 to 1965, the Argentinean Emilio Ambasz became Curator of Design at the *Museum of Modern Art (MOMA), New York from 1970 to 1975 where he organized the landmark *Italy: The New Domestic Landscape Exhibition* in 1972. This showcase for Italian avant-garde design thinking explored the idea of objects as part of a total environment—rather than individual, stand-alone, aesthetically self-conscious products—as seen in the work of groups such as *Archizoom and *Superstudio. He also curated the 1974 MOMA exhibition *The Chairs of Charles R. Mackintosh* and, in 1976, designed MOMA's environmentally focused exhibition entitled *The Taxi Project: Realistic Solutions Today*. As an industrial, graphic designer and exhibition designer, he established architectural and design offices in New York and Bologna, Italy, in 1976. The Emilio Ambasz Design Group was founded in New York in 1981. Design successes included the *Ergonomic *Vertebra* chair for Open Ark (1976), which responded to the movements of the user, the *Dorsal* seating system (1981), spotlights for Logotec (1981), and the *Osiris* lighting system for Erco Leuchten (1983). He has held many educational roles in Europe and the United States, including a visiting professorship at the Hochschule für Gestaltung at

*Ulm, Germany, in 1967. He has also won many design awards including the American Institute of Graphic Arts in 1973, the US National Design Award in 1980, and the *Compasso d'Oro in 1981.

American Society of Industrial Designers *See* INDUSTRIAL DESIGNERS SOCIETY OF AMERICA.

American System of Manufactures (19th century) The American System of Manufactures came to international attention at the *Great Exhibition of the Industry of All Nations, London, of 1851, and reflected the rapid strides in technology and industrialization that had been taking place for several decades in the United States. The USA won more awards in proportion to the number of its exhibits at the exhibition than any other participating nation. These included the McCormick reaper, sewing machines, clocks, and the Colt revolver. So striking and innovative were the American exhibits that the British government subsequently sent a team of experts to report back on American industrial progress, recognizing that the United States was emerging as a leading industrial force and competitor. One of the key features of the American System was its use of interchangeable parts as a means of reducing manufacturing costs. The origins of the American System of Manufactures lay in the early recognition that national affluence was only likely to come about if manufacturing output could be dramatically enhanced and competitively priced products made available to the consumer. Fields that showed significant early developments in this mission were clock manufacture (with innovations pioneered by such figures as Eli Terry in the early 19th century), the axe handle industry of the 1830s and 1840s (particularly the work of engineer Elisha K. Root and entrepreneur Samuel Collins), and

a

AMSTERDAM SCHOOL

Very different in spirit to the rational aesthetic of its *Modernist counterpart in Holland, De *Stijl, the decorative work of the Amsterdam School (the name by which a number of architects were known) was characterized by a more individualist style whose origins lay in Expressionism, the flowing lines and decorative tendencies of the painter Jan Toorop, and aspects of the architectural design of Dutchman Hendrikus Berlage and American Frank Lloyd *Wright. The major designer-architects of the group were Michel de Klerk and Piet Kramer. Like many other designers of the late 19th and early 20th centuries they believed in the integration of architecture, interiors, furnishings, and fitments, ideas that they first put into practice in Amsterdam's Scheepvaarthuis (Shipping House, 1912–16) where they assisted architect Johan van der Mey. This was rich in detail, whether in terms of the intricate wrought iron detailing on the exterior or its highly decorative interior metal fittings, stained glass, and textiles. Many of their ideas were seen in the Amsterdam-based periodical *Wendingen (1918–31), the group's mouthpiece, particularly in its earlier years. De Klerk and Kramer's architectural designs were characterized by the sculptural and decorative use of brickwork, both in terms of undulating surfaces set off by intricate decorative detailing, and the organic, expressive forms of the buildings themselves. This was strikingly evident in De Klerk's Eigen Haard (Own Hearth) housing development of 1914–16, where the decorative style permeated the building, whether in terms of the individualistic design of door and window frames, door furniture, house numerals, and other details including expanses of hung tiling. Further opportunities for the Amsterdam School arose through Amsterdam Muncipal Council's acceptance in 1917 of Berlage's plans for the development of Amsterdam-South, including Kramer and De Klerk's celebrated housing development for the De Dageraad (The Dawn) housing association between 1919 and 1921. De Klerk's furniture often showed Oriental influences in its form and details and catered for a wealthy clientele, though Kramer was more alive to the requirements of a wider audience. Nonetheless, the underlying spirit of the Amsterdam School was essentially anti-industrial and veering towards a craft aesthetic. The final showing of significance of designs by members of the group was in the Dutch Pavilion at the *Paris Exposition des Arts Décoratifs et Industriels Modernes, 1925.

firearms, the Colt revolver factory producing 1,000 guns a day using a 300-horsepower steam engine. Similar ideas were also explored in the burgeoning typewriter and watch manufacturing industries in the second half of the 19th century. So significant was the impact of the American System on the transformation of an agricultural nation to a leading industrial force that one writer has likened its impact on American manufacturing techniques to the dramatic Japanese 'Economic Miracle' in the decades following the end of the Second World War.

American Union of Decorative Artists and Craftsmen (AUDAC, established 1928) AUDAC was founded at a time when concerted attempts were being made to promote modern American design and

ANTHROPOMETRICS

A systematic study of the measurement of humans, anthropometrics was increasingly used in the decades following the end of the Second World War by designers concerned with design problems that involved human movement. Their adoption of a more scientific and methodical approach to design problems had much in common with the approaches explored at the Hochschule für Gestaltung at *Ulm from the mid-1950s and the *Design Methods movement in the 1960s. Both favoured a team-based approach over the conceptions of the individual (and thus fallible) designer. The origins of anthropometrics developed alongside ergonomics (the systematic analysis of work efficiency relating users to their environment) in the Second World War. Used in the design of the controls of military equipment and other fields, the armed forces in the United States and Britain provided guides for their designers. Studies such as W. E. Woodson's *Human Engineering for Equipment Designers* were published in the USA in 1954. It was also brought into the mainstream design arena by Henry Dreyfuss whose *Designing for People* was published in 1955. Other well-known texts in the field have included Alexander Kira's *The Bathroom Book* (1966), which was concerned with problems of designing for cleanliness and hygiene and was based on a seven-year research project at Cornell University.

See also ERGONOMICS.

decorative arts and was modelled on European precedents such as the *Societé des Artistes Décorateurs in France. Many major figures connected with American decorative arts were members and its ideas were promoted through exhibitions held in 1930 in Manhattan and in 1931 in Brooklyn together with its *Illustrated Annual of American Design* (1931), which contained essays by Frank Lloyd *Wright, Norman *Bel Geddes, Lewis Mumford, and others. Many members of AUDAC collaborated with Donald *Deskey on the design of the interior furnishings of Radio City Music Hall, New York, in the early 1930s. However, owing to the economic depression of the times, the 1931 exhibition at Brooklyn Museum was AUDAC's last formal public event.

Amsterdam School *See* box on p. 14.

Andrews, Gordon (1914–2001) A well-known Australian who did much to establish the design profession in Australia,

Andrews worked across a range of design disciplines, including graphics, industrial, and interiors. He originally trained in engineering at Sydney Technical College before taking up graphic design and finding employment in a Sydney advertising agency. During the late 1930s he worked in London, visiting the *Paris Exposition in 1937, and returning to Sydney in 1939. After the war a number of department stores did a great deal to introduce modern Australian design and designers, including that of David Jones in Sydney (established in 1840). Andrews acted as design consultant to the company in the late 1940s and worked in a number of fields including packaging design and product design. Amongst such work was a three-piece aluminium saucepan set marketed under the *Rex* label and a modern, almost functionalist phonogram. His furniture designs were also sold in Marion Best P/L, one of a number of design studios and retailers that did a great deal to introduce modern

a | **ANTI-DESIGN**

This movement originated in Italy in the 1960s as a reaction against what many avant-garde designers saw as the impoverished language of *Modernism, the emphasis placed on style and the aesthetics of good form by many leading manufacturers and celebrated designers. This sense of dissatisfaction with the increasingly widespread diminution of the social relevance of design at the expense of capitalist enterprise had been increasingly aired during the 1950s, particularly in the context of the *Milan Triennali. It was also mirrored in the wider economic, political, social, and cultural debates that gripped Italy in the 1960s.

Ettore *Sottsass Jr was a key exponent of the Anti-Design outlook, as were the *Radical Design groups *Archigram and *Superstudio, all expressing their ideas in the production of furniture prototypes, exhibition pieces, and publication of manifestos. Anti-Design sought to harness the social and cultural potential of design rather than embrace style as a means of increasing sales. Where Modernism was typified by notions of permanence, Anti-Design embraced the ephemerality of *Pop (shown at the Venice Biennale of 1964), consumerism, and the language of the mass media; where the Modernist palette was generally muted with a prevalence of blacks, whites, and greys, Anti-Design explored the rich potential of colour. Where Modernism admired the integrity of material properties in their own right, Anti-Design embraced ornament and decoration. Furthermore, where Modernism inclined to concepts of *Good Design and the adage 'form follows function', Anti-Design considered the expressive potential of *kitsch, irony, and distortion of scale, characteristics that were also to become hallmarks of *Postmodernism and important features of *Memphis design.

Australian design and designers to the public. Best also promoted his interior designs. He worked for corporate clients, being commissioned to design furniture for Olivetti showrooms in London (1954) and Sydney (1956) which was later marketed in modified form as his *Rondo* and *Gazelle* chairs. In the late 1950s Andrews and his designer wife Mary opened 'Andrews' Designs' in Sydney for which he produced furniture, textiles, jewellery, and interior design. But perhaps he was best known for his design of the first Australian decimal currency bank notes (1966). He also received international recognition, being nominated as a Fellow of the Society of Industrial Artists (*see* CHARTERED SOCIETY OF DESIGNERS) in London (1955) and elected as an Honorary

Designer for Industry of the Royal Society of Arts, London (1989).

Anthropometrics *See* box on p. 15.

Anti-Design *See* box on this page.

Apple Macintosh Computer (established 1976) Almost ever since Apple Computer was founded in 1976 by Steven Wozniak and Steven Jobs the company has been at the forefront of many striking innovations in the Personal Computer (PC) industry. The company did not attract much attention until the launch of its Apple *II* with colour monitor and a plastic case in 1977, a configuration further improved in 1978 with the launch of the Apple *Disk II*, the cheapest and most practical PC on the

market. By 1980, the company had several thousand employees and was beginning to penetrate overseas markets, producing its millionth computer in the following year. 1983 saw the introduction of highly innovative software entitled *Lisa* that provided an easy to use package of pull-down menus, windows, and digital graphics. In 1984 the Apple Macintosh was introduced, incorporating *Lisa*, and for a decade setting the standard for those in the creative industries, graphic, interior, architectural, and industrial design. Its sleek, neat light casing designed by Hartmut Esslinger of *Frogdesign (who had first worked with Apple on the identity of the Apple *IIc*) gave it a stylish identity that distinguished it from its prosaic *IBM PC competitors. It became *Time* magazine's Design of the Year. The Macintosh's characteristically clever blend of accessible software and well-designed hardware proved highly attractive to users, opening up for millions a world previously seen as the preserve of the computer specialist. Such perceptions were further enhanced with the introduction of *PageMaker* in 1985, a versatile program that made the attainment of professional layouts, blending digital images and text, readily accessible in-house without recourse to outside specialists. Desk-top publishing (DTP) was thus made available to owners of Apple equipment. As a result of increasingly overpowering competition from Microsoft *Windows* Apple went through difficult times, despite the introduction of *PowerBooks* in 1991, *PowerMacs* in 1994, and the launch of the online Apple Store in 1997. The stylish *i-Mac*, designed by Jonathan Ive and the Apple Design team, was introduced in 1998 and the brightly coloured *i-Book* in 1999, once again bringing desirable yet affordable products to a wider, fashionable audience. In the 21st century the Apple *i-Pod* revolutionized the downloading, storing, and playing of vast amounts of music, also becoming a well-designed status symbol. In 2003 Ive was elected as a *Royal Designer for Industry.

Arabia (established 1873) This Finnish pottery company was established as a subsidiary of the Swedish *Rörstrand company in its quest to secure Russian markets. Although its early years were dominated by the aesthetic outlook and technological practices of its parent, by the turn of the century it was producing a number of designs that reflected Finnish turn-of-the century nationalism. This was seen at the Paris International Exhibition of 1900, where it was awarded a Gold Medal for the *Fennia* range. Far greater independence was gained by the acquisition of Arabia by Finnish business interests in 1916 and the company proved commercially successful. The company's first tunnel kiln, introduced in 1929, was the largest in the world and did much to help the firm become one of the largest pottery manufacturers in Europe before the Second World War. In 1932 a Swedish modernizer Kurt Ekholm became artistic director, establishing artists' studios in the factory and thereby bringing together art and industry. After the end of the Second World War Arabia began to gain widespread recognition for its aesthetic output with Eckholm's appointment of Kaj *Franck as chief designer. Frank sought to mass produce well-designed everyday wares exemplified in his *Koti* (Home) dinnerware for the Finnish welfare agency. One of his best-known modern and commercially successful designs was his 'mix-and-match' *Kilta* dinnerware service, which was in production from 1953 to 1974. Other designers who came to the fore in this period included Ulla Procopé, who produced the popular and highly practical *Liekki* dinnerware service (1958). The 1970s and 1980s were more problematic with a series of takeovers and

mergers culminating in the 1990 takeover of Arabia, Rörstrand, *Gustavsberg, and *Iittala by the Finnish Hackman Group's Designer Oy, a design consortium committed to high standards of design that helped to restore the company's prestige.

Arad, Ron (1951–) One of Britain's most internationally renowned and individual designers in the early 21st century, Israeli-born Arad studied at the Jerusalem Academy of Art in 1971 before moving to London in 1973, where he studied in the School of Architecture at the Architectural Association from 1974 to 1979. In 1981 he founded One Off Ltd. in 1981 with Denis Groves and Caroline Thorman, an enterprise featuring a design studio, workshop, and showcase for his designs in London's fashionable Covent Garden. Much of his early work was characterized by his use of 'found' materials, as exemplified by his *Rover* chair of 1981, fabricated from tubular steel and seats from old Rover cars, and *Aerial* light (1981) from a car antenna. A similar contrast to the slick *Modernist aesthetic of many contemporary audio products could be seen in his *Concrete Stereo* of 1983, in which the turntable is set in a 'distressed' rough concrete block. In this first phase of his career Arad also worked in steel, as in his *Well-Tempered Chair* for *Vitra (1986) and *Bookworm* shelf for *Kartell (1993). In 1989, again with Caroline Thorman, Arad founded Ron Arad Associates (from 1993 incorporating One Off), an architecture and design practice in Chalk Farm, London, reflecting the expansion of his work into interior design. Commissions included Bazaar, a Gaultier for Women boutique in London (1986), the Michelle Ma Belle fashion shop in Milan (1993), the Belgo Central restaurant in Covent Garden (1995), the foyer for the new Tel Aviv Opera House (1989–94), the Galerie Achenbach in

Düsseldorf, and a series of *Adidas/Kronenberg Sports Cafés in France (1996). During these years he had also moved away from the notion of 'one-off' designs towards the production of designs that could be put into mass production, developing a productive relationship with many leading European manufacturers. Amongst these were *Driade, including his *Zigo* and *Zago* chairs (1993), and the *Empty Chair* and Fly *Ply* table (1994). His work for Moroso included the *Misfits* (1993) and *Sof-Sof* (1995) seating systems, for Vitra the *Tom Vac* chair (1997), and for Kartell the *Fantastic Plastic Elastic* chair (1998) and the *Infinity Winerack* (1998). His designs for *Alessi included the *Sound Track* CD storage system (1998) and snack bowls (1999). Arad's international standing is reflected in the acquisition of his designs by all the major design museums throughout the world as well as in the large number of internationally mounted exhibitions that have significantly featured his work. Prominent amongst the latter have been *Intellectual Interiors* in Tokyo (with Philippe *Starck, Rei *Kawakubo, and Shiro *Kuramata) in 1986, *Nouvelles Tendances* at the Pompidou Centre, Paris, 1987, *One Off and Short Runs* at the Centre for Contemporary Arts, Warsaw in 1993, *The Work of Ron Arad* at the Museum of Applied Arts, Helsinki, in 1995, *Ron Arad and Ingo Maurer* at the *Milan Triennale of 1995 (followed by other shows with *Maurer at Spazio Krizia, Milan, in 1996, 1997, and 1998), and the *Not Made by Hand, Not Made in China* exhibition in Milan in 1999. His work has also been recognized in a number of prestigious design awards. These have included Designer of the Year at the Salon du Meuble, Paris (1994), Internationaler Designpreis Baden-Württemberg at the Design Centre Stuttgart (1999), the Barcelona Primavera International Award for Design (2001), the Gio Ponti International Design Award, Denver

(2001), and the Oribe Art & Design Award, Japan (2001). He has also played a role in international design education as Professor of Product Design at the Hochschule in Vienna (1994–7) and several professorial roles in Furniture and Product Design at the *Royal College of Art since 1997.

Archer, L. Bruce (1922–) A highly influential figure in the design methods movement, Archer taught industrial design engineering at the *Central School of Arts & Crafts, London, before taking up a post as visiting professor at the Hochschule für Gestaltung at *Ulm, Germany, in 1961 to 1962. The curriculum there had moved firmly away from notions of the designer as an individual creative artist to a member of a team with a wide range of disciplinary skills who was able to solve design problems in an informed way. Archer's analytical approach to design was conveyed in a number of seminal articles in *Design magazine and made itself felt in his teaching and research activities at the *Royal College of Art, London. There, from 1962, he headed the Research Unit of the School of Industrial Design (Engineering) under Misha *Black. Funded by a number of key external bodies including the Nuffield Foundation, some major projects were successfully carried out by Archer's Research Unit, most importantly one devoted to hospital bed design that pioneered an extensive and systematic methodology. In 1967, L. Bruce Archer's work was recognized by the RCA: he was promoted to a professorship and the Research Unit given departmental status on its own right as the Department of Design Research. Amongst Archer's most important publications are *A Systematic Method for Designers* (1964), *Technological Innovation: A Methodology* (1971), and *Design Awareness and Planned Creativity in Industry* (1974).

Archigram (established 1961) The Archigram group provided a breath of fresh air in the architectural and design professions in Britain during a vibrant period of social and cultural change in Britain in the 1960s and 1970s. The name 'Archigram' derived from the words 'architecture' and 'telegram', their elision indicating that the group's aim was to convey an immediate and fresh message about the nature of architecture. The founding members of the group—architects, designers, and environmental researchers—were Warren Chalk, Peter Cook, Dennis Crompton, Ron Herron, David Greene, and Michael Webb, who collectively expressed their ideas in their magazine *Archigram*, which first appeared in broadsheet form in 1961. The form of this publication captured the unconventional ethos of the group, drawing on the lively graphic traditions of comic art rather than the often portentous texts of the manifestos of earlier avant-garde architectural and design groups. Like the *Futurists in Italy in the early decades of the 20th century they were excited by the dynamism of the modern metropolis, the imaginative possibilities of new technologies, and the vigour induced by the spirit of change. Such ideas were also in tune with the contemporary mores of the *Pop era that challenged the formal values associated with *Modernism and the conservative values prevalent in much of the architectural profession. Like the *Independent Group, active in 1950s Britain, they had a keen interest in science fiction and comic strip imagery, using it to telling effect in their 1963 exhibition, *Living City*. Held at the ICA (the Institute of Contemporary Arts) in London the exhibition suggested radical ways in which the city could evolve rapidly in response to changes in lifestyle, work, and leisure. This was followed by *Walking City* (1964), inspired by the enormous

technology-laden mobile gantries that serviced space rockets, *Plug-In-City* (1964–6), and *Instant City* (1968). The latter was concerned with the ways in which the new technologies of communication could transform communities by means of travelling media and information 'festivals'. These would move on, having linked the communities which they had visited to the 1960s equivalent of the late 20th-century idea of an 'information highway'. Their work ranged from a capsule design shown at the 1970 Expo in Osaka to stage sets for the rock group Queen. Many of Archigram's ideas have been explained by its major spokesman, Peter Cook, in a number of books including *Archigram 1861–1970* (1970) and *Archigram* (1974).

Architectural Review (1896–) Originally a periodical largely concerned with the aesthetics of British *Arts and Crafts architecture, the London-based *Architectural Review* (AR) later became a significant vehicle for the discussion of many aspects of design practice, theory, and culture. In 1913 it underwent a radical redesign, with an increased page size and enhanced standards of photographic reproduction and, at the same time, its content was broadened to embrace more fully furniture, interiors, and other design topics. Both developments were intended to woo the interested general public in addition to members of the architectural and design professions.

In the 1920s and 1930s coverage of Scandinavian and European design was considerably increased, and a number of eminent figures drawn from the artistic and literary worlds were commissioned as contributors. An important shift of emphasis followed the appointment of Hubert de Cronin Hastings as editor in 1927 and John Betjeman as assistant editor in 1929. However, more significant still was the appointment of J. M. Richards as Betjeman's replacement in 1935, from which time the *AR* was characterized by a much more vigorous coverage of *Modernist architecture and design. Important contributors during these years included the historian and design researcher Nikolaus *Pevsner and Philip Morton Shand, who was friendly with leading practitioners such as Walter *Gropius, Alvar *Aalto, and Le *Corbusier. Furthermore, an increasing range of articles by progressive foreign architects and designers was carried. As well as many articles which addressed questions of functionalism and industrial design, Richards's own contribution also affected the appearance of the magazine: leading articles were printed on handmade paper and wallpapers were incorporated into the editorial pages. This use of varied papers to signify shifts in content in different sections of the magazine lasted for more than 50 years. Also significant in the *AR*'s advocacy of modernism was its use of high-quality photography, with Frank Yerbury, M. O. Dell, and H. L. Wainwright prominent in the field.

After the Second World War (during which Pevsner undertook a spell as temporary editor), Hastings and Richards resumed editorial control. Whilst the *Festival of Britain of 1951 provided an important platform for the *AR*'s Modernist leanings, a discernible breath of fresh air accompanied the appointment to the staff in 1952 of Peter Reyner *Banham. He brought with him a profound interest in materials and techniques as well as a developing interest in American popular culture and, from 1960, edited a 'World' section which, through its scanning of more than 100 magazines, kept readers up to date with international developments and debates of significance.

The 1960s witnessed considerable upheavals at the *AR* with the departure of Banham in 1964 and the retirement of Pevsner

from the editorial board in the following year. In a period of significant social change and given the allure of *Postmodernism there was growing uncertainty and debate about the future direction of architecture and Modernism. Financial problems also began to impose themselves and, in 1970, Hastings sacked Richards before stepping down himself three years later. During the 1980s, despite a more positive sense of editorial direction with the publication of themed issues across a wide range of topics from shopping centres to the environment, problems of finance and changes of ownership continued to overshadow the magazine's prospects. In the 1990s new ownership was accompanied by increased investment and managerial improvements and a period of greater stability ensued.

Archizoom (established 1966) This Italian avant-garde design studio was founded in 1966 in Florence, Italy, by four architects—Andrea *Branzi, Gilberto Corretti, Paolo *Deganello, Massimo Morozzi—and two designers—Dario Bartolini and Lucia Bartolini. Very much part of the Italian *Anti-Design or *Radical Design movement, they worked on exhibition installations and architecture, also designing interiors and products. At a time of vigorous debate about the meaning and purpose of design Archizoom was vociferous and challenging in terms of theory and practice, drawing on a wide range of sources including *Pop and *Kitsch as a means of undermining the elegant lines and forms for which mainstream Italian design had established an international reputation. Well-known examples of their outlook at that time included the *Dream Beds* series of 1967. In 1968, at the *Milan Triennale, it organized the 'Centre for Eclectic Conspiracy'. Four years later, its members declared the 'right to go against a reality that lacks "meaning" . . . to act,

modify, form, and destroy the surrounding environment'. The elastic-seated *Mies* chair (1969) for Poltronova, with its ironic commentary on the apparent properties of functionalism, is a well-known example of their work. Other key projects included *No-Stop City* (1970) and the group's work featured in the seminal 1972 exhibition curated by Emilio *Ambasz at the *Museum of Modern Art, New York, in 1972—*Italy, the New Domestic Landscape*.

Arkady (1935–9) Published in Warsaw this illustrated Polish periodical of art and design sought to promote modern design to a broader readership than catered for by journals for design and architectural professionals. It adopted a 'Regionalist' position—one that endorsed the search for a modern architectural and design style which respected local materials (such as timber), modes of construction, and geographical environment rather than the more austere functionalist aesthetic of the *International Style.

Armani, Giorgio (1934–) The Italian Armani name is widely associated with sophisticated, fashionable clothing design for men and women with many outlets throughout the world. Armani brand names include Giorgio Armani, Emporio Armani (established 1981), Armani Jeans (1981), Borgonuovo 21, Armani Golf (established 1966), and Armani Neve (winter sportswear, established 1996). Armani's largest export market is the United States, spearheaded by two major stores on Madison Avenue, New York. Armani's career began in 1957, working for the leading Italian department store La *Rinascente before joining Nino Ceruti as a fashion designer from 1964 to 1970. He then worked as a freelance designer, establishing his menswear label in 1974 and women's wear in 1975. His smart, yet casual, designs were far looser than the

a | ART DECO

The term 'Art Deco' has been used to describe design and architecture from the 1910s, 1920s, and 1930s that was characterized by bright colours, geometric shapes, and decorative motifs deriving from a wide range of visual sources from the early years of the 20th century. The term—also known as *moderne* or *modernistic*—was an abbreviation of the French words 'art' and 'décoratif', themselves derived from the *Paris Exposition des Arts Décoratifs et Industriels of 1925. However, the stylistic label 'Art Deco' only entered common currency in the mid-1960s when the Musée des Arts Décoratifs in Paris mounted an exhibition entitled *Les Années '25': Art Déco/Bauhaus/Stijl/L'Esprit Nouveau* (1966). It was given a further boost by the publication of a book by Bevis Hillier, *Art Deco of the 20s and 30s* (1968). Typical Art Deco motifs included flat abstracted garlands of flowers, flowing fountains, running deer, chevrons, lightning flashes, and sunbursts. They could be applied to anything from furniture, firescreens, and fountain pens to teacups, textiles, and toasters. In the 25 years or so of its duration, the Deco style may be seen to have made the transition from the sophisticated and somewhat elitist world of cocktail parties in the 1920s to the mass-produced, glitzy, and accessible world of the suburban cocktail cabinet of the 1930s.

The visual origins of the style included Cubist painting (particularly the more two-dimensional forms of Synthetic Cubism), the vivid colours associated with Matisse and the Fauves, the abstracted botanical and zoological forms explored by Raoul Dufy and members of Paul *Poiret's Atelier Martine. Léon Bakst's striking and often orientalizing stage and costume designs for Diaghilev's Ballets Russes were also powerful ingredients. A widespread interest in ethnography, 'primitivism', and the collecting of 'primitive' artefacts in the early years of the 20th century also informed many designers' use of exotic woods, snakeskin, ivory, and other materials drawn from the French colonies. However, an interest in a rather more rectilinear and structured use of form and ornamentation was at the root of other strands of Deco. This stemmed from the work of Charles Rennie *Mackintosh and designers associated with the early phases of the *Wiener Werkstätte, particularly Josef *Hoffmann and Koloman *Moser. A further boost to the rather geometric structure of many Deco designs was given by Egyptian motifs with the opening of Tutankhamun's Tomb in 1922, as well as the widespread use of stencil techniques which underpinned many cheaper wallpaper, logo, and trademark designs. The nationalistic heritage of 18th-century design and ornament was a further significant stylistic sourcebook for French artistes-décorateurs, particularly furniture makers, as the 1925 Paris Exposition had been conceived as an important international stage for the work of the country's best designers. Although the Exposition had originally been intended to bring together industry and artistic endeavour, most of the works on display celebrated luxury and expense, features that characterized much of the work of members of the *Société des Artistes Décorateurs (SAD) who held pride of place. Largely geared to catering for the affluent tastes of an affluent urban cultural elite the Société's leading figures included Jacques-Émile Ruhlmann, Jean Dunand, René *Lalique, Louis Süe, and André Mare.

The dissemination of French decorative art was aided by the launching of a number of French luxury liners such as the *Paris* (1921), the *Île de France* (1927), and the

Normandie (1935). Like major international exhibitions these floating palaces were symbols of national prestige. Often subsidized by the French government they afforded significant opportunities for French artistes-décorateurs to bring their work to an international, often wealthy, transatlantic travelling public. Important too in transmitting many of its features was the increasingly powerful and popular medium of film, especially the output of Hollywood, which often drew on Art Deco as a basis for its most striking sets. Pivotal in this were the highly glamorous sets overseen by art directors such as Cedric Gibbons of MGM (including *Our Dancing Daughters*, 1928, *Our Modern Maidens*, 1929, and *Our Blushing Brides*, 1930) and Van Nest Polglase of RKO (including the 'latest idea in interior architecture for the modern home' of *The Magnificent Flirt*, 1928, *Flying Down to Rio*, 1933, and *Top Hat*, 1935). Magazines such as *Vogue* and *Vanity Fair* were further vehicles for the promotion of stylistic trends, reflected in the design of many other publications that took on a more contemporary feel, with sans serif typography and geometric decoration.

In the years following 1925, the Art Deco style was widely disseminated across Europe and the United States as well as many other countries including South Africa, India, China, Australia, and New Zealand. This proliferation was furthered by the experiences of visitors to the Paris Exposition as well as the considerable international publicity and comment that it generated. Although the USA did not participate in the 1925 Exposition Herbert Hoover, Secretary of Commerce, appointed a commission to report back on European developments in the decorative arts. The commission consisted of 108 officials, manufacturers, art guilds, designers, museums, journalists, and trade associations, including the Furniture Designers Association, the Society of Interior Decorators, and the Silk Association of America. Following this, a number of American museums and department stores mounted exhibitions of French decorative arts. These built on an interest in European decorative arts that had been growing through the influence of a number of European designer immigrants to the Unites States including Josef *Urban, Paul *Frankl, Raymond *Loewy, and Kem *Weber. Equally, quite a number of American designers had visited Europe in the 1920s, including Ruth *Reeves, who had studied with Fernand Léger, Donald *Deskey, Walter Dorwin *Teague, and Russell *Wright. Deco was also an important ingredient of American department store window displays, such as that by Norman *Bel Geddes for Franklin Simon, New York, which also owed much to the poster designer A. M. *Cassandre. The style was a characteristic of the interior design of many American skyscrapers, especially their foyers that often also used indirect lighting effects in ways that had been seen in interiors at Paris. Deco patterns were also often found on their exteriors, particularly at the lower levels when they could be appreciated from the street. New materials such as *Bakelite, Vitrolite, and chromium plating (*see* CHROME) were also important ingredients of the style, seen to stunning effect in the interiors and furniture of Radio City Music Hall in the Rockefeller Center, New York, coordinated by Donald Deskey in the early 1930s.

Art Deco was also seen in Britain, often in the form of geometric sunburst motifs found on tea services, garden gates and fences, stained glass windows in domestic hallways, and radio cabinet loudspeaker grilles. In addition to enjoying Deco in

a

the luxury film sets on the cinema screen, the general public also experienced it in the design of leisure architecture including hotels, theatres, lidos, and cinemas. Typical of the latter were the interiors and exteriors of the Odeon cinemas, characterized by the decorative manipulation of abstract forms, finishes, and colours.

Art Deco also became something of a critical battleground with *Modernist writers like Le *Corbusier writing in his book *L'Art décoratif d'aujourd'hui* (1925) that 'the more cultivated a people becomes, the more decoration disappears'. For Corbusier 'the luxury object is well made, neat and clear, pure and healthy', the opposite of the ephemeral sensuosity of Deco. Seemingly self-indulgent and closely associated with the idea of 'jazz' and the 'jazz age', writers such as Nikolaus *Pevsner used the idea of 'jazz' styling as a term of disapproval. Nor were its qualities approved of in pro-Modernist circles in the USA including the *Museum of Modern Art, New York, established in 1929. Most of its design exhibitions of the 1930s were devoted to the work of European Modernists, following in the aesthetic footsteps of the 'Machine Art' Exhibition of 1934, curated by Philip *Johnson.

The revival of interest in Art Deco in the 1960s and 1970s coincided with an increasing dissatisfaction with the restrictive aesthetic of Modernism and the more fertile and pluralistic terrain of *Postmodernism. The most thorough and wide-ranging study of the style to date has been the major publication of *Art Deco 1910–1939* (2003) edited by Charlotte and Tim Benton and Ghislaine Wood, all of whom curated the groundbreaking accompanying exhibition at the *Victoria and Albert Museum.

more tailored look of much contemporary clothing, Armani women's wear in particular being characterized by its unstructured jackets and suits and the use of high-quality fabrics. The first Armani perfume was launched in 1982, Armani glasses in 1987, Armani shoes in 1987, with a range of home accessories being sold through Emporio Armani. Armani has received several design awards including the Neiman Marcus Award (1979) and the Council of Fashion Designers of America (1983).

Art Deco *See* box on pp. 22–24.

Artek (established 1935) Deriving from a *Modernist inspired fusion of the words 'art' and 'technology', the innovative Artek company and shop was founded in Helsinki by husband and wife design team Alvar and Aino *Aalto, together with the wealthy art lover Marie Gullichsen and her industrialist husband Harry. The company sought to manufacture and market affordable, well-designed, modern wooden Finnish furniture and furnishings, making Aalto's bent plywood furniture, lighting, textiles, and glassware available to a wide public through wholesale and retail sales—alongside more exotic items such as Moroccan rugs. Many of the company's wares were seen in the *Paris Exposition of 1937 and the *New York World's Fair of 1939–40, attracting favourable critical attention. After the war the company trimmed back earlier ambitions for the promotion of modern design culture and in 1963 it merged with Billñas, leading to the withdrawal of Alvar Aalto. However, by the 1980s, a number of fresh overseas market opportunities were developed in the United States, Japan, and the southern hemisphere. The company was acquired by Proventus Design in 1997.

Artel Cooperative (early 1900s–1924) These Czech craft and furniture workshops, based in Prague, owed their inspiration to the *Wiener Werkstätte and generated designs in ceramics, textiles, carpets, furniture, and metal with the intention of re-establishing a more aesthetic everyday environment. Amongst keen purchasers of Artel's work was the novelist Franz Kafka, who lived in Prague. Artel's founders included Jaroslav Benda, Pavel Janák, Helena Johnová, Marie Teinitzerová, and Otakar Vondrácek. Early Artel designs included toys, boxes, beads, and buttons and the Cooperative sold its products through its shop, which moved several times during the life of the enterprise. It also promoted its wares through exhibitions, commencing in 1908 when it had a stand and display at the Prague Chamber of Commerce. A major source of inspiration was to become *Czech Cubism, a style mainly associated with architecture that drew on the multifaceted 'simultaneous' forms of French Cubist painting, and there were close links between the designers associated with the Prague Artist's Workshops (*see* CZECH CUBISM) and the Artel Cooperative. Designers for Artel included architect, artist, and theorist Vlastislav Hofman, Ladislav Sutnar, and architect-designer Rudolf Stockar, manager of the Cooperative's workshops before the First World War. Many of Artel's ceramics were manufactured by Rydl and Thon in Svijany-Podolf and a number of their textile designs produced in a factory in Dvúr Králové. Before the outbreak of war in 1914 Artel products were also seen at the *Deutscher Werkbund exhibition at Cologne, although the aesthetic flavour of their designs was far removed from the functional aesthetic of much progressive German design on display. In 1916 Rudolf Stockar and František Kysela designed the interiors and decoration of the sweetshop in the Ligna Palace in central Prague, blending Cubist decoration with indigenous folk art motifs, a nationalist consciousness that was to become more pronounced after the establishment of an independent Czechoslovakian state in 1918. In the same year Artel had a major public display at the Prague Museum of Decorative Arts, where it sought to reconcile modern forms with tradition, an outlook that became increasingly important in the post-First World War period. By this time the continued viability of Artel was becoming increasingly problematic and despite a major advertising campaign by Milena Jesenka, the position failed to improve and the organization came to an end in 1924.

Arteluce (established 1936) Founded by aeronautical engineer and modern lighting pioneer Gino Sarfatti in Milan, Arteluce gained renown in the 1950s as an innovative lighting company. Many leading designers were commissioned, including Franco *Albini and Marco *Zanuso, and the company gained attention through participation in many exhibitions at home and abroad, winning a Diploma of Honour at the 1951 (IX) *Milan Triennale and *Compasso d'Oro awards in 1954 and 1955. In 1974 the company became a division of the *Flos group, employing designers such as Matteo *Thun, Ezio Didoni, Perry A. King, and Marc Sadler, who was awarded a Compasso d'Oro in 1995 for his *Drop 2* wall lamp.

Artemide (established 1959) Founded in 1959 in Milan by Ernesto *Gismondi and Sergio Mazza, in its early years the company moved rapidly from craft-based to industrial design. Noted particularly for its lighting it includes amongst its most celebrated designs *Magistretti's *Eclipse* (1966) and Richard *Sapper's iconic *Tizio* (1972) lamps. The company also produced furniture, exploring the possibilities of plastics as in

a

ART NOUVEAU

The term 'Art Nouveau' derived from the name of the Paris gallery and workshops opened by Samuel *Bing in 1895. It has been used to denote the flowing organic forms of the decorative arts that proliferated across Europe during the last decade of the 19th century and the early years of the 20th century. Flourishing in France, but with a strong presence in Belgium, Germany (*Jugendstil*), Italy (*Stile Liberty* or *Stile Floreale*), Spain (*Modernismo*), Holland (*Nieuwe Kunst*), and other European countries, as well as further afield as in the United States of America, the term itself pointed emphatically to a rejection of historicism and tradition in favour of a new aesthetic appropriate for a new century. Its historical importance lies in this rejection of the past rather than the establishment of a firm basis for designs that were readily adaptable for economic mass production such as those to be embraced by the *Deutscher Werkbund in the years leading up to the First World War. Deriving from such diverse sources as the graphic work of Arthur Heygate *Mackmurdo, Aubrey *Beardsley, Japonisme, Rococo, and the Celtic Revival, Art Nouveau's asymmetrically and sinuous characteristics were generally more compatible with the crafts. However, its forms were disseminated widely through magazines such as the *Studio*, *Ver sacrum*, *L'Art décoratif*, *Pan*, *Dekorative Kunst*, and *Jugend* as well as the *Paris Exposition Universelle of 1900, which was perhaps the apogee of French Art Nouveau, although the style was also evident in the international exhibitions in Turin (1902) and St Louis (1904). Also important in spreading the style were shops such as *Liberty's in London, and La Maison Moderne and Galerie L'Art Nouveau in Paris. Designers associated with the Art Nouveau included Hector *Guimard and Émile *Gallé in France, Victor *Horta, Henry van de *Velde, and Alphonse *Mucha in Belgium, Charles Rennie *Mackintosh and the Glasgow School in Britain, Anton *Gaudí in Spain, Ödön Faragó in Hungary, and Louis Comfort *Tiffany in the United States.

Magistretti's *Selene* dining chair and *Studio 80* table. In 1991 the company bought the Murano glassworks and launched its *Milano-Venezia* light collection made in Murano glass. The company has received widespread recognition for its conspicuous success in gaining numerous design awards and prizes. These have ranged from the *Compasso d'Oro (Magistretti, *Eclipse* light, 1967, De Lucchi-Fassina *Tolomeo* halogen lamp, 1989, and a company Career Award, 1995) and the *Milan Triennali (five awards) to the European Design Prize 2000 (Gismondi, *e.light*) and IF Product Design Award 2001, Hanover. Artemide products are also well represented in leading design museums including the *Museum of Modern Art and Metropolitan Museum in New York, the Musée des Arts Décoratifs, Paris, the *Victoria and Albert Museum, London, and the Museum of Modern Art, Stuttgart. By the early 21st century Artemide had production centres in Italy, France, Germany, the United States, Hungary, and the Czech Republic, as well as sixteen subsidiaries and affiliated companies and 35 distributors worldwide.

Art et Décoration (1897–1939) With an outlook and layout similar to the British magazine the *Studio* this leading French periodical was edited by Thiébault-Sisson

and published by the Librairie Centrale des Beaux-Arts in Paris. In its early years it featured the work of leading *Arts and Crafts and *Art Nouveau designers and was geared to an amateur, culturally inclined audience. Although tending to focus on the handcraft-intensive work of artistes-décorateurs such as Jacques-Émile Ruhlmann, more progressive design trends were also analysed by such contributors as Francis Jourdain.

Art Moderne *See* ART DECO.

Art Noveau *See* box on p. 26.

Arts and Crafts Exhibition Society (established 1888) For about twenty years the Society was an important advocate for the ideals of the *Arts and Crafts Movement in Britain, having been formed at a time when theoretical debates about art, craft, and possible relationships with industrial production were beginning to sharpen. Although the Society's exhibitions were regularly mounted in Britain from 1888, they also participated at international exhibitions overseas, including Turin in 1902, St Louis in 1904, and Ghent in 1913. Key figures involved with the Society in its early years included its first president Walter *Crane, W. A. S. *Benson, Lewis F. *Day, J. D. Sedding, Heywood Sumner, and Selwyn *Image. There were also a number of publications that disseminated the Society's outlook. The most important of these were *Arts and Crafts Essays by Members of the Arts and Crafts Exhibition Society* (1893) and a second book of essays entitled *Handicrafts and Reconstruction* (1919), the contributors to which included *Lethaby and Benson. The Society also published a periodical entitled *Arts and Crafts Quarterly* (1919–20), its brief existence coinciding with a diminution of its influence in the face of competition from such organizations as the *Design and Industries Association and the *British Institute of Industrial Art.

Arts and Crafts Movement *See* box on p. 28.

Arts Ménagers *See* SALON DES ARTS MÉNAGERS.

Art Workers' Guild (established 1884) This select organization was an important discussion forum for the arts and crafts in Britain, having been formed from two existing groups, the St George's Art Society (founded in 1883) and The Fifteen (founded in 1880). The former was largely composed of pupils of the architect Norman Shaw, its committee members including W. R. *Lethaby; the latter was largely driven by the energy of its secretary, Lewis F. *Day. Both societies were concerned with a unification of art, architecture, and the decorative arts and crafts and came together in 1884 to form the Art Workers' Guild. However, differences of opinion about the importance of the role of publicity and mounting public exhibitions led to a split in which some members seceded to form the *Arts and Crafts Exhibition Society in 1886. Many important figures associated with the arts and crafts were involved with the Guild, including C. R. *Ashbee, W. A. S. *Benson, Walter *Crane, A. H. *Mackmurdo, William *Morris, and C. F. *Voysey.

Arzberg (established 1887) This German ceramics manufacturer is perhaps most widely recognized in the history of design for its clearly articulated, undecorated, yet distinctive white designs by Herman Gretsch, the 1382 tableware service of 1931. These domestic icons of German *Modernism embraced the progressive aesthetic spirit pursued by many designers associated with the *Deutscher Werkbund, the *Bauhaus, and the progressive municipal authorities in the mid-1920s, such as Frankfurt and Stuttgart, symbolically embracing the Modernist maxim of 'form follows function'. Gretsch had become consultant to the

ARTS AND CRAFTS MOVEMENT

The ideology of the Arts and Crafts Movement represented a reaction against the moral and material consequences of the industrial revolution. Its followers were concerned with the negative social and aesthetic impact of Victorian urbanization and what was believed to be an assault on the creative integrity of the design process through the division of labour and other industrial methods of production. Among the major designers associated with the movement were William *Morris, A. H. *Mackmurdo, Lewis F. *Day, C. R. *Ashbee, and C. F. *Voysey. The roots of the movement lay in the writings and work of the architect and designer Augustus Welby Pugin (1812–52) and the eloquent Victorian artist and critic John *Ruskin. The latter's major books *The Seven Lamps of Architecture* (1849) and *The Stones of Venice* (1851–3) equate the quality of design with the quality of the society that produced it, drawing analogies between the decline and fall of the Venetian Empire and social and aesthetic change in Victorian Britain. He called for a rejection of the increasing material preoccupations of contemporary society and a return to the dignity of labour enjoyed in pre-industrial times. William Morris, a dominant figure in the Arts and Crafts Movement, explored similar ideas in his writings and design work. Arts and Crafts designers embraced a number of common principles. These included an honest use of materials and methods of construction as opposed to the more widespread celebration of ingenious applications of new materials and processes to imitate other production processes and finishes. There was also a widespread use of nature-based decorative motifs and a general commitment to the principles of craft, rather than industrialized, production. There was also a move by some groups of designers away from towns and cities to rural locations as a means of creating communities of craft workers, often building on the vernacular skills still being practised in the country. Typifying such an outlook was Charles Robert Ashbee's Guild of Handicraft, which moved to Chipping Camden in Gloucestershire in 1902. From the 1880s onwards a number of Guilds were established including the Art Workers' Guild (established 1884), the Century Guild (1882–8), and the Guild of Handicraft (established 1888). The idea of Guilds looked back to medieval times when groups of craftsmen worked together collaboratively. An early Arts and Crafts manifestation of this idea had been William Morris's firm, Morris, Marshall, Faulkner, and Co. (*see* MORRIS & CO.) founded in London in 1861. Many of the ideas of the Arts and Crafts Movement were disseminated by the writings of a number of its participants, magazines such as the Century Guild's *Hobby Horse* (established 1884) or the *Studio* (established 1893), and participation in exhibitions at home and abroad.

See also ARTS AND CRAFTS EXHIBITION SOCIETY.

company in 1931, designing seven patterns during his period of employment. After the Second World War, in 1952, he was succeeded as artistic director by Heinrich Löffelhardt, who continued the tradition of clean, organic forms which were much in tune with the aesthetic ideals of the *Rat für Formgebung (German Design Council), established in 1953. Such work also paralleled the post-war aesthetic ideals pursued by his friend Wilhelm *Wagenfeld in work for *Rosenthal, seen in his *Gloriana* dinnerware

(1953) as well as contemporary metalware designs for *WMF. Löffelhardt's work was recognized internationally, his *2050* tableware winning a prize at the *Milan Triennale of 1960. After a turbulent financial period in the early 1970s when it was taken over, the company re-established its *Good Design philosophy with designs by the Swiss Hans Theo Baumann (including the *Turku* service of 1972). This company hallmark was also clearly visible in designs twenty years later, such as the *Cult* service (1995) by Dieter Singer.

Ashbee, Charles Robert (1863–1942) An important link with progressive design thinking and practice in Europe and the United States at the end of the 19th and early 20th centuries, Ashbee was a central figure in the British *Arts and Crafts Movement as well as its dissemination abroad. His design philosophy also played a role in the reconciliation of the principles of honesty of construction and appropriate use of materials with mechanized production. In many ways this culminated in the underpinning of the outlook of many of those associated with the foundation of the *Deutscher Werkbund in 1907. Not only was Ashbee a silver and metalware designer whose work was exhibited in Austria, Germany, and France and a co-founder of the Guild of Handicraft, he was also a writer on design matters. After training in architecture in the early 1880s he became increasingly interested in socialist ideas and the writings of John *Ruskin, interests that played a part in the formation of the Guild of Handicraft in the East End of London in 1888. This cooperative of craft workers in leather, wood, metal, and jewellery contributed to the second exhibition of the *Arts and Crafts Exhibition Society in 1889. From 1893 to 1894 Ashbee also designed the family home, *Magpie and Stump*, in Cheyne Walk, London, and Guild members working

on the interior and other houses in the street. In 1896 Ashbee was elected to the *Art Workers' Guild, commencing its first printing enterprise, the Essex House Press two years later. Also in 1898, the Guild produced furniture designed by *Baillie Scott for the dining and drawing rooms designed by Ashbee and Baillie Scott in the Neue Palais of Ernst Ludwig, the Grand Duke of Hesse, in Darmstadt. Like many other individuals and organizations involved in the 'art industries' at the time, Ashbee's Guild of Handicraft also opened a shop in Bond Street, London, in 1899. In 1902 the Guild—by this time involving up to 150 people—moved to the rural Cotswolds setting of Chipping Campden in Gloucestershire and continued to attract the attention of designers and design thinkers at home and abroad. Ashbee travelled to the United States in 1896 and 1900-1, during the latter visit meeting the American architect-designer Frank Lloyd *Wright. Somewhat ironically, in the same years when its influence abroad was increasingly significant, the Guild itself began to run into difficulties following its move to Chipping Campden. It was dissolved in 1908, Ashbee writing about the underlying problems in *Crafsmanship in Competitive Industry* in the following year. Unlike a number of earlier arts and crafts theorists and practitioners, Ashbee was more overtly sympathetic to a reconciliation of the movement's principles with use of the machine. It has been suggested that such an outlook was influenced by Ashbee's contact with Wright. It was also an idea developed more radically in Germany by Hermann *Muthesius, who had studied the British Arts and Crafts at first hand and been a founder member of the Deutscher Werkbund in 1907.

Ashley, Laura (1925–85) Laura Ashley, née Mountney, design entrepreneur, designer, and interior decorator, was born in

Wales and after the Second World War worked in the London offices of the Women's Institute. After marriage to Bernard Ashley in 1949 she began experimenting in the early 1950s at home with printed textiles designs, the modest beginnings of a design enterprise that was put on a more systematic footing in the 1960s after a move back to Wales. The Ashleys developed what was to become a large international enterprise at Carno, building up a loyal workforce of local people aided by government grants for depressed rural areas. Commencing with clothing in 1967 and the opening of its shop in the Fulham Road, London, where Terence *Conran's first *Habitat shop had been launched in 1964, there followed a period of rapid expansion during the 1970s and 1980s. The company's designs were characterized by notions of rural 'Englishness', drawing on inspiration from flora and fauna pervaded with a strong sense of nostalgia, very much the opposite of the modernizing urban chic which characterized the Habitat outlook. Laura Ashley had a design philosophy that was generally put into practice by others, although she had a clear sense of what she wanted to promote, often resulting from research into the past. By the 1980s the company was selling goods across a wide front: clothing, fabrics, interior decoration, wallpapers, and paint. From 1981 Laura Ashley goods became available via *Mail Order catalogue, a time by which the company had many retail outlets worldwide, including twelve in the USA, with others in Canada, Australia, and Germany. In addition to the annual catalogues the Laura Ashley 'lifestyle' idea was further promoted through such texts as the *Laura Ashley Book of Interior Decoration*. By the time of Laura's accidental death the company was a large international company still run by her husband Bernard, who was knighted in 1987.

Aspen Design Conference (established 1951) *See* INTERNATIONAL DESIGN CONFERENCE IN ASPEN.

Associazione per il Disegno Industriale *See* ADI.

Aston Martin (established 1914) This high-profile automobile manufacturer has been recognized by cinema audiences throughout the world as the producer of the Aston Martin *DB5* driven by James Bond in the 1965 film *Goldfinger*, with a further link between Aston Martin and Bond in the film *Living Daylights* (1987). The company's British origins lay in the early 20th century when the first car was built by Robert Bamford and Lionel Martin as a competitor to *Bugatti. After the end of the First World War the company was refinanced and taken over by Lionel Martin and a series of racing cars competed in Europe in the 1920s and 1930s. The name 'Aston' was added to 'Martin' as the cars had great success in the Aston Clinton Hill Climb races. After the Second World War the company emerged as a high-profile manufacturer of sports cars, following the 1947 takeover of the company by David Brown (DB), who also took over the Lagonda Company, another British manufacturer of high-performance cars. A DB series of Aston Martin sports cars was initiated in the 1950s with the 2.6-litre Aston Martin *DB2*, continuing until 1965 with the *DB6*. The Aston Martin company was sold in 1972, followed by a number of further changes of ownership, culminating in its complete takeover by *Ford in 1994. Celebrated later models included the *Virage* sports car (1988) and the *DB7 Vantage* (1992).

Atelier Martine *See* POIRET, PAUL.

Atika (established 1987) This group of young Czech designers who had recently graduated from the Prague Academy of

Arts, Architecture, and Design reacted strongly against the restrictive nature of design in a socialist state, having been attracted to designers working in a *Postmodern idiom. Particularly influential was the Czech-born designer Borek *Sípek who, having left Czechoslovakia in the political upheavals of 1968, began visiting the country once more from the mid-1980s. The group's first exhibition, held in 1987 in Prague, proved highly controversial and was roundly criticized in some quarters for its Western influences. Other conservative critics disliked the ways in which the exhibited one-off, handmade works rejected all notions of straightforward functionalism through their embrace of a rich variety of materials and expressive forms, underpinned by often complex meanings. Typifying such ideas were Bohuslav Horák's *Decaying Leaf* sofa in leather, steel, and acrylic (1988) and Jaroslav Susta's individualistic *Green Frog* painted wooden chair (1987). The founder members of Atika were Vít Cimbura, Bohuslav Horak, Jírí Javurek, Jírí Pelcl, and Jaroslav Susta. Other subsequent shows of the group's work included exhibitions at the Dilo Gallery in Na Mustku, Prague (1988), the Neotu Gallery, Paris (1989), the Tiller Gallery, Vienna (1990), and the Clara Scremini Gallery, Paris (1992).

AUDAC *See* AMERICAN UNION OF DECORATIVE ARTISTS AND CRAFTSMEN.

Audi (established 1909) This car manufacturer's early years had a chequered history with a series of takeovers and reorganizations. One of the most significant was the formation of the Auto Union from Audi, DKW, Horsch, and Wanderer in 1932, the still distinctive Audi logo of four interconnecting rings being marked by this coming together of the four companies. However, the Auto Union was later taken over by *Mercedes in 1958 and again in the mid-1960s by *Volkswagen. The highly successful Audi 100 (1965) proved to be the saviour of a financially troubled company and commenced a process of placing an increasing premium on design, exemplified by collaboration with the Italian car body styling firm *Bertone on the Audi 80 (1972). In 1982 the company launched its lively four-wheel drive *Quattro* sports saloon and, in 1984, the new model Audi 80. The 1990s saw further initiatives with the launch of the A4 and A6 saloons overseen by Peter Schreyer, who had become chief designer in 1994. Schreyer also designed the A3 hatchback (1996) and the striking and distinctive TT Coupé (1997).

Aulenti, Gae (1927–) Architect, designer, and theorist Gae Aulenti has been one of the best-known women working in Italian design in the second half of the 20th century, her reputation being enhanced by a major award at the 1964 *Milan Triennale, her participation in the seminal *Italy: The New Domestic Landscape* at the *Museum of Modern Art, New York in 1972 (*see* AMBASZ, EMILIO) and her award-winning layout of the Musée d'Orsay in Paris (1980–6).

Aulenti trained in architecture at Milan Polytechnic during the 1950s and, from 1954, she served as a member of the editorial staff of *Casabella*. She also became a member of *ADI (and later vice-president from 1966 to 1969) and served on the editorial board of the magazine *Lotus International*. In addition to her striking 'Arrivo al Mare' installation in the Italian Pavilion at the 1964 Milan Triennale, utilizing Picasso-inspired silhouettes and mirrors, during the 1960s she also designed furniture for a number of clients. These included the department store La *Rinascente, *Zanotta, Poltranova, and *Knoll, expanding in the 1970s to include Martinelli Luce and

*Artemide, for whom she designed lights. In 1972 she contributed a historically charged 'environment' to the *Italy: The New Domestic Environment* exhibition in New York, as well as an essay in the catalogue underlying her interest in the theoretical underpinning of her architectural and design practice. She worked on exhibition design for various clients including *Fiat, a number of whose motor show stands she conceived from 1968 onwards. Aulenti was also involved in theatre set design in the second half of the 1970s, working with the Prato Theatre Design Workshop. In the 1980s she was involved with the design of a number of gallery and museum projects and urban spaces. These included the Modern Art Gallery at the Pompidou Centre in Paris (1982–5), the Museum of Catalan Art in the National Palace of Montejuic in Barcelona (1987), and the new entrance to the railway station in Florence (1988–90).

Australian Design Award (ADA, established 1987) The Design and Development Division of Standards Australia supports a range of design promotional initiatives including seminars on design and innovation, national and international exhibitions, and the Australian Design Award. This prestigious award was established by the *Industrial Design Council of Australia (IDCA, established 1957) and sought to recognize and award design excellence and innovation, to improve standards of design in industry, to promote the benefits of design to the public, and to foster innovation. Its *logo originally consisted of the upper triangular portion of a capital 'A' inset into a blue rectangle but now takes the form of a deep blue D shape with a star, referring to Design and the national flag. The ADA followed a number of other awards instituted in previous decades by the IDCA, including the Prince Philip Prize for Australian Design, established in 1967 (he had also contributed the Prince Philip Prize for Elegant Design for the Council of Industrial Design (see DESIGN COUNCIL) in Britain in 1959). Other IDCA awards that also related to British precedent included the Design Selection Label (later the *Good Design Label) and the Australian Design Index. In 1991, following a review by representatives of government, industry, and the design profession, the Australian Design Award was allocated to the Design and Development Division of Standards Australia (established 1922) with many offices in Australia and abroad. Relaunched yet again in 1993 under the Standards Australia Quality Assurances Services (but reverting back to Standards Australia in the following year), the Australian DesignMark Programme consisted of three tiers of award: the Australian DesignMark, the Australian Design Award itself, and the Australian Design of the Year. Like the Japanese *G-Mark competition in later years, the Australian scheme also admitted both national and imported products as a means of exposing national manufacturers and the design profession to good practice internationally. In 1994 the Ford *Falcon* won the Australian Design Award of the Year, one of many well-known items of popular everyday design that have won the ADA, including the Victe lawnmower, the Sunbeam *Mixmaster*, the Dolphin torch, and the Australian Test Series helmet. In 1997 the Australian Design Awards began a process of collecting entries to the competition by means of the internet with a College of Industrial Designers established to act as an adjudicating panel drawn from a much broader perspective than the previous panel assessment of individual products.

Baillie Scott, Hugh McKay Bakelite Balla
Ballmer, Walter B&B Italia Bang & Olufse
(Peter) Reyner Barbie Barman, Christian
Barthes, Rola Bass, batch produc
Bayer, Herbe Bayerisch otoren Werk
Aubrey Beck enry ehrens, Peter B
Benetton Be on, Benson, Willi
Bernadotte, ard Ber Oliver Percy
Bertone Bib IB Desig onsultants B
Bill, Max Bir o Bjorn, Actor
Bernadotte BKI Black, Misha Block Blo
BMW Boilerhouse Bonsiepe, Giu Boras
Boras Wäfveri Borax Boue, Michel Boul.
boutiques Braddell, Dorothy Bradley, Wi
Brandt, Marianne Branson Coates Branz
Breuer, Marcel BRIO Brionvega Britain (
exhibition [1946] British Empire Exhibitic
ody, N
illie S
alter
Barbi
Rolan
Herbei
Beck,
on Be
adotte
e Biba
l, Max
tte Bl
house
Bora
ell, Do
e Bra
tel BR
6] Bri
Institu
gatti,
Giaco

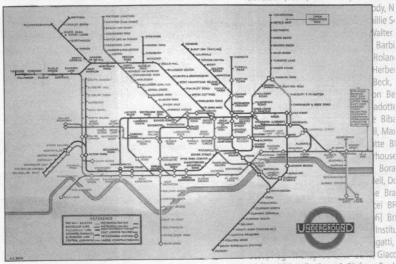

Walter B&B Italia Bang & Olufsen Banh
Barbie Barman, Christian Barnack, Osca
Bass, Saul batch production Bauhaus B
Bayerische Motoren Werke Beardsley, Au
C. Behrens, Peter Bel Geddes, Norman
Benktzon, Maria Benson, William Arthur
Sigvard Bernard, Oliver Percy Bertoia, Ha
BIB Design Consultants BIC Bijkenkorf, [
Samuel biro Bjorn, Acton Bjorn & Berna
Misha Block Blok Blueprint BMW Boil
Giu Boras Cotton Studio Boras Wäfveri
Michel Boulanger, Pierre boutiques Bra
Bradley, William branding Brandt, Maria
Coates Branzi, Andrea Braun Breuer, M.
Brionvega Britain Can Make It exhibition

Baillie Scott, Hugh McKay (1865–1945)
A leading figure in the late *Arts and Crafts
Movement in Britain, Baillie Scott was
widely known in Germany and Austria
through the frequent appearance of his
work in the pages of the widely read maga-
zine the *Studio*. As a result, along with the
designer C. R. *Ashbee, in 1897 he was com-
missioned to design the dining and drawing
rooms for the Neue Palais of Ernst Ludwig,
the Grand Duke of Hesse, in Darmstadt
where there was a thriving artistic colony
(see DARMSTADT ARTISTS' COLONY). These
rooms also contained many items of furni-
ture designed by Baillie Scott. After training
as an architect in Bath, from 1886, three
years later Baillie Scott moved to the Isle of
Man, where he studied at the School of Art.
He was influenced by C. F. A. *Voysey's
architecture and A. H. *Mackmurdo's furni-
ture and wallpapers but was in turn seen as
a significant designer in his own right. In
1905 Hermann *Muthesius, the German
design writer, educator, and architectural
attaché at the German Embassy in London,
published his influential exposition of the
English Arts and Crafts, *Das Englische Haus*,
containing illustrations of Baillie Scott's
work. Baillie Scott also designed furniture,
interiors, and other work for the Deutsche
and *Dresdener Werkstätten in the years
leading up to the First World War, a period
in which his architectural work also fea-
tured frequently in the *Studio Yearbook of
Decorative Art*.

Bakelite (1907–) Bakelite, the trade
name for phenol-formaldehyde or phenolic
resins, was the first totally synthetic plastic

and was patented by Dr Leo Baekeland in
1907. In order to put his invention into
commercial production in 1910 he founded
the American General Bakelite Company. It
became the Bakelite Corporation in 1922
and was taken over by the Union Carbide
and Carbon Company in 1939. Bakelite also
impacted on Europe with Baekeland's es-
tablishment of the Bakelite Corporation of
Great Britain in 1922. Although laminated
phenolic resins were originally used for
the manufacture of gears, Bakelite sub-
sequently emerged as an important new
material in product design. This followed
the expiry of Baekeland's patents in 1927
when many new variants of phenolic resin
became available under a variety of trade
names. This new competition forced down
prices and also produced brightly coloured
variations of a material that had previously
been black or dark brown in appearance.
Many industrial designers in the United
States were enthusiastic about the smooth,
lightweight, and durable forms that were
easily manufactured using the new resins.
Raymond *Loewy, for example, used Bake-
lite to telling effect in the smoothly
rounded casing for his celebrated 1929
design for a Gestetner duplicating machine.
Keeping the product firmly in the public
eye, Bakelite was displayed at the 1933
*Chicago Century of Progress Exposition.
Bakelite also had widespread currency in
Britain, particularly in innovative radio cab-
inets manufactured by E. K. Cole Ltd. such
as the rounded form of the *Model AD65* radio
designed by Wells *Coates (1934) and the
elegant *Model AC74* radio by Serge *Cher-
mayeff. Phenolics were also used in furni-

ture manufacture, as in the commercially successful French outdoor café range by Manufacture d'Isolants et Objets Moulés launched in 1932. Following their introduction in the years before the First World War phenolic laminates were employed for several decades in a variety of uses, from decorative panels to dress fabrics.

See also FORMICA.

Balla, Giacomo (1871–1958) Balla is often portrayed as a painter closely associated with Italian *Futurism although in fact, like a number of others associated with the group, his work crossed into a number of creative disciplines including fashion and the applied arts. In 1914 he wrote the *Manifesto on Menswear*, later retitled *Antineutral Clothing*, a dramatic exhortation to dispense with the mundaneity of everyday menswear in favour of dynamic, expressive, and aggressive Futurist clothing. Like his fellow Futurists he sought to sweep away all vestiges of Italy's cultural heritage in favour of an emphatically 20th-century way of life. He conceived of Futurist menswear as allowing its wearers to respond to mood changes through 'pneumatic devices that can be used on the spur of the moment, thus everyone can alter his dress according to the needs of his spirit'. It could also be animated by electric bulbs. He had an exhibition at the Casa D'Arte Bragaglia in Rome in 1918, in conjunction with which he co-published his *Colour Manifesto*. He was also committed to Futurist applied arts and furniture, brightly painted and with richly animated surfaces, and showed them at his Futurist House in 1920, the year in which he collaborated on the journal *Roma futurista*. He also exhibited at the *Paris Exposition des Arts Décoratifs et Industriels of 1925 and the International Exhibition at Barcelona in 1929. However he failed to get his Futurist designs put into mass production and during the 1930s gradually distanced himself from such an outlook.

Ballmer, Walter (1923–) Well known for his advertising, graphics, and industrial design for the Italian office equipment manufacturer *Olivetti, Swiss-born Ballmer studied graphic design at the Kunstgewebeschule in Basel from 1940 to 1944. He worked in publishing before moving to Italy in 1947 to join Studio Boggeri in Milan (established 1933). An established and successful graphic design office, Studio Boggeri executed a number of graphic design commissions for the office equipment manufacturer Olivetti and, from 1956, Ballmer went on to work as a graphic designer in Olivetti's advertising department where he remained until 1981. The visual clarity and deceptive simplicity of his graphic design work revealed something of his Swiss training and informed much of his publicity design for the company. Amongst his work for Olivetti was the coordination of a number of exhibitions shown in Italy and abroad, including *Olivetti-Style* (1961), *Olivetti Innovates* (1965), and *Olivetti Image* (1968). He was made a member of *Alliance Graphique Internationale (AGI) in 1970 and, in 1975, received a Gold Medal for *Olivetti-Image* at the Ljubljana Bio 5.

B&B Italia (established 1974) Originally launched in 1966 as C&B Italia by Cesare *Cassina and Pietro Busnelli this Italian firm's work specialized in *Polyurethane furniture, for which it soon established a reputation as an innovator. This was sustained by the establishment in 1968 of a research centre under architect and furniture designer Francesco Binfaré. C&B Italia commissioned many leading Italian designers to explore the exciting possibilities of this new medium, including Mario Bellini, who contributed the *Amanta* chair in 1966,

and Gaetano *Pesce, who designed the *Up* chair in 1970. However, the company's success was such that Cesare Cassina withdrew on account of the strong competition it afforded his own Cassina furniture manufacturing company. Since its retitling as B&B Italia in 1974, the company has continued to innovate in design and materials, particularly its main outputs in polyurethane furniture. Leading designers working for the company have included Afra and Tobia *Scarpa (whose designs included the *Artone* chair of 1985), Vico *Magistretti (whose work included the *Quartetto* and *Sestetto* tables of 1974), Antonio *Citterio (whose output included the *Sity* sofa of 1980), and Paola Nava (whose designs included the *Baia* sofa of 1977).

Bang & Olufsen (established 1925) Founded in 1925 by Peter Bang and Sven Olufsen this celebrated Danish manufacturer of stylish audio-visual equipment did not place a high premium on design until 1963, when the industrial design consultancy *Bjorn & Bernadotte and their former employee Jacob *Jensen were employed to counteract a slump in sales. As a result a stylish product identity emerged, characterized by clean lines, crisp minimalist graphics, and almost scientifically ordered control systems. In 1966 the *Beolit 500* portable radio was awarded the Danish ID Prize. Within a decade the company enjoyed an international reputation, underlined in 1978 by the *Museum of Modern Art, New York's exhibition entitled *Bang & Olufsen: Design for Sound by Jacob Jensen*. Nonetheless, the company was less successful economically than stylistically and in 1990 *Philips took on 25 per cent ownership. However, a management restructuring reversed this position and the company regained its pre-eminent position as a leading force in styl-ish audio-visual products for an affluent international clientele.

Banham, (Peter) Reyner (1922–88) Banham was a key figure in the history of design whose writings, both historical and critical, did much to enthuse the first generation of design historians in Britain. Studying art history at the Courtauld Institute of Art, University of London, from 1948, he went on to study for a Ph.D. under Nikolaus *Pevsner. With Eduardo Paolozzi, Richard Hamilton, and others Banham was also a founder member of the *Independent Group (IG) at the Institute of Contemporary Arts in the early 1950s. The IG did much to shift aesthetic attitudes away from the enduring values of *Modernism, the fine arts, and art historical establishment towards a standpoint that embraced advertising and popular culture, particularly that from the United States, presaging the era of *Pop. Banham's enduring interest in American culture was further stimulated by a Graham Foundation Scholarship, which took him to the USA from 1964 to 1966. Banham's informed fascination with technology and gizmos, stimulated by an apprenticeship in the aircraft industry during the Second World War, was reflected in many of his writings, as was his ability to communicate lucidly on many levels, perhaps honed through a prolific journalistic output. As well as many articles for *New Statesman* (1958–65), *New Society*, and *Design* magazine he was also a staff writer for the *Architectural Review* (1952–64). His many books included *Theory and Design in the First Machine Age* (1960) (the published outcome of his Ph.D. thesis), *The Architecture of the Well-Tempered Environment* (1969), *Los Angeles: The Architecture of Four Ecologies* (1971), and *Megastructures: Urban Futures of the Recent Past* (1977). From 1964 he worked at the Bartlett School of Archi-

tecture London, becoming Professor of Architecture at University College, London, in 1969. He also played an active role in the development of studies in the history of design in Britain. In addition to work on *Mechanical Services* (1975) for the Open University Course on the *History of Architecture and Design 1890–1939* , he participated in pioneering design history conferences at Newcastle Polytechnic in 1975 and Middlesex Polytechnic in 1976. He became a Patron of the *Design History Society after its foundation in Brighton in 1977, having moved to the United States in 1976, where he took up a series of academic posts.

Barbie (1959–) Created by Ruth Handler, wife of one of the company's co-founders, and launched by the American toy company *Mattel at the 1959 New York Toy Fair, Barbie doll was originally marketed as a glamorous, bodily developed teenage fashion model with a range of fashions and accessories. With ponytail hairstyle, black and white striped bathing suit, and sunglasses she proved an instant and phenomenal sales success with young girls, despite the initial reservations of retail industry buyers. Over 350,000 Barbies were purchased within a year. Very much responding to contemporary fashion, youth culture, and notions of *'Lifestyle', Barbie underwent a number of constructional changes. These included a swivel waist for dancing (1969), a whole range of movable bodily joints for the 'New Living Barbie' (1970), hands that could hold accessories such as a telephone or portable TV (1972), and a 'Free Moving Barbie' mechanism which allowed her to wield a tennis racket or golf club. Barbie proved highly attractive to young girls over a long period. Her male counterpart, fashion-conscious boyfriend Ken, joined Barbie in 1961. Barbie's gender and sociocultural stereotype, which even extended to the inclusion of a wedding dress, the most popular of her outfits, was to a minor degree negated by some of the professional roles that she adopted over the years including doctor, firefighter, astronaut, and presidential candidate. In similar vein, amongst other friends introduced to the range was an African-American, Chrissie (1968), and a disabled friend in a wheelchair, Becky (1997). Barbie has been marketed worldwide since 1963 and has proved highly successful. As a result, she has been manufactured under licence, commencing in England, France, Germany, Italy, and elsewhere. About one billion Barbie dolls have been sold worldwide since 1959, with annual sales of over £1 billion. However, in 2004, much as if they were real Hollywood personalities, it was decided that Barbie and Ken were to end their long-standing relationship. To complement Barbie's latest incarnation as a Californian beach girl a new character has been launched, an Australian surfer named Blane.

See also ACTION MAN; SINDY; MATTEL.

Barman, Christian (1898–1980) An important first-generation British industrial designer of the interwar years, Barman is widely recognized for his 1936 electric iron for HMV, a company for whom he began designing in 1933. He had studied architecture at Liverpool University and ran his own practice until 1935 when he was invited by Frank *Pick to take up the post of Publicity Officer at London Transport. He played a key role in presenting its design policy until 1941. The latter had enjoyed a progressive period of innovations in architecture, equipment, signage, graphic design, and street furniture under Pick's stewardship. After a period as assistant director of Post-War Building at the Ministry of Works and publicity officer for the Great Western Railway, from 1947 to 1963

Barman was head of publicity for the British Transport Commission. He was elected as a *Royal Designer for Industry in 1948, served as president of the Society of Industrial Artists (see CHARTERED SOCIETY OF DESIGNERS) from 1949 to 1950 and received the Order of the British Empire in 1963. He also edited the *Architectural Review and the Architects' Journal and published a number of books on design including Early British Railways and The Man Who Built London Transport: A Biography of Frank Pick (1979).

Barnack, Oscar (1879–1936) The first effective 35 mm camera, the Leica 1, was put into production in Germany in 1925 and made photography much more readily available to everybody. This compact and lightweight model was the result of twelve years of experimentation by Oscar Barnack, a precision engineer at the Leitz optical laboratories in Wetzlar (established 1869). Originally trained as a mechanic he joined the Ernst Leitz company in 1911, working as a master mechanic. His remarkable design solution resulted in Barnack's rejection of the conventional cumbersome glass plate negative format and adoption of a 24 × 36 mm reel-to-reel film format. In 1913 Barnack developed his first experimental small format camera, the basis for the Leica A of 1918 and the first production model, the Leica 1 of 1925. (The name Leica is a contraction of the words Leitz and camera.) The Leica 1 was highly practicable with 36 exposures per film and a high-quality lens and mechanics. Its concern with high-quality functionality and technological innovation was reflected in its unfussy design, qualities that have been reflected in Leica camera design to the present day, as in the Leica C1 of 1999 designed by Achim Heine. Amongst early users of the first mass-produced Leica cameras were the influential *Bauhaus graphic designer and teacher

Herbert *Bayer and leading German photo-journalists such as Erich Salomon.

Barthes, Roland (1915–80) Influential in the development of cultural studies and subsequently widely read by design historians, the impact of Barthes's writings in Britain was slowed somewhat by delays in translation from the French. In the case of Mythologies (1957), his most widely known book in the context of design, it was not translated for fifteen years. From 1960 onwards Barthes taught courses involving the sociology of signs, symbols, and representations at the École Pratique des Haut Études, Paris, playing an enduring role in debates about semiology. In Mythologies he laid out his approach in an essay entitled 'Myth Today'. In other essays he explored the meanings of a variety of occurrences and objects in everyday life. These ranged from wrestling and striptease to advertisements, photography, and automobiles, particularly 'The New Citroën' (the DS19). He saw the latter as 'almost the exact equivalent of the great Gothic cathedrals...the supreme creation of an era, conceived with passion by unknown artists and consumed in image if not in usage by a whole population which appropriates them as a purely magical object'. He also wrote about meaning in the context of fashion in The Fashion System of 1967 in which he discussed layers of meanings in fashion language, dress codes, and style. Other key texts by Barthes included Elements of Semiology (1964) and The Pleasure of the Text (1973). In 1976 he was appointed Chair of Literary Semiology at the Collège de France.

See also SEMIOTICS.

Bass, Saul (1920–96) Born in New York, graphic designer and art director Saul Bass trained as an animator under Howard Trafton at the Art Student League in New York (1936–9) and the European-influenced

designer Gyorgy Kepes at Brooklyn College (1944–5). After moving to Los Angeles in 1946 and introducing sophisticated East Coast graphic solutions to the highly commercial ethos of the West Coast, he founded Saul Bass Associates. He was responsible for a number of logos, including AT&T and Warner Communications, and corporate identity schemes for airlines, including Continental. He first attracted more widespread attention after moving into film, designing the artwork, trailer, and titles for his father-in-law Oscar Preminger's *Carmen Jones* in 1954. This was followed by work for Preminger's *The Man with the Golden Gun* (1956), Billy Wilder's *Seven Year Itch*, and a series of striking collaborations with Alfred Hitchcock. These involved the title shots for *North by Northwest* (1959) and *Psycho*, for which he was also employed as Pictorial Consultant for the famous shower scene. With his striking credit sequences and animations Bass exerted tremendous influence over film title work, including *Around the World in 80 Days* (1956), *Anatomy of a Murder* (1959), *Goodfellas* (1990), and *Casino* (1996) and many others. He also made the US contribution to the 1968 *Milan Triennale and was later recognized for his striking poster for the 1984 Los Angeles Olympics.

Batch Production This approach to design production—producing individual designs in limited quantities—was common amongst many smaller companies or craft workshops for much of the 20th century, allowing them to respond quickly to different commissions and market opportunities without the necessity of being tied down to the relatively inflexible and expensive technologies associated with the modes of mass-production *Fordism. With the rise of *Computer-Aided Manufacturing systems larger manufacturers have also

been able to be more flexible and swiftly responsive to the increasingly diverse consumer demands of the global market place. This ability to produce smaller production runs had the added economic advantage of dispensing with the need for large storage areas to hold stock and was an integral part of the *just in time manufacturing and distribution systems that were introduced increasingly from the 1980s.

Bauhaus (1919–33) There is little doubt that this German school of design was the most influential of the 20th century. Many of the leading figures of *Modernism including Walter *Gropius, Herbert *Bayer, Marcel *Breuer, László *Moholy-Nagy, Wilhelm *Wagenfeld, Anni and Josef *Albers, Marianne *Brandt, and Gunta *Stölzl were closely identified with it, either as members of staff or students, and many of its avant-garde ideas were disseminated through the publication of fourteen *Bauhausbücher* (Bauhaus Books) between 1925 and 1930. A *Bauhaus* journal also appeared periodically between 1926 and 1931. As well as attracting many foreign visitors during its life in Germany (in Weimar 1919–25, Dessau 1925–32, and Berlin 1932–3), the emigration of many of its leading teachers to Britain, the United States, and elsewhere following the rise to power of the National Socialists further boosted its reputation as a progressive centre for art, architecture, and design education. The commitment of the Bauhaus to notions of a socially democratic vision of a well-designed environment, the idea of an *International Style, and its position to the left of the political spectrum proved problematic in the sensitive economic climate of the 1920s and 1930s. Nikolaus *Pevsner's *Pioneers of the Modern Movement: From William Morris to Walter Gropius* of 1936 (reformulated in 1949 as *Pioneers of Modern Design* in conjunction with the

*Museum of Modern Art, New York) did much to validate the historical importance of the Bauhaus. He presented it—via the principles of the design reformers of the *Arts and Crafts Movement—as the culmination of the avant-garde's rejection of Victorian historical encyclopaedism. Pevsner's 'Pioneers' favoured an aesthetic that symbolically embraced the realities of the new century through exploration of new materials, modern mass-production technologies, and abstract form, ideas that were at the heart of the Bauhaus outlook from the early 1920s onwards. The achievements of the school were recognized by the Museum of Modern Art in New York in 1938 when it mounted an exhibition devoted to the Bauhaus from 1919 to 1928. However, this proved attractive to many historians and ideologues in the aftermath of the Second World War. They were further aided in their task by the establishment of the Bauhaus Archive in Darmstadt in 1960 (moving to Berlin in 1971), the formation of a Bauhaus Archive in Dessau and the mounting of a number of dedicated exhibitions and publications.

The Bauhaus was founded in 1919 under the directorship of Walter Gropius, bringing together two Weimar art and architecture schools under the title of Staatliches Bauhaus Weimar. The Founding Manifesto of 1919 revealed the institution's ideological links with the crafts and the idea of the unification of all the arts. In the initial years there was something of an Expressionist outlook, perhaps reflecting the mistrust of many of the avant-garde in large-scale industry, which was felt to be partly responsible for Germany's participation in the First World War. At this stage Johannes *Itten was a key figure, running the six-month foundation course (*Vorkurs*) that was centred on the exploration of materials and form. This was followed by simultan-

eous studies with an artist (*Formlehre*) and craftsman (*Werklehre*) and culminated in the study of architecture and building. An early major project which brought together all of these elements was the building of the wooden Sommerfeld House designed by Walter Gropius and Hannes Meyer. Some historians have seen this as an Expressionist enterprise, although others have interpreted its timber construction and decorative detailing inspired by folk art as a natural response to the shortage of building materials and access to modern equipment. However, in the early 1920s there was a very distinct shift of direction with the arrival of the *Constructivist artist Wassily Kandinsky in 1922 and László Moholy-Nagy in 1923. The modernizing impact of De *Stijl and Russian Constructivism was also significant at this stage. A Bauhaus Exhibition was mounted in 1923 as a means of demonstrating the economic relevance of the School to the funding authorities. The adoption of a new Bauhaus slogan—'Art and Technology in a New Unity'—was reflected in the Modernist aesthetic of Gropius' office. Able to be viewed by the public, the furniture, designed by Gropius himself, was geometric in form and compatible with modern mass-production technologies. Also reflecting contemporary commitment to the exploration of abstract form were the wall hanging by Else Mögelin and rug by Gertrud Arndt, students in the Weaving Workshop. A key exhibit in 1923 was the Haus am Horn, designed by Georg Muche and Adolf Meyer, with interiors, furniture, fittings, and equipment produced by the Bauhaus Workshops as prototypes for industrial production. In the same year a business manager was appointed as part of a strategy to secure income through partnerships with industry rather than local government. However, the Bauhaus generally proved unable to meet delivery dead-

lines, provide well-designed stands at trade fairs, or price goods at competitive prices. There were other problematic aspects of Bauhaus outlook, particularly in the ways in which Gropius sought to limit the number of female students to the institution through the introduction of a more rigorous entry policy. The position of women was further undermined by attempts to restrict them to the 'female' crafts of weaving, bookbinding, and pottery rather than those fields more closely allied with architecture, the stated goal of the institution. Figures such as the lighting and metalware designer Marianne Brandt were notable exceptions to the general rule. Perhaps ironically in this context, the Weaving Workshop at Dessau under Gunta Stölzl was a leading centre for industrial training and equipped women graduates for work in industry.

For political reasons the Bauhaus was forced to move from Weimar to Dessau in 1925–6, where it occupied striking new Modernist buildings, with interiors, furniture, and fittings reflecting a symbolic commitment to functionalism, the exploration of new materials and abstract form, and compatibility with contemporary production technology. These ideas could also be seen in advertising and typographic work by Herbert Bayer, tubular steel furniture by Marcel Breuer, metalware by Moholy-Nagy, and the Vorkurs by Josef Albers. Although Gropius and Moholy-Nagy left the Bauhaus in 1928 notions of designing for industry were applied with greater success in the later 1920s. Commercial links were established with Körning & Mathiesen in Leipzig (lighting), Rasch Brothers in Hanover (wallpaper), and Polytextil-Gesellschaft in Berlin (textiles). Hannes Meyer succeeded Gropius as director in 1928, giving way to *Mies Van Der Rohe in 1930. Just as the Bauhaus had been forced to

move from Weimar in 1925 the school had to move from Dessau to Berlin in 1932 following difficulties with the National Socialist City Council. Its life was limited and the Bauhaus was closed in 1933.

Bayer, Herbert (1900–85) Associated with the *Bauhaus in Germany in the formative years of his career Austrian-born Bayer was a leading graphic and exhibition designer associated with *Modernism who emigrated to the United States in 1938, where he became a significant figure in advertising and education.

After an early apprenticeship in arts and crafts in Linz and employment in an architecture and design studio in Darmstadt in 1920 he became a student at the Weimar Bauhaus from 1921 to 1924. De *Stijl and *Constructivism and the teaching of the painter Wassily Kandinsky influenced his early graphic designs, including a series of banknotes for the State Bank of Thuringia in 1923. When the Bauhaus moved to Dessau in 1925 Bayer was made head of the new Department of Typography and Advertising. In the same year he had proposed a lower case *Universal* sans serif typeface that embraced the idea of modern, efficient lettering that dispensed with capital letters. In 1928 he set up in practice in Berlin where he worked across a wide range of graphic media, including exhibitions, advertising, editorial and typographic design, and explored new techniques such as photomontage. He continued to work with former colleagues at the Bauhaus: in 1930 he worked with Marcel *Breuer and László *Moholy-Nagy on the design of the *Deutscher Werkbund exhibition at the Spring Salon of the *Société des Artistes Décorateurs in Paris and, in the following year, with Moholy-Nagy and Walter *Gropius on the Building Workers' Union exhibition in Berlin. Bayer's work at the

Werkbund exhibition also included photographic displays of earlier Bauhaus and Werkbund displays, hung at angles from walls and ceiling to permit easier viewing. He also designed the catalogue in red and black print. From 1928 to 1938 he was art director to the Dorland advertising agency in Berlin, his work including photographic covers for the cultural periodical *Die Neue Linie* between 1930 and 1936. However, in the difficult political climate of the late 1930s he emigrated to the United States, where he contributed to the 1938 *Bauhaus 1919–1928* exhibition at the *Museum of Modern Art, New York. Living in New York, he became a consultant art director to the J. Walter Thompson advertising agency during the Second World War and, from 1938 to 1945, was also a director at Dorland International Design in New York before moving to Aspen, Colorado, in 1946. He taught at the Aspen Institute and became a founder of the *International Design Conference. He also worked for the *Container Corporation of America, from 1946 to 1975, becoming chairman of its Design Department in 1956. Other important clients included the General Electric Company. As a result of his involvement in a wide range of design activities Bayer played an important role in the dissemination of Modernist graphic design and advertising in the United States.

Bayerische Motoren Werke *See* BMW.

Beardsley, Aubrey (1872–98) One of the leading *Art Nouveau graphic artists in Britain, Beardsley courted controversy with a number of his sexually charged illustrations, particularly those for Oscar Wilde's *Salome* (1894) and literary quarterly, *The Yellow Book* (1894–7). His strong linear, black and white style has an almost calligraphic fluency, yet also bears affinities with Japanese woodblock prints that had

exerted such a strong interest amongst artists and designers in the second half of the 19th century after trade links with Japan were restored. His first important commission was an 1892 edition of Malory's *Morte D'Arthur*, followed by the showcasing of many aspects of his work in the influential magazine the *Studio* in 1893. His notoriety gathered pace with his taking on the art editorship of *The Yellow Book* in 1894, a potent vehicle for artistic expression. His scandalous reputation was further highlighted by allegations about his relationship with the poet, playwright, and critic Oscar Wilde, leading to his dismissal from *The Yellow Book* after only four issues. This did not prevent his taking up another art editorship, this time for the literary quarterly, the *Savoy*, the first issue of which was published in 1896. He died of tuberculosis at the age of 26.

Beck, Henry C. (1903–74) Beck is most widely known for his landmark design of the London Underground map (1931–3) which, with some modifications for new lines and stations, still forms the basis of the design in use in the early 21st century. The clarity of its visual organization through the use of colour-coded lines has subsequently influenced the design of urban transport maps in many countries of the world. Beck worked on variations to the map until 1959 but after the construction of the Victoria Line all of his subsequent proposals were turned down. Beck's designs complemented Edward Johnston's elegant, crisp, and extremely legible *Railway* typeface for London Underground signage, first introduced in 1916, as well as other aspects of London Transport's modern corporate identity established by Frank Pick in the 1920s and 1930s, including street furniture and stations by Charles Holden.

Behrens, Peter (1868–1940) Behrens is often seen as the first designer to project a modern face, or *corporate identity for industry, designing buildings, products, housing, showrooms, publicity material, and furniture for the German electrical manufacturer *AEG from 1907 to 1914. In many ways this anticipated the model adopted by the first generation of American industrial design consultants in the 1920s and 1930s including Walter Dorwin *Teague, Raymond *Loewy, and Norman *Bel Geddes. Behrens is also widely recognized by historians as the architect-designer in whose office three key figures of European *Modernism—Walter *Gropius, *Mies Van Der Rohe and Le *Corbusier—all worked for periods between 1908 and 1911. Initially Behrens trained as a painter at the Kalsruhe School of Art from 1886 to 1889 and, during the 1890s, worked for a number of German literary and art journals including *Pan. He also became a member of the Munich Secession and a founder member of the *Munich Vereinigte Werkstätten in 1897. Behrens designed across a wide range of media from graphics to furniture, pottery, and metalwork. In 1899 he joined the *Arts and Crafts Movement-influenced artists' colony at Darmstadt, established by Duke Kudwig II von Hessen in 1898. Behrens exhibited a house at the 1901 Darmstadt Exhibition, receiving widespread critical attention for his furniture, fittings, and interiors which, although moving away from the more flowing *Art Nouveau forms that had characterized much of his earlier design output, utilized expensive materials and finishes. Commissioned by the Hamburg Museum of Applied Art Behrens designed the entrance hall and furniture for the German Pavilion at the Turin International Exhibition of Applied Art of 1902, at which he also exhibited a library commissioned by Alexander Koch. Their aesthetic

ethos still reflected something of the spirit of Art Nouveau and was in marked contrast to much of his more functional work in the years leading up to the outbreak of the First World War. During those years he moved away from a crafts outlook to one much more firmly embedded in the realities of economic, modern mass-production technologies. Behrens became director of the Düsseldorf School of Applied Arts from 1903 to 1907 and introduced a number of significant changes in the curriculum, steering it towards the needs of art industry and domestic design through greater emphasis on materials, techniques, and workshop-based instruction. In June 1907 he was appointed as artistic consultant to AEG. Amongst the many architectural designs that he produced for the company the most widely reproduced is the Berlin Turbine Factory of 1908–9 although, as mentioned above, he designed kettles, lamps, electric fans, and other products, as well as shops, brochures, publicity material, and workers' housing. He also designed workers' furniture in Berlin (1912). In addition to his industrial consultancy work for AEG in the early 20th century Behrens also worked for a number of other manufacturers, including Ruckert in Mainz, Rhenische Glasshütten AG, and the Delmenhorster Linoleum Fabrik (1905–6), and produced four typefaces for the Klingspor foundry in Offenbach in 1908. In 1907 Behrens became a founder member of the *Deutscher Werkbund (DWB), an organization that sought to modernize German design through the reconciliation of art and modern industrial production. He exhibited his Festival Hall at the celebrated 1914 DWB Exhibition at Cologne, a show that proved to be of considerable influence to the development of Modernism outside Germany, later designing a number of DWB pamphlets. Following a phase of Expressionist work

after the war Behrens continued to design buildings with Modernist characteristics. These included his landmark *New Ways* house in Northampton (1923–5), the first international style house in Britain, the Viennese Pavilion Conservatory at the 1925 *Paris Exposition des Arts Décoratifs et Industriels and a terrace block at the DWB's Weissenhofsiedlung Exhibition in Stuttgart in 1927. Although maintaining his Berlin home and architectural practice he taught at the Vienna Academy office as professor of the Master School for Architecture (1922–36), taking on a similar role at the Berlin Academy (1936–40).

Bel Geddes, Norman (1893–1958) Bel Geddes was perhaps the most flamboyant publicist for the new profession of industrial design that emerged in the USA in the 1920s and 1930s. His visions of the future were widely publicized in popular magazines, his own book *Horizons* (1932), and high-profile events such as the 1939 *New York World's Fair. Although many of his designs remained as paper visions he played an important role in the germination of American industrial design: Henry *Dreyfuss was apprenticed to him in 1923–4, Eero *Saarinen worked with him in 1934, and Eliot *Noyes was Design Director in his practice in 1946. Geddes was also considered by the American business magazine *Fortune in its seminal 1934 article 'Both Fish and Fowl' to represent the responsible arm of the industrial design profession.

After studying briefly at the Art Institute in Chicago, Bel Geddes became a practising portrait painter by 1913 before moving into advertising design. By 1918 he had become involved in theatre design, including sets for the Metropolitan Opera in New York (1918) and sets for W. D. Griffiths and Cecil B. De Mille in Hollywood (1925), but entered the burgeoning profession of industrial

design in 1927. Amongst the influences on him was Le *Corbusier's *Towards a New Architecture*, which he bought in English translation in 1927. He went on to design in a variety of media and was portrayed in 1934 by *Fortune* as maintaining a balanced stance in the often vilified new industrial design profession. By this time Bel Geddes's design practice had more than 30 staff involved in various aspects of design, from drafting and modelling through to technical matters, with outside specialists being brought in as necessary. Bel Geddes's commissions included office interiors for the J. Walter Thomson advertising agency (1929), metal bedroom furniture for Simmons (1929), window displays for the Franklin Simon department store in New York (1927–9), *Oriole* gas stoves for the Standard Gas Equipment Company (1932), and radios for Philco (1931). Bel Geddes did much to promote the idea of *streamlining whether in prototype cars for the Graham Paige Company (1928–34), work on the *Chrysler *Airflow* advertising campaign of 1934, dramatic plans for airliners, ocean liners, railway trains, motor coaches, and even architecture, industrial machinery, and domestic appliances. Many of his visions concerning the radical transformation of the everyday environment that the industrial designer could bring about in the later 20th century were contained in his *Horizons*. This blend of social utopianism, design rationale, and the contemporary fascination for science fiction and technocracy was extensively reviewed in the national press and clearly impacted on contemporary design and engineering thinking. A number of his futuristic designs were realized, at least in miniature form, in what may be regarded as his visionary tour de force, the *Futurama* for the General Motors Pavilion at the New York World's Fair of 1939. Visited by more than 5 million this was one of the most

popular exhibits at NYWF and portrayed a future metropolis of 1960, complete with streamlined transportation systems and segregation of pedestrian and motorized traffic. This vision was also seen and discussed in his book *Magic Motorways* (1940). In the post-Second World War period Geddes's practice suffered a series of setbacks, including a rift with its leading figures in 1943 and, by the early 1950s, a serious decline in fortunes.

Benetton (established 1966) By the early 21st century the Italian multinational company Benetton had become one of the largest retailers in the world with outlets in more than 120 countries. The company markets four different brand identities: *United Colours of Benetton* casual wear for the family; *Sisley* for older consumers; *012* baby and toddler clothing; and *Playlife* sportswear. Within a dozen years of its establishment this clothing manufacturing company, founded near Venice by Luciano Benetton, commenced its programme of international expansion. This was helped by the standardization of the company's retail outlets, which were designed in such a way as to show off Benetton products in an alluring manner. Benetton was quick to utilize computing systems in the automation of its operating processes, both in the manufacture of clothing and in the monitoring of stocks and sales. As such, the company was an early exponent of the *just in time production and distribution system, a philosophy that a number of progressive manufacturer-retailers adopted in the late 20th century. In northern Italy in the early 1990s Benetton built two new factories that utilized advanced computing technology in the linking of production controls with an efficient ordering and distribution system. Benetton became widely known for its dramatic, and often controversial, advertising campaigns directed by the fashion photographer Oliviero Toscani. These centred on themes such as 'All the Colours of the World' (1984), 'United Colours of Benetton' (1990), and 'HIV Positive' (1992). The company also captured tremendous publicity through its involvement in Formula 1 motor racing, televised throughout the world.

Benktzon, Maria (1946–) *See* ERGONO-MIDESIGN.

Benson, William Arthur Smith (1854–1924) Well known as a designer and manufacturer of metalwork, particularly early electrical appliances, Benson was also well known as a designer of furniture and wallpapers. Although his roots lay in the *Arts and Crafts Movement he was also important in linking its principles with modern modes of production and new technologies. His electrical appliances were admired by a leading propagandist for higher standards of design in German industry, Hermann *Muthesius, who had experienced British design at first hand from 1896 to 1903. Samuel *Bing sold Benson's work in Paris in his celebrated Galerie L'Art Nouveau.

At the outset of his professional career as a designer Benson set up a metal manufacturing workshop in 1880, following a period working in the architectural offices of Basil Champneys. He went on to open a factory in Hammersmith as well as a shop in Bond Street in central London in 1887. A member of the *Art Workers' Guild and a key figure in establishing the *Arts and Crafts Exhibition Society that seceded from it, Benson became chairman of Morris & Co. following the death of *Morris in 1896. Benson was also a founder member of the *Design and Industries Association (DIA) in 1915.

Bernadotte, Sigvard (1930–80) *See* BJORN & BERNADOTTE.

Bernard, Oliver Percy (1881–1931) After a colourful adolescence working at sea, in the theatre, and scene painting, Bernard travelled to the United States in 1905. He found work as a scenic artist before working as technical director for the Boston Opera Company and as a resident scenic artist for the Grand Opera Syndicate at Covent Garden, London. After a period during the First World War working as a Camouflage Officer in the Royal Engineers and serving overseas he worked again in theatre design, designing the Ring Cycle for Sir Thomas Beecham at Covent Garden in 1921. He also became a consultant to the Board of Overseas Trade, working on many decorative designs and displays at the Wembley Empire Exhibition in London in 1924 and as technical director to the British Pavilion at the *Paris Exposition des Arts Décoratifs et Industriels, 1925. His most significant role was perhaps that of consultant design director to the catering company of J. Lyons & Co. Heavily influenced by continental trends in the decorative arts, especially in their ornamental uses of new materials such as chromium plate, he designed the dramatic entrance of the Strand Palace Hotel, London, in 1929. Often using colourful, decorative motifs in conjunction with atmospheric indirect lighting, he designed a range of decorative interiors for several Lyons Corner House restaurants in London. From 1931 to 1932 he was also consultant designer to an offshoot of Ackles & Pollock, *PEL (Practical Equipment Limited), which became one of the leading manufacturers of tubular steel furniture in Britain. He designed PEL's London showroom, also working on tubular steel furniture for *Cox & Co.

Bertoia, Harry (1915–78) Bertoia was a highly successful American furniture designer in the decades immediately following the end of the Second World War. Although born in Italy he emigrated to the USA with his parents in 1930. After attending the Art School of the Detroit Society of Arts and Crafts in 1936 he gained a scholarship to the *Cranbrook Academy of Art, Michigan, in the following year. After completing his studies in 1939 he became a teacher in metalwork and jewellery at Cranbrook until the shortages of materials in the Second World War led to its closure. His jewellery designs of that period have been likened to those of the American sculptor Alexander Calder, sculptural form becoming an increasing preoccupation throughout his professional life. After a brief period in the Cranbrook graphics department he moved to California in 1943, joining fellow Cranbrook alumni Charles and Ray *Eames. He worked with them from 1943 until 1946 when he left their studio, dissatisfied with the lack of credit that he felt that he deserved for his furniture design inputs as well as the Eames' concentration on wood rather than the metal he preferred. In 1950 Bertoia moved to Pennsylvania to work for Hans and Florence *Knoll (the latter another Cranbrook graduate) and began working on designs for wire mesh metal furniture that was conceived as functional sculpture. In 1952 his *Diamond* and *Bird* chairs were put into production by Knoll Associates and, within a decade, his design work proved so commercially successful that he was able to retire from furniture designing on the royalties gained. He concentrated on sculpture for the rest of his life, although remaining a consultant to Knoll. He undertook a number of commissions for architectural sculpture, gaining a gold medal from the Architectural League of New York in 1954 and the American Institute of Architects in 1973.

Bertone (established 1912) Although founded by Giovanni Bertone before the

First World War as a car body workshop it was not until his son Nuccio joined the Italian firm in 1934 that the company began to emerge as a leading *carrozzerie*. After the Second World War a number of classic body styles were produced including the Alfa Romeo *Giulietta Sprint* (1954), the *Spider 850* (1964) and the Lancia *Stratos* (1971). Other noted designs have included the *Volkswagen *Polo* (1975), the *Citroën *BX* (1982) and, more recently, the *Fiat *Punto Cabrio* (1994).

Biba (1964–75) Biba was an essential ingredient of the 'Swinging London' of the 1960s. Founded by Barbara *Hulanicki, who had studied fashion illustration at Brighton School of Art, the business was launched by selling cheap, fashionable clothes by mail order. The first Biba fashion boutique was opened in London's Knightsbridge in 1964. Essentially nostalgic yet glamorous, the Biba 'look' drew on a variety of exotic sources ranging from the Hollywood of Fred Astaire and Ginger Rogers and *Art Deco through to *Art Nouveau, highly visible in the swirling, curvilinear forms of John McConnell's company *logo of 1968. Having produced its first catalogue in the same year, the company extended its product lines with the launch of its cosmetics range in 1970. Biba moved into its final location, the former Derry & Toms department store, in 1973, where interiors such as the Rainbow Room reflected the romance of the 1930s it sought to espouse. Although the business closed in 1975, the company was relaunched in 1995 by Ellen Shek.

BIB Design Consultants (established 1967) Founded by Nick Butler in London BIB has been a leading British product design consultancy for several decades. Butler, a graduate of the *Royal College of Art, was influenced by American practice, having won an *IBM Fellowship to the United States. BIB offers a wide range of services, including company audits, design feasibility studies, human factor analysis, interactive interface design, product engineering, model making and prototyping, concept generation, and product design innovation. Typifying the latter is the Oasis *Turbo Table* (1998), a fan-assisted ironing board. Other products for an international range of clients have ranged in scale from the tiny *Durabeam* flashlight for Duracell to large-scale heavy duty equipment such as the JCB *Sitemaster*, from the Minolta *7000 SLR* camera (1992) to the Artemis Office *Desking System* (1998). Work for BT has included the *Tribune* telehone (1990) as well as free-standing payphone housing. BIB has also received many design awards, and the company's work is represented in collections such as the *Victoria and Albert Museum, the Science Museum, and *Design Museum, all in London, and the *Museum of Modern Art (MOMA), New York. Butler himself has played an active role in external design initiative including in the Department of Trade & Industry's *Design for Profit* campaign of the 1980s. He has also judged for the *Design Council Award Scheme and the BBC Design Awards.

BIC (established 1953) The throwaway BIC™ *Crystal* ballpoint pen has become a ubiquitous everyday item with sales of more than 15 million per day, although by the later 20th century the BIC company had diversified into a wide range of products, including disposable razors. Capitalizing on the technology of the *Biro pen that had been developed commercially by in the 1940s, Marcel Bich established a pen factory in Clichy, France, where he introduced the first of his BIC ballpoint biros in 1953. Having captured an increasing share of the European market, Bich purchased the Waterman Pens Company of New York

in 1958 and introduced the first of his disposable, transparent *Crystal* biros in the United States. Promoted through a television advertising campaign under the banner 'Writes First Time Every Time— and for only 29 cents' this cheap, yet simple, transparent design has been a huge commercial success worldwide for almost 50 years.

Bijenkorf, De (established 1913) This imposing central Amsterdam department store was closely identified with the promotion of *Modern design in the decades following the end of the First World War, a period in which traditional styles generally prevailed. Glass by the *Leerdam manufactory, ceramics by the Sphinx Potteries, and textiles by De *Ploeg were among the products sold. Such policies were more strongly pursued after the end of the Second World War when, from 1948, it put on a series of exhibitions devoted to modern furniture and furnishings under the slogan 'Ons Huis Ons Thuis' (One's House is One's Home). The chief furniture buyer, Martin Visser, promoted contemporary art and design through the store, including exhibitions of the Cobra Group of Artists in the furniture department. A number of Cobra artists, including Karl Appel, were commissioned to design textiles for the company. During the 1950s Bijenkorf promoted products by progressive companies such as Gispen and t'Spectrum and also familiarized Dutch consumers with the design work of Charles *Eames and contemporary Scandinavians. This progressive retailing policy became less pronounced in succeeding decades.

Bill, Max (1908–4) Swiss-born Max Bill worked in a number of design fields including architecture, typography, graphics, product, stage, exhibition, furniture, as well as sculpture and journalism. He was also involved in design education, most notably the rectorship of the Hochschule für Gestaltung (HfG) at *Ulm. His rather austere, rational aesthetic is closely associated with the ideals of the *Swiss Style (also known as the International Typographic Style). After three years as a silversmith student at the Zurich School of Applied Arts, Bill studied at the Dessau *Bauhaus between 1927 and 1929, an experience that was influential in shaping the creative outlook that dominated most of his subsequent career. He then returned to Zurich to work as an artist, graphic designer, and architect. As well as playing a key role in the development of concrete art, together with a group of Swiss *Constructivist designers Bill produced a number of posters commissioned by the Zurich Museum of Applied Arts in the 1920s and 1930s. He also designed the Swiss Pavilion for the 1936 *Milan Triennale. A member of the CIAM (*Congrès Internationaux d'Architecture Moderne) and the UAM (*Union des Artistes Modernes), during the 1940s Bill became increasingly involved with industrial design and organized a *Gute Form* ('Good Form') exhibition for the Swiss Werkbund, commencing a touring itinerary in Basle in 1949. This interest in what was essentially a *Modernist aesthetic led to his involvement in the foundation of the HfG, taking up the inaugural rectorship from its launch in 1953. Bill's own commitment to Bauhaus principles can be seen in early appointments made to the HfG, including Josef *Albers, Johannes *Itten, and *Mies Van Der Rohe. Bill was also commissioned to design new buildings, furniture, and fittings for the school that were officially opened by Walter *Gropius in 1955. However, within a short period, younger members of staff at Ulm increasingly questioned the relevance of a curriculum closely linked to what they saw as outmoded, indi-

vidually centred ideas of creativity associated with the Bauhaus approach of the 1920s, rather than a more scientific, interdisciplinary approach appropriate to the 1950s. This led to Bill's resignation from the rectorship in 1956 and from the school in 1957. In the same year he designed his widely known stainless steel and aluminium clock, with its crisply articulated, minimalist face. This was one of a number of clock and watch designs Bill executed in the 1950s and 1960s for Junghans (established 1861), a company with close links to the HfG. From then until his death Bill concentrated increasingly on his fine art interests. Bill was a member of many design and professional organizations including the Institut d'Esthétique Industrielle in Paris, the *Deutscher Werkbund, and the American Institute of Architects.

Bing, Samuel (1838–1905) A key figure in the promotion of *Art Nouveau, German-born Bing originally trained in ceramics before moving to Paris in 1871 following the end of the Franco-Prussian War. After opening a shop he travelled to the Far East in 1875, before returning once more to Paris, where he opened another trading outlet, La Porte Chinoise, in which he sold oriental objets d'art. This became a focal point for those interested in Japanese art, Bing later going on to edit the periodical *Le Japon artistique* from 1888 to 1991. Louis Comfort *Tiffany was a notable customer of Bing's, the latter becoming Tiffany's European distributor in 1889. In 1892 Bing travelled to the United States charged with a commission from the French government to report on the industrial arts in the United States. He visited the *Chicago World's Columbian Exhibition in 1893, publishing his findings in 1895. Perhaps inspired by Tiffany, Bing took an increasing interest in contemporary design developments and

opened a Parisian gallery and workshops called L'Art Nouveau in 1895, giving its name to the fashionable fin-de-siècle movement (*see* ART NOUVEAU) that swept through Europe and beyond. Designers shown by Bing included *Beardsley, W. A. S. *Benson, *Crane, *Gallé, *Lalique, *Morris, and van de *Velde. Also of considerable significance was Bing's Pavilion at the *Paris Exposition Universelle of 1900, where he commissioned interiors from Georges de Feure, Édouard Colonna, and Eugène Gaillard.

biro (established 1943) The biro, or ballpoint pen, was developed commercially by Hungarian brothers László (1900–85) and George Biró in the 1940s, though its antecedents may be traced back to a patent registered in 1888. This was for a pen that could write on rough surfaces designed by the American inventor J. J. Loud. The Biró brothers had emigrated to Argentina where they registered their patent for a ballpoint pen in 1943, having solved a number of problems. The licensing rights were purchased by the British government as a means of developing a pen that would not leak at altitude for the Royal Air Force. The invention also attracted the attention of the US government in 1944 and in the following year the Eterpen Company, soon taken over by the Eversharp Company, began to market ballpoint pens in Buenos Aires. The proprietary name of biro was registered in Britain in 1947 where Martin Brothers began to market ballpoint pens. Other competitors emerged in the later 1940s but market confidence was dented by the number of poor quality products. However, when the Parker Pen Company entered the ballpoint market in 1954 with its *Jotter* pens, available in different point sizes, the market became more positive. In terms of popular ballpoint pens, the initiative was taken up by the *BIC company, established by Marcel Bich

in the early 1950s. BIC began marketing its best-selling *Crystal* disposable biro in the 1960s, reaching annual daily sales of nearly 13 million by the late 20th century.

Bjorn, Acton (1910–92) *See* BJORN & BERNADOTTE.

Bjorn & Bernadotte (B&B, established 1950) This industrial design consultancy was founded in 1950 in Copenhagen by the Swedish silversmith and industrial and furniture designer Sigvard Bernadotte and the Danish architect Acton Bjorn and was the first of its kind in Denmark. Bernadotte had visited the United States in 1950 and was impressed by American industrial design practice, later writing a book entitled *Industrial Design: Modern Industrial Formgiving* (1953). Jacob *Jensen was one of the company's first employees, joining in 1951 and heading the studio from 1954. By the end of the decade the company had eighteen employees, several of them from overseas, and was able to take on many commissions. Perhaps the most important of these were from *Bang & Olufsen, a relationship that commenced in 1953 and included Bjorn's design of the *Beolit 500* portable radio of 1964. B&B helped a number of other Scandinavian companies explore new materials, technologies, and aesthetic possibilities although their client list was international. Such an outlook was first embraced in the simple, functional forms of the *Margrethe* series of melamine bowls from 1950. Bernadotte became the president of *ICSID in 1961 and founded his own design studio in Stockholm in 1964.

BKI *See* NEDERLANDISCHE BOND VOOR KUNST IN INDUSTRIE.

Black, Misha (1910–77) Industrial designer, architect, and educator Misha Black was born in Russia, moving to London when he was 18 months old. Despite a short period of study at the *Central School of Arts and Crafts and in Paris he was largely self-taught, beginning his professional career in graphic art and exhibition stand design. After forming Studio Z in 1930, in 1934 he joined the Bassett-Gray Group of Artists and Designers, one of the first multidisciplinary design consultancies in Britain. This became the Industrial Design Partnership (1935–40) which Black established with Walter *Landor and Milner *Gray. Work in the 1930s included exhibition design for the MARS (Modern Architectural Research Society) exhibition and as interior designer for the British Pavilion at the 1939 *New York World's Fair. During the Second World War Black worked for the Ministry of Information and, with Milner Gray and Herbert *Read, was a founder member of the *Design Research Unit (DRU) established in 1943. He gained considerable critical attention as an architect-designer at the South Bank, London, site of the 1951 *Festival of Britain. Black's work with the DRU led to design consultancy with a range of key clients including British Rail, London Transport, BOAC, and the Hong Kong Rapid Transport System. In 1959 he was appointed as Professor of Industrial Design at the *Royal College of Art, a highly influential role in design education that he held until retirement in 1975. This proved of seminal importance in British design education, bringing industrial and engineering design together and conferring them with academic status in a higher education sector largely dominated by the fine arts. He was extremely active in the promotion of the design profession on a wide number of fronts. This included membership of the Society of Industrial Artists (SIA, established 1930—*see* CHARTERED SOCIETY OF DESIGNERS) of which he became president from 1954 to 1956, of the Council of Industrial Design (*see* DESIGN COUNCIL) from 1955 to

BLOK

(Established 1924) A group of *Constructivist artists opposed to the decorative and nationalistic preoccupations of the *Cracow School, Blok was launched formally with the first issue of the magazine of the same name in March 1924. The group's theoretical concerns were articulated by Mieczyslaw Szczuka and Teresa Zarnowerówna and, with an emphasis on technology and utilitarianism rather than aesthetics, were closely aligned with those of the Russian Vladimir *Tatlin. However, such a shift away from 'pure art' towards functionalist concerns caused considerable artistic controversy, leading to the dissolution of the group and magazine in 1926. Many of the group associated with another Polish *Modernist pressure group *Praesens, which was established in the same year.

1964 and of the *Design and Industries Association (DIA). Black was also a founder member and later president (1959–61) of the *International Council of Societies of Industrial Design (ICSID) which first met in London in 1957, a member of the Faculty of *Royal Designers for Industry from 1957 (master, 1973–4), and was knighted in 1972.

Block (1979–89) This influential periodical was established at an important time for the development of art, design, and cultural studies in higher education in Britain. Conceived 'as a vehicle of communications with a small and scattered community of like-minded, Marxist and polemical practitioners . . . [involved in] . . . establishing undergraduate and graduate degrees in art, cultural studies and design history', it was established at Middlesex Polytechnic (now University), the seat of the first masters degree in the History of Design in Britain. *Block*'s relationship with the practice of design history was of considerable importance as it argued for a rejection of prevalent and established academic approaches of art history influencing the subject in favour of radical alternatives that sought to understand the social and existential meanings of things. Among the more important influences on editorial policy was the Centre for

Contemporary Cultural Studies at Birmingham University, the writings of Raymond Williams, Pierre Bourdieu, and Jean Baudrillard, and the theoretical approaches of Michael Althusser and Michael Foucault. Economically produced in black and white, with an effective and unfussy layout in the manner of a broadsheet supplement, *Block* carried articles by a number of significant writers including John Heskett, Adrian Rifkin, Toni del Renzio, Dick Hebdige, Lisa Tickner, Judith Williamson, Tony Fry, Stuart Hood, and Griselda Pollock.

Blok *See* box on this page.

Blueprint (established 1983) The launch of this British multidisciplinary architecture and design magazine was in many ways part of the so-called 'Designer Decade' when the fashionability—and comparative success—of the design business was accompanied by a widespread consumer preoccupation with style. Sponsorship included many well-known names of the design world, including Terence *Conran, Brian Tattersfield, and Richard Rogers. However, under Deyan Sudjic's editorship (until 1993) the magazine had a slightly irreverent, occasionally satirical edge and did not conform to the kind of visual stereotyping that

might have been expected of a periodical that was subtitled *London's Magazine of Design, Architecture and Style*. Instead it was designed in a tabloid newspaper format with relatively low production values and large photographs. The first issue included an article on Eva *Jiricná, with another by Peter York on the meaning of clothing. Many significant writers and commentators on design including cultural studies writer Dick Hebdige, typographic historian Robin Kinross, and one-time editor of *Design magazine James Woudhuysen have made contributions. Since Sudjic left in 1993 subsequent editors have included Marcus Field and Grant Gibson and its place as an international design journal widely read by professionals has been secured, with an estimated global readership in 2003 of 31,000. Its remit includes architecture and interiors, fashion, furniture, industrial design, and design education and training and its visual presence is enhanced by the commissioning of up-and-coming photographers.

BMW (Bayerische Motoren Werke, established 1916) After its origins in aero engine manufacture, this Munich-based company became involved in motorcycle production in 1923 before moving into licensed production of the BMW *Dixi* automobile in 1928. In the 1930s the company produced many models in its own right, several of them sports cars such as the highly competitive *328* of 1936. During the Second World War the company built engines for the Luftwaffe, including the Focke Wulf *FW190*. After the war the company manufactured saloon cars, such as the *501* and *502* models of 1951, as well as sports models such as the *507* of 1956 by A. G. Goertz. It also produced the *Isetta* 'bubble car' in 1955, a very small, lightweight, and fuel-efficient model that more realistically addressed the straitened

circumstances of the times. With the remarkable recovery of the Germany economy, BMW launched the *1500* model automobile and, with the introduction of further models such as the *2, 3, 5, 6*, and *7* series, saw itself able to compete with prestigious automobile marques, such as Mercedes Benz. Designers such as Wilhelm Hofmeister, Paul Bracq, and Caus Luthe were instrumental in bringing this about, building on quality engineering and restrained, yet distinctive styling. Claus Luthe, who had designed for *Fiat and *Audi-NSU from the mid-1950s was chief designer from 1976 to 1990. Building on the 3- and 5-series launched in the mid-1970s he worked on the introduction of BMW models at the luxury end of the market such as the 7-series. These helped to establish the company as a major producer of well-engineered, high-specification, high-quality models sought after by business executives throughout Europe. In 1982 the company entered the Formula 1 Grand Prix motor racing championships, first winning the World Championship in 1983 with a Brabham-BMW driven by Nelson Piquet. By the late 1980s the company withdrew from this sporting arena, not rejoining it until 2000. In 1994 BMW took over the British automobile manufacturer Rover, responsible for the *Mini, Land Rover*, and *MG* models, although this proved a difficult relationship and soon led to the reselling of much of Rover. In the following year Chris Bangle designed the *Z3* sports car, which was given worldwide currency through James Bond's appearance at its wheel in the film *Goldeneye* of 1995.

Boilerhouse (1982–7) Directed by Stephen Bayley and supported by the Conran Foundation, the Boilerhouse Project at the *Victoria and Albert Museum ran from 1982 to 1987. Set in a light and predomin-

antly *Modernist environment it provided a showcase for contemporary design. Whilst located in the V&A the Boilerhouse mounted many exhibitions, addressing such complex issues as 'Taste', 'Art & Industry', as well as popular shows on *Memphis furniture, and youth culture. The Boilerhouse demonstrated the public interest in the exhibition of consumer products, whether past, present, or future. The Project came to maturity with the 1989 move to the *Design Museum in Butler's Wharf, London, a 1950s building adapted for use as a gallery of modern design by Conran Roche.

Bonsiepe, Giu (1934–) A key figure in the development of industrial design theory and practice in Latin America, Giu Bonsiepe both studied (1955–9) and taught (1960–8) at the Hochschule für Gestaltung (HfG) at *Ulm. The rational approach to problem solving in design adopted at Ulm, as opposed to the more aesthetically driven principles of *'Good Design', did much to inform his subsequent outlook. After the closure of the HfG in 1968 he went to Chile to work as a freelancer and design consultant to several projects in the context of governmental institutions charged with industrial development. Latin America proved a fertile ground for his design philosophy and his writings were available in several countries including Chile, Cuba, Argentina, and Brazil. After a period in Argentina from 1973 to 1980 he went to Brazil to work in the National Council of Scientific and Technological Development. He then spent three years (1987–90) in a Californian software company, Interface Design. From 1993 he was employed by the International School of Design in the University of Applied Sciences, Cologne, where his work embraced medical education software, the role of new media in the communication of knowledge, and web design for companies

and institutions. In 2003 Bonsiepe left the International School of Design in Cologne for Brazil to establish a Masters degree at the Escola Superior de Desenho Industrial in Rio de Janeiro. Bonsiepe has been a prolific writer throughout his career, his output including *Theory and Practice of Industrial Design* (1975), *Design on the Periphery* (1985), *Interface: Design: Understand Again* (1996), and its revised version *Interface: An Approach to Design* (1999), a CD Rom on *Infodesign* (1993), and the coordination of three CD-Roms and a book on *Bricolage* (2001).

Boras Cotton Studio *See* BORAS WÄFVERI.

Boras Wäfveri (established 1870) The company was established in the textile manufacturing area of south-western Sweden. Although the employment of artists for textile design was rare until the 1930s, when a small number were taken on by Boras Wäfveri, it was not until the establishment of a design department in 1966 that a change of attitude was really felt. Subsequently entitled the Boras Cotton Studio, much of the output was geared to the design of cotton fabrics for public buildings. Inez Svensson had been made art director in 1957, soon establishing an artistic impetus for the company's textile designs with the recruitment of Sven Fristedt to the Boras Cotton Studio. From 1968 onwards the company commenced its annual policy of selecting ten artists for its textile collection and in the early 1970s worked with the *Tio-Gruppen (Group of Ten) which had been founded in Stockholm in 1970 by Gunila Axén, Inez Svensson, and others.

Borax A term used by many critics of streamlined, gaudy, ephemeral—particularly American—products in the years following the Second World War. Typical of this breed was American writer-curator Edgar Kaufmann Jr., who wrote a celebrated

article entitled 'Borax—or the Chromium-Plated Calf' in the *Architectural Review* of October 1948. He warned British readers of the dangers of ephemeral design, obsolescence, and superficial styling, characteristics that were essentially antithetical to the *Modernist aesthetic of clean, abstract forms and the tenets of 'Good Design'. These were promulgated by organizations such as the Council of Industrial Design (*see* DESIGN COUNCIL) in Britain, the *Deutscher Werkbund in Germany, and the *Museum of Modern Art in New York. 'Borax' is thought to derive from 1920s American slang for showy product promotions offered by the Borax soap company.

Boué, Michel (1936–71) *See* RENAULT.

Boulanger, Pierre (1886–1950) *See* CITROËN.

Boutiques The term 'boutique' was derived from the French and has been used to mean 'small shop' for over 200 years. In the 1950s boutiques—small shops that sold couturier-designed ready-to-wear clothing for a fashionable, affluent clientele—were often found in larger department stores but, by the 1960s, were generally free-standing retail outlets that sold trendy, stylish clothing and accessories to the young. They were closely associated with the *Pop movement and often seen as the retail backbone of the 'Swinging London' of the 1960s. Notable examples of this genre included 'Quorum', established in London in 1964 by Ossie Clark and Alice Pollock, the often nostalgically tinged *Biba, and the individualistic eclecticism of 'Granny Takes a Trip' in the King's Road, London.

Braddell, Dorothy (1889–1981) An important British domestic planner, decorative artist, and interior and graphic designer Dorothy Braddell made a significant impact on the design of kitchens and domestic appliances alongside scientific management of the home. She also wrote eloquently on these areas in a number of leading publications in the field. Her work was shown at prestigious exhibitions, ranging from *British Art in Industry* at the Royal Academy (1935) to *Britain Can Make It* at the Victoria and Albert Museum (1946). It was also shown regularly at the *Daily Mail* *Ideal Home Exhibitions. After King's College, London, she studied art at Regent School Polytechnic and at the Byam Shaw School of Art, winning a National Gold Medal for decorative design. Following the First World War she worked in advertising and promotion, one of her most important clients including Shell-Mex Ltd. In line with the newly founded Campaign for the Preservation of Rural England Shell-Mex Ltd. had become increasingly committed to the promotion of environmentally sensitive advertising and signage and Braddell produced a wide range of promotional material from advertising hoardings to exhibition stands. At the 1932 Motor Show her work was in *Art Deco style, with recessed lighting, *Modernist chromium plated steel furniture, and zebra skin-like furnishing fabrics. She also explored the Deco vocabulary on the Viyella Stand at the 1932 Ideal Home Exhibition. Between the 1930s and 1950s Braddell also focused on interior design and domestic planning, very much in tune with the aims of the campaigning Electrical Association for Women and contemporary thinking on scientific management in the home. She worked for many commercial companies, often acting —unusually for a woman at that time—in a consultancy capacity. Much of her domestic planning design was seen in exhibitions at home and abroad, mainly featuring domestic room settings, especially kitchens. She wrote that 'I think it can be truly said that good planning is the

first essential of labour-saving.' Much of her work featured Aga cookers (manufactured in England by Allied Ironfounders) incorporated into modern, labour-saving settings with integrated work surfaces and built-in cupboards. She also worked closely with manufacturers on appliance design itself, most notably with the Parkinson Stove Company. Her room settings also featured in a number of significant international exhibitions, most notably in the British Pavilion at the Paris Exhibition of 1937. All the designs shown there were selected by the *Council for Art and Industry. She continued to be busy into the 1960s.

Bradley, William (1868–1962) One of the first Americans to work in the *Art Nouveau style, Bradley was an accomplished graphic designer and art editor, influenced by the British *Arts and Crafts Movement, particularly the work of William *Morris and Aubrey *Beardsley. Known as 'the American Beardsley', his posters were renowned from the mid-1890s onwards when the poster craze began to sweep America. Bradley's work was widely disseminated through its publication in La Plume, the London-based poster magazine The Poster (1898–1901), and the Berlin-based Das Plakat (1910–21). It was also shown in Samuel *Bing's celebrated L'Art Nouveau gallery in Paris. Considerable insights to Bradley's career and influences are afforded by his autobiography published late in his life, entitled Will Bradley: His Chap Book (1955). From around 1880 onwards Bradley had worked in the printing trade in Michigan, becoming involved in many aspects of printing, advertising, and layout. He subsequently moved to Chicago and, in 1887, worked for Knight and Leonard, a leading print firm, before becoming a freelancer in the 1890s. Bradley was able to see many

facets of European and American art and design at the *Chicago World's Columbian Exhibition in 1893, in the following year winning his first poster commission, linked to a book cover, title page, and page decorations for When Hearts are Trumps by Tom Hall. In the same year he designed The Masqueraders poster for the Empire Theatre, New York. Evident in these and other works was the influence of the rather sinuous linearity that characterized Beardsley's oeuvre and the flat blocks of colour associated with Japanese woodblock prints. Amongst Bradley's best-known posters were those for The Chap Book, Scribner's book The Modern Posters, and Victor Bicycles. Bradley also executed several other designs for The Chap Book magazine and, between 1894 and 1896, eighteen covers for The Inland Printer. His many other commissions included covers for Harper's Weekly and Harper's Bazaar. In 1895 Bradley established the Wayside Press, which amongst other forms of printed material designed by Bradley himself, published his art journal, Bradley: His Book, from 1996 to 1997. Bradley had become interested in the Barton Collection of Colonial New England books, which he had seen in Boston Public Library, reviving an interest in Old Caslon typeface and the creation of what was known as 'The Chap Book Style'. In the early 1900s Bradley became consultant to the American Type Founders Company (established 1892), designing typefaces and The American Chap Book for which he also wrote. Much of his work was now involved in art directorship, including that of several leading American journals such as Collier's and Good Housekeeping. From 1915 to 1917 he took over the art supervision of a film series for William Randolph Hearst and, in 1920, became art director for Hearst magazines, newspapers, and films.

Branding The means by which names, logos, symbols, trademarks, or product design endow goods or services with a recognizable presence and a set of associated values or expectations on the part of the consumer. Its origins lay in the literal branding of vagabonds with a 'V', thieves with a mark on the left cheek, or army deserters with a 'D', all with a red-hot poker making the bearers of such brands instantly recognizable to society at large. By the latter part of the 20th century branding could be applied to clothing, cigarettes, cars, food, drinks, 'new universities', and many other goods and services. Powerful brand identities range from *Levi Strauss denim jeans to *Louis Vuitton suitcases, and from *Apple computers to *Adidas sporting goods. Through the purchase of specific brands such as these consumers are able to associate themselves symbolically with particular *lifestyles.

Brandt, Marianne (1893–1983) The *Modernist German designer Marianne Brandt was one of the few women associated with the *Bauhaus to make her reputation in design fields outside the conventional arts and crafts territories associated with women such as textiles, weaving, and pottery. Her metalware tea services and light fittings from the 1920s have become widely known, with a number of them produced under licence from the mid-1980s by the Italian firm *Alessi.

From 1911 to 1917 Brandt studied fine art at the Royal Saxon Academy for the Fine Arts, working as a freelance artist for some years after graduation. In 1923 she enrolled at the Bauhaus, studying on the *Vorkurs* (Foundation Course) offered by Josef *Albers and László *Moholy-Nagy before moving on to the metal workshop in 1925–6 where she served in a managerial capacity from 1927 to 1929. Her domestic

metalware designs during the Bauhaus years, like that of many of her academic peers, were influenced by the abstract, geometric forms of *Constructivism and De *Stijl. They were, however, esentially handcrafted prototypes for industrial production. Her lighting designs included an adjustable ceiling light (1926), designed with Hans Przyrembel for the new Bauhaus buildings at Dessau, and the *Kandem* bedside table lamp (1927). After gaining her Bauhaus diploma in 1929 she worked briefly in Gropius' studio and then at the Ruppelwerk factory in Gotha from 1930 to 1933 as head of the decorative arts department, before becoming a freelance artist until 1939. Several of her lighting designs were put into production by firms such as Körting & Mathiesen and Leipzig Leutzch, both of Leipzig. After the Second World War, on the invitation of the institution's director Mart Stam, from 1949 to 1951 she taught in the ceramics department of the School of Applied Arts in Dresden. She then moved to the Institute of Industrial Arts in Berlin-Weissensee, where she stayed from 1951 to 1954, before once again resuming fine art activities.

Branson Coates (established 1985) *See* COATES, NIGEL.

Branzi, Andrea (1938–) A highly influential Italian architect, designer, and theorist since the late 1960s, Branzi has been involved with many progressive elements of Italian design. These include the *Radical Design group *Archizoom, of which he was a co-founder in 1966 in Florence, where he graduated from the Architecture School in the same year. Opposed to the constraints of functionalism and the restrictive dictates of manufacturing industry he was influenced by the aesthetic freedoms of *Pop and the semiotic potential of design explored by contemporary writers such as

Gillo Dorfles and Umberto Eco. As editor of *Casabella* in the early 1970s he wrote about the ideas and practice of many of the more progressive tendencies in Italian design before becoming involved with such important avant-garde groups as *Studio Alchimia and *Memphis. His prolific design output also included the *Domestic Animals* series (1985) for Zabro (*see* ZANOTTA) and the *Mamma-à* tea kettle for *Alessi. Branzi was awarded a *Compasso d'Oro in 1987 for his contributions to design. Between 1983 and 1987, the same years in which he was editor-in-chief of *Modo* magazine, he became director of *Domus Academy, a leading Milanese design institution that took into its approach many of the radical currents that had been emerging in Italian design over the previous fifteen years. Much of his thinking about design was evidenced in his seminal text of 1984, *The Hot House: Italian New Wave Design*. He also organized the 1991 exhibition *European Capital of the New Design* at the *Centre Georges Pompidou, Paris, in which he looked at the internationalization of what was termed *New Design in Milan, Barcelona, and other centres with a radical design climate.

Braun (established 1921) This German electrical and audio-visual equipment manufacturer has for more than half a century been associated with high-quality designs, many of which have featured prominently in museum collections and design competitions around the world. Its origins lay in the radio accessory manufacturing company founded in 1921 by Max Braun near Frankfurt. However, it was not until after the end of the Second World War that the company expanded its product range to include the domestic appliances upon which its international reputation soon began to emerge. Following the death of Max Braun in 1951 his sons Artur and

Erwin took over the management of the company, diversifying into electric razors and audio equipment, including the *Kombi* radiogram by Wilhelm *Wagenfeld. However, the establishment of the Hochschule für Gestaltung (HfG) at *Ulm in 1953 had a profound influence on the design of Braun products, cemented by the appointment of Dr Fritz Eicher, a lecturer from the HfG, as head of Braun's design department in 1956. This Ulm-Braun axis had commenced in 1954 with the involvement of Eicher and fellow HfG lecturers Hans Gugelot and Otl *Aicher. This was invigorated further through the employment of two graduates of the Wiesbaden Academy of Applied Art, Dieter *Rams (who joined in 1955, becoming Braun's design director in 1960) and Gerd Alfred Müller. Epitomizing the functional aesthetic that was to become the hallmark of Braun products over succeeding decades was the elegant restraint of the ascetic *Phonosuper SK4* radiogram of 1956, designed by Rams and Gugelot. This 'look' was further consolidated in Müller's design of the *KM31 Kitchen Machine* of 1957 with its clean sculptural forms punctuated by minimalist graphics. Such a visual presence was at the root of its corporate and brand identity. Braun products were increasingly widely exposed in the latter part of the 1950s, receiving favourable attention for their display (designed by Gugelot) at the *Milan Triennale of 1957. They also featured at the Frankfurt Radio and Television Exposition and the Berlin International Building Exhibition where Braun products were displayed in the majority of show houses. The clean *Modernist appearance of Braun products was closely identified with the international *'Good Design' ethos of the 1950s and 1960s and was in complete contrast to the extravagant styling of many ephemeral products, an iconic potential that was confirmed by the New

York *Museum of Modern Art's exhibition of Braun products in 1964 (a number of which had featured in MOMA's permanent collection since 1958. However, the company's absolute and exacting commitment to quality design did not equate with commercial success and the company was taken over by Gillette in 1967. This facilitated greater international market penetration and product diversity across a number of fields, from hairdryers to coffee machines and calculators to electric toothbrushes. Nonetheless the functionalist appearance remained an essential ingredient of the Braun agenda. By the 1990s, with the consumer appetite for originality and wit in everyday products undiminished by the economic recession of the 1980s, many Braun products took on a more colourful, less restrained appearance in order to remain competitive in the highly competitive market place for domestic goods.

Breuer, Marcel (1902–81) A noted *Modernist designer and architect closely associated with the German *Bauhaus, Breuer was a pioneer in the field of tubular steel furniture design in the 1920s and 1930s, following on from a period in which he concentrated on innovative and experimental wooden furniture. Subsequently, his architectural and design work became widely influential in Europe and the United States and was widely promoted through manufacture, publication, and exhibition.

Originally from Hungary, after a brief period at the Academy of Fine Arts in Vienna Breuer enrolled at the Bauhaus in Weimar in 1920. There he encountered many avant-garde ideas, particularly those relating to *Constructivism and De *Stijl with their characteristic Modernist manipulation of abstract forms. The structural characteristics of his wooden furniture of the early 1920s showed the influence of Dutch designers Gerrit Rietveld and Theo van Doesburg. Breuer was employed as a head of the furniture workshops at the Bauhaus from 1925 to 1928, a period in which he also began designing tubular steel furniture, influenced—it is maintained—by bicycle design. He was responsible for the design of much of the furniture for the new Bauhaus buildings when the academy moved from Weimar to Dessau in 1925. An early example of his tubular steel design was his *Model B3* chair of 1925 (later known as the *Wassily* chair, after his Bauhaus colleague, the Russian painter Wassily Kandinsky). With its clearly articulated planes of stretched black fabric for seat, back rest, and arms, set within a light standard-strength tubular steel frame, it almost resembled a piece of Constructivist sculpture. Nonetheless, through its use of new materials and contemporary forms, it was in fact a striking Modernist metaphor for the traditional club armchair. Also using tubular steel he designed modular storage systems and, from 1927 onwards, the Standard Möbel firm of Berlin manufactured a number of his furniture designs. In 1928 he moved to Berlin to practise as an architect but worked principally on interiors and furniture and it was not until 1932 that he realized his first architectural work, the Harnischmacher House in Wiesbaden. From 1932 to 1934 he was mainly based in Switzerland, where he produced a number of furniture designs for Wöhnbedarf in Zurich. With the help of his former Bauhaus colleague Walter *Gropius in 1935 he moved to Britain, where he made contact with Jack *Pritchard, a founder of the *Isokon Furniture Company which was committed to the production of Modernist architecture and design. Amongst his five designs for Isokon was the *Long Chair* of 1935–6, made from plywood and based on one of his earlier aluminium chair designs.

There was also a discernible influence from the organic plywood designs of Alvar *Aalto, whose work was becoming more widely known at the time. He also worked in an architectural partnership with the committed British Modernist F. R. S. Yorke. After a brief spell as Isokon's Controller of Design in 1937, he emigrated to the United States, renewing his association with Walter Gropius on the architectural staff at Harvard University and the establishment of a joint architectural practice in Cambridge, Massachussets (which lasted until 1941). During these years he also continued to design plywood furniture, including commissions for Bryn Mawr College (1938) and the Pennsylvania Pavilion at the *New York World's Fair of 1939, and the International Competition for Low Cost Design at the *Museum of Modern Art, New York in 1948. During the 1950s his architectural practice flourished, leading to the formation of Marcel Breuer Associates in 1957, which won a number of important commissions including the Whitney Museum of American Art, New York (1963–6).

BRIO (established 1884) The Swedish company BRIO is the world's largest manufacturer of wooden toys, exporting to more than 30 countries with key markets in the United States, Germany, and the United Kingdom. Ivar Bengtsson, the company's founder, first established a factory for the production of woven baskets in Osby, Sweden, in 1884. In 1908 the business was transferred to his sons, the name BRIO deriving from the words *Br*others *I*varsson at *O*sby (a comparable derivate to that of Ingmar Kamprad at *IKEA, also in Sweden). One of BRIO's most widely known early wooden toys was the *Goinge* wooden horse (1907 to 1960), the best-selling toy in Sweden in the first half of the 20th century. By the time of the outbreak of the First

World War the company was offering for sale more than 6,000 items, available through mail order and travelling salesmen, including baskets, toys, glass, and ceramic products. In 1930 the first products manufactured explicitly under the BRIO name were two red lacquered wooden cars. The first mass-produced BRIO wooden toy was the wooden dog *Sampo*, designed by Walter Wars of Switzerland in 1945. BRIO wooden train and railway sets were also introduced in this period, the standing of such toys being considerably enhanced by their purchase by the Swedish royal family. Significant company expansion was undertaken in succeeding decades with the establishment of subsidiaries in Denmark and Norway in 1964, Finland in 1970, Germany and Britain in 1974, and the United States in 1977. This was followed by a number of takeovers including those of Alga, Sweden's leading games company in 1982, Galtex in Poland in 1997, and Ambi toys in Holland in 2000. BRIO wooden toys are manufactured from beech and birch and, with a reputation for safety and durability, are widely acknowledged as toys that stimulate children's imaginations.

Brionvega (1945–92) A leading manufacturer of stylish audio-visual equipment, this Italian manufacturing firm was founded in Milan by Giuseppe and Rina Brion, initially commencing as a radio manufacturer before moving into the production of televisions a decade later. However, design played only a minimal role in the company's profile until the early 1960s when designers of the calibre of Mario Bellini, Achille and Piergiacomo *Castiglioni, and Richard *Sapper became involved in creating a distinctive, technologically sophisticated aesthetic for the firm's products. Characteristically innovative television designs for the company included Italy's

first transistorized TV, the compact *Doney* set of 1962. This was followed by the 1964 *Algol* and 1969 *Black ST 201* televisions by Marco *Zanuso and Sapper, a clean-formed minimalist cube that only came to life when the set was switched on. Rather more playful was the Castiglioni Brothers' *RR 126* stereo system of 1964, which opened out to reveal its controls. Other well-known designs included Bellini's *TVC 26* stereo system of 1970. However, during the 1980s design no longer enjoyed the high corporate priority of previous decades and the company was wound up in 1992.

Britain Can Make It Exhibition (*BCMI*, 1946) This morale-boosting design exhibition was held at the *Victoria and Albert Museum and was the first major public promotion organized by the newly established Council of Industrial Design (COID; *see* DESIGN COUNCIL). Aimed at enhancing Britain's post-war export trade, encouraging manufacturers to invest in design, and educating consumers of the benefits of well-designed environments and products, the exhibition attracted 1,432,369 visitors over a fourteen-week period. Designed by James *Gardner with Basil Spence as Consulting Architect visitors were able to consider many aspects of design in a series of sequenced exhibits, commencing with 'From War to Peace' (the reconciliation of wartime production and organizational techniques with the opportunities of peacetime), 'What Materials are Made of' (raw materials in production), through to such displays as 'Shop Window Street' where all kinds of goods (such as pottery, glassware, hardware, and shoes) were enticingly displayed. Of considerable interest to the public was the Furnished Rooms Section, which displayed a whole series of room settings by leading designers (including Dorothy *Braddell, Edna Moseley, Elizabeth Denby, Max-

well Fry and Jane Drew, Frederick Gibberd, and David Booth) who responded to the call for the provision of a variety of furnished living environments for fictitious families drawn from a range of occupations, income levels, ages, and family sizes. The public were also involved in educating themselves in design matters by participation in the Design Quiz. Issued with a series of plastic coins on entry to the exhibition they were able to 'vote' for their favourite designs in different categories by placing coins in the appropriate slots of a number of 'Quiz Banks' displaying photographs and questions that were to be found at various points in the itinerary. Such means were typical of the COID's desire to educate the public in matters of *'Good Design' over the next two decades. There was quite a mixed reaction to the exhibition from manufacturers, a considerable number of whom were irritated by the fact that the COID-appointed selection committees rejected about two-thirds of the 15,836 goods submitted by industry for inclusion in the exhibition. Many industrialists also failed to appreciate one of the key pieces of COID propaganda, the section entitled 'What Industrial Design Means', designed by Misha *Black. This slightly ponderous and heavily didactic display sought to show how industrial designers made design decisions, working in conjunction with management, engineers, and sales representatives. Dissatisfied manufacturers felt that the 'taste-making' metropolitan elite of the London-based COID did not fully appreciate the realities of manufacturing in the regions, had limited understanding of the markets that they sought to satisfy, and generally believed state intervention to be undesirable. At the time of BCMI the manufacturing and design restrictions for the *Utility Scheme overseen by the Board of Trade were still in place on the domestic market. In fact, many

of the goods on display at the exhibition were prioritized for export and not available for purchase; some would be by January 1947, and others at an unspecified future date. About 7,000 overseas buyers visited the exhibition, which was calculated to have generated orders of between £25 and £50 million pounds.

British Empire Exhibition (1924) The vast British Empire Exhibition (BEE) of 1924 covered 216 acres (87 hectares) in Wembley, London, attracting 27 million visitors over the two seasons that it was open. It revealed the extent to which many people in Britain looked to the empire (which covered about 20 per cent of the world's land surface) as a powerful means of economic survival in the difficult climate of the interwar years. Their outlook was stimulated by propagandist initiatives and organizations such as the Empire Free Trade Crusade, the United Empire Party, and the Empire Marketing Board set up under the Dominions Office in 1926 as well as the fact unfavourable trade tariffs made it significantly more difficult to compete in other markets. Furthermore, in terms of the Wembley exhibition displays the widespread emphasis on technical virtuosity, engineering and scientific achievements, and the material benefits of empire significantly outweighed any visibility of progressive developments in design that bodies such as the *British Institute of Industrial Art (incorporated 1920) or the *Design and Industries Association (DIA, established 1915) had sought to initiate, although the numerous advertising kiosks (including those for Eno, Oxo, Mackintosh, the *Daily Telegraph*, and the *Daily Sketch*) by Joseph *Emberton were striking contemporary design solutions for effective commercial propaganda. Economic commitment to the empire implied less emphasis on the more

design competitive markets of continental Europe or the industrially competitive markets of the United States. The British Empire Exhibition endorsed the widespread belief that at Wembley 'all modern decoration must be more or less based on tradition', an idea echoed in the Palace of Arts, which housed a series of rooms in the styles of 1750, the 1820s, 1852, 1888, and 1924. There was also a strong retrospective flavour in the display of one of the leading furniture firms participating, *Waring & Gillow, with exhibits that included a Georgian Library and a Chinese Lacquer Room, as well as a Modern Bedroom. The latter, though not steeped in the past, was conservative in feel and represented a modernized arts and crafts outlook. Also looking to the past was the elaborate reconstruction of Tutankhamun's Tomb, widely celebrated since its discovery by Howard Carter in late 1922. This event had captured the public's imagination through wide media coverage and the marketing of all kinds of Egyptiana, ranging in scale terms from Huntley & Palmers' biscuit tins, ceramic ware, and furniture design through to buildings such as cinemas. Important also amongst the Wembley British Empire Exhibition displays were those that sought to show Britain as a 'civilizing' and 'improving' force in her colonies and dominions. Amongst the many African exhibits, for example, were showcases of living native craftsmen—including weavers, potters, metalworkers, goldsmiths, leatherworkers, and embroiderers—all of whom could be seen plying their trade. Their promotion in this manner was seen to represent the imperial 'civilizing' process, whereby craft workers could follow their occupations peacefully within the security of the empire. In addition to their economic potential, indigenous handicrafts were also seen by some critics as a potentially fresh

source of inspiration for designers in Britain. The dominions and colonies were also seen as important sources for the raw materials that fuelled British manufacturing industry. However, as the interwar years unfolded views of the empire, its projection, and significance changed markedly as can be charted through the many colonial and imperial exhibitions of the period, including the Antwerp and Paris Colonial Exhibitions of 1930 and 1931 through to the British Empire Exhibitions of Johannesburg in 1936 and Glasgow in 1938. By the time of the latter a much more progressive view of empire was promoted through its modern buildings and displays, giving greater emphasis to the growing self-confidence of the colonies and dominions.

British Institute of Industrial Art (BIIA, 1920–33) This design promotional body was incorporated in 1920 with the aim of raising standards of design in British manufacturing industry in tandem with the improvement of public taste. Such notions of design reform underpinned the outlook of many campaigning bodies in Britain (such as the *Design and Industries Association, the *Council for Art and Industry, and the *Design Council) and elsewhere. Supported by government funding for the early stages of its existence, the BIIA established its Exhibition Gallery in Knightsbridge, London. The BIIA also established a Bureau of Information that provided information about design, designers, and design education alongside wider developments in Britain and overseas. A design collection was built up including exemplars of metalwork, ceramics, glass posters, books, and printing, although the organization's commitment to mass-produced goods was limited in favour of more handcrafted modes of production. However, the gallery eventually proved a casualty of the with-

drawal of government funding after 1921 and its collections were moved to the nearby *Victoria and Albert Museum. Exhibitions were mounted both at the V&A and in the provinces, often attracting sizeable attendances. Perhaps the most significant BIIA exhibition was the 1929 *Industrial Art for the Slender Purse* mounted at the V&A. Although government funding had ceased following the economic slump of 1921, the BIIA continued to play a role in national design matters. It sought to influence the quality of the state's commissioning of design through liaising with the Post Office, the Royal Mint, the Stationery Office, and the Boards of Education and Trade. It also contributed to a number of significant reports including the influential Balfour Report on Trade and Industry (1927). Overall, like so many design reform agencies its impact on manufacturing industry was comparatively limited.

Brody, Neville (1957–) From the 1980s British designer Neville Brody established an international reputation for experimental design in a wide range of visual communication media, capitalizing on the creative potential of *Apple Macintosh computers. This was given 'official' approbation by the exhibition of his work at the *Victoria and Albert Museum, London, in 1988, and a one-man show in Tokyo two years later. His prolific output included a range of commissions involving digital typography, magazine design (including art direction of the innovative style magazine *The Face*), postage stamp design, and television graphics. After studying graphic design at the London College of Printing from 1976 to 1979, Brody was involved in design for the British music industry, including a range of sleeve designs for independent record companies such as Rocking Russian, Stiff Records, and Fetish Records. He attracted greater public atten-

tion through his work on *The Face* from 1981 to 1986, drawing freely for his visually exciting layouts and typography on avant-garde artistic ideas of the 1920s and 1930s such as those of De *Stijl and Russian *Constructivism. Far removed from contemporary editorial conventions Brody's work had a studied informality in the thoughtfulness devoted to the construction of its layouts, with blocks of texts often placed horizontally or vertically on the page, their often distinctive layouts contrasting strikingly with hand-mediated imagery and photography. Such ideas exerted a significant international impact on the appearance of magazine, advertising, and retailing design. From 1983 to 1987 he also designed covers for the style-conscious London listings magazine *City Limits* before going on to design for *Arena*, the men's magazine, from 1987 to 1990. For the latter he employed a much more restrained, minimal aesthetic. He founded The Studio in London in 1987 and soon attracted a range of international clients including conservation activists Greenpeace, Japanese stores retailers such as Parco, the Dutch postal service PTT, and the Austrian state broadcasting company ORF. Reflecting his growing interest in the design of his own typefaces, in 1990 he established Font-Works in London, also becoming a director of FontShop International in Berlin and launching the experimental typographic magazine *FUSE*. He has placed considerable emphasis on the role of the computer as a graphic design tool, the development of digital typography, and electronic design as an important means of communication

Buehrig, Gordon (1904–) Buehrig was one of the leading stylists in the American automobile industry, particularly noted for his classic designs for Auburn, Cord, and Duesenberg of the interwar years. His 1936 Cord *810* was selected by the *Museum of Modern Art, New York, for its *Eight Automobiles* exhibition in 1951. It was described in the catalogue with a reverence generally reserved for works of fine art as having 'each part...treated as an independent piece of sculpture, the whole collection being partially related by similar details for each unit'. In many ways this reflected his own view of himself as an automobile sculptor and architect rather than automobile engineer. He was said to have been influenced by reading the 1927 translation of Le *Corbusier's *Vers une architecture* (1923) but his outlook had much in common with the first generation of American industrial designers such as Raymond *Loewy and Norman *Bel Geddes. Buehrig first became significantly involved in automobile design in 1924 when he was employed as a trainee by the Gotfredson Body Company in Wayne, Michigan, before moving on two years later to work as a draughtsman at the Dietrich Body Company in Detroit. This was followed by a spell at the Edward G. Budd Company and then at Packard before he joined the new and innovative Art and Colour Section at *General Motors under its inaugural head Harley *Earl in 1927. However, Buehrig was highly ambitious and moved to the Stutz company in Indianapolis in 1928 where he worked on the bodywork designs for the company's entries for the 1929 Le Mans 24-hour race. In 1930 he moved on to the Auburn-Cord-Duesenberg company as chief designer. However, in the wake of the Wall Street Crash of 1929 the recession was felt strongly in the luxury car sector and Buehrig briefly moved back to the Art and Colour Section at General Motors in 1933 on the invitation of Howard O'Leary, Earl's assistant. After returning to Auburn-Cord-Duesenberg he began working on his ideas for the front-wheel drive Cord *810*. There

was a rush to produce 100 hand-built proto-types for the 1935 Auto Shows in New York, Chicago, and Los Angeles, although they were non-functioning due to the non-completion of the transmission. The flowing, rounded forms, with headlights integrated into the bodywork and long, sweeping chrome lines of the radiator detailing attracted considerable publicity and public attention and many favourable articles in the motoring press. A considerable number of advance orders were placed by customers who received bronze models of the *810* while they waited for delivery. The car went into production in 1936 with a choice of four models: the *Westchester Sedan*, the *Beverley Sedan*, the *Convertible Sedan*, and the *Convertible Coupé*. He also designed the Cord *812* before leaving for the Edward G. Budd Company to work on prototype designs as chief designer from 1936 to 1938. This was followed by a decade as a freelance designer, interrupted only by a brief spell with Studebaker under Raymond Loewy, until in 1949 he took up the post of head of the Body Development Studio, one of five studios of the *Ford Styling division. He worked on a number of designs including the 1951 *Hardtop*, the highly successful 1952 *Ranchwagon*, and the Lincoln *Continental Mark II*, for which he was the chief body designer from 1952 to 1957. After a period as head of station wagon planning he became a principal design engineer in the material applications group from 1959 until 1965 when he retired from Ford.

Bugatti, Carlo (1856–1940) A leading figure in design and the decorative arts in Italy in the late 19th and early 20th centuries, Carlo Bugatti is perhaps best known for his exotic, handcrafted furniture designs. Many progressive developments in the 19th century, particularly the British *Arts and Crafts Movement and *Art Nouveau,

influenced his work. By the early years of the 20th century, his work was characterized by an original and distinctive manipulation of materials and flat decorative forms with reminiscences of exotic, oriental, and Middle Eastern forms. He is remembered also as the father of Ettore (1881–1947) and grandfather of Jean (1909–39), key members of the famous Bugatti automobile company. His other son, Rembrandt Bugatti (1885–1916) was a celebrated animal sculptor.

After studying art at the Brera Academy in Milan, he established a furniture workshop in the city in 1888. His earliest designs were typified by a wooden bedroom suite that he designed to celebrate his sister's marriage in 1880. Blending pseudo-Moorish details with naturalistic painted decorative features reminiscent of Japanese design, its aesthetic typified his early work. Such features were noted in favourable reviews of his furniture at the 1888 Italian Exhibition at Earl's Court, London. By the middle of the following decade he began to make greater use of geometrically derived patterns and strong shapes, together with a frequent use of vellum, a phase of activity that culminated in the award of a Silver Medal at the Paris Exposition Universelle of 1900. However, it was at the 1902 Turin International Exhibition of Decorative Arts that he attracted widespread notice, showing four rooms and a furniture collection. Dramatic shapes, flowing, sculptural Art Nouveau-redolent forms, and striking interior surface patterns—particularly in his 'Snail Room'—led to the jury's unanimous award to Bugatti of the Diploma of Honour. In 1904, for family reasons, he moved to Paris, where he resumed his practice of the fine arts whilst continuing to produce work for leading stores such as Bon Marché in Paris and De Vecchi in Milan. In December 1907 he showed silverware at

the Galerie Hébrard in Paris, attracting avourable notice in the *Studio. His use of organic, naturalistic detail, often based on insect and animal themes, continued at the Salon des Artistes-Décorateurs in 1910 and 1911 and was praised on each occasion in the periodical *Art et décoration*. He also designed jewellery, employing similar decorative motifs.

CAD Cadillac Calor CAM Canon Carpა
Cassandre Cassina Castelli Castelli, Giი
Ferrieri, Anna Castიclი, Achille Castiც
Castle, Wendეი Centraიchool of A
Centre de Cიon Industrielle Centre G
Centrokapიი Centrum Industriële Vormც
Gabrielle (ო') Chartered Society of ქ
Chermayeffიე Chermayeff & Geismა
Chicago Cenეf Progress Exposition [
Chicago World'sიhibition [1
chrome chromium-plated Chrysler Corp
Seymour CIAM Cieslewicz, Roman Cigა
Circle Citterio, Antonio Citroën Cliff, Cლ
Coates, Nigel Coates, Wells Colani, Luiც
Henry Colombini, Gino Colombo, 'Joe' (
Commercial Art Compasso d'Oro compა

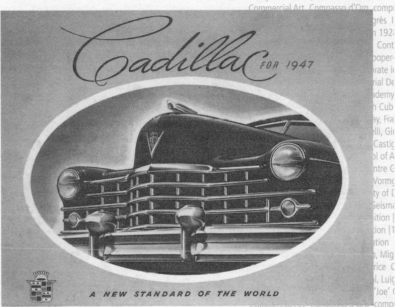

grès I
ი 192ა
Cont
boper-
რate iი
rial De
ademy
ი Cub
აy, Fra
ელli, Giი
Castiც
ol of A
ntre G
Vormც
ty of ქ
Geismა
ქition [
ქion [1
ქtion
ა, Miდ
rice C
ქl, Luiც
'Joe' (
computer-aided manufacture Congrès I
Architecture Moderne [various from 192ა
Constructivism Consumers' Union Conი
of America Contemporary Style Cooper-
Corbusier, Le Corning Glass corporate iი
Art and Industry Council of Industrial Dე
Cracow Workshops Cranbrook Academy
Walter Cute Cyrén, Gunnar Czech Cub
Cadillac Calor CAM Canon Carpay, Fra
Cassandre Cassina Castelli Castelli, Giი
Ferrieri, Anna Castiglione, Achille Castiც
Castle, Wendell CCI Central School of A
Centre de Création Industrielle Centre G

CAD *See* COMPUTER-AIDED DESIGN.

Cadillac (established 1902) *See* GENERAL MOTORS.

Calor (established 1917) This French domestic appliance company developed alongside the growth of electricity consumption in France. However, despite interventions such as that of Jean Parthenay of the Technès design consultancy (*see* VIENOT, JACQUES) who designed an electric fan for the company in 1959, its design policy only took on a high profile in the difficult economic climate of the 1980s. The company encountered difficulties in this period of recession, responding by bringing in the French design consultancy ADSA (established 1975) to advise on the development of an innovative design strategy that emphasized research, design innovation, and marketing as key factors in reviving the company's fortunes. This new design policy became visible with the launch of the award-winning *Jet Line* 30 iron (1987) by Pierre Paulin (one of the founders of ADSA) and, in 1990, Calor was one of the five French companies selected for the Prix du Design de la Communauté Européenne. Since 1972 Calor had been part of the SEB (Société d'Emboutissage de Bourgogne) which, also in the 1970s, acquired Tefal and Rowenta.

CAM *See* COMPUTER-AIDED MANUFACTURE.

Canon (established 1933) This multinational manufacturer of film, video, television, and X-ray cameras and a wide range of increasingly sophisticated office equipment was established by Goro Yoshida and Saburo Uchida in Japan as the Precision Optical Research Laboratories. Registering the Canon trademark for its products in 1935 the company produced its first 35-millimetre camera, the *Kwanon*, conceived as a competitor to the German *Leica* and other western brands. Other early initiatives included the production of X-ray cameras for both military and civilian use, launched in 1941. After the war Takeshi Mitarai, the company president from 1942 to 1974, did much to ensure the company's foundations for future success, promoting the slogan 'Catch Up and Overtake Leica'. In 1947 the company changed its name to the Canon Camera Co., intending to unify its brand and image as a platform for penetrating Western export markets. (In 1969 Canon was taken up as the corporate name.) Mitarai, like Konusuke *Matsushita, visited the United States in 1950 in order to assess its export potential, leading to the opening of a New York branch on 5th Avenue in 1955, although this initiative proved problematic. Design had become an increasingly important aspect of company philosophy during the years of economic recovery after the Second World War. Following the example of Matsushita in 1951, Canon's industrial design department was established in 1953 in order to develop the Canon *V* camera. One of the first Canon products to receive a design award (the *G-Mark) was the *8T* 8-millimetre easy-to-operate film camera of 1957 aimed at the growing market of home movie makers, followed by the *P-8* film projector of the following year. This policy was followed through in more practical, yet

elegant designs such as the competitively priced 1961 *Cine Canonet* 'electric eye' movie camera. This was also geared to the requirements of amateur users and a recipient of the G-Mark award. It also proved so popular on its launch that a central Tokyo department store sold out in two hours, the product going on to sales of 210,000 in ten months. This period witnessed the company's diversification into business machines as a means of securing long-term profitability, a commitment echoed in the company slogan 'Cameras on the right side, business machines on the left'. An early success in the highly competitive field of electronic calculator manufacture was the *Canola 130* electronic calculator of 1964, a far smaller, simpler, and more elegant design than that of most of its market competitors, although the *Sharp Corporation proved to be a fierce competitor in the field. Research, like design, was an integral part of the company's success: the Research Division was established in 1958, the Product Design Development Division in 1964, and the consolidated Research and Development Division in 1966, becoming the Canon Research Centre in 1969. The company's global ambitions were realized with the establishment of overseas production plants in Taiwan (1970), the United States (1974), and West Germany (1977). In the remaining decades of the 20th century many innovative and well-designed products were released including the first personal plain paper copying machine, the *NP-1100*, in 1970, the *AE-1* camera, the world's first fully automatic single lens reflex camera of 1976, through to the mini-digital *IXY DIGITA* camera of 2000. Canon has been keen to promote itself through sponsorship, as with its official sponsorship of the 1984 Olympic Games in Los Angeles, through a commitment to active recycling policies in the following decade, and the

exhibition of its products, technological prowess, and visions of the future as at the Canon Expo 2000 seen in New York, Paris, and Tokyo.

Carpay, Frank (1917–85) Carpay's career as a ceramic, textile, and graphic designer in New Zealand epitomized the difficulties of introducing a modernizing aesthetic in a country with a limited tradition of design other than the more traditional patterns imported from Europe (or those of indigenous culture). Dutch-born designer Carpay was trained at the's Hertogenbosch Technical School in Holland, where he acquired a range of design and craft skills. After the Second World War he was made design director (1946–50) at Het Edele Ambacht, a small manufactory of ceramics, glass, furniture, and metalwork. Leaving the company in 1950, he travelled to the south of France, where he met Pablo Picasso, who was involved with ceramic design. On his return to Holland Carpay established his own pottery, although for various reasons this proved a short-lived venture. In 1953 he emigrated to Auckland, New Zealand, where a job was created for him at the Crown Lynn ceramics factory. He was responsible for decorative work, including the *Handwerk* range characterized by individualistic brushwork and reminiscences of Picasso and Matisse. However, despite being exhibited in several venues in New Zealand and attracting some critical attention the range was discontinued and Carpay laid off in 1956. Frank Carpay Designs Limited moved into screenprinting, commencing with tablemats decorated with Maori-inspired patterns, extending into beach towels, printed fabrics, and beachwear in the 1960s. His beachwear captured the imagination of the young style-conscious audience of the period, his interest in patterns drawn from Pacific culture

anticipating more positive trends two decades later.

Casabella (established 1928) Originally entitled *Casa Bella* this architectural and design magazine was founded by Guido Marangoni. Taken over by *Domus in 1933 it was edited by the architect-designer Guiseppe Pagano with Eduardo Persico as his assistant. After the Second World War it was edited by Ernesto Rogers (1953–63), previously editor of *Domus*, and featured the work of up and coming architects and designers such as Gae *Aulenti and Aldo Rossi: G. A. Bernasconi succeeded Rogers, gaving way in turn in 1971 to Alessandro *Mendini, who did much to promote a new generation of avant-garde designers. *Casabella* was taken over by Electa in 1975, following which Tomás *Maldonado became editor, working under a management committee. He was succeeded by Vittorio Gregotti.

Cassandre (Adolf Jean-Marie Mouron, 1901–68) One of the most important poster designers of the 20th century, Cassandre lived in Russia until 1918, when he moved to Paris, studying at the La Grande Chaumière and the Académie Julian. His first poster for *La Bûcheron* dated from 1923 when he adopted the name A. M. Cassandre for his commercial graphic work. His output was closely allied to the work of the other leading French poster designers of the 1920s—Paul Colin, Charles Loupot, and Jean Carlu—making use of the flat, abstract forms associated with late Cubism and the *Modern Movement. By the late 1920s his striking geometricized poster designs for railway and ocean liner companies became widely known on both sides of the Atlantic. Prominent among them were such dramatic images as his *Etoile du Nord* (1927) poster for French railways and that of the *Normandie* (1935) for the CGT shipping line. Other well-known commercial work by Cassandre included his poster designs for the Nicolas wine company. He was a member of the *Union des Artistes Modernes and, in the 1930s, became interested in Surrealism. Cassandre also had a strong affinity for lettering and typography and began designing typefaces from the late 1920s. His alphabets included *Bifur* (1929), *Acier* (1930), *Peignot* (1937), and *Graphica 81* (1950) for Olivetti typewriters. Between 1936 and 1939 he travelled several times to the USA, designing covers for *Harper's Bazaar* as well as other graphic work for the *Container Corporation of America and *Ford. Confirming his status as a leading designer the *Museum of Modern Art, New York held its *Posters by Cassandre* exhibition in 1936 and, in 1950, the Musée des Arts Décoratifs in Paris also mounted an exhibition of his work. During the 1930s Cassandre had developed interests in theatre design and rediscovered his interest in painting to which activity he devoted much of his energy from 1940 onwards.

Cassina (established 1927) Cesare and Umberto Cassina founded this well-known furniture company in Meda, Milan, in 1927. It soon moved from the manufacture of historicizing wooden pieces into the provision of quality modern furnishings and living room ensembles for La *Rinascente store and other major buyers, allowing the company to survive the difficult economic climate of the 1930s. The company gained wider recognition in the 1950s, brought about through commissioning progressive designs from architects (such as Gio *Ponti's *Superleggera* chair of 1956) and the growing international status of Italian design. Commissions also began to flow in from a number of sources, from hotels, restaurants, and public bodies to ocean liners, including the *Andrea Doria* and the *Michelangelo*, irrevocably moving Cassina away from

its craft origins towards large-scale industrial production with an emphasis on quality and design values. Cassina products are often renowned for their innovative qualities, as seen in the *Wink* chair by Toshiyuki Kita and *Aeo* by Paolo *Deganello. Other designers who worked for the company included *Albini, Mario Bellini, *Branzi, *Magistretti, *Ponti, *Pesce, and *Starck. However, in 1965 the company also began production of its *Maestri* series. This comprised reproductions under licence of classic designs by Le *Corbusier, Paul Jeanneret, and Charlotte *Perriand, later expanded to include *Mackintosh, *Rietveld, and Gunnar Asplund. About 30 per cent of the company's sales are accounted for by the *Cassina I Maestri*, the remainder by contemporary products. Cassina products are represented in leading design museums throughout the world and the company has showrooms in Milan, New York, Paris, and Tokyo. About 80 per cent of the company's production is devoted to export markets. Although the French company Strafor Facom acquired a shareholding interest in 1989 Cassina is still run by an Italian management team.

Castelli (established 1877) This well-known Italian furniture manufacturer was founded by Cesare Castelli in Bologna in 1877 on craft-based lines. However, after the Second World War it established a growing reputation for innovative design and modular office furniture systems. A designer closely associated with the company in this period was Giancarlo Piretti, who commenced his professional career in their employ. His designs included the award-winning folding *Plia* chair (1967) made from transparent plexiglass and steel 1967 (winning the *Compasso d'Oro in 1981), the folding *Plana* chair (1969), and *Platone* armchair (1971). In 1979 Piretti

worked with Emilio *Ambasz on the *Vertebra* office furniture range (receiving the Compasso d'Oro in 1981). Other designers associated with the company included Rodolfo Bonetto and Richard *Sapper, who designed a number of office furniture ranges for the company, including *Dalle nove alle cinque (From nine to five)* in 1987.

Castelli, Giulio (1929–) *See* KARTELL.

Castelli-Ferrieri, Anna (1920–) *See* KARTELL.

Castiglione, Achille (born 1918) After graduating in architecture from Milan Polytechnic in 1944, Achille Castiglione worked in a wide range of design fields in collaboration with his brothers Livio (1911–79) and Piergiacomo (1913–68), both of whom had themselves previously graduated in architecture from the same institution. In 1944 he set up in practice with his brothers, who had earlier run a Milanese design studio from 1938 to 1940 with Luigi Caccia Dominioni, where they designed a radio for Phonola. The brothers concentrated on lighting and exhibition design, some outcomes of which were seen at the *Milan Triennali of 1951, 1954, and 1957. In 1952 Livio left the practice to work independently, whilst Achille and Piergiacomo continued to produce stylish and original designs. In furniture these included the famous *Mezzadro* cantilever stool of 1957, utilizing a mass-produced tractor seat (although not put into production by *Zanotta until 1971), and the *Sella* seat, also of 1957 and for Zanotta, using a bicycle saddle. In the same year they exhibited these ideas exploring the idea of 'readymades' in a show in Como entitled *Forme e Colori nella Casa d'Oggi*. They also used readymade components as a feature of their lighting designs, as in the *Bulb* lamp with its exposed bulb shown at the 1957 Triennale and the *Toio*

lamp of 1962 for *Flos that utilized a mass-produced car headlight. Other well-known lights designed by the Castiglione brothers included the *Luminator* for Arform in 1955 and the sweeping *Arco* lamp in marble and steel for Flos in 1962. Their designs also embraced a wide range of products such as the red plastic vacuum cleaner for REM in 1956 and the zoomorphic *RR126* stereo system for *Brionvega of 1965. After Piergiacomo's death in 1968 Achille continued to produce innovative work for a range of companies including Ideal Standard and Alessi. A founder member of the Association of Italian Designers (ADI) in 1956, he taught industrial design at Turin Polytechnic from the late 1960s onwards.

Castiglione, Piergiacomo (1913–68) *See* CASTIGLIONE, ACHILLE.

Castle, Wendell (1932–) Well known for his art furniture this American established a reputation for high levels of craftsmanship and understanding of materials as well as drawing on a range of European artists and styles for inspiration. His early work, such as the critically acclaimed wooden *Scribe's Stool* of 1959–62, was strongly sculptural in feel, recalling the flowing forms of *Art Nouveau, sculpture by Giacometti, and furniture by Finn Juhl as well as showing the legacy of the American sculptor and furniture maker Wharton Esherick (1887–1970). This also reflected his training in sculpture in metal and wood at the University of Kansas. In the 1960s he worked in other materials, including fibreglass, drawing on *Pop and contemporary Italian design, going on, in the later 1970s and 1980s to explore the possibilities of Surealism and *trompe l'œil* and draw upon the eclectic possibilities of *Postmodernism.

CCI *See* CENTRE DE CRÉATION INDUSTRIELLE.

Central School of Arts and Crafts (established 1896) This important art school was established by London County Council in 1896 'to encourage the industrial application of decorative art', an aim that was developed strongly by its first principal, architect, educator, and conservationist William R. *Lethaby (appointed jointly with the sculptor George Frampton) in the years leading up to the First World War. Lethaby was in sole charge from 1900 to 1912, during which period the school moved to new, purpose-built buildings in Southampton Row and saw the organization of a curriculum that emphasized an understanding of materials and workshop-based experience at the hands of professional designers. Many of the first generation of staff were drawn from the membership of the *Art Workers' Guild and their practice-centred approach marked a distinct break from the generally prevalent drawing-based education offered elsewhere. In 1912 Fred Burridge succeeded Lethaby as principal, with the expanded school centred upon five major departments that included furniture, printing, and silver and goldsmithing. Printing and book design in particular had a distinguished profile, with Edward *Johnston (from 1899 to 1912), J. H. Mason (from 1905 to 1940), and Douglas Cockerell amongst its earlier appointments to the staff, with students of the stature of Eric Gill and Neil Rooke. In the 1930s the Central took on a greater commitment to industrial design education with the establishment of a course on Design for Light Industry in 1938. This direction was developed further after 1945 by a graduate of the Department of Metal Studies (1926–29), Douglas *Scott, who established a systematic industrial design curriculum. This emphasis on design contributed to the shift in title of the institution away from its initial

attachment to 'arts and crafts' to a designation as Central School of Art and Design in 1966. The school's principal William Johnston had initiated a number of changes in the post-war years with shifts in the design curriculum, including textiles, theatre, and ceramics. Other developments took place alongside educational changes resulting from the National Council for Diplomas in Art and Design as well as expansion. In January 1986 the school became a constitutent college of the newly formed London Institute, a bringing together as a single federated body by the Inner London Education Authority of all the major art, fashion, printing, and other design-related disciplines under its control. In 1989 it merged with the St Martin's School of Art, becoming Central Saint Martin's College of Art and Design. It is now a constituent college of the London University of the Arts.

Centre de Création Industrielle (CCI, established 1969) The CCI was established in 1969 as part of the UCAD (*Union Centrale des Arts Décoratifs), with François Mathey of the Musée des Arts Décoratifs, Paris, Yolande Amic, and François Barré playing key roles in its realization. It was integrated into the nascent *Centre Georges Pompidou in 1973 with the aim of further developing a cultural brief that embraced the organization of exhibitions, the issuing of publications, and the development of a design documentation centre. Its design remit encompassed a broad sweep of design disciplines including graphics, the latter evidenced by the work of Swiss designer Jean Widmer, designer of the CCI's founding logo and several posters promoting the organization's activities. Early CCI initiatives included publication of *Le design parlera-t-il français?* and the mounting of its first exhibition, *Qu'est-ce que le design?* in the Musée des Arts Décoratifs in 1969. Its *Design français* exhibition in 1971 also sought to nurture French design, focusing on the work of younger practitioners. Since then the CCI has curated more than 150 design exhibitions such as the 1975 travelling exhibition *Du Bauhaus à l'industrie, Wilhelm Wagenfeld, objets quotidiennes* (see WAGENFELD, WILHELM). The Centre Georges Pompidou, incorporating the Public Information Library (BPI), the National Modern Art Museum (MNAM), and CCI opened in 1977, endowing the latter with an increased profile and public presence. In the wider world of design museums and collections the CCI posed some fundamental challenges, suggesting that the significance of design might be better understood through design documentation rather than collecting icons of cultural cachet. Many of those associated with the CCI and its quarterly publication *Traverses* rejected contemporary leanings towards the *Modernist aesthetic and its emphasis on form. For example, the 1980 *L'Objet industriel: empreinte ou reflet de la société?* exhibition addressed design from three main standpoints—conception, distribution, and consumption—with a complex series of analyses of detailed related concerns. These included such considerations as who buys the product, what is the precise nature of that which is being bought, and what are the reasons for its purchase, the limitations of its use, and the duration of its lifespan. However, following a decree in 1992, the CCI lost its autonomy and was merged with the MNAM, with the aim of creating one of the world's leading collections of arts, architecture, and design. In the same year a *Manifeste* exhibition programme was mounted at the Pompidou Centre, including the design-based *Manifeste* 2, which put on public exhibition the CCI's new permanent design collection, a concept that had been given concrete form in 1991.

However, this exhibition also revealed something of a change in outlook from the original questioning and probing of the CCI in its earlier years, comprising (with an added French emphasis) many of the more mainstream icons of 20th-century design found in design collections elsewhere in the world. Reinforcing this French inflection, in the winter of 1993–4 the CCI organized a retrospective exhibition of one of the most significant French designers of the second half of the 20th century, Roger *Tallon. The Pompidou Centre's structure of four departments, one of which combined the MNAM and the CCI, was given a further fresh inflection in 1998 with a commitment to providing enhanced support for creative practice as well as collection development. In 1997 the Pompidou Centre had closed for renovation, reopening in 2000. By the early 21st century the MNAM-CCI held 1,500 design objects (including drawings and models as well as manufactured products) alongside the work of 4,200 artists and 36,000 examples of the visual arts (including photography and film).

Centre Georges Pompidou (established 1977) One of the most significant French centres for national art and culture, this Parisian complex (often known as 'the Beaubourg') has included a museum, library, and centres for research in art, architecture, and design. It has proved to be highly successful in appealing to visitors from home and abroad, attracting more on a daily basis than the Eiffel Tower, Versailles, or the Louvre Museum. After becoming French president in 1969, Georges Pompidou pursued his radical cultural vision of creating a cultural centre that would bring together the worlds of museology and creative practice, setting the creative and performing arts alongside a

library, cinema, and audio-visual research. This was realized through the initiation of an ambitious building programme in the centre of Paris in 1972. The Pompidou Centre itself was a radical design of glass and metal, with moving escalators, walkways, and brightly coloured service ducts revealed boldly on the exterior. Designed by architects Renzo Piano and Richard Rogers it was opened by President Giscard d'Estaing in 1977 and incorporated the Public Information Library (BPI) with almost 500,000 volumes, backed up by modern technologies, multimedia, and a large collection of magazines. It also incorporated the National Modern Art Museum (MNAM) and the Industrial Design Centre (*Centre de Création Industrielle, CCI, established in 1969). The radicalism of the enterprise was underlined by the appointment of Pontus Hulten, a foreign national and former director of the Moderna Museet in Stockholm, to direct the museum. The Swiss graphic designer Jean Widmer, who also designed the first logo and a number of striking posters for the CCI, conceived the early corporate identity for the Pompidou Centre. However, in 1995 the Pompidou Centre was reorganized into four departments, one of which combined the MNAM and the CCI with the aim of creating one of the world's leading collections of art, architecture, and design. In 1997 the Pompidou Centre was closed for renovation, reopening in 2000 with a further shift in policy that had been set in place in 1998 with the aim of providing more effective support for creative practice as well as the collections. By the early 21st century the MNAM-CCI collection included the work of 4,200 artists, 36,000 examples of the visual arts (including photography and film), and more than 1,500 design objects (including drawings as well as manufactured products).

Centrokappa (established 1972) *See* KAR-TELL.

Centrum Industriële Vormgeving (CIV, 1962–70) The Dutch Centre for Industrial Design (CIV) was established with the backing of the Ministry of Economic Affairs under the auspices of the *Instituut voor Industriële Vormgeving (IIV, Institute of Industrial Design) and the newly founded (1960) Council of Industrial Design (Raad voor Industriële Vormgeving). The latter included representation from industry, the retailing and educational sectors, and the design profession. Located in H. P. Berlage's celebrated Amsterdam Stock Exchange (1898–1903) with M. Beck as director this national centre was opened by Princess Beatrix in 1962 and became a showpiece for well-designed Dutch products selected by committee. The permanent exhibition space contained about 400 products from about 120 manufacturers and, following the model of the state-funded *Design Centre (established in 1956) in London, also held an index of goods. There were also temporary exhibitions, the first of which, *The Laid Table in Nine Countries*, was highly controversial in the fact that Dutch manufacturers felt that a nationally funded enterprise should not promote foreign goods at their expense. From an early stage it was fraught with financial difficulties and repeatedly went back to government departments for additional funding. Nonetheless, despite its promotion of *'Good Design' and its often didactic approach, it was well attended by the public, who were keen to see the ways in which designers might improve the domestic living environment through new designs for furnishings, lighting, and kitchen and bathroom equipment. By 1968 the position of the IIV and the Centre for Industrial Design had become very difficult and the Ministry of Economic

Affairs intervened sufficiently to lead to the closure of the centre in 1970.

Chanel, Gabrielle ('Coco') (1883–1971) Widely known for her creation of the 'classic' tailored suit and 'little black dresses' often worn with strings of pearls, French couturier Chanel's enduring appeal was attested to by the launching of the *Coco* musical on Broadway in 1969. Her career began as a hat designer in Paris in 1908, and in 1914 she opened boutiques in Paris and the fashionable northern French resort of Deauville. She soon gained a reputation for chic and, two years later, ventured into haute couture in Biarritz in the south of France. The famous Chanel suit evolved in the 1920s and was worn with matching silk shirt and two-toned shoes. The boutique was closed during the Second World War, reopening in 1954 when the Chanel style once again flourished. The simple, eminently practical dimension of Chanel's outlook proved attractive to many and was influential on ready-to-wear goods. After her death the business was taken forward by a number of designers including Yvonne Dudel and Jean Cazaubon, who worked on the couture collections from 1975 to 1983, and Karl Lagerfeld, who took over the couture and, from 1984, the ready-to-wear collections.

Chartered Society of Designers (CSD, established 1930) The origins of the CSD lay in the formation of the Society of Industrial Artists (SIA) in Britain in 1930, a time when the nature and definition of both designer and the design profession were a matter of public debate. Manufacturing industry and the business community were generally sceptical of the potential economic advantages that investment in design could deliver, as was evident in the generally low status of designers' pay and status discussed in the *Council for Art and Industry's

comprehensive 1937 Report on *Design and the Designer in Industry*. During the 1930s SIA branches were established in a number of the regional centres of manufacturing industry such as Manchester (textiles), Stoke on Trent (pottery), Birmingham, and Liverpool. Nonetheless, despite efforts to augment national membership the total number of members lay only at 250 by 1936. In the same period the society also inclined towards what was known as 'commercial art' and advertising rather than industrial design per se.

Following the establishment of the Council of Industrial Design (*see* DESIGN COUNCIL) in 1944 and its commitment to educate manufacturing industry, educators, and the general public in design matters, the SIA decided to initiate a more rigorous approach to membership in 1945. This represented a marked shift away from the relatively informal attitudes of earlier decades, with the dissolution of existing membership, the establishment of a Selection Committee to vet applications, and the implementation of rigorous guidelines. These required members to demonstrate their experience of designing for mass production, whether in terms of industrial design or marketing and advertising. Indeed, the SIA sought to validate its position through its efforts to advise designers about contracts and fees and the establishment of a *Code of Professional Conduct*. With the growth in the number of design consultancies in Britain in the 1950s there was a growing unease about the term 'Artist' as an appropriate descriptor for a profession which sought recognition for itself on a par with engineers, lawyers, doctors, and architects. This led to a recasting of the organization's title in 1965 as the Society of Industrial Artists and Designers (SIAD), a shift which was consolidated in succeeding decades with the recognition of the signifi-

cance of design management. This drive resulted in a further change in title to the Chartered Society of Designers (CSD) in 1987. In the 1990s, the CSD worked closely with the Design Council, the British Council, and the government in the promotion overseas of British design as an important instrument of innovation, creativity, and economic and social well-being.

Chermayeff, Serge (1900–96) Russian-born architect and designer Serge Chermayeff (born Issakovitch) emigrated to Britain as a child and was educated at Harrow. However, plans for higher education at the University of Cambridge were dashed with the loss of the family's money following the outbreak of the Russian Revolution in 1917. After a period as a journalist and dancer, in 1924 Chermayeff became an interior designer. After marrying into the controlling family of the furnishers *Waring & Gillow, he became a British citizen and was appointed director of the Modern Art Studios. Together with the French designer Paul Follot, in 1928 he mounted an important exhibition of Modern Art in Decoration and Furnishing at the firm's London showrooms, consisting of 68 room settings. Although many of these were in the contemporary French *Art Deco style the modernizing flavour of many other aspects of the show was favourably reviewed in the *Architectural Review*. Other significant interior commissions included the Cambridge Theatre, London (1930), and work at the BBC (1932) which he executed alongside other promoters of the *Modernist aesthetic in Britain, Wells *Coates and Raymond MacGrath. Chermayeff's functional stacking tubular steel furniture designed for the BBC was manufactured by *PEL Ltd. and subsequently widely used in cafés, canteens, and halls throughout Britain. Other design work of the period that has

become widely known was the *Bakelite *AC* 64* radio (1933) for the manufacturer E. K. Cole Ltd. Chermayeff was zealously committed to the Modernist cause as seen in his unsuccessful attempt—with Eric *Gill, Amadée Ozenfant, H. T. Wijdeveld, and the composer Paul Hindemith—to establish the Académie Européanne Mediterranée, a projected new *Bauhaus in the south of France. In 1933 he exhibited a pronouncedly Modernist, somewhat austere, Weekend House at the 1933 Dorland Hall Exhibition, a landmark show in the promotion of avant-garde design in Britain. The display included furniture by Plan Ltd., a company he had founded, and was envisaged as a prototype for low-rise housing. In the same year he launched an architectural practice in central London, taking on the German architect Erich Mendelsohn as partner, and was made a Fellow of the Royal Institute of British Architects. Chermayeff and Mendelsohn undertook a number of important commissions that helped draw Modernist architecture to British critical and public attention. These included the De La Warr Pavilion at Bexhill-on-Sea (1935), the first English public building in the Modernist glass, steel, and white-surfaced style, and the Cohen House in Church Street, London (1936). However, he dissolved his partnership with Mendelsohn in 1936 and closed his business in the late 1930s on account of lack of business and the outbreak of the Second World War, emigrating to the United States. He was appointed to Brooklyn College in 1942, establishing the Department of Design, and in the following year was elected to the American Institute of Architects. In 1946 he became a US citizen and, succeeding *Moholy-Nagy, was made president of the Chicago Institute of Design, followed by appointments at the Massachusetts Institute of Technology and Harvard, where he was Professor of Architecture

(1953–62), and at Yale (1962–7). In 1974 he was awarded the Gold Medal of the Canadian Institute of Architects.

Chermayeff & Geismar Inc. (established 1960) Chermayeff & Geismar, a major New York design consultancy, has established a strong reputation for many design services including corporate identity, graphic design, typography, book design and signage, and exhibition design. First established in New York as Brownjohn, Chermayeff & Geismar Associates in 1957 it became Chermayeff & Geismar in 1960 after Robert Brownjohn (1925–70) left the partnership to join advertising agency J. Walter Thomson in London. The two remaining founders were the pioneering graphic designers Ivan Chermayeff and Tom Geismar who had met each other whilst students in the School of Art & Architecture at Yale University in the mid-1950s. Chermayeff was the son of the renowned *Modernist designer Serge *Chermayeff, who had emigrated to the United States from Britain in 1940, taking over from László *Moholy-Nagy as director of the *Institute of Design, Chicago, in 1947. In the early 21st century Ivan Chermayeff and Geismar worked alongside the other principals in their consultancy: corporate identity designer Steff Geissbuhler, exhibition designers Keith Helmetag and Jonathan Alger, and graphic designer Emanuela Frigeriosa.

Amongst the early corporate identity schemes for which the consultancy gained a reputation were those for the Chase Manhattan Bank (1959), Mobil Oil (1964), and Rank Xerox (1965). Tom Geismar was the moving force behind many of these schemes as well as for designs for the *Museum of Modern Art, New York (1970), the National Park Service, and the National Aquarium. Geismar was also involved in exhibition design, including the USA

Pavilion at Expo 70 in Osaka, Japan, and the Statue of Liberty Museum, New York. Geismar later chaired the US Department of Transportation Advisory Committee, resulting in a new system of standardized road signage systems for which he received a Presidential Design Award from President Reagan in 1985. Well known for his design of symbols, *logotypes, and corporate identity schemes, Swiss-trained Geissbuhler joined Chermayeff & Geismar in the mid-1970s and built up a distinguished client list that included TimeWarner, NBC, the Union Pacific Corporation, and the US Environmental Protection Agency. His key projects also included architectural graphics for the *IBM Building in New York and identity systems for the New York Public Library. In addition to many distinctive exhibition designs, Helmetag has also worked on information systems and signage for Terminal 4 at JFK Airport, New York, as well as schemes for Dulles and Logan Airports. Another of Chermayeff & Geismar's principals and a Yale University graduate with a major in architecture, Jonathan Alger, combined architecture, graphic design, and narrative as an underpinning of many of his exhibition designs for leading museums and libraries, including the New York Hall of Science, the National Museum of American History and the Library of Congress. Italian-born and trained designer Emanuela Frigeriosa was employed by Chermayeff & Geismar from 1990 after working as a designer in London, Milan, and Tokyo during the 1980s. As well as packaging designs for Liz Claiborne's fragrances, Frigeriosa executed many company graphics standards manuals, as well as promotional materials and publicity for leading companies such as *Knoll, the furniture manufacturer. She has also designed books for leading cultural institutions such as the Museum of Modern Art, New York, and renowned art publishers such as Abrams in New York.

The consultancy and its principals have received countless honours and awards. Chermayeff & Geismar received the first International Design Award from the *Japan Design Foundation in 1983. Ivan Chermayeff's awards include the Gold Medal from the American Institute of Graphic Arts (AIGA), the Yale Arts Medal for Outstanding Accomplishments in the Arts, and the Industrial Arts Medal from the American Institute of Architects. The Royal Society of Arts in London has also elected him as a *Royal Designer for Industry. Geismar received a Gold Medal from AIGA, Algar also being granted several awards by the same body as well as the Art Directors Club of New York. Frigerio has received many design awards from the AIGA and other prestigious organizations.

Those associated with Chermayeff & Geismar have had many organizational involvements. Ivan Chermayeff has served as president of AIGA and, since 1967, has been a director of the *International Design Conference in Aspen (IDCA). In 1990 he and Jane Clark Chermayeff chaired the 40th Aspen International Design Conference on the theme of children. Geismar has also had significant AIGA involvements, serving as director and vice-president. He is also a member of the *Alliance Graphic Internationale (AGI) and the Art Directors Club of New York's Hall of Fame. Geissbuhler too has had a close association with the AGI, serving as a member of its International Executive Committee and as its US president. Helmetag was elected to the board of directors of the Society of Environmental Graphic Design in 2003. Most of the partners have also had substantial involvements with design education at the highest level.

Chicago Century of Progress Exposition (1933–4) This immensely popular exhibition on the shore of Lake Michigan attracted almost 49 million visitors over the two seasons that it was open. Initially conceived as an international exhibition to commemorate the 100th anniversary of the incorporation of the city of Chicago, the original ambitions of the 1933 Chicago Exposition were badly hit by the widespread economic and political consequences of the 1929 Wall Street Crash. As a result, the US National Research Council seized the initiative and sought to develop the exhibition theme around the considerable impact that science had exerted on the American way of life over the previous century. It also provided an opportunity to look towards a more prosperous future enhanced by technological progress. As was also to be the case at the *New York World's Fair of 1939–40, major corporations such as *General Motors, *Chrysler, *Ford, and Westinghouse played key roles in portraying the theme from their own particular corporate perspective, housed in colourful modernistic pavilions. Joseph Urban was coordinator of the colour schemes of the exhibition buildings that gave rise to the popular description of the exhibition site as 'Rainbow City' (as opposed to the 'White City' epithet of the *Chicago World's Columbian Exhibition of 1893). A number of exponents of the newly emerging American industrial design profession were also involved in the portrayal of a modern, technologically informed society. These included Norman *Bel Geddes, who was lighting consultant, Walter Dorwin *Teague, consultant to several major exhibitors including the Ford Motor Company, for whom he designed the Rotunda, John Vassos, who designed the streamlined Exposition entry turnstiles, and Gilbert Rohde. Popular science fiction inspired the Sky Ride on which visitors could travel 200 metres above the centre of the site in double-decker rocket cars, whilst on the ground they were able to encounter visions of the future in buildings such as George Keck's circular steel and glass *House of Tomorrow*, complete with aircraft hangar and garage for an automobile, an experience enhanced by the aerodynamic Goodyear blimp floating overhead, the streamlined Chrysler *Airflow* automobile in the 'Wings of a Century' exhibit, and Buckminster *Fuller's teardrop-formed, three-wheeled *Dymaxion Car No. 3*. They could also see the potential of the photoelectric cell and marvel at the General Motors and Firestone assembly lines. In 1934, when the Exposition was opened for a second season, the public's imagination was caught by the streamlined railway locomotives Union Pacific *M10,000* and the Burlington *Zephyr*, their sleek forms quite unlike anything they had previously seen on the American railroads. Crowds flocked in unprecedented numbers to see the record-breaking stainless steel *Zephyr* (also the star of the 1934 Hollywood railway movie *Silver Streak*) and the fast, lightweight aluminium alloy *M10,000*, promoted as 'Tomorrow's Train Today'. Such designs were in tune with the populist visions of the future portrayed in industrial designer Norman Bel Geddes's 1932 book *Horizons*, although the latter's ambitious architectural ideas for the Century of Progress Exhibition (including a tower top revolving restaurant and *Aquarium Restaurant* situated on the wall of a dam) were never built.

The prevailing style of many of the pavilions at the Chicago Century of Progress Exposition was inspired by *Art Deco, was highly colourful, and, in pavilions such as the Travel and Transport Building, gave off a futuristic aura. Growing public belief in scientific and technological progress as a

means of stimulating consumption and recovering economic stability was reflected both in the scale and visitor attendance at the exhibition. Covering almost twice the acreage of the later 1937 *Paris Exposition, as well as attracting 40 per cent more visitors, the Chicago Exposition also made a modest profit, unlike the vast majority of other contemporary large-scale displays. However, just as at the emphatically futuristic New York World's Fair of 1939–40, there were also some real concessions to American history, with a replica of Fort Dearborn as it was in 1833 and a replica of Abraham Lincoln's log-cabin place of birth. Although very limited in numbers, national overseas participants were generally unwilling to present themselves in a backward-looking manner at a time of international economic recovery. Nonetheless, there were many historicizing commercial venues that drew on heritage themes, such as those devoted to the spirit of Merrie England or the Streets of Paris, as well as a number of other atmospheric national 'villages'. Nonetheless, the public's imagination was more potently fuelled by a vision of the future that found expression in the consumption of streamlined radios, toasters, vacuum cleaners, and other domestic appliances, as well as its admiration for emphatically new, efficient, and comfortable forms of public transport.

Chicago World's Columbian Exhibition (1893)

The World's Columbian Exhibition was planned to commemorate the 400th anniversary of Columbus' 'discovery' of the New World and attracted more than 27 million visitors in the six months that its vast 685-acre (277-hectare) site was open. Unlike a number of the large international exhibitions, such as those in Paris in 1878 and 1889, the exhibition buildings were designed to a coherent plan and built in a consistent 'Neoclassical Florentine' or Beaux-Arts style. Despite this quasi-Imperialistic style, which appeared disappointingly conservative and unadventurous to European critical eyes, it exerted a considerable influence on many American public and commercial buildings in the following decades. Painted in uniform white the exhibition buildings gave the fair the popular title of 'White City', the only exception to this being the ornamental and colourful Transportation Building designed by Louis *Sullivan and Dankmar Adler. Chicago was a major industrial city, being the epitome of modern industrial manufacturing techniques, a major industrial centre, and the hub of the national railway network. As in other international exhibitions from the *Great exhibition of 1851 onwards, the public were able to marvel at technological progress, particularly electricity. Technology was closely linked to progress, a theme taken up in subsequent American international expositions, most notably the *Chicago Century of Progress Exposition of 1933 and the landmark *New York World's Fair of 1939–40. At Chicago 1893 Edison's incandescent lighting not only intensified the brightness of the white finishes of the neoclassical architecture and sculpture throughout the site but was widely in evidence within the displays themselves, as in the Westinghouse and General Electric exhibits in the Electricity Building and the manufacturing industry presentations in the Machinery Hall. Electricity for the exhibition was powered by steam engine and provided three times the electrical consumption needed for the rest of the city. Visitors also experienced the world's first Ferris Wheel (a marvel that competed with the Eiffel Tower at the Paris Exposition Universelle of 1889 and stood 250 feet (75 metres) high with 36 compartments containing up to 60

passengers each), a moving pavement, the world's first elevated electrical railway, and Thomas Edison's Kinetograph, a forerunner of the cinema projector. On the Midway Pleasance the glass factories of the Libby Glass Company and the Venice and Murano Company also showed glass being made on site, where it could be purchased. The Transportation Building showed the latest developments in that arena, including automobiles, railways, and a cross-section of an ocean liner, whilst moored to the main pier on the shores of Lake Michigan was the US battleship *Illinois*. The largest building was that devoted to Manufactures and the Liberal Arts where all the major European and American manufacturers were displayed in a 30-acre (12-hectare) display site. American manufactures were represented in large quantities and comprised the largest collection of exhibits ever shown by a host nation at an international world's fair. Although it was felt by some American critics that overseas competitors overshadowed certain design fields, as in the case of porcelain and cut-glass (Austria and Bohemia) or silks (France), they felt that the US showing marked considerable advances from an industrial and artistic standpoint, certainly since the nation's first incursion as host to an international exhibition, the Philadelphia Centennial Exposition of 1876. Amongst the more prestigious and expensive items on show at Chicago in 1893 were the products of the Gorham Manufacturing Company and *Tiffany & Co., the latter exhibiting more than 1,000 pieces valued at more than $2 million. This included the so-called million dollar vase as well as many other expensive items of jewellery and glassware. Of the British companies ceramic manufacturers Doulton & Co. and Burslem Potteries were prominent; also noteworthy were the Goldsmiths and Silversmiths Companies.

Sèvres was prominent in the French display, with French textiles receiving much favourable comment, whilst metalware featured strongly in the German and Austrian displays. In fact 47 nations were represented from Europe and Scandinavia, North and South America, the Caribbean, Africa, Asia, and Australasia. The largest displays were those from Germany, France, and Great Britain, followed by Austria, then Belgium, Russia, and the British colonies. Also noteworthy at the 1893 Exposition was the Women's Building, designed by Sophie Hayden, the winner of an all-women national competition. This was the first time at any international exhibition that women's designs were shown prominently in a specially dedicated building. The work displayed ranged from the ethnographic through to areas of work traditionally associated with women such as embroidery, needlework, and lace, but also included ceramics, domestic appliance and product design, and a model kitchen.

The Columbian Exhibition was also the first world's fair with a separate amusement area and this played host to a number of national projections. It portrayed amongst other enticing displays a 'Street in Cairo' (including Egyptian temples, theatre, and Sudanese huts), and Turkish (including mosque, bazaar, Bedouin camp, and Persian tent), German, Lapland, Javanese, and Austrian villages. Visitors were also able to dine in a 1776 log cabin, drink coffee in the Javanese Lunch Room, be entertained by a gypsy band in the Hungarian Orpheum, and experience Irish industries and customs in a replica Donegal Castle.

Chrome This silvery, reflective metallic finish was first discovered in France in the late 18th century, but did not become commercially viable until 1925. From then on it became increasingly commonly used for

chromium-plated finishes to a wide range of goods including tubular steel furniture by designers such as Marcel *Breuer, *Mies Van Der Rohe, and Le *Corbusier, decorative finishes to domestic products, and automobile detailing in the 1920s and 1930s. It was found in the USA in many contexts in the 1930s, from jukebox, refrigerator, and cooker ornamentation to decoration in railway carriage interiors, cocktail bars, diners, and shops.

Chromium-plated *See* CHROME.

Chrysler Corporation (established 1925) After a background in the railway and motor industries Walter P. Chrysler (1875–1940) founded the Chrysler Motor Corporation in 1925 as president and chairman of the board. Later becoming one of the big three American automobile manufacturers (with *General Motors and the *Ford Motor Corporation) Chrysler was to embrace a number of leading brands including Plymouth and DeSoto Motor Corporations, which were founded in 1928, the same year in which Chrysler bought Dodge Brothers. Important early figures included Oliver Clark, director of the company's coachworks, who established the Art & Colour Section in 1928, and Carl Breer, who was technical director from 1925 to 1949. A widely known automobile design was the striking *Airflow* of 1934, the publicity campaign for which involved the industrial designer Norman *Bel Geddes, who was also consulted by the company on body styling. The *Airflow* was developed by three influential engineers, Carl Breer, Fred Zeder, and Owen Skelton and was known as America's 'first streamlined car'. It also did much to improve passenger comfort and one model, the Chrysler Custom Imperial Airflow CW limousine was the first American car to have a single-piece, curved windscreen. Partly as a result of a number of

teething problems and the reluctance of the public to embrace such a radical design, the *Airflow* failed to capture the public imagination. Subsequently Ray Dietrich, Head of the Art & Colour Department from 1933 to 1938, was charged with ironing out some of the difficulties and developing new models, a policy largely followed by Henry King from 1938 to 1953. Nonetheless, the *Airflow* helped to establish Chrysler as a design innovator, an association developed dramatically after the Second World War in the innovative concepts of Virgil *Exner in the 1950s. In 1937 the Chrysler Corporation built more than a million cars in a single year and, by the following year, produced 25 per cent of all the cars produced in the USA. After the Second World War, like its major competitors, Chrysler began to market a number of technical innovations with evocative names such as the *Gyromatic* transmission of 1949, *Hydroglide* power steering in 1950, *Power-Flite* transmission in 1953, and *Hy-Drive*, *PowerGlide*, and *TorqueFlite* systems in 1954. However, one of the most significant stimuli to the evocative 'space age' styling of the 1950s was Exner, who had joined Chrysler from the Studebaker Corporation in 1949, becoming director of styling from 1953 to 1961. Endorsing the influential corporate role that Exner played at Chrysler was his appointment as vice-president in 1957. In design terms Exner was very much concerned with the dramatic styling of tailfins as seen in his 1955 designs for the *Flight Sweep I* and *Flight Sweep II* cars, ideas that were put into production in the company's 1957 models. Amongst the production models on which Exner's reputation was built was the *Imperial* of 1957, the first American car with curved side glass. Elwood Engel became head of design from 1961 to 1974, coming from the Ford Motor Corporation, where he had been responsible for the 1961

Lincoln. He also presided over the end of the tailfin styling era in 1962, the introduction of the column gear shift, and was in charge of the development of the Plymouth *Barracuda* (1964), the Dodge *Charger* (1968), and the Dodge *Challenger* (1970). From the 1980s, under Tom Gale, the vice-president of design, Chrysler again became an innovative force in automobile design with models such as the *Viper*, the *Prowler*, the *Neon*, and the *PT Cruiser*.

Chrysler had been active in developing its international interests including, in 1964, the acquisition of a major interest in the Rootes Group in the UK (including the Hillman, Sunbeam, Singer, Humber, and Commer brands). In 1987 it acquired the American Motors Corporation, the fourth largest automobile producer, and with it the Jeep brand, and merged with Daimler-Benz in 1998. The opening of the Walter P. Chrysler Museum in Auburn Hills, Michigan, in 2000 marked the Corporation's contribution to automobile history. On display are many of the company's brand names, including DeSoto, Dodge, Hudson, Nash, Rambler, Willys, and Jeep, as well as a replica of Walter P. Chrysler's office.

Chwast, Seymour (1931–) Chwast was an influential American graphic designer and illustrator who worked closely with Milton *Glaser and was a co-founder of Push Pin Studios and the *Push Pin Graphics* magazine, in 1954 and 1955 respectively. Like his associates at Push Pin Studios he did much to undermine the abstract forms, ordered layouts, and machine aesthetic of *International Style graphics by using hand-drawn lettering and illustrative content. Amongst his influences were 19th-century popular advertising, together with its typography and garish colours. His output was prolific and included a wide var-

iety of realizations including posters, magazines, books, packaging, record covers, and animated films. A contemporary of Glaser at the Cooper Union for the Advancement of Science and Art in New York, he studied painting, illustration, and design there from 1948 to 1951. He then gained professional experience, designing in a junior capacity at the *New York Times*, followed by time at *House and Garden* and *Glamour* magazines. In 1954, together with Milton Glaser and illustrators Edward Sorel and Reynold Ruffins, he founded Push Pin Studios and in the following year, with Glaser and Ruffins, *Push Pin Graphics*. Chwast edited the latter, an important vehicle for graphic experimentation, until 1981. During the 1980s he worked in partnership with Herb *Lubalin and Alan Peckolick, forming Pushpin, Lubalin, Peckolick in 1981. His work became widely known internationally, commencing with the retrospective exhibition of Push Pin Studios' work in the Musée des Arts Décoratifs, Paris, in 1970, inclusion in *A Century of American Illustration* at the Brooklyn Museum, New York, in 1973, and a one-man show at the Galerie Delpire in Paris in 1974. His awards included election to the Hall of Fame of the Art Directors Club of New York in 1983 and the medal of the American Institute of Graphic Arts (AIGA) in 1985.

CIAM *See* CONGRÈS INTERNATIONAUX D'ARCHITECTURE MODERNE.

Ciganda, Miguel Ángel (1945–) This versatile Spanish designer commenced his career in 1968, working on interiors, public spaces, and, from 1984, industrial design. Key commissions have included the Spanish Pavilion at the Seville World's Fair. He has worked with many international and Spanish companies such as *Akaba (since 1986), Casas, and Mariá Martínez Otero.

Circle (1937) This important *Modernist publication was edited by J. L. Martin, Ben Nicolson, and Naum Gabo and published by Faber, publishers of other important texts (such as Herbert *Read's Art & Industry of 1934) that sought to promote an awareness in Britain of avant-garde tendencies in design, the fine arts, and architecture in Germany, France, and other European countries. *Circle* sought to promote the belief that there were all kinds of interconnections between many fields exploring new ideas, including seemingly diverse disciplines such as the fine arts, engineering, architecture, typography, and biotechnics. A survey of international *Constructivist art, its contributors included Walter *Gropius, Marcel *Breuer, Le *Corbusier, Siegfried *Giedion, and Herbert Read.

Citroën (established 1919) André Citroën founded this world-famous automobile manufacturing company in Paris. His entrepreneurial background had included the manufacture of gears and artillery ammunition in the First World War. Over the decades since it was founded the company established a reputation for innovative design, including the *2CV*, the *DS*, and the *SM*, although this was less marked towards the end of the 20th century. The company logo, comprising two chevron gear teeth, referred to its early history in gear manufacture. The company's first automobile was the *Type A 10 HP* of 1919, designed and engineered by Jules Salomon. Significantly Citroën was influenced by developments in the American automobile industry, particularly the use of assembly-line production, an economic outlook complemented by an increased emphasis on styling from the early 1930s. A sculptor and stylist Flaminio Bertoni was employed by Citroën from 1932 to 1964, doing much to develop the appearance of the company's cars. However, development of the *YCV Traction Avant*, a highly innovative front-wheel drive model of 1934, was very costly and led to the takeover of Citroën by the Michelin tyre company. An early project to revive the company's fortunes commenced in 1935—the development of a utilitarian car for use by French farmers and their families. Pierre Boulanger, an architect who had previously designed workers' housing for Michelin, was charged with this project—the *2CV* or *Deux-Chevaux*—and worked closely with the engineer Maurice Brogly (and later André Lefèbvre). Large-scale market surveys were undertaken, followed by the field-testing of prototypes, and production started at the outbreak of the Second World War, only to be abruptly halted. The *2CV* was finally launched at the Paris Motor Show of 1948. It became widely popular in circles never envisaged, including hippies, housewives, and *Habitat shoppers, remaining in production until 1990 when it was replaced by the *AX*. Bertoni had worked on the minimal styling of the Citroën *2CV* in the 1930s and, after the Second World War, on the dramatic, elegant sweeping forms of the *DS19* of 1955 and the Citroën *Ami 6* of 1961. Visitors to the Paris Motor Show of 1955 were not only struck by the aerodynamic shape of the *DS19* but also admired the 'space age' appearance of its dashboard and controls. Its technical equipment such as hydropneumatic suspension, front-wheel disc brakes, and foot-operated parking brake also struck a contemporary chord. After some early teething problems the comfortable *DS19* (*Déesse* or 'Goddess') went on to sell more than 1.4 million between 1955 and 1973 and was much admired by Roland *Barthes, design writers, and critics. In 1964 Bertoni was succeeded as head of styling by Robert Opron, whose designs included the tapered form of the *CX* of 1974. During this period,

an important role was also played by Michel Harmand, a French car designer with a background in the Fine Arts, who was at Citroën from 1964 to 1987, when he moved on to *Peugeot, who had taken over Citroën in 1975. He specialized in the design of car interiors, evolving innovative dashboard designs for the CX and controls for the *Visa*, the *GSA*, and the *BX*. The Italian car-styling company *Bertone designed the latter car in 1982. Other designers associated with design at Citroën included Trevor Fiore, a British car designer with a background at the British Motor Corporation and the Raymond *Loewy office. A consultant to Citroën in 1980, he became head of styling from 1980 to 1982, being succeeded by Carl Olsen, an American car designer whose previous industrial experience included a period in the Styling Section at General Motors (1957 to 1961). In 1987 Arthur Blakeslee, an American car designer with a background at Chrysler UK and Simca, took charge of Citroën's Style Centre.

Citterio, Antonio (1950–) A leading Italian architect and interior, furniture, and industrial designer, Citterio explored the possibilities of new materials and technologies rather than aligning himself to the more obviously fashionable aesthetic of *New Design. Citterio has designed for a number of leading manufacturers including *B&B Italia, *Kartell, *Flos, and *Vitra and his work and outlook is well known internationally. He graduated in architecture in 1975, having set up a studio with the furniture and industrial designer Paolo Nava in 1972. He went on to execute furniture designs (1978) for Flexform (established 1959), kitchen design (1980) for Boffi (established 1947), and a showroom (1982) and the *Sity* sofa (1985) for B&B Italia. In 1987 he linked up professionally with

Glen Oliver Löw, with both designers collaborating on Kartell's *Mobil* storage system (1994), which won a *Compasso d'Oro award in 1995 and became part of the permanent collection of the *Museum of Modern Art, New York. Citterio also collaborated with Löw on a number of office furniture design systems for Vitra.

Cliff, Clarice (1899–1972) Well known for her *Art Deco designs such as the colourful *Bizarre* range that was put into production in 1929, Cliff's work was highly popular in the following decade and still remains highly collectable in the early 21st century. A working-class girl from the Potteries, she originally began work in the ceramic industry as an enameller in 1912 before moving to the Stoke-on-Trent ceramic manufacturer A. J. Wilkinson as a lithographer. She made the transition to fully-fledged designer at Wilkinsons, taking evening classes at the local art school in Burslem (1924–5), going on to the *Royal College of Art in 1927 to study sculpture and visiting Paris in 1927. The latter influenced Cliff in her bold, geometric, and colourful designs. Cliff's *Bizarre* range proved to be highly popular and established her as a leading ceramic designer and she was made artistic director at the company in 1930, the year in which she produced a series of figures entitled *The Age of Jazz*. To enhance the reputation of the firm she also commissioned many leading British artists including Frank Brangwyn, Laura Knight, and Paul Nash.

Coca-Cola (established 1886) Coca-Cola is the most recognized brand in the world and has been closely identified with notions of consumption and democracy in the United States. Following the invention of the drink in 1886, the Coca-Cola company was put on firmer foundations by Asa G. Chandler six years later. By the turn of the century he

had evolved a prolific advertising campaign, the budget for which was $100,000 in 1901. Alexander Samuelson developed the Coca-Cola bottle in 1913. Put into mass production two years later by the Root Glass Company in Terre Haute, Indiana, the new design was a response to the company's perceived need to develop an instantly recognizable product identity capable of protection by trademark and patent laws. In fact, the company's design brief was to 'find a Coca-Cola bottle which a person will recognize as a Coca-Cola bottle even if he feels it in the dark. The Coca-Cola bottle should be shaped that, even if broken, one could tell at a glance what it was.' The distinctive Coca-Cola script (as well as the name and slogan 'Delicious and Refreshing') had been designed earlier by company bookkeeper and amateur calligrapher, Frank Robinson. So commercially successful was Coca-Cola over the following decades that by the time of the Second World War it was seen as such an evocative symbol of the American way of life that the company undertook to supply American troops with the drink wherever they were, thus maintaining morale. A similar strategy was repeated in the Korean and Vietnam Wars. After the war the American industrial designer Raymond *Loewy designed the distinctive streamlined red *Dole Deluxe* Coca-Cola dispenser in 1947, the *Dole Super* dispenser in 1951, and a Coca-Cola bottle opener in 1956. In 1954 Loewy also turned his attention to a redesign of the distinctive bottle (redesigned several times in its long history), although he acknowledged that the original was 'the most perfectly designed package in the world'. Loewy's brief was to give the bottle 'a more refined silhouette'. Other ideas that Raymond Loewy Associates worked on for Coca-Cola included a drinks cooler (1945) and a truck design (1946). Coca-Cola has continued to develop globally whilst largely maintaining the visual characteristics of its brand identity and by the early 21st century was sold in more than 200 countries.

Coates, Nigel (1949–) Founder of the radical NATO (Narrative Architecture Today, established in London in 1983) design group and partner in the Branson Coates architecture and design studio (established in 1985), Coates was instrumental in contributing an outlook that combined a keen understanding of the visual vocabulary of contemporary street culture with a sophisticated insight into imaginative architectural possibilities. The groups with which he has been professionally associated have impacted on the urban environment with a series of designs for clubs, bars, restaurants, and retail outlets. After studying at Nottingham University (1968–72) and the Architectural Association in London (1972–4) the theoretically informed Coates went on to set up NATO with colleagues and students, followed by the Branson Coates studio. The dramatic changes that had radically undermined the status quo in British design in previous decades, including *Pop and *Punk, informed an architecural and design outlook which acknowledged the visual richness of street culture and the possibilities offered by avant-garde developments in the fine arts and new media. The power of drawing and the ability of installations to evoke atmosphere also played an important role in the group's work, leading to such dramatic creations as the Café Bongo in Tokyo in 1986. Branson Coates have also designed a number of striking retail outlets including an interior for Katherine Hamnett's shop in Sloane Street, London, in 1988. The interior walls were enlivened by large fish tanks, complemented by a copy of the Surrealist artist Salvador Dali's celebrated lip sofa and

baroque furnishings. Other retail outlet designs included those for Jasper Conran in Tokyo (1989) and a shop for the clothing company Jigsaw in London (1991). Amongst the company's restaurant and bar designs have been the Metropole, Tokyo (1985), the Noah's Ark restaurant, Sapporo, and the Bargo Bar, Glasgow (1996). Furniture ranges named after the cafés designed by Branson Coates were launched, including the *Jazz* and *Metropole* in 1987, and the *Noah's Ark* collection in 1988. The company has also undertaken a number of exhibition designs including the *Erotic Design* show at the *Design Museum, London (1997), the state-sponsored *Powerhouse::uk* exhibition promoting contemporary British design in Horseguards Parade, London, and *The Body Zone* in the Millennium Dome, Greenwich (2000). Other notable commissions have included the striking stainless steel forms of the National Centre for Popular Music (1999, now closed) in Sheffield and the British Pavilion for Expo '98 in Seville. Coates has played a significant role in architectural design education through teaching at the Architectural Association, London, and the *Royal College of Art, where he became Professor of Architecture and Interior Design in the mid-1990s.

Coates, Wells (1895–1958) Coates was a leading figure in *Modernism in Britain in the 1930s, recognized for his original contributions to architecture, interiors, furniture, fittings, and product design. His wide-ranging clients included the British Broadcasting Company (BBC), *Isokon, Modernist furniture manufacturer *PEL, progressive radio manufacturer Ekco (E. K. Cole), aircraft manufacturer *De Havilland and the British Overseas Airways Corporation (BOAC). Born in Tokyo Coates travelled to Canada in 1913, where he commenced his studies in Mechanical and Structural Engineering at McGill

University. After serving in the First World War he resumed his studies at the University of British Columbia, gaining a BA in 1919 and B.Sc. in Engineering in 1922, before moving to London to take a Ph.D. in 'The Gases of the Diesel Engine'. He then pursued a career in journalism, visiting Paris and developing a strong interest in the work of Le *Corbusier. His involvement with design began with the design of standardized shop fittings in plywood for the Crysede Silks shop in Cambridge in 1928, followed in 1929 by a factory interior in Welwyn Garden City for the innovative Cresta Silks company founded by Tom Heron. This led to a further commission for an inexpensive but modern standardized shop design for Cresta, resulting in the innovative Brompton Road outlet in London. This design was characterized by the abstracted lettering of the company name, constructed in metal and set in deep relief. Other progressive designers working for Cresta in this period included Edward McKnight *Kauffer (stationery and packaging) and Paul Nash (textiles). In 1928 Coates had met Jack *Pritchard of the Venesta Plywood Company, a fellow admirer of Le Corbusier and European *Modernism. This resulted in the commission for what was to be one of the most celebrated of Coates's designs, the Lawn Road Flats in Hampstead, London, for which the designs were completed in 1932. Coates had been influenced by ideas of modern living in minimum spaces explored at the 1929 *Congrès Internationaux d'Architecture Moderne (CIAM) in Frankfurt. Coates's ideas of built-in furniture and fittings and 'Minimum Kitchen' for the Lawn Road Flats were displayed in the interior shown at the 1933 *Industrial Art in Relation to the Home* exhibition in London. Aimed at young professionals, in fact the Flats housed many Modernist émigrés from Nazi Germany including Walter *Gropius, László *Moholy-Nagy, and Marcel

*Breuer. Coates had also been commissioned, alongside Modernists Raymond McGrath and Serge *Chermayeff, to design for the BBC and contributed innovative solutions for the Dramatic Effects and News Studios. Coates's commitment to the Modernist cause was further consolidated by his involvement in the foundation of Unit One in 1933, a pressure group of avant-garde artists and architects including sculptors Henry Moore and Barbara Hepworth, painters Ben Nicholson and Paul Nash, and architects Colin Lucas and Coates himself. He also played a key role in the formation in 1933 of the MARS (Modern Architectural Research) Group at the invitation of the CIAM. Coates also played an active role in furniture design at the time including tubular steel furniture for Hilmor and PEL that was used in another of his well-known blocks of apartments, Embassy Court in Brighton (1935). He also designed wooden furniture for Isokon, used in the Lawn Road Flats, and for P. E. Gane of Bristol. In terms of industrial products he also contributed a number of designs for Ekco including the highly popular *Bakelite *AD 65* radio of 1934 and *PC1 Thermovent* heater of 1937, cased in phenolic plastic. After the Second World War he continued to work on fresh ideas, exhibiting his *Wingsail Catamaran* prototype at the *Britain Can Make It* exhibition of 1946 and designing the Telekinema and TV Pavilion for the South Bank site *Festival of Britain in 1951. However, his post-war work never recaptured the sheer verve and originality of his design work and professional activity of the 1930s. His distinctive contribution was recognized in his appointment as *Royal Designer for Industry (RDI) in 1944 and as Master of the Faculty of RDI in 1951.

Colani, Luigi (1928–) German designer Colani worked across a wide range of products as well as many experimental concepts never put into production and did much to promote himself as a design 'celebrity', even changing his first name from Lutz to the more 'designer-friendly' Luigi. He studied art in Berlin in 1946 before moving to Paris to study aerodynamics at the Sorbonne in 1948. He went on to work for the Douglas Aircraft Company from 1952 to 1954, followed by a period working on aerodynamic forms for a number of automobile companies including *Fiat, *Alfa Romeo, *BMW, and *Volkswagen. In 1968, in response to considerable demand for Colani-designed products, he opened his own design company in Westphalia, working on a wide range of furniture, automobile, and product commissions for companies such as Cor (*Orbisi* chair, 1969), *Rosenthal (*Drop* tableware, 1972), and *Canon (*T90* camera, 1983). Many of these designs reflected a penchant for flowing, organic forms with an aesthetic affinity with high technology, an outlook that derived from his interest in aerodynamics. In the 1980s he established himself in Japan working for many leading companies such as *Sony, *Nissan, and Seiko, also establishing the Colani Design Centre in Berne, Switzerland, in 1986. His work covered almost every sphere of human activity, was often signed to give it 'designer' cachet, and was celebrated in the *Colani Designs and Visions* exhibition in Bremen, Germany, in 1998.

COID *See* DESIGN COUNCIL.

Cole, Henry (1808–82) One of the major forces in British design education in the 19th century, with a particular emphasis on its relevance for industry, Cole was also significantly involved in setting up the *Great Exhibition of 1851, and the establishment of the *Journal of Design*. From the age of 15 he was involved with public records, eventually rising to the post of Assistant Keeper at the Public Record Office in

1838. Under the pseudonym Felix Summerly he became involved in a number of design-related activities including the publication of illustrated children's books, the first Christmas card, designed by J. C. Horsley in 1846, the year in which Cole won a Silver Medal from the Royal Society of Arts for his design of a tea service that was later put into production by Minton. In 1847 he founded Felix Summerly's Art Manufactures, commissioning a number of artists to produce a series of designs in different media. His interest in art manufactures was followed through in his organization of a series of annual exhibitions from 1847 to 1849 through the Society of Arts, which he had joined in 1846. Having worked closely with Prince Albert and other members of the Royal Commission for the Great Exhibition, Cole was also involved with the London International Exhibition of 1862 and the Paris International Exhibitions of 1855 and 1867. With the artist Richard Redgrave as its editor he also founded the *Journal of Design and Manufactures* (1849–52), an important campaigning voice for improvements in British design education. In 1852 Cole was made joint secretary with Lyon Playfair of the Department of Practical Art, established in the same year by the Board of Trade to administer the Government Schools of Design. He became secretary in his own right in 1858, a position he held until 1873. He was also responsible for building up a collection of design that was to form the basis of the collections of the *Victoria and Albert Museum. He was knighted in 1875.

Colombini, Gino (1915–) An Italian designer well known for his elegant designs of household goods in plastic for *Kartell, for which he also gained a number of *Compasso d'Oro awards in 1955, 1957, 1959, and 1960. He had been a pupil of Franco *Albini,

collaborating with him from 1933 onwards. He later became involved with Kartell from its foundation in 1949, working for the Italian furniture manufacturer Bonacina (established 1909) and Poliber Renos from the 1960s onwards.

Colombo, 'Joe' Cesare (1930–71) Colombo initially trained as a painter at the Brera Academy of Fine Arts and joined the Nuclear Painting Movement before studying architecture at Milan Polytechnic. In 1962 he opened his own design office and led progressive Italian design with a series of products in new materials, mostly in plastics. He was influenced by the atmosphere of *Pop art and worked on many experimental ideas including multi-functional, mobile 'living units' such as the exhibition of *Italy: The New Domestic Landscape* shown at the *Museum of Modern Art, New York, in 1972. His design innovations included one of the first one-piece injection-moulded plastic chairs and a complete kitchen on wheels. Similar ingenuity can be seen in his 1970 design of the brightly coloured *ABS *Boby* trolley for Bieffeplast. Running on castors, with pivoting drawers and shelves, and multiple compartments, it was suitable for use as an office or bathroom organizer, bedside table, or storage unit. Colombo received many design awards, among them two *Compasso d'Oros in 1967 and 1970. He worked for a wide range of companies, amongst them Comfort (including the 1963 *Astrea* armchair and sofa) and *Kartell (including the 1975 *Universale* chair in ABS, as well as many lights).

ColorCore (established 1980s) A material developed by Formica International Limited as the company became more involved in promoting its products for design-conscious markets, ColorCore was a material in which the surface colour permeates through the

main body, extending its possible uses in furniture and other applications. The company also developed the Color+ Color range of 108 solid colours in six major groups of varying shades and hues, allowing users to specify their requirements with increasing precision. A number of prestigious design competitions using the material were initiated in the mid-1980s with tours of prestigious galleries throughout the United States. ColorCore became a material widely used by avant-garde furniture designers in the 1980s and 1990s.

See also FORMICA.

Commercial Art (1922–59) This British magazine devoted to all aspects of graphic design and display was launched at a time when 'commercial artists' were striving hard to be recognized as design professionals. Taken over by the *Studio* in 1926, the fragility of their status was reflected in the frequent subsequent changes in title: *Commercial Art and Industry* (1932), *Art and Industry* (1937), and, eventually, *Design for Industry* (1959).

Compasso d'Oro (established 1954) The Compasso d'Oro (Golden Compass) competition and award for product aesthetics was established by Aldo Borletti at the Italian department store La *Rinascente at the X Triennale (See MILAN TRIENNALI) in Milan in 1954. The store had been committed for many years to the promotion of standards of excellence in Italian design and the award was the first of its kind in Europe. The Compasso d'Oro also provided stimulus for the recognition of stylish modern Italian design at home and abroad, its early recipients amounting almost to a roll of honour of prominent designers and manufacturers in post-war Italy. They included Marcello *Nizzoli, designing for Necchi and *Olivetti, Gino Sarfatti for *Arteluce, Gino Colombini

for *Kartell, Franco *Albini for Poggi, Roberto *Sambonet for his own company, Marco *Zanuso for Borletti, and Dante *Giacosa for *Fiat. Critiques of the early award-winning products were to be found in the short-lived Italian design magazine, *Stile industria*. The Compasso's aesthetic inclination towards the prevailing international concept of *'Good Design' was acknowledged in awards such as those presented to the Danish Den Permanente (1958) and the British *Council of Industrial Design (1960).

After 1959 the award scheme was managed jointly by La Rinascente and *ADI (the Italian Association of Industrial Design), the latter organization assuming complete control in 1962. As with many other such design awards there were criticisms of the emphasis on aesthetics at the expense of social relevance. Furthermore, the jury was drawn from the confines of the Italian design world until the 1970s when it was broadened in outlook by the inclusion of foreign designers and others working in related fields. These have included the French cultural theorist Jean Baudrillard, the American industrial designer Arthur *Pulos, the Russian Yuri *Soloviev, design historian-critics Fredrik Wildhagen and Victor Margolin, the French design 'superstar' Philippe *Starck, and the Finn Antii *Nurmesniemi.

The XVII Premio Compasso d'Oro of 1995 reflected the organizers' efforts to emphasize the international prestige of the award rather than the perception that it was a competition driven largely by the ambitions of a comparatively restricted circle of Italian designers and producers. Although entries were still accepted from individual designers and manufacturers, an initial selection of suitable products was identified by representative groups drawn from all over Italy. The criteria were also widened

to include products designed by non-Italians but manufactured in Italy, and vice-versa. In addition a Young Design Award was instituted to encourage a younger generation of designers aged 32 years or less.
See also DESIGN AWARDS.

computer-aided design (CAD) CAD involves the designer's use of the computer as a versatile alternative to more traditional modes of drawing and modelling and is today an indispensable tool for graphic and product designers, engineers, interior designers, and architects. Its basic two-dimensional graphic origins lay in the United States Air Force's SAGE air defence system in the mid-1950s and was developed at the Massachussets Institute of Technology's (MIT) Lincoln Laboratory. In 1961 Ivan Sutherland, a doctoral student at MIT, first envisaged a computerized sketchpad that would replace traditional modes of design drawing and by the end of the decade the Computervision company had sold the first commercial CAD system for production drafting to Xerox. By this time attention had begun to turn to the possibilities of computer-aided three-dimensional modelling. However, in their early stages of development all CAD applications were phenomenally expensive, as were the large computers that powered them. As a result they were generally restricted to large automotive and aerospace corporations such as Chrysler, Ford, General Motors, and Lockheed. By the early 1970s *General Motors had developed the first DAC (Design Automated by Computer) production interactive graphics manufacturing system and in 1975 Lockheed sold software equipment licences to Avions Marcel Dassault (AMD) for purchased CADAM (Computer-Augmented Design and Manufacture). The development of increasingly sophisticated and accessible systems was rapid and, by the 1980s, appli-

cations were developed for personal computers. By the late 20th century the dramatically increased speed, enhanced memory, and very much smaller size of computers, together with highly sophisticated and affordable software have meant that basic packages for two-dimensional and three-dimensional graphics became standard in design and architectural studios and education. They are also readily available to everyday consumers using personal computers who are able to use software for designing bathrooms, kitchens, etc. The huge advantage afforded by digital systems for drawing and modelling is that they allow designs to be seen from any angle as well as easily manipulated, whether in terms of choice of colours, textures, or revisions. Such digital designs can be stored electronically and speedily transmitted, with relevant data fed directly into the manufacturing process.
See also COMPUTER-AIDED MANUFACTURE.

computer-aided manufacture (CAM) CAM involves the use of a computer to control the manufacture of products. The first CAM software involved a computer linked to a milling machine but, since the mid-1980s, CAD and CAM have become closely interrelated.

Congrès Internationaux D'Architecture Moderne (CIAM, established 1928) This international architectural organization was formed by a number of progressive architects who adhered to the ideas of *Modernism and was brought about through the patronage of Madame Hélène de Mandrot, a wealthy widow associated with the arts. Initial membership of the group included architects and designers Le *Corbusier, Gerrit *Rietveld, Robert *Mallet-Stevens, El *Lissitsky, and Karl Moser, who became its first president. Siegfried *Giedion was CIAM's secretary-general,

a post he held for more than two decades. In the interwar years CIAM met at La Sarras, near Geneva, in 1928, in Frankfurt in 1929 (where discussions centred on ideas of living in minimal dwellings), in Athens in 1933 (which gave rise to the organization's Athens Charter and ideas of the 'Functional City'), and in Paris in 1937. CIAM provided an effective forum for debate amongst Modernist theorists and practitioners although its vitality faltered in the years following the end of the Second World War, when critiques of Modernism became increasingly attractive to the avant-garde. It was finally dissolved following its last meeting in Dubrovnik in 1956.

Conran, Terence (1931–) Conran has played a seminal role in changing attitudes in design retailing in Britain since 1964 when he established the first *Habitat in the Fulham Road, London. An active designer and entrepreneur he has influenced many facets of contemporary life, whether in terms of the appearance and consumption of well-designed modern products, the promotion of design in museum contexts as in the *Design Museum, London, or the establishment of a number of well-known restaurants. His commitment to higher standards of design in daily life has managed to capture the imagination of consumers in ways that the non-commercial and occasionally high-minded didacticism, of state-funded organizations such as the *Design Council have often failed to do. Conran's *House* Book of 1973 proved influential for the domestic lifestyle of many, an outlook reinforced by the many books about interiors, crafts, decorative arts, cookery, and gardening published by Conran Octopus books. A student in textile design under Eduardo Paolozzi at the Central School of Art and Design (*see* CENTRAL SCHOOL OF ARTS AND CRAFTS) in 1949, he worked at the Rayon Centre, London, in 1950 and, in the following year, as a designer in Denis Lennon's studio. Conran played a minor role designing furniture for the 1951 *Festival of Britain before setting up a small furniture and design workshop in 1952, his early clients including Edinburgh Weavers and John Lewis. He commenced his entrepreneurial career in the mid-1950s with the launch of his *Soup Kitchen* restaurant, the first of three in London, with a fourth in Cambridge. He went on to establish the Conran Design Group in 1956, working in a number of fields, including textiles, ceramics, and furniture, and was particularly influenced by the elegance of contemporary Italian design and the clean modern lines that characterized post-Second World War Scandinavian goods. Conran's first Habitat store was opened in 1964 and the idea (aided and sustained by his close associate Oliver *Gregory) rapidly expanded through a network of Habitat and Conran stores across Britain, Europe, and the USA. Many of the goods sold in the early years proved highly attractive to a younger generation of consumers open to fresh ideas, whether French cookware, brightly coloured Eastern European coffee pots and mugs, or stylish furniture at affordable prices. Habitat's approach was influenced by the Swedish design retailer *IKEA (which, in the 1990s, took over Habitat). The success of his venture led to the floating of the Habitat chain on the Stock Market in 1981 and the allocation of some of his profits to establish the charitable Conran Foundation. Conran took over the high-quality design retailer, *Heal's in 1983. Other notable retailing chains in which Conran has had a substantial managerial involvement included Mothercare (children's products), bought in 1982, and British Homes Stores (mass-market clothing and domestic products), purchased in

CONSTRUCTIVISM

In the years leading up to the outbreak of the First World War Russian designers were exploring new aesthetic vocabularies that revealed an awareness of avant-garde developments in France, Germany, and Italy as well as their own indigenous folk-art traditions. New abstract forms were evolved, as seen in a series of Suprematist paintings of Kasimir Malevich and sculptural corner constructions by Vladimir *Tatlin. Suprematist painting comprised abstract coloured shapes set against light grounds in order to convey feelings of ascending, floating, and falling, a visual vocabulary that was subsequently applied to theatre settings and costumes, ceramics, street propaganda, and architecture. However, such Suprematist artefacts may perhaps be seen as 'applied art' in the more literal meaning of the terms than the more directly socially and politically committed work of the Productivists, outlined below. The October Revolution of 1917 provided Russian Constructivist designers, architects, and artists with an opportunity to play a significant part in the 'construction' of the social, economic, and political changes sought by the Bolshevik revolutionaries, harnessing their creative talents to educate the masses as well as revolutionize art and design education. However, by about 1920 a number of differences of opinion about the role of arts in post-Revolutionary Russia had arisen between the different factions of the Constructivist avant-garde. On the one hand, artists such as Naum Gabo and Wassily Kandinsky believed strongly in the creativity and inner spirituality of the individual artist, independent of practicalities and functions. Others, such as Tatlin, Alexander *Rodchenko and his textile designer wife Varvara *Stepanova, wanted to bring about more social and practical applications for their work, allied to the potential of mass production. Such an outlook, termed Productivism, won the backing of the Proletcult (organization of Proletarian Culture) that had links with the trade unions. Tatlin worked on such utilitarian designs as workers' clothing, a fuel efficient stove, and his projected Monument to the Third International, envisaged as a towering structure that would disseminate Revolutionary propaganda and employ the latest broadcasting technologies, whilst Rodchenko explored the full range of the design spectrum including posters and packaging, signage, periodicals, ceramics and industrial products. Others, such as the graphic and exhibition designer El *Lissitsky, explored crisp, sans serif typography and new modes of communication such as photomontage that epitomized the spirit of technological progressiveness in the contemporary world. Also demonstrating symbolic affinities with modern production technologies in the geometric vocabulary and abstracted forms used in their textile designs, Liubov Popova and Stepanova worked for the Tsindel textile factory near Moscow in early 1920s. The Constructivist ethos was also clearly promulgated at the *Paris Exposition des Arts Décoratifs et Industriels of 1925 in Konstantin Melnikov's striking design for the USSR Pavilion, which also contained Rodchenko's design for a Workers' Club with its utilitarian interior and furnishings. Constructivism also played an influential role in both the development and dissemination of *Modernism across Europe, including the *Bauhaus in Germany and the activities of the De *Stijl group in Holland. However,

although the progressive vocabulary of the Constructivists fell out of favour and was replaced by the more readily assimilated Socialist Realism favoured by Stalin in the later 1920s and 1930s the term has subsequently been applied to later artistic developments characterized by their sense of structure, rationality, and geometric elements.

1986, which, with Habitat, became Storehouse plc with Conran as chairman and chief executive. Economic problems in Britain in the later 1980s led to Conran's withdrawal from the enterprise in 1990. However in 1992 he bought back the Conran Shops that he had first established in 1973 to complement the increasingly numerous Habitat outlets, later opening Conran stores in Japan, Germany, and France. For many years Conran had also been concerned to establish a new museum devoted to design at a time when few museums were committed to the display and understanding of contemporary design culture. The first steps were taken with the opening of the *Boilerhouse Gallery in the *Victoria and Albert Museum in 1981, under the curatorship of Stephen Bayley, and culminated with the establishment of the *Design Museum in Butler's Wharf, London, in 1989. These twinned initiatives were intended to provide designers, design students, and the public with the means of stimulating design awareness on a broader front than had been the case with the state-funded *Design Council. Throughout his life Conran has continued to be involved with the design process, setting up Conran Associates in 1971, a consultancy with a leaning towards corporate identity and product design. In connection with the latter he won a *Design Centre Award in 1974 for a series of brightly coloured plastic containers for Crayonne, a subsidiary of Airfix Plastics. His interest in furniture design has remained undiminished since his con-

tributions to the 1951 Festival of Britain. In 1983 he established a furniture-making company, Benchmark Woodwork and, in 2002, he produced his first range of mass-produced furniture since launching Habitat almost four decades earlier with a collection for *G Plan entitled Content by Conran. This range is marketed in furniture warehouses, with the aim of selling quality furniture at low prices. His interest in restaurants has also spanned half a century, with a considerable acceleration in the 1990s, his more recent ventures including the Bluebird restaurant (1990), Le Pont de la Tour (1991), and the Great Eastern Hotel (2000). Terence Conran was knighted in 1983 for services to British design and retailing.

Constructivism *See* box on pp. 93–94.

Consumers' Union (established 1936) The Consumers' Union (CU) was founded in New York as a pressure group for educated consumers at a time when the USA was experiencing the rapid transformation of everyday life by an ever-increasing and bewildering range of appliances and consumer goods. The CU sought to provide consumer advice and to test products objectively, communicating its findings in its periodical *Consumer Union Reports* (later *Consumer Reports*). Between 1945 and 1950 the magazine's circulation rose from 50,000 to 500,000, continuing to rise over the next twenty years to 1,800,000 (with a far greater readership). However, like its British counterpart the Consumers' Association, it was mainly supported by educated profession-

CONTEMPORARY STYLE

This style was in vogue in the 1950s and was closely associated with the many of the new designs seen at the *Festival of Britain exhibition of 1951, the major site for which was the South Bank in London. The Festival was a dramatic post-war celebration of colour and modernity following the constraints of a decade of austerity and limited room for freedom of expression under the *Utility Design regulations. The 'Contemporary' look, sometimes also known as the 'Festival Style', was characterized by the use of organic forms and bright colours as seen in Lucienne *Day's *Calyx* textile design of 1950 and in the rather expressive, spindly linear forms of Ernest *Race's *Antelope* chair. Fabricated from enamelled steel rods and moulded plywood seat its slightly splayed legs were set into small molecule-like ball feet, the latter a feature on many domestic products in the 1950s, whether plant pot holders, magazine rack holders, coat hooks, furnishing fabrics, or light fittings, or the design of space dividers and balustrades in retail outlets and offices. The work of the Festival Pattern Group (*see* FESTIVAL OF BRITAIN) also drew on science as a metaphor for contemporaneity, exploring as the basis for surface pattern design the intricate abstract forms of crystallography, a scientific field in which Britain was a world leader. The design output of this group inspired designs that were adopted by 26 British manufacturers and were applied to all kinds of flat surfaces including ceramics, glass, textiles, carpets, wallpapers, and packaging and may be seen to have influenced designers such as Marianne Straub. The Contemporary Style was also closely aligned to the quality of line in the work of fine artists such as Joan Miró and the colourful abstract elements of Alexander Calder mobiles and the sculptural inclinations of Barbara Hepworth and Alberto Giacometti. The molecular look was also taken up in other countries, as in George *Nelson's 1949 *Atomic Clock* for the *Howard Miller Company in the United States or the focal point of the Brussels International Exhibition, the Atomium (based on the magnification by 165 million times of an iron molecule) by André Polack and André Waterkeyn. The organic form of much Contemporary Style furniture, ceramics, glass, and metalware was also an international currency and could be seen in products such as Tapio *Wirkkala's *Kantarelli* vase of 1947, Arne *Jacobsen's *Ant Chair* of 1951, Carlo *Mollino's *Arabesque* table of 1950, or Isamu *Noguchi's *Akari* paper lamp of 1954.

als who were among the more discriminating and knowledgeable consumers.

Container Corporation of America (CCA, established 1926) This leading American packaging manufacturing company distinguished itself through its high premium on design and high-quality advertising. Much of the impetus for this came from the company's founder Walter Paepcke, whose commitment to progressive design thinking was underlined by his support for the *Institute of Design, Chicago, and Aspen *International Design Conference, both of which were significantly influenced by European *Modernism. The appointment of Egbert Jacobsen as director of design at CCA in 1936 was a landmark, followed by the development of an effective company *Logotype and the institution of a positive

*corporate identity programme. Many well-known European artists and designers were commissioned by the company, including A. M. *Cassandre, Herbert *Bayer, László *Moholy-Nagy, Jean Carlu, Fernand Léger, Gyorgy Kepes, and Herbert Matter. A number of notable advertising campaigns ensued, including the wartime 'Paperboard Goes to War' (Jacobsen, Carlu, and Matter) and 'Great Ideas of Western Men (1950). CCA's corporate identity was updated in 1957 by the design director Ralph Eckerstrom, with further visual, particularly typographic, changes being enacted in the following decade by John Massey, who became design and advertising manager in 1961 and replaced Eckerstrom as design director in 1964. In 1967, further underlining CCA's commitment to design innovation, Massey established a subsidiary for the development of corporate identity schemes for external clients, the Centre for Advanced Research in Design.

Contemporary Style *See* box on p. 95.

Cooper-Hewitt Museum (established 1897) Established in New York as the Cooper Union Museum for the Arts of Decoration (as part of the Cooper Union for the Advancement of Science and Art) it was aimed at design students and designers and was concerned with everyday design. Located in the Andrew Carnegie Mansion on 5th Avenue, New York, it was dedicated to the collecting and exhibiting of both contemporary and historical design. However, a distinct shift of emphasis was brought about through the appointment in 1946 of Calvin S. Hathaway, from the Pennsylvania Museum of Art. He was director from 1951 until 1967 when the library and collections were taken over by the Smithsonian Institution. In 1976 it moved premises, was renamed the Cooper-Hewitt National Museum of Design, and came under the directorship of Lisa Taylor. The collection contains more than 250,000 objects over a large chronological period and is organized in four departments: Product Design and Decorative Arts; Drawings, Prints, and Graphic Design; Textiles; and Wallcoverings. In addition to its extensive holdings of objects, drawings, and photographs there are a number of important design archives including those of Henry *Dreyfuss, Donald *Deskey, and Gilbert *Rohde. The museum has also mounted a series of design exhibitions which embrace graphic design, industrial design, architecture, and the decorative arts. The Cooper-Hewitt inaugurated the *National Design Awards in 1997 and, in 1998, a state-of-the-art Design Resources Center was established in a building physically linked to the Andrew Carnegie Mansion by the Agnes Bourne Bridge Gallery.

Corbusier, Le (1887–1965) Born Charles Édouard Jeanneret, Swiss-born architect, designer, and theorist Le Corbusier was one of the most important creative figures in architecture of the 20th century, founder of the *Modernist periodical *Esprit Nouveau* in 1920, author of a number of influential books including *Vers une architecture* (1923), *L'art décoratif d'aujourd'hui* (1925), and *Les 5 points d'une architecture nouvelle* (1926), and a co-founder in 1928 of the *Congrès Internationaux d'Architecture Moderne (CIAM). He also coined the maxim that the modern home was 'a machine for living in'.

After an early career as a watch engraver in the Swiss town of La Chaux de Fonds, winning a prize at the 1902 International Exhibition of Modern Decorative Art in Turin, he studied architecture at the local art school and, after a period of travel, moved to Paris in 1908 to work in the architectural offices of the reinforced concrete specialist Auguste Perret. In 1910 Le Corbusier went to Berlin to work under the

proto-modernist architect and designer Peter *Behrens before returning, via Eastern Europe, to his home town in 1912 to teach architecture and the decorative arts. From 1914 to 1916 he devoted his energies to architectural theory, including his ideas for the concrete-structured Dom-ino House, before returning to Paris in 1917 where he met the painter Amadée Ozenfant and took up painting. Influenced by the formal aspects of Cubism and the emphatic 20th-century spirit of *Futurism they invented Purism, a clean, pure-formed Modernist aesthetic promoted in their manifesto *Après le Cubisme* of 1918 and followed up in the publication of the periodical *Esprit nouveau* from 1920 to 1925. Le Corbusier's ideas about what he saw as the decadence of excessive and inappropriate ornament in the contemporary decorative arts were developed critically in his book *L'art décoratif d'aujourd'hui*. They were realized in physical form in the light, clearly articulated interiors of his Pavillon de L'Esprit Nouveau at the 1925 *Paris Exposition des Arts Décoratifs et Industriels, a stark contrast to the decorative exuberance of most of the more commercially oriented and fashionable pavilions on show. Its modular structure contained standardized unit furniture, mass-produced bentwood *Thonet chairs, and abstract paintings by Fernand Léger hung on plain, undecorated walls. Further important visual and spatial characteristics that were underpinned by his theoretical premisses were also seen in his two apartment buildings at the internationally influential Weissenhof Siedlungen housing exhibition in Stuttgart and the celebrated Villa Savoye of 1929–31. It was in this period that he turned to modern furniture design, working closely with his cousin Pierre Jeanneret and Charlotte *Perriand, the latter having been influenced strongly by Le Corbusier's writings. Her practical experience of design and knowledge of materials such as tubular steel were important means of translating Le Corbusier's design ideas into material objects. This was exemplified by designs from the late 1920s such as the *B301 Grand Confort* armchair, the *B302* swivel chair, and the *B306 Chaise-Longue* which combined tubular steel frames with leather or skin upholstery and were first manufactured by Thonet. Further demonstration of his ideas for contemporary interiors and furniture—or 'Equipment for Living'—were shown at the 1929 Salon d'Automne, where the three collaborated in a design for a modern apartment. In 1930, the year in which Le Corbusier became a French citizen, they also exhibited a plywood display stand for the Venesta plywood company at the Building Trades Exhibition in London, although this commission marked the end of Le Corbusier's involvement with furniture design. In 1930 he joined the *Union des Artistes Modernes (UAM), a progressive collective of designers that had been established in the previous year as a reaction against the conservatism of the *Societé des Artistes Décorateurs. From the 1930s he devoted his energies to architecture and was involved in urban planning projects and, between 1947 and 1952, the realization of his housing project, the Unité d'Habitation block of flats in Marseilles. This building marked a key shift from his sleek 'machine age' forms of the 1920s and early 1930s, being finished in rough concrete, using colour and sculptural form as expressive elements. Other notable later architectural projects included the Chapel of Notre-Dame-du-Haut in Ronchamp (1950–5), the planning of the city of Chandigarh in India, and the Monastery of Sainte-Marie-de-la-Torette at Evreux (1957–60). In the mid-1950s Le Corbusier also undertook tapestry designs for the Law Courts at Chandigarh and the Unesco

Building in Paris. From the mid-1960s his (and Perriand and Jeanneret's) furniture designs have continued to be reproduced by the Italian furniture firm *Cassina and take their place as icons of 20th-century design.

Corning Glass (established 1851) This American glassmaking company has become widely known for its ovenware and development of heat resistant materials such as Pyrex and Pyroceram. Pyrex, a form of transparent, heat-resistant glass invented in 1913 by Jesse T. Littleton at Corning, was itself developed from an earlier strong, glass-based material called Nonex ('non-expansion'). The latter was the result of work undertaken in 1908 by Eugene Sullivan, the first director of research at Corning, in order to reduce breakages. The first Pyrex ovenware range was launched in 1915 and, in the same year, was also used for Silex coffeemakers made by the Frank E. Wolcott Manufacturing Co. In 1941 Corning Glass produced the Chemex paper filter coffeemaker with its flask (patented by Peter Schlumbohm in 1938) manufactured from Pyrex. Other developments involving Pyrex took place at Corning in the 1930s, including *Range Top Ware* (1930) and *Flameware* (1934), the latter's pressed-glass cookware products including frying pans and saucepans. The range was expanded and further developed over 40 years, being discontinued in 1979. The company had established its own design division in New York in 1948, directed by John B. Ward, with an early brief to revitalize the appearance of Pyrex ovenware and *Flameware* products. In 1973 the design division was decentralized alongside the company as a whole, with the establishment of seven design centres and a design team of 23. Other important Corning Glass innovations included Pyroceram (1953), a white

heat-resistant material with a ceramic appearance used for the *Corningware* oven-to-tableware range launched in 1958. Notable Corning product ranges included design award-winning *Terra* bake-serve products (1965), *Store 'N' See* ware (1968), and *Corelle Living Ware* (1970). The latter was a break-resistant dinnerware that proved a tremendous sales success, selling more than 2 billion pieces by the end of the 20th century.

Corporate identity Corporate identity is the visual means by which organizations, businesses, and manufacturers are recognized and distinguished from each other. It is also a means of conveying the ways in which they carry out, and values inherent in, their activities. Although corporate identity is often closely linked to *logotypes, at its most effective it also embraces other aspects of corporate expression such as architecture, interiors, furnishings and uniforms, stationery, publicity, even codes of company behaviour. Some writers have looked to what they see as early exponents of the idea, such as the army of ancient Rome, the Catholic Church, or the railway companies of the 19th century with their distinctive liveries, mainline stations, carriage interiors, dining services, cutlery, and menu designs. Corporate identity schemes may be used to make large corporations appear less dominant or threatening through the creation of positive individual identities for their subsidiaries, or to give related smaller companies greater global presence through the development of some readily communicable aspects of shared identity. Many design historians have pointed to the work of Peter *Behrens for the *AEG in Germany in the years leading up to the First World War, although it is in the world of the large American multinationals that corporate identity is at its most recognizable with the architecture,

signage, uniforms, and food at *McDonald's providing a potent contemporary example of the ways in which both the positive and negative aspects of identity can be read. Other notable examples of effective corporate identity include office equipment manufacturers *Olivetti and *IBM, and furniture manufacturers *Knoll.

Council for Art and Industry (CAI, 1934 to early 1940s) Announced in the House of Commons in late 1933, the Council for Art and Industry (CAI) was established in response to the 1932 Gorell Committee's findings about the economic implications of the lack of a British governmental policy on design. Commencing work in January 1934 under the chairmanship of Frank Pick and financed by the Board of Trade, the CAI had a membership of 27, representing the business, manufacturing, retailing, and design communities. The organization, like many other design reform agencies at home and abroad, sought to improve the public's understanding of the social, cultural, and aesthetic benefits of design, to enhance standards of design education, and to influence manufacturers as to the economic advantages that would accrue from investment in design. Its major legacy lay in a series of reports that were published from 1935 onwards, commencing with *Education for the Consumer* in 1935, followed by *Design and the Designer in Industry* (1937) and *The Working Class Home* (1937). The former revealed the generally low standing, poor pay, and often inappropriate training of designers in manufacturing industry, whilst the latter—despite its original intentions to the contrary—revealed how difficult it was for families with average incomes to equip their homes with well-designed goods at prices they could afford. The Council came in for criticism from many quarters, not least in relation to the display of British goods at the *Paris Exposition des Arts et Techniques dans la Vie Moderne of 1937. For the first time British manufacturers were unable to buy space and the selection was entirely down to the CAI, thus making it vulnerable to criticism on a number of fronts, not least because the general thrust of the displays appeared to be centred on sport, leisure, and cultural heritage rather than the Exposition's main theme. Manufacturing industry was generally resistant to the organization's design promotional agenda as it viewed the CAI as an elitist metropolitan body that had little real knowledge of the difficult working realities of manufacturing in the provinces.

Council of Industrial Design *See* DESIGN COUNCIL.

Cox & Co. (established 1927) A pioneer of tubular steel furniture in Britain, Cox & Co.'s origins lay in the manufacture of automobile components but soon moved into tubular steel car seats and folding garden furniture. However, after exposure to examples of *Thonet tubular steel furniture in 1930, the company manufactured a range of modern designs. In the following year the company won orders for 5,000 chairs from Bobby's department store in Bournemouth and 2,500 tables for Dreamland in Margate, and also produced designs by C. A. Richter for Bath Cabinet Makers. This was followed by a series of orders for furniture designed by Raymond McGrath and Serge *Chermayeff for the BBC's Broadcasting House in London (1931–2), by Oliver *Bernard for Lyon's Corner Houses (1933), and tip-up seating for the Royal Institute of British Architects (RIBA) in 1935. The company moved into government contracts during the Second World War, returning to the production of furniture and other products in the post-1945 era.

Cracow Workshops (established 1913) The Cracow Workshops (Warsztaty Krakówskie), a cooperative of artists and craftsmen, were an important part of concerted efforts to establish a national Polish style through *Arts and Crafts, drawing on the vernacular forms of indigenous folk art as major sources of inspiration. Many Polish designers, architects, artists, and intellectuals believed that their national cultural and political identity had been continually eroded by imperial powers, a conviction that had gathered pace in the late 19th and early 20th centuries.

Particularly significant in this quest for a national style were the activities of the Polish Applied Art Society (Towarszytwo Polska Sztuka Stosowana) established in 1901, which collected folk art as sources of inspiration for the applied arts and published its own journal (*Materialy Polskiej Sztuki Stosowanej*) from 1902. The outlook of the Cracow Workshops was influenced by the British Arts and Crafts movement and was also paralleled in some ways by other European groups such as the Gödöllő Workshops in Hungary and the artistic colony at Abramtsevo in Russia. The Cracow Workshops produced folk art-inspired metalwork, tapestries and textiles, ceramics, furniture, and bookbindings. After the end of the First World War the work of the 'Cracow School' (as many designers loosely aligned with the quest for a Polish national style deriving from vernacular traditions became known collectively) was widely recognized. This was particularly so in the Polish Pavilion at the *Paris Exposition des Arts Décoratifs et Industriels of 1925, designed by Jósef Czajkowski (a member of the Polish Applied Art Society and the Cracow Workshops). The Polish displays in the Pavilion, the Galerie des Invalides, and the Grand Palais reflected the endeavours of the Cracow Workshops and the Polish Applied Art Society in an extensive display of applied arts which included everyday objects, furniture, metalwork, ceramics, stained glass windows, batiks, 'kilim' rugs, and bookbindings.

Cranbrook Academy of Art (established 1925) The Cranbrook Academy of Art has been highly influential in the evolution of modern American design in the 20th century with a list of celebrated graduates including Charles and Ray *Eames, Harry *Bertoia, Florence *Knoll, and Jack Lenor *Larsen. The Academy was founded near Detroit as a utopian, arts and crafts-oriented institution and was the brainchild of George Booth, a wealthy newspaper proprietor. He had been inspired by the idea of artistic communities such as that at Darmstadt and sought to promote an equivalent in the United States. Booth brought his ideas to fruition with the help of the Finnish architect-designer Eliel *Saarinen, who had emigrated to the United States in 1923. Saarinen was very much the inspirational force behind the first 25 years of the Academy, becoming its first president in 1932, a post he held until 1946. As well as the fine arts, the departments included textiles (run by Loja Saarinen), ceramics, metalwork, architecture, and design. Saarinen introduced a number of the Academy's more gifted alumni onto the staff, including Charles Eames and Harry Bertoia, as well as his son Eero, and continued to play an academic role in architectural and design pedagogy in the institution until 1950. It was not until the 1970s that radical curriculum initiatives in design were embarked upon, when the design department came under the aegis of Michael and Katherine McCoy from 1971 to 1995. Information design, electronic design, and product design were taught alongside the theoretical

underpinnings of *Postmodernism. Rejecting the tenets of *Modernism, design studies reflected an increased interest in product semantics and post-structuralist theory and in the mid-1980s again brought Cranbrook into the vanguard of North American design academies.

Crane, Walter (1845–1915) A leading British designer, illustrator, and painter, Crane was a prominent figure in the *Arts and Crafts Movement and influenced by the Pre-Raphaelite painters. He travelled and exhibited widely in Europe and the United States of America and was also a significant and influential writer and lecturer on design matters, a socialist thinker and propogandist, as well as an important force in progressive design education, having been appointed as principal of the *Royal College of Art, London, in 1898. After an early apprenticeship in wood engraving Crane steadily built up a reputation as an illustrator in the 1860s. By the early 1870s his work showed the influence of Japanese woodblock prints alongside an increasing mastery of colour, particularly in a number of successful children's books. During these years he also worked on decorative ceramic designs for *Josiah Wedgwood (1867–71), on tiles for Maws (1874), and, later, on various ceramic commissions for Pilkington's Tile and Pottery Company (from 1901). Furthermore, Crane was a prolific wallpaper designer, producing more than 50 designs for Jeffrey & Co. from 1874 onwards, and also worked in the field of printed and woven textiles from the late 1880s. Other fields in which Crane made contributions included stained glass and mosaic design, furniture, metalwork, carpet design, and embroidery. In 1884 he became a founder member of the *Art Workers' Guild, going on to become the first president of the *Arts and Crafts Exhibition Society in 1888 when a number of members of the Guild seceded in order to set up a new organization more committed to the public promotion and exhibition of their creative work. Crane played an important role in British design education, becoming head of design at Manchester School of Art in 1893, working briefly at the University of Reading in 1897 before being appointed as principal of the Royal College of Art in 1898, a post he held for a year. Crane's international reputation gathered pace during the 1890s: he visited the United States in 1890–1; a retrospective exhibition of his work was held at the Fine Art Society, London, in 1891 before touring the United States and Europe; and his work was also shown at Samuel *Bing's celebrated Galerie l'Art Nouveau which opened in Paris in 1895. There was also increasing and favourable coverage of Crane's work in reviews in leading magazines. A number of his lectures were published, including his Cantor Lectures on *The Decorative Illustration of Books* (1896), *The Bases of Design* (1898), and *Line and Form* (1900). His books included *The Claims of Decorative Art* (1892), *Ideals in Art* (1905), *An Artist's Reminiscences* (1907), and *William Morris to Whistler* (1911).

Cute A powerful Japanese cultural phenomenon, Cute (or 'Kawaii', meaning childlike) first emerged in the 1970s and was characterized by a playful aesthetic, often in shades of cherry-blossom pink, that was marketed by many manufacturers across a wide range of goods and services. One of the best-known exponents of Cute was the Sanrio company's *Hello Kitty, a cartoon-like cat whose branded image was applied to all kinds of consumer products, from children's toys to credit cards and mobile phones. After a rather romantic 'look' in the 1980s 'Cute' took on a more humorous edge in the 1990s. After a slight ebbing of its popularity, it then took on a strong *Retro

CZECH CUBISM

(1910–25) Influenced by the forms of contemporary Cubist painting seen in Prague galleries and salons in the early 20th century, Czech Cubism embraced architecture, design, and the decorative arts and flourished most prolifically in the years immediately preceding, and following, the outbreak of the First World War. Highly visible in the urban environment in the design of theatres, cafés, tenement blocks, houses, villas, and factories, this visually distinctive and dynamic style was characterized by multifaceted surfaces, strong diagonals, and fragmented forms. It was, in many ways, a three-dimensional counterpart to the 'simultaneous' forms seen in French Cubist painting. It also made a break with the functionalist tendencies in contemporary architectural training and the *Arts and Crafts ethos that infused design education. Leading designers in Czech Cubism included Pavel Janák, Josef Gocar, Vlastislav Hofman, and Otakar Novotny. An early landmark in the style was Josef Gocár's *House at the Black Madonna* of 1912 in Prague with its Cubist entrance, balcony railings, and capitals. Similar Cubist forms were evident in the built-in furniture, fittings, and interior of the café on the first floor. Another notable early Czech Cubist commission was the 1912–14 interior of the cinema in the Koruna Palace in central Prague, designed by Ladislav Machon, with wallpapers designed by František Kysela of the Prague School of Applied Arts. The style was also evident in street furniture, as in the Brancusi-like columnar and sculptural forms of a 1912 lighting standard in the New Town in Prague, now attributed to Emil Králícek. Of considerable importance in the proliferation of this Czech Cubist style were the Prague Art Workshops (Prazske Umemecke Dilny, PUD), which, like their Prague counterpart the *Artel Cooperative, were based on precedents such as the *Wiener Werkstätte in Austria. PUD was established in May 1912 by a group of architects who had been associated with the Prague Group of Fine Artists (Skupina Vytvvarych Umelcu, founded 1911). One of the group's main aims was to focus on furnishings for the home with a stated principle that furniture should be 'not only as economical as possible but always strictly artistic'. The Prague Art Workshops published their first pattern book in 1913 in which it was stated that the architect members were being joined by František Kysela and other painters who were involved in the design of wallpapers, textiles, and carpets, thus providing a full portfolio of skills for domestic design. This ability to design all aspects of the domestic living environment was reflected in the display of the work of PUD designers at the seminal 1914 *Deutscher Werkbund exhibition at Cologne. In marked contrast to the more functional aesthetic that marked many of the more progressive displays at Cologne, Pavel Janák showed Czech Cubist furniture, a table lamp, and a chandelier, with wall decorations by Kysela. A striking sofa designed by Josef Gocár, with its back composed of triangular elements, was also shown at Cologne. Czech Cubist products were often sold through the Artel Cooperative shop, which moved several times in the life of the organization, and Artel's magazine *Drobné Uméni* (Minor Arts). After the First World War and the establishment of an independent Czechoslovakian state, the abstract surfaces of Cubist design were blended with indigenous folk art motifs and the characteristic

traits and colouring of *Art Deco. Such late tendencies often embraced more rounded forms and were known as Rondocubism, seen, for example, in decorative semi-circular motifs on the exterior of Josef Gocár's 1922 Mánes Hall in the New Town, Prague.

C

or Super-Cute ('Chou-Kawaii') dimension, perhaps on account of Cute's first generation of consumers becoming teenagers and young adults seeking to harness earlier memories to their young adult lives, albeit with a sense of irony or an appreciation of *kitsch. Although voraciously consumed by South East Asian teenagers it also exerted a considerable impact on Western youth culture. The Cute cult was widely covered in style magazines such as the *Face* or experienced more directly through the Japanese rock band Shonen Knife, a support act for Nirvana. Shonen Knife projected a little girl image sustained by lyrics about jellybeans and *Barbie dolls. Blended with the potent 1990s Japanese High-School Girl ('joshi kosai') brand, such an aesthetic influenced the 'baby doll' dress and Doc Martens boots look known as the 'Riot Grrls'.

Cyrén, Gunnar (1931–) Swedish silver, glass, and industrial designer. After completing an apprenticeship in silversmithing and a period of study at the Konstfackskolan in Stockholm Cyrén worked as a silversmith in Uppsala. In 1959 he was appointed to the *Orrefors glassworks, where he mastered the new medium. He soon attracted critical attention through work exhibited at Svensk Form in Stockholm in 1961 and 1963. Working closely with the factory's glassblowers his work became widely known for its use of bright colours that were vividly seen in his *Pop* glasses of 1966. He was awarded the prestigious *Lunning Prize in the same year. Following a period as artistic director at the company he returned to his home town of Gävle in 1970 and began designing for *Dansk International, a firm with a high reputation for Scandinavian tableware. In 1973 he once more took up silversmithing, establishing a studio and shop and from 1976 worked for Orrefors on a freelance basis.

Czech Cubism *See* box on pp. 102–103.

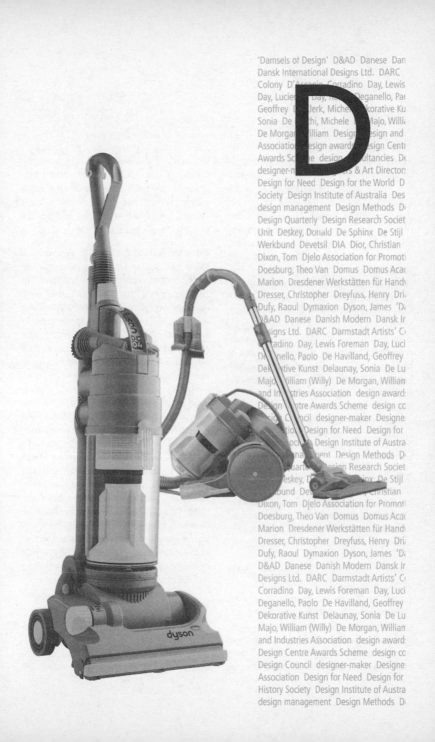

'Damsels of Design' D&AD Danese Dan
Dansk International Designs Ltd. DARC
Colony D'Ascanio Corradino Day, Lewis
Day, Lucien Day, Re Deganello, Pac
Geoffrey Delerk, Miche korative Ku
Sonia De chi, Michele Majo, Willi
De Morgan illiam Design esign and
Association esign award esign Centr
Awards Sc e design ltancies D
designer-m s & Art Directors
Design for Need Design for the World D
Society Design Institute of Australia Des
design management Design Methods D
Design Quarterly Design Research Societ
Unit Deskey, Donald De Sphinx De Stijl
Werkbund Devetsil DIA Dior, Christian
Dixon, Tom Djelo Association for Promoti
Doesburg, Theo Van Domus Domus Acac
Marion Dresdener Werkstätten für Handv
Dresser, Christopher Dreyfuss, Henry Dri
Dufy, Raoul Dymaxion Dyson, James 'Di
D&AD Danese Danish Modern Dansk Ir
signs Ltd. DARC Darmstadt Artists' C
adino Day, Lewis Foreman Day, Luci
De nello, Paolo De Havilland, Geoffrey
Dek ative Kunst Delaunay, Sonia De Lu
Majo illiam (Willy) De Morgan, Willian
and In stries Association design award
Desi tre Awards Scheme design cc
si C ncil designer-maker Designe
tio Design for Need Design for
oci Design Institute of Austra
na ment Design Methods D
uarte arign Research Societ
eskey, D ox De Stijl
bund De hristian
Dixon, Tom Djelo Association for Promoti
Doesburg, Theo Van Domus Domus Acac
Marion Dresdener Werkstätten für Handv
Dresser, Christopher Dreyfuss, Henry Dri
Dufy, Raoul Dymaxion Dyson, James 'Di
D&AD Danese Danish Modern Dansk Ir
Designs Ltd. DARC Darmstadt Artists' C
Corradino Day, Lewis Foreman Day, Luci
Deganello, Paolo De Havilland, Geoffrey
Dekorative Kunst Delaunay, Sonia De Lu
Majo, William (Willy) De Morgan, Willian
and Industries Association design award
Design Centre Awards Scheme design cc
Design Council designer-maker Designe
Association Design for Need Design for
History Society Design Institute of Austra
design management Design Methods D

'Damsels of Design' (current in the 1950s) This celebrated group of women designers were recruited by leading automobile stylist Harley *Earl for work in the Styling Section at *General Motors. Dubbed the 'Damsels of Design' by the press they received significant publicity and included amongst their number Dagmar Arnold, Jane Van Alstyne, and Gere Kavanaugh. Fully trained in industrial design they played an important role in establishing the credibility of women designers in a mainstream industrial context. In addition to their styling of GM car interiors and controls together with choice of textiles and colour combinations, they also worked on the styling and detailing of domestic appliances and details for the Frigidaire Production Studio. They were involved in the 'Kitchens of the Future' shows of the 1950s, a domestic showcase parallel to the razzmatazz of General Motors' *Motoramas. Earl valued the GM 'Damsels' highly, both in terms of their insights into the needs and desires of women drivers and the considerable design expertise that they brought to the Styling Section. However, after Earl's retirement they lost their standing in an industry still heavily dominated by males and traditional power structures.

D&AD (Designers & Art Directors Association, established 1962) Established in London with the aim of improving levels of creativity in British advertising and graphic design, the Association's membership is drawn from those who have been selected for awards at D&AD exhibitions and is, in turn, well represented in the jury membership. It publishes its *Annual*, a selection of the best examples from the shows. It also runs an education programme, staffed by leading designers, for young professionals at the outset of their careers. It has been criticized at times for being self-replicating.

Danese (established 1957) Founded in Milan by Bruno Danese and Jacqueline Vodoz, the company specialized in *editing, designing, and marketing well-designed everyday products with a modern aesthetic. There were three major areas of focus: domestic and office products, artistic editions, and children's games and stimuli for creative play. The company employed many well-known avant-garde designers, including Enzo Mari and Bruno *Munari (who were responsible for much of the company's output), Achille *Castiglione, and Angelo Mangiarotti. Amongst the most celebrated Danese products were Munari's melamine *Cube Ashtray* (1957) and Mari's aluminium and PVC *Formosa* desk calendar (1963). The history of the company was celebrated in a 1988–9 travelling exhibition entitled *Objects Danesi: profil d'une collection*. Danese was sold to the French company Strafor/Facom in 1992, was acquired by Carlotta de Bevilacqua in 1999 and is now part of the *Artemide group which caters for a sophisticated metropolitan clientele.

Danish Modern *See* box on p. 107.

Dansk International Designs Ltd. (established 1954) Founded by American entrepreneur Ted Nierenberg in 1954 Dansk soon established a reputation for

DANISH MODERN

This term, like its counterparts Scandinavian Modern and *Swedish Modern, was widely used from the 1950s onwards to describe those qualities of Danish design that acknowledged some of the characteristics of *Modernism but was characterized by the use of more traditional materials, natural finishes, organic shapes, sculptural form, and a respect for craftsmanship. Such ideas perhaps originated in the design and teachings of Kaare *Klint before the Second World War, but were more closely identified with the work of leading furniture designers such as Finn *Juhl, Hans *Wegner, and Arne *Jacobsen.

well-designed tableware embodying the elegant post-war Scandinavian aesthetic which married craft traditions to industrial production. The Dansk range encompassed products in glass, ceramics, wood, plastics, and stainless steel. Although the company mainly employed Scandinavian designers such as Jens *Quistgard, its principal designer for many decades since its inception, it also utilized other well-known figures such as the American Jack Lenor *Larsen. Although Dansk's head offices are in New York the firm has more than a hundred factories across the world, together with many retail outlets.

DARC *See* DOMUS ACADEMY.

Darmstadt Artists' Colony (1899–1914) In 1899 the Grand Duke Ernst Ludwig of Hesse established one of the leading centres of *Jugendstil architectural, design, and decorative arts practice in Darmstadt in 1899. The Artists' Colony brought together leading artists and craftsmen as a means of improving German public taste and endowing the contemporary applied and decorative arts with a sense of German identity. This conjunction of national identity, design reform, and economic success was in tune with contemporary progressive design thinking. There had been a background of involvement with the *Arts and Crafts Movement in Britain with the Grand Duke Ernst Ludwig commissioning Hugh *Baillie

Scott in 1897 to design the dining and drawing rooms of his Neue Palais in Darmstadt. However, one of the main thrusts of the Darmstadt Artists' Colony initiative was to move away from a dependency on foreign influences and reinvigorate quality standards in German design and decorative arts. An important figure in the establishment of the Colony and the promotion of the applied arts in Germany was Darmstadt-based Alexander Koch, who had published and edited the journal *Innendekoration* (1891–1939) and *Deutsche Kunst und Dekoration* (1897–1933). The latter, in particular, argued that leading German artists should become involved in the applied arts as a means of raising standards. The applied and decorative arts were felt to have suffered from a lack of high-calibre artistic intervention. The creative personalities initially involved in the Artists' Colony at Darmstadt were the fine artist and designer Hans Christiansen—invited by the Grand Duke to found the Colony—interior designer Patriz Huber, and weaver and embroiderer Paul Bürck. They were soon joined by the Austrian Joseph Maria *Olbrich and German Peter *Behrens. An important part of the project was the building of a number of public buildings and artists' houses, many of them designed by Olbrich. The designers sought support from the Grand Duke for an exhibition in Darmstadt in 1901. Organized by Olbrich and

displayed in a number of temporary exhibition buildings as well as the artists' houses, the exhibition made a financial loss and drew some negative criticism, not least due to the fact that the Colony was the subject of royal patronage. The exhibits were seen as exemplars of the 'total work of art'—coordinated architecture, interiors, furnishings, and applied arts: Darmstadt was represented at the 1900 *Paris Exposition Universelle, where the Darmstadt Room designed by Olbrich won a Gold Medal, at the Turin Exposizione Internazionale d'Arte Decorativa Moderna of 1902, and the St Louis Exhibition of 1904. A ceramics factory was established in 1906, followed by a glass factory in 1908. However, the First World War brought the Darmstadt venture to an end.

D'Ascanio, Corradino (1891–1981) A leading Italian aeronautical designer and engineer, D'Ascanio is perhaps most widely recognized for his design of the *Vespa motor scooter (1946) for the *Piaggio company. He graduated in mechanical industrial engineering at Turin Polytechnic in 1914, joining the Technical Office of the Società d'Aviazione Pomilio in 1916. In 1925, with Peter Trojani, he founded his own company with the specific aim of designing helicopters. After some early setbacks the Italian Air Ministry commissioned a third prototype, which established new helicopter flight records for height, distance, and duration. In 1932 D'Ascanio joined Piaggio, a leading Italian manufacturing company involved in aeronautics, shipping, and railway engineering, where he was involved in aeronautical design. However, after the Second World War he was commissioned by Enrico Piaggio (1905–65) to design the *Vespa*, which became a phenomenal success in Italy and overseas. He also designed the highly versatile and successful *Ape* three-wheeled scooter-truck of 1948 and the less successful small two- or four-seater *Vespa 400* of 1957. He continued to design helicopters, including the *PD 3* and *PD 4* helicopters (1949–52).

Day, Lewis Foreman (1845–1910) An important figure in the *Arts and Crafts Movement in Britain, Day's early design work was in glass painting and design. Having built up experience working for three different companies from 1865 to 1870 he established his own stained glass business in London. Within a short time he developed a reputation for surface pattern in a range of media including wallpapers for W. B. Simpson & Co., textiles for Turnbull & Stockdale, and tile designs for both Maws and Pilkingtons. He was an active member of the *Art Workers' Guild and a founder member of the *Arts and Crafts Exhibition Society, as well as a stalwart member of the Council of the Royal Society of Arts (RSA) for much of the period between 1877 and his death in 1910. His 1886 series of Cantor Lectures on 'Ornamental Design' for the RSA sparked off a number of influential publications, including the Anatomy of Pattern (1887), The Planning of Ornament (1887), Pattern Design (1903), Ornament and its Application (1904), and Nature and Ornament (1908–9). Day also played a significant role in the education sector, serving as an examiner for the Department of Science and Art and later the Board of Education as well as lecturing at the *Royal College of Art. He was a prolific writer for a wide range of journals, including the Magazine of Art, the Art Journal, and the Journal of Decorative Art. In addition to other more substantial publications such as Windows (1897) and Stained Glass (1903), he also wrote on Alphabets Old and New (1898) and Lettering in Ornament (1902). His influence was also felt in the arrangement of the collection of the

*Victoria and Albert Museum when it was established in the new building in 1909, having served on the consultative committee.

Day, Lucienne (1917–) Lucienne Day emerged as one of the most significant British textile designers in the post-Second World War period, attracting attention with her 1950 *Calyx* design for *Heal Fabrics Ltd., which attracted attention at the 1951 *Festival of Britain. Although she was internationally recognized at the 1951 and 1954 *Milan Triennali where, respectively, she was awarded a Gold Medal and the Gran Premio, she won awards in other fields, including carpet design. She also designed tableware for *Rosenthal between 1957 and 1969, including the *Four Seasons* service of 1958, and collaborated with her husband Robin *Day on aircraft interiors for the British Overseas Airways Corporation (BOAC) between 1963 and 1967. She was elected as a *Royal Designer for Industry in 1962 and served as a Council Member of the *Royal College of Art from 1963 to 1968.

Day, Robin (1915–) Robin Day was recognized as a leading British furniture designer from the 1940s onwards, especially for his design work for the manufacturing company *Hille. His training took place between 1931 and 1933 at the art school in High Wycombe, an important centre for furniture manufacture, followed by a period working for a local firm. With his wife Lucienne *Day, he opened his own design office in London in 1948 coming to critical attention when, with Clive Latimer, he won first prize for storage furniture at the New York *Museum of Modern Art's Low Cost Furniture Competition in 1948. This was followed by a commission from Hille Ltd. to design a contemporary dining room for the 1949 British Industries Fair, a large-scale annual showcase for British manufacturing industry that was dominated by designs which generally looked either to the past or a highly improbable version of the future. His relationship with Hille flourished thereafter, resulting in commercially successful designs including the plywood *Hillestack* chair (1950–1), the *Q-Stack* chair (1953), and *Form* unit seating (1957). He was also quick to respond to the possibilities afforded by advances in plastics technology with his *Polypropylene *Mark 1* (1962) and *Mark 2* (1963) chairs, the latter selling millions and becoming a design icon. Other furniture successes included the *Disque* knockdown table for cafeterias (1967) and seating for the Barbican Centre, London. Day was also one of a generation of British designers who came to prominence at the *Festival of Britain of 1951, designing signposts, litter bins, and seating for the Festival Hall on the South Bank, London. In addition to his work for Hille, Day also designed a range of products for the British audio-visual manufacturing company Pye, including radios and television sets, perhaps the most noted of which was his 1957 television with metal legs. He also played a significant role in design education in the later stages of his career, in charge of the London College of Furniture from 1974 to 1978. In 1981 his significance as a designer was recognized by the mounting of a major exhibition of his work at the *Victoria and Albert Museum. In 2001 another major show of both his and his wife's designs was mounted at the Barbican Centre, London.

Deganello, Paolo (1940–) Italian architect, designer, and writer Deganello graduated from the School of Architecture in Florence in 1966, becoming a co-founder of the radical design group *Archizoom. He has been involved in a number of architectural projects, including an urban

development plan for Prato-Calenzano (1963–72) and, in 1975, was a co-founder of the Colletivo Technici Progettisti, participating in many architectural competitions and publications. He is also an articulate writer, contributing to many leading periodicals in the field including *Domus and *Casabella. After moving to Milan in 1972 he designed the *AEO* sofa for *Cassina (1973). Other Deganello designs for Cassina included the *Torso* armchair (1982) and the *Artifici* tables (1985). Other companies for whom he has worked include *Driade, *Vitra, and *Zanotta.

De Havilland, Geoffrey (1882–1965) The pioneering British aircraft designer and manufacturer De Havilland studied mechanical engineering at Crystal Palace Engineering School between 1900 and 1903. Following an apprenticeship in Rugby and a period as a draughtsman at the Wolsey Tool and Motor Car Co. he then worked in the sign office of the Vanguard Omnibus Co. During this time he designed the innovative *Blackburn* motorcycle and, in 1909, an aeroplane and engine, one of the first British aircraft. In the following year he was employed by the government to develop his ideas. In 1914 the Aircraft Manufacturing Company employed him to lead a design team, which resulted in a number of aeroplanes being put into large-scale production in the First World War. He founded the De Havilland Aircraft Manufacturing Company in 1920, designing and supplying airliners as well as the *Tiger Moth* light aircraft in 1925; 2,500 of the latter were produced over the next twelve years and, in 1931, the *Tiger Moth* trainer that was later used by the RAF in the Second World War was launched. The company developed its own aero-engines from 1927 and produced the *Dragon, Express*, and *Dragon Rapide* airliners

in the following decade. In the Second World War De Havilland produced the *Mosquito*, an extremely important contribution to the battle for air supremacy. In the post-war years De Havilland developed a number of jet fighters which were taken up by the navy and air force. The company also pioneered the jet age of civil aviation with the *Comet* airliner that took to the air in 1949 and inaugurated the age of jet passenger transatlantic travel. The *Trident* jetliner first flew in 1962, 117 being built. De Havilland retired in 1955, although he remained as company president until the De Havilland companies were taken over by Hawker Siddely Aviation Ltd. in 1959. Geoffrey De Havilland was knighted in 1944 and received a wide range of national and international honours.

De Klerk, Michel (1884–1923) *See* AMSTERDAM SCHOOL.

Dekorative Kunst (1897–1929) Edited by H. Bruckman and J. Meier-Graefe, this magazine gave considerable coverage to the work of leading European designers, including *Ashbee, *Benson, *Endell, *Morris, and van de *Velde. Although he mixed in artistic circles in Berlin, Meier-Graefe was also well acquainted with many designers including Morris and Aubrey *Beardsley, whom he met on a visit to England in 1893, Samuel *Bing, and van de Velde, whom he met on visits to Paris and Brussels in 1895. In its early years Meier-Graefe (under a pseudonym) wrote a high proportion of the articles in *Dekorative Kunst*, although from around 1905 he began to distance himself from such practices.

Delaunay, Sonia (1885–1979) A leading 20th-century painter, printmaker, designer, and businesswoman, Sonia Delaunay's colourful designs exerted a considerable impact over several decades. Born (née

Stern) in St Petersburg she went on to study at the Karlsruhe Academy of Fine Art (1903–5) in Germany before moving to Paris in 1905 to further her artistic career at the Académie de la Palette. She experienced at first hand the colourful works of the Post-Impressionists and the Fauves and married an influential dealer and collector, William Uhde. She met a leading avant-garde French painter, Robert Delaunay, in 1909 and, following divorce from Uhde, married him in the following year. They were both involved with Orphism and Simultaneity, exploring the possibilities of colour and non-representational abstract forms. This led Sonia to experiment with the creation of colourful objects and fabrics around the family home, including lampshades and curtains, and she produced her first 'Simultaneous' dresses in 1912. After a period in Spain (where she opened her shop *Casa Sonia* in Madrid in 1918) and Portugal during the First World War, the Delaunays returned to Paris in 1921. Sonia began working with the Dadaist Tristan Tzara on 'poem dresses' and costume designs for his play *Couer à Gaz*. Her vivid, geometrically based textile designs were also becoming widely known, leading her to put her artistic activities on a more secure business footing. In 1925 she showed her fashion, fabric, and furniture designs at her Boutique Simultanée on the Pont Alexandre III at the *Paris Exposition des Arts Décoratifs et Industriels. Well-known photographs from the same year show models wearing her clothing designs set against a *Citroën *B12* decorated with her Simultaneous designs. Her clients included a number of celebrities and film stars such as Nancy Cunard and Gloria Swanson. Sonia's work also featured at the 1937 *Paris Exposition des Arts et Techniques dans la Vie Moderne, undergoing a strong revival of interest in the 1960s and 1970s.

De Lucchi, Michele (1951–) One of the leading figures of Italian avant-garde design of the 1970s and 1980s associated with the *Anti-Design movement, *Radical Design, and the experimental ideas of *Studio Alchimia and *Memphis, De Lucchi has designed furniture, domestic appliances, interiors, lighting, and office equipment for a variety of companies around the world. His clients have included corporations such as *Olivetti and the Deutsche Bank, as well as flagship design manufacturers *Kartell and *Artemide. After studying architecture at the University of Florence (1969–75) De Lucchi continued at his alma mater as a teaching assistant before moving to Milan in 1978. In 1973 he had also founded an experimental architectural group, Cavart, that lasted for three years and in 1977 had worked with Centrokappa (*see* KARTELL) on the organization of the exhibition *Il design italiano negli anni cinquanta* (*Italian Design in the 1950s*). In Milan he joined Studio Alchimia in 1978, becoming a founder member of Memphis in 1981. After *Sottsass had disbanded the latter in 1988, De Lucchi established his own design studio with Angelo Micheli. The practice became highly successful, building up a client list that has included Arflex, Cleto Munari, Pelikan, *Rosenthal, and *Vitra. He also carried out store design for Mandarin Duck and *Fiorucci. In 1998, also in collaboration with Angelo Micheli, he founded the Studio aDML. He has won a number of design awards including a *Compasso d'Oro in 1989 for his *Tolomeo* office lamp (1986) for Artemide and has taught industrial design at the University of Florence.

De Majo, William (Willy) (1917–93) Born in Vienna De Majo studied at the Vienna Commercial Academy in preparation for a career in the family textile business. However, he opted for a freelance

career in graphic design, establishing a studio in Belgrade in 1936. In 1939 he emigrated to Britain, where he worked as a broadcaster with the BBC Overseas Service before serving as a pilot with the Royal Yugoslav Air Force during the Second World War. In 1946 he established W. M. de Mayo and Associates, specializing in graphic design and exhibition work, gaining a wide range of commissions that ranged from the highly detailed series of Letts diaries to the large-scale Farm and Factory Exhibit, Ulster, for the 1951 *Festival of Britain. In 1963 he became the founder president of the *International Council of Graphic Design Associations (ICOGRADA) which has represented since then the interests of the graphic design profession in over 60 countries. His role as a speaker at many international design conferences and as chair of many important design committees established him as an important voice, a position that was recognized by the Society of Industrial Artists and Designers (*see* CHARTERED SOCIETY OF DESIGNERS), which awarded him its Design Medal in 1969.

De Morgan, William (1839–1917) An *Arts and Crafts designer and writer, De Morgan was educated at University College, London, and the Royal Academy Schools. In the early 1860s, after meeting the socialist artist, designer, and writer William *Morris and the artists Edward Burne-Jones and Dante Gabriel Rossetti, he became increasingly interested in stained glass and tile design, commencing production for Morris, Marshall, Faulkner & Co. (*see* MORRIS & CO.) from 1863. He began decorating pottery at the end of the decade and soon had his own flourishing business, setting up a pottery in Chelsea. He became deeply interested in experimenting with different techniques and processes, working on various brightly coloured lustres that were to become the

hallmark of his pottery. A number of De Morgan designs were shown at the Paris International Exposition of 1878 and important commissions included the Arab Hall of the celebrated artist Lord Leighton's house in Holland Park, London (1879). His friendship with Morris, with whom he had been experimenting on mosaic designs, flourished to the extent that in 1882 he expanded his pottery by moving to Merton Abbey, where Morris had begun to print textiles the previous year. De Morgan remained there until 1888 when, due to health problems, he was forced to move to a new factory at Fulham in partnership with the architect Halsey Ralph Ricardo. In the same year he showed at the first exhibition of the *Arts and Crafts Exhibition Society. In the following decade he travelled to Italy and worked on designs inspired by Italian majolica as well as entering into partnership with Frank Iles and Charles and Fred Passenger, an arrangement which lasted until 1905 when he retired. Amongst later commissions were his tile designs produced for six ocean liners of the Peninsular and Oriental (P&O) Company, including the *Arabic*, the *China*, the *Malta*, and the *Persia*. In later years De Morgan became increasingly involved in writing novels, including *Joseph Vance* (1906), *Somehow Good* (1908), and *A Likely Story* (1911).

Design (1949–95) *Design* magazine was launched in 1949 as the official mouthpiece of the Council of Industrial Design (COID, later *Design Council), its first issue carrying an article by COID director Gordon *Russell entitled 'Good Design is not a Luxury'. Well illustrated and informative, editorial policy sought to convince manufacturers and educators of the social and economic benefits of better standards of design and industry. Indirectly it also reflected the more widespread campaigning

in design circles (of, for example, the *Chartered Society of Designers) for greater professional recognition and increased status for the designer in industry and business. By the mid-1950s it also attracted the attention of many overseas organizations committed to the principles of *'Good Design' and was read in almost 60 countries. Set in opposition to the growing tide of American consumer goods, ephemeral styling, and notions of obsolescence that gathered pace as the 1950s unfolded, *Design* adopted an interest in a more scientific approach to design matters. This was evidenced in a series of articles by L. Bruce *Archer, himself influenced by the outlook of the Hochschule für Gestaltung at *Ulm, Germany. From 1956 the magazine also began to publish regular reviews of engineering products. During the 1960s, reflecting a clear shift in outlook of the COID itself, increasing attention was also paid to engineering and capital goods, which culminated in the organization's redesignation as the Design Council in 1972. However, apart from a few feature articles, the magazine still paid comparatively scant attention to more popular ephemeral trends in consumption such as *Pop, adhering instead to an outlook rooted in *Modernism and notions of Good Design. By the 1980s, the increasing proliferation of magazines about 'lifestyle' design and the emergence of more lively and entertaining journals geared to the contemporary needs of the design profession, such as *Blueprint* and *Design Week*, signalled the growing difficulties in the market place for *Design* (paralleling both public and official views about its parent organization, the Design Council). Despite a revamping in terms of content and appearance, the latter by *Pentagram in 1990, the magazine ceased publication in 1994 as the activities of the Design Council itself were severely curtailed by the Conser-

vative government. It reappeared for a while in the following year as a promotional arm of the Design Council rather than a journal competing in the market place but no longer played a genuinely significant role in national or international design debates.

Design and Industries Association (DIA, established 1915) Inspired by the agenda and prolific activities of the *Deutscher Werkbund (DWB), which had been established in Germany in 1907 to improve standards of design in manufacturing industry and everyday life, the DIA was established in London in 1915 with similar aims. The DIA sought to promote better understanding between manufacturers, designers, and retailers and to foster 'a more intelligent understanding amongst the public for what is best and soundest in design'. However, it attracted neither the membership numbers nor the influence of its German counterpart and often oscillated between being an organization unable to free itself from the principles of the *Arts and Crafts Movement and a body committed to the promotion of an emphatically 20th-century industrial aesthetic. The founder members of the DIA included Harold Stabler, Ambrose *Heal, Cecil Brewer, and Harry Peach, all of whom had been impressed by the range of products and buildings on display at the Deutscher Werkbund exhibition in Cologne in 1914. Early DIA exhibitions were devoted to printing, textiles, and household goods and the Association also organized seminars and lectures on design matters. In its early phases it also geared itself to promoting design in everyday life, as in the 1920 exhibition of *Household Things* at the Whitechapel Gallery in London, which comprised eight furnished rooms, and the publication, in the same year, of a report on

the labour-saving home. From 1922 the DIA developed its profile through the publication, an equivalent to the DWB's *Jahrbücher*, with essays and captioned photographs of objects that were seen to embrace ideas of *'Good Design'. The DIA also sought to involve itself with wider issues of town and environmental planning, in line with many of the activities of the Campaign for the Preservation of Rural England (CPRE). This included the publication of a series of *Cautionary Guides* that campaigned against the intrusive nature of badly placed advertising hoardings, petrol stations, and other insensitively designed elements of the urban and rural landscape. The DIA also published a number of journals, although readership was limited and all went through difficult times. *Design in Industry* was launched in 1932, but lasted for only two issues; *Design for To-Day* ran from 1933 to 1935; and *Trends in Everyday Life* lasted for only two issues in 1936. Such a patchy performance ran in tandem with DIA membership, which in 1932 was only 602 and peaked at 865 in 1935. During the Second World War the DIA worked closely with the Army Bureau of Current Affairs, organizing exhibitions that travelled to schools on army buses. From 1942 it also organized a series of *Design Round the Clock* exhibitions, showing photographs of objects that people used throughout the working day, both at home and at work, as well as commuting. All photographs were captioned outlining the aspects of 'Good Design' in the objects portrayed. After the war the impact of the DIA was to some extent compromised by the establishment of the state-funded *Council of Industrial Design in 1944 and its *Design Centre, established in central London in 1956, though both shared a similar outlook epitomized by the DIA's booklet *Enemies of Design* (1946). Nonetheless, it organized a *Register Your Choice* exhibition at Charing Cross Underground Station in 1953 in which two contrasting room settings were displayed, one of modern design, the other displaying popular styles, with both being comparable in cost. The public were asked to register their choice, with 60 per cent preferring the modern setting. As with a number of other bodies in Britain and overseas, the DIA's impact in terms of design reform in industry and the market place became increasingly muted with the emergence of *Postmodernism, *Pop, and *Punk and other alternatives that reflected the increasingly diverse tastes of consumers.

Design Awards *See* AUSTRALIAN DESIGN AWARD; COMPASSO D'ORO; DESIGN CENTRE AWARDS SCHEME; G-MARK; GD; MARK; LUNNING PRIZE; MAINICHI DESIGN PRIZE. *See also* JAPAN DESIGN FOUNDATION; GOOD DESIGN.

Design Centre (1956–94) The Council of Industrial Design's (COID, *see* DESIGN COUNCIL) Design Centre in the Haymarket, London, was established in 1956 and became, over the next four decades, an important and highly visible presence for official design promotion in Britain and influenced the setting up of similar centres in many other countries. Since the 1920s, several British design organizations had campaigned for a permanent metropolitan exhibition venue where manufacturers, retailers, buyers, and consumers could view, and be informed about, the best of British design. The idea had also been considered in a number of official reports such as the Gorell Report of 1932 and the Weir Report of 1943. Government approval for the Centre was given in 1954 and the central London venue opened in 1956 with an estimated 22,500 visitors in the first week who were able to see over 1,000 products drawn from 433 British firms. The Centre even had its own identity symbol designed by Hans

*Schleger (Zéro). Exhibitions were mounted throughout the Centre's life, often attracting large crowds as with the *New Designs for British Railways* exhibition of 1963 that drew almost 30,000 visitors a week. Other exhibitions were able to stimulate important economic debates, as with the *Designed in Britain—Made Abroad* display of 1981, which underlined the fact that many innovative and original British designers were more readily employed by progressive companies overseas than in the generally more conservative environment of British manufacturing industry. The Design Centre also housed the COID's *Design Review*, a photographic and information register of selected products by British designers and manufacturers. Interested parties—retailers, buyers, manufacturers, and others from home and abroad—could consult what were felt to be the best exemplars of British products, design talent, and manufacturing expertise. These were selected by committees involving the COID's director, Council members, and independent consultants and were characterized by the values associated with *'Good Design'. The *Design Centre Awards Scheme was set up in 1957, an annual selection of a small number of well-designed British products. The distinctive black and white triangular Design Centre Label was introduced in 1959, entitling manufacturers whose goods had been displayed in the Centre to attach them to their products for publicity purposes. In the mid-1960s the public display areas were extended to include more exhibition space, together with a souvenir and, later, a bookshop that soon became a leading source for recent publications on design. However, it was some of these developments that were later to give rise to criticisms of the ways in which the Design Centre and Council were viewed. In 1983 a survey of design consultants carried

out for the magazine *Campaign* indicated dissatisfaction with several aspects of the Council's operations, feeling that too much attention was being paid to souvenirs and education. Some members of the Conservative government were also concerned about the Council's involvement with retailing and what might be seen as non-core activities. Despite the establishment of a Young Designers Centre in 1989 and other progressive initiatives, the Design Centre fell prey to the wider economic cuts faced by the Design Council and closed in 1994.

Design Centre Awards Scheme (1957–88) The Council of Industrial Design (*see* DESIGN COUNCIL) launched its annual Design Centre Awards Scheme in 1957, very much in line with general principles of the Italian *Compasso D'Oro awards scheme instituted three years earlier. The first panel of judges included Richard Godden, Dick Russell, Brian *O'Rorke, Milner Gray, and Astrid Sampe and selected twelve exemplars of the best of contemporary British design. The first winners included Robin *Day, for a sofa bed manufactured by *Hille and a television set made by Pye, Lucienne *Day for her Imperial Axminster carpet produced by Tomkinsons, David *Mellor for his *Pride cutlery manufactured by Walker & Hall, and John and Sylvia Read for a lampshade made by Rotaflex. In 1959 the annual Design Centre Awards were augmented by the Duke of Edinburgh's Prize for Elegant Design which, in its first year, was won by C. W. F. Longman for a *Packaway refrigerator made by Prestcold. Its pristine, white form, devoid of pattern or stylistic features exemplified the *'Good Design' aesthetic favoured by many at the COID during these years and was very much opposed to the ephemeral styling features of contemporary American domestic products. Over the years the range

of products included in the Design Centre Awards Scheme was extended in line with the wider outlook of the COID. Such awards included street lighting columns designed by Richard Stevens and P. Rodd (1960), a pay-on-answer telephone box by Douglas *Scott (1962), and hospital wall lights by Roger Brockbank (1965), all reflecting a tendency that led to the establishment of a Capital Goods Section of the Design Awards in 1967. These included a Hy-Mac Excavator designed for Peter Hamilton Equipment (1967), a *Sentinel* diesel shunting locomotive by Rolls-Royce (1968), and the *Boss Mark III* range of fork-lift trucks by Lancer Boss (1970). The Awards Scheme lasted until 1988 when it was felt by many that it had run its course as a model for emulation.

Design Consultancies These emerged as increasingly significant in the 1920s and 1930s when many major manufacturing clients, especially in the United States, sought to make their products more attractive in the increasingly competitive consumer market places of the industrialized world. As many products were increasingly geared to the idea of built-in obsolescence, the need for product differentiation and desirability took on a greater urgency and companies began to seek external advice in shaping their design policies. Pioneering American industrial designers such as Raymond *Loewy, Norman *Bel Geddes, Walter Dorwin *Teague, and Henry *Dreyfuss forged close links with major companies such as *Chrysler, *General Motors, *IBM, Texaco, the Pennsylvania Railroad, and Bell Telephone, organizing their businesses as consultancies with a range of expertise that embraced design, engineering and production, model making, and marketing. Although a number of these early consultancies were quite significant in terms of size (Geddes, for example,

employed about 30 in 1934), and self-promotion, it was not until after the Second World War that design consultancies became significantly widespread in the United States and the rest of the industrialized world, a number becoming almost as multinational and global as many of their more significant clients.

Design Council (established 1944) Originally founded as the Council of Industrial Design (COID) under the British Board of Trade in 1944, this body was perhaps the world's most influential state-funded design promotion organization of the second half of the 20th century. It also influenced the establishment of many similar bodies in Europe, the Far East, and Australia. In its formative years the COID was seen as an important propagandist in Britain's post-Second World War efforts to penetrate overseas markets with well-designed goods. On founding its chief aims were to promote *'Good Design' in British industry and to disseminate design advice and information to manufacturers, government departments, and others. It was also charged with the organization of design exhibitions, advice on design education and training, and the schooling of the public in the social and aesthetic benefits of well-designed goods.

The COID's first major project was the mounting in central London of the 1946 *Britain Can Make It* (*BCMI*) exhibition, designed by James *Gardner and architect Basil Spence. In addition to its propagandist role in relation to manufacturers and consumers *BCMI* was also planned as a shop window for British industrial design in the market places of the world. It was visited by 1,432,369 visitors and sought to educate the public through such displays as Misha *Black's 'What Industrial Design Means' and the holding of a *Design Quiz* which gave visitors the chance to involve themselves

with the precepts of 'Good Design'. There were also all kinds of room settings to interest the public in the possibilities of a well-designed post-war world, an outlook reinforced in succeeding years by the furnishing of show houses around Britain. In the following year the COID mounted an *Enterprise Scotland* exhibition in Edinburgh. Other activities initiated by the COID in the 1940s included a series of 'Design Weeks' around Britain, consisting of exhibitions, lectures, conferences, and discussions and also put together educational packages with wall charts and other visual material for distribution in schools. Training courses were mounted for retailers, buyers, and others involved in the distribution of design and, in 1949, the COID's major propagandist magazine, *Design, was launched. Another major exhibition initiative in which the COID played a chief role was the *Festival of Britain of 1951. Originally conceived as an international exhibition, the Festival was downgraded to a national exhibition with major design displays on the South Bank, London, as well as the Exhibition of Industrial Power in Glasgow and the Ulster Farm and Factory Exhibition in Belfast. A Land Travelling Exhibition, with an emphasis on industrial design and production techniques, toured many major industrial cities whilst a Sea Travelling Exhibition toured ten major British ports. On the South Bank, the COID was responsible for selecting all of the industrially produced goods on site. The public could see many aspects of design relating to the home in the Homes and Gardens Pavilion, where many interior settings were on display. At the Live Architecture exhibition in East London they could also view a show house, a primary school, and shopping centre. For much of the period the Festival Pattern Group was coordinated by the COID's Industrial Officer, Mark Hartland Thomas. It

sought to use crystallographic diagrams as the basis for contemporary surface patterns for a wide range of design media including textiles, ceramics, tableware, glass, paper, and furniture. Twenty-six manufacturers participated in the scheme including *Josiah Wedgwood, Chance Brothers, Goodearl Brothers, Spicers, and Warerite. Central to the COID's strategy of the 1950s was the establishment of the *Design Centre in the Haymarket, London, in 1956. A Scottish Design Centre was set up in the following year.

The Design Centre in London was a permanent venue where manufacturers, retailers, buyers, and consumers could view exhibitions of contemporary design, an aspiration of most British design organizations since the First World War. Also housed in the Design Centre was the COID *Design Review*, where selected British designed goods could be seen in photographic form with details of manufacturers and designers. These designs were generally *Modernist in spirit and diametrically opposed to the heavily styled, ephemeral products often seen in American films and glossy magazines. Such values of the COID were closely associated with the ideas of *'Good Design', an aesthetic outlook also favoured by the *Museum of Modern Art, New York, in its design collecting and exhibiting policy of the period. In 1957 the Design Centre Award Scheme was established: twelve domestic designs were selected as exemplars of Good Design, an idea parallel in many ways to the *Compasso d'Oro scheme initiated by La *Rinascente department store in Italy three years earlier (*see also* DESIGN AWARDS). In fact, in 1959 the COID was itself awarded the Compasso D'Oro's Gran Premio Internationale as 'the oldest and most efficient government organization for the development and popularization of good design'.

During the 1960s the 'Good Design' policies promulgated by the COID came under increasing pressure from growing consumer interest in the ephemeral values of *Pop, a reality acknowledged by the COID's director Paul Reilly in an article in *Design* magazine in 1967 entitled 'The Challenge of Pop'. In the same years the Council broadened its approach to embrace engineering and capital goods within the remit of industrial design. This position was strengthened by the findings of the Fielden Reports on *Engineering Design* (1963) and *Industrial and Engineering Design* (1965) and the Conway Report on *A National Design Council* (1968). Although a head of steam had been gathering for the establishment of a separate Council of Engineering Design it was agreed to establish a new, single Council that wedded the ideology and outlook of the COID with the needs of engineering design. As a consequence, the newly-named Design Council was established in 1972. In the following year, having been purchased by the new Council, *Engineering* magazine was launched under Design Council auspices and a Design Advisory Service established. Furthermore, in the wake of the Design Council's (Moulton) Report on *Engineering Design Education* (1976) engineering design staff were employed to develop design teaching, an activity that had an increasing industrial focus in terms of policy, even if with limited impact. The 1977 Carter Report on *Industrial Design Education in the United Kingdom*, the 1983 Hayes Report on *The Industrial Design Requirements of Industry*, and the 1983 Mellor Report on *Standards of Consumer Goods in Britain* all gave rise to concerns about the direction of the Design Council. It was also accused in a 1983 survey of leading consultants of having become overly concerned with souvenirs and retailing. In the same year a Funded Consultancy Scheme was set up whereby

Design Council representatives offered companies technical and design expertise and slogans such as 'Design for Profit', closely attuned to the thinking of Margaret Thatcher's Conservative government, soon became the order of the day. Current thinking was embraced by the Design Council/ Department of Trade & Industry (DTI) Report on *Policies and Priorities for Design* (1984), the *Design Council Strategy Report* (1988), and the Government White Paper on competitiveness, *Forging Ahead*. However, during the 1980s the Council experienced a series of economic cuts, a position that came to a head in 1994 when a full-scale review of the Council's work entitled *The Future Design Council: A Blueprint for the Council's Future Purpose, Objectives, Structure and Strategy* (the Sorrell Report) was published. After presentation to Ministers at the Department of Trade and Industry it resulted in the closure of the London Design Centre and all of the Council's regional offices and the halting of the publication of *Design* magazine, hand in glove with a large-scale redundancy programme. In 1996 the Design Council worked closely with the British Council and the Royal Society of Arts in a programme entitled Excellence by Design that sought to promote contemporary British culture and industry abroad. A number of other reports with a similar outlook were commissioned and published, including the 1997 Design Council Report on *Britain ™: Renewing our Identity* that argued for the projection of a Britain characterized by inventiveness, creativity, and progressive thinking. This was reinforced by a discussion paper entitled *New Brand for New Britain: The Countdown to the Millennium* (1997) and ideas pursued in the launch of a scheme for the promotion of Millennium Products, selected for their sense of imagination, inventiveness, and fresh thinking. Selected by representative

DESIGN FOR NEED

With ever-increasing levels of consumption and disposable income in the decades following the end of the Second World War, there were a growing number of critical voices including Vance *Packard, Victor *Papanek, and Richard Buckminster *Fuller. Such critiques of industrialization and consumption had been long-standing, from Victorian writers such as John *Ruskin in his critique of material over-indulgence, *The Stones of Venice*, continuing through the 20th century to the writings of Naomi *Klein, particularly *No Logo: Taking Aim at the Brand Bullies* (2000). The design profession was understandably slow to respond to many of these concerns, implicated as it was in mediating between producer and consumer. In 1969 ICSID (*International Council of Societies of Industrial Design) held a conference in London entitled 'Design, Society and the Future' at which leading designers reflected upon the social, moral, and economic consequences of their actions. The oil crisis of 1973 brought about by the Middle Eastern War, coupled with the inability of American technological superiority to bring the Vietnam War to a speedy resolution, raised a number of fundamental questions about the nature of progress. Once again the design profession sought to address such issues through another ICSID conference. Mounted in London and entitled 'Design for Need', the Third World, alternative technology, and design for disability were among the topics addressed. Design for disability was not widely practised though one major Swedish consultancy, *Ergonomidesign, specialized in many aspects of the field. Two of its leading members, Maria Benktzon and Sven-Eric Juhlin, were pioneers in the field and sought to devise aesthetically pleasing and stylish design solutions for everyday products, so bringing the disabled into the mainstream of consumption. (By 2003 Ergonomidesign employed 27 industrial designers, engineers, and ergonomists.) From the 1970s onwards debates about design for need were increasingly concerned with environmental and ecological questions, stimulated by growing concerns about the finite nature of fossil fuels and the consequences of global warming.

See also ERGONOMICS; GREEN DESIGN.

panels such products were widely promoted, including a display at the Millennium Dome site in London in 2000 and a series of Millennium Products shows touring around the world in the succeeding period.

Design for Need *See* box on this page.

Designer-Maker This term is generally used to describe those who both design and make their own products, including furniture makers, jewellery designers, and others who bring together their creative ideas and making skills in individual production of their designs. Such ideas were widely practised by *Arts and Crafts Movement designers and their followers but also became an important descriptor for many designers seeking alternatives to mass-production orthodoxies in the later 1960s and 1970s. It was also useful for designers involved in the small-scale batch- or serial production of goods who wished to find a term to describe their outlook in a way that distanced them from the 'artiness' of many associated with the crafts.

Designers & Art Directors Association *See* D&AD.

Design for the World (established 1998) Founded by the leading international design organizations—*ICOGRADA (graphic design and visual communication), *ICSID (industrial design), and *IFI (interior architecture)—with the help of the Barcelona Design Centre, this organization seeks to apply design skills and knowledge to those who most need them, such as victims of disaster or problems in the third world. It is in many ways a late 20th-century initiative that seeks to counter the views of the design profession as seen in the critical writings and views of many—from Victor *Papanek to Naomi *Klein—and an attempt to make a more positive intervention in regaining the moral initiative in ways that earlier interventions such as *Design for Need in the 1970s had failed to deliver. Those involved with Design for the World have sought to promote the effectiveness of the design process in improving the objectives of relief and humanitarian organizations and initiatives in relation to disasters, education, disadvantaged people, and development issues. It also seeks to act as a broker between volunteer designers and interested parties. Early projects included involvement in a refugee camp analysis in Tanzania and a social housing project in a problematic area of Barcelona with further stimulus given by the Graphic Design Conference for Social Causes held in Barcelona in 2002. IFI had also initiated a similar, but 'hands on' initiative through its Pro Vitae programme established in 1997.

Design History Society (established 1977) Founded in Britain as a means of bringing together those involved in the emerging academic discipline of design history, an early impetus was provided by the Design History Research Group. Essentially an informal group of lecturers and researchers with an interest in the history of design, it met irregularly often in relation to exhibitions and conferences. Of major significance were three major annual design history conferences launched in 1975, 1976, and 1977 held at Northumbria, Middlesex, and Brighton Polytechnics (all redesignated as universities in 1992). Northumbria Polytechnic and then the Design Council subsequently published the papers of the three conferences, entitled *Design 1900–1960: Studies in Design and Popular Culture* (1975), *Leisure and Design in the Twentieth Century* (1976), and *Design History: Fad or Function?* (1977). It was at the 1977 Brighton Conference that the Design History Society (DHS) was conceived. The DHS issued a regular newsletter and organized an annual conference and other events to give proceedings a firmer basis. It has a wide international membership and the Society's annual conferences have continued to the present day—the 2004 conference was in Belfast. The *Journal of Design History*, published by Oxford University Press, was launched in 1987.

Design Institute of Australia (DIA, established 1983) Formally designated as the Design Institute in 1983 this design promotional organization grew out of the Industrial Design Institute of Australia (IDIA) founded in 1958 by the Society of Designers for Industry (SDI). The latter was the first Australian professional design organization, founded a decade earlier in Melbourne in 1948. Members of the Interior Designers Association of Australia (also established in 1948) also joined the IDIA, followed, in 1965, by members of the Society of Industrial Designers Australia. In 1967 IDIA took on a more international orientation, becoming a member of the *International Council of Societies of Industrial Design

DESIGN METHODS

The Design Methods movement emerged in the 1950s as it was increasingly realized that creative individuals working in isolation were no longer able to solve the bigger and more complex problems facing them in the post-Second World War period. This was reflected in the curricula of progressive institutions such as the Hochschule für Gestaltung at *Ulm, where design was set alongside other disciplines such as anthropology, sociology, behavioural psychology, and recent cultural history and theory. A much more systematic and rational approach to design emerged alongside a greater emphasis on teamwork and the bringing together of experts in different disciplinary fields. The first major conference, *Systematic and Intuitive Methods in Engineering, Industrial Design, Architecture and Communication* was held at Imperial College, London, in 1962, and was followed by a series of conferences and publications on both sides of the Atlantic. Significant amongst the many publications in the field have been L. Bruce *Archer's *Systematic Method for Designers* (1965), J. Christopher Jones's *Design Methods: Seeds of Human Futures* (1970), and Nigel Cross's *Design Methods Manual* (1975).

(ICSID, founded 1963). In the following decade, from 1979 to 1984, the IDIA published *Design in Australia*, edited by Ron Newman. In 1982 the IDIA took another step in terms of international visibility by joining the *International Federation of Interior Designers/Architects (IFI) and, in the following year, was renamed as the Design Institute of Australia (DIA). Increasing its visibility and influence, in 1998 the DIA merged with the Australian Textile Design Association (ATDA) and the Society of Interior Designers of Australia (SIDA). Three years later the DIA awarded the 'Selections' awards for furniture and product design for the *Australian Design Awards.

Design Issues (established 1984) This international journal of design history, criticism, and theory was launched from the School of Art & Design at the University of Illinois at Chicago, its sponsor until 1993. Its editors have reflected the breadth of its ambitions with design historian and critic Victor Margolin, architecture and design historian Dennis Doordan, and design theorist and polemicist Richard Buchanan

providing a positive stimulus to the establishment of the journal as one with a distinctive character amongst the panoply of contemporary publications in the field. In many senses it may be seen as an American counterpart to *Design Studies* with a commitment to embracing design history, theory, and criticism as elements within design studies, an outlook reinforced by a 1993 editorial that signalled the board's ambition to encourage more articles from practising designers. The international coverage embraced by its contributors has been significant and it has also carried a number of landmark and polemical articles about the nature of design historical studies. The success of the journal may be gauged from the fact that it began as a twice-yearly journal but is now published quarterly by the Massachusetts Institute of Technology.

Design management This important area of activity was concerned with the management of the design process within a company or corporate setting and was pioneered by individuals such as Michael Farr of Michael Farr (Design Integration) Ltd. in

Tottenham Court Road, London. He wrote an early book on *Design Management* in 1966, suggesting ways in which design projects should be managed, accompanied by systematic flow charts and diagrams to explain the process. Such an approach was in tune with a growing contemporary interest in *Design Methods from the early 1960s. The London-based Royal Society of Arts also recognized the importance of design methods with the institution of its Presidential Awards for Design Management in 1965. Amongst early companies to receive the awards were *Heal's, *Hille, London Transport, and *Conran. Since that period many larger design consultancies have for some years offered managerial, financial, and business analysis as important dimensions of their professional portfolio. The Society of Industrial Artists and Designers (*see* CHARTERED SOCIETY OF DESIGNERS) established its Design Management Group in 1981, publishing its *Design Management Seminars* two years later. The London Business School, particularly through the initiatives of Peter Gorb, also ran Design Management Seminars in the 1980s. Such ideas were explored elsewhere in the industrialized world with the establishment of International Conferences of Design Management and the publication of associated papers.

Design Methods *See* box on p. 121.

Design Museum (established 1989) The origins of this enterprise lay in the Boilerhouse Project at the *Victoria and Albert Museum, which ran from 1982 to 1987. A showcase for modern design, the Boilerhouse was directed by Stephen Bayley and supported by the Conran Foundation. It mounted a prolific number of exhibitions, addressing such complex issues as 'Taste' and the use of carrier bags as symbols of consumption as well as popular shows on *Memphis furniture, *Sony products, and

youth culture. Attracting 1.5 million visitors the Boilerhouse demonstrated the public interest in the exhibition of consumer products, past, present, and future. From 1989 the Project came to maturity with the move to the Design Museum in Butler's Wharf, London, a 1950s building adapted for use as a gallery of modern design by Conran Roche, architectural planners. The aim was to have a permanent collection and study facilities, complemented by in-house and touring exhibitions. The inaugural show, *Commerce and Culture*, was opened by Prime Minister Margaret Thatcher, a symbolic link with government which was not followed up financially in funding terms until 1999/2000. However, other partnerships with government departments were broached, including a design promotion exhibition organized for the Department of Trade and Industry in Hong Kong (1992), Bahrein (1994), and Korea (1994), and a series of initiatives with the Department of Education and Employment. Soon after its inauguration Bayley left as director and was replaced by Helen Rees, who left in 1992. This was a difficult time for the museum as it was widely criticized for the display and selection of its collection and a period of funding difficulties led to a number of job losses. However, building on links that had been developed with the educational sector, the Dyson Centre for Design Education and Training was opened in 1997 as a means of furthering the educational objectives of the museum. In 1999 James *Dyson succeeded the museum's founder Sir Terence *Conran as chairman and a brighter and more secure future seemed assured. However, despite industrial sponsorship and links with government departments, the Design Museum's location perhaps resulted in its limited success in terms of visitor numbers. Indeed, for the first decade

of its new life as the Design Museum at Butler's Wharf, its total visitor numbers still remained considerably lower than in the four years of its earlier life as the Boilerhouse at the V&A. Plans have been set in place to revitalize and further extend the museum's exhibition space in the early 21st century.

Design Quarterly (established 1946) This American periodical was originally named the *Everyday Design Quarterly: A Guide to Well-Designed Production* to complement the Walker Art Centre's Everyday Art Gallery in Minneapolis, which was envisaged as a 'consumer's art gallery' and a stimulus for 'a better environment for daily living'. The Centre promoted a wide range of modern design including product design, architecture, and transportation. The magazine reflected a similar range of material and propaganda, changing its title to *Design Quarterly* in 1954. The major emphasis was for many years oriented towards American design and, from 1970, it launched the first of a long-standing series of special issues. In the early 1990s it expanded its scope to include many more fields of design including fashion, graphic design, interiors, engineering, and the urban environment. It is now published by the Massachusetts Institute of Technology.

Design Research Society (DRS, established 1967) Growing out of the *Design Methods movement that had been gathering pace in the 1960s, the DRS has an international membership of designers, architects, and academics. Affiliated to the *Chartered Society of Designers since 1989 its mission is to disseminate knowledge of design, design theory, design processes, and design practice. It publishes a quarterly journal, *Design Studies*, a newsletter, *Design Research*, and an online discussion forum.

Design Research Unit (DRU, established 1943) The Design Research Unit (DRU) was one of the first generation of British design consultancies that sought to offer a wide range of specialist services covering the design spectrum. In the wake of discussions with Marcus Bramwell, managing director of Stuart's Advertising Agency, it was established in 1943 by Herbert *Read in offices in Knightsbridge, London. It emerged as an increasingly significant design consultancy in the years following the Second World War, forging links between design and industry and gaining many prestigious commissions for the designers working under its umbrella. Two of the DRU's more important early members were Misha *Black and Milner *Gray, both of whom had been involved with the Industrial Design Partnership of 1935, itself a reformation of an earlier pioneering consultancy, the Bassett-Gray Group of Artists and Writers. Other associates included the designer Norbert Dutton, the architects Frederick Gibberd and Sadie Speight, and the structural engineer Felix Samuely. The DRU made important contributions to the *Britain Can Make It Exhibition (*BCMI*) of 1946 and the *Festival of Britain of 1951 and continued to cater for a wide range of commissions embracing specialisms such as engineering and product design, interior design, and corporate identity. At *BCMI* the DRU designed the Quiz Machines that sought to gauge public taste as well as the highly didactic 'What Industrial Design Means' display (by Black, Bronek Katz, and R. Vaughan). Key DRU commissions included the 1954 Electricity Board Showrooms, by Black, Gibson, and H. Diamond, the BOAC engineering hall at London Airport (Heathrow) by Black, Kenneth Bayes, and BOAC staff from 1951 to 1955, and a number of interiors for the P&O Orient Line's new liner *Oriana* by Black and Bayes in 1959. Other companies

d

for whom DRU worked included Ilford, Courage, Dunlop, London Transport, and British Railways, including the sleek *D2000* locomotive by Black and Beresford Evans.

Deskey, Donald (1894–1989) Deskey did much to help shape the *Streamlined Modern style that became widespread in 1920s and 1930s USA. After a period studying architecture at the University of California and painting at the Art Students League in New York City and the School of the Art Institute of Chicago, and a period working at an advertising agency, he travelled to Paris in 1923 where he studied painting and worked as a graphic designer. Deskey was particularly influenced by the 1925 *Paris Exposition des Arts Décoratifs et Industriels and, after his return to New York in 1926, he did much to popularize in the United States what became known later as the *Art Deco style. This was achieved by blending progressive European trends in the decorative arts with first-hand experience of the emerging field of industrial design. In 1926 he began as an industrial design consultant and worked on a variety of furniture, furnishings, and textiles for the Deskey-Vollmer Company (1927–31), which he founded with Philip Vollmer. He also designed window displays for a number of the leading department stores on Fifth Avenue, New York. His designs were characterized by a use of abstract, geometric patterns, and new materials such as chromium plate (*see* CHROME), *Bakelite, and aluminium. From the late 1920s he designed interiors for a number of wealthy clients, including John D. Rockefeller (1929–31). With Lee Simonson and Kem Weber he co-founded the *American Union of Decorative Artists and Craftsmen (AUDAC) in 1928, seeking to bring together artists and designers to promote modern American design. His reputation was such

that he won the competition to design the interiors of Radio City Music Hall in the Rockefeller Center, New York, in 1932–3. Deskey's designs, particularly for furniture and lighting, showed his indebtedness to French decorative arts. He was awarded a Grand Prix and Gold Medal at the 1937 Exposition Universelle in Paris and also worked on a number of displays at the *New York World's Fair of 1939. He established his own design consultancy, Donald Deskey Associates, in 1946 and remained active until 1970, working on large corporate accounts such as Proctor & Gamble.

De Sphinx (established 1827) One of the major pottery producing firms in Holland, De Sphinx began as a glassmaking concern in 1827 and operated under the name Petrus Regout & Co. until 1899. During this period the company rapidly increased in size, employing more than 800 by the end of the 19th century and exported internationally. Production was wide-ranging and included domestic and commercial goods of all kinds. Generally these were characterized by historicist styles and patterns until new technologies and materials impacted upon the industry. In Holland this was accompanied by relevant educational change in ceramic education, including the establishment of a State School of Pottery in Gouda in 1922. In 1917 the ceramic designer and modeller J. H. Lint was appointed to reinvigorate the company's products, a task taken over from 1924 to 1929 by Willem Rozendaal who was interested in the technical possibilities of pottery manufacture. Guillaume Bellefroid became the company's highly influential design director between 1929 and 1946, establishing a marked shift of direction away from the historicism that had characterized much of the company's production towards a modern industrially produced aesthetic.

He designed more than 30 services in this period, many of which were visual embodiments of a contemporary functional aesthetic geared to mass-production technology. His most successful design was perhaps the *Maas* tea service (1934) with its clean lines, simple forms, and economic price. However, competitive pricing and low profit margins were hallmarks of De Sphinx, a sales-driven outlook that restricted the possibilities open to designers. Indeed, between 1946 (when Bellefroid left the company) and 1950 (when Pierre Daems was appointed as designer) the company did not employ a designer as it deemed it unnecessary at a time when there was little demand for new lines. In 1958 the company merged with Société Céramique to form N.V. Sphinx-Céramique.

De Stijl *See* STIJL, DE.

Deutscher Werkbund (DWB, established 1907) This important design organization sought to improve the quality of German design in industry. Founded in Munich in 1907 it campaigned to bring together designers, manufacturers, writers, and others in a progressive organization that promoted modern design. Important in the formation of the DWB were the liberal-democratic politician Friedrich Naumann and Karl Schmidt, the founder of the Dresdener Werkstätten für Handwerkskunst (the Dresden Workshops for the Arts and Crafts) and the influential architect, educator, and writer, Hermann *Muthesius. Other noted early members of the organization included designers Richard *Riemerschmid, Bruno Paul, and Peter *Behrens. Amongst the DWB's early preoccupations was the issue of standardization and a perceived need for economic, yet aesthetically pleasing, mass-produced goods. Muthesius was a keen advocate of such an approach that leaned towards

standardization whilst Henry van de *Velde argued strongly that it severely compromised individual artistic creativity. Such ideas surfaced strongly at the 1914 DWB exhibition at Cologne where a number of the exhibition buildings, particularly those by Walter *Gropius and Adolf Meyer, embraced an uncompromisingly industrial aesthetic with large expanses of glass blending with the manipulation of functional form. Many designers visited this exhibition from across Europe, including a number from Britain who went on to play a significant part in the formation of the *Design and Industries Association in 1915. Other organizations inspired by the DWB included the Österreichischer Werkbund (established 1912) in Austria, the Schweizerischer Werkbund (established 1913) as well as a significant shift in the outlook of the *Svenska Slöjdföreningen.

The DWB promoted its ideology on a number of fronts, including the *Jahrbücher* (*Yearbooks*) that were published between 1912 and 1920. They contained critical essays and photographs with extended captions that sought to exemplify what it felt was the best in modern industrial design. Also published from 1916 were the *Deutscher Warenbücher* (*German Products Directories*). After the First World War the DWB re-emerged as an important stimulus for aesthetic debate, publishing the periodical *Die Form* (from 1922) and, as the economy recovered, mounted a number of important exhibitions. Significant was the 1924 *Forme ohne Ornament* (*Form without Ornament*) exhibition in Stuttgart where handcrafted, preindustrial, and industrially manufactured designs were displayed. Both types were significant since, particularly in progressive circles, ornament was seen as indulgent and unnecessary. On a much larger scale was the *Die Wohnung* (*The Dwelling*) exhibition at the Weissenhof-Siedlungen in Stuttgart in

1927 in which a number of leading *Modernist architects including *Mies Van Der Rohe exhibited show houses that, together with their interiors and furniture, fully embraced a contemporary Machine Age aesthetic. The exhibition caused considerable controversy, particularly among conservative furniture manufacturers and architectural critics, who found the flat-roofed exhibits distinctly un-Germanic. In 1930 the DWB exhibited in Paris, although in the increasingly oppressive political climate in Germany itself it came under increasing pressure before being disbanded by the National Socialist government in 1934. After the Second World War the DWB was reestablished in 1947 although the organization never regained its earlier standing. Amongst its outputs were the 1949 *Neues Wohnenund deutsche Architektur seit 1945* (*New Dwellings and German Architecture since 1945*) in Cologne and the periodical *Werk und Zeit* (*Work and Life*). Also in 1949, with influence from members of the DWB the Social Democrats voted for the principle of a *Rat für Formgebung (German Design Council), the establishment of which was approved by parliament in 1953. Although still in existence today, the influence of the Werkbund is considerably diminished, although its history is recorded in the Werkbund Archive.

Devetsil (1920–31) This avant-garde Czechoslovakian group of designers, architects, painters, theorists, and writers was founded in Prague in 1920, flourishing during the rest of the decade with an associated group based in Brno from 1923. Despite several members' roots in *Czech Cubism there was a strong Constructivist flavour in much of Devetsil's graphic work, influenced by knowledge of the work of El *Lissitzky and Russian *Constructivism. The group was also interested in popular culture, jazz, film, and other aspects of con-

temporary life. Karel Teige (1900–51), one of the group's leading figures, was important in the promotion of its outlook, bringing its ideas into public view through publication, exhibitions, and theatrical events. He was aware of many progressive trends through first-hand experience of them, visiting Paris several times in the 1920s, making contact with the *Bauhaus in Weimar, and spending a month in the Soviet Union in 1925. Devetsil's printed output included a series of Prague-based periodicals such as *ReD* (1922), of which Teige was the editor in chief and designer; others included *Disk* (1923–5) and *Tam-Tam* (1925–6) and the Brno group's periodicals included *Index* (1929–39). Key Devetsil exhibitions included the *Bazaar of Modern Art* (1923) and the *Devetsil Spring* show (1927). Design activities spanned several fields including graphics, typography, furniture, interiors, film, theatre set design, and photography. Devetsil's architectural interests were strongly represented by Ardev, a subgroup founded in 1923 that advocated the clarity of form and machine age aesthetic associated with *Modernism.

DIA *See* DESIGN AND INDUSTRIES ASSOCIATION.

Dior, Christian (1905–58) Widely known for his full-bodied 'New Look', which was launched in 1947 and captured the attention of women on both sides of the Atlantic after the material restrictions of the Second World War. This romantic, highly feminized style was characterized by a thin waist and long, full skirts and narrow bodice, as a result attracting censure in some quarters on account of its implicit undermining of the new freedoms enjoyed by women in the war years. Dior began his fashion career in Paris in the mid-1930s and, after military service in the south of

France during the Second World War, returned to Paris in 1944. After a period in the fashion house of Lucien Lelong he opened his own establishment in 1946 and did much to re-establish Paris as the 'fashion capital' of the world after the disruption of war. In 1948 he agreed to the licensed production of clothes, perfumes, ties, and other accessories as a means of spreading the Dior name internationally. After the highly popular 'New Look' of 1947 Dior was responsible for a number of striking new lines launched annually, the best known of which was perhaps the 'A' line of 1956, following on from the 'H' line of 1954 and the 'Y' line of 1955. A number of distinguished designers have been involved with the House of Dior, including Yves *Saint Laurent, who took over after Dior's sudden death. Other distinguished designers followed including Gianfranco Ferre and John Galliano.

Ditzel, Nanna (1923–) A leading Danish 20th-century designer, Nanna Ditzel worked in furniture, textiles, and jewellery design over many decades and was one of the few women designers in that country to achieve celebrity status. After studying under the highly influential furniture designer Kaare *Klint at the Academy of Arts in Copenhagen, she moved into furniture design, a field in which she attracted critical attention with her classic design for a children's high chair (1955), the Ring easy chair (1957), and the hanging Hammock chair (1957) in wicker. She had been married in 1946 and worked jointly with her husband on a wide range of products, including several for the silversmithing company Georg *Jenson, for whom they worked from 1954. After her husband's death in 1961 Ditzel's furniture took on a more experimental edge, exploring the potential of foam and fibreglass, materials with which a number

of avant-garde designers such as Verner *Panton were working. In this period she also worked on a number of striking textiles including the celebrated Hallingdal series (1964), which has remained in production for several decades. In 1968 Ditzel remarried and moved to London for almost twenty years, during which period she designed for a range of Danish and British companies. After returning to Copenhagen in 1986 when in her early eighties, she began working for Fredericia, a leading Danish manufacturer with a reputation for high-quality furniture. This relationship denoted yet another fresh direction in her career, her Bench for Two (1989) and dramatic red and black plywood Butterfly chair (1990) marking a shift in the Fredericia company's profile—embracing the avant-garde. Ditzel's Trinidad chair, Tobago table (both 1993), and Tempo chair (1998) followed. She received many awards during her long and distinguished career, including the *Lunning Prize in 1956, silver medals at the *Milan Triennali of 1951, 1954, and 1957, followed by a gold in 1960, and the ID Prize for her Trinidad chair in 1995.

Dixon, Tom (1959–) Well known as a highly original British furniture designer capable of combining fantasy and utility, Tom Dixon injected a freshness into the *Habitat chain of stores following his appointment as its art director in 1998. With a background in nightclub design in the early 1980s, he first emerged as a designer with a post-industrial outlook, his work taking on a strongly sculptural feel in its adoption of ready-made industrial objects or scrap that were welded together in the fabrication of furniture and fittings. Indicating such tendencies in its title he established his Creation Salvage studio in 1985. Amongst significant early commissions were Rococo chocolate boutique (with

André Dubreuil) in fashionable Kings Road, London (1985), and a chandelier and capitals for Nigel *Coates's *Metropole* restaurant in Tokyo (1987). In 1991 he established his space studio, which, in 1994, became the Space Shop. In the 1990s he established a wider reputation through closer association with internationally renowned furniture manufacturers such as Cappellini (established 1946) in Italy. Many Capellini-commissioned products had a pronounced sculptural feel, as seen in Dixon's critique of the flowing lines of Italian furniture of the 1950s in his 1992 *Bird Chair* and 'S' chair, the latter in wicker and rush on a steel frame.

Djelo Association for Promoting Craft Art (Udruga za Promicanje Umjetnog Obrta Djelo, 1926–early 1930s) This association was established by Tomislav Krizman, a leading figure in the development of Croatian arts and crafts in the early 20th century. He had been responsible for the exhibits in the Serbian, Croatian, and Slovenian Pavilion at the 1925 *Paris Exposition des Arts Décoratifs et Industriels and had recognized the difficulties of effecting a radical change in national arts and crafts activities without significant technological and economic advances. As a result any progressive notions of functionalist design were restricted by the reality of small-scale series production. Nonetheless Krizman's approach provided the basis for a wider social and cultural decorative arts initiative with a strong commitment to the production of national products. Drawing together a number of artists from different institutions the Djelo group grew out of this ideology, assisted in its social goals by Krizman's establishment of a collective of manufacturers, retailers, and financiers to make and sell their designs. Having published its manifesto in 1926, the first Djelo exhibition was mounted in Zagreb in 1927

with the backing of a number of large manufacturing companies. However, despite such initial industrial interest and the group's commitment to the creation of original and popular decorative art the Djelo ideology failed to translate its social and aesthetic ambitions into commercial reality.

Doesburg, Theo Van (1883–1931) Founder of the influential De *Stijl architectural and design group the Dutch artist, designer, and writer Van Doesburg provided much of its theoretical underpinning through the *De Stijl* journal, which he edited from 1917 to 1931. Influenced in his aesthetic approach by the Dutch artist and fellow member of De Stijl, Piet Mondrian, Van Doesburg was also active in several design fields including interiors, stained glass, floor tiling, and mosaics. Between 1921 and 1923 he lived in Weimar, Germany, home of the *Bauhaus and sought to influence its progressive curriculum, also participating in the 1922 Weimar International Congress of Constructivists and Dadaists. Through such activities, coupled with his editorship of *De Stijl*, he was an important catalyst for the internationalization of many facets of the De Stijl design philosophy.

Domus (established 1928) Initially subtitled 'L'Arte della Casa' this magazine devoted to architecture and design has been at the forefront of design debate in Italy since its foundation by Gio *Ponti in 1928. Although largely concerned with a *Novecento aesthetic in the 1930s it also devoted some attention to more progressive tendencies, as exemplified by Persico's 1934 article 'A New Start for Architecture'. Under the editorship of Ernesto Rogers in the immediate aftermath of the Second World War the magazine was at the forefront of leftist debates about the place of practical,

functional, and well-designed goods in a democratic society. It took on a less radical but widely discursive stance in its next phase with Ponti taking over editorship from 1947 until 1979. It was during this period that Italian design achieved international recognition for its elegance and sophistication. The more radical Alessandro *Mendini took on the role until 1986.

Domus Academy (established 1982) This postgraduate design school was founded in 1982 in Milan by Maria Grazia Mazzocchi, Valerio Castelli, and Alessandro Guerriero and sought to build positively on many of the ideas of Italian *Radical designers of the 1960s and 1970s. Under the directorship of Andrea *Branzi its progressive curriculum was geared to the perceived needs of contemporary design, and included Industrial Technology, the Culture of Behaviour, the History of the Culture of Planning, and Social and Economic Forecasting alongside design projects. Conceptual in its approach the Domus Academy is very much conceived as a research laboratory of the future and offers Masters Diplomas in Design, Fashion Design, and Urban Management. Committed to multidisciplinary thinking and teamwork the Academy attracts students from all over the world. In 1995 the Domus Academy won a Career Prize from the *Compasso d'Oro in 1995 for 'its constant attention to trailblazing topics, from humanising technology to exploring the nexus between design and fashion, from considerations about the sociology of design to design management and service design, together with the quality of its teaching and publishing activities'. Since 1985 the Domus Academy Research Centre (DARC) has undertaken design research for industry, other research institutes and public and private bodies, its clients including *Apple, Mitsubishi, *Philips, *Sharp,

Uchida, Telecom Italia, and Whirlpool. It has won a number of awards for such work including the Honda Award 1997 and the Mitsubishi Competition 1998.

Dorn, Marion (1896–1964) Marion Dorn was one of the most important textile and rug designers of the first half of the 20th century. In addition to furnishing textiles she also designed interiors, wallpapers, graphics, and illustrations. Born in the United States she studied graphics at Standford University, moving into textile design in the early 1920s. Significant in forming her design outlook was a trip to Paris in 1923 with the American textile designer Ruth Reeves, who was well connected with a number of leading French designers such as Raoul *Dufy. In the same year she moved to London with designer Edward McKnight *Kauffer (with whom she lived until his death in 1954) establishing herself as an illustrator and designer of batiks. During the 1920s her designs began to attract attention, being illustrated in *Vogue* and *The Studio Yearbook of Decorative Art* (*see* STUDIO) and exhibited at the International Exhibition of Arts and Crafts, Leipzig, in 1927. She was subsequently awarded a number of significant commissions for rugs and carpets for several hotels. These included the Berkeley, London (1931, 1935, and 1939), Claridges, London (1932), the prestigious Midland Hotel, Morecambe (1932–3), designed by Oliver Hill, and the Savoy, London (1933–4). Other commissions of note related to transport design, including Cunard's prestigious ocean liner *Queen Mary* (1935), the Orient Line liners *Orion* (1935) and *Orcades II* (1937), and moquette seating fabrics for the design-conscious London Passenger Transport Board (1936–7). She also exhibited at a number of exhibitions that were significant showcases for design in Britain. The most important

were held in London: the Dorland Hall Exhibition of Industrial Design Relating to the Home (1933), the British Art in Industry Exhibition at the Royal Academy (1935), and the Everyday Things Exhibition at the Royal Institute of British Architects. She also exhibited five textile designs at the *Paris Exposition of 1937. She had established her own company, Marion Dorn Ltd., in 1834. Among the British companies she designed for were the Wilton Royal Carpet Co., Edinburgh Weavers, Warner & Sons, Donald Brothers, and Old Bleach Linen. Following the outbreak of war, Dorn and Kauffer moved to America in 1940. Although she never found success comparable to that which she had enjoyed in Britain she designed for a number of companies including F. Schumacher & Co. (1950), Katzenbach & Wareen (1952), and Greeff Fabrics (1956).

Dresdener Werkstätten für Handwerkskunst (Dresden Workshops for Arts and Crafts, established 1898) The aim of this design reform organization was to produce well-made German domestic furniture, building on the *Arts and Crafts Movement ideals of respect for materials and appropriate methods of construction. An important difference from its British precedent was the higher profile accorded to the role of the machine as a means of production. Karl Schmidt, a trained carpenter, founded the Dresdener Werkstätten at Hellerau, near Dresden, after a year spent in England. The Workshops began with Schmidt and two assistants but grew rapidly in size, reaching eighteen employees within a year and more than 200 within five years. New technologies were deployed in the production of goods in order to make them accessible to a wider public through reasonable prices. Unlike many of the Arts and Crafts precedents in Britain machinery

was seen as an additional aid for production rather than a threat to craft skills. Many leading designers were associated with the Dresdener Werkstätten, most notably Richard *Riemerschmid and Bruno *Paul. Women designers were also active in the enterprise, including Margarete Junge and Gertrude Kleinhempel. Amongst its more ambitious projects was the Werkstätten's involvement in the design of ships' furniture following a visit from Schmidt to the Kiel shipyards in 1903. This resulted in Riemerschmid being commissioned to design a number of interiors for the SMS *Danzig*. They were carried out by the Werkstätten in 1905. Bruno Paul also won a number of ship design commissions for the North German Line, including interiors for the *George Washinton* and *Prinz Friedrich Wilhelm* liners, both completed in 1908. Five years earlier Riemerschmid had been involved in the serial production of machine-made furniture for the Werkstätten, including kitchen, living room, dining room, study, and bedroom ensembles. A number of them were produced in 'knockdown' format as a means of reducing transportation costs. Building on such progressive initiatives, the Third German Applied Arts Exhibition was mounted. Held in Dresden in 1906, it marked a wider shift in the attitudes of German design reformers as a Selection Committee was established to ensure that the exhibition was restricted to modernizing products that embodied the spirit of social, cultural, and economic reform. Almost inevitably the Dresdener Werkstätten were well represented with their own pavilion containing seventeen rooms by Riemerschmid. The politician Friedrich Naumann and design reformer Hermann *Muthesius made keynote speeches. In 1907 the Dresdener Werkstätten and the Munich Werkstätten für Wohnungs-Einrichtung (Workshops for Domestic

Furnishings) combined to become the Deutsche Werkstätten. However, major initiatives in terms of design reform in Germany shifted to the *Deutscher Werkbund (DWB), which was established in 1907.

Dresser, Christopher (1834–1904) Educated at the Government School of Design, London (1847–54), the British designer, theorist, and botanist Christopher Dresser went on to play a leading role in design debates in Britain in the second half of the 19th century. He worked in a wide range of design media including furniture, metalware (including work for James Dixon & Son), cast iron (including work for the Coalbrookdale Company), ceramics (including work for Mintons), glass (including work for James Coupar & Sons), wallpaper and textiles (including work for Warner & Sons). Designers such as Richard Redgrave, Owen Jones, and Henry Cole influenced his early thinking, which sought to reconcile design with industrial production as a means of bringing well-designed products within the price range of a wide public. In this respect his 1862 book, *The Art of Decorative Design*, introduced Dresser's design thinking to a large readership, ideas which were further developed in his later work on *The Principles of Decorative Design*, published in 1873. In a more practical vein in 1880 he established the short-lived (and unsuccessful) Art Furnishers' Alliance in Bond Street, London, as more direct means of introducing high standards of design to the consuming public. In his design work he used modern materials where appropriate and applied a systematic, almost scientific approach to the construction of form, the application of colour and framing of proportion.

Dresser had been deeply interested in botany in the earlier phases of his career, reflected in his appointment to the chairs of Botany at South Kensington (1860) and of Ornamental Art and Botany at the Crystal Palace (1862). His writings on the subject led to the award of a doctorate by Jena University in 1860. He also believed that the abstraction of natural forms provided the basis for ornamentation, a view that ran counter to the prevalent Victorian obsession with historical eclecticism. Natural forms offered designers in the second half of the 19th century an alternative to the widespread dependency on historical styles, an alternative approach evident in many *Arts and Crafts Movement designs and much *Art Nouveau work at the turn of the century. Japanese and oriental art, increasingly widely known in the West from the mid-century, also offered designers another choice in the later decades of the 19th century. Dresser himself developed a keen interest in Japanese design, examples of which he had seen at the 1862 International Exhibition in London in which he exhibited some of his own designs. In 1876–7 he made his first visit to Japan, subsequently setting up the company of Dresser & Holme to deal in Japanese and oriental goods. He also published a book entitled *Japan: Its Art and Art Manufactures* (1882) and was influenced in his own design work by the art forms about which he wrote so eloquently. He has been seen by some as the first industrial designer (although it should be noted that this is a very different interpretation of the term when compared to the commercial and interdisciplinary outlook of American designers such as Raymond *Loewy, Norman *Bel Geddes, and Walter Dorwin *Teague in the 1930s). Historical recognition of his contribution to the course of *Modernist design was initiated by Nikolaus *Pevsner in his influential book *Pioneers of the Modern Movement* (1936).

Dreyfuss, Henry (1904–72) One of the least flamboyant of the generation of American industrial designers who emerged in the interwar years, Dreyfuss did much to establish design consultancy as a reputable and business-like profession. His early experience was in theatre design, being apprenticed to Norman *Bel Geddes (1923–4), and he turned to industrial design in 1929 when he opened his design office. One of his first clients was the Bell Telephone Laboratories. He began working for them in 1930, designing the *Bakelite *300 Model* telephone in 1937 as well as the *500 Model* (with Robert Hose) in 1949 and the *Trimline* in 1964. In common with many of his other design solutions his telephone design took into account the relationships between the product and the human body. Other clients included AT&T (from 1930), Westclox (alarm clocks from 1932), Hoover (domestic appliances from 1934), Deere & Co. (tractors from 1937), RCA (television sets from 1946), the New York Railroad Company (the 1936 *Mercury* locomotive and the *20th Century Limited* train of 1938), Polaroid (from 1961), and American Airlines (from 1963). At the *New York World's Fair of 1939, with the architect Walter K. Harrison, he designed a model city, *Democracity*, housed in the Perisphere that was at the focal centre of the exhibition site. This planned metropolis of the future bears comparison with the more ambitious and sensationalizing *Futurama* display designed by Norman Bel Geddes for *General Motors. Dreyfuss's thoughts on the earlier phases of industrial design may be seen in his 1939 book *Ten Years of Industrial Design*. In 1955 his text *Designing for People* was published, making use of human measurements—or anthropometrics—as an integral aspect of the design process. This was followed up in his 1960 book, *The Measure of Man*, prepared in collaboration with Niels

Diffrient. He was the first president of the *Industrial Designers Society of America in 1965.

Driade (established 1968) This Italian furniture company has been to the forefront of fashionable design since its inception at the Milan Furniture Fair of 1968. Founded by Enrico Astori, his sister Antonia and Adelaide Acerbi, Antonia Astori was herself a prolific designer for the company and was involved with the shaping of its visual identity, also producing a highly successful series of geometrically conceived, clearly articulated storage systems such as *Oikos* of 1972, *Kaos* of 1986, and *Pantos* of 1993. The company manufactured many of its own products but also subcontracted, or edited, the fabrication of others. Many leading designers were commissioned to design furniture for the company including Enzo Mari (*Delfina* chair, 1974), Achille *Castiglione (*Sancarla* chair, 1982), Philippe *Starck (*Lord Yo* chair, 1994), Alessandro *Mendini, and Borek *Sípek. In 1996 the firm began production of its own magazine *Driade Edizioni*.

DRU *See* DESIGN RESEARCH UNIT.

Dufy, Raoul (1877–1953) Although widely celebrated as a French painter associated with the colour-intensive work of Henri Matisse and the Fauves in the early 20th century, Dufy also made a significant contribution to the decorative arts, particularly textile designs, which he produced for the Lyons firm of Atuyer, Bianchini & Férier (later Bianchini-Férier) from about 1912. After training at the École des Beaux-Arts in Le Havre he went on in 1896 to study at the École des Beaux-Arts in Paris. Immersed at the centre of the contemporary art world he was variously influenced by Post-Impressionism, Fauvism, and Cubism. In 1909 he made a series of woodcuts for the *Bestaire*, a

book of poems by Guillaume Apollinaire, that in turn led to a series of commissions from the couturier Paul *Poiret and his Atelier Martine, including printed textiles for dresses characterized by their bold colours and strong designs. A long association with Bianchini-Férier followed this, lasting till 1928. He also worked on ceramic decoration, working closely with the Catalan potter José Lloréns from about 1923 to 1930. In the 1930s Dufy also produced a number of designs for large-scale tapestries and furniture fabrics for French patrons. He designed textiles for foreign clients such as the American Onandaga company and also produced decorative engraving schemes for the *Corning Glass Company.

Dymaxion *See* FULLER, RICHARD BUCKMINSTER.

Dyson, James (1947–) British inventor, entrepreneur, and industrialist Dyson first came to notice with his design of the *Ballbarrow*, which won a Building Design Innovation Award (1977). Having sold his interests in this product, he developed the innovative *G-Force* vacuum cleaner. Unable to interest any European manufacturers to invest in its manufacture he worked with a Japanese company that launched it in 1986. His pink, *Postmodern design soon attracted critical attention and was included in a number of significant exhibitions of British design. In 1993 Dyson opened a Research Centre and Factory in Chippenham, Wiltshire, producing the *DC01* cleaner which became the best-selling cleaner in the market place. Dyson objects have become style icons, reflected in the 1996 launch of the colourful limited edition De *Stijl *DC02* vacuum cleaner, the standard edition of which was awarded Millenium Product status by the *Design Council in 1998. Dyson products may be found in many design collections around the world including London's *Design Museum and the *Victoria and Albert Museum. They are also widely exhibited around the world, as at the Osaka Design Centre, Japan, in 2003. In 1997 Dyson became a member of the Design Council and a Trustee of the Design Museum. His interest in education is reflected in the establishment of the Design Museum's Dyson Centre for Design Education and Training and his membership of the Council of the *Royal College of Art, his alma mater where he studied furniture and interior design in the late 1960s. His company has diversified into washing machines and has subsidiaries in Spain and Japan. More recently he has transferred his manufacturing capacity from Britain to South East Asia.

d

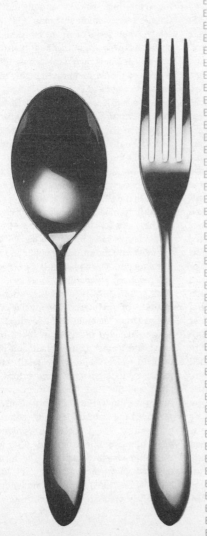

E

Eames, Charles Eames, Ray Kaiser Earl, I
Eastlake, Charles Eckersley, Tom editing
Ekuan, Kenji Electrolux Elkington & Com
Emberton, Jos Endell, August engine
Erector ergonomics Ergonomidesign Eri
Ericson, Estrid Esprit nouveau, L' Ettinge
Exner, Virgil Eames, Charles Eames, Ray
Earl, Harley Eastlake, Charles Eckersley, 1
Eidos Ekuan, Kenji Electrolux Elkington
Emberton, Jos August engine
Erector ergonomics Ergonomidesign Eri
Ericson, Estrid Esprit nouveau, L' Ettinge
Exner, Virgil Eames Charles Eames, Ray
Eastlake, Char ersley, Tom editing
Ekuan, Kenji ux Elkington & Com
Emberton, dell, August engine
Erector e Ergonomidesign Eri
Ericson, nouveau, L' Ettinge
Exner, Vi Charles Eames, Ray
Earl, Ha , Charles Eckersley, 1
Eidos Electrolux Elkington
Ember ndell, August engine
Erecto Ergonomidesign Eri
Ericson nouveau, L' Ettinge
Exner, V Charles Eames, Ray
Eastlake kersley, Tom editing
Ekuan, Ke lux Elkington & Com
Emberton, ndell, August engine
Erector ergo Ergonomidesign Eri
Ericson, Estrid t nouveau, L' Ettinge
Exner, Virgil E Charles Eames, Ray
Earl, Harley Ea e, Charles Eckersley, 1
Eidos Ekuan, H Electrolux Elkington
Emberton, Jose ndell, August engine
Erector ergon Ergonomidesign Eri
Ericson, Estrid nouveau, L' Ettinge
Exner, Virgil Ea Charles Eames, Ray
Eastlake, Charl ersley, Tom editing
Ekuan, Kenji E ux Elkington & Com
Emberton, Jos dell, August engine
Erector ergon Ergonomidesign Eri
Ericson, Estrid nouveau, L' Ettinge
Exner, Virgil E harles Eames, Ray
Earl, Harley E Charles Eckersley, 1
Eidos Ekuan, ectrolux Elkington
Emberton, Jos ell, August engine
Erector ergon rgonomidesign Eri
Ericson, Estrid ouveau, L' Ettinge
Exner, Virgil Ea arles Eames, Ray
Eastlake, Charle rsley, Tom editing
Ekuan, Kenji Elec k Elkington & Com
Emberton, Joseph Endell, August engine
Erector ergonomics Ergonomidesign Eri

Eames, Charles (1907–78) The distinguished American designer, film-maker, and architect Charles Eames studied architecture at Washington University in St Louis in 1924. Having worked in private practice in the early 1930s, he won a fellowship in 1936 to study architecture and design at the *Cranbrook Academy of Art, which proved to be a highly significant experience. He headed the Cranbrook Academy's Experimental Design Department from 1937 to 1940 and formed friendships with Eero *Saarinen (the son of Cranbrook's president, Eliel), Florence *Knoll, and Ray Kaiser (*see* EAMES, RAY KAISER) whom he married in 1941 and who became his close collaborator for the rest of his career. For some years he also worked closely with the architect and designer Eero Saarinen. The Eameses' work attracted attention at the *Organic Design in Home Furnishing* competition held at the *Museum of Modern Art, New York in 1940–1. Charles Eames, assisted by Ray and in collaboration with Saarinen, won two prizes, one for a moulded plywood chair and the other for modular design. The Eameses moved to California in 1941 and worked with Saarinen for the US Navy on a series of moulded plywood splints and stretchers that were instrumental in the development of their future furniture. In 1946 the Eameses produced their famous *LCW* (Lounge Chair Wood) moulded plywood chair, which was first manufactured by the Molded Plywood Division of the Evans Products Company (1946–9) and then the *Herman Miller Furniture Co. (1949–57). This and other designs were shown at a 1946 exhibition at MOMA entitled *New Furniture Designed by Charles Eames* (with no mention of Ray), establishing their—but critically and historically Charles's—reputation at home and overseas. A whole series of organically designed chairs followed from the late 1940s onwards, using new materials such as *glass-reinforced plastic, and proved highly influential. A celebrated example was the 1948 *DAR* armchair, produced by the Herman Miller Furniture Co. from 1950 until the 1970s. The Eameses' modular work, first seen in the 1940 *Organic Design* competition, was seen subsequently in work such as the storage unit, model *ESU 421-C* of 1949 that established a type often found in homes and offices in the 1950s. The practicality of such a modular outlook was echoed in the design of the Eameses' home in Santa Monica (1947–9), sponsored by the *Arts and Architecture* magazine and attracting public and critical attention. Open-plan in layout, it was ordered from standardized, prefabricated parts and in 1978 received the American Institute of Architects' Twenty-five Year Award. Other celebrated Eameses furniture designs included the 1956 moulded rosewood and leather lounge chair and ottoman, to which for many years all senior managers in large-scale corporations aspired, and the 1962 *Tandem* metal-framed furniture for O'Hare Airport, Chicago, which set the standard for subsequent airport seating. The Eameses also produced many films, commencing in 1950, as well as multimedia presentations. The former included *Mathematica* (1961) for *IBM, *Powers of Ten* (1968) for the Commission of the College of Physics, and commissions for

the US government. Amongst the latter was a presentation on seven screens using 2,000 images in twelve minutes on *Glimpses of the USA* for the American National Pavilion at the Moscow World's Fair of 1959. Through their ceaseless experimentation in plywood, glass-reinforced plastics, and other materials and media, the Eameses came to rank amongst the most influential designers of the 20th century.

Eames, Ray Kaiser (1913–88) The important contributions that Ray Kaiser made to furniture design and other innovative work in film and multimedia generally attributed to her husband Charles *Eames have, until comparatively recently, been considerably downplayed. Her background was in the fine arts, studying at the May Friend Bennett School in Millbrook, New York (1931–3), and then with the painter Hans Hoffmann between 1933 and 1939. She continued her studies at the *Cranbrook Academy from 1940 to 1941 where she met and married Charles Eames in 1941. This resulted in a productive, innovative, and fertile working relationship in many fields of design and visual culture. She also designed a number of textiles, some of which were put into production, and played a strong role in the Eameses' film, exhibition, and multimedia work.

Earl, Harley (1893–1969) Harley Earl is closely linked with the idea of the annual model change of automobiles, induced by extravagantly new styling features, colour schemes, and accessories. Conscious of the power of consumer desires as a route to corporate profitability, he played a key role in the emergence of *General Motors as a major force in American automobile manufacture. The almost baroque essays in chrome seen in radiator grilles and the allusions to rocketry and science fiction in the sweeping tail fins and brake light clus-

ters evident in many Earl-inspired designs of the post-Second World War period were symbolic of the conspicuous material affluence of 1950s USA. They aroused considerable antipathy in those circles that sought to promote the restraint associated with *'Good Design', such as Edgar Kauffman Jr. at the *Museum of Modern Art, New York, and amongst others concerned with consumer affairs such as Ralph *Nader.

Earl studied engineering at Stanford University after the First World War. However, he gave up his studies to work in his father's coach-building company, the Earl Automobile Works. His early styling experience was gained in customizing cars for Hollywood stars until the family firm was bought out after the Los Angeles Auto Show of 1919. Harley Earl was kept on as chief designer and increasingly worked on customizing Cadillac chassis, becoming friends with the Cadillac Division president, Lawrence Fisher. General Motors employed Earl from 1925, an early project being the softly curved 1927 Cadillac *La Salle*, the first mass-production model designed by a stylist. He was made the first head of GM's Art and Colour Section in 1927, which, a decade later, became the Styling Section. It grew from a staff of 50 in 1927 to more than 1,000 when Earl retired in 1959. The curving, sculptural forms that characterized many of Earl's automobile designs derived from his use of clay models as an important part of the design process, a technique explored in the product design field by American industrial designers such as Raymond *Loewy. Earl's 1937 Buick *Y Job* was typical of the forward looking thinking associated with the design of concept (or 'Dream') cars that, although too costly to produce at the time, anticipated many of the more extravagant General Motors designs of ten or fifteen years later. The Second World War and its aftermath had suppressed the

demand for cars, but by the late 1940s the position had improved significantly. The striking styling of the 1948 Cadillac was noted for the use of chrome and tail fins derived from the *P-38 Lightning* bomber plane, features that Earl subsequently developed more extravagantly in other models over the following decade. The 1950 long, low, extravagantly tail-finned Buick *LeSabre* was another important landmark in the development of Earl's design thinking, as was the *Corvette* sports car of 1953. The latter was exhibited as a Dream Car at the *Motorama Show of 1953 and proved a solid success with its panoramic curved windscreen, tail fins, 'Blue Flame' engine, low centre of gravity, and *Fibreglass body panels. More extravagant 'Cars of the Future' were the science fiction rocket shapes of *Firebird* of 1956 and *Firebird III* of 1959. Earl became a vice-president of General Motors in 1940, playing a highly influential role in determining the corporation's design policies until he retired in 1959. Earl had also employed a number of women industrial designers in the Styling Section at General Motors, starting in 1943. Much of their work centred on the interiors of cars, ranging from colours and fabrics through to controls. In the mid-1950s there were sufficient numbers for them to be referred to in the press as the *'Damsels of Design' and they included Dagmar Arnold, Gere Kavanaugh, and Jane Van Alstyne, all of whom had qualified in industrial design. In 1945 he established his own firm, Harley Earl Inc., which, in 1964, merged with Walter B. Ford Design Associates to form Ford & Earl Design Associates.

See also MITCHELL, WILLIAM.

Eastlake, Charles (1836–1906) British architect and designer Eastlake is perhaps best remembered for his advice manual of 1868, *Hints on Household Taste in Furniture, Up-* *holstery and Other Details*, a publication that was widely read in both Britain and the United States. After studying architecture at the Royal Academy Schools in the 1850s Eastlake turned to journalism, though maintaining connections with the establishment through employment as assistant secretary (from 1866) and secretary (from 1871) to the Institute of British Architects, followed by a Keepership at the National Gallery, London (from 1878 to 1898). Eastlake published an extensive series of articles on matters of taste, first in the *Cornhill Magazine* in 1864, and then in *The Queen*, from 1864 to 1865. The latter formed the basis of *Hints on Household Taste*, which was intended as a popular guide for discerning consumers, running into four editions in its first year in Britain, with six in the USA between 1872 and 1879. Eastlake was also active as a designer, designing wallpapers for Jeffrey & Co., as well as textiles, and furniture.

Eckersley, Tom (1914–97) A leading figure in British graphic design in the post-Second World War period, after studying at Salford School of Art Eckersley set up in commercial practice with former fellow student Eric Lombers in London in 1934. They were commissioned by a range of clients including London Transport and Shell, both organizations with an enlightened attitude to poster design, and showed an awareness of continental developments. Crawfords, one of the leading advertising agencies in London, also commissioned them. In this period Eckersley was teaching at Westminster School of Art. During the Second World War he worked as a cartographer before being moved to the Royal Air Force's publicity unit where he produced posters for the Ministry of Food, the Ministry of Information, and the General Post Office (GPO). After the war key clients included British European Airways (BEA),

KLM, Ealing Studios, Gillette, and the Royal Society for the Prevention of Accidents. In 1957 he was appointed as head of design at the London School of Printing and Graphic Arts where he remained until 1976, also serving on the National Council for Academic Awards. He won professional recognition through the award of an OBE for services to poster design in 1949 and election to a *Royal Designer for Industry in 1963.

Editing 'Editing' design involves product development, marketing, and distribution but, as a means of remaining flexible and cost-effective, contracting out the actual manufacture of the end products to external companies, often small in size, with limited production runs. Typical of this trend are firms such as *Danese and *Dansk International.

Ehrich, Hans *See* A&E DESIGN.

Eidos (established 1990) One of the leading international specialist software developers for interactive games, this British company originated in video services. With the appointment of Charles Cornwall as chief executive in 1995 the company moved into the games industry and underwent a period of rapid expansion, with its listing on the London Stock Exchange and takeovers of other companies in the field. The most significant of these were Domark in 1995 and CentreGold (including Core Design, the developer of *Tomb Raider*) in 1996, the year in which *Tomb Raider* was released. The establishment in 1998 of offices in Tokyo and Singapore furthered the company's international ambitions. The phenomenal success of some of the company's products was exemplified by the release in 1999 of the football game *Championship Manager 3*, selling 55,000 copies in the first two days and making it the fastest selling game in British PC history.

The popularity of *Tomb Raider* was confirmed with the release in 2001 of the Paramount film *Lara Croft: Tomb Raider*, with box office takings of over $48 million on the first weekend of its release in the United States. In the same year *Who Wants to be a Millionaire?* (first released in 2000) became Britain's best-selling game ever, followed by *Tomb Raider II* and *Tomb Raider*. In 2002 Eidos announced *Fresh Games*, a new brand that aimed to bring Japanese games to the global market place, including such titles as *Mr Mosquito*, *Legaia 2*, and *Mad Maestro*.

Ekuan, Kenji (1929–) A founding member of the internationally renowned Japanese consultancy *GK Design, Ekuan has been responsible for many designs of note ranging from the pioneering Kikkoman soy sauce bottle through to Yamaha motorcycles, the Narita NEX express train, and the Akita bullet train. He was an important pioneer of industrial design in Japan, playing a key role in the bringing together of designers and leading organizations and writing eloquently on the meaning of objects in everyday life. He graduated from the Tokyo National University of Fine Arts and Music in 1955 having studied under the highly influential teacher Iwataro *Koike alongside Shinji Iwasaki, Kenichi Shibata, and Haratsugu Ito, who together became known as the 'Group Koike', the core of GK Design. Ekuan played an important role in the company's success through his ability to develop a network of industrial contacts and play significant roles in a number of design organizations. In 1960 he was elected president of the *Japan Industrial Designers Association (1960) and in 1976 his international standing was confirmed by his election to the presidency of ICSID (the *International Council of Societies of Industrial Design). In 1987 he was awarded the prestigious

biennial Osaka International Design Award, one of many such awards he has received. Ekuan gained a reputation for a philosophical approach to design that doubtless derived from his training as a Buddhist priest prior to his design education in Tokyo. In an essay of 1984 entitled 'Smallness as an Idea' he wrote of the *butsudan*, a small portable Buddhist altar that could be placed in the home as a means of communicating with one's ancestors, part of a Japanese outlook in which material products are endowed with spiritual values. A later, more fashionable text, *The Aesthetics of the Japanese Lunchbox* (1998), further developed this idea of an interrelationship between Japanese traditions and contemporary design practices. He suggested that the lunchbox is a key to understanding the Japanese way of making things and that 'the spirit of [its] form ...points to an ingenious technology that will preserve a rich legacy for the future'. Other key texts by Ekuan include *Industrial Design: The World of Dogu, its Origins, its Future* (1971), *The Philosophy of Tools* (1980), and *The Buddhist Automobile and the Automobile* (1986). Other roles played by Ekuan included directorship of the Street Furniture Committee at the Expo '70 World's Fair and executive producer of the International Design Festival at Osaka (1983).

Electrolux (established 1921) The origins of the largest manufacturer of domestic appliances in the world date from 1919 with the merger of Lux and Elektromekanista in Sweden. Important early company products were the *Model V* vacuum cleaner (1921) and the *Model D* refrigerator (1925), setting the stage for a significant expansion of the company with the establishment of factories in Germany (1926), England (1927), France (1927), and the USA (1931). Although enjoying high-volume sales as a result of the interwar (electricity-connected) housing boom, from the late 1930s the company began to invest in industrial design as a marketing tool. The American industrial designer Raymond *Loewy was employed for this purpose, followed after the war by Sixten *Sason, whose company designs included the *Z80* vacuum cleaner (1957). In recent decades Electrolux has purchased many well-known brands, including *Zanussi (1984), Buderus (1989), and *AEG (1994). This has allowed the company to match labels to particular market—or niche—sectors, a process of establishing 'Brand Families' first initiated in 1988.

Elkington & Company Ltd. (established 1829) This British company was well known for its electroplated designs in the Victorian era, some of which were displayed at the 1851 *Great Exhibition, London. Originally set up to manufacture gold, gilt, and silverware, the electroplating process was perfected in 1840 and was a field in which the company dominated. Elkington & Co. had factories in London, Liverpool, Dublin, and Birmingham and its products included tableware, hollowware, and artworks.

Emberton, Joseph (1889–1956) Not always recognized today as the historically significant and revealing *Modernist architect and designer that he was, Joseph Emberton was seen as sufficiently important to be included in the *Museum of Modern Art, New York's second architectural exhibition, *Modern Architecture in England—1937*. Though most widely known in architectural histories for his Modernist Royal Corinthian Yacht Club (1931), other important Emberton commissions of the interwar years included Simpson's in Piccadilly, London (1936)—for which he designed the building, interiors, lighting, furniture, and fittings—and the HMV store

in Oxford Street, London (1939). His inter-war furniture often utilized tubular steel and was characterized by a lack of orna-ment and other traits associated with Mod-ernism. His prolific output included housing, shops, factories, offices, inter-national exhibition buildings (including nu-merous advertising kiosks at the *British Empire Exhibition of 1924) and entertain-ment buildings. The latter included a number of buildings at Blackpool Pleasure Beach in the late 1930s, including the Fun House (1935), the Grand National (1936), and the Casino (1939). Important post-war work included housing developments and the redevelopment of the Paternoster site near St Paul's, London (1956).

Endell, August (1871–1925) German architect and designer Endell is widely known for the expressive, flowing forms of the façade and interiors of the Elvira photo-graphic studio in Munich (1897–8), his first architectural commission. A leading figure of the German *Jugendstil, in 1892 Endell had moved from Berlin to Munich. He moved into the fields of architecture and design, strongly encouraged by Herman *Obrist, and, from 1898, was involved with the *Munich Vereinigte Werkstätten für Kunst im Handwerk (United Workshops for Art in Craftwork). He designed in several fields including furniture, textiles, jewel-lery, and graphics, his work featuring fre-quently in journals such as *Pan. In 1901 he returned to Berlin, where he ran a design school from 1904 to 1914. At the 1914 *Deutscher Werkbund (DWB) exhibition in Cologne, Endell exhibited a decorative interior design for a railway dining-car for the Van Dr Zypen & Charlier company. In the DWB debates between Hermann *Muthesius and Henry van der *Velde, re-spectively representing standardization and the primacy of individual artistic ex-

pression, Endell was firmly on the side of van der Velde. Endell argued that unless the DWB recognized the status of the artist in industry, DWB design for industry would be restricted to a form of high-class branding for the companies involved. In 1918 he was appointed to the directorship of Breslau Academy. Originally Endell had studied philosophy, an approach that influenced many of his writings on art theory, includ-ing *Um die Schönheit (On Beauty)* of 1906.

Engineering Design This term is gener-ally applied to design that is concerned with the technical workings of mechanized products and machines rather than their aesthetic characteristics. This may be exem-plified by the automobile industry where stylists (as, for example, at *General Motors) were used to form a 'bridge' between the mechanical engineers and consumers by endowing cars with a visual identity through such means as body shape, dash-board or radiator grille design, as well as colour choices or interior fabrics.

Erector (established 1913) The highly popular Erector constructional toy was invented by the American inventor A. C. *Gilbert in 1913. Originally marketed under the name 'Mysto Erector Structural Steel Builder' it soon became one of the most popular toys in America, selling more than 30 million sets over the next 50 years. Its perforated miniature girders (said to have been inspired by skyscraper construction in New York) could be attached to gears, pulleys, bolts, and screws. This range was expanded in the 1920s to include curved girders which allowed the construction of more elaborate models, including Ferris wheels, lorries, and airships and, in 1940, the famous Parachute Jump set. Ten years later the Erector Amusement Park set was introduced. In 1930 Gilbert had bought the rights to the US manufacture of the English

ERGONOMICS

Although there had been many studies into work efficiency earlier in the century, particularly in such fields as kitchen design, which underwent considerable changes in the early 20th century, the use of the term 'ergonomics' in connection with design was increasingly used in the decades following the end of the Second World War. Literally meaning the scientific study of the efficiency of human beings in their work environment, ergonomics was an important aspect of efficient work practices during the war. Known also as 'human engineering' or 'human factors' in the United States and 'biotechnics' in a number of European countries it was of increasing interest to those involved in design in industry and resulted in the establishment of numerous societies (such as the Ergonomics Research Society, established 1949), courses, and conferences around the world. Such leanings were in tune with the rise of the *Design Methods movement that emerged in the later 1950s, an approach to designing that had a legacy in certain aspects of *Design Management and the focus of the Design Research Society. Ergonomics also emerged in relation to the study and influence of *Anthropometrics.

See also GILBRETH, LILLIAN; SCHÜTTE-LIHOTSKY, MARGARETE.

constructional toy *Meccano, although this aspect of Gilbert's operation only lasted until 1938. After Gilbert died in 1961 the company became bankrupt in 1966, the rights to the company name and Erector being taken over successively by the Gabriel Toy Co., Ideal Toys, and others before being purchased by Meccano SA in the late 1980s.

Ergonomics *See* box on this page.

Ergonomidesign (established 1969) Founded in Stockholm in 1969, this Swedish consultancy has established an international reputation for the production of elegant, yet highly practical, designs for the disabled and, in 2003, employed 27 industrial designers, engineers, and ergonomists. Key members have been Maria Benktzon (b. 1946) and Sven-Eric Juhlin (b. 1940) who joined Ergonomidesign in 1973 and 1976 respectively. Pioneers in the field, they were committed to finding aesthetically pleasing and stylish design solutions that were able to bring the disabled into the mainstream of everyday consumption.

In 1972 they had worked on a project on ergonomic handles and grips for the Swedish Institute for the Handicapped, geared towards those with impaired muscular strength. Building on this experience, rigorous research and consultation with medical experts underpinned many of their designs. Their 1974 *Ideal* kitchen knife, manufactured by the leading Finnish company Hackman for the Institute for the Handicapped, exemplifies this. Although designed for those with arthritic hands, its attractive design appeals to a far wider audience. Its aesthetic standing is acknowledged by its inclusion in the Permanent Collection of the *Museum of Modern Art, New York, and its social significance by the fact that it is still in production. Other notable designs that Ergonomidesign has worked on include *Eat and Drink* tableware (1978), aesthetically pleasing but designed for those with disabilities (also in the MOMA Permanent Collection and a recipient of the Excellent Swedish Design Prize) and the highly flexible and versatile *Ambulance*

Stretcher (1983), designed for Hejde Ambulanser and used in all ambulances in Sweden (awarded the Excellent Swedish Design Prize in 1987). Practical design solutions also underpin the safe and easy-to-use *Baby Carrier* for BabyBjorn (Design of the Decade Award, 1999, and Focus Mobilitat Award, 2001) and the *Injection Pen for Genotropin* (1996), which was designed for children with hormone growth deficiency (Gute Industriform Germany Award, *IDSA, and Good Design Japan Awards, all 1996). In 2002 Ergonomidesign founded a new company in Japan (Ergonomidesign Japan), the first Swedish industrial design consultancy located abroad, with Dag Kilogstedt as its managing director. In the same year the company was awarded a Gold Prize at the Japanese *Good Design Award competition for its design of the *Speedglass* welding helmet and *Adflo* respirator, one of only two non-Japanese of ten awards. It also received four Design Awards in the same competition, including products for Bahco Tools and a plate and spoon for BabyBjorn.

Ericson, Estrid (1894–1981) Pewter designer and design entrepreneur Estrid Ericson was the founder of the highly influential Stockholm store and manufacturer *Svenskt Tenn, a company closely associated with the *Swedish Modern aesthetic and success in export markets. From 1913 to 1915 she studied at the Stockholm University School of Arts and Crafts and, after working at Svensk Hemslöjd and Willman and Wiklund, founded Svenskt Tenn with pewter designer Nils Fougstedt in 1924. In the following years the company's reputation was enhanced by participation in a number of exhibitions in Stockholm, Gothenburg, Zurich, New York, Copenhagen, and Barcelona, although its most significant success was at

the 1925 Exposition des Arts Décoratifs et Industriels, where Ericson was awarded a Gold Medal. In 1932 she made her first contacts with the émigré Austrian designer Josef *Frank, who, two years later, joined Svenskt Tenn and became a shaping force in the company's design outlook. The work of Ericson and Frank continued to receive critical acclaim through exhibitions in Sweden and abroad, including the *Paris Exposition des Arts et Techniques dans la Vie Moderne 1937, the *New York World's Fair of 1939–40, and the Golden Gate International Exposition in San Francisco of 1939. The company continued to prosper in the post-Second World War years. At the age of 81 Ericson sold it to the Kjell and Marta Beijer foundation in 1975 although she retained her managerial role for a further four years before handing over to Ann Wall. She continued to design until her death in 1981 when she left her estate to a foundation named after her.

Esprit nouveau, L' (1920–6) This avant-garde magazine, edited by Amadée Ozenfant and Le *Corbusier, carried a wide range of topics and ideas, ranging from arts and literature to architecture and science. Initially subtitled 'Revue internationale d'esthétique' and later 'Revue internationale illustré de l'activité contemporaine ... arts, lettres, sciences' it provided Le Corbusier with a vehicle to explore his ideas on urbanism and architecture and present a radical vision of a *Modernist world.

Esslinger, Hartmut *See* FROGDESIGN.

Exner, Virgil (1909–73) One of the foremost American automobile stylists in the years following the end of the Second World War, Exner is most widely known for his extravagant 'idea cars' and sculptural essays

in 'space age' tail fin designs for the *Chrysler Corporation. He attended art classes at the University of Notre Dame briefly in 1926–7 before taking up a job working on advertisements for the Studebaker Company. Having come to the attention of Harley *Earl at *General Motors, he was hired to work in the Pontiac design studio. Later, in 1938, he worked for Raymond *Loewy's consultancy on the design of Studebaker cars, including the 1947 *Starlight* coupé, for which most of the critical acclaim has gone to Loewy. In 1949 he became head of the Advanced Styling Studio at Chrysler and worked on a number of 'idea cars' such as the *K-310*, the Dodge *Firearrow*, the DeSoto *Adventurer*, and the Plymouth *XNR*, all of which were crafted by the *Ghia coachbuilders in Italy. In fact Exner transformed the appearance of Chrysler cars from boxlike structures to long, low, elegant machines, shifting the company's design policy away from one that was dominated by body engineers. Exner's aesthetic was characterized by the use of elongated tail fins, an overall aesthetic that he called the 'Forward Look'. This, combined with a number of technological innovations, led to a significant increase in Chrysler's market share and his election to the post of vice-president of styling in 1957, the same year in which he and his design team received a Gold Medal award from the Industrial Designers' Institute. One of the reasons for the strongly 'sculpted' feel of many of these designs resulted from Exner's tight control of the clay modelling studio and insistence on the final say in the approval of die models. Exner himself felt that his major contribution at Chrysler was not so much in his designs for the corporation but in the ways in which he transformed the styling organization at Chrysler. He left Chrysler in 1962, setting up his own industrial design consultancy in Michigan. He worked on a variety of projects including pleasure boats for the Buehler Corporation, plans for a revival of classic Duesenberg cars, and designs for Stutz, Packard & Mercer.

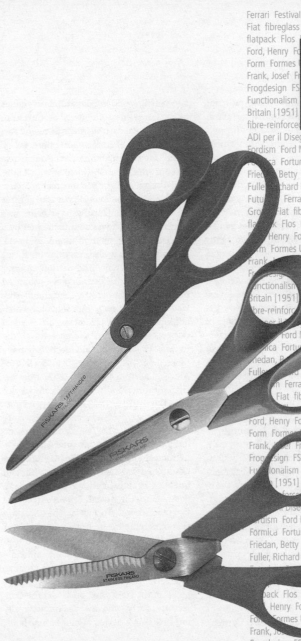

Ferrari Festival of Britain [1951] Festival
Fiat fibreglass fibre-reinforced plastic Fi
flatpack Flos Fondazione ADI per il Dise
Ford, Henry Fo Europe Fordism Ford N
Form Formes es Formica Fortune Fra
Frank, Josef Fr Paul T. Friedan, Betty
Frogdesign FS ller, Paul Fuller, Richa
Functionalism ndació BCD Futurism I
Britain [1951] tival Pattern Group Fia
fibre-reinforced astic Fiskars flatpack
ADI per il Disegno Italiano Ford, Henry F
Fordism Ford Motor Company Form For
 ca Fortune Franck, Kaj Frank, Jose
Frie Betty Fritz Hansen Frogdesign
Fulle chard Buckminster Functionalisn
Futu Ferrari Festival of Britain [1951
Gro Fiat fibreglass fibre-reinforced pl
fla k Flos Fondazione ADI per il Dise
 Henry Ford Europe Fordism Ford N
 m Formes Utiles Formica Fortune Fra
Frank Paul T. Friedan, Betty
Fi g Paul Fuller, Richa
 unctionalism BCD Futurism I
Britain [1951] Pattern Group Fia
 bre-reinforc ic Fiskars flatpack
 er il gno Italia Henry F
 Ford Moto any F For
 ica Fortu ck, Kaj Fra Jose
 iedan, B Hansen Frog sign
Fulle d Buckminster Fu ionalisn
 Ferrari Festival of tain [1951
 Fiat fibreglass f re-reinforced pl
 azione ADI per il Dise
Ford, Henry Ford Europe Fordism Ford N
Form Forme Formica Fortune Fra
Frank, Fram Friedan, Betty
Frog sign FSB Fu Fuller, Richa
H ionalism Fund D Futurism I
 [1951] Fes ern Group Fia
 fasc iskars flatpack
 Disegno Italiano Ford, Henry F
 rdism Ford Motor Company Form For
Formica Fortune Franck, Kaj Frank, Jose
Friedan, Betty Fritz Hansen Frogdesign I
Fuller, Richard Buckminster Functionalisn
 [1951
 pl
back Flos Fondazione ADI pe se
 Henry Ford Europe Fordis rd N
For ormes Utiles Formica une Fra
Frank, J edan, Betty
Frogdesign FSB Fuller, Paul Fuller, Richa
Functionalism Fundació BCD Futurism I

Ferrari (established 1947) The prancing horse logo of this leading Italian car manufacturer has long been recognized throughout the industrialized world, with victories in countless automobile racing championships culminating with successive victories in the Formula 1 Championship in the early 21st century. Founded by Enzo Ferrari in Modena for the production of sports cars, the company's cars have subsequently exuded style and eroticism, commencing with the *Type 125* of 1947. Amongst the eminent designers who worked for Ferrari were *Bertone, who designed the *Dino 308 GT4*, and *Pininfarina, whose work for the company included the *GTB4 Daytona* of 1968, the exuberant *Testarossa* of 1984, the *328 GTB* of 1985, and the *Mythos* of 1989. Other designers who helped to sustain the Ferrari aura of luxury included Iosa Ghini, who designed showrooms for the company in 1994.

Festival of Britain (1951) The Festival of Britain (FOB) was seen both as a public morale booster and an opportunity to remind the world of Britain's contribution to past, present, and future contributions to society, culture, and technological progress. More specifically in terms of design it provided the *Council of Industrial Design (COID) with an important stage for the promotion of well-designed British products in her national drive for economic recovery in the post-Second World War period, particularly on the major South Bank, London, site. However, the Festival was not merely a London-based exhibition as there were also, in addition to the South Bank, sites in the capital at Battersea Pleasure Gardens

and Lansbury and major exhibition venues in Glasgow (the Exhibition of Industrial Power) and Belfast (the Ulster Farm and Factory Building). Furthermore, there was a Land Travelling Exhibition, the main features of which were concerned with industrial design and production technologies, which toured the major industrial centres of Birmingham, Manchester, Leeds, and Nottingham. This was complemented by a Sea Travelling Exhibition mounted on the Festival Ship *Campania*, visiting ten major ports around Britain. The patriotic flavour of the Festival was considerably enhanced by Abram *Games's festive design of a stylized Britannia in red, white, and blue which appeared on a wide range of Festival posters, publications, and souvenirs. The idea of the Festival had been originally mooted in 1943 by the Royal Society of Arts, followed in 1945 by a letter from design authority and reforming campaigner John Gloag to *The Times* and an open letter from *News Chronicle* editor Gerald Barry to Stafford Cripps at *The Times*. It had also been originally envisaged as an international exhibition, an idea endorsed by the Ramsden Committee in 1946. However, although intended as an exhibition that would demonstrate to the world Britain's recovery from the Second World War, the uncertain economic climate in Britain of the later 1940s led to the downgrading of the Festival from an international to a national exhibition. It also became something of a political football in the late 1940s, particularly at the hands of the right-wing press and the Conservative Party, who saw it as economically imprudent in a period of rationing, labour,

and materials shortages. However, when the Festival actually opened it caught the public imagination with optimistic notions of a future world brought about by advances in science and technology, of better designed domestic and urban environments, a vision far removed from the contemporary constraints of wartime austerity and continuing rationing. Eight and a half million visitors flocked to the South Bank site alone. From the outset design was an important consideration throughout the official Festival sites, with control of design selection delegated to the COID, itself well represented on the major Festival committees. One of the COID's main jobs was to select all industrially produced products on show. Commencing in 1948, a photographic index of all products—the *Stock List*, later renamed the *Design Review*—selected by the selection panels that represented particular industries, was launched. In order to qualify for selection products had to be designed and manufactured in Britain and in current production. One of the main venues where the public could see the ways in which design could impact upon their lives was in the Homes and Gardens Pavilion on the South Bank, where many furnished rooms were on display, showing modern domestic furniture, furnishings, ceramics, glass and metalware, and domestic equipment. In the Living Architecture Exhibition in Poplar in East London, part of the display was (following the modus operandi of many design reform organizations in Britain) a show house, furnished for less than £150 with items approved by the COID. As part of a future wider urban environment visitors to Lansbury could also see a model shopping centre and primary school. Other aspects of environmental design at the Festival—street furniture, lighting, concrete flower planters, signposts, and architectural lettering—

exerted a considerable influence on townscapes and shopping precincts in Britain over the following decade. The COID also sought to harness design to advances in technology and science—also displayed in other Festival sites such as the Science Museum, London, and embodied in Ralph Tubbs's striking Dome of Discovery and Powell and Moya's tapering Skylon—through the activities of the Festival Pattern Group, coordinated by Mark Hartland Thomas, the COID's Chief Industrial Officer. Crystallography was a field in which Britain led the world and its diagrammatic representations of a variety of substances provided the Festival Pattern Group's inspiration for carpet, textile, ceramic, glass, and many other forms of applied surface pattern. It eventually involved 26 manufacturers including *Josiah Wedgwood, Warner & Sons, Warterite, Chance Brothers, and Goodearl Brothers. Visitors to the South Bank could experience at first hand many of the Festival Pattern Group's designs in the Regatta Restaurant designed by Misha *Black. But the difficulties of 'inventing' a contemporary style, especially if generated by an agency of the state, proved problematic for both manufacturers and consumers and Festival Patterns had only an ephemeral appeal for consumers. However, as Michael Frayn suggested in his seminal essay on 'Festival' in 1960, the modern designs seen in many of the displays on the South Bank symbolized the social democratic values of the educated middle classes. The latter were described as 'Herbivores' and their opposite, the rather more conservative 'Carnivores', as the right-wing upholders of the traditional values of an imperial Britain embedded in the pre-war years. In the same way, the modern design outlook of the COID at the Festival was counterbalanced by much that was enjoyed by the public at the Festival

Pleasure Gardens in Battersea. These ranged from the Regency pastiche settings by Osbert Lancaster and John Piper to the period glamour of costumed Nell Gwynne orange-sellers and Roland Emmett's parody of the pioneering steam locomotives of the Industrial Revolution in his eccentric, widely publicized Far Tottering and Oyster Creek Railway.

Festival Pattern Group See FESTIVAL OF BRITAIN.

Fiat (established 1899) Founded in Turin by Govanni Agnelli in 1899, the Italian Fiat (Fabbrica Italiana Automobili Torino) company grew to become Europe's leading automobile manufacturer. For much of its existence the company has been involved with the volume production of cars, commencing with the *Tipo Zero* of 1912, and was heavily influenced by *Fordist approaches to mass production. The First World War increased demand for the company's products and in 1919 the company began work on a new factory at Lingotto designed by Giovanni Matteo-Trucco with its almost *Futurist test track on the roof. Although luxury and racing cars were a significant feature of Fiat's profile in its earlier years the company increasingly sought to cater for a larger market sector. Designs such as the *508 Balilla* saloon of 1932 and the affordable, small Fiat *500* of 1936, popularly known as the *Topolino* (Mickey Mouse), designed by the engineer Dante *Giacosa, reflected such an outlook. It also hired stylists such as *Bertone and *Pininfarina to work on designs such as the streamlined Fiat *1500* of 1935 and established a new factory at Mirafiore in 1939 to cope with increased demand for the company's products. After the Second World War the company's rapid growth was an integral part of Italy's 'Economic Miracle', accompanied by a number of innovative small cars for the

urban environment, the rear-engined Fiat *600* of 1955 and the *Nuova 500* of 1957 designed by Giacosa. This tradition of compact cars has been a constant thread of Fiat's production, other notable stylish yet practical designs being the 1980 *Panda*, the 1983 *Uno*, and the 1993 *Punto* designed by Giorgietto *Giugaro, who had first worked for Fiat at the company's Centro Stile, established in the mid-1950s with Felice Mario Boano and his son Gian Paolo. Throughout its history of growth and development the company made many acquisitions, including Lancia and *Ferrari in 1969 and *Alfa Romeo in 1987.

Fibreglass See GLASS-REINFORCED PLASTIC.

Fibre-Reinforced Plastic See GLASS-REINFORCED PLASTIC.

Fiskars (established 1949) This Finnish tool manufacturing company has achieved international recognition for its simple, ergonomic designs, gaining a number of design awards for its products, including the IDN Prize in the Netherlands in 1988, the IDF Good Industrial Design Prize in Germany in 1994 and 1996, and the European Design Prize in 1997. The Fiskars *Classic* scissors designed by Olof Bäckström with their distinctive orange ergonomic handles of 1967 achieved the status of a design icon. They also marked the success of the company in making the transition from a national manufacturer to one which made a significant impact on export markets in the United States, Great Britain, and elsewhere. Quality control has been an important aspect of company policy and all Fiskars products are tested rigorously under working conditions. Design innovation was also important in the company's success, with notable examples being the *Handy* axe (1995) and the *Clippers* garden

pruners (1996), both designed by Olavi Lindén.

Flatpack The flatpack has become an intrinsic part of everyday life in the worlds of retailing and consumption. The term generally relates to items of furniture that have been specially designed to be taken away from stores, their component parts packed flat to minimize size, and assembled by consumers in their homes. This aspect of self-assembly has been simplified as far as possible and requires only very basic tools such as a screwdriver and a minimal level of skill. Packed flat at the factory in which the parts are made, this enables quantities of furniture to be transported economically, leading to savings in distribution costs for the manufacturer, storage costs for the retailer, and thus for the consumer. Such ideas have a long history, going back to the middle of the 19th century and earlier. The manufacturer *Thonet had used the technique for the distribution of its furniture, as with its famous *No. 14* chair of 1858, which was composed of six basic component parts and assembled with minimal skill at the retail end of the business, selling several million units by the early 20th century. The concept became increasingly widespread in the decades following the end of the Second World War, popularized by companies such as *IKEA in Scandinavia, which introduced its first self-assembly flat-pack range in 1956 and a self-service open warehouse in Stockholm in 1965. With the rapid growth of car ownership, later considerably boosted by the notion of shopping-as-leisure and out-of-town retail outlets, the attraction of drive-away flat-packs was considerable and exploited by a growing number of retailers, including *Habitat in Britain.

Flos (established 1962) The furniture manufacturers and entrepreneurs Dino *Gavina and Cesare *Cassina founded Flos, a company that became one of the leading Italian light manufacturers in the second half of the 20th century. Its origins lay in the energy of Arturo Eisenkeil who, in 1959, was seeking to find applications for a new, plastic-based material that he was importing to Italy from the United States. Called 'cocoon', it was a spray-on plastic coating that Gavina and Cassina recognized as having potential for lighting design. From the outset Flos established its reputation through its innovative lighting designs from Achille and Piergiacomo *Castiglione, their early designs for Flos including the *Arco* floor lamp (1962), and the *Toio* lamp (1962), the latter fashioned from a car headlight mounted on a pole. Many well-known designers went on to design for the company including Tobia *Scarpa, who contributed the *Fantasma* floor lamp (1962), the *Biagio* table lamp (1968), and *Arriette-1-2-3* ceiling lamp (1973). Other distinguished designs included the *Parentesi* (1970, winner of the *Compasso d'Oro in 1979), designed by the automobile stylist Pio Manzu and Achille Castiglione. In 1974 Flos purchased one of its competitors, *Arteluce, another Italian progressive lighting company. Other designs for Flos and Arteluce included Australian Marc *Newson's *Helice* aluminium floor lamp (1992) and Frenchman Marc Sadler's *Drop* rubber wall lamp, which was awarded a Compasso d'Oro in 1995. The first Philippe *Starck lamp *Ârà* was produced in 1998, followed by the commercially successful colourful plastic *Miss Sissi* lamp (1991, awarded the Compasso d'Oro in 1995), the *Rosy Angelis* (1994), *Romeo Moon* (1996), and *Archimoon* (1998) series. Other lights commissioned by Arteluce in the closing years of the 20th century include Jasper Morrison's *Glo-ball* series (1998), Kostatin Gricic's *May Day* floor or suspension lamp, and Antonio *Citterio's ceiling lamp.

Fondazione ADI per il Disegno Italiano (established 2001) Founded in Milan, the Foundation for Italian Design was an important initiative of *ADI (Associazione per il Disegno Industriale, established 1956) and sought to promote the history of Italian design and its cultural legacy as well as looking to the future. It sought to educate the public in the ways that design could interrelate. Of major significance in the Foundation's mission was its commitment to the management of the historical *Compasso d'Oro Collection, which included all the award-winning products from 1954 to the present day. A further ambition of the Foundation was to bring together private and public organizations in support of the establishment of a Design Museum.

Ford, Henry (1863–1947) Born into a farming family in Greenfield, Michigan, in the United States, Henry Ford moved to Detroit in 1879 to work in machine shops, securing a post as an engineer with the Edison Iluminating Company in 1891. He made his first automobile in 1896 and, after three years, gave up his work with Edison to concentrate on automobile production with the Detroit Automobile Company, for which he was chief engineer and partner. At this time he produced two vehicles, a *Quadricycle* car and a delivery wagon. After a couple of abortive starts the *Ford Motor Company was established in 1903, early landmarks of which included the launch of the *Model T* in 1908, the establishment of the moving assembly line in 1913, and the building of the world's biggest automobile manufacturing plant in Baton Rouge (1917–27). By 1921 the Ford Motor Company accounted for 55 per cent of the total output of the automobile industry. Five years later, in 1926, Henry's son, Edsel B. Ford, became president of the company. On the latter's death in 1943 Henry took

up the presidency once more until his grandson, Henry Ford II, assumed the post in 1945. The automobile—like the railway, the radio, cinema, and the aeroplane—irrevocably transformed the face of American society and culture. In fact Henry Ford had recognized the significance of this as early as 1912, beginning to collect agricultural equipment and machinery from about 1912. From the mid-1920s this was consolidated as a firm project to establish the Henry Ford Museum and Greenfield Village as embodiments of US material progress, involving collaboration with Edward J. Cutler. The Edison Institute (Henry Ford Museum and Greenfield Village) was opened to the public in 1933, focusing on two key themes that commented upon the changing face of the USA. The Henry Ford Museum was dedicated to the history of invention and technology as reflective of cultural change; and Greenfield Village of the changing ways of life in America as seen in the preservation of farm buildings, shops, and businesses relocated in a village setting. Ford strongly believed in the power of objects, rather than books, as the communicators of ideas. The Edison Institute was listed as a National Historic Landmark in 1981 and was closed for a year from 2002 for restoration and rehabilitation. Ford and his son Edsel (1893–1943) established the Ford Foundation in 1936, first limited to the State of Michigan in the USA. From 1950 it became international and one of the richest philanthropic organizations in the world.

Ford Europe (established 1967) *See* FORD MOTOR COMPANY.

Fordism *See* box on p. 151.

Ford Motor Company (established 1903) This large multinational motor manufacturing corporation was established in Michigan in the USA in 1903. Created

FORDISM

An evocative concept for much of the 20th century, Fordism derives from the ideas of mass production evolved by Henry *Ford in the American automobile industry in the years leading up to the First World War. It remained a dominant economic approach in the market places of the industrialized world until the 1960s when many widespread assumptions about mass production and, more especially, the conformity of the consumer began to be challenged by a growing number of designers, thinkers, and consumers. The latter no longer accepted uncritically the dictates of powerful manufacturers who continued to provide ever-cheaper products for seemingly ever-expanding, yet homogeneous, markets in the decades immediately following the end of the Second World War. Some of these challenges to the industrial, corporate status quo were enshrined in the emerging outlooks of *Pop, *Postmodernism, and *Anti-Design, evolving at a time when terms such as 'Post-Industrial', 'Post-Fordism', and 'niche-marketing' also came into being. Texts such as Charles Jencks and Nathan Silver's *Adhocism: The Case for Improvisation* (1972), Eugene Schumacher's *Small is Beautiful: A Study of Economics as if People Mattered* (1973), and Ivan Illich's *Tools for Conviviality* (1973) signalled differing responses to such debates.

The most significant innovation in the context of Fordism had been the introduction of a moving assembly line in 1913, cutting the assembly time for a complete *Model T* Ford chassis from a little over twelve hours to about one and a half. Together with the allied concept of Taylorism—an approach to industrial efficiency on the factory floor evolved by Frederick Taylor, author of *Principles of Scientific Management* (1911)—Fordism had obvious economic implications for standardized mass production throughout the industrialized world. It represented the ever-increasing desire of manufacturers to expand the volume of production while, at the same time, reducing individual unit costs. Whilst it did much to underpin the economic power of the United States and other leading industrial nations, Fordism also attracted many vociferous critics, such as Aldous Huxley. In his novel *Brave New World* of 1932, Huxley portrayed standardization and conformity as serious threats to the freedoms associated with individualism and emotional expression. In his pessimistic vision of the 'Brave New World' Fordism had become the dominant religion, with Ford as God and Ford's best-selling autobiography as a replacement for the Bible. Charles Chaplin, who had experience of the automobile industry of Detroit, also attacked ideas of Fordism in his film *Modern Times* (1936), where the sheer monotony of assembly-line work drove the worker insane.

through the energy of Henry Ford, by the 21st century the Ford Motor Company embraced a number of famous brands including Lincoln, Mercury, Mazda, *Aston Martin, *Jaguar, Land Rover, and *Volvo. The most important early automobile produced by Ford was the *Model T*, introduced in 1908 and priced at $950 and remaining in production until 1927, by which time sales had reached 15 million. Essentially a utilitarian workhorse, one of its major attractions was its price, an attraction that lost its appeal with the introduction of the annual model change and greater range of

body styles and colours by other manufacturers, such as *General Motors, in the 1920s. An important innovation at Ford was the introduction of the moving assembly line, introduced in 1913 at Ford's Highland Park factory in Michigan, which had been designed by architect Albert Kahn. With its subdivision of labour and coordination of tasks, the moving assembly line led to considerable increases in efficiency, thereby giving the company a competitive edge and lowering the price for consumers. Ford also paid his workers almost double the wages paid by his rivals and reduced the working day. A change of emphasis became apparent in 1925 when the Ford Motor Company took over the Lincoln Motor Company and began to produce luxury cars, followed by a move into the middle-price range with the creation of the Mercury division in the 1930s. By 1927 the Ford Motor Company had developed its massive Baton Rouge factory in Michigan to such an extent that all aspects of automobile manufacturing, from raw materials to assembly, took place within a single complex. In the same year the Ford *Model A* was introduced, with a choice of colours and body styles, signalling a pronounced shift from the original Ford philosophy of 'any colour so long as it's black' to one that accepted styling as an essential aspect of consumer life in the USA. The next important innovation was the *V-8* engine, introduced in 1932. The company's Styling Department had been established in 1931 in which Eugene T. *Gregorie played an important role (1935 to 1938) and where, after the Second World War, George *Walker was also a strong influence (1949 to 1961). Well-known Walker-led models included the '49, the celebrated Ford *Thunderbird* (1955), and *Mustang* (1964), all of which were taken up in the late 20th century and early 21st century in Ford's Living Legends Studio, which designed and put into production new variants of these models, seen as 'powerbrands'. Another noted designer who worked for Ford in the post-war years was Gordon *Buehrig, whose designs included the 1951 *Hardtop*, the 1952 *Ranchero*, and the Lincoln *Continental Mark II*. After Ford became a public company in 1956 it developed a programme of global expansion in the 1960s symbolized by the formation of Ford Europe in 1967 from its British and German offshoots, which had themselves first been established, respectively, in 1911 and 1931. Well-known Ford models manufactured in Europe included the *Escort* (1968), the *Capri* (1969), derived from the American Ford *Mustang*, the *Sierra* (1982), designed by Uwe Bahnsen, the *Ka* (1996), developed under designer Claude Lobo, and the *Focus* (1999).

Form (established 1905) This important Swedish design periodical, the mouthpiece of the Swedish Society of Industrial Design (*Svenska Slöjdföreningen), was launched in 1905 under the title *Svenska Slöjdforeningen Tidskrift*, which was maintained until 1932. For many years it was a persuasive advocate of the role of art in industrial production and improving the taste of Swedish consumers. It is now issued on a bi-monthly basis with summaries in English and covers a wide range of design topics, with a particular emphasis on Sweden, with occasional special issues.

Formes Utiles (established 1949) This French organization was founded as a direct by-product of the 1949 *Union des Artistes Modernes (UAM) exhibition in Paris on the theme *Formes Utiles, Objets de Notre Temps*. It continued to debate the role of functionalism in design in the 1950s, seeing 'useful forms' as those which struck a precise balance between their function, structure, and

meaning. After gaining its independence from UAM in 1950 Formes Utiles mounted annual exhibitions at the *Salons des Arts Ménagers until 1987. It also published its magazine *Formes utiles*.

Formica (established 1913) Formica, a laminated plastic material, was filed for a patent in the United States in 1913, and the company started in the same year. However, its early applications were quite different from the durable laminated sheets with decorative surfaces associated with wipe-clean restaurant tabletops and interior decoration. Tough yet lightweight, at the beginning Formica proved to be a commercially attractive insulating material, well suited to applications in the rapidly growing electricity industry. A dramatic boost was given to the company in 1917 when the USA entered the First World War, with orders for radio insulators being placed by the Navy and the Signal Corps, in addition to demands for lightweight pulleys in Formica by aircraft manufacturers. In the early 1920s the company expanded and commenced production of automotive timing gears, selling significant quantities to Chevrolet, Studebaker, Buick, Pontiac, and others by the early 1930s.

The company had commenced production of laminates that imitated various veneers and these were first used on radio sets. However, with the advent of more efficient means of rotagravure printing processes initiated in 1927 Formica was able to produce a richer, more convincing series of wood-grain or marble effect sheets that could be used to decorative effect on furniture and interior furnishings. The enormous range of potential applications for this decorative material was evident and a sales force was established to capture the interest of architects, furniture manufacturers, and designers. One of the most pres-

tigious projects with which Formica was associated was in decorative wall surfaces in decorative wall surfaces in Cunard's *Queen Mary* ocean liner in 1937. It had earlier been widely used in Radio City Music Hall in the Rockefeller Center, New York. During the 1930s a range of technical improvements were made, increasing the range of available colours and designs, perhaps the most important being the introduction of the melamine resin in 1938.

With American involvement in the Second World War the company benefited from defence contracts, developing new insulating materials and alternative materials for the fabrication of aircraft propellers (*Pregwood*). In the post-war period the company focused on potential markets for the decorative laminates in both the public and private sectors. In the seven years after the war, 6 million houses were built in the USA with 2 million having Formica countertops in their kitchens. The material was also increasingly widely adopted in bathrooms. In 1957 the Formica company was purchased by the industrially powerful American Cynamid Company, and in 1960 the plastics giant De La Rue and Cynamid formed the new Formica International Limited, significant developments that facilitated the proliferation of decorative laminates around the world. The company made great efforts to promote its potential for architecture and design, as in its Formica House seen at the 1964 New York World's Fair. Ten years later the company established a Design Advisory Board and in 1980 the company launched its *Design Collection* laminates, no longer seen as substitutes for other materials but as aesthetic ends in themselves. Important was the development of *Color-Core, a new laminate in which the surface colour permeated right through the material, extending its potential uses for design, particularly furniture. Two prestigious and

critically successful ColorCore design competitions were launched in the 1980s, the first of which, *Surface and Ornament* (1983), was open to designers, architects, and jewellers and subsequently toured the world. Designers involved included Robert *Venturi, Stanley *Tigerman, Arata Isozaki, and Frank *Gehry. The second, *Material Evidence*, was a furniture competition involving designers used to working in wood and opened at the Renwick Gallery, Washington, prior to touring the United States. In the late 1980s further materials innovations were launched, including the *2000X* solid surfaced countertop range. This was promoted through a design competition for architects and designers entitled *From Table to Landscape*. Following other innovations and updating of existing ranges, in 1996 the company launched Formica Flooring, a laminated product that proved extremely popular. In the same year 1,200 Authorized Formica Design Centres were opened in kitchen and bathroom retail outlets as a means of persuading consumers of the potential impact of Formica products.

Fortune (established 1930) This important monthly American business magazine was founded by the publisher Henry Luce and was a strong advocate of the potential of industrial design for American manufacturing industry. It also set high standards in editorial design circles with a number of distinguished art directors contributing to its distinctive appearance, commencing with Thomas M. Cleland, who was followed after the Second World War by German émigré Will Burtin, the European-influenced Leo Leonni who succeeded him, and *Bauhaus-trained Walter Allner, who worked for the magazine from 1962 to 1974. Also notable for their high standards of design were the often colourful dramatic covers and illustrations. It was stated in February 1930 that 'the covers are to be a special feature' and that 'a design by a distinguished artist will appear each month, which will be made especially for printing in flat colours and will have the character of an original print'. They did much to convey the spirit of progressive technology that proved so exciting to the American public of the 1930s. Amongst the more celebrated designers contributing such work were Fernand Leger, Bauhaus graduate and tutor Herbert *Bayer, Hungarian-born Gyorgy Kepes, who had worked closely with *Moholy-Nagy in Britain and the United States, and American born Lester Beall.

Franck, Kaj (1911–89) A leading and influential Finnish industrial designer, Franck was a seminal figure in Finnish post-Second World War ceramic and glass design, ranking in importance alongside *Wirkkala and Timo *Sarpaneva. Throughout his career Franck's designs were characterized by a simplicity and clarity that acknowledged the power of vernacular traditions. He studied furniture and interiors at the Central School of Design in Helsinki from 1929 to 1932. He began his professional career designing lighting for Taito Oy in Copenhagen in 1933, furniture for Te Ma Oy, also in Copenhagen, from 1933 to 1937, and textiles for Associated Woollen Mills in Hyvinkää from 1937 to 1939. After the war Franck began to discover his true *métier* and artistic personality. He began working for *Arabia in 1945, producing dinnerware such as the celebrated 'mix and match' 1952 *Kilta* range which has sold more than 25 million pieces (and, after 1977, was marketed in a microwave safe version, *Keema*). He was made head of design at the company in 1950, a post he held until 1961. A glass designer for *Iittala in the late 1940s, he was made artistic director at the Nuutajärvi-Notsjö glassworks, a

post which he held from 1951 to 1976. From 1968 to 1973 he was also artistic director at Oy Wärtsila. In addition to a distinguished design career he also taught design, commencing in 1945 at his alma mater where, from 1960 to 1967 he was design director and, in 1970, was made professor. He won a number of prestigious awards including a gold medal at the 1951 *Milan Triennale and the Gran Premio in 1957. He was also awarded the *Lunning Prize in 1955 and the *Compasso d'Oro in 1957. A major exhibition of his work was held at the Museum of Modern Art in New York in 1992.

Frank, Josef (1885–1967) Austrian born Josef Frank emigrated to Sweden in 1934, where he worked for the *Svenskt Tenn design company until his death. His work is closely identified with the *Swedish Modern aesthetic that emerged in 1930s and was widely admired in the decades following the Second World War. After studying architecture in Vienna he completed his doctorate on the Renaissance architect and theorist Leonard Battista Alberti in 1910. Before the First World War he worked on architecture and interiors including the interior of the Museum of East Asian Art in Cologne in 1910. After the war he entered academic life, becoming Professor of Building Design at the Wiener Kunstgewerbeschule in 1919, a post he held until 1925. From 1921 to 1924 he worked alongside Peter *Behrens, Josef *Hoffmann, Oskar Straad, and Oskar Wlach on the design of Viennese apartment buildings and, in the following year, founded the Haus und Garten interior design firm. Most of his work in the later 1920s and early 1930s was centred on private and public housing, the most high profile of these projects being the design of a two-family home for the celebrated *Deutscher Werkbund housing exhibition at Stuttgart in 1927. In

1932 he made contact with Estrid *Ericson, the founder of Svenskt Tenn, and two years later emigrated to Sweden where he worked for the company until his death 33 years later. He played a key role in the company's showing at exhibitions in Warsaw and Prague in 1938 and the international *Paris Exposition des Arts et Techniques dans la Vie Moderne 1937, *New York World's Fair of 1939–40, and Golden Gate International Exposition in San Francisco of 1939. In the post-Second World War period his work continued to be widely admired and was celebrated in the *Josef Frank—20 Years at Svenskt Tenn* exhibition at the National Museum, Stockholm, in 1952. In 1965 he was awarded the Austrian national architecture prize and his work was celebrated in the Österreichische Gesellschaft für Architectur in Vienna.

Frankl, Paul T. (1887–1958) Paul Frankl was widely recognized for his attempts to establish an American iconography in furniture design, most notably with his 'skyscraper' furniture as powerful symbols of American economic power and technological progress. He was one of a number of European artists and designers who had emigrated to the USA in the early decades of the 20th century (along with Raymond *Loewy, Peter *Müller-Munk, Kem *Weber, and Josef *Urban) transmitting a progressive, yet decorative, aesthetic. An Austrian by birth, he had originally studied architecture and engineering in Vienna and other major European artistic centres, also travelling to Japan. He emigrated to the USA in 1914, where he soon established himself as a furniture and interior designer. He opened a shop in the early 1920s, selling his own furniture designs as well as imported wallpapers and textiles. He was a member of the *American Union of Decorative Artists and Craftsmen (AUDAC),

contributing an essay to its *Annual of American Design 1931*. He was an articulate writer, producing a number of books promoting modern decorative arts: *New Dimensions* (1928), *Form and Re-Form* (1930), and *Machine-Made Leisure* (1932).

Friedan, Betty (1929–) Widely known for her feminist text *The Feminine Mystique* of 1963, Betty Friedan came to represent the cause of many women 'trapped' in the rapidly growing post-war suburbs in the United States. After studying at Smith College from 1938 to 1942 she abandoned a doctorate in psychology, having studied at graduate school at Berkeley for a single year. She pursued a career in journalism, working for the Federated Press until 1946, when she was dismissed on account of her radical opinions at a time when the political climate was highly sensitive. She then worked for a union newspaper from 1946 to 1952. Having married in 1947, she moved to the suburbs, where she brought up her three children. This suburban experience endowed her with some real insight into the ways in which consumption-led housewives were 'trapped' in their homes. She painted a radically different picture from the one conjured up by the conventional American Dream. There the American housewife was 'freed by science and labor-saving appliances from the drudgery, the dangers of childbirth and the illnesses of her grandmother . . . she was free to choose automobiles, clothes, appliances, supermarkets; she had everything that women ever dreamed of'. In 1966 Friedan founded the National Organization for Women (NOW) which helped further consolidate her place at the heart of the feminist movement of the 1960s.

Fritz Hansen (established 1872) This major Danish furniture manufacturing company was founded in Copenhagen by cabinetmaker Fritz Hansen, who initially made and supplied furniture components and moved into the production of bentwood furniture. By the 1930s, in addition to wooden furniture, the company began to develop designs in tubular steel by the Dutch designer Mart Stam and others. However, after the Second World War the company began a series of important collaborations with architects and designers that transformed its output and reputation. One of the best known of these was Arne *Jacobsen, whose famous *Ant* (1951–2), *Egg* (1958), and *Swan* (1958) chairs have proved enduring successes in the market place. Other designer-manufacturer collaborations have included the *Chinese* armchair (1945) by Hans *Wegner, the *PK 22* chair (1956) by Poul *Kjaerholm, the *Superellipsis* table by *Mathsson and Piet Hein (1964), and the *System Chair 123* (1974) by Verner *Panton, as well as designs by foreigners such as Vico *Magistretti. Although the company was taken over in 1979, following a difficult financial period, it has retained its reputation for high-quality furniture and expanded its overseas markets.

Frogdesign (established 1969) This design consultancy had its roots in Esslinger Design, founded in Germany by Hartmut Esslinger in 1969, and has become a leading international force, best known for product design with a client list that has included *Apple, *AEG, Erco, *Rosenthal, *Sony, *Villeroy & Boch, Texas Instruments, and the airline Lufthansa. After graduating in electronic engineering at Stuttgart University and industrial design at the College of Design at Schwäbisch Gmund, Esslinger's early design work included products for the audio-visual equipment manufacturer Wega (taken over by Sony in the 1970s) and Hansgrohe, a leading German bathroom equipment specialist. In the 1980s

Esslinger worked on the identity of the Apple *IIc* computer, leading to the launch of the Apple Macintosh computer in 1984. Esslinger's sleek, light casing endowed it with a stylish yet accessible identity that set it apart from the relative mundaneity of its *IBM PC competitors and proved to be an important ingredient of the great attraction of Apple Macintosh for the everyday user. This stress on 'user-friendly' products was taken further in the company slogan 'form follows emotion', where the use of colour combined with an organic sensuousness has been tempered by a consumer-oriented understanding of functionalism. In 1982 Esslinger renamed his company as Frogdesign—the first four letters of which derived from the initials of the Federal Republic of Germany, establishing an office in California in the same year, followed four years later by another in Tokyo. By the 1990s the company's worldwide presence had extended to include further offices in the United States as well as Singapore and Taiwan. It had also extended its operations to include new media and corporate identity departments that, in the early 21st century, accounted for the major part of Frogdesign's business. The company's designs have won numerous awards internationally including the *Rat für Formgebung (German Design Council) Award for Product Design in 1969 and the Japanese MITI *G-Mark prize in 1990.

FSB (Franz Schneider Brakel, established 1881) Although the company had designed Walter *Gropius door handles for the famous Fagus works for many decades its products were generally aesthetically unremarkable. However, in the mid-1980s—like a number of other German manufacturers, such as the metalware producer *WMF and the ceramics, glass, and furniture makers Quartett—the company sought to invigor-

ate its products through inviting nine leading international architects and designers to conceive of designs for future household products. They included Hans *Hollein, Arata Isozaki, Alessandro *Mendini, and Dieter *Rams. Their design propositions were launched publicly in 1986 and discussed at a highly successful design symposium and designer workshops event, drawing attention to a rich variety of possible aesthetic solutions to everyday products.

Fuller, Paul (1897–1951) Best known for his classic jukebox designs for the *Wurlitzer Company in the 1930s and 1940s, Fuller emigrated to the United States from Switzerland soon after the end of the First World War. In the mid-1920s he worked as a designer of product displays for one of the leading Chicago department stores, Marshall Field & Co. In the following decade he turned his hand to a display relating to 'The Black Forest' for the *Chicago Century of Progress Exposition of 1933 before joining the Rudolf Wurlitzer Company two years later. He designed seventeen characteristically brightly coloured and 'lit-up' Wurlitzer jukeboxes whilst chief designer (1935–48) for the company, including the *312* (1936), the classic arch-topped *750 Peacock* and *850* models (1941), the *1015* (1946), and the *1100* (1947). He also designed an 'Alpine Village' display for the *New York World's Fair of 1939–40. In 1949 he opened his own design office, focusing his energies on furniture and piano design.

Fuller, Richard Buckminster (1895–1983) American Buckminster Fuller was widely known in and beyond the United States as an inventor, engineer, scientist, architect, philosopher, and writer who was committed to technologically sophisticated and innovative solutions to everyday living, informed by a strong regard for renewable

FUNCTIONALISM

The phrase 'form follows function' was coined by the American architect and designer Louis *Sullivan in 1896 in relation to organic growth. It has also been closely associated with ideas of 'fitness for purpose' advocated by many of those associated with design reform in the 19th century as well as the passionate advocates of *Modernism in the early decades of the 20th. However, notions of 'functionalism' for many Modernists were as much symbolic as real and reflected a commitment to a particular way of thinking about design. Their embrace of the 'machine aesthetic' was infused with enthusiasm for new materials and technologies and the exploration of abstract forms. Despite their apparent commitment to ideas of standardization few Modernists entirely surrendered their aesthetic principles for uncompromising functionalism.

See also MUTHESIUS, HERMANN; DEUTSCHER WERKBUND; CONSTRUCTIVISM.

energy resources. He was firmly opposed to what he saw as the outlook of the new profession of industrial design that had emerged in the United States in the later 1920s and 1930s (*see* LOEWY, RAYMOND; BEL GEDDES, NORMAN; TEAGUE, WALTER DORWIN), regarding it as characterized by superficial styling and notions of built-in obsolescence. Widely recognized for the invention of the geodesic dome, Fuller's ideas gained increasing currency in radical circles in the decades following the Second World War. He lectured around the world to audiences drawn from professionals and students who increasingly questioned burgeoning levels of conspicuous consumption in a period when there were growing anxieties about the longer-term availability of fossil fuels. Fuller wrote 28 books that together achieved sales of more than a million, with his ideas in tune with other writers such as Alvin Töffler, author of *Future Shock*. He also registered 25 US Patents.

After studying mathematics at Harvard University from 1913 to 1915 Fuller went on to serve in the US Navy from 1917 to 1919. From this time Fuller developed a keen interest in experimentation, innovation, and economic design solutions, particularly those that gained the maximum advantage from the minimum use of materials and energy. He called this outlook 'Dymaxion' and applied its philosophy to the design of housing and cars. His Dymaxion House concept, initially conceived in 1927, embraced the idea that its component parts could be factory made, were easily transportable and assembled on site, and utilized resources efficiently. At its core it had a central mast that contained the heating, lighting, and plumbing services, later reaching a high level of sophistication in the prototype lightweight Dymaxion Dwelling Machine developed at Wichita, Kansas, before the end of the Second World War in 1945. Seen as a radical and positive solution to housing shortages by *Fortune* business magazine, when the war came to an end it proved impossible to raise the $10 million necessary to put it into mass production at the hands of the Beech Aircraft Company. Other Dymaxion projects included the Dymaxion Bathroom (1932–8), Dymaxion Cars (1932–4), and Dymaxion Deployment Units (1940–1). Fuller's three-wheeled Dymaxion Cars (able to carry ten passengers) were streamlined in shape, with a maximum speed of

FUTURISM

(1909–1930s) The Italian avant-garde group known as the Futurists was launched through the publication of the Futurist Manifesto in Paris in 1909. Led by the writer, poet, and critic Filippo Tommaso Marinetti, the Futurists rejected the rich cultural legacy of Italy's artistic past in favour of the dynamism of modern technology and contemporary urban life, charged by the excitement of the new. They were largely based in the industrial north of Italy, which had seen the building of its first power station in Milan in 1883 and the launch of the *Fiat automobile factory in Turin in 1895. Industrialization had come to Italy comparatively late in comparison with its growth over a much longer period in Britain and Germany. Its highly visible impact dramatically led the Futurists to embrace the realities of intense social, cultural, and technological change. Their love of speed and danger was epitomized by contemporary racing cars, symbols of national pride and competitiveness. As Marinetti wrote in 1909: 'We declare the world's splendour to be enriched by a new beauty, the beauty of speed. A racing car . . . a roaring car . . . is more beautiful than the Victory of Samothrace'. The Futurists' admiration for rapid change as a vital ingredient of contemporary life was manifest in their belief that life should end at the age of 30. Although initially focused on the fine arts and literature, Futurism embraced many other dimensions of the visual arts and design, including architecture, fashion, furniture, typography, film, photography, theatre, and music. Futurist typographic layouts as seen in Marinetti's 'Parole in Liberta' (Words in Freedom) rejected traditional layouts in favour of dynamic, free flowing forms, with letters of differing sizes and emphasis. Giacomo *Balla's 1914 *Manifesto on Menswear* (later retitled *Antineutral Clothing*) sought to overcome the tyranny of the suit in favour of Futurist clothing which could be phosphorescent, decorated with electric light bulbs, and even inflated at will by the wearer to create a dramatic effect. Futurist ideology was also applied to the urban environment by the architect Antonio Sant'Elia who in 1914 exhibited a series of visionary drawings for the 'New City' in Milan and published his *Manifesto of Architecture*. Although a number of Futurists were killed in the First World War, Balla, Enrico Prampolini, and Fortunato Depero continued to promote Futurist furniture, interiors, and decorative objects in exhibitions in Rome and Milan in 1918 and 1919. Marinetti himself sought to ally Futurism after the First World War with the political agenda of the Fascists. However, it found its greatest expression in graphic renditions of Futurist cityscapes and posters in the 1920s.

120 miles per hour, a steerable tail wheel, and the ability to travel over rough terrain. Widely publicized in the media, three experimental versions were produced but, due to unfortunate publicity relating to an accident outside the *Chicago Century of Progress Exposition in 1934, Fuller's concept was never put into production. Like many of Fuller's other ideas that were not taken up it posed a threat to the styling-led outlook of the major automobile manufacturers.

After the Second World War Fuller developed the geodesic dome, a form of lightweight tensegrity structure that could span large spaces, gaining the patent in 1954.

These were taken up by the Ford Motor Company at Deaborn (1952), by the US Air Force for its Early Warning System Radomes (from 1955 onwards), with an example also manufactured from card by the Container Corporation of America for the *Milan Triennale of 1954, where it was awarded a Gran Premio. Geodesics were also built for many US government contributions to trade fairs around the world, as well as the New York World's Fair of 1964, and it has been estimated that more than 300,000 have been built for a variety of uses, from corporate to military, and from commercial enterprises to emergency housing.

Fuller held a number of teaching, research, and consultancy posts at several universities from the late 1940s when he began teaching at Black Mountain College. In addition to many honorary academic awards, he was the recipient of many architectural and design awards including the Gold Medal of the American Institute of Architects (1970). Eight years after his death the Henry Ford Museum and Greenfield Village commenced a programme of restoring, rebuilding, and opening to the public Fuller's Wichita Dymaxion House (1945). It was completed and opened to the public in 2001. Fuller's many books have included *Ideas and Integrities* (1963), *Operating Manual for Spaceship Earth* (1969), and *Utopia or Oblivion* (1970).

Functionalism *See* box on p. 158.

Futurism *See* box on p. 159.

Fundació BCD (Barcelona Centre de Disseny, established 1973) A private, non-profit-making foundation, the Barcelona Centre for Design (BCD) was established in 1973 with the aim of promoting design both as an instrument for industrial competitiveness and as a vehicle for providing society with a better quality of life. One of BCD's core activities is the development of marketing opportunities for Catalan and Spanish goods at home. Like many other design promotion organizations the BCD offers design advice and training to companies, particularly in the fields of product, environmental, packaging, and communications design. It is involved in developing effective design networks and runs a design information and documentation centre. Since 1987 the BCD has played a key role in the *Premios Nacionales de Diseño (National Design Prizes) which were founded by the BCD and the Ministry of Industry and Energy (later Science and Industry). Since 1997 BCD has also organized the biennial *Primavera del Diseño* (Barcelona's International Design Festival) established in 1991.

Gallé, Émile Gallen-Kallela, Akseli Game
Gardella, Ignazio Gardner, James Gaudí,
Gaultier, Jean-Pa..... GD Mark Ge
Gehry, Frankeral Motors Georg Jens
German D..... Council Ghia Giacosa, D
Siegfriedbert, A. C. Gilbreth, Lillian C
Ernest G....., Alexan..... ...ondi, Erne
Giorgettoaro Design Industrial
Glaser, Milt..... ...ss-reinfo.....d plastic G
G-Mark Gocar, Workshop:
William Goed Wonen Good Design Goc
G Plan Grange, Kenneth Graves, Michae
Gray, Milner Great Exhibition [1851] gre
Gregorie, Eugene T. (Bob) Gregory, Oliver
Gresley, Nigel Gretsch, Hermann Gropiu
..... Gucci Guerriero, Alessandro Gugel
.....d, Hector GustavSberg Gallé, Ém
.....mes, Abram Gardella, Ignazio
..... Gaultier, Jean-Paul Gavini
.....Bel Gehry, Frank Gene
.....rman Design Coun
.....d Gilbert, A. C. C
..... Girard, Alexand
.....tto Giugaro Des
.....er, Milton glass-r
.....ocar, Josef Gödö.
..... Goed Wonen C
.....range, Kenneth
.....r Great Exhibitio
.....e T. (Bob) Gregor
.....Gretsch, Hermann
.....erriero, Alessandr
.....vSberg Gallé, Ém
.....Gardella, Ignazio
.....Jean-Paul Gavini
.....ehry, Frank Gene
.....man Design Coun
.....d Gilbert, A. C. C
.....t Girard, Alexand
.....tto Giugaro Des
.....aser, Milton glass-r
.....ark Gocar, Josef Gödö
.....rd William Goed Wonen C
.....ard G Plan Grange, Kenneth
.....een Gray, Milner Great Exhibitio
.....gn Gregorie, Eugene T. (Bob) Gregor
Vittorio Gresley, Nigel Gretsch, Hermann
Group of Ten Gucci Guerriero, Alessandr
Guimard, Hector GustavSberg Gallé, Ém
Akseli Games, Abram Gardella, Ignazio
Gaudí, Antoni Gaultier, Jean-Paul Gavini
Geddes, Norman Bel Gehry, Frank Gene
Jensen Solvsmedie German Design Coun

Gallé, Émile (1846–1904) A leading figure in French *Art Nouveau ceramics and glass, Gallé is closely identified with the establishment of the École de Nancy in 1901, an enterprise that sought to decentralize French decorative arts from its Parisian dominance. His richly decorative work is inspired by his lifelong interest in botany and literary symbolism. Born in Nancy, he was apprenticed in his father's studios, where he gained experience of glass decoration and pottery. He also took lessons in drawing and botany before going on to pursue philosophy and minerology at Weimar from 1865 to 1866. Following this, he spent a period studying glassmaking in the Burgun, Schverer et Cie factory at Meysenthal before returning to Nancy to continue his experiments with glass. In 1871 he was involved with the organization of the *Art de France* exhibition in London, following which he established his own glass studios in Nancy. He later showed ceramics at the Paris Exposition Universelle of 1878 where exposure to the work of his contemporaries inspired him to pursue a more adventurous direction in his own artistic output. In 1883 he established woodworking studios and began to work in marquetry and, in the following year, exhibited at the *Union Centrale des Arts Décoratifs with 300 pieces of pottery and glass in a variety of styles. At the 1889 Exposition Universelle in Paris he showed furniture and glass designs, reflecting his interests in literary symbolism and nature as a source of inspiration. This resulted in the award of a Grand Prix and the French Legion of Honour and marked the maturity of an identifiable 'Gallé stylé'. In this period Gallé was working both in 'hand' and 'art' glass, the latter geared towards larger-scale production. Having established an Art Nouveau glassmaking business in 1889, in 1894 he built a large new glassworks at Nancy, employing a team of craftsmen-designers to work on designs that drew heavily on nature as a major source of inspiration. His workforce had reached 300 by 1900, the year in which he won further prizes for his glass and furniture at the *Paris Exposition Universelle and wrote *Contes pour L'Art*. In 1901, with Victor Prouvé and Louis Majorelle, he established the École de *Nancy, 'a provincial alliance of art industries' that sought to decentralize the decorative arts. A successful exhibition of the École's work was shown in Paris in 1903. In the following year (in which he also died), he opened a shop in London.

Gallen-Kallela, Akseli (1865–1931) Gallen-Kallela was a Finnish artist and designer closely associated with notions of National Romanticism, especially relating to the region of Karelia, also a source of inspiration for the Finnish composer Jean Sibelius. Of particular influence was the collection of folk poems formed in the middle of the 19th century by Elias Lönrot. Following a national competition in 1891 Gallen-Kallela illustrated this national epic known as the *Kalevala*, the vivid images of which soon became widely known throughout Finland. He also made a significant contribution to the Finnish Pavilion at the Paris Exposition Universelle of 1900 in which he painted frescoes on *Kalevala* themes in the

main dome, as well as designing textiles and furniture. His furniture designs were made by the Iris company, founded by a close friend, Louis Sparre. Like many other ventures associated with *Arts and Crafts, the Iris company was concerned with the production of well-designed, well-made furniture and ceramics. Gallen-Kallela's designs at Paris 1900 attracted considerable attention leading to the award of a number of Gold and Silver Medals at the exhibition. He worked in a wide range of design media, including *ryiji* rugs, which he modernized using geometric motifs derived from the Finnish landscape. His distinctive contribution to Finnish culture is preserved in the Gallen-Kallela Museum, which was originally built by him as a studio and family home between 1911 and 1913 and now contains a large body of his work, including paintings, graphics, textiles, jewellery, stained glass, and architectural designs.

Games, Abram (1914–96) One of Britain's leading graphic designers of the 20th century Games enjoyed a successful career that commenced in the 1930s and endured for more than six decades. Unlike a number of his contemporaries, such as F.H.K. *Henrion, who were influential in the development of design consultancies in Britain, Games was fiercely independent for much of his professional life, eschewing conformity in educational, commercial, and institutional regimes. After a brief, frustrating period at Saint Martin's School of Art in 1930 Games was employed as an assistant to his photographer father and then in the commercial art studios of Askew-Young (1932–6). However, from 1936 (when he was dismissed from Askew-Young) he worked as an independent designer. In his early years he was influenced by designers such as A.M. *Cassandre, Jean Carlu, Paul Colin, and Edward McKnight *Kauffer.

Aided by the publicity afforded by an article featuring his work in *Art & Industry* he was commissioned for poster designs by a number of important clients for whom design was important in corporate projection, including London Transport, the GPO (General Post Office), and Shell. Jack Beddington, the highly influential design director at Shell, recommended his appointment to the Public Relations Department at the War Office in 1941. As an official war poster designer he produced more than 100 posters that reflected an eye for striking, yet simple, *Modernist designs effectively conveying important messages to both civilians and fighting forces. A number of these designs proved controversial, including a 1941 Auxilliary Territorial Service recruiting poster that portrayed a glamorous woman soldier (the 'blonde bombshell') and his contribution to the *Your Britain, Fight for it Now* campaign for the Army Bureau of Current Affairs in 1942. The former was criticized both by the Army and the government as over-glamorizing the ATS. The latter, which revealed his socialist beliefs through the juxtaposition of a post-war vision of modern schools, housing, and health centres and the miserable reality of contemporary life endured by many, attracted the wrath of the War Cabinet. Although occasionally using photography as an ingredient in his work and highly skilled in the use of *Airbrush technique, drawing was at the root of his design work. After the war, Games returned to freelance design practice, based in his north London home, again working for a range of prestigious clients such as British European Airways (BEA), the British Overseas Airways Corporation (BOAC), *The Times*, the *Financial Times*, Murphy Television, and Guinness. In 1948 a number of leading British designers were invited to design a symbol for the *Festival of Britain of 1951. Against strong

competition which included Edward Bawden, Robin *Day, F. H. K. *Henrion, and Richard Guyatt, Games won the competition with a strikingly upbeat and festive design of Britannia in red, white, and blue which was found on a wide range of Festival posters, publications, and souvenirs. In addition to the wide range of graphic designs that covered a wide spectrum from postage stamps (including the 1948 Olympic Games and award-winning Jersey stamps of 1976) to book covers, from posters to corporate symbols (including the BBC (1952) and GKN (1968)), Games also worked in the field of product design. His best-known design in this field was the highly successful Cona Coffee machine which went into production 1959. Games received a number of awards in recognition of his versatility as a leading designer, including the OBE (1957), election as *Royal Designer (1959), the Queen's Award for Industry (1965), and a *D&AD lifetime achievement award (1991). He was also involved in design education, teaching at the *Royal College of Art (1946–53) in Professor Guyatt's School of Graphic Design and, particularly in the latter stages of his career, lecturing on and exhibiting his work at many universities and art schools throughout Britain.

Gardella, Ignazio (1905–) Involved with *Rationalism Italian architect and designer Milanese-born Gardella emerged as an influential figure in the years immediately following the end of the Second World War. He had studied civil engineering and architecture and was involved with the activities of the CIAM (Congrès Internationaux d'Architecture Moderne), his earlier buildings including a Tuberculosis Outpatient Clinic and Laboratory in Alessandria (1936–8). After the Second World War he designed buildings for clients including *Kartell at Binasco (with Anna Cas-

telli Ferrieri, 1966), *Alfa Romeo at Arese (1970), and *Olivetti at Ivrea (1959) and Düsseldorf (1960). He was also involved with design, including participation in the progressive 1946 exhibition of furniture for small apartments mounted by RIMA (Riunione Italiana Mostra per l'Arredamento), design of *The Chair* exhibition at the 1951 *Milan Triennale, and of the *Diagramma* chair for *Gavina (1957). He had also founded his own furniture firm Azucena in 1947 for which he designed pieces in the 1950s, a period in which he also participated in a jury for an early *Compasso d'Oro competition.

Gardner, James (1907–95) A leading British exhibition and museum designer, Gardner also worked as graphic artist and industrial designer. He attended Westminster School of Art, followed by a six-year apprenticeship at Cartier's the Jewellers of Bond Street, London. Subsequently he was employed at the Carlton Studios, a London-based commercial design consultancy, for much of the 1930s. However, it was not until after the Second World War that Gardner began to emerge as a major figure in museum and display design. He became chief designer for the landmark 1946 *Britain Can Make It* exhibition. This was the first of a series of commissions for the Council of Industrial Design (*see* DESIGN COUNCIL), including the *Enterprise Scotland* exhibition of 1947 and the *Festival of Britain of 1951. Other important official commissions followed, including the British Government Pavilion at the Brussels World Fair of 1958 and the British contribution to the Montreal World Fair of 1967. In the latter he portrayed the dynamic, creative side of life in 1960s Britain including in his display Carnaby Street fashions and an Austin Mini decorated with the Union Jack. He was also involved in mainstream

industrial design and interior design commissions. These included a prestigious commission from Cunard to design the superstructure and interior for their *QE2* ocean liner, for which he supervised work in 1966. Gardner's museum display work attracted particularly favourable notice from exhibition design professionals due to the way in which he was able to communicate the complexities of science, technology, and history in a simple yet effective manner. Amongst his greatest achievements were the Evoluon Museum for Philips in Eindhoven (1966), the Museum of the Diaspora in Tel Aviv (1978), the National Museum of Natural Science in Taiwan (1988), and the Museum of Intolerance, Los Angeles (1993). In 1989 he was awarded the *Chartered Society of Designers Medal for outstanding achievement in industrial design.

Gaudí, Antoni (1852–1926) Antoni Gaudí attracted considerable attention for his highly original and distinctive contributions to architecture in design in late 19th- and early 20th-century Spain. For the most part his original yet often technically sophisticated buildings were located in Barcelona, his artistic career developing alongside the establishment of Catalan identity. His early studies involved philosophy, history, economics, and aesthetics before he went on to study architecture under Gothic Revival architect Juan Martorell at the Escuela Tecnica Superior de Arquitectura. He graduated in 1878 when the region's cultural and political renaissance—the Rainaxença—was at its height. In the same year he presented a project for workers' housing at the Paris Exposition Internationale of 1878, the year in which he also designed lamp-posts in the *Modernismo style in the Plaça Reial in Barcelona. His standing had risen sufficiently to be

commissioned to build the Transatlantic Pavilion at the Barcelona World Fair of 1888 where he came under the influence of the *modernistas* (practitioners of Modernismo), the burgeoning Catalan avant-garde. Other influences included *Violet-Le-Duc, *Ruskin, and the *Arts and Crafts Movement. Gaudí's first commission of significance was for the Casa Vicens (1883–8) in Barcelona, built for a ceramics industrialist. This striking design involved considerable decorative use of brightly coloured ceramics on both the exterior and interior. The latter was in the Mudejar style, drawing on Arab ornamentation and the decorative styles found in 15th-century Granada. Of considerable importance to the further development of Gaudí's career was his relationship with the Güell family of industrialists. This led to a number of significant and striking commissions including the Pavellons Güell (1884–7), the Palau Güell (1886–8), and the Park Güell (1901–14). The striking sculptural and decorative quality of the roof of the Palau Güell (which also contained Gaudí furniture) was fashioned from the projecting chimneys and ventilation pipes. He covered them in broken pieces of ceramics (*trencadís*) that were to become a hallmark of much of his later work. The Parc Güell, never fully finished (and becoming public property in 1923), was a residential garden in Barcelona based on English models exploring the concept of the 'Garden City', such as Bedford Park. The Parc Güell contained a number of organically influenced buildings and combined Moorish traditions with flowing forms, especially in the serpentine bench running around the main plaza, colourfully decorated in broken pieces of ceramics. Other commissioned buildings included the Casa Calvet (1898–1904), which also included Gaudí-designed furniture (including the *Calvet* chair, originally of 1902, which

was reproduced as a heritage classic in the 1970s by *B. D. Ediciones de Diseño). These were the first of his furniture designs to reveal a strong naturalistic inspiration. His mature buildings included the striking Casa Batlló (1904–6) and the Casa Milà (1904–6) also known as *La Pedrera* or 'Quarry'. The undulating, flowing forms of the façade and the dramatic sculptural and decorative forms of the roof of the latter are amongst the most striking of Gaudí's designs. Gaudí's work was also increasingly widely recognized outside Catalonia, being exhibited at the Grand Palais in Paris in 1910, and at the Salón de Arquitectura in Madrid in 1911. However, Gaudí's attempt to build a 20th-century cathedral—the Sagrada Familia in Barcelona—preoccupied him until the end of his life and is perhaps his most widely known work. Still unfinished in the 21st century its organic sculptural forms bear testimony to Gaudí's structural and decorative imagination, rich with decorated organic detailing, much of it enhanced by Gaudí's hallmark of surface patterns created from pieces of broken ceramic. There is considerable debate about the extent to which the ongoing building programme remains faithful to Gaudí's original ideas.

Gaultier, Jean-Paul An extremely high-profile designer on account of his striking and often controversial fashion designs, French designer Gaultier has also worked on costumes for films and for the rock star Madonna, strikingly packaged perfumes and imaginative furniture, as well as releasing a record and co-presenting a *kitsch-oriented television programme *Eurotrash*. He emerged on the fashion scene in 1976 with his first ready-to-wear collection for Jean-Paul Gaultier Women; Jean-Paul Gaultier Men was launched in 1983. Many of Gaultier's collections have drawn on wide-ranging cultural and exotic references including *Dada•ste* (1983), *Russian* (1986, drawing on Russian *Constructivism), *The Rock Stars* (1987), and *Piercings and Tattoos* (1994). In 1989 he worked on the costumes for Peter Greenaway's celebrated film *The Cook, the Thief, his Wife and her Lover* (1989), later designing the costumes for Spanish film director Pedro Almodóvar's *Kika* (1994), Marc Caro and Jean-Pierre Jeunet's *City of the Lost Children* (1995), and Luc Besson's *The Fifth Element* (1997). Attracting widespread media attention and the eyes of a different audience were his celebrated costumes for Madonna's *Blond Ambition* world tour (1990). In 1993 Gaultier launched his first perfume for women and his first Hauture Collection *Gaultier Paris* in 1997. His design interests extend across a wide range of clothes and accessories including couture, ready-to-wear for men and women, jeans, leather goods, costume jewellery, umbrellas, scarves, ties, shoes, and glasses.

Gavina (established 1960) The origins of this Italian furniture-manufacturing firm lay in Bologna, where Dina Gavina began furniture production in 1949, although the company was not formally established until 1960. Gavina sought to explore a more artistically charged yet contemporary aesthetic that provided an alternative to the functional aspects of *Rationalism, the progressive language of the Italian avant-garde in the interwar years. Notable designs commissioned by Gavina included the lyrical, flowing form of Achille and Piergiacomo *Castiglione's *Sanluca* chair (1960), Marco *Zanuso's *Lamda* chair (1963), and Afra and Tobia *Scarpa's *Bastiano* sofa (1961, later produced by *Knoll International). In 1962 the company also attracted favourable attention through its reproduction of the 1920s classic tubular steel furniture by the *Bauhaus teacher Marcel *Breuer. Gavina was well connected in the Italian design

world and played an influential role in its development and was a co-founder with Cesare *Cassina of the innovative Italian lighting manufacturer *Flos. In 1968 Gavina sold his company to Knoll International.

GD Mark (established 1985) The Korean GD system echoed many others that had been in place in a number of other countries from the mid-20th century onwards (*see* DESIGN AWARDS). Seeking to attract the attention of Korean manufacturing industry and the consuming public to the economic and social benefits that may accrue from well-designed products, over 2,300 GD awards have been made by the *Korea Institute of Design Promotion. The criteria used to select such goods include product aesthetics, relationship with the user, environmental awareness, economic considerations, and consumer satisfaction.

Geddes, Norman Bel *See* BEL GEDDES, NORMAN.

Gehry, Frank (1929–) One of the most prominent American architects and designers of the late 20th and early 21st centuries, Canadian-born Gehry established an international reputation for his dramatic and innovative explorations of materials and structures. His work with American sculptors Richard Serra and Claes Oldenburg reflected his interest in unconventional and imaginative design solutions. After studying architecture at the University of Southern California and urban planning in the Graduate School of Design at Harvard, from which he graduated in 1957, he worked in a number of architectural offices including those of Victor Gruen Associates, Pereira and Luckman of Los Angeles, and André Remondet in Paris, where he lived between 1960 and 1962. In the latter year he established his own architectural prac-

tice in Santa Monica, California, assisted by Greg Walsh. In the late 1960s he experimented with laminated corrugated cardboard furniture, producing the economical *Easy Edges* series that included the *Rocking Chaise Longue* and the *Wiggle* chair. In the following decade he devoted his attentions to more gallery-oriented and exclusive furniture designs including the *Experimental Series*. In the 1980s he worked on furniture designs for *Knoll International, including the *Bentwood Collection* fabricated from interwoven maple wood strips taken from packing cases for apples, with ice hockey terms providing the names for individual items such as the *Powerplay* armchair and *Off Side* ottoman. Other designs for Knoll included the *FOG* (named after his initials) stacking chair of 1999 made of cast aluminium and stainless steel. Knoll International's Gehry Collection won numerous international design awards including *Time*'s best design, the *Roscoe Award, the ID Award (a Danish prize for product design), and the ASID (*see* INDUSTRIAL DESIGNERS SOCIETY OF AMERICA) Award, all for 1992. Gehry's buildings include the California Aerospace Museum, the Guggenheim Museum in Bilbao, the Fish Dance restaurant in Kobe, and the Entertainment Centre in Disneyland Paris. He has taught at a number of academic institutions including Harvard and Yale and is a Fellow of the American Institute of Architects.

General Motors (established 1908) Under the leadership of William C. Durant, General Motors (GM) was formed from a number of earlier automobile manufacturing initiatives in the United States. These included the Olds Motor Vehicle Company (established 1897), the Cadillac Automobile Company (established 1902), the Buick Automobile Company (established 1903), the Oakland Motor Car Company (established

1907, later Pontiac Motor), and the Chevrolet Motor Company (established 1911). This diverse constituency was reflected in the company's devolved design policy with the different divisions designing, manufacturing, and styling under different brand names. Fundamental in the long-term success of the company was the election in 1923 of Alfred P. Sloan as GM president and chairman of its Executive Committee in 1923. This appointment, one that he held until 1956, was important in establishing GM as a serious rival to the *Ford Motor Company, with Sloan's stated strategy of 'a car for every purse and purpose' (1924) instrumental in this. Equally significant was the appointment of Harley *Earl as chief stylist to the company in 1925, who also enjoyed long-term employment at the company until 1959. One of Earl's first significant design projects was the 1927 Cadillac *La Salle* with its flowing lines, the first mass-production model worked on by a stylist. In the same year Earl became the first head of GM's Art and Colour Section which, a decade later, became the Styling Section (later retitled Design Staff in 1972 and Design Center in 1992). Another Harley Earl design of note in the interwar years was the Buick *Roadmaster* of 1936. In the following year Earl produced the first of GM's 'concept' or 'Dream Cars', the Buick *Y Job*. Long and low, with elegant chrome detailing and electric windows it gave the public a dramatic vision of GM cars of the future. The importance of styling and the annual model change was reflected in the growth of the Section, building from a staff of 50 in 1927 to more than 1,000 in the late 1950s. GM divisions were also responsible for innovations other than styling, including the introduction of synchromesh gears by Cadillac in 1928 followed by shatterproof safety glass in 1929. In the following year the Cadillac *V-16* became the first produc-

tion car with a sixteen-cylinder engine, setting new standards for power and performance. Further safety considerations were also informed by GM's introduction of impact and rollover tests in 1934. The interwar years also saw considerable expansion of the company into overseas markets, commencing in 1923 when GM established its first European assembly plant in Copenhagen, Denmark. Manufacturing operations commenced in South America in 1925, in Australia in 1926, in Japan in 1927, in India in 1928, and in 1929 GM acquired the Adam Opel automobile manufacturing company in Germany. The ambitions of General Motors by the end of the 1930s were epitomized by the corporation's striking *Highways and Horizons* exhibit at the *New York World's Fair of 1939–40. Housed in a dramatic, streamlined building by architect Albert Kahn. Visitors were taken around the central display of Norman *Bel Geddes's dramatic *Futurama* on a moving travelator, giving them a vision—with full commentary—of the landscape of the United States in 1960, as if seen from a low flying aircraft. The dramatic futuristic metropolis of 1960, the highpoint of the exhibit, was characterized by large skyscrapers and multi-laned highways with streamlined cars and commercial vehicles. Emphasizing how important motor transportation was to this corporate glimpse of the future, visitors to the GM Pavilion emerged from the travelator onto a full-scale rendering of a 1960 street intersection where traffic and pedestrians operated on different levels.

After the Second World War the visual symbolism of progressive technology, accompanied by a meta-language of scientific allusion, built on the futuristic visions portrayed by large-scale corporations at the New York World's Fair. Such ideas were introduced to the public by terms such as

Hydra-matic (the first completely automatic shift transmission first introduced on Oldsmobile models of 1940), *Dynaflow* (the automatic transmission introduced by Buick in 1948), and *Powerglide* (introduced by Chevrolet in 1950). In the same period Cadillac and Oldsmobile introduced their high-compression V-8 engine, including the Oldsmobile *Rocket*, which went into production in 1948, commencing the 'Rocket' fever that gripped the stylists of the automobile industry over succeeding years. Harley Earl's styling of the chrome detailing and tail fins of the 1948 Cadillac derived from the *P-38 Lightning* bomber plane, features that were given fuller expression in other production models and a series of 'Dream Cars' or 'Cars of the Future' over the following decade. This was seen in the dramatic tail fins of the long, low Harley Earl-styled Buick *Le Sabre* of 1951 and a number of the futuristic 'Dream Cars' seen at the General Motors *Motorama shows staged by GM between 1949 and 1961. These included the *XP 21 Firebird* experimental gas turbine car (1954), the *Firebird II* and the 'Highway of Tomorrow' (1956), and the *Firebird III* (1959). Something of this progressive vocabulary was also visible in the styling of the Chevrolet *Corvette* sports car, which was put into volume production in 1953 as a counter to the growing number of sports cars being imported to the United States from Europe (11,000 in 1952).

General Motors had many other manufacturing interests, including aviation, railways, and domestic appliances. The latter were embraced by the Frigidaire Division, which mounted a series of promotional events for 'space age' kitchens that paralleled the futuristic aspects of the Motoramas. Entitled 'Kitchens of Tomorrow', these shows commenced in 1956 with complete room settings designed by GM Styling and built by the H. B. Stubbs Company.

With Earl's retirement from GM as vice-president in 1959, until 1977 Bill Mitchell played an important role in redefining the appearance of the corporation's automobiles, moving away from the extravagant styling and conspicuous consumption that had characterized American cars of the 1950s. He was more sympathetic to the more compact forms of European models that influenced the aesthetic of the 1959 Chevrolet *Corvair*. Subsequent figures of importance to design and styling at GM included Irvin W. Rybicki, Charles Jordan, and Wayne Cherry, the Advanced Concepts Center being established in 1983.

See also MITCHELL, WILLIAM.

Georg Jensen Solvsmedie *See* JENSEN, GEORG.

German Design Council (established 1953) *See* RAT FÜR FORMGEBUNG.

Ghia (established 1915) A leading Italian automobile body stylist company founded by Giacinto Ghia in Turin in 1915, the Carozzeria Ghia was known for classic designs such as the *Volkswagen *Karmann Ghia* (1955), car bodies for *Chrysler and luxury models, such as the Maserati *Ghibli* (1968). Giorgetto *Giugaro had become a director at Ghia in 1965 but the company was bought by the American manufacturer *Ford in 1972, resulting in designs for the Ford *Capri Ghia* (1974) and *Escort Mark II* (1975).

See also KARMANN, WILHELM.

Giacosa, Dante (1905–96) Giacosa was the celebrated Italian engineer who designed two of *Fiat's most celebrated small cars, symbols of the company's desire for affordable, mass-produced, and utilitarian urban transport. These were the Fiat *500* of 1936, known as the *Topolino* or 'Mickey Mouse', and the Fiat *Nuovo 500* of 1957. Having studied mechanical engineering at

Turin Polytechnic from 1922 to 1927, Giacosa moved into car design, joining Fiat in 1930. After a period designing diesel and aircraft engines he was put in charge of the company's automobile section. The resulting *Topolino* of 1936 was an important contribution with a number of innovations in the design of the chassis, the front suspension, and the placing of the engine, the latter being designed by Virgilio Borsattino. These and other engineering innovations helped facilitate the design of the car's striking aerodynamic body, produced in conjunction with the head of Fiat's body-styling department, Rodolfo Schaeffer. However, the project as a whole was coordinated and realized by designer-engineer Giacosa. The *Topolino's* 569 cc engine was also highly economical, running at around 80 miles to the gallon (30 km/litre), speedy enough at 50 mph (80 kph), and the car itself attractively priced at less than 10,000 lire. It remained in production, with some minor changes in its B and C versions, until 1955, by which time it had sold more than 500,000 units. After the Second World War Giacosa was associated with a considerable number of Fiat models. These included many other small car designs such as the rear-engined Fiat 600 of 1955 (with over 3 million produced globally), the highly economical and innovatory Fiat *Nuovo 500* of 1957, the Fiat 127 of 1971 and the 126 of 1972. Of these, the air-cooled, two cylinder rear-engined Fiat *Nuovo 500* has perhaps been the most widely known. Giacosa played a central role in the design of its body as well as overseeing the project as a whole.

Giedion, Siegfried (1888–1968) Giedion's text, *Mechanism Takes Command: A Contribution to an Anonymous History* (1948), has made a notable contribution to the ways in which the history of design has evolved, moving emphasis away from prevailing approaches that were generally concerned with style, artistic influences and movements and concentrating on the ways in which technology has impacted on all spheres of everyday life over a long period of history. Giedion had studied in Vienna, Zurich, and Munich under the influential German art historian Heinrich Wölfflin and was later closely associated with the German *Modernist architect, designer, and founder of the *Bauhaus, Walter *Gropius. Giedion was also an important figure in the early years of the CIAM (*Congrès Internationaux d'Architecture Moderne), founded in 1928 when he was appointed its secretary and, though a historian, acted as keen advocate of modern architecture for many years. In the United States he taught at the Massachusetts Institute of Technology and Harvard University, where he became chairman of the Graduate School of Design. The themes of his Charles Eliot Norton lectures at Harvard (invited through Gropius) provided the basis of another influential publication, *Space, Time and Architecture* (1941), and his other writings included *Walter Gropius, the Man and his Work* (1954).

Gilbert, A. C. (1884–1962) An American inventor of note and originator of the *Erector constructional toy in 1913, Gilbert originally trained at Yale Medical School before going on to found the Mysto Manufacturing Company (established 1909), which sold magic sets. In 1913 he launched the first *Erector* construction set, which consisted of perforated miniature girders which could be attached to gears, pulleys, bolts, and screws. It was considered by some to be more realistic than its British predecessor, *Meccano, launched by Frank *Hornby in 1901. Like Hornby, Gilbert's educational inventions covered a diverse field, including chemistry sets, a glass-

blowing kit (1920s), model trains (1946 to 1966, including the popular American Flyers), and an 'Atomic Energy Lab', complete with radioactive components and a working Geiger counter (1952).

Gilbreth, Lillian (1878–1972) A pioneering figure in scientific management in the home, Lillian Gilbreth has been credited with the invention of the foot-pedal operated rubbish bin and refrigerator door shelving. She worked closely with her husband Frank (1868–1924), and the Gilbreths used their own domestic setting and twelve children as the focus for many of their analyses into the efficient running of the home. Lillian studied literature at both undergraduate (1900) and Masters levels (1902) at the University of California at Berkeley. She married Frank in 1904 and, after an interval raising her family and working with her husband she gained a Ph.D. in the Psychology of Management at Brown University in 1915 with a dissertation addressing the elimination of waste in teaching—bringing together education and time and motion study.

Both Lillian and Frank Gilbreth were associates of Frederick Winslow Taylor, whose influential studies on efficiency in the workplace undertaken in the late 19th century were to impact upon many aspects of 20th-century life, ranging from *Fordism in the motor industry and efficiency in the home. Frank Gilbreth had been interested in such studies early in his career and applied them to bricklaying with substantial gains in efficiency. He also developed ways of recording movements visually with an apparatus he called the Cyclograph. Frank established himself as a business consultant with Lillian working alongside him at home with their family providing much of the data for their work on scientific management in the home. Frank filmed the children in their

daily routines and analysed their movements. In turn they recorded their experiences on charts. Lillian and Frank were partners in the management-consulting firm Gilbreth Inc. Lillian was a significant pioneer in engineering and scientific management and became a member of the Society of Industrial Engineers in 1921. In 1930 Lillian was commissioned by the Brooklyn Gas Company to analyse the kitchen as a problem of industrial production. This was one of the industry's early attempts to rationalize kitchen layouts, building on studies such as those by compatriot Christine Frederick's *Scientific Management in the Home* (1915) and Margarete *Schütte-Lihotsky in Frankfurt, Germany, in the mid-1920s. For the Brooklyn Gas Company Lillian sought to lay out the kitchen in such a way that it was made more efficient by sequencing the equipment to cut down any unnecessary tasks. Her consultancy clients also included General Electric.

After Frank's death in 1924 Lillian had become the first woman member of the American Society of Mechanical Engineers in 1926 and in 1935 was made a Professor of Management at Purdue University, the first female professor in the School of Engineering. However, after Frank Gilbreth's death she had faced a number of difficulties in a male-dominated profession, reflected earlier in the attitude of publishers who were often unwilling to credit her in books written jointly with her husband as they favoured male names. She also found that comparatively few in business were willing to take her seriously as an engineer, industrial psychologist, and specialist in industrial management. In 1966 she was awarded the Hoover medal of the American Society of Civil Engineers.

Gill, Eric (1882–1940) After an early architectural apprenticeship (1900–3) and

evening classes at the *Central School of Arts and Crafts, London, under the calligrapher and typographer Edward *Johnston, Gill moved to Ditchling near Brighton in 1907. For much of his early career he was heavily influenced by the philosophy of the *Arts and Crafts Movement, an outlook which strengthened his leanings towards communal living and making that he experienced through participation in a religious community of craftsmen, the Guild of St Joseph and St Dominic, in 1918. After moving to Wales he began to take a greater interest in lettering and illustration, undertaking work for Robert Gibbings's Golden Cockerel Press, as well as the design of typefaces such as *Gill Sans* (1929) and *Perpetua* (1930) for the Monotype Corporation. In 1928 he moved to Buckinghamshire and established his own press. With Serge *Chermayeff, Amadée Ozenfant, H. T. Wijdeveld, and the composer Paul Hindemith, he was also involved with plans to establish a new Bauhaus in the south of France, the Académie Européenne Mediterranée, a project which never came to fruition. Although he continued to work on sculptural commissions such as decoration for the new headquarters of London Underground (1929–30), British Broadcasting House (1929–31), and the Assembly Hall of the League of Nations in Geneva, his design work was recognized by his election as *Royal Designer for Industry in 1936.

Gimson, Ernest (1864–1919) A leading British craftsman, Gimson first trained under a minor Leicester architect and studied at Leicester School of Art. After hearing him lecturing on 'Art and Socialism' in Leicester in 1884, Gimson met William *Morris, who suggested that he could combine his socialist principles and practical skills by working with the British *Arts and Crafts architect J. D. Sedding. Like

many other arts and crafts practitioners Gimson became interested in *vernacular traditions, learning about traditional rush-seated chair-making from the rural craftsman Philip Clissett. Gimson soon built up a reputation for furniture design, although his company's success largely removed him from the process of making. He became involved with the *Art Workers' Guild and, in 1890, with W. R. *Lethaby and Detmar Blow, set up Kenton & Co., a company based on the principles of *Morris & Co. In 1893, the year after Kenton & Co. closed, Gimson moved to Gloucestershire with the furniture maker Sidney Barnsley and his architect brother Ernest. Made by Sidney Barnsley, Gimson's furniture continued to be characterized by a profound respect for the process of making and the appropriate use of materials. Gimson also worked in other design media, including metalwork and plasterwork, again informed by a knowledge of traditional techniques. Many of his designs and room settings were exhibited at the *Arts and Crafts Exhibition Society. Gimson's work and outlook provided a significant link between the largely handcrafted preoccupations of designers associated with the 19th-century Arts and Crafts reform movement and the drive of 20th-century organizations such as the *Design and Industries Association (DIA) to reconcile such precepts with industrial production. However, when in 1916 Gimson was offered membership of the DIA by Lethaby he refused it on the grounds that he did not wish to be associated with design for industrial manufacture.

Girard, Alexander (1907–93) American designer Girard's career embraced a wide range of disciplines including architecture, interiors, furniture, industrial, and graphic design. Having been brought up in Flor-

ence, Italy, he studied at the Architectural Association in London, graduating in 1929. He also studied in Rome and New York, where he opened an office in 1932. An early success in his architectural career was a Gold Medal at the 1929 International Exhibition at Barcelona for the design of the Italian Pavilion and that of the Guild of Florentine Craftsworkers. Having moved to Detroit in 1937 much of his early work was connected with the American automobile industry, for which he worked on interiors for Ford and Lincoln, becoming Colour Consultant to the *General Motors Research Centre in 1945. In 1952 he was appointed as Design Director of Textiles at leading furniture manufacturer *Herman Miller, for whom he also designed Textiles and Objects Shops in New York in 1961. In 1964 he was responsible for the distinctive corporate identity of Braniff International airlines that included a multicoloured fleet of aircraft. Girard was widely recognized through the gaining of a number of prestigious awards, including the Gold Medal from the American Crafts Council in 1955 for stimulating interest in folk art, a topic about which he wrote as well as revealing influences in his textile design. He was also a keen collector of folk artefacts from around the world and often incorporated colourful, geometric motifs into his textiles.

Gismondi, Ernesto (1931–) Italian designer and engineer Gismondi played an important role in progressive design circles. Having undertaken aeronautical and aerospace studies in Milan (graduating in 1957) and Rome (1959), he founded the lighting manufacturing firm *Artemide in Milan in 1959 with Sergio Mazza. From 1970 onwards he designed a number of lights himself, including the *Tholos* wall lamp (1979) and the *Zen* (1988) and *Tebe* floor lamps. His professional and entrepreneurial involve-

ment with progressive design currents in Italy was further evidenced by his sponsorship and presidency of the progressive *Memphis design group, as well as the vice-presidency of *ADI (Associazione per il Disegno Industriale), membership of the Council for the *Milan Triennale, and a number of ministerial commissions on various aspects of design.

Giugaro, Giorgetto (1938–) One of Italy's most renowned car designers, since the 1980s Giugaro has also been involved with design in many other fields including industrial design, clothing, and accessories. Having studied at the Turin Academy of Fine Arts his work attracted the attention of Dante *Giacosa, who recruited him to the Centro Stile at *Fiat in 1955. He moved on to join the car-styling company *Bertone in 1959 where his work included the Alfa Romeo *Giulia GT* and the Fiat *850 Spider*. In 1965 he became design director at the Turin-based *Ghia car body design company, working on projects for *Volkswagen and the Japanese Isuzu company, as well as designs for the 1966 Motor Show, most significantly the Maseratii *Ghibli* and De Tomaso *Pampero*. In 1968, with Aldo Mantovani and Lucio Bosio, he founded Italdesign, a company that offered a far more comprehensive service to automobile manufacturers than its body-styling predecessors, offering specialist advice relating to all stages from original design ideas through to the practicalities of mass production. Italdesign has been commissioned by many leading European manufacturers including *Audi, *BMW, *Fiat, *Renault, and *Volkswagen, working on such well-known models as the Alfa Romeo *Alfasud* (1972), the VW *Golf* (1974), and the Fiat *Panda* (1980), *Uno* (1983), and *Punto* (1993). Giugaro Design was established in 1981 as an industrial design consultancy with a client list

that has included Nikon, Seiko, and Necchi. Giugaro spA was established in 1987 to offer services relating to fashion and accessories.

Giugaro Design (established 1981) *See* GIUGARO, GIORGETTO.

GK Industrial Design Associates (established 1953) Now one of Japan's leading design consultancies, GK was founded in 1953 by four ex-students of Iwataro *Koike at the Tokyo National University of Fine Arts and Music—the company's initials deriving from 'Gruppe Koike'. In fact Koike was himself involved in a number of early GK design commissions. Amongst the company's early products were the *YD-1* sports motorcycle designed by Shinji Iwasaki and GK (1956) and the elegant (plastic-topped) glass soy sauce bottle for the Kikkoman Corporation (1959). The latter became a classic design which has remained in production for decades and won a *G-Mark Long Life Award in 1986. Kenji *Ekuan, one of GK's founder members, played an important role in the company's success through his cultivation of industrial contacts and key roles in design organizations.

In the later 1960s the company's activities took on a more comprehensive remit, including many aspects of signage and street furniture at Expo '70 in Osaka. From the mid-1970s GK set up a number of discrete companies to deal with a wide range of specialist services: product design and strategic planning; architecture and environmental design; graphics, from identity to software design; sport and leisure products; and technology and transportation. The company also has companies outside Japan, in the USA and Holland.

Glaser, Milton (1929–) A well-known American graphic designer, illustrator, and art director who is closely associated with the celebrated Push Pin Studios in New York and *Push Pin Graphics* magazine, Glaser has had a long and distinguished design career that has been highly influential on both sides of the Atlantic. He has also worked in furniture, product, and interior design. He studied painting, typography, and illustration at the Cooper Union for the Advancement of Science and Art in New York from 1948 to 1951, before moving to the Academy of Fine Arts in Bologna, Italy, where he studied under the celebrated painter Giorgio Morandi from 1952 to 1953. After returning to the United States he founded the Push Pin Studios in New York in 1954 with Seymour *Chwast, Edward Sorel, and Reynold Ruffins, establishing *Push Pin Graphics* magazine with Schwast and Ruffins in the following year. His graphic style at that time was eclectic and original, drawing on a wide variety of sources and style ranging from the Italian Renaissance to comic strips and visual ephemera. Push Pin Studios was a driving force in the advertising during the 1960s and 1970s, during which period Glaser absorbed the bright colours and bold forms of Op and *Pop Art typified in his iconic *Dylan* poster of 1967. Art director and vice-president for the *New York Magazine* from 1968 to 1976, he also played a key design role in many other magazines including *Paris Match*, the *Village Voice*, and *Esquire*. The Musée des Arts Décoratifs in Paris held a major retrospective of Push Pin Studio graphics in 1970 and Glaser's own work was celebrated in an exhibition at the *Museum of Modern Art, New York, in 1975. Glaser left Push Pin Studios in 1974, setting up Milton Glaser Inc. to follow up other his design interests—including furniture, product, and interiors—alongside his fertile interest in print. Key professional bodies in which he has held influential positions include the vice-presidency of the American Institute of

Graphic Arts (AIGA) and presidency of the *International Design Conference in Aspen in 1989.

glass-reinforced plastic (GRP) Known as glass-reinforced plastic (GRP) in Britain, fibre-reinforced plastic (FRP) in the USA, or by the trade name fibreglass (after the manufacturing company Fibreglass Ltd.), GRP has been used for a wide range of applications from car body panels and boat hulls to furniture and tennis rackets. It has the virtue of a good weight to strength ratio, rust resistance, and ability to be moulded in a wide variety of ways. It became increasingly widely used in the post-Second World War period, a pioneering design being the celebrated DAR Armchair by Charles and Ray *Eames for the 1948 Low-Cost Furniture Design Competition at the *Museum of Modern Art in New York. Very much paralleled by the organic forms found in much contemporary product, train, and automobile design in Italy, the flowing, sculptural form of the seat (supported on a metal frame) expressed the creative possibilities of the new medium. These were realized in subsequent designs such as Eero *Saarinen's elegant Tulip armchair of 1956. Verner *Panton was another designer to explore the expressive qualities of the medium in his moulded, cantilevered chair of 1960 first manufactured in West Germany. Many furniture designs first manufactured in GRP have subsequently been manufactured in *ABS plastic. Early use of GRP in automobile manufacture included the roof of the Citroen DS (1955) and the body panels of the Chevrolet Corvette (1953). From the 1970s improved production processes engendered more widespread uses in architecture and interior design, whether in terms of weather resistant details and services or bathrooms.

Global Tools (1973–5) Planned as a series of experimental design laboratories or counter-school of architecture and design, its Italian founder members appeared on the May 1973 cover of the design magazine *Casabella, edited by one of the group's members, Alessandro *Mendini, and a focal point for the diffusion of many avant-garde ideas. One of the original aims was to find a means of disseminating information about creative ideas and networks that was equivalent to an almost contemporary American 'bible' of alternative living, The Whole Earth Catalogue. The latter sought to provide individuals and communities with mail order access to the technologies, equipment, and knowledge necessary for independent living in the late 1960s and 1970s. Global Tools' ideas were much more open-ended and unpredictable: through an anticipated series of seminars (on such themes as 'The Body', 'Construction', 'Communication', 'Survival') and the planned establishment of a number of free laboratories in Milan, Florence, Rome, Naples, and Padua, Global Tools sought to establish the conditions to free up individual creative energy from the logical constraints that had constrained it for centuries. The membership of Global Tools included Ettore *Sottsass, Mendini, Gaetano *Pesce, and members of the radical groups *Archizoom and *Superstudio. Global Tools' ideas were outlined in the January 1975 edition of Casabella but, within months, the group had folded before the seminar programmes had progressed beyond the first session devoted to 'The Body'. Nonetheless the debates and discussions surrounding its formation provided a platform for the formation of *Studio Alchimia and *Memphis.

G-Mark (1957–93) The Japanese Ministry of International Trade and Industry (MITI) established this award in 1957, following

earlier examples of *'Good Design' awards schemes such as the *Compasso d'Oro established by the Italian department store La *Rinascente in 1954. The scheme was originally intended to encourage Japanese designers to produce original designs rather than imitate foreign products. The G-Mark itself was a special logo designed by Yusaka Kamekura that could be applied to products following their recognition as design exemplars by the Good Design Selection System. The selection of such products was made by specialist committees and was a responsibility of the Design Promotion Council that had been established in 1957 under the wing of MITI. The aim was to encourage high standards of design and innovation in Japanese industry. Nonetheless, in its earlier years the scheme was not without its severe critics in the design world, many of whom felt that it favoured consumer products rather than industrial equipment, the latter being ineligible until the range of award categories was expanded in 1984, when exemplars of overseas design were also eligible. Early winners of the G-Mark award included a *Canon *8T* 8-millimetre movie camera, (1957), a Toshiba rice cooker designed by Yoshiharu Iwata in 1954 (award winner in 1958), Sori *Yanagi's aluminium *Speed* kettle manufactured by Nikkei (1958), and oil and vinegar bottles designed by Saburo Funakoshi and manufactured by Hoya Glass Works (1960). In 1975 organization of the scheme was assigned to the Japan Industrial Design Promotion Organization (established 1969) and in 1984 was expanded to include products from overseas. During the G-Mark's lifespan awards were made to almost 27,000 products. The scheme was reborn in 1998 as the *Good Design Award.

See also DESIGN AWARDS.

Gocar, Josef (1880–1945) *See* CZECH CUBISM.

Gödölló Workshops (1903–21) This artists' colony was situated in Gödölló, near Budapest, and was formed by several artist-craftsmen including the painter and decorative artist Aladár Körösfö-Kriesch, the Swedish applied artist Leo Belmonte, architect István Medgyaszay-Benkó, graphic and applied artist Sándor Nagy, and others. Like many such ventures around the turn of the 19th and 20th centuries the participants were interested in forging a sense of Hungarian national identity through their creation of artefacts that derived from indigenous peasant traditions. Many of these were seen at the major international exhibitions in the late 19th century and especially at the *Paris Exposition Universelle of 1900 and the St Louis Exposition of 1904. The outlook of William *Morris and the *Arts and Crafts Movement in Britain was also influential, with exhibitions in Budapest of work by English schools of applied arts in 1898 and British applied artists in 1902. Futhermore, in 1900, there had been a Walter *Crane exhibition in Budapest, accompanied by a special edition of the journal of the Hungarian Decorative Arts Society (*Magyar Iparmüvéset*). Members of the Gödölló Workshops were engaged with furnishing their own houses and produced furniture and weavings, thereby preserving vernacular traditions. A strong source of influence was Transylvanian folk art, particularly from Kalotaszeg, from the mid-1880s a major centre for the study of folk arts. The Gödölló Workshops were also supported both by the Magyar Iparmüvészeti Társulat (Hungarian Decorative Arts Society) and the government. The craftsmen's aim was also to counter the drift away from rural communities to the cities by regenerating the home industries and teaching children a variety of traditional crafts. The Workshops exerted a considerable influence on education

GOOD DESIGN

Although countless definitions of 'Good Design' have been offered by designers, critics, theorists, and historians for centuries a very particular concept of the term was current in the decades immediately following the end of the Second World War and represented opposition to superfluous styling as a means of increasing sales. In many ways it may be seen as the latter phase of a design reform continuum first articulated by Nikolaus *Pevsner in his 1936 *Pioneers of the Modern Movement*, in which the moral precepts of William *Morris and the *Arts and Crafts Movement were reconciled with modern manufacturing processes, new materials, and the manipulation of abstract form in early 20th century Germany. Edgar Kaufmann Jr., Director of Industrial Design at the Museum of Modern Art (MOMA), New York, in the 1940s and 1950s, had issued a stark warning in the *Architectural Review* of August 1948. He drew attention to what he described as 'Borax or the Chromium Plated Calf', castigating what he saw as a prevalent and spreading American tendency of 'style follows sales'. Kaufmann pursued such views through the curation of a series of *Good Design* exhibitions at MOMA from 1950 to 1955 that contained many objects that endorsed the European *Modernist aesthetic and built upon the design tendencies that had been apparent since the establishment of the Department of Architecture and Industrial Art at the Museum in 1932. The MOMA Design Collection was inaugurated with the 1934 *Machine Art* exhibition curated by the arch-Modernist Philip Johnson. These *Good Design* displays were mounted in conjunction with the Chicago Merchandise Mart and supported and advertised by retail stores that also utilized the 'Good Design' labels that manufacturers attached to selected products. Like Modernism, 'Good Design' was characterized generally by an emphasis on pure form rather than decoration, a restrained palette and an appropriate use of materials. European exemplars were further endorsed by MOMA's 1952 exhibition of *'Olivetti Design in Industry' and its inclusion of *Braun products in its permanent display in 1958. This American perspective was confirmed by Jay Doblin's article on '100 "Best Designed" Products' in *Fortune* magazine in 1959 (republished in 1970 as *100 Great Product Designs*), a survey of the opinions of 100 'leading designers, architects, and design teachers around the world'. Although a number of the products selected did reflect some aspects of ephemeral styling, the top three designs were *Nizzoli's Olivetti *Lettera* 22 typewriter (1947), the *Eames side-chair for *Herman Miller (1947), and *Mies Van Der Rohe's *Barcelona Chair* (originally 1929, but reproduced by *Knoll Associates after the Second World War). Other Modernist products from Europe and Scandinavia featured significantly in Doblin's list.

Of course, in Europe itself there was a great deal of 'Good Design' propaganda, with institutions such as the British Board of Trade funded Council of Industrial Design (COID, *see* DESIGN COUNCIL), established in 1944, its *Design Centre (established 1956), and *Design Centre Awards (established 1957). Such an outlook was reinforced by state initiatives in other countries such as the *Rat für Formgebung (Design Council) in Germany, established in 1953 following an act of the German Parliament in 1951, a country which had also seen Max *Bill's *Die Gute Form* (*Good Form*) exhibition in 1949.

In France the Ministry of Industry and Commerce launched the Beauté France label for well-designed products and, influenced by such European precedents, the Ministry of Trade and Industry (MITI) in Japan established its *G-Mark award for aesthetic excellence in design in 1957. Other contemporary initatives included the Dutch *Stichting Goed Wonen (Good Living Foundation, established in 1948) and the 'Good Design' promotions of the De *Bijenkorf department store. In Italy the department store La *Rinascente initiated the *Compasso d'Oro design awards in 1954. The British COID and its promotion of 'Good Design' also had an impact on design promotional organizations in New Zealand and Australia. In the latter, alongside a whole range of 'Good Design' initiatives the *Industrial Design Council of Australia established in 1960 its Good Design Label, which bore the message 'Selected as Good Design for Australian Design Index—Industrial Design Council of Australia'.

See also DESIGN AWARDS.

before the First World War but eventually failed in 1921.

Godwin, Edward William (1833–86) Godwin was a British architect and designer of furniture, wallpapers, stained glass, dress, and other design media. Friends with the painter James McNeil Whistler, a leading Japanophile, Godwin was perhaps best known for his designs inspired by oriental art and design of which he was a keen collector. Like many of his contemporaries his interest in Japanese goods was given a particular impetus by the 1862 International Exhibition in South Kensington, London, in which there was a significant display of Japanese work. Godwin's early architectural work, including his winning entry for the competition for Northampton Town Hall of 1861, was in the Gothic Revival style, as was his early furniture. He had established an office in London in 1865, setting up his Art Furniture Company two years later. His keen interest in Japonisme and Japanese prints was evident in William Watt's catalogue, *Art Furniture Designed by Edward W Godwin FSA* (1877). Godwin also designed Whistler's White House in Tite Street, London, in 1877, Whistler recipro-

cating artistically in his decorations for Godwin's furniture shown at the Paris International Exhibition of 1878. Later work ranged across a number of other period styles, from Greek to Jacobean.

See also AESTHETIC MOVEMENT.

Goed Wonen See STICHTING GOED WONEN.

Good Design See box on pp. 177–178.

Good Design Award (established 1998) This prestigious Japanese design award scheme was the successor to the *G-Mark awards (1957 –93) established by the Ministry of International Trade and Industry and has become one of the important public faces of Japanese design. Like its predecessor G-Marks the new awards are managed by the *Japan Industrial Design Promotion Organization and are allocated in three principal category areas: Product, Architectural and Environmental Design, and New Tendency Design. The latter category, created in 1999, embraced such significant social issues as the global environment and ageing populations. There are also a large number of Special Awards including, in addition to the Good Design Grand and Good Design Gold Prizes, cat-

egories such as Ecology Design, Interactive Design, Urban Design, and Long-Selling Good Design. Applications for Awards are submitted by manufacturers, retailers, and others and are assessed by juries that include designers, academics, and journalists. In 2002 there were 990 entries from 463 companies that were selected as Good Design Award Winners. The Grand Prize was awarded to Moerenuma Park in Sapporo, an environmental greenbelt project, originally conceived by the sculptor Isamu *Noguchi, who died in 1988, and realized by the architect Shoji Sadao, also on the directorate of the Isamu Noguchi Foundation. Gold Prizes for 2002 included awards to the Harley Davidson *V-ROD* motorcycle, Digitalstage's *Life with Photocinema* image-editing software, Toshiba's *IH-25PB* electro-magnetic cooker, and *Ergonomidesign's Welding Helmet and Respiratory System.

G Plan (established 1888) From its origins in the furniture-making town of High Wycombe where Ebenezer Gomme founded it at the end of the 19th century, the company grew to become one of the largest furniture producers of durable, high-quality wooden furniture before the Second World War. The brand-name 'G-Plan' was launched at the London Furniture Exhibition in 1953 and, through a sustained advertising programme, soon became highly visible to consumers eager for new ideas in the wake of the ending of government restrictions. Gomme was associated with a fresh, contemporary style as seen in its first model in light oak, the *Brandon*, an aesthetic that was later to become widely associated with teak. The company's popular teak veneered *Fresco* range, one of the its best-selling items, was introduced at the *Ideal Home Exhibition of 1966 and was still in production in the early 21st century,

when it was still characterized by features of style and quality.

The company had gained considerable experience for high-quality furniture, enhanced by its adoption of sophisticated construction methods. This had been gained from corporate involvement in aircraft production during both World Wars, with the company working on wooden components of the *De Havilland *DH9* in the First World War and the *Mosquito* fighter-bomber in the Second. In the post-war years the company produced furniture on a significant scale but also continued to blend this with high levels of traditional craft skills. It was also innovatory, becoming a leading British exponent of modular furniture. This allowed consumers to buy individual items over a period of time with the firm knowledge that they would still be able to match other items previously purchased. The company's first range in the field was called *Form Five* and comprised base units and co-ordinated display cabinets and shelving rather than the more self-contained customary individually styled suites. G Plan assumed a distinctive brand identity and was widely advertised and promoted in a coordinated fashion in directly linked retail outlets. Efficient production methods also led to a dramatic increase in profits in the 1950s. However, these were tempered by the economic difficulties experienced by the furniture industry in the 1960s, leading to the production of a number of other styles, not all of which—such as the *Limba* range—were favoured by the buying public.

In 1987 the Gomme family sold its shares to the company's directors who, in turn, sold them to the Christie Tyler Group in 1990. Six years later the Morris Furniture Group gained the licence to manufacture and market G Plan products and went on to develop and extend the range. The clean lines associated with the original

Scandinavian-influenced aesthetic of the G Plan ranges of the 1950s and 1960s is still largely evident in the *Aspen* and *Cosmopolitan* series. However, others such as the *Lafayette* and *Signature* have a more retrospective feel, drawing loosely on French and *arts and crafts precedents.

Grange, Kenneth (1929–) One of Britain's leading product designers in the second half of the 20th century, Grange has worked for a number of important clients including Kodak, Maruzen, *Bang & Olufsen, *Kenwood, Gillette, British Rail, GEC, Parker Pens, Reuters, and Shisheido. He was also a founding member of *Pentagram in 1972, taking on the product end of the design consultancy's commissions until 1998, when he left. After training as an illustrator in 1927 and working as an assistant at Arcon Chartered Architects he went on to work as an exhibition designer for Bronck, Katz, and Vaughan from 1948 to 1950, followed by a period at Gordon Bowyer's design practice until 1953. He also worked for Jack Howe before establishing his own design studio in 1958. A key early commission was for the Kodak exhibit at the 1958 World's Fair in Brussels, marking the beginning of a long-term relationship with the Kodak company. In 1959 he began work on the *A44* camera, the first of a number of such commissions that included the *Brownie* in 1964 and the *Instamatic* in 1970. He also began a long-term designer–client relationship with the domestic appliance manufacturer Kenwood, bringing commercial success to its *Chef* range of foodmixers with a stylish redesign (*A307*) in 1960. His work for the company also included the *Chefette* handmixer of 1966. Other celebrated domestic appliances that he designed in this period included the Milward *Courier* battery shaver of 1963 and the Ronson *Comet* cigarette lighter of 1968, the clean lines of each indicative of his economic yet aesthetically sensitive approach to design problem solving. He believed that the product designer should strive for innovative rather than merely stylish design solutions. He also received a number of commissions from Japanese companies such as Maruzen from 1968 to 1972, for whom he designed sewing machines, typewriters, and calculators. Larger-scale commissions included the High-Speed Train for British Rail in 1977 and the redesign of the London Taxi twenty years later. He was elected as a *Royal Designer for Industry (RDI) in 1969 and became an adviser to the British *Design Council ten years later. He also received ten *Design Awards between 1959 and 1981.

Graves, Michael (1934–) A leading American architect and designer closely associated with *Postmodernism, Graves has worked in a wide range of design media including textiles and rugs, furniture and domestic products, murals, and posters. He studied architecture at the University of Cincinnati and Harvard where he gained his Master's degree in 1959. He was subsequently awarded a two-year Fellowship at the American Academy in Rome, where he experienced classical architecture and Mediterranean culture at first hand. On his return to the United States he began lecturing in architecture at Princeton University in 1962, becoming a full professor a decade later and continuing to teach there for almost three decades more. For a while he worked closely with Peter Eisenman on experimental ideas relating to the city and the environment that featured in a number of critically contentious exhibitions in New York. However, he attracted considerable attention with his design of the Public Services Building in Portland, Oregon, of 1980–2, laden with narrative and literary elements completed in 1982. He had been in-

volved with the design of furniture and showrooms for Sunar, an American company, from 1977 onwards, drawing on an eclectic range of sources from Biedermeier to *Art Deco, the flat decorative forms of which had also been evident in the Public Services Building despite its strong feeling of contemporaneity. Similarly, although his maple, black ebony, and leather chairs and sofa from the *Michael Graves Collection* (1984) for Sawaya & Moroni and his Hollywood *Plaza* dressing table for *Memphis all drew loosely on Art Deco for inspiration they also had a distinctly late 20th-century character. Many architects, such as Graves, were at this time increasingly involved with designing small-scale products for the home. Often characterized by a distinctly architectural flavour they were sometimes referred to as 'micro-architecture'. Architects enjoyed the challenge of designing for an affluent urban clientele who were keen to purchase affordable domestic products by well-known designers whose architectural work was out of their economic reach. Graves undertook a number of such designs for the Italian housewares manufacturing company *Alessi, including his six-piece service for the company's *Tea & Coffee Piazza* series (1983). He also designed the whistling *Bird* kettle for Alessi (1985) and ceramics for the American firm *Swid Powell, including the *Big Dripper* porcelain coffee pot (1986). He established his practice in Princeton as a young architect in 1964, and by the early 20th century Michael Graves & Associates had grown to 85 employees, with studios devoted to architecture, interiors, and product design. He also established the Graves Design Studio Store in Princeton where consumers could purchase more than 500 objects for the home or office either in person or by mail order or telephone. Graves's best-known buildings include the San Juan Capistrano

Public Library (1980–3) in which he drew on the Spanish Missionary style, Humana Building (1982–5) in Louisville, the Swan and the Dolphin Hotels (1989–90) at Disney's World Epcot Center, Florida, and the headquarters for the Ministry of Health and Sport in The Hague, the Netherlands. A Fellow of the American Institute of Architects (AIA) Graves has received over 150 design awards. He also won the 1999 National Medal of Arts and, in 2001, gained both the Frank Annunzio Award in the Arts and Humanities, and the AIA's Gold Medal.

Gray, Eileen (1878–1976) The designer and architect Gray was born into an aristocratic family in Ireland, receiving little formal education prior to her joining the Slade School of Art in London in 1898. While in London she became very interested in the art of lacquering, a craft which she furthered after moving to Paris in 1902, where she studied at the Académie Colarossi and Académie Julien until 1905. She worked with the Japanese craftsman Sugawara from 1907 to 1914, designing lacquered furniture and building up key contacts such as the couturier Paul *Poiret. In 1913 she showed her work at the Salon de la Société des Artistes in Paris. From 1915 to 1917 she ran a lacquerwork and furniture workshop in London with Sugawara. She went on to extend the range of her decorative design repertoire, producing handmade, abstract-patterned rugs and carpets and opening her Jean Désert furniture gallery in 1922 (which closed in 1929). However, by the mid-1920s Gray moved away from the richness of pattern and finish in the decorative arts towards the more austere aesthetic associated with *Modernist architecture and design and in 1924 a special issue of the Dutch avant-garde magazine *Wendingen* was devoted to her work.

From 1926 she worked on architectural schemes with Jean Badovici, the Romanian architect, critic, and editor of *L'Architecture vivante*, including the Modernist Maison en Bord de Mer (E-1027) in the south of France, the living room of which contained a mural painted by Le *Corbusier. The furniture in this house was also Modernist, exploring the aesthetic possibilities of new materials such as chromium-plated tubing and glass. In 1937 she displayed a scheme for a cultural centre in Le Corbusier's Pavilion at the *Paris Exposition Universelle of 1937. However, after the Second World War her career underwent something of a slump and it was not until the late 1960s that her work regained the attention that it deserved. This was underlined in the 1970s by a series of exhibitions at the Royal Institute of British Architecture's Heinz Gallery, the *Victoria and Albert Museum, and the *Museum of Modern Art, New York. In 1972 she was elected as a *Royal Designer for Industry, becoming a Fellow of the Royal Institute of Irish Architects in the following year.

Gray, Milner (1899–1997) Gray was one of the key figures of British industrial design in the 20th century, having played an important role in establishing design as a recognized profession, the emergence of British design consultancies, and the development of *Design Management. He studied painting and design at Goldsmiths College School of Art, London University, where he was a fellow student and friend of the artist-designer Graham Sutherland. During the First World War he served in the Royal Engineers where, like other celebrated artists and designers in both World Wars, he was involved in camouflage work. In 1930 he became a founder member of the Society of Industrial Artists (SIA, *see* CHARTERED SOCIETY OF DESIGNERS), which

sought to gain professional recognition for the designer in industry. By this time multidisciplinary design consultancies had begun to emerge in the United States. Almost by way of response Gray established the Bassett-Gray Group of Artists and Writers in 1934 which became the Industrial Design Partnership (1935–40), dealing mainly with graphics and product design. One of the cofounders of the latter, Misha *Black, joined with Gray and Herbert *Read to establish the *Design Research Unit (DRU) in 1943, a consultancy which sought to provide design expertise for post-war industry, commerce, and the state. It became widely recognized for corporate identity design for many leading companies and organizations, such as Courage Breweries, ICI, and the British Aluminium Company.

During the Second World War Gray had worked for the Ministry of Information as an adviser on exhibition design, a field of expertise which was successfully applied in the *Design at Home* exhibition of 1945, the *Britain Can Make It* exhibition of 1946, and the *Festival of Britain of 1951. Gray was also involved in design education, with numerous teaching appointments at leading art schools, including the Royal College of Art and the Sir John Cass School, where he was principal from 1937 to 1940. He also advised the BBC on its series *Looking at Things*, which was broadcast between 1949 and 1955. He was active as a lecturer and writer on many aspects of design, including *Package Design* (1955) and *Lettering for Architects and Designers* (1962). Through the DRU he also played a significant role as a consultant to industry. One of his most ambitious projects was the framing, in 1964, of the British Railways corporate identity programme, the working party for which he had chaired.

He also received official recognition: in 1938 he was elected Royal Designer for In-

dustry, was appointed Master of the Faculty of *Royal Designers for Industry in 1955, and was awarded the SIA's first Gold Medal for outstanding design achievement.

Great Exhibition (1851) Opened with great pomp and ceremony by Queen Victoria this seminal international exhibition was held in what the periodical *Punch* dubbed 'the Crystal Palace', a prefabricated structure of iron and glass designed by Joseph Paxton and erected in Hyde Park, London. It attracted more than 6 million visitors, involved more than 15,000 exhibitors, and had more than 10 miles (16 km) of display frontage. Fifty per cent of the exhibiting space was devoted to 7,351 British and Empire products and the rest to 6,556 products from overseas. Although it had been hoped that the Great Exhibition would bring together positively the fields of art, science, and manufacture, in the event it attracted considerable critical debate. Many of the highly ornamented and decorative designs exhibited technical ingenuity for its own sake and, as a result, attracted the antipathy of leading Victorian design critics. These included Richard Redgrave, Ralph Nicholson Wornum, Owen *Jones, and others opposed to what Augustus Welby Pugin and John *Ruskin saw as morally decadent and constructionally dishonest products. The 17-year-old William *Morris was also horrified by what he saw. However, it should also be remembered that many of the designs that featured on such an important international stage were especially made to win prestige and were therefore by nature more decorative and deliberately eye-catching than many more functional and ornamentally restrained designs for everyday mass production. International exhibitions, by their very nature, were designed to explore new markets, to consolidate existing ones, or to

establish leadership in particular fields, thus providing important platforms for national economic and industrial policy initiatives.

The Great Exhibition of the Works of Industry of all Nations had its generic roots in a series of French National Exhibitions that had begun in Paris in 1798 where manufacturers from many branches of industry showed a wide range of products including ceramics, glass, furniture, and textiles. Just as the French National Exhibitions had been intended to restore French manufacturing industry to its former position of dominance in the wake of the political upheavals of the Revolution, so the Great Exhibition of 1851 was the culmination of a number of initiatives in the 1830s and 1840s to re-establish the position of British industry as the 'workshop of the world' after a period of decline following the Napoleonic Wars. These included the establishment in 1935 of a Parliamentary Select Committee on *The Arts and their Connection with Manufacturers* and the subsequent institution of a national framework for design education. By 1849, the 11th French National Exhibition attracted 4,500 exhibitors and its scale and ambition resulted in key British design propagandists Henry *Cole and Digby Wyatt being asked to report back on it to the Royal Society of Arts (RSA). In Britain, during the 1840s, the Royal Society of Arts had itself mounted a series of small-scale competitions promoting British industrial products that embraced the principles of artistic design. Such initiatives had brought Cole into the Society and, from 1847, developed into a series of annual exhibitions of industrial products culminating in the show of 1849, which attracted 73,000 visitors over a period of seven weeks. With the support of Prince Albert, the president of the RSA, and spurred on by Cole and Wyatt's 1849

report that the French were themselves considering an international exhibition, British ambitions were raised to do the same and a Royal Commission was swiftly established early in 1850 to oversee its development. Although the RSA severed its formal connections with the exhibition as a result, a number of its key members continued to serve on the commission.

At the Great Exhibition itself the public could admire many works that could be seen to embrace the interlinked fields of art, science, and manufacture, typified by a range of high-quality products manufactured by the Coalbrookdale Company. Amongst them were the ornamental gates to the exhibition, an Iron Dome, chairs, sculptures, and a variety of detailed ornamental castings, a number of which were designed by artists that had been employed by Henry Cole for his Felix Summerley's Art Manufactures. Of considerable public interest were the machine tools and other exhibits that reflected the advances that had been made in civil and mechanical engineering, including railway locomotives, Nasmyth's steam hammer, marine engines by Maudslay and others, more than twenty machine tools manufactured by Whitworth, and the crowd-pulling envelope-making machine by De La Rue. Such attention reflected the considerable esteem that the public held for Victorian engineers. Visitors were also able to indulge their curiosity in countless other exemplars of technical virtuosity, whether a garden seat for Queen Victoria carved from a block of coal, a penknife with 80 blades and tools, or steamship furniture capable of conversion to life-rafts. The literal absurdity of such exhibits was satirized in *Punch* magazine's account of 'Mr Punch's Counter at the Great Exhibition', a distant resonance of Jonathan Swift's ironic portrayal of the Royal Society in his satirical novel *Gulliver's Travels* pub-

lished 125 years earlier. By the mid 19th century materials such as papier maché had achieved a considerable level of durability, approaching that of wood, and could be seen in a wide variety of artefacts, from chairs to pianos. Articles manufactured from gutta percha, a material first introduced to the British public in the 1840s and patented in 1844, were also displayed at the exhibition. It was able to be moulded, stamped, coloured, cast, and polished and was used for a wide variety of goods, including ornaments. Also widely admired for their novelty in 1851 were electroplated industrial art products and examples of Parian were, a medium imitating marble and capable of holding considerable detail that had been developed by ceramic manufacturers Minton & Copeland in the 1840s.

Amongst the many functional exhibits on display in the Crystal Palace the greatest impression was made by those from the United States of America that capitalized on the exploitation of standardization as a means of harnessing the true potential of mass-production technologies for mass markets. This outlook became known as the *American System of Manufactures and was seen in products such as Colt's firearms, Hobbs' locks, McCormick's reaper and sewing machines. Its economic potential was sufficient to bring about the establishment of a Royal Commission that reported on the *Machinery of the United States* in 1854–5.

The Great Exhibition proved to be a highly profitable venture with a profit of £186,437, the surplus being used for educational purposes including the purchase of 87 acres (35 hectares) in South Kensington, London, as a centre for the arts and sciences. It was here that the 1862 International and the 1886 Colonial and Indian Exhibitions were later mounted and now housed a number of key buildings connected with the arts and sci-

GREEN DESIGN

The term 'green' became increasingly commonplace in the 1970s and was closely associated with debates relating to environmentalism and ecology. 'Green' politics had first emerged in Europe, particularly in West Germany, where there were powerful environmental pressure groups such as the Grüne Aktion Zukunft (Green Action for the Future), which campaigned against nuclear power. In Britain the Greenpeace organization was established. Although a number of ecologically conscious enterprises such as Anita Roddick's Body Shop (established 1976) had been founded in Britain it was not until the following decade that 'green design' began to be widely discussed in the design press. Essentially, green design embraces ecological considerations, sustainability, recycling, conservation of resources, and cleaner, quieter, and safer domestic environments.

Many of the achievements of technology and science, symbolic representatives of *Modernism and *Fordism, had been under challenge for some time. In 1960, Vance Packard had written *The Waste-Makers: A Startling Revelation of Planned Obsolescence* and, two years later, Rachel Carson had published her best-selling *Silent Spring*. The latter was a strident attack on the American agri-chemical industry and drew attention to the potentially devastating impact of pesticides. Furthermore, the work and writings of French Modernist architect and designer Le *Corbusier that had so dominated the outlook of progressive town planners for years was also challenged in a number of radical texts such as Jane Jacobs's 1961 polemical book *The Death and Life of Great American Cities*. In design terms in the decades following the end of the Second World War, the architect, inventor, designer, writer, and thinker Richard Buckminster *Fuller was a strident critic of the industrial design profession. Writing and lecturing to audiences around the world he highlighted the shortcomings of industrial design, particularly in relation to its squandering of finite resources and encouragement of obsolescence. Also significant in critiques of large-scale manufacture and mass consumption were the writings of Eugene Schumacher and Ivan *Illich who respectively wrote *Small is Beautiful: A Study of Economics as if People Mattered* and *Tools for Conviviality*, both from 1973. Three years later Peter Harper and Geoffrey Boyle edited *Radical Technology*, proposing that greater emphasis should be placed on small-scale techniques with individuals and communities managing production on a human scale under workers' and communities' control.

The 1980s saw many publications relating to green design, as well as a *Green Designer* exhibition at the *Design Centre, London, in 1986. Alongside talk of the 'ethical '90s' in the 1990s the literature in the field also expanded with texts such as Dorothy Mackenzie's *Green Design: Design for the Environment* (1991) and Brenda and Robert Vales's *Green Architecture: Design for a Sustainable Future* (1991). However, as the expansion of Roddick's Body Shop chain attests (1,400 shops opening in the first twenty years of the company's operations with over 70 outlets in Japan), being environmentally and ecologically conscious also brought highly lucrative business. As confirmed in 1990 by management consultants Touche Ross, many major European companies felt it important to mediate their output with environmental

considerations. This could be seen at *Philips and *Zanussi in Europe and *IBM in the United States and was further reflected in contemporary consumer interest in ethical investment on the Stock Exchange. The *Design Museum, London, mounted an exhibition exploring the theme of green design in 1990. The fact that 'green design' and 'green capitalism' were still essentially elements in the world of consumption gave rise to a number of critiques: in Britain, Sandy Irvine's *Beyond Green Consumerism* (1989), and, in the United States, *Green Business: Hope or Hoax?* (1991).

See also DESIGN FOR NEED.

ences including the *Victoria and Albert Museum, the *Royal College of Art, Imperial College, and the Science Museum. The 1851 exhibition also stimulated a whole series of other international exhibitions, commencing with the Great Industrial Exhibition in Dublin and the World's Fair in New York in 1853, followed by the Exposition Universelle in Paris in 1855.

Green Design See box on pp. 185–186.

Gregorie, Eugene T. (Bob) (1908–2002) Gregorie was a highly significant designer at the *Ford Motor Corporation in the period immediately following the end of production of the celebrated, functional rather than aesthetic, *Model T* automobile and was particularly noted for his work on Lincoln automobiles. After leaving school he took up an apprenticeship with a marine design company and forged an early career in yacht design. After the Wall Street Crash, with a consequently lean time in the yacht design business, he became increasingly involved in car body design, including work for *General Motors. He was first employed as a draughtsman at Ford in 1931 and was involved with the design of Lincoln automobiles at the luxury end of the Ford range. From 1935 to 1938 Gregorie had a key role in Ford's Styling Department (established in 1931) where he first made an impact through his introduction of number of changes to the Lincoln *Zephyr*, moving the engine from the rear to the front to produce

a clean, streamlined design. The highly coordinated overall design, including detailing such as the integration of the headlights into the bodywork, reflected Gregorie's complete involvement in the design process from conception through to production as well as his background in yacht design. He went on to work on the Mark I Lincoln *Continental* that was launched in 1939 and remained in production until 1948, apart from a brief hiatus in the Second World. The *Continental* was selected by the *Museum of Modern Art, New York, for its 1951 *Eight Automobiles* exhibition, thereby confirming its standing as a significant and critically successful piece of design. Gregorie had developed a productive working relationship with Edsel Ford, the company's president from 1918, and left Ford following the latter's death 1943. He returned to the company for a further two rather difficult years before moving to Florida in 1946 where, once again, he took up yacht design.

Gregory, Oliver (1930–93) A British designer specializing in commercial and domestic interiors, Oliver Gregory was perhaps best known as a key figure in establishing the 'look' of Terence *Conran's *Habitat shops in the 1960s. After a period of National Service in the RAF Police and taking up an apprenticeship in cabinetmaking Gregory travelled to Melbourne, Australia, in 1956. He worked on Kurt

Geiger department stores for the shop-fitting firm Brooks Robinson, soon becoming a partner in an architectural firm. On his return to England he joined an architectural practice and met Terence Conran in 1960. They became close friends and Gregory soon contributed his ideas to the Habitat interiors of quarry tiles, wooden ceilings, and white-washed walls and spotlights seen in the first Habitat store that opened in the Fulham Road, London, in 1964. Gregory went on to play an important role in developing the national and international Habitat brand. He also designed a number of Habitat products, going on in the 1980s to supervise the redesign of the store interiors for Mother-care, Richards, and *Heal's, all of which had become part of the Conran empire. For much of his life Gregory had a keen interest in restaurants, briefly setting and running up his own restaurant in 1968, and was involved, with Conran and London art dealer John Kasmin, in the establishment of the tastefully designed and equipped Neal Street Restaurant in Covent Garden, London, in the early 1970s.

Gregotti, Vittorio (1927–) A signifi-cant Italian architect, designer, design his-torian, theorist, and critic, Gregotti was editor of many leading Italian design peri-odicals. He graduated in architecture from Milan Polytechnic in 1952 and has had a lifelong involvement with the field as a practitioner, academic, and writer. He es-tablished Gregotti Associati, of which he was president, in 1974. He was professor of architectural composition at the University of Venice, taught in the architectural schools at Milan and Palermo, as well as acting as a visiting professor at many other leading architectural institutions through-out the world. As a designer he was associ-ated with the *Neo-Liberty movement in the 1950s, particularly the bentwood *Cavour*

chair (1960) designed with his first architec-tural partners Giotto Stoppino and Lodovico Meneghetti, with whom he was associated from 1953 to 1968. Early in his professional career he also served as a jury member for the *Compasso d'Oro design competition. His design work includes projects for La *Rinascente department stores, graphics for *Ferrari, as well as a number of museum interiors. He was involved with many inter-national competitions, designing the intro-ductory section of the XIII *Milan Triennale, for which he was awarded the International Grand Prize. He was also the director of Fine Arts and Architecture at the Venice Biennale from 1974 to 1976. A pro-lific writer on architectural and design matters, he contributed to mainstream newspapers as well as the more specialist press. The latter included *Casabella* (1953–5), and *Casabella-Continuità* for which he was editor in chief from 1955 to 1963. He was also director of *Edilizia moderna* (1963–5), *Rassegna* (1979–98) and, from 1982 to 1996, of *Casabella*. He contributed to many key publications on Italian design including a historical essay for the catalogue for the landmark exhibition on *Italy: The New Do-mestic Landscape* curated by Emilio *Ambasz at the Museum of Modern Art in New York in 1972. He also authored (with M. de Giorgi, A. Nulli, and G. Bosoni) the substan-tial text *Disegno del prodotto industriale* (*Design of the Industrial Product*, 1982).

Gresley, Nigel (active from 1905) An in-novative railway engineer and designer, Gresley's designs for the London and North Eastern Railway (LNER) were charac-terized by their streamlined appearance, es-pecially the record-breaking A4 Class *Mallard* which set a world-speed record of 126 miles per hour (201 km/hr) in 1938. Gresley was the Chief Mechanical Engineer at the LNER and worked closely with his

Principal Assistant, O. V. S. Bulleid, and LNER engineers on the design of a number of streamlined locomotives and carriages in the 1930s. On leaving school Gresley had first entered the railway industry as an apprentice, working his way upwards to a position of responsibility. One of his first railway locomotive designs was the *No. 10,000* of 1930, complete with aerodynamic features and profile. Such ideas were developed, improved, and wind-tunnel tested on the design for the streamlined *No. 2001* of 1935 and taken further on his concept of the A4 type locomotives that were characterized by an aerodynamic wedge-shaped front that owed something to the locomotive designs of Bugatti on the Continent. The first LNER streamlined express was the silver-grey liveried *Silver Jubilee*, designed under Gresley and Bulleid, which entered service in 1935. Gresley was friends with Sir Charles Allom of White Allum Ltd., who was responsible for the design of the interiors. LNER's streamlined train portfolio was expanded in 1938 to include the *Coronation* and *West Riding Limited*.

Gretsch, Hermann (1895–1950) German ceramic designer Gretsch was trained at the Technische Hochschule in Stuttgart from 1922 to 1923, following which he studied graphics and ceramics at the city's School of Applied Arts. In 1931 he designed the clean-lined, *Modernist Arzberg 1382* tableware service for the Carl Schumann factory in Bavaria which remained in production throughout the 1930s, was awarded a Gold Medal at the 1936 *Milan Triennale, and continued to be manufactured until the 1960s. From 1932 the ceramic manufacturing company *Villeroy & Boch employed him in the design of dinnerware services. Gretsch was also an important member of the *Deutscher Werkbund, even after its demise as an independent body under the

Nazi's Reichskammer der Bildenden Künste (Reich Chamber of the Visual Arts, RdbK) in 1934. He was appointed to head the Werkbund division of the RdbK in 1935, although it achieved little of note. However, in 1940 he wrote *Gestaltendes Handwerk* (*Creative Handicrafts*) which, despite its publication in the context of German crafts in the Third Reich, very much reflected a Werkbund credo of clean, undecorated forms as compatible with modern technological modes of mass manufacture as with hand production.

Gropius, Walter (1883–1969) A leading German architect, designer, and educator, Gropius was one of the most influential figures of *Modernism. His ideas were promoted through membership of the *Deutscher Werkbund and participation in its critical debates, his directorship of the ideologically powerful *Bauhaus in the years after the First World War, and emigration to Britain and then the USA in the 1930s. He began his architectural studies in Munich in 1903, followed by a period in Berlin from 1905 to 1907. From 1908 to 1910 he worked in Peter *Behrens's Berlin studio (where *Mies Van Der Rohe and later Le *Corbusier were also based for a while), after which he set up in business with Adolf Meyer, a partnership that lasted until 1925. An early influential building designed by Gropius and Meyer was the Fagus Factory (1911–14). Its clean lines and standardized elements influenced the form of his model factory building at the 1914 Deutscher Werkbund exhibition in Cologne, where he also exhibited a railway compartment. He had also been involved in the design of furniture and a diesel locomotive for the Königsberg locomotive factory. After the First World War he was a leading figure in the Arbeitsrat für Kunst (Workers' Council for Art), before being appointed as director

of the Staatliches Bauhaus School in Weimar in 1919, effectively a merger of the former schools of fine and applied arts. This new institution brought together an exciting blend of teachers and students, embracing a wide range of avant-garde aesthetic ideas. His own response to such ideas could be seen in his designs for his office in 1923, especially the lamp which owed a debt to Gerrit *Rietveld. However, the Bauhaus was often viewed with suspicion by municipal authorities and was consequently subject to considerable political challenge, a position which led to Gropius' resignation in 1928. Following a visit to the USA to study housing, he established his own practice, designing modular furniture and Adler automobiles. In 1929 he was made vice-president of the *Congrès Internationaux d'Architecture Moderne. In the following year, with the help of Herbert *Bayer, Marcel *Breuer, and László *Moholy-Nagy he organized the Werkbund exhibition at the Salon des Artistes Décorateurs in Paris. The theme of the exhibit was the design and furnishing of a ten-storey hotel, Gropius planning the steel-framed structure and communal spaces such as a gallery/library and a coffee bar. In the face of increasing political hostility to Modernist ideas and organizations such as the Deutscher Werkbund he left Germany for London in 1934, where he worked with the architect Maxwell Fry. Living in the Modernist Lawn Road Flats in Hampstead, London, designed by Wells *Coates he also designed for the *Isokon group, becoming its director in 1936. He emigrated to the USA in the following year, becoming the head of the Graduate School of Design at Harvard University until 1952. He also worked with Breuer from 1937 to 1944, founding a new practice, The Architects Collaborative (TAC), in 1946. Amongst his best-known designs of this period were two

porcelain tea services in 1969 for *Rosenthal, for whom he also designed two factories.

Group of Ten *See* TIO-GRUPPEN.

Gucci (established 1904) Beginning life as a workshop producing riding boots and hand luggage this famous leather goods and fashion accessories firm originated as a leather goods workshop in Florence in 1904. Founded by Guccio Gucci, the first shop opened in 1922. His son, Aldo, moved to New York in 1953 and succeeded in creating new markets for the company's products, attracting the attention of celebrities such as Audrey Hepburn, Jackie Kennedy, Grace Kelly, and Elizabeth Taylor. In the 1960s the double 'G' trademark, designed by Aldo's son Paolo, soon became a byword for high fashion in both the USA and Europe. However, following 1977 Paolo's rise to vice-presidency and managing directorships of Gucci Shops Inc. and Gucci Parfums of America, a series of vexatious family litigations and tax irregularities eventually led to the selling of 50 per cent of the company's shares to the Investcorp, an Arab investment bank. After a further period of family in-fighting during the 1980s the Guccis finally lost control of the company to Investcorp in 1994. Since then there has been significant investment in design and advertising and the company name has again been successful in the international market place.

Guerriero, Alessandro (1943–) A highly influential catalyst in much avant-garde Italian design, architect and design theorist Guerriero, with his sister Adriana, founded the *Studio Alchimia in Milan in 1976, members of which included Alessandro *Mendini, Andrea *Branzi, Ettore *Sottsass, and Paola Navone. In 1982 he was awarded the *Compasso d'Oro for his re-

search into design and was involved in the foundation of the *Domus Academy in Milan. Other innovative projects have included the establishment of the Futurarium in Ravenna in 1995, a laboratory without disciplinary boundaries, the opening of a new studio, 'Radiosity', with Alberto Biagetti in late 1996, a new *Benetton Museum with Alberto Toscani and the Casa della Felicità for the *Alessi family at Omegna. His books have included *Elogio del banale* (*Eulogy of the banal*), *Progetto infelice* (*Unhappy project*), and *Disegni alchimia* (*Alchimia designs*).

Gugelot, Hans (1920–65) An influential product designer closely identified with the radical Hochschüle für Gestaltung (HfG) at *Ulm in Germany and the clean, systematic, and functional styling of *Braun products of the later 1950s and 1960s, Gugelot initially trained in engineering (1940–2) and architecture (1940–6) in Switzerland. He worked in Bauhaus graduate Max *Bill's office in Zurich, following the latter to the HfG when invited by him to lead the product design programme in 1954. He subscribed to the Ulm philosophy of design that rejected traditional notions of the intuitive, creative individual designer in favour of a collaborative multidisciplinary and scientific approach to design. With other Ulm lecturers, Otl *Aicher and Fritz Eicher, Gugelot was invited to work with Braun on a consultancy basis, commencing with the design of radios. He also worked closely with Dieter *Rams of Braun on the minimalist design of the *SK4* radiogram cabinet (1956), as well as a number of other products in the following years including the *Sixtant* razor (1962) with Gerd Alfred Müller. He also managed a number of live products with his students, including designs for the Hamburg U-Bahn underground (1959–62). Other clients included Bofinger, for whom he designed the modular *M125* office system (1957), and Kodak for whom he designed the *Carousel* slide projector (1962).

Guimard, Hector (1867–1942) A leading exponent of *Art Nouveau in France, working right across the architectural and design spectrum, Guimard studied at the École des Arts Décoratifs, Paris, from 1882 to 1885 and later, in 1889, at the École des Beaux-Arts. After a number of early interior and architectural commissions he worked on the Castel Béranger block of flats (1894–7) where he was given artistic licence. Having been influenced by the writings of the French theorist and architect-designer Eugène Viollet-Le-Duc in the 1880s he visited both England and Belgium in the mid-1990s and became interested in the work of Victor *Horta whose buildings were conceived as a total work of art, from architecture to interior design, furniture and fittings, wallpaper and textiles. Similarly in the Castel Béranger, Guimard attended to all aspects of the building, documenting them in his book *Le Castel Béranger: l'art dans l'habitation moderne* (1898). Characterizing his expressive Art Nouveau style he explored the eloquent potential of wrought ironwork in the flowing, curvilinear, and asymmetrical forms of the entrance gate, motifs that were followed through elsewhere in the building. Guimard's work for the Paris Metro, for which, commencing in 1903, he designed a number of underground stations in which, as at the Castel Béranger, he explored the potential of cast and wrought iron and glass in the dramatic entrances. Other notable projects included his own house (1909–12) and the Hôtel Mezzura (1910) and he exhibited a wide range of his designs at the Salon des Artistes-Décorateurs between 1910 and 1913. After the First World War, although he began working on more standardized

forms and showed at the 1925 *Paris Exposition des Arts Décoratifs et Industriels, he no longer exerted a powerful influence on modern design.

Gustavsberg (established 1825) This leading Swedish pottery manufacturer has a long and distinguished history. It was established near Stockholm in 1825, importing English industrial expertise, workers, and clays. The company's output in the late 19th century was influenced by the spirit of Swedish National Romanticism, evidenced in a series of Viking Revival vases and similar products. In 1895 Gunnar Wennerberg, with a background in painting, porcelain design at Sèvres, textile and glass design, joined the company as artistic director and brought an *Art Nouveau flavour to the company's wares. In 1917, responding to the *Swedish Society of Industrial Design's efforts to bring about a closer liaison between art and industry, Wilhem *Kåge was appointed as Gustavsberg's artistic director, a post he held until 1947. An early Kåge design for the company was the 1917 *Blue Lily* service aimed at working-class consumers, although it never caught on with its intended market sector. He also designed much more radically functional and *Modernist work, as with the *Practika* service produced from 1933. In 1937 the company was sold to the Swedish Cooperative Union and Wholesale Society (KF Konsum) resulting in modernization of the factory, the creation of a sanitary ware division, and the establishment of the Studio. In 1949 Stig Lindberg took over the artistic directorship from Kåge, his teacher, and introduced a series of biomorphic forms and patterns. Later he also designed for the company's plastics division. Karen Björquist became art director in 1980.

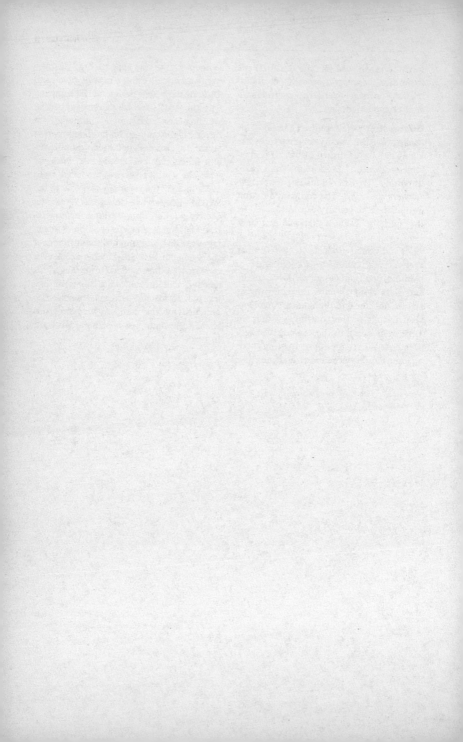

Habitat Harley-Davidson Hasselblad Ha
Heal, Ambrose Heal & Sons Henningsen,
Henrion, F. H. K. (Frederick Henry Kay) H
Furniture Company Hicks, David high-te
Hilfiger, Tommy Hille Hochschule für Ges
Hoffmann, Josef Hollein, Hans Honda M
Hornby, Frank Horta, Victor Howard Mill
Hulanicki, Barbara Habitat Harley-David:
Hasuike, Makio Heal, Ambrose Heal & S
Poul Henrion, F. H. K. (Frederick Henry K:
Furniture Company Hicks, David high-te
Hille Hochschule für Gestaltung, Ulm Ho
Hollein, Hans Honda Motor Company H
Horta, Victor Howard Miller Clock Co. H
Habitat Harley-Davidson Hasselblad Ha
Heal, Ambrose Heal & Sons Henningsen,
Henrion, F. H. K. (Frederick Henry Kay) H
Furniture Company Hicks, David high-te
Hilfiger, Tommy Hille Hochschule für Ges
Hoffmann, Josef Hollein, Hans Honda M
Hornby, Frank Horta, Victor Howard Mill
Hulanicki, Barbara Habitat Harley-David:
Hasuike, Makio Heal, Ambrose Heal & S
Poul Henrion, F. H. K. (Frederick Henry K:
Furniture Company Hicks, David high-te

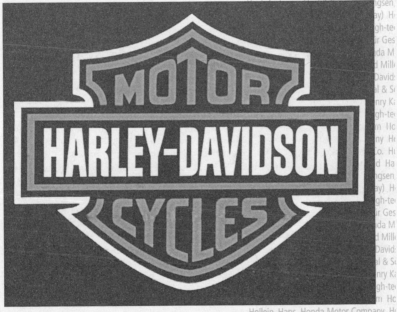

Hollein, Hans Honda Motor Company H
Horta, Victor Howard Miller Clock Co. H
Habitat Harley-Davidson Hasselblad Ha
Heal, Ambrose Heal & Sons Henningsen,
Henrion, F. H. K. (Frederick Henry Kay) H
Furniture Company Hicks, David high-te
Hilfiger, Tommy Hille Hochschule für Ges
Hoffmann, Josef Hollein, Hans Honda M
Hornby, Frank Horta, Victor Howard Mill
Hulanicki, Barbara Habitat Harley-David:
Hasuike, Makio Heal, Ambrose Heal & S
Poul Henrion, F. H. K. (Frederick Henry K:
Furniture Company Hicks, David high-te

Habitat (established 1964) The first Habitat shop was launched in 1964 in London's Fulham Road by British design and lifestyle entrepreneur Terence *Conran, who recognized the changing consumer patterns signalled by the emergence of the fashionable youth-oriented boutiques of Carnaby Street and the music of the Beatles and the Rolling Stones. He sought to provide enhanced opportunities to purchase stylish modern design at affordable prices, a market sector which traditional British furniture retailers had largely ignored. Catering for the young professional market sector, Habitat sourced well-designed products from a number of countries, whether cheap, brightly coloured enamelled jugs and mugs from Poland or furniture from Italy. The Fulham Road shop was the first of a number of British outlets that totalled more than 30 by 1980, in addition to the opening of several branches overseas following the launch of a Paris store in 1973. Habitat began its *mail order catalogue operations in 1969, with a print run of 300,000, a figure that had risen five times within a decade. Drive-away stores were also introduced, first at Wallingford and then, in 1977, on a more ambitious scale at Wythenshawe, near Manchester, with play areas for children, although these were modest by way of comparison with *IKEA, a company Habitat had sought to emulate. By the 1980s Habitat was a global business with outlets in Europe, the United States, and Japan, merging with Mothercare and *Heal's and being launched on the Stock Exchange in 1981. However, in the difficult economic climate of the 1980s the company began to lose its way until it was taken over by IKEA in 1995. With the arrival of Tom *Dixon as art director in 1998 the company began to recapture the sense of freshness and innovation that had marked its earlier years under Conran.

See also GREGORY, OLIVER.

Harley-Davidson (established 1902) Many of the products of this American motorcycle manufacturing company have become symbols of national identity, none perhaps more so than the customized Harley-Davidson chopper seen in the 1969 film *Easy Rider*. The potency of the brand can be inferred from the company's introduction of the *Heritage Classic* motorcycle in 1995. Following the marketing of the first Harley-Davidson in 1903, one of its most distinctive products was the *61 EL*, known as the '*Hog*', designed by the William Harley and William and Walter Davidson in 1936. The post-Second World War period proved a difficult one for the company, a position further undermined by the representation of 'bikers' as morally decadent in the 1954 film *The Wild Ones*. Japanese motorcycle imports such as *Honda and Kawasaki increased significantly in the 1960s and in 1969, the year in which the film *Easy Rider* portrayed the 'biker' as a latter-day 'pioneer', the company was sold. It was reacquired by its former management in 1981 and, within a decade, the company was producing 60,000 motorcycles per year. In the 1980s and 1990s the company produced a number of *Retro models including the *Heritage Classic* of 1995, a design that in many ways recreated the image and identity of the 1936 '*Hog*'. It offered Ameri-

can consumers the opportunity to purchase the image and American values of a seemingly 'individual' and 'customized' product. It was, of course, mass produced and also very distinctive in styling terms from its Japanese competitors.

Hasselblad (established 1948) This Swedish camera manufacturing company was founded in 1948 with the launch of the classic single-lens reflex 1600F camera in New York. The company's founder, Victor Hasselblad, produced the HK7, single-lens reflex reconnaissance camera for the Swedish Air Force, evolving the technology during the Second World War. However, much of the enduring commercial success of the 1600F was due to the intervention of one of Sweden's pioneering industrial designers, Sixten *Sason, his black and silver functional aesthetic enduring for more than 50 years. NASA used Hasselblad photographic equipment in space in the 1960s.

Hasuike, Makio (1938–) After studying architecture and industrial design in Tokyo, followed by a year working for Seiko, Hasuike established his own consultancy in Milan. He has designed for a wide range of leading companies, including coffee machines for Gaggia, electronic products for Panasonic, sanitary ware for *Villeroy & Boch and tableware, Grand Gourmet kitchen knives (1994), and cookware for *WMF. His output has also included accessories for work and the office under the brand name MH Way. His international reputation has been enhanced by receipt of the *Compasso d'Oro as well as the Grand Prix at the XXV *Milan Triennale.

Heal, Ambrose (1872–1959) A leading figure in the development of *Heal's as a leading London store for the retailing of modern furniture, furnishings, and equip-

ment for the home, Ambrose Heal was firmly committed to raising standards of design in everyday life. This was reflected in his role as a founding member of the *Design and Industries Association (DIA) in 1915 and his promotion of *Modernism through the range of goods sold in the store from the late 1920s onwards. After leaving the Slade School of Art he served an apprenticeship as a cabinetmaker from 1890 to 1893 when he joined the family furniture-making and retailing firm, then called Heal & Son, becoming a partner in 1898, managing director in 1907, and chairman in 1913. He was also active in designing furniture for the company from 1896, producing a series of catalogues such as Plain Oak Furniture (1898) and Simple Bedroom Furniture (1899). In these he revealed his early commitment to *arts and crafts principles, including the appropriate use of materials and honesty of construction, was a member of the *Art Workers' Guild, and exhibited at the *Arts and Crafts Exhibition Society. In 1900 Ambrose Heal also took charge of the company's publicity and advertising and, through the commissioning of leading illustrators, graphic designers, and photographers, did much to raise the corporate profile in the early decades of the 20th century. After the First World War he developed a friendship with Gordon *Russell and also kept a watching brief on design developments in Germany, Sweden, and elsewhere. Membership of the DIA stimulated his interest in the design potential of new materials such as chromium-plated steel tubing, which he employed in a number of designs, including those shown at the 1935 British Art in Industry exhibition at the Royal Academy, although these were attacked by some critics on account of their expense and lack of understanding of Modernist principles. He was also committed to more eco-

nomic furniture for everyday use, heavily promoting it from 1932 onwards. Ambrose Heal was knighted in 1933, was elected as a *Royal Designer for Industry in 1939, and was awarded the Royal Society of Arts' Albert Gold Medal for services to industrial design. He handed over the chairmanship of Heal's to his son in 1953. Heal was also a keen student of design history with a number of significant publications, including London Tradesmen's Cards of the Eighteenth Century (1926) and London Furniture Makers from 1660 to 1840.

Heal & Son (established 1810) This leading London firm has had a distinguished history in furniture manufacture and retailing that developed steadily since its establishment as a furniture store by John Harris in 1810. It has subsequently been widely recognized as a retailer of quality furniture, furnishings, and domestic equipment and was for many years in the 20th century attractive to an affluent clientele with an interest in well-designed goods. In many ways the company's history mirrors many aspects of that of British design reform, with strong influences from the *Arts and Crafts Movement, the *Design and Industries Association (of which Ambrose *Heal was a founding member) and a growing awareness of Scandinavian design. After the Second World War it also established a reputation for innovative textile design with commissions from many leading designers. In 1983 the store was taken over by Terence *Conran's Storehouse group, going public in 1997. In the early 21st century it maintains a reputation for retailing quality design, although vastly increased competition in this sector has been reflected in the gradual diminution of its profile from the 1980s onwards. The firm was first located in Tottenham Court Road in 1811 and, by the middle of

the 19th century, had begun to move from its original focus on beds to include bedroom furniture. By the 1880s its activities had expanded to include a new department for sitting room furniture. In 1893 Ambrose Heal joined the family business and for the next 60 years played an important role in building the reputation of the firm as a leading London retailer of good quality design. In the years before the First World War he helped promote an arts and crafts ethos in many of the products sold by the company and was himself bound up in such ideals in his own designs, some of which were seen at the *Paris Exposition Universelle of 1900. The company's image was promoted through catalogues, often with essays by leading figures such as Gleeson White, editor of the periodical the *Studio, and well-designed publicity material. In 1913 Cecil Brewer (like Ambrose Heal, a founder member of the DIA in 1915) and A. Dunbar Smith designed a new building for the company in Tottenham Court Road. It included the Mansard Gallery (open from 1917 with Prudence Maufe), an important vehicle for bringing together art and design as key elements of the company's public profile. After the First World War the outlook of the DIA and Ambrose Heal's friendship with Gordon *Russell led to a growing interest in good modern furniture design, further consolidated by the contributions of Arthur Greenwood and J. F. Johnson to the design team. The slump of the early 1930s also led to the company placing increased emphasis on more economic ranges, a number of which were shown as room settings in the Mansard Gallery. The more progressive aspects of Modernism were catered for in the chromium-plated tubular steel furniture manufactured by the likes of *PEL and *Thonet. Designs by Alvar *Aalto and Marcel *Breuer for *Isokon were also marketed. Heal's pottery and glass depart-

ment, under the management of Harry Trethowan, also acknowledged modern trends overseas, particularly Swedish glass manufactured by *Orrefors. After the Second World War one of the key successes was the development of Heal's Fabrics, under the direction of Tom Worthington and Prudence Maufe. Many young and emerging designers were commissioned to produce designs, including Lucienne *Day, whose *Calyx* design of 1951 won a prize at the 1951 *Milan Triennale, and an international reputation was gained for excellence and innovation in textile design that continued to develop in the 1960s. In the same period furniture design still remained a strong core of the Heal's profile with investment in Clive Latimer's *Plymet* (plywood and metal) furniture and backing for his and Robin *Day's prize-winning involvement in the Low-Cost Furniture Competition at the *Museum of Modern Art, New York, in 1948. Many of Heal's designs were seen at the *Festival of Britain in 1951 and provided a platform for the company's continued success in the decades following the end of the Second World War until the 1970s. After the retirement of Ambrose Heal in 1953 the company continued to expand and develop its profile in the domestic, contract, and export markets until the oil crisis, alongside growing competition, began to cause problems and despite a number of strategic attempts to counter this, such as the *Classics* design show of 1981, the writing was on the wall for a philosophy that sought to promote the somewhat dated notion of *'Good Design' (just as was the case at the *Design Council) at a time when the design climate had been enriched by the challenges of *Pop, *Postmodernism, and *Punk. In 1983 the company was sold to Terence Conran's Storehouse Company for £4.8 million but, despite considerable investment of money, energy, and

talent the company never fully regained the status that it had held in earlier decades as the leading retailer of well-designed products for the home.

Hello Kitty (established 1974) Originally designed as a greetings card for children when launched in 1974 by the Japanese company Sanrio (established 1960), this patented brand cartoon-like image of a cat (a lucky emblem in Japan) has subsequently been applied to more than 1,000 products ranging from domestic appliances, computer keyboards, personal stereos, and credit cards to sweet wrappers, t-shirts, and eyelash curlers (*see also* BRANDING). Hello Kitty even took her place alongside the puppy Pochacoo as one of the Sanrio characters in the Japanese theme park, Puroland, in Tama City, Tokyo. Part of the Japanese *Cute ('Kawaii') culture phenomenon, Hello Kitty products have penetrated world markets from Hong Kong and other south-east Asian countries to Britain, where she has featured on t-shirts in Miss Selfridge and Top Shop. Although primarily geared towards children through the promotion of all kinds of cheap giftware, club culture and young women have also appropriated Hello Kitty as an ironic style statement. She has been applied to more than 3,000 products worldwide producing an annual turnover for Sanrio of more than $9 billion by the early 21st century.

Henningsen, Poul (1894–1967) One of Denmark's major figures in 20th-century lighting design, Henningsen was also an independent architect, designer of theatre interiors and tubular steel furniture, critic, and editor of the magazine *Kritisk Revy* (*Critical Review*). He trained at the Danish College of Technology, commencing work as an architect in 1920 alongside the design of lighting for interior and street settings. Highly critical of the widespread lack of

imagination in domestic lighting in Copenhagen, Henningsen came to prominence with the first of his multi-shade lamps designed in 1924, setting the pattern for his subsequent lighting work. Known as the *Paris Lamp* (and later as the *PH* lamp) it won a competition for a light fitting for the *Paris Exposition des Arts Décoratifs et Industriels of 1925, where he was awarded a Gold Medal, and was put into production by the Danish lighting manufacturer *Louis Poulsen. Henningsen's design principles were based on the scientific analysis of the ways in which lampshades distribute light, glare, and reflection. The *PH* lampshades were composed of a series of separate, interleaved elements that gently diffused the light throughout the space in which it was situated as well as directing it downwards. These lights were affordable to the majority of consumers but, in addition to their domestic applications, were in generic form widely used in larger spaces ranging from restaurants to indoor sporting arenas. In addition to the design of many pendant, wall, table, and public space lighting designs throughout his career, his critical and creative written work was also of note. In addition to editing *Kritisk Revy* from 1926 to 1928, he edited the Louis Poulsen firm's *Nyt* magazine from 1941 until his death and launched a consumer magazine in 1964.

Henrion, F. K. (Frederick Henry Kay) (1914–90) Henrion was one of the most important designers in Britain in the development of corporate identity design with a distinguished portfolio of posters, packaging, and exhibitions. He also played an important role in British graphic design education as well as playing a prominent developmental role in international organizations such as the *International Council of Graphic Design Associations (ICOGRADA) and the *Alliance Graphique Internationale

(AGI). Born in Nuremberg in Germany, in the 1930s he studied under the poster and theatre designer Paul Colin in the artistic hothouse of Paris, where he also came across the work of *Cassandre, the work of the Surrealists, and *Modernist experiments in photomontage and collage. After working on a freelance basis on the design of posters, packaging, and exhibitions in London and Paris in the later 1930s he settled in England in 1939. During the Second World War he worked for the Ministry of Information in Britain as well as for the US Office of War Information based in London. He contributed to the *Britain Can Make It* exhibition of 1946, showing the extensive range of his expertise through his design for a sewing machine. He also designed the Agriculture and Country Pavilions for the 1951 *Festival of Britain and, in 1967, the Union Jack motif on top of the British Pavilion at Expo '67 in Montreal, Canada. In 1951 he founded his own design consultancy, Henrion Design Associates, which offered services in product, graphic, and exhibition design and soon established a reputation for corporate identity schemes with clients that included Blue Circle Cement, car manufacturers British Leyland, Tate & Lyle, BEA (British European Airways), and the Dutch airline KLM. In 1972 Henrion Design Associates changed its name to HDA International, reflecting the wider international scope of its activities and, ten years later, Henrion became a consultant to Henrion, Ludlow & Schmidt, specialists in corporate identity. Henrion played a significant role in design education, lecturing at the *Royal College of Art, London, from 1955 to 1965 and heading the Faculty of Visual Communication at the London College of Printing from 1976 to 1979. He was awarded an OBE in 1951, was president of AGI, was a key figure in the development of ICOGRADA, and was a Master of the Faculty of the *Royal Designers

for Industry in 1971–2. His analytical approach to corporate identity design can be seen in his 1967 book *Co-ordination and Corporate Image*, which he co-published with mathematician Alan Parkin.

Herman Miller Furniture Company (established 1923) Along with *Knoll International this company established its reputation as a leading furniture-manufacturing company in the United States in the decades following the end of the Second World War. Its standing was enhanced by its employment of a distinguished list of designers that included George *Nelson, Charles and Ray *Eames, Isamu *Noguchi, and Verner *Panton. The origins of the business lay in the Star Furniture Company (established 1905), later renamed the Michigan Star Furniture Company (1919). However, Dirk Jan De Pree and his father-in-law Herman Miller established it on a more secure financial footing in 1923 when they bought a controlling share of the stock, renaming the firm the Herman Miller Furniture Company. Early designs produced by the company followed traditional lines and it was not until 1931 when Gilbert Rohde was employed as the company designer that a more progressive design outlook was established. However, following Rohde's death in 1944 and the appointment of the influential and pro-*Modernist George Nelson as design director in 1946 the company's international reputation began to be established. Other designers closely associated with Nelson, such as Charles and Ray Eames and Noguchi, added to the company's growing reputation for modern furniture. A number of the Eameses' early innovative organic designs such as the *LCW* wooden lounge chair (1945–6) and the *DAR* armchair (1948–50) were, respectively, put into production by Herman Miller from 1949 to 1957 and from 1950 to the early 1970s. The company

also produced the highly practical Eameses' Storage Unit (1949), designed for both homes and offices, from 1950 to the mid-1950s as well as the stylish low *ETR* coffee table (1950), from 1951 to 1964. Other celebrated Eames furniture designs for Herman Miller included the iconic 1956 moulded rosewood and leather lounge chair and ottoman. In 1952 the company also moved into the production of wallpapers and textiles under the leadership of Alexander *Girard, who had a background in architecture and interior design and had been colour consultant to the *General Motors Research Center. His textile designs were characterized by bright colours and geometric shapes and he also went on to design Herman Miller Inc. Textiles and Objects Shops in New York (1961). The Herman Miller Company took a new direction from 1960 when the Herman Miller Research Corporation was formed. Concerned with office systems and business furniture design Robert Probst was responsible for this sphere of the company's work, designing the Action Office System first launched in 1964, towards which Nelson (with his experience of system furniture that commenced with his Storage Wall of 1945) also made a design contribution. The Action Office idea moved away from conventional arrangements of free-standing 'island' desks and included screens, storage systems, and a variety of work surfaces. It was also influential in the rethinking of office environments to include electronic equipment and incorporate new working practices. Other work in the field has included the *Ethospace* office system (1984) by Bill Stumpf, who had joined the company in the early 1970s. Important contributions by Stumpf to the Herman Miller range included the innovative gas cylinder mounted *Ergon* chair, introduced in 1976, the *Equa* chair (designed with Don Chadwick), released in 1984, and the *Aeron* chair of 1995, the latter

given the accolade of Design of the Decade by the *Industrial Designers Society of America (IDSA).

Hicks, David (1929–98) Internationally recognized as a distinctly English interior designer and decorator, Hicks studied at the *Central School of Arts and Crafts, London. However, the opportunity to decorate his mother's house in fashionable Belgravia, London, brought him to public notice through a feature in *House and Garden*. In the 1950s he went into partnership with Tom Parr (who was later employed by Colefax & Fowler). In the 1960s he catered for the fashionable, but affluent, younger market sector of the period, designing textiles, carpets, and ties characterized by bold colours and geometric patterns. In 1960 he had married Lady Pamela Mountbatten, Prince Philip's first cousin, which established many connections for interior design commissions. The establishment of David Hicks Ltd. in 1969 opened up many further opportunities, with a prestigious client list including Helena Rubenstein and Princess Anne. He also won important commissions in the public eye, such as the nightclub on the *QE2* ocean liner and the British Embassy in Washington. His work was hallmarked by bold combinations of the modern and the traditional, whether in contrasts of furniture, furnishings, and materials or his use of bold colours. Apart from his interiors, which featured in many magazines around the world, his influence was further disseminated through his very visual books, including *David Hicks on Decoration* (1966) and *David Hicks on Bathrooms* (1970).

High-Tech A term used increasingly widely from the early 1970s to denote 'high technology', High-Tech was often associated with the utilization of advanced technology, as seen in contemporary architecture such as that of the *Centre Georges Pompidou,

Paris (1972–7). Designed by architects Renzo Piano and Richard Rogers it was largely fabricated in glass and metal, with many functions and services—such as escalators, walkways and services—clearly articulated on the exterior of the building. Other architects and designers associated with this outlook included Norman Foster in the Lloyd's Building (1979–86), London, and the Hong Kong and Shanghai Bank building in Hong Kong (1979–86). Many of its qualities could also be found in the interiors of designers such as Nigel *Coates and Eva *Jiricna. The increasing fashionability of a style of architecture, interior, and product design that took on the symbolism of high technology was given a further fillip by the publication in New York in 1978 of the widely-selling book *High-Tech: the Industrial Design and Source Book*. Its authors, American journalists Joan Kron and Suzanne Slesin, suggested the appropriation for domestic use of mass-produced items generally used in a work context, such as industrial shelving and storage systems, stainless steel bowls from the catering industry, or rubber flooring. Such ideas had been explored in the *Eameses' Californian house thirty years earlier where component parts were ordered from catalogues. However, many subsequent products were especially designed to capture a specific High-Tech 'feel', as in geometrically based wallpapers and textiles derived from graph paper grids, the widespread use of perforated steel sheets, and 'space age' gadgets. Supposedly a fusion of 'high style' and 'technology', High-Tech was often marketed in pre-packaged form in fashionable retail stores like *Habitat, rather than being an imaginative redeployment of readymade, industrially-produced components by individual consumers. In its *Catalogue* of 1980/81 Habitat defined its *Tech* style as 'a new look, reflecting the influence of the industrial style in home furniture'.

Hilfiger, Tommy (1951–) One of the highest-profile American clothing companies from the 1980s onwards Tommy Hilfiger Inc. markets a range of personal *Lifestyle products including menswear, women's wear, sportswear, children's wear, glasses, scents, and domestic furnishings. The beginning of Hilfiger's retail career in clothing was less than auspicious, his first outlet, *The People's Store*, going bankrupt in 1976. However, instead of buying in design as he had for *The People's Store*, Hilfiger began designing clothing for his other outlets. After moving to New York Tommy Hilfiger Inc. was founded in 1982, with Hilfiger serving as president until becoming director in 1992. Commencing with men's jeans and sportswear the multi-million dollar Tommy Hilfiger brand has become popular across many products associated with self-image and is embraced by a wide spectrum of consumers internationally. In 1995 the Council of Fashion Designers of America named Hilfiger as the Menswear Designer of the Year. In the same year he was honoured by the 'From the Sidewalk to the Catwalk' Award at the first VH1 Fashion and Music Awards.

Hille (established 1906) Since the Second World War this British furniture manufacturing company has established a reputation alongside the innovative ideas of designer Robin *Day. Its origins lay as a family business producing handcrafted reproduction furniture with an aesthetic policy that responded to consumer demand. However, this outlook changed in the late 1940s when the company began producing modern furniture designed by Day alongside reproduction 18th-century styles for the important American export market. Day became a consultant to the company in 1949, modernizing many aspects of the company's public identity, its showrooms, and exhibitions. A notable early instance of

the latter was Day's design of a contemporary dining room for the 1949 British Industries Fair, normally a very conservative showcase for British manufacturing industry. His work for the company also penetrated international showcase for progressive design including the highly profiled *Milan Triennali at which Hille and Day were awarded a Gold Medal in 1951 and two Silver Medals in 1954. Successful designs included the plywood *Hillestack* chair (1950–1), the *Q-Stack* chair (1953), and *Form* unit seating (1957). In the same period Hille took up licences to reproduce furniture designs from overseas companies, most notably designs by *Herman Miller and *Knoll from the USA. However, Hille also sold licences for foreign companies to reproduce designs by Day and Hille, enhancing its reputation overseas. An important shift in the company's outlook followed a period of experimentation with new plastics technologies, notably *Polypropylene, through which Day found elegant and practical design solutions in his *Mark I* (1962) and *Mark 2* (1963) chairs. The latter sold millions and became a design icon. In 1967, like a number of Italian companies in the same period, Hille established an experimental plastics workshop in order to maintain a competitive edge. In the late 1960s the company also developed its office furniture and office systems ranges, emerging strongly with the Hille Office Landscape System in 1973.

Hochschule für Gestaltung, Ulm (1953–68) *See* ULM, HOCHSCHULE FÜR GESTALTUNG.

Hoffmann, Josef (1870–1935) A leading member and founder of the Wiener Secession (1897) and *Wiener Werkstätte (1903), architect and designer Hoffmann was one of the most influential figures in the field in the early 20th century. After commencing his

studies at the Royal State Technical School in Brno in 1887 he went on to study architecture at the Academy of Fine Arts in Vienna from 1892 to 1895, where his tutors included Otto *Wagner. He designed the *Ver sacrum room at the first Wiener Secession exhibition in 1898. Hoffmann fell under the influence of British designers Charles Rennie *Mackintosh and Charles Robert *Ashbee, whose Guild of Handicraft proved an important stimulus for the establishment of the Wiener Werkstätte (Viennese Workshops) with designer Koloman *Moser and industrialist Fritz Warndorfer in 1903. Between then and 1931 the Werkstätte produced furniture, metalware, and jewellery designs by Hoffmann, often characterized by qualities of geometry and rectilinearity. Hoffmann had begun teaching architecture at the Vienna School of Applied Arts in 1899, a post that he maintained until 1941. One of his most important commissions was the Palais Stoclet in Brussels (1905–11), for which he designed the whole ensemble from building through to interiors and furniture and worked alongside the distinguished Viennese artist Gustav Klimt and artist-designer Carl Otto Czeschka. He also designed furniture for the *Thonet company including his Sitzmaschine ('Sitting Machine') of 1908. Following on from the ideas of the *Deutscher Werkbund established in 1907, Hoffmann founded the Austrian Werkbund in 1912 and headed it until 1920. He also designed the Austrian Pavilions at the 1914 Werkbund exhibition in Cologne, the 1925 *Paris Exposition des Arts Décoratifs et Industriels, the 1930 *Stockholm Exhibition, and the Venice Biennale of 1934.

Hollein, Hans (1934–) Austrian architect and designer Hans Hollein's career has embraced the fine arts, furniture and silverware design, education, and writing. His mature work is closely associated with the tenets of *Postmodernism as seen in his interior design for the Austrian Travel Centre in Vienna that draws on many allusions to travel, whether gilded metal palm trees, the railings of an ocean liner complete with lifebuoy, or a broken classical column. He has also designed furniture for *Memphis, ceramics for *Swid Powell, and tables for *Alessi. Hollein graduated from the Academy of Fine Arts in Vienna in 1956, winning a Harkness Fellowship for travel to the United States. He went on to graduate studies at the Illinois Institute of Technology and the University of California, Berkeley, gaining an MA in Architecture in 1960. After a period employed by architectural firms in the United States, Australia, Sweden, and Germany, in 1964 he moved back to Vienna, where he set up his own architectural practice. He gained his first architectural commission in 1965. Many significant commissions followed, as well as the winning of a number of international competitions. These included that for the Museum of Modern Art in Frankfurt, designed in 1983 and completed in 1991. In 1985 he designed a touring exhibition on Viennese culture, Dream and Reality, originating in Vienna and visiting a number of cities around the world. He aptly summed up his architectural and design outlook when he declared that he had 'tried to expand the scope and range of artistic and architectural invention. Therefore my interests dwell not only on the sizeable building proper, but on the utterances you can make on a small scale as well, especially in relation to the needs daily life carries with it—the room, the object you feel and touch.' In addition to the teaching of architecture and design in Vienna from the mid-1970s, he was also in charge of the Austrian architectural contributions to the Venice Biennale from 1978 to 1990. He has designed for

many leading companies including furniture for *Herman Miller, *Knoll International, *Driade, and Poltranova. He has also designed textiles and theatre sets and has been granted solo exhibitions of his work at many leading international museums and galleries.

Honda Motor Company (established 1946) Founded in Hammamatsu by Soichiro Honda as the Honda Technical Research Institute, the company began its life in motorcycle manufacture at a time when public transport systems were inadequate and fuel prices high. Following its redesignation as the Honda Motor Company in 1948, the Honda *Dream Type D* motorcycle was the first machine with engine and frame produced by the same manufacturer. The Honda *Cub F* (1952), with its distinctive red engine and white fuel tank, attracted widespread attention and was even sold by catalogue. The company also moved into the motor scooter sector, introducing the *Juno* 200 cc model as a competitor to the Italian *Vespa* copies being manufactured in Japan. By the mid-1950s Honda had become a dominant force in Japanese motorcycle production, beginning a programme of overseas expansion from 1959 with the establishment of the American Honda Motor Co. Instrumental in such success had been the *Super Cub* motorcycle, an economic, practical, and lightweight machine which was designed for use by both men and women. Launched in 1958, it became so successful in the market place that analogies were drawn with the Volkswagen *Beetle* and the Ford *Model T*. In 1959 it was the first Honda motorcycle sold in the United States, with other overseas sales companies being established in Europe. Furthermore, the company's profile was considerably enhanced over the following decades by success in motorcycle racing. In the early 1960s Honda also began

to manufacture small four-wheeled, front-wheel drive vehicles such as the *N360*. Honda began to penetrate the US automobile market in 1969. However, the company's reputation in this field was not cemented until the compact, economically priced Honda *Civic* was launched in 1972, followed by the *Accord* in 1976. From 1983 onwards the company opened production lines outside Japan in the USA and Europe.

Hornby, Frank (1863–1936) Born in Liverpool, England, Frank Hornby was the inventor of the world famous educational construction toy *Meccano. Originally a book-keeper to David Elliott, a Liverpool-based meat importer, he persuaded the latter to provided the capital for his new venture. Hornby's company also manufactured other toys including chemistry kits (Kemex), electrical kits (Elektron), Hornby model trains, and later Dinky Toys (model cars).

Horta, Victor (1861–1947) A leading Belgian *Art Nouveau architect and designer best known for his buildings, interiors, furniture, and furnishings in Brussels in the late 19th and early 20th centuries, Horta studied drawing, textiles, and architecture at the Académie des Beaux-Arts in Ghent from 1874 to 1877, before going on to work in Paris until 1881 to 1884 at the Académie des Beaux-Arts in Brussels. His work over a ten-year period from 1893 marked his involvement with the flowing forms of Art Nouveau and was characterized by the idea of the 'total work of art' in which furniture, furnishings, and interior decoration were part of a fully integrated building. Horta was influenced by the rationalist principles of *Viollet-Le-Duc as revealed in the decorative use of structural ironwork that became a hallmark of his buildings. His first major work was the Hôtel Tassel (1892–3) for the engineer Émile Tassel, in which he paid

close attention to ornament and decoration, making considerable use of organic motifs drawn from nature and the expressive form of the 'whiplash' as in the dramatic iron staircase. His most extravagant building was perhaps the Hôtel Solvay (1895–1900) for the industrialist Armand Solvay. He also designed the Maison du Peuple (1895), making considerable use of iron and glass. Not only was Horta aesthetically progressive in his rejection of historicist forms he also used electricity to light his buildings. He was well connected in Art Nouveau circles, designing a shop façade (not executed) for the Art Nouveau entrepreneur Samuel Bing in Paris, and his work was featured in the inaugural issue of the periodical *Art et décoration* in 1897. He also designed furniture and decorations for the Brussels Pavilion at the Turin Esposizione Internazionale d'Arte Decorativa Moderna of 1902, one of the last major exhibitions of Art Nouveau buildings and design. After the early years of the 20th century Horta's work took on a more academic direction and from 1912 he was a professor at the Académie des Beaux-Arts in Brussels where he became the director from 1927 to 1931.

Howard Miller Clock Company (established 1925) Originally named the Herman Miller Clock Company (having family links with the more famous Herman Miller Furniture Company) this Michigan-based firm established its reputation at the *New York's World Fair of 1939–40 where it displayed clocks in a contemporary style after over a decade of working on more traditional models using imported clock movements. After the Second World War (during which the company had produced anti-aircraft covers for aeroplanes manufactured by the *Ford Motor Company) the Howard Miller Clock Company manufactured several contemporary style products for George *Nelson Associates, including the *Ball* (1949) and *Asterisk* (1950) wall clocks. The former, with its hours marked out in molecular-like balls, shared the interest in atom-based forms of designers working in the *Contemporary Style whilst several of the other products for Nelson assumed some of the characteristics of contemporary sculpture. It has been suggested that these almost abstract designs were the work of Nelson associates Isamu *Noguchi and Irving Harper. After this brief foray into a progressive vocabulary suited to the post-Second World War corporate aesthetic of *Modernism, the Howard Miller Clock Company once again reverted to more traditional models before moving into digital clocks and alarms in the 1970s and 1980s, a period in which it also worked on domestic models. Also at this time the company diversified into furniture manufacture, purchasing the Hekman Furniture Company in 1983.

Hulanicki, Barbara (1938–) Most widely known for the founding of the fashionable clothing store *Biba, Polish-born Hulanicki studied fashion illustration at Brighton School of Art before going on to launch a mail order business selling cheap clothes to her own designs. This led to the opening of the first Biba *Boutique in London in 1964, the business going on to become a style landmark of the later 1960s and early 1970s. Biba failed in 1975 and Hulanicki moved to Brazil, where she once more opened clothing stores. After her return to Britain six years later she opened a Barbara Hulanicki shop in London, again selling her own label clothes. In 1983 she launched Hulanicki Cosmetics, selling up in 1987 when she settled in Miami in the United States. On returning to Britain in 1996 she opened another boutique, Fitz-Fitz. Her autobiography, *From A to Biba*, was published in 1983.

IBM (International Business Machines, established 1924) American multinational corporation IBM has established a leading position in world markets as a provider of well-designed office and business equipment with a distinctive, symbolically efficient aesthetic that marked its products from the middle of the 20th century under the design leadership of Eliot *Noyes. The roots of the company lay in the late 19th century when the US Census Bureau needed access to efficient means of tabulating census data to record the large number of immigrants to the country and the establishment of the Tabulating Machine Company with an innovatory punch card tabulating machine. Following a range of mergers in the early 20th century and the involvement of Thomas Watson Sr. in the senior management structure of the new Computing-Tabulating-Recording Company (C-T-R) in 1914 the company underwent further expansion, changing its name in 1924 to International Business Machines Corporation (IBM). By this time the company had three manufacturing plants in Europe. Unlike many companies in the Depression of the 1930s IBM won the contract to keep employment records for 25 million people in the wake of the Social Security Act of 1935, with other government contracts following. It also invested in modern research and development laboratories in Endicott, New York. During the Second World War IBM began to become involved in the development of computers with the Automatic Sequence Controlled Calculator in 1944 developed into other large calculating machines in the later 1940s. During the 1950s a number of computers were developed including the IBM *701* (1952), used for government and research work, the IBM *7090*, an early fully transistorized mainframe used by the US Air Force, and the IBM *305 Random Access Method of Accounting and Control* (RAMAC) of 1957, the year in which IBM introduced Fortran, one of the most common languages for technical work. In 1952 Thomas Watson Jr. was made president of IBM and chief executive officer in 1956. Watson was instrumental in bringing about significant changes to IBM's corporate design outlook, inspired by what he had seen of the products, advertising, and publicity at *Olivetti, the Italian office equipment manufacturing company. He appointed Eliot Noyes as consultant director of design in 1956, Noyes already having had a professional relationship with the company, working on the IBM account whilst he was design director at Norman *Bel Geddes's design consultancy after the Second World War. After setting up Noyes & Associates in 1947 and completing work on the IBM *Model A* electric typewriter, which had been left unfinished when Bel Geddes's office closed in 1947, he was awarded the consultancy for IBM products in 1948. When he took up the post of consultant director of design Noyes brought in a number of key designers to help shape IBM's corporate identity. These included the graphic designer Paul *Rand who, like Noyes, had an affinity with a European *Modernist aesthetic, George *Nelson, another advocate of Modernism, both in his writings and design work, and Edgar Kaufmann Jr., director of the Department of

Industrial Design at the *Museum of Modern Art, New York. IBM's design policy was explained in the company's Design Practice manual written by Noyes and realized throughout the company's activities. Paul Rand used German designer Georg Trump's *City* typeface of 1930 as the basis for the IBM *logotype of 1956. Former *Bauhaus graduate and teacher Marcel *Breuer, former Bauhaus director Ludwig *Mies Van Der Rohe, and Eero *Saarinen designed IBM buildings, as did Noyes himself, including the 1963 IBM building in Garden City, New York. Charles and Ray *Eames were also employed to design exhibitions for IBM as well as producing a number of films to explain the workings of computers. One of the best-known IBM products designed by Noyes was the *Selectric I* electric typewriter of 1961 with an innovatory interchangeable 'golfball' printing element, the carriage remaining fixed. Noyes had worked on its elegant casing from 1959 onwards. The attractive, functional aesthetic endowed this and other IBM products with an aura of efficiency, giving secretarial and administrative work a sense of status. The use of colour for the casings of many of these machines injected a further feeling of 'joie de vivre' rather than the dull monotony associated with routine work. The *Selectric II* was launched in 1971 and, by 1975, *Selectric* typewriters accounted for almost three-quarters of the US typewriter market. This position changed with the advent of the personal computer (PC) in the 1980s, IBM entering the market after *Apple. After a drop in profits the company underwent a reorganization in the 1990s.

ICOGRADA *See* INTERNATIONAL COUNCIL OF GRAPHIC DESIGN ASSOCIATIONS.

ICSID *See* INTERNATIONAL COUNCIL OF SOCIETIES OF INDUSTRIAL DESIGN.

Ideal Home Exhibitions (established 1908) Sponsored by the *Daily Mail* newspaper, these exhibitions provide an insight into popular taste and aspiration across all aspects of domestic design and organization in Britain. The first exhibition of 1908, held at the Olympia exhibition complex in London, attracted 160,000 visitors to a display of show houses and labour-saving equipment and was followed by three further shows before the First World War in 1910, 1912, and 1913. The latter included an avant-garde room furnished by the *Omega Workshops, a company that was influenced by the Fauvists and Cubists in France and the *Wiener Werkstätte in Austria. Although the First World War interrupted the sequence of the Ideal Home Exhibitions, their popularity increased considerably alongside the British house-building boom of the 1920s and 1930s—even in the slump of the early 1930s attendances were close to 700,000. Held annually from 1920 to 1939 (on a larger scale from 1923 with the opening of an extension to Olympia), housing types for a variety of income brackets were displayed alongside all kinds of new appliances and ideas about domestic planning and management. Futuristic ideas were also a popular magnet, as in the 1928 exhibition where the *Modernist House of the Future was equipped with underfloor heating, pneumatic furniture, disposable (cardboard) 'crockery', and a garage hangar for an 'aerocar'. After the Second World War, the exhibitions resumed in 1947 although they took on a more commercial air with the leasing of stands to generate income. The Council of Industrial Design (COID, *see* DESIGN COUNCIL), hoping to extend its influence to a wider audience, sought to interest the public in the ways in which design could benefit society by participating in a number of Ideal Home Exhibitions. In 1948 it commissioned a designer to

furnish the Ministry of Health's Aluminium House on a budget of £250 and, in the following year, commissioned five designers to furnish and equip the Ministry of Health's terraced houses for a *Four Ways of Living* exhibition that proved popular with the public. Attendances at Ideal Home Exhibitions after the Second World War continued at a significant level, showing the enduring popular interest in domestic design: in 1951 there were 1,135,102 visitors, in 1965, 1,128,123, and in 1975 879,564. However, the increasingly widespread influence of television and the growth in the number of Do-It-Yourself superstores and home furnishing and decorating magazines provided alternative outlets for public interest. Nonetheless, the exhibitions continued to attract public interest. For example, in the first post-war exhibition of 1947 there was a section entitled 'Science Comes Home' that sought to show the ways in which technological and scientific advances made in the war years could be applied to the home. In 1956 another House of the Future was displayed. Designed by Alison and Peter Smithson, this mass-produced house with its built-in appliances and equipment sought to portray automated living in the 1980s. The living room featured a remote-controlled radio-television and controls for raising and lowering sections of the floor to become coffee or dining tables. The kitchen had a dishwasher that also disposed of all waste, a sink with waste-disposal unit, and a microwave oven; other equipment included an electrostatic dust collector that could operate on its own. In the following decades technologically oriented displays continued to attract attention. To parallel the many other design awards that were being instituted in the 1950s and 1960s, in 1965 the *Daily Mail* Ideal Home Exhibition brought in its own design award scheme, the Blue Riband. The aim was to encourage British and foreign manufactur-

ers to introduce new products at the exhibition. The latter qualified if they had been launched on the British market within the previous twelve months and presented a new idea or major development to an existing design. In 1975 the *Daily Mail* established a separate company, Angex, to take on the responsibility for the Ideal Home Exhibitions. From 1979 onwards the exhibitions were held at Earl's Court, London.

IDSA *See* INDUSTRIAL DESIGNERS SOCIETY OF AMERICA.

IFI *See* INTERNATIONAL FEDERATION OF INTERIOR DESIGNERS/ARCHITECTS.

Iittala (established 1881) A celebrated Finnish glass manufacturer with a long history, Iittala's international reputation was forged after the Second World War through major company's designers such as Kaj Franck, Tapio *Wirkkala, and Timo *Sarpaneva, all of whom have been associated with the best of Scandinavian glass design. The Iittala glassworks, founded by a master glassblower in 1881, was taken over in 1917 by the Ahlström company which had itself already acquired the famous Karhula glassworks. Subsequently known as Karhula-Iittala, the Karhula works was more closely associated with mass-produced glass and Iittala with blown glass, the *Aaltos winning a number of competitions sponsored by Karhula in the 1930s. After the war Kaj Frank won a glass competition sponsored by Iittala in 1946 and was employed by the company until 1950. Wirkkala, also a winner of the 1946 competition, worked in art glass at Iittala having first attracted attention with his famous, evocatively organic *Kantarelli* vase of 1947, based on the chanterelle mushroom. The second version was awarded a grand prize at the 1951 *Milan Triennale. Timo *Sarpaneva began designing for the company in 1950, winning

recognition in the 1954 Milan Triennale for his *Lancet II* (1952) and *Orchid* (1953). Many of his designs were characterized by a strongly sculptural, asymmetrical, and abstract appearance. Amongst his most widely known achievements has been the *Finlandia* art glass collection of 1974. Other designers working for the company have included Valto Kokko, who began working for Iittala in 1963, Jorma Vennola, who started in 1975, and Mikko Parppanen, who commenced in 1983. In 1988 Iittala merged with the Nuutajärvi-Notsjö glass company to become Iittala-Nuutajärvi and was itself taken over by the Finnish housewares manufacturer Hackman in 1990, along with *Arabia and *Rörstrand.

IKEA (established 1943) This furniture and furnishings company was founded in Sweden by Ingvar Kamprad (b. 1926). In the late 1990s it had almost 130 stores in 30 countries worldwide. The IKEA mail order catalogue, which in 1997 was issued in 39 editions in 31 countries in 17 languages, has become a powerful vehicle for attracting potential customers for the company's products, many of which are laid out in enticing room settings. IKEA's philosophy was encapsulated within its marketing strategy maxim 'We shall offer a wide range of home furnishing items of good design and function, at prices so low that the majority of people an afford to buy them.'

The origins of the company lay in Kamprad's entrepreneurial activities as a wholesale buyer and seller of a wide range of everyday commodities to neighbours in his farming community. The name IKEA was launched in 1943, deriving from the initials of Kamprad's name, town, and region. By 1950 the company had moved into furniture retailing, an area of corporate activity which assumed an increasingly dominant role. Even at this early stage IKEA furniture

relied on qualities of Swedish heritage characterized by a use of natural materials, humanizing functionalism, and clarity of form. The first full-blown IKEA catalogue was issued in 1951, the first furniture showroom opening in Almhult, Sweden, two years later. In 1955 the company began designing its own furniture, with the introduction in 1956 of its self-assembly flat-pack range—an important ingredient of popular success. The first IKEA store opened in Almhult in 1958. Another important aspect of the company's succesful retailing strategy was marked by the addition of a restaurant in 1959, making the shopping experience more relaxing for those coming from further afield. Subsequently, the provision of children's play areas also became a commonplace feature imitated by other companies. The 1960s marked a steady expansion with the introduction of a second IKEA store in Oslo, Norway, in 1963 and the introduction of a self-service open warehouse system at IKEA, Stockholm, which opened to huge crowds in 1965. In order to enhance design standards in 1975 the company hired an outside consultant, Niels Gammelgaard, a Dane. He produced a number of designs for the company and in the 1980s established Studio Copenhagen as an external design supplier. It was also in the 1980s that IKEA's corporate identity was radically updated by the Hans Brindfors advertising agency. The company's expansion gathered pace in the 1970s and 1980s: in 1973 the first store outside Scandinavia opened in Switzerland and in the following decade new outlets included Saudi Arabia (1983), the USA (1985), the UK (1987); in the 1990s new locations included Hungary and Poland (1990), the Czech Republic (1991), and Slovakia (1992).

The range of products is overseen by IKEA of Sweden with up to twenty designers employed on a full-time basis, with a further

100 designers, mainly Swedish, working around the globe. Although the products are generally characterized by a sense of value for money blended with practicality and style, there have been isolated attempts to present a more progressive aesthetic, most notably the PS (Postscript) Collection of 40 pieces designed by nineteen Scandinavian designers, which was launched at the Milan Furniture Fair of 1995. However, the collection was not designed for mass production, was only shown in selected stores, and thus did not fit in with the wider corporate philosophy of affordable products. Another innovative designer product range entitled 365+ was launched in 1997.

Illich, Ivan (1926–2002) Illich was one of a number of critical thinkers who, in the 1970s, questioned the ways in which society was organized. Like Ernst Schumacher, author of *Small is Beautiful: A Study of Economics as if People Mattered* (1973), designer, architect, engineer, and thinker Richard Buckminster *Fuller, author of *Utopia or Oblivion* (1970), and others whose voices were heard in the debates about post-industrialization, Ivan Illich wrote a number of texts that embraced parallel concerns. Most significant among these were *De-Schooling Society* (1971) and *Tools for Convivality* (1973), in which he argued that *Fordist technologies turned people into the adjuncts of bureaucracies and machines. Illich was born in Vienna and later studied theology in Rome and history at the University of Salzburg in the 1940s, writing a doctoral thesis on the historian Alred Toynbee. After being ordained as a priest in Rome in 1951 he moved to Manhattan, where he worked for the Puerto Rican community. After periods in Puerto Rico he moved to New Mexico, where he established the controversial Centre for Intercultural Documentation

and, from 1964, organized seminars on 'Institution Alternatives in a Technological Society'. A fiercely critical voice in the Roman Catholic Church he applied his antipathy to bureaucracy in education and other institutions in his search for alternatives to industrial monopolies in a post-industrial age. Although he continued to write prolifically, his influence was at its height in the 1970s.

Image, Selwyn (1840–1930) A British designer with close ties to the *Arts and Crafts Movement, Image worked in stained glass, embroidery, bookbinding, typography, and graphic design. He was also an articulate writer on design, was Master of the *Art Workers' Guild in 1900, the Slade Professor of Fine Arts at Oxford from 1910 to 1916, and a member of the *Design and Industries Association, established in 1915. In his early years he was influenced by John *Ruskin, whom he met at Oxford, later working closely with the designer A. H. *Mackmurdo and the Century Guild. Image's line-block design for the cover of the inaugural 1884 issue of the *Hobby Horse*, the Guild's publication, is widely known. Other celebrated works include the design of embroideries for the Royal School of Needlework and bookbindings such as that for the novel *Stefania* (1893). In the same year he contributed to *Arts and Crafts Essays by Members of the Arts and Crafts Exhibition Society* and, two years after his death in 1930, his letters were published, having been edited by his friend Mackmurdo.

Independent Group *See* box on p. 211.

Industrial Arts Institute (IAI, established 1928) Established in Sendai, Japan, the Industrial Arts Institute (IAI) came under the aegis of the Ministry of Commerce and Industry (which later became the Ministry of International Trade and Industry—MITI) in 1932. Originally conceived as an agency for the promotion of

INDEPENDENT GROUP

(1952–5) A radical, informally associated group of young British artists, architects, and writers, the Independent Group (IG) questioned the assumptions of *Modernism through its interests in contemporary American popular culture, the aesthetics of expendability. It has also been seen as laying down the foundations for the emergence of *Pop. However, recent researchers into the activities of the IG have established that they were by no means as coherent as a number of the Group's members have subsequently suggested, rather the informal gatherings of a relatively small group interested in a range of contemporary cultural concerns. Leading figures within this gathering included writer, architectural, and design historian and critic Reyner *Banham, fine artists Richard Hamilton and Eduardo Paolozzi, critic Lawrence Alloway, architectural writer John McHale, photographer Nigel Henderson, and the architects Alison and Peter Smithson. The IG was centred on the Institute of Contemporary Arts (ICA) in London whose president was Herbert *Read, whose aesthetic principles were immersed in the Modernist outlook of the interwar avant-garde. The first informal gatherings of the IG took place in 1952, initiated by a presentation by Paolozzi of advertisements and images drawn from American popular culture, followed by a talk by the philosopher A. I. Ayer and a discussion on kinetic art. Banham became the Group's convenor later in the year, bringing into focus issues of science and technology. In 1953 an exhibition on the *Parallel of Life and Art* was mounted at the ICA, a show drawing on a wide range of photographic images opposed to the aestheticism of the establishment and involving a number of those connected with the IG, namely Henderson, Paolozzi, and the Smithsons. There were further seminar series, on a more organized footing, that ran in 1953–4 and 1955, the first convened by Banham and the second by McHale and Alloway, which included discussion of aesthetics and Italian product design, fashion and fashion magazines, Detroit automobile styling, and commercial music. Richard Hamilton also organized the 1955 *Man, Machine and Motion*, a photographic exhibition that paralleled some of the concerns of the seminar discussion. The last meeting of the Group took place in the summer of 1955, the time at which Lawrence Alloway was appointed as assistant director of the ICA. However, the IG heavily influenced the *This Is Tomorrow* exhibition held at the Whitechapel Gallery, London, in 1956, which included a proto-Pop environment by Hamilton, McHale, and architect John Voelker, a visual communication collaboration by Alloway, Tony del Renzio, and Geoffrey Holroyd, and the *Patio & Pavilion* by the Smithsons, Paolozzi, and Henderson.

mass-production techniques and new products to smaller companies in northern Japan, it also published a monthly design journal and held an annual exhibition to showcase new products. After moving to Tokyo in 1933, it became the leading body for design development in Japan for the next 40 years. It published the influential periodical *Kogei Nyusu* (*Industrial Art News*, 1932–74) and continued to put on annual exhibitions, the first of which was mounted in the Mitsukoshi department store in 1933. The German designer Bruno Taut visited the show and was highly critical of the

ways in which Japanese designers mimicked European products, suggesting instead a reconciliation of indigenous craft skills with the realities of modern mass-production technologies. Other foreign designers with close links to the IAI included the French architect-designer Charlotte *Perriand, who arrived in Japan in 1940. During the 1940s the Institute employed many designers (such as Isamu *Kenmochi, Iwataro *Koike, and Jiro *Kosugi) who were to emerge as key figures in the post-Second World War period. It played a critical role in this period of Japanese reconstruction and occupation by the American General Headquarters, working closely with companies such as Toshiba and Mitsubishi. During the 1950s, seeking to dispel the widely held view overseas that Japanese goods were inferior and poor value for money, it also promoted Japanese design abroad at important international design showcases such as the *Milan Triennali of 1957 and 1960 and the Brussels International Exhibition of 1958. In 1969 the Institute was restructured and renamed.

Industrial Design (established 1954) Founded at a time when the industrial design profession was becoming firmly established in American manufacturing industry, *Industrial Design* has long been established as the leading magazine for industrial designers in the United States. Retitled *ID Magazine of Industrial Design* in 1980, since its establishment it has carried a broad range of critical material relating to the practice, culture, and business of design. It is published eight times a year, including the prestigious *Annual Design Review* that embraces consumer products, furniture, equipment, environments, packaging, graphics, and student projects.

Industrial Design Council of Australia (IDCA, established 1958) Funded by the Commonwealth government in response to pressure from a number of Australian design associations, the IDCA was established in 1958 under the directorship of Colin Barrie to promote industrial design as an important aspect of successful manufacturing industry. Its first chair was the industrialist Essington Lewis and inaugural director design educator Colin Barrie. Many of IDCA's initiatives followed on from those of the Council of Industrial Design (*see* DESIGN COUNCIL) in Britain: the establishment in 1960 of the black Good Design Label that bore the message 'Selected as Good Design for Australian Design Index—Industrial Design Council of Australia'; the opening of the first Australian Design Centre in Melbourne in 1960 in which the IDCA featured *'Good Design'; and the launch in 1967 of *Design Australia*, the IDCA's official journal (ceasing publication in 1975). Prince Philip also instituted his Prize for Australian Design in 1974, in place for eleven years, which also had a Good Design Label, in this case a silver tag with black logo. In 1978 the IDCA instituted the *Australian Design Award to replace the original Good Design Label (which had ceased in 1975). In 1970 the IDCA had gained sponsorship from Dunhill for the setting up of a lecture series that involved many leading international designers, including Misha *Black (1970), Marco *Zanuso (1971), and Kenji *Ekuan (1973). In 1978 the Australian government withdrew its funding for the IDCA, causing it to seek self-sufficiency through the support of industry, state, and other federal funding opportunities. In the following year the IDCA instituted its Design Council Selection Policy, a less prestigious level of design recognition than the Australian Design Award but identified by a green variant of the blue labelling of the latter. Again, like earlier initiatives, this could be traced to the pro-

motional design activities of the British *Design Council. In 1980 the Australian Design Centre was launched in Sydney in 1981. In 1992 design awards were given an additional profile when the *Powerhouse began a series of annual 'Selections' from products in the Australian Design Award competition. The IDCA was reformulated in 1987 after a government review and was renamed the Australian Design Council, taking on the additional role of design training. In the same year the Australian Design Award was rebranded with a DA logo in blue, white, and red. However, in 1993, after a review by representatives of government, the design profession, and industry, management of the Australian Design Award was handed over to the Design and Development Division of Standards Australia and relaunched as the Australian DesignMark Programme.

Industrial Designers Society of America (IDSA, established 1965) The roots of IDSA can be traced back to a number of earlier organizations set up before the Second World War. These included the *American Union of Decorative Artists and Craftsmen (AUDAC), founded in 1928, the National Furniture Designers' Council (NFDC) which lasted from 1933 to 1934, and the Designers' Institute of the American Furniture Mart, founded in 1936. Two years later the latter formed the Chicago-based American Designers Institute (ADI), which drew on a much wider range of specialist expertise, ranging from industrial design to graphics and the decorative arts under the presidency of John Vassos. In 1951 ADI moved its administration to New York, changed its name to the Industrial Designers Institute (IDI), and established an annual programme of National Design Awards which ran until 1965. However, rather more significant was the Soci-

ety of Industrial Designers (SID), which was founded in 1944 by fifteen designers who were well grounded in industrial design practice. Under the presidency of Walter Dorwin *Teague the SID sought to establish a firm platform to advance recognition of the professional designer in the rapidly exanding and competitive market places of the post-war era. The SID became the American Society of Industrial Designers (ASID) in 1957, the same year in which the Industrial Design Education Association (IDEA) was founded as neither of the professional bodies admitted educators. By 1965 these three bodies had between them a membership of about 600 representing a wide spectrum of professional interests relating to industrial design and they merged to become the Industrial Designers Society of America (IDSA). Its first chair was John Vassos and first president Henry *Dreyfuss. In 1980 the annual National Design Awards were re-established. Membership in 2000 amounted to more than 3,000.

Industrial Design Institute of Australia *See* DESIGN INSITITUTE OF AUSTRALIA.

Innocenti (established 1926) The origins of this Italian automobile and motor scooter company lay in a steel tubing business set up in 1926 by Ferdinando Innocenti. In 1933 the company expanded and moved to the Lambretta area of Milan, entering also into the manufacture of automotive parts. With the anticipated outbreak of war further expansion took place and a new factory was built. However, bombing destroyed it, preventing the company from getting back into production until 1946. Ferdinando realized that the public were eager for access to cheap transportation and saw the production of a scooter as a solution. Launched in 1947 the *Lambretta* motor scooter, designed by Cesare Pallavicino and Pierluigi Torre, was the result. By comparison with the

*Piaggio Company's *Vespa* scooter, designed by Corradino *D'Ascanio and put on the market in the previous year, the *Lambretta* was rather less refined in design terms: it was defined by a rather basic functional appearance rather than the more aerodynamically rounded or streamlined body forms of its *Vespa* counterpart. Nonetheless, *Lambretta* styling soon gained its own sense of panache, becoming a desirable symbol of independence and mass mobility. However, with improvements in the Italian standard of living, accompanied by higher levels of disposable income, many Italian consumers turned to cars such as the small, economic *Fiat *Nuovo 500* of 1957 designed by Dante Giocosa, as a more desirable alternative. By the early 1960s scooters had become closely associated with youth culture. By this time Innocenti had moved into automobile production, launching the *A40* (Austin *A40*, built under licence) at the Turin Motor Show of 1960 along with the *950 Spider*, a restyled Austin-Healey *Sprite*. Modifications of other British Motor Corporation (BMC) cars followed, also built under licence. However, British Leyland (a later reorganization of the BMC) bought out the Innocenti automobile production lines in 1972, putting into production a new *Bertone-designed version of the *Mini* in 1974. In the following year, due to the economic problems faced by British Leyland, Innocenti was taken over by the Italian government.

After graduating in engineering in 1947 Ferdinando's son Luigi joined the company.

Institute of Design (established 1944) The Institute of Design in Chicago was established by László *Moholy-Nagy in 1939 following a number of short-lived antecedents beginning with the New Bauhaus in Chicago established in 1937 under the directorship of Moholy-Nagy with fellow ex-*Bauhaus staff member Walter *Gropius

as consultant. Although sponsored by the Association of Arts and Industries, the levels of financial support were insufficient to prevent the closure of the institution in 1938. In the following year, Moholy-Nagy founded the School of Design in Chicago, injecting his own financial support underpinned by that of former colleagues from the New Bauhaus. Important also in funding terms was the Chicago industrialist Walter P. Paepcke, founder of the design conscious *Container Corporation of America, whose commitment maintained the institution's financial viability for a number of years. The new School marked an important landmark in American design education, imbued with the spirit of the German Bauhaus and its legacy of the fusion of art, science, and technology as seen in Moholy-Nagy's posthumous book, *Vision in Motion* (1947). In 1944 the name of the institution was changed to that of the Institute of Design and in 1946, following Moholy-Nagy's death, Serge *Chermayeff was appointed as the new director. In 1949 the Institute of Design was incorporated into the Illinois Institute of Design at Chicago and was granted university status. After a short interregnum following Chermayeff's resignation in 1951 Jay Doblin was appointed as the new head of the Institute, with four major departments of visual design, product design, photography, and art education providing focus for students after they had completed the obligatory foundation course.

Instituut voor Industriele Vormgeving (IIV, Institute of Industrial Design, 1951–76) *See* NEDERLANDISCHE BOND VOOR KUNST IN INDUSTRIE.

Instytut Wzornictwa Przemyslowego (IWP, established 1950) The Institute of Industrial Design (IWP) was founded in Warsaw in 1950 under the

directorship of Wanda Telakowska, who had previously been in charge of the Buiro Nadzoro Estetyki Producji (BNRP, Office for the Supervision of Aesthetic Production, established in 1947) within the Ministry of Culture and Art. The IWP was a state-funded organization, within the Ministry of Consumer Goods Industry, and was charged with promoting the social and economic significance of design as well as improving standards of design within the furniture, textile, clothing, glass, and ceramic industries. Its slogan in the early years was 'Everyday Beauty for All'. However, by the 1960s, its outlook embraced an *ergonomic approach to the design process and applied a rigorous, scientific, and methodological approach to clothing, interior, and other aspects of design in its research laboratories. Given the restricted nature of consumer markets in Eastern Europe it was understandable that considerable importance was attached to the gathering of ergonomically based data and statistical evidence for manufacturers, often in the form of standards. The IWP was also concerned with industrial design training and education for young designers and consideration of the ways in which folk art designs might be reconciled with mass production. By the time that the Institute of Industrial Design came under the auspices of the Ministry of Scientific and Technical Progress in 1985, the IWP had embraced a number of key areas: design for the disabled, design and furniture for urban and rural housing, design for the work environment, design for industry, and the promotion of design amongst professionals and the public through educational activities and studies of materials. The IWP presents its achievements and research findings through publications, conference presentations, and national and international exhibitions of Polish design. Its publications include *Express Information* and *Design Library*, the latter concerned with design history and theory. IWP also established a 'Good Design' label for Polish products selected by an interdisciplinary jury of design experts as well as a biennial exhibition devoted to the best designs of young Polish designers. It also has an exhibition gallery and research library with more than 42,000 volumes and 700 national and international periodicals.

International Council of Graphic Design Associations (ICOGRADA, established 1963) Generally known by its acronym, this internationally oriented professional organization acts in the collective interests of national societies and organizations representing the graphic design and visual communications profession on a worldwide basis. The idea of ICOGRADA was first broached in London during 1962 and came into being in April 1963 following a meeting with delegates from 28 of the world's leading graphic design associations with Willy *De Majo as its inaugural president. ICOGRADA was the first body to represent their collective interests internationally and was born at a time when designers were still seeking recognition for their profession on a par with that accorded accountants, lawyers, and others. The founder member associations were concerned with the ways that their discipline intersected with all levels of education, commerce, industry, culture, and the environment on the wider, international front. As F. H. K. *Henrion, president from 1968 to 1970, commented in a brochure in 1971: 'It does not matter anymore whether you are working in the east, the west, the south or the north, problems become increasingly the same. Not only the problems of method and design theory but particularly problems of education. More than ever it is necessary to have a forum where all designers'

problems can be freely discussed and all information freely exchanged. ICOGRADA is just that.' Early ICOGRADA congresses were held in Zurich (1964), Bled (1966), Eindhoven and Brussels (1968), Vienna (1970 and 1971), London (1972), Krefield and Düsseldorf (1974), Edmonton, Canada (1975), Lausanne and Zurich (1977), a cycle that continued productively through to the 21st century with a conference in Nagoya, Japan, in 2003. ICOGRADA furthered its aims through the organization of conferences, congresses, exhibitions, and publications. Throughout its existence ICOGRADA always placed great importance on education with many large student conferences. In 2002 the ICOGRADA Education Network (IEN) was inaugurated in Brno in the Czech Republic and its website launched in 2003. The aim of the IEN was to bring together institutions offering graphic and communication design programmes on an international front and in its first year brought together institutes from almost twenty countries in Australia, Europe, the Middle East, South America, India, South East Asia, and South Africa. By the early 21st century ICOGRADA represented over 70 design associations in more than 50 countries worldwide, holding regular international conferences and exhibitions, establishing working parties to report on specific professional concerns, and promoting graphic design education. Its archives are located at the University of Brighton, England.

International Council of Societies of Industrial Design (ICSID, established 1957) One the first professional design organizations to be established on a truly international basis (along with *ICOGRADA and *IFI), ICSID was founded as a non-government, non-profit-making organization in 1957. By the early 21st century its membership had grown to more than 150 member societies in more than 50 countries, providing a network of information exchange through congresses, conferences, regional meetings, and publications centred on design. It is concerned with many aspects of the design profession, its process and relevance, including its role in society, business, planning, and the environment, as well as more specifically professional concerns such as intellectual property rights. The latter includes the bimonthly organizational newsletter and specific publications such as the *World Directory of Design* and *Hall of Fame: Companies Searching for Excellence in Design. A Review of the Twentieth Century*.

International Design Conference in Aspen (IDCA, established 1949) The aim of the International Design Conference in Aspen (IDCA), Colorado, has been to provide an international forum for discussion of the place of design in the contemporary world and of the ways in which the contemporary world impacts upon design. Designers from a wide range of disciplines—from industrial and environmental design to fashion—have contributed to the debates, which have been further enhanced by contributors from other fields, including scientists, industrialists, business people, and educators. IDCA is a non-profit educational organization governed by a board of directors composed of designers, architects, planners, curators, educators, and business people. IDCA is located close to the conference site on the Aspen Meadows Campus designed by Herbert *Bayer in the 1950s (renovated in 1994).

Industrialist Walter Paepcke and his wife, who wanted to establish a forum where leading figures from around the world could meet and exchange ideas, brought IDCA to life. Their vision was first given

INTERNATIONAL STYLE

The term 'International Style' denoted the spread of *Modernism as it became more widely disseminated through the attention paid to progressive educational institutions such as the *Bauhaus, the increasing number of avant-garde books, magazines, and manifestos, and organizations such as the CIAM (*Congrès Internationaux d'Architecture Moderne). Although Walter Gropius had published *Internationale Architektur* in 1925 of greater significance was the *Modern Architecture: International Exhibition*, curated by Philip *Johnson and Henry Russell Hitchcock at the *Museum of Modern Art, New York, in 1932. Their accompanying book was entitled *The International Style: Architecture since 1922*. There were many notable (though never very widespread) examples of the style built during the 1930s despite a fierce antipathy to its radicalism expressed by Fascistic and totalitarian regimes that sought to employ an architectural language geared to their overtly national or imperialistic aims. In the decades immediately following the Second World War the International Style was widely used for the corporate buildings, offices, interiors, and furnishings of multinational companies.

concrete form in 1949 at a conference in Aspen opened by Albert Schweitzer. IDCA itself was established in 1951 to bring together designers, industrialists, engineers, and others to meet on an annual basis in a single place at a particular time. The 1951 conference was devoted to the theme *Design as a Function of Management* in order to encourage the participation of members of the business community. Other early conference themes included *Design and Human Values* (1957 and 1958), *The Corporation the Designer* (1960), *Sources and Resources* (1966), and *Environment by Design* (1970). Occasionally national perspectives were addressed including *Japan at Aspen* (1979), *The Italian Idea* (1981), *Outlook: Views of British Design* (1986), *The Italian Manifesto* (1989), and *Gestalt: Vision of German Design* (1996). Other contemporary issues were also often taken on board ranging from *The Future Isn't What It Used to Be* (1983) to *Designdigital* (1999).

International Federation of Interior Designers/Architects (IFI, established 1963) This professional international organization was established in 1963 by a small number of European design associations and was very much part of the wider international movement to establish the design profession as an important tool in business and global trading. *ICSID had been founded in 1957 to promote the cause of industrial design and *ICOGRADA, like IFI, in 1963 in relation to graphic design and visual communication. By the early 21st century IFI had grown to represent 57 professional associations, institutions, and design schools in 39 countries in all five continents.

International Style *See* box on this page.

International Typographic Style *See* SWISS STYLE.

Internet By the late 20th century the internet had become the principal global means of information exchange for individuals as well as multinational corporations. Its origins lay in the internal linking of computers in the US Defense Department in the 1960s and research relating to the control of missiles and bombers. These so-called intranets evolved into the internet (a contraction

of 'internetwork'), a term first used in the 1970s but increasingly widely used from the later 1980s and early 1990s. The networking of computers was first publicly seen at the 1972 International Computer Communication Conference (ICCC), the same year in which early applications of electronic mail were being explored. Other developments followed as efforts intensified to build communications between different groups of researchers or military constituencies. The introduction of the internet as it is recognized today was facilitated by co-operation between US federal agencies and other international organizations. The World Wide Web, a term that came into current usage in the 1990s, was a means of accessing information—text, graphics, sound, visual, moving image, and virtual reality. It became a vehicle for a whole range of electronic (or 'e-') services such as shopping, banking, travel, and insurance as well as an increasingly prominent means of personal and business communication, e-mail. Its popularity was closely interlinked with the widespread use of Personal Computers (PCs) and the international proliferation of internet cafés, providing individuals with almost limitless possibilities for communication. The design of websites—increasingly important to corporations, public institutions, and organizations as a means of giving them a competitive edge—has become a highly profitable aspect for graphic, communication, and multimedia design consultancies, although it has become increasingly common for individuals and families to design their own.

ISBN The International Standard Book Number is a classification used to identify all books, its ten digits being used to signify the publisher, the country of its origin, and the title. It is generally found together with details such as copyright and other such details in the preliminary pages and on the rear cover.

Isokon (established 1931) This British design firm represented a significant attempt to harness the spirit of *Modernism as represented by progressive designers in France and Germany to housing and furniture design. The name of the company derived from the term 'Isometric Unit Construction', in effect a modular means of construction. The formation of the company stemmed from an association between Jack *Pritchard of the Venesta Plywood Company and the designer and architect Wells *Coates. This modular system was first explored in the concrete Lawn Road Flats complex in Hampstead, London (completed in 1934) where Coates incorporated ideas of 'minimum living' into the kitchens and bathrooms of the apartments, a concept that had been broached in American Christine Frederick's influential text *Scientific Management in the Home* (1915), had been given tangible form in Margarete *Schütte-Lihotzky's 'Frankfurt Kitchen' of 1924, and had been a theme discussed extensively at the 1929 *Congrès Internationaux d'Architecture Moderne (CIAM). Wells Coates showed a 'Minimum Flat', based on the Lawn Roads Flats, at the 1933 Dorland Hall *Industrial Art in Relation to the Home* Exhibition of 1933. The Lawn Road Flats attracted a number of key figures from the design and architecture world, notably Walter *Gropius, Marcel *Breuer, and László *Moholy-Nagy, all of whom worked for the Isokon Furniture Company, as well as others such as the crime novelist Agatha Christie. In 1932 Pritchard and Coates began designing furniture, much of it in laminated plywood, Coates's early designs including modular shelving units manufactured by Venesta. This idea was developed

further with the establishment in 1935 of the Isokon Furniture Company to which Gropius was appointed Controller of Design. The company presented a progressive visual identity from the graphics by Moholy-Nagy, furniture by Breuer (including a chaise longue and a nest of tables) and Gropius (including an aluminium wastepaper basket). Breuer's chaise longue showed the influence of Finnish designer Alvar *Aalto, whose work had been shown in London in the previous year. However, although Breuer's design not did prove to be a best-seller, it was widely influential. The Isokon Furniture Company also sold the products of other companies with a progressive design policy, including *PEL and Finmar. Although Gropius and Breuer moved to the United States in 1937 Isokon continued production until the outbreak of the Second World War, with designs by an Austrian immigrant, Egon Riis. These included the *Isokon Penguin Donkey* bookrack and the *Bottleship*. Isokon did not resume furniture production until 1963 when Ernest *Race's redesign of these two items were marketed once more.

ISOTYPE (International System of Typographic Picture Education) ISOTYPE was devised as a way of conveying statistics by means of visual symbols. It was an important aspect of an international graphic language first devised by Otto Neurath (1882–1945) in Vienna after the First World War. Originally called the Vienna Method of Pictorial Statistics, ISOTYPE was intended to aid the public understanding of complex statistical information relating to housing, health, education, and other key priorities in the difficult economic and political circumstances of 1920s Vienna by presenting the information in a visually intelligible format. The statistics were converted into visual forms by what was termed the Transformation Team led by Marie Reidemeister (1898–1986) Neurath's future wife. Neurath put the work on an international footing by establishing links with organizations in London, New York, and Amsterdam. In the face of adverse circumstances in Vienna, he and his colleagues moved to The Hague in 1934, changing the name of their method from the Wiener Methode der Bildstatistik to ISOTYPE in the following year. The German invasion of Holland forced them to move to Britain in 1940 where they established the Isotype Institute in Oxford in 1942. Under Marie Reidemeister's direction following her husband's death in 1945 the Institute moved to London in 1948, where it remained until 1972 when it closed. The Otto and Marie Neurath Isotype Collection is housed at Reading University.

Issigonis, Alec (1906–88) Best known for his small car designs, particularly the revolutionary design of the Mini that came to symbolize the youth-oriented metropolitan *Pop culture of the 1960s, Issigonis had a long and distinguished career in the British motor industry, entering it in 1928 and retiring from Leyland Motors in 1971. Born in Turkey, political circumstances forced his family to leave the country in 1922 and he moved to London in the following year, enrolling at Battersea Polytechnic to study engineering. He began working as a draughtsman in the motor industry in 1928, followed by a period at Rootes Motors (1934–6) where he worked on independent front suspension systems. He began working for Morris Motors in 1936 where, in the war years, he worked on the design of the innovatory Morris Minor, launched in 1948. The rounded body shape became a highly familiar sight on British roads, with over 1.6 million sold before production was halted in 1971. After a period working at the Alvis automobile company from 1952

to 1955, he took up the post of chief engineer at the British Motor Corporation (BMC), formed from the amalgamation of the Austin and Morris companies. In 1957 he began working on a small car design that would compete with the 'bubble cars' that became popular with the petrol shortages following the Suez crisis of 1957. The end product, the Morris *Mini Minor* and the Austin *Seven* of 1959, was striking visually and technologically, with its ten-inch wheels, front-wheel drive, transverse engine, and rubber suspension. The car was competitively priced and, after a slow start, sales picked up during the early 1960s, the car proving attractive to a wide range of users including many of those associated with 'Swinging London'. It was also a symbol of national projection, a Mini with a Union Jack painted on the roof (like the 'mini-skirt') being a prominent feature of the fashion-conscious display designed by James *Gardner for the British Pavilion at Expo '67 at Montreal. Over 5 million Minis were sold, including the Mini-van, Mini-estate, and the fashionable Mini-Moke. The more spacious 1962 *Morris 1100* proved another success for Issigonis. Styled by.*Pininfarina the car became a great sales success, outstripping those of the Mini and, significantly, the *Ford *Cortina* launched in the same year. Issigonis became engineering director of BMC in 1964, the year in which he was elected a *Royal Designer for Industry and awarded a CBE. In 1969 he was knighted for services to engineering, design, and the British Motor Industry. He retired from British Leyland (which took over BMC in 1968) in 1971.

Itten, Johannes (1888–1967) A well-known artist, designer, and educator, Itten is perhaps best known for contributions to the Foundation Course (*Vorkurs*) at the *Bauhaus in Weimar between 1919 and 1923.

Born in Switzerland, Itten's early career was in primary school education but he gave it up to study fine art briefly at the École des Beaux Arts in Geneva. However, dissatisfied with the conservatism of the curriculum he went on to study mathematics and science at university before studying painting at the Stuttgart Academy from 1913 to 1916. Well aware of the avant-garde ideas of the Blaue Reiter and Cubism, he exhibited at the Sturm art gallery in Berlin. He then moved to Vienna to teach and pain at his own art school and, having been introduced to Walter Gropius by Alma Mahler (who was married to Gropius) took up a teaching post at the Bauhaus in 1919. In his classes he encouraged students to experiment with form, colour, and texture but his commitment to eastern mysticism and the wearing of monk-like robes led to tensions with Gropius, the institution's director. Furthermore, in the difficult political and economic climate in early 1920s Germany Gropius came under increasing pressure to demonstrate the relevance of the Bauhaus in daily life. As a consequence, Itten's experiential and expressionist approach to creativity was increasingly at odds with Gropius' growing commitment to the machine aesthetic as a key goal of the Bauhaus's educational curriculum. On leaving the Bauhaus Itten studied philosophy in Zurich before setting up his own design school in Berlin from 1926 to 1931. He also became director of the technical school for textiles at Krefeld from 1932 to 1938. He left Germany, first working in Amsterdam and then moving to Zurich where he became the director of the Museum and School of Applied Arts from 1938 to 1953. From 1943 to 1953 he also directed the technical school for textiles and the Rietberg-museum.

Ive, Jonathan *See* APPLE.

J

Jacobsen, Arne (1902–71) After training as a mason in Copenhagen Jacobsen studied architecture from 1924 to 1927 under architect-designer Kay Fisker and Kaj Gottlobat at the Royal Danish Academy of Arts. After three years in civic architectural practice he established his own office in 1930, many of his early architectural projects being influenced by the spirit of *Modernism that he had encountered at first hand in Germany. However, despite exhibiting a chair at the 1925 *Paris Exposition des Arts Décoratifs et Industriels and designing wallpapers and textiles whilst in Sweden in the early 1940s, he did not turn to industrially produced furniture design until 1950 when he worked in collaboration with the Danish furniture manufacturer *Fritz Hansen. This culminated in the design of three classic chairs, the *Ant* (1951–2), the *Swan* (1958), and the *Egg* (1958). The *Ant* chair was influenced by the moulded plywood experiments of Charles and Ray *Eames. Jacobsen's distinctive three-legged design was far more progressive than the work of his near contemporary Hans *Wegner, who infused traditional designs with a contemporary spirit. Awarded a Grand Prix at the XI *Milan Triennale of 1957, it did much to establish Jacobsen's international reputation. The original was formed from teak ply, a wood favoured by Danish Modernists, but has been subsequently produced in many different colours and remains a bestseller. The organic, almost sculptural *Swan* and *Egg* armchairs, constructed of upholstered fibreglass shells on aluminium bases, were for the SAS Royal Hotel in Copenhagen, a project for which Jacobsen designed all the elements from the building to furnishing textiles and tableware. He had a thorough knowledge of materials and manufacturing techniques and worked in a variety of media other than domestic and office furniture. This included lighting for the *Louis Poulsen Company, such as the 1956–7 *Visor* desk lamp, and minimalist cutlery for A. Michelsen, including the AJ model 600 range of 1957 which was later used in the 1968 science-fiction film *2001: A Space Odyssey*.

Jacuzzi Company (established early 1900s) Since the late 1960s the name Jacuzzi has become internationally synonymous with the whirlpool bath. Jacuzzi, the world's best-selling brand, has been at the forefront of innovation in the field with over 250 registered patents for water jet technology, air controls, and other key elements across the product range. This commitment to product development has ensured the company's place at the forefront of the industry across the world. The Jacuzzi Company's origins lay in the emigration of the Jacuzzi family from Italy to California in the early years of the 20th century. Over the years Jacuzzi Brothers established a reputation for inventions in a wide variety of product fields. Significant in the development of the Jacuzzi was the invention in 1956 of a portable hydrotherapy pump for the treatment of arthritis, the resulting product being sold to schools and hospitals. In the following decade, Roy Jacuzzi capitalized on the growing North American market for health and fitness products, inventing and marketing the

first fully integrated whirlpool bath by incorporating jets in the side of the bath. Registered under the trademarked name of Jacuzzi, the product proved a market success, its market dominance reinforced by continuing innovations and refinements to the system. These included heating and water filtration systems and the development of larger spa units that could accommodate several people, the first of which was made in 1970. The Jacuzzi family sold its interests to the Kidde company in New York in 1979, although Roy Jacuzzi remained to manage the Jacuzzi side of the business.

Jaguar (established 1945) The origins of this world famous British automobile manufacturer lay in the Swallow Sidecar Company, established in 1922. Following the production of its first car, the *SS1*, in 1931 the company became SS Cars in 1933 with William Lyons as managing director. In the years leading up to the Second World War it emerged as a significant manufacturer, using the Jaguar name for the first time in 1935. Three years later it produced the SS100 *Jaguar* Coupé, its fastest and most famous pre-war model that could reach 100 mph (160 kmph) and won a number of international races. It set the tone for one of the most celebrated British automobile brand names in the decades following the Second World War and associations of speed and power with the word 'jaguar' became embodiments of those qualities linked to the Jaguar company itself. Founded in 1945 by William Lyons, Jaguar Cars Ltd. soon established a reputation for high-performance sports cars, especially the *XK120 Roadster* of 1948, further bolstered by a series of Jaguar victories at the Le Mans 24-hour races, commencing in 1951. In 1955, seeking to widen its market appeal and underpin its economic future,

the company produced the *Mark 1* Jaguar, a saloon model that embodied ingredients of its commercial success, elegance, sophistication, and desirability. This was replaced in 1959 with the elegant *Mark II*, which, with its sensuous tapered forms, comfortable leather seats, and polished wooden dashboard, proved highly successful. In 1961 the company launched its *E-Type* sports car, one of its most widely known and sought-after models with its elongated bonnet and top speed of 152 mph (243 km/hr). Closely associated with notions of 'Swinging London' and the fashionable world of *Pop, models were owned by many celebrities including playboy Manchester United footballer George Best, Beatle George Harrison, musician David Bowie, and film star Britt Eckland. The archetypal 'classic' Jaguar, 74,000 were produced between 1961 and 1975. Its iconic status was further underlined when, in 1996, an early *E-Type Roadster* was taken into the Permanent Collection of the *Museum of Modern Art, New York, only the third car to have achieved such recognition. More recently it featured prominently in the *Austin Powers International Man of Mystery* spy spoof films set in the 1960s, in which Powers drove a Union-Jack painted model. Mike Myers, the star who played Austin Powers, also promoted the new Jaguar *XK8* seen in a specially painted Union-Jack version at the 2002 New York International Auto Show. Although a number of Jaguar models, such as the *E-Type*'s replacement the *XJ-S*, proved successful on both sides of the Atlantic the company's fortunes in the later decades of the 20th century were volatile, with a series of takeovers and amalgamations, the most significant of which were its takeover of Daimler in 1960, its merger with the British Motor Corporation in 1966, its privatization in 1984, and subsequent takeover by *Ford Motors of Detroit in 1988. Its international

standing in the early 21st century was enhanced by its return to high profile Formula 1 motor racing in 2000, although it has not recaptured its racing successes of 50 years earlier.

Jalk, Grete (1920–) After studying philosophy at Copenhagen University and training as a cabinetmaker in the early 1940s, Jalk studied furniture design at the Copenhagen School of Arts, Crafts, and Industrial Design and the Royal Danish Academy of Arts. Best known for her furniture design, including laminated plywood furniture for manufacturer Poul Jeppesen, such as the *side chair* of 1962, and tubular steel furniture for manufacturer Fritz Hensen, such as the *easy chair* of 1964, she also worked in other design media, including textiles, metalware, and wallpaper. One of the major exponents of *Danish Modern in the 1950s and 1960s she also wrote about furniture design, including *Dansk Møbelkunst* (*Danish Furniture Art*).

Japan Advertising Artists Club (JAAC, 1951–70) This pioneering organization did much to establish Japanese graphic design during the national economic renaissance of the 1950s. In 1951 JAAC held its inaugural poster exhibition in Tokyo, a policy that began to elicit media interest in advertising design. However, in the 1960s JAAC's outlook attracted increasing criticism for its over-dependency on exhibitions as a forum for progressive ideas. Furthermore, a perceived emphasis on aesthetics at the expense of social relevance gathered pace during the turbulent years of the 1960s, compounded by accusations of elitism, led to the disbanding of the organization in 1970.

Japan Design Foundation (established 1981) Since its inception in November 1981, the Japan Design Foundation has become a key organization for the promotion internationally of Japan as an important centre for design debate, discourse, and exhibitions, particularly the Osaka International Design Competitions held biennially from 1983 onwards. From 2003, when the chosen theme was 'Rethink Consumption', arrangements for the competition were reorganized, particularly the final stages of the adjudication process that involved industrialists, designers, and finalists as a means of bringing about new business opportunities.

After a sustained period of economic growth in Japan, which began to gather pace during the 1950s, the importance of design as a significant factor in product development was increasingly recognized both by private industry and the state. The Japanese Ministry of International Trade and Industry (MITI) played a key role in stimulating such interest in design over several decades. In the late 1970s its Design Promotion Workshop for Export Promotion and Design Promotion Council proposed the mounting of a major international design competition as a means both of demonstrating Japanese design achievements to the world and of strengthening cultural exchange. It was soon decided that this would take place biennially from 1983 in Osaka, the site of the 1970 Japan World Exposition (which had explored the theme of global harmony and 20th-century industrial society) and one of the first cities in Japan to establish a design centre. An organizational committee was set up in October 1981 and officially sanctioned in the following month by MITI as the Japan Design Foundation (JDF). From 1982 the JDF mounted a series of design conventions as a means of promoting, under the umbrella title of the International Design Festival, Osaka, the linked developments of the International Design Competition, the International De-

sign Award, and the International Design Exhibition. The International Design Competition embraces all fields of design practice including graphics, architecture, product, and environmental design and is sanctioned by *ICSID, *ICOGRADA and *IFI. From its inception it regularly attracted over 1,000 entries, a very high percentage of which have been drawn from overseas, attracted both by the prize money of $80,000 and broad-based themes such as 'gathering' (1983), 'interaction' (1985), 'water' (1987), 'fire' (1989), and 'earth' (1991). International Design Awards made by the JDF have included those to Margaret Thatcher (1983, for her design promotional activities as UK prime minister), *Pentagram (1983), Maria Benktzon and Sven-Eric Juhlin (1983, see ERGONOMIDE-SIGN), *Bang & Olufsen (1985), Douglas *Scott (1985), Kenji *Ekuan (1987), Norman Foster (1987), the Dutch Postal Telegraph and Telephone Services (1987), Otl *Aicher (1989), Yuri *Soloviev (1989), Antii *Nurmesniemi and Vuokko Eskolin-*Nurmesniemi (1991), the Department of Architecture and Design, *Museum of Modern Art, New York (1993), Arthur J. Pulos (1995), Hans *Wegner (1997), and Issey *Miyake (2001). In 1993 the JDF established the Asian Pacific Design Network, building on its Pan-Pacific Design Exchange Programme (initiated in 1990) in order to encourage a greater mutual understanding of traditions and cultures in the region. In order to assist in this programmes for Design Study, Design Cooperation Promotion, and Information Exchange were set in place. In 2002 the JDF published *Design for Every Being : History of JDF 20th Anniversary* and expanded its website (launched 1997) to provide much fuller information about the organization and its activities as well as an e-mail news service.

Japan Graphic Designers Association (JAGDA, established 1978) Established as an organization concerned with the professional needs of the graphic design profession rather than a forum for artistic expression as the *Japan Advertising Artists Club (JAAC, 1951–70) had been, JAGDA's early years were marked by some confusion amongst the membership about the benefits that would accrue from participation and, in 1981, the Association was radically restructured, following the election of a new committee. In the same year, the Association published the first issue of its annual, *Graphic Design in Japan*. A work of high quality with first-rate production values it did much to grow JAGDA's membership over the following years.

Japan Industrial Designers Association (JIDA, established 1952) This important organization was founded by twenty-five leading Japanese industrial design pioneers and reflected the perceived need to campaign for a wider recognition of the significance of this new profession. The Association's logo, based on the letter 'd', was designed by Yusaku *Kamekura in 1953 when he joined JIDA. Over the next half-century the Association became an important mouthpiece for designers in Japan with a membership drawn from the professional and educational circles.

Japan Industrial Design Promotion Organization (JIDPO, established 1969) Founded in 1969 under the Ministry of International Trade and Industry (MITI) the Japan Industrial Design Promotion Organization has been the most important body for design promotion in Japan. This followed two decades of activity after the Second World War in which the development of export markets in the United States and Europe, alongside a growing awareness of the significance of design in economic

competitiveness, was an important national goal. JIDPO played a seminal role, building on the focused activities of the *Industrial Arts Institute and other design-related initiatives. Seeking to stimulate design consciousness in industry JIDPO also fostered the setting up of regional design centres to assist companies in embedding design as an important business tool, a strategy that developed beyond the improvement of individual products to a more comprehensive design outlook. The latter sought to highlight the ways in which design could be used as a visionary tool capable of proposing imaginative new models for contemporary living, building on a 1993 report entitled *A New Design Policy in Response to A New Age*. Furthermore, in addition to its key role in relation to the *G-Mark and *Good Design Awards, JIDPO supported a range of other design promotional activities in the late 20th and early 21st centuries. These included national 'Design Day', held each October since 1990, the 'World Good Design' initiative that provided information about international *Design Awards, and the Japan Design Net managed by the Tanseisha company, a specialist in the mounting of exhibitions and events. In 1999 JIDPO also assisted in the establishment of the Japan Union of Design Enterprises with the aim of fostering good practices that forged links between the design, industrial, and business sectors as well as protecting the intellectual property rites of designers. JIDPO publishes a quarterly magazine, *Design News*, which addresses a wide range of design concerns including business, the environment, and lifestyles.

Jeanneret, Charles Édouard (1887–1965) *See* CORBUSIER, LE.

Jeep (1941–) The word 'Jeep' became widely recognized in the second half of the 20th century, following the production of the general-purpose military vehicle in the United States that commenced in 1941. In the late 20th century its heavily styled successors took on *Lifestyle connotations with the popularity of sport utility vehicles (SUVs) amongst 1980s and 1990s consumers who were often less concerned with off-road performance capabilities than image. Its origins lay in the development of a general-purpose (GP, the sound of which letters gave rise to the name 'Jeep') army vehicle developed by Delmar G. Roos, a Willys automobile engineer, before it was standardized by the US Army in 1941 and put into production for the military by the American Bantam Car Company, Willys, and *Ford. After the war a redesigned model, the *CJ-2A Universal Jeep* went into civilian production in 1945. In the following year a station wagon version, the *Wagoneer*, designed by Brooks Stevens, was launched, followed two years later by the convertible *Jeepster*. For several decades Stevens continued to design Jeeps, including the 1974 *Cherokee* manufactured by American Motors which was taken over, together with the Jeep name, by Chrysler.

Jencks, Charles Alexander (1939–)
The American architecural theorist, historian, practitioner, and designer Charles Jencks came to public attention with his 1977 book *The Language of Post-Modern Architecture*. After studying at the Universities of Harvard (English Literature and Architecture) and London, he taught at the Architectural Association, London, in 1968, and at the University of California at Los Angeles (UCLA) from 1974. Like Robert *Venturi and Reyner *Banham (under whom he had studied) before him, he believed that the restrictive architectural and design vocabulary of *Modernism was no longer appropriate in an era of rapid change and variety. In

his 1973 book *Modern Movements in Architecture* he had considered the limitations of the visual syntax of the international style with its emphasis on form rather than decoration, on monochrome rather than colour. Jencks believed that the iconography of popular culture and the vernacular was a means of enriching the everyday urban environment. He was involved in a number of design projects including the *Tea and Coffee Piazza* series for *Alessi (1983). Jencks also designed *Postmodernist furniture for his own Thematic House in London, designed with architect Terry Farrell from 1979 to 1984. Some of his designs were sold by Aram Designs in London in 1985.

Jensen, Georg (1866–1935) This celebrated silversmith was one of Denmark's best-known designers, giving his name to an enduring manufacturing firm associated with high-quality products. Having been apprenticed to a goldsmith in the 1870s and having later graduated in sculpture at the Royal Academy of Art in Copenhagen in 1892, Jensen won a grant from the Danish Academy to travel in France and Italy. After a brief spell working with Danish silversmith Mogens Baillin, Jensen opened his own company in 1904 in Copenhagen, initially producing modestly priced jewellery and later moving into holloware and flatware (1906). Many designers contributed to the growing success of the company, particularly Johan Rohde in the early stages, and, by 1908, the business employed nine silversmiths and two apprentices. The company had also begun to expand quite early on in its history, opening a branch in Berlin in 1909 for the sale of Jensen products and Royal Copenhagen porcelain, although this closed in 1914. In 1916 shares were sold in order to cater for increased production and the Georg Jensen Solvsmedie (Georg Jensen Silversmiths) was formed as a result,

bolstered further by substantial capital investment in the company in the following year. The company experienced serious difficulties in the economic slump of the early 1920s but the position improved with the appointment of Frederik Lunning (*see* LUNNING PRIZE) who opened a Georg Jensen Solvsmedie shop in London in 1921 and New York in 1924. Amongst the key designers working for the firm were Harald Nielsen, the Swedish designer Count Sigvard Bernadotte, and Henry Pilstrup. Apart from a brief spell in Paris (1925–6) Jensen himself held the post of artistic director for the firm, with others controlling the silversmith and retailing operations. Before his death in 1935, Jensen won many awards at international exhibitions including a Grand Prix at the *Paris Exposition des Arts Décoratifs et Industriels, 1925, the International Exposition in Barcelona in 1929, and the Brussels World's Fair of 1935. After the Second World War the company continued to flourish, attracting new talent such as Henning Koppel and Nanna *Ditzel, both of whom began working on commissions for the firm from 1954 onwards and, later, Allan Scharff and Jørgen Møller. From the 1970s onwards Georg Jensen Silversmiths underwent takeovers and mergers with a number of companies involved with jewellery, glass, and tableware, first by the Royal Porcelain Factory in 1972 and as part of a large group under the name of Royal Scandinavia Ltd. in 1997.

Jensen, Jacob (1926–) After training at the Copenhagen Commercial Arts School Jensen worked for the *Bjorn & Bernadotte industrial design consultancy from 1951, within three years becoming head of the studio. He launched his own studio in 1958. However, his main claim to fame derives from his professional relationship with *Bang & Olufsen, lasting from 1963

to 1991. The clean, elegant, and highly sophisticated concerns that characterized the company's products were celebrated at the 1978 *Bang & Olufsen: Design for Sound by Jacob Jensen* exhibition at the *Museum of Modern Art, New York, where 28 of his products were displayed. Jensen also designed for other clients, including the *GM200* vacuum cleaner for Nilfisk (1992), and standard and microwave ovens for Guggenau (1993).

Jiricná, Eva (1939–) Jiricná studied at the Czech Technical University, Prague (1956–62), and the Academy of Fine Arts, Prague (1962–3). She moved to London in 1968, working on the design of schools for Greater London Council. She was then involved for nearly ten years on the (never realized) redevelopment project for Brighton Marina, during which period she extended her knowledge of engineering and material properties. She also became a British citizen in 1976. A sophisticated use of *high-tech materials (such as chrome, steel, glass, combined with a cool palette) characterized much of her subsequent interior design work over the next two decades. Notable examples included Joe's Café, London (1986), the Joseph (Ettedgui) Shop in the Fulham Road, London (1986), Legends Nightclub, London (1987), and the display cases in the Sir John Soane Museum, London (1993). In 1986 Jiricná formed her own architectural and design company, Eva Jiricná Architects and her work has become widely known. Since 1990 she has visited the Czech Republic regularly and was invited in 1993 by President Václev Havel to be architectural consultant to the Council of the President. The Orangery at Prague Castle (1998) was an important, sophisticated stainless steel and glass commission. Amongst more recent projects was the *Zone of the Spirit* section in the Millennium Dome at Greenwich, London (1999). She has

worked at many architectural schools in Europe and the USA as well as heading a studio at the Academy of Arts and Design, Prague, in the 1990s. Amongst the awards she has received was election as *Royal Designer for Industry (1991) and a CBE for services to interior design (1994).

Johnson, Philip (1906–) Probably most significant for his writings on architecture and design and curatorial role at the *Museum of Modern Art (MOMA) in New York, American born architect Johnson studied architectural history at Harvard University, graduating in 1930. He became director of the Architecture Department at the recently established MOMA where, in 1932, he made his mark with his organization with art historian Henry Russell Hitchcock of the *Modern Architecture: International Exhibition*, giving rise to the term *'International Style' and introducing the work of European architects to America. The term was also deployed in the title of their 1932 book *International Style: Architecture since 1922*. Johnson also organized the first design specific exhibition in 1934. Entitled *Machine Art* it emphasized clean, geometric forms with a minimum of decoration and a commitment to the exploration of new materials and modern methods of mass production. Its focus was strongly opposed to the more commercially oriented outlook of American *streamlining and very much in tune with the tenets of European *Modernism. Also close to the outlook of Herbert *Read in his book *Art & Industry* of the same year it set the tone for MOMA's design exhibitions throughout the rest of the decade, which featured very few designs by Americans. In 1940 Johnson studied architecture under German immigrant Marcel *Breuer at Harvard, graduating in 1943 and practising as an architect for three years when he returned to New York

to become Director of Architecture at MOMA (1945–54). After the Second World War his architectural designs of the decades, such as his own *Glass House* at New Canaan, Connecticut (1949), showed an indebtedness to European precedents, most notably the German Modernist Ludwig *Mies Van Der Rohe, who had moved to the United States in 1938. However, later in life Johnson abandoned the clarity of the Modernist vocabulary in favour of *Postmodernism, as in his New York AT&T Building with its idiosyncratic Chippendale-style gable, also alluding to the cradle of the traditional telephone. Johnson's Postmodernist influence was also felt in the decorative arts through his involvement in early discussions at *Swid Powell, the fashionable New York producer of tableware for affluent urbanites.

Johnston, Edward (1872–1944) Johnston was an important British calligrapher, typeface designer, and educator. After ill-health had cut short his study of medicine at Edinburgh University he decided to pursue his long-standing interests in lettering and illumination. He was introduced to the designer and educator William *Lethaby, who suggested that he study manuscripts in the British Museum. Johnston went on to teach writing and calligraphy at the *Central School of Arts and Crafts, London (1899–1912), and the *Royal College of Arts. He also designed typography and his emphatically modern letterforms for London Underground signage commissioned by Frank Pick in 1916 won widespread recognition. Johnston was also responsible for the modernization of the London Underground logo, resulting in the famous circle and bar motif. He undertook a range of design work for private presses such as the Doves Press (co-founded by one of his pupils, T. J. Cobden-Sander-

son), including a number of initials for the Doves *Bible* (1905). His influence was felt strongly in Germany partly on account of his work for Count Kessler's Cranach Press, founded in Weimar in 1913. Johnston wrote a number of influential texts, including *Writing and Illuminating, and Lettering* (1906), *Manuscript and Inscription Letters* (1909), and *A Book of Sample Scripts* (1914). He was also one of the editors of the typographic and printing journal *The Imprint* (1913–15).

Jones, Owen (1809–74) Owen Jones, architect and ornamental designer, had trained under the architect L. Vuillamy (1825–31) and at the Royal Academy, London. He travelled extensively during the 1930s and was especially influenced by Arabic ornamentation. In the 1840s he was one of the circle of the powerful Victorian designer and educator Henry *Cole, joining the Society of Arts in 1847, and was appointed Superintendent of Works at the *Great Exhibition of 1851. In the same year Cole's *Journal of Design* included a textile sample designed by Jones, as well as four articles by him together with approval of his design for the London shop front for Chappells, the music publishers. In 1852 he was made joint director of the decoration of the Crystal Palace which reopened in Sydenham in 1854, his colourful designs for which included the Egyptian, Greek, Roman, and Alhambra Courts. Indeed, Jones's particular design strengths lay in interior decoration in connection with which he designed carpets, wallpapers, and furniture. He was awarded gold medals for designs shown at the International Exhibitions at Paris in 1867 and Vienna in 1873, having earlier been awarded the gold medal of the Royal Institute of British Architects (1857). One of Jones's most influential contributions was his book *The Grammar of Ornament* (1856), which introduced to an international

readership a large collection of colourful and detailed chromolithographic plates drawn from a wide range of cultures and periods. This *Grammar* had developed from principles explored in articles for the *Journal of Design* and lectures delivered at the Royal Society of Arts and Marlborough House, London. Jones's many other texts included *An Attempt to Define the Principles which should Regulate the Employment of Colour in the Decorative Arts* (1852) and *Plans, Elevations, Sections and Details of the Alhambra* (1842–5).

Josiah Wedgwood & Sons (established 1759) Josiah Wedgwood (1730–95) founded this celebrated British pottery firm in Burslem, Staffordshire, in 1759. By the late 18th century the company's wares were widely known in fashionable circles throughout Europe, especially creamware designs in the Neoclassical style. Other important landmarks in this fashionable vein were the introduction of Black Basalt porcelain in 1768 and Jasperware in 1774, the latter being fired in the widely recognized 'Neoclassical' blue, as well as green, yellow, lilac, brown, and black. Neoclassicism reflected a resurgence of interest in classical antiquity sparked by a northward migration of Italian artists unsettled by declining patronage in Italy, sustained by the Grand Tour and a consequent emphasis on studies in antiquarianism and archaeology. Important also in Wedgwood's success in the 18th century was his commitment to mass produce and market goods efficiently through the division of labour and utilization of the new canal system as a means of distribution together with the use of catalogues and a London showroom to stimulate consumer interest. The 19th century was a more difficult period for the company's fortunes but the early 20th century saw a reinvigoration of the company's fortunes reflected in the establishment of a showroom in Paris in

1902. Wedgwood also attracted attention for its hand-painted artistic wares that were overseen by Alfred and Louise Powell. Furthermore Daisy Makeig-Jones's *Fairyland Lustre* was launched in 1915 and was in demand until the late 1920s, helping to reestablish the company's reputation for ornamental bone china. In the 1930s the company produced designs that embraced *Modernist characteristics, notably a series of matt glaze wares in simple geometric shapes by Keith *Murray. Victor Skellern was art director from 1934 to 1966, playing an important role in the modernization of the company by placing greater emphasis on technological innovation and experimentation. During the Second World War, in keeping with the strictures of *Utility design in other fields of domestic design, he designed a highly practical, austere earthenware range called *Victory Ware*. In the following decade he designed the *Strawberry Fields* range with Millie Taplin, one of the first products to win a *Design Award from the Council of Industrial Design (*see* DESIGN COUNCIL) in 1957. From the 1950s onwards the company expanded through the takeover of many smaller ceramics competitors such as the Susie Cooper Pottery in 1966, but in terms of design generally relied more on tradition than radical innovation. In 1986 Wedgwood was bought by Waterford to form a huge conglomerate for ceramic and glass production. In keeping with the company's association with history, heritage, and quality the Wedgwood name was retained and many early company designs were produced to satisfy growing overseas demand.

Jugendstil *See* box on p. 231.

Juhl, Finn (1912–89) One of the most important Danish designers of the 20th century and closely associated with the concept of *Danish Modern, Juhl was widely known for his furniture design and product design

JUGENDSTIL

This term (meaning 'youth style') was used in Germany and Scandinavia to describe *Art Nouveau and derived from the decorative arts magazine *Jugend* (1896–1914), published in Munich and widely circulated amongst those interested in the decorative arts. This organic, curvilinear style was at its height in Scandinavia, particularly Helsinki, around 1900.

with a lesser, but deserved, reputation for his architecture and interiors. He studied architecture at the Royal Danish Academy of Fine Art from 1930 to 1934, following which he worked for some years in the architectural practice of Vilhelm Lauritzens. In 1944 he was appointed to the staff of the School of Interior Design at Frederiksberg, opening his own design consultancy in Copenhagen in 1945. It was at this time that he emerged as a furniture designer of note, admired for his rejection of the functional anonymity of Kaare *Klint's designs in favour of a more individual artistic approach. He worked closely with the cabinetmaker Niels Vodder in the production of a number of rather sculptural items of furniture including the upholstered, organic, yet light in appearance, *Chieftain* armchair of 1949. During this and the following decade he produced several series of seating designs, using metal frames as well as the more dominant material of wood. Juhl also designed a wide range of items for Baker Furniture of Grand Rapids in the United States (1949–51) and, in the late 1950s, designed wooden furniture for mass production for the Danish company France & Son. Amongst his best-known interior designs were the Trusteeship Council Room at the United Nations Headquarters (1951) and a room at the Kunstindustrimuseum (1952). However, Juhl's designs were not restricted to furniture and interiors as he was also commissioned to design typewriters for *IBM, refrigerators for General Electric, ceramics for Bing & Grøndahl, and glassware for Georg *Jensen. He won many design awards including five Gold Medals at the *Milan Triennali in 1954 and 1957 and the AID (American Institute of Design) Prize in 1964.

Juhlin, Sven-Eric (1940–) *See* ERGONOMIDESIGN.

Just in time This practice became an increasingly important aspect of economic manufacture and distribution in the closing decade of the 20th century. By automatically linking sales data gained from retail outlets and checkout terminals with centralized corporate manufacturing and distribution systems 'just in time' obviated the need for manufacturer-retailers such as the Italian clothing company *Benetton to hold large quantities of stock in store (thus wasting valuable space). Such companies took full advantage of the manufacturing possibilities afforded by *Computer-Aided Manufacture (CAM) and, in the widespread drive for increasing efficiency in a highly competive market place, this 'just in time' tailoring of production to retail outlet allowed for economic small-scale production runs that were closely linked to changing and sometimes volatile consumer demands.

K

Kåge, Wilhelm (1889–1960) Kåge trained as a painter in Gothenburg, Stockholm (1908–9), and Copenhagen (1911–12) before attending the Plakatschule in Munich in 1914. He worked as a poster designer before joining the *Gustavsberg ceramics factory as art director in 1917, a position he held until 1949. He designed the earthenware *Blue Lily* service for the Home Exhibition, Stockholm, in 1917, an exhibition promoting well-designed interiors and products for working-class families. In the 1920s he worked on more exclusive pieces, including an almost neoclassical bowl for the 1925 *Paris Exposition des Arts Décoratifs et Industriels, which was awarded a Grand Prix. The *Stockholm Exhibition of 1930 saw the emergence of a far more modern, functional aesthetic, one to which Kåge contributed through his austere designs for the *Praktika* range which went into production in 1933. Like his earlier *Blue Lily* design, *Praktika* was not successful with the public, in contrast to the gentler, decorated *Pyro* service that proved a great commercial success. In the 1940s Kåge continued to design mass-produced tableware alongside artistic ceramic pieces. After being replaced by Stig Lindberg as art director in 1949 he produced designs for the company until his death.

Källemo (established 1965) This innovative Swedish furniture company was founded by Sven Lundh in 1965, gaining a reputation for the production of limited edition, original, and unconventional designs. A notable design that was put into production in 1982 by Källemo was a concrete chair designed by Jonas Bohlin, first spotted by Lundh at the Stockholm Art Academy's student exhibition of 1962. The use of an industrial material was quite opposed to the prevailing aesthetically charged crafts-oriented ethos of much Scandinavian Modern design. Källemo designs are characterized by their unconventionality and individualism and amongst the most significant designers associated with the company are Mats Theselius (including a couch in steel and leather of 1991 and iron-plate easy chair of 1994), John Kandell (including the *Solitaire* chair and table of 1985), and Bjørn Nørgaard (including the *Sculpture* chairs of 1995).

Kamekura, Yusaku (1915–) A key figure in the emergence of Japanese contemporary design as a significant presence on the international stage in the years following the Second World War. A graphic designer of considerable note, his professional expertise ranged across advertising, logos, packaging, and book design. Like a number of his contemporaries he was influenced strongly by German *Modernism and Russian *Constructivism whilst a student at the Modernist-influenced New Academy of Architecture and Industrial Arts in Tokyo from 1935 to 1937. Following his studies he worked for the publishing firm Nippon Kobo (later entitled the International Industrial Arts Information Centre) until 1960, having become its art director in 1940. He was a founder member of the influential *Japan Advertising Artists Club in Tokyo in 1951 and, although a graphic designer, in 1953 he became a member of the *Japan

Industrial Designers Association (established 1952), a progressive design promotional body, and designed its logo. He also designed the logo for the prestigious *G-Mark (Good Design Selection System), first awarded in 1957. Four years earlier, together with Isamu *Kenmochi, Masaru *Katsumie, Riki *Watanabe, Sori *Yanagi, and other designers of emerging influence in Japan, he had become involved in the formation in 1953 of the International Design Committee (later renamed the Good Design Committee (1959) and Japan Design Committee (1963)). This body campaigned to develop an international design consciousness in Japan through the development of links with overseas design organizations, together with participation in key conferences and exhibitions. Important commercial clients included Nippon Kogaku (later the Nikon Corporation), for whom he designed a striking visual promotional programme, commencing in 1954. In 1960 he was a founding member of the *Nippon Design Centre, which he managed until setting up his own design practice in 1962 through which he worked for a wide variety of commercial clients. In 1964, like many important Japanese designers of his generation, he was involved with the design programme of the Tokyo Olympic Games coordinated by Masaru Katsumie, designing its symbol as well as a series of pictograms and memorable posters. His striking official poster, selected against strong competition from other leading Japanese graphic designers, won a number of prizes including the Gold Medal of the Tokyo Art Directors Club in 1961, the *Mainichi Design Prize in 1963, and the International Poster Biennale, Warsaw, in 1966. He was also commissioned for a series of innovative official posters for the athletic competitions in which he combined striking photographs with his Olympic identity. He also designed

posters for Expo '70 in Osaka, the Winter Olympics in Sapporo in 1972, and Expo '89 in Nagoya. He was also commissioned by a number of design-linked government-funded bodies such as the Japan Export Trade Organization (JETRO) and the Ministry of Trade and Industry (MITI). In 1978 he was elected President of the *Japan Graphic Designers Association (JAGDA). Eleven years later he founded and edited the graphic design magazine *Creation*.

Karmann, Wilhelm (1914–98) German born car manufacturer Karmann was widely recognized for his contribution to many celebrated car designs, the most well known being the 1955 *Karmann Ghia* for *Volkswagen. His father had established a coach-building company in Osnabrück, Germany, which from the early years of the 20th century catered for the growing automobile industry. Although he began his professional career in the family business Wilhelm Karmann went on to study at the Institute for Coach-Building and Vehicle Production at Bernau (1935–7), followed by a period as an engineer in a vehicle construction company. Rejoining the family business in 1939 he was soon involved in military production for the Second World War, followed by military service in 1941 and capture by the Americans. He rejoined the Karmann company in 1945, taking over as its chairman following the death of his father in 1952. Much of the company's subsequent success was due to its long-standing relationship with Volkswagen, commencing with the *Beetle* convertible in 1949. Of major importance for the Karmann company's subsequent reputation was the *Karmann Ghia*, its elegant, flowing lines and sales of nearly 500,000 attracting international attention (*see* GHIA). The company also had substantial success with the Volkswagen *Scirocco* (with sales of 700,000) and

Golf convertible (with sales of 400,000). Other well-known cars developed by Karmann included the *Jaguar *XJS* convertible and the *Porsche *968*. By the time of Wilhelm's death the Karmann company was a significant international concern with subsidiaries in Portugal and Brazil and 6,000 employees.

Kartell (established 1949) A noted and often innovative manufacturer of a wide range of stylish products, the Kartell company was founded by chemical engineer Giulio Castelli in 1949. Based at Binasco near Milan, the company's rise to prominence in the 1950s coincided with the growing international recognition of Italian design as a leading force in the decades following the end of the Second World War. The company's commitment to research, innovation, aesthetics, and quality did much to change attitudes to everyday domestic products made in plastic, leading to many medals for its designs at the *Milan Triennali. In 1954 the company established a European pool for the exchange of technology and marketing analysis in order to promote plastics more widely, its research achievements over many years being recognized by the award of a *Compasso d'Oro in 1979. Organized into two divisions of Habitat (furniture for the house, office, and contracts, established in 1963) and Labware (hardware for laboratories) in the early 2000s the company exports 75 per cent of its turnover in 60 countries.

One of the company's earliest products was a ski rack for automobiles designed by Carlo Barassi and Roberto Menghi, perhaps an indicator of the style-conscious affluent market orientation of many of its consumer products. Gino Columbini headed the company's technical office and designed a variety of domestic products in the 1950s, winning a number of Compasso d'Oro

awards. These included awards in 1955 for the *KS 1146* bucket and lid, the *1065* tub in 1957 and the *1171* dish drainer in 1960. Another leading designer for the company—and its artistic director for many years—was Anna Castelli-Ferrieri, trained architect, Italian correspondent of the London-based *Architectural Review*, founding member of the Italian Association for Industrial Design (*ADI), and, in the 1980s, teacher of industrial design at the *Domus Academy and Milan Polytechnic. Although she had married Giulio Castelli in 1943 it was two decades before she played a significant role in designing domestic goods for Kartell. Kartell participated in the *Italy: The New Domestic Landscape* exhibition at the *Museum of Modern Art in New York in 1972, contributing three avant-garde domestic environments by Gae *Aulenti, Ettore *Sottsass, and Marco *Zanuso. In the same year Centrokappa, a research and study centre closely affiliated to the Kartell group, was established under Valerio Castelli both to coordinate the Kartell corporate image and also promote Italian design internationally. It also organized a number of exhibitions of plastic furniture and Italian design, winning a Compasso d'Oro in 1979.

Notable designers for Kartell have included many leading Italian designers in the second half of the 20th century, including Sergio Asti, Gae Aulenti (the *Jumbo* table of 1965), Achille and Pier *Castiglione (lighting), Joe *Colombo (whose designs included the *ABS stacking chair *no. 4860*), and Richard *Sapper, who collaborated with Zanuso on a range of colourful polyethylene children's chairs, which won a Compasso d'Oro in 1964. In 1988 Claudio Luti, formerly of Versace, became president of the company. In the 1980s Philippe *Starck designed a number of products for the company, including the tubular steel

and plastic *Dr Glob* chair of 1988, and in the 1990s Antonio *Citterio's designs included the *Battista* and *Filippo* trolleys and the *Mobil*, storage system, all designs in plastic and metal. The Kartell Museum was founded in 1999 and has archived and exhibited the company's history.

Katsumie, Masaru (1909–83) Katsumie held an important place in the development of the design profession in Japan as well as the promotion of a greater understanding of Western, especially *Modernist, design. The latter was evidenced through his organization of the 1954 *Gropius and the Bauhaus* exhibition at the National Museum of Modern Art in Tokyo, his 1957 translation of Herbert *Read's celebrated *Art & Industry* text of 1934, and his own book *Guddo Dezain* (*Good Design*) of 1957 (1957 was also the year in which *Pevsner's *Pioneers of Modern Design* was translated into Japanese). Along with a number of other key figures in the development of Japanese design consciousness and practice after the Second World War (including Isamu *Kenmochi, Yusaku *Kamekura, Riki *Watanabe, and Sori *Yanagi) he was involved in the formation in 1953 of the International Design Committee. (This was subsequently renamed the Good Design Committee (1959) and Japan Design Committee (1963).) This sought to bring together Japanese critics and creators to develop an international design consciousness through the development of links with overseas design organizations and participation in conferences and exhibitions. In 1953 he founded the Japanese Society for the Science of Design (JSSD), an important body in the establishment of design as a significant academic discipline. He also taught at the pioneering Kuwasawa Design School (established in Tokyo by Yoko Kuwasawa) which was visited by the German designer

Walter *Gropius in its first year, 1954. Katsumie also played a significant role in design journalism through his contributions to *Industrial Art News* (*Kogei Nyusu*, a publication of the influential governmental agency, the Industrial Arts Institute) in the late 1940s and founding of the periodical *Graphic Design* in 1959. The 1960 World Design Conference (WoDeCo) was held in Tokyo and did much to bring notions of visual communication to the fore. Influenced by such ideas Katsumie came to wider international attention through his role as design coordinator and art director for the 1964 Tokyo Olympic Games and subsequent involvement in Expo '70 at Osaka and the 1972 Winter Olympics at Sapporo.

Kauffer, Edward McKnight (1890–1954) A highly influential American poster artist and graphic designer who also designed textiles and carpets, Kauffer was an important force in defining the visual language of *Modernism in Britain, where he lived from 1914 to 1940. He was commissioned by a wide range of important clients ranging from public bodies such as London Transport and leading companies such as Shell and BP to smaller, aesthetically progressive companies such as Cresta Silks, which also commissioned other progressive designers such as Wells *Coates for its shop and factory designs and Paul Nash for textiles. Kauffer also published his own book, *The Art of the Poster*, in 1924. After training in painting at evening classes at the Mark Hopkins Institute in San Francisco (1910–12) and the Art Institute, Chicago (1912), Kauffer travelled to Paris to continue his studies at the Académie Moderne. On the outbreak of the First World War in 1914 he moved to London, where he continued to experience the work of the avant-garde, particularly Cubism, *Futurism, and its British

counterpart, Vorticism, and was a founder of Group X with Wyndham Lewis and others. In 1915 he gained his first poster commission for the London Underground, which became one of the most important commissioning bodies for contemporary poster design in Britain. Kauffer's visual vocabulary drew on his knowledge of contemporary art forms, as in his 1919 *Soaring to Success* poster for the *Daily Herald* in which the abstracted forms of the flying birds clearly betrayed his early Vorticist leanings. In addition to frequent poster work for London Transport (for whom he produced over 140 posters) he also worked for Francis Meynell's high-quality Nonesuch Press from the early 1920s, contributing book jackets and illustrations alongside other distinguished individuals such as book artist Reynold Stone, German typographer Rudolf Koch, and illustrator Georg Grosz. His interest in such work was consolidated through his appointment as art director to the publishers Lund Humphries in 1930. He also designed rugs with his partner (later wife) Marion Dorn, also American born and resident in London from 1923 to 1940. Both showed designs of Wilton Rugs in 1929 although he went on to absorb the influence of Surrealism in the biomorphic nature of a number of later designs. Both she and Kauffer were among the many designers commissioned to work on the Orient Line's new ship, the *Orion*, in 1935. The *Museum of Modern Art (MOMA) in New York, by awarding him a one-man show in 1937, acknowledged his importance as a major force in poster design. He also made use of techniques such as photomontage, airbrushing, and photomurals. His standing in Britain was also high since, although he was a foreign citizen, the Royal Society of Arts in London had made Kauffer an Honorary Designer for Industry in 1936. In 1940 Kauffer returned to the USA, designing

posters for the US Treasury and, in 1941, catalogue covers for the MOMA exhibitions *Organic Design in Home Furnishings* and *Britain at War*. After the end of the Second World War he worked for a number of key clients including American Airlines (1946–53).

Kawakubo, Rei (1942–) Tokyo-born Rei Kawakubo is the inspiration behind the internationally recognized Comme des Garçons fashion name. After graduating in 1964 in fine arts and literature at Keio University in Tokyo she worked in the public relations department of the Asahi Chemical Industry textiles and chemicals company. She became a freelance stylist in 1967, building on her earlier fine art experience and work with art directors and others at Asahi. Kawakubo's Comme des Garçons Company was formally established in Tokyo in 1973, although she had been working under the name since 1969. She began working in women's wear and later, in 1978, menswear. In 1980 Kawakubo moved to Paris, opening her first boutique. Her first store had opened in Tokyo in 1976, her outlets growing rapidly to more than 300 by the late 1980s, more than 70 of them from outside Japan. Store design has been an important part of the overall ethos of the Comme des Garçons brand. Characterized by white and minimalist interiors, the company's retail outlets were designed by Kawakubo and Japanese architect Takao Kawasaki. Kawakubo's clothing has often been seen to embody notions of anti-fashion, often asymmetrical in appearance, using folds and pleats, exposed stitching, together with the incorporation of 'found' materials and the use of contrasting textures and fabrics. She was awarded the *Mainichi Design Prize in 1983 and 1987 and received the Veuve Cliquot Businesswoman of the Year award in 1991.

Kelmscott Press (1891–8) *See* MORRIS, WILLIAM.

Kenmochi, Isamu (1912–71) One of the most significant figures in the emergence of Japanese industrial design after the Second World War, Kenmochi graduated in 1932 from the Tokyo College of Industrial Arts. Like many of the first generation of Japanese industrial designers he was also a member of the Industrial Arts Institute (IAI) where he worked in the Woodwork Technology Department. At the IAI he worked alongside design pioneers such as Jiro Kosugi and Mosuke Yoshitake and was influenced by European *Modernist designers such as Bruno Taut, an adviser to the Institute in late 1933 and early 1934. Having been transferred from the IAI to the Ministry of Armaments, his knowledge of materials was extended by his research into the ways in which woods could be used in aircraft construction.

After the Second World War Kenmochi made a study tour of the USA in 1952, reporting back on his experiences in the influential periodical *Kogei Nyusu (Industrial Art News)*. In 1952 he also became a founding member of the *Japan Industrial Designers Association. Kenmochi's links with the international design community were further enhanced through his attendance at the Aspen *International Design Conference of 1953. In the the same year, together with other leading designers of the post-Second World War years such as Masaru *Katsumie, Yusaku *Kamekura, Riki *Watanabe, and Sori *Yanagi, he was also involved in the formation of the International Design Committee. The latter subsequently became the Good Design Committee (1959), then the Japan Design Committee (1963) and sought to foster relationships with overseas design organizations as well as participation in conferences and exhib-

itions. For the IAI *Design and Technology* exhibition of 1954 Kenmochi designed a wood and bamboo dining-chair that, like many other progressive pieces by contemporaries such as Yanagi and Watanabe, combined traditional materials with new technologies and aesthetic ideas. He took this philosophy forward in a 1958 commission from the Yamakawa Rattan Company to produce an organic, almost sculptural, chair. Reflecting a growing international awareness of Japanese design originality, this important icon of contemporary Japanese furniture was purchased for the design collection of the *Museum of Modern Art, New York, in 1964 and was awarded the *G-Mark in 1966. Furthermore, having first gone into production in 1960 it was awarded the G-Mark Long Life prize in 1982. A further essay in sculptural form in furniture was executed for the *Tendo Mokko Company in 1961. The resultant *Kashiwado Chair* was named after a famous sumo wrestler and was formed of blocks of lacquered Japanese cedar. He had, in fact, left the IAI in 1955 to establish his own design consultancy, Kenmochi Design Associates where, in the early years he continued to work on furniture and interior design. The award of a *Mainichi Prize for industrial design evidenced the continuing significance of furniture design to the company in 1963. Important commissions included the Japanese Pavilion at Expo '58 in Brussels on which the firm collaborated with the architect Kunio Mackawa, winning a Gold Medal, and street furniture for Expo '70 in Osaka, awarded a second Mainichi Prize.

Kenwood (established 1947) The Kenwood domestic appliance company was established in Woking, England, in 1947 by the engineer-entrepreneur Kenneth Wood and Roger Laurence, commencing with the manufacture of the *A100 Turnover Toaster*,

which followed well-established precedents. However, the company's second product, the *A200* food mixer (1948), signalled a change in the company's fortunes. Its successor, the Kenwood *Chef* was launched at the *Ideal Home Exhibition of 1950 and proved highly attractive to housewives who delighted at its ability to chop, mince, mix, and knead. Wood's marketing flair had much to do with the success of his company, which, by the mid-1950s was exporting more than 80 per cent of its products with a turnover of £1.5 million. However, the *Chef* became a design classic as well as a commercial success with its stylish redesign (*A307*) in 1960 by the industrial designer Kenneth *Grange, who had been brought in by Wood and who was to become closely associated with the design of a number of the company's products. However, after a number of setbacks the company was taken over by Thorn Electrical Industries in 1968. A more flexible kitchen appliance, the food processor, had been established by Pierre Verdun with his *Robot-Coupe* (1963) and geared to the mass market by Carl Sontheimer's derivative *Cuisinart* (1973). Kenwood moved into the food-processor market in 1979 with its *Processor-de-Luxe* (*A352*), followed by the *Gourmet* range (1982). In 1989 the company was bought out from Thorn EMI by the management and, three years later, was launched on the Stock Exchange to become Kenwood Appliances plc. In 1993 the company took over Waymaster for weighing scales and water-filter products, setting up its Housewares Division in the same year. The company, whose headquarters are located in Havant, England, now has manufacturing facilities in the UK, Italy, and China and a distributor network in over 80 countries.

KIDP *See* KOREA INSTITUTE OF DESIGN PROMOTION.

Kilkenny Design Workshops (established 1963) Prior to the establishment of the Kilkenny Design Workshops by the Irish government in 1965, there had been limited scope for industrial design in Ireland. Although there had been some acknowledgement of the potential of industrial design to boost the export potential of Irish industries before the Second World War, by the 1950s there were only two design consultancies of note: the Design Research Unit of Ireland (specializing in exhibition design) and Sigma Consultants (specializing in furniture, advertising, and package design). However, in 1960 the Irish design climate began to change with an invitation made by the Irish government's Exports Board to an expert group of Scandinavian designers to consider potential strategies for design in Irish industry. The ensuing report (*Design in Ireland: Report of the Scandinavian Design Group in Ireland April 1961*) was published in 1962 and advocated the reform of design education alongside the necessity of enhancing the importance of design in craft-based industries such as textiles, ceramics, glass, and metalwork. In the following year the Kilkenny Design Workshops (KDW) were established as the first state-owned design consultancy and soon established a reputation as an important centre for industrial, graphic, and craft design. In the 1970s the KDW also moved into the field of engineering design. Designers from overseas also worked at the KDW and played an influential role in the further development of design consciousness in Irish industry.

King, Perry *See* KING-MIRANDA ASSOCIATI.

King-Miranda Associati (established 1977) This design consultancy was founded in Milan by Perry King and Santiago Miranda offering expertise across a wide range of services, interiors, and product

Seen to imply characteristics that indicate sentimentality, vulgarity, or even pretentiousness, the meanings of 'kitsch' were intelligently explored in an essay of 1939 by the American critic Clement Greenberg entitled 'Kitsch and Avant-Garde'. However, although the word may be found in a number of contexts in the earlier part of the 20th century, its conscious adoption in opposition to the tenets of *Modernism and *'Good Design' may be found in a number of *Postmodern designs and the activities of design groups such as *Archizoom, *Studio Alchimia, and *Memphis. Important in this respect were the writings of the Italian historian, theorist, and critic Gillo Dorfles, particularly his 1969 collection of edited essays entitled *Kitsch the World of Bad Taste*, which explored many aspects of the iconography of popular culture.

types. These ranged from consumer goods to furniture, lighting, and telecommunications, with expertise in research and innovation also playing a key role in the company's activities. King had studied industrial design in the UK, moving to Italy in 1964 to work for Olivetti, where he collaborated with Ettore *Sottsass and Miranda. Miranda had graduated from the School of Applied Arts in Seville, moving to Milan in 1971, where he was employed as a consultant to *Olivetti. King-Miranda's clients have included *Akaba, *Arteluce, Black & Decker, Ericsson, *Fiat, *Flos, Olivetti, and Expo '92 in Seville. Both partners have connections with design education, King as professor at Milan Polytechnic and visiting professor at the *Royal College of Art and Miranda also as professor at Milan Polytechnic and Member of the Scientific Committee of the European Institute of Design in Madrid. They have also been recognized through awards, King being elected as *Royal Designer for Industry in 2000, Miranda winning the *Premio Nacional de Diseño (Spanish National Prize for Design) in 1989 and the Andalucian Prize for Design in 1995.

Kitsch *See* box on this page.

Kjaerholm, Poul (1929–80) Kjaerholm was one of the most renowned Danish fur-

niture designers of the 20th century and did much to consolidate Denmark's international reputation in the field after the Second World War. After a cabinetmaking apprenticeship in 1949 Kjaerholm went on to the School of Commercial Art in Copenhagen in 1952. From an early stage of his career he was interested in experimenting with materials other than the traditional medium of wood. Steel frames combined with natural materials, aluminium with plywood, and other combinations informed the range of elegant, clearly articulated and precise design solutions that characterized his work. From the mid-1950s he worked for Kold Christiansen, an entrepreneur who supported Kjaerholm's outlook, producing an extensive range of furniture types. An early design that marked his distinctive style was the plywood *PKO* of 1952. His elegant, minimalist *PK61* coffee table of 1955 represented a clever questioning of the functionalist aesthetic with the 'irrational' supporting frame visible through the rectilinear glass top. He attracted international attention from his contributions to the *Formes Scandinaves* exhibition in Paris in 1958 and the award of the prestigious *Lunning Prize in the same year. His work also attracted attention at the *Milan Triennali of 1957 and 1960 where he was awarded

Grand Prizes. The economic flowing, elegant form of his chaise longue, the *PK24* of 1965, combining steel and woven cane, typifies his mature style. In 1967 he was awarded the Danish ID Prize for product design. After his death in 1980 many of his classic designs were put into production by the leading Danish furniture manufacturing firm *Fritz Hansen.

Klein, Calvin (1942–) New York-born fashion designer Calvin Klein has become a household name in the fashion business and an important figure in the marketing of 'designer labels'. His work has also been widely commented upon as a result of a number of controversial advertising campaigns as well as featuring well-known models such as Brooke Shields, Kate Moss, Mark Wahlberg, and Christy Turlington. He studied clothing design at the Fashion Institute of Technology in Manhattan, graduating in 1964. After a brief period as an apprentice in the garment industry, with the help of a loan from a friend and a smaller investment of his own he established his own clothing company in 1968 and soon sold, slightly fortuitously, a collection of his clothing to the fashionable Bonwit Teller New York department store. He moved into the field of designer sportswear in 1973 and, having featured in fashion magazines such as *Harper's Bazaar* and *Vogue*, went on to launch his body-hugging tailored 'designer jeans' collection ('Nothing comes between me and my Calvins'). From their launch they sold in phenomenally large quantities. He expanded into the boxer shorts and briefs market in 1982, the logo—as with his jeans—becoming an important selling tool. By the end of the decade he had also launched into scents with *Obsession* and *Eternity*, further expanding his business empire to include swimwear, accessories (such as bags and shoes), cosmetics, and even home decor. He has been widely recognized by his peers in the fashion business, winning the Council of Fashion Designers of America's Award for design of womenswear and menswear in 1982, 1983, 1986, and 1993, in the latter year also being named America's best designer.

Klein, Naomi (1970–) Naomi Klein is a journalist and author who attracted international attention with her best-selling book *No Logo: Taking Aim at the Brand Bullies* (2000), a critique of the consequences of the shift from manufacturing to marketing in the 1980s and the increased emphasis on the consumption of brands rather than products. She also drew attention to the gulf between the 'lifestyle' of consumption in the First World and the realities of production in 'sweatshop' conditions in the Third World. *No Logo* has attracted the attention of many designers, particularly students, reflecting the profession's periodical and often powerful critiques of the ethics of production and consumption seen in the writings of John *Ruskin and William *Morris in the 19th century, and writers such as Vance *Packard and Victor *Papanek in the 20th. Klein's journalistic career has included work on the *Toronto Star* and the *Globe and Mail* and her research for *No Logo* was based on four years' research in Canada, the United States, the UK, and Asia. She was awarded the National Business Book Award in 2001 for the best business-related book published in English in Canada. More recently she has published *Fences and Windows: Dispatches from the Frontlines of the Globalisation Debate* (2002), a collection of articles and talks relating to the emergence of the global grass-roots movement, although this was less directly concerned with design per se.

Klint, Kaare (1889–1954) After an initial period of fine art painting, Klint studied architecture and design at the Copenhagen Academy under his architect father P.V. Jensen Klint and Carl Petersen. Although he drew on the past for inspiration, particularly English 18th-century furniture, he always endowed his work with a contemporary edge, as in the chairs he designed in 1914 (in collaboration with Petersen) for the art gallery at Fäborg. Other notable examples of this attitude to the past included his folding *Safari* chair and reworked deckchair, both of 1933, which drew on vernacular traditions yet at the same time updated them. Most of his furniture designs were made by the cabinetmaker Rudolf Rasmussenand. He was keen to relate the forms and proportions of his furniture to the workings of the human body (*Anthropometrics), also designing practical storage furniture with regard to the dimensions of the objects that it sought to contain (*Ergonomics). His reputation spread outside Denmark as his designs were shown at many exhibitions abroad, including the 1929 Barcelona Exhibition (where he was awarded a Gold Medal), the Brussels International Exhibition of 1935, and the *Paris Exposition of 1937. Although mainly a furniture designer he made occasional forays into other fields of design: in 1944, for example, he designed folded paper lampshades for the company Le Klint that are still in production today. As a design educator, he also had opportunities to influence future generations of Danish designers: in 1924 Klint became a lecturer in furniture design at the Copenhagen Academy where his students included Børge Mogensen and Nanna *Ditzel. He was later made Professor of Architecture in 1944.

Klutsis, Gustav (1895–1944) Latvian-born Klutsis was a *Constructivist artist, designer, and teacher who worked on Russian Revolutionary propagandist posters and related agitprop work, was involved in the organization of the USSR Pavilion at the *Paris Exposition Internationale des Arts Décoratifs et Industriels of 1925 and taught at the *Vkhutemas (Higher Artistic and Technical Workshops) from 1924 to 1930. After studying in Riga from 1913 to 1915 and Petrograd from 1915 to 1917, he joined the Latvian Rifle Regiment. He went on to enter the State Free Art Studios (Svomas) where he studied under Kasimir Malevich and Antoine Pevsner. Influenced by the abstract forms of Suprematism and Constructivism, he experimented with materials in their own right before adopting a more utilitarian outlook in the design of agitprop propaganda and events. His posters often used photomontage as a means of enhancing their meaning and political message. After a period working on typographic and graphic design in the early 1930s he eventually fell prey to the Stalinist purges and died in a labour camp.

Knoll, Florence Architect and furniture and textile designer, Florence Knoll was in charge of Knoll International (*see* KNOLL ASSOCIATES), a leading American furniture design company, from 1953 to 1965. She studied at the progressive *Cranbrook Academy from 1934 to 1935, at the School of Architecture at Columbia University, and again at Cranbrook in the following years before going on to study at the Architectural Association in London in 1937 to 1938. Consolidating her commitment to a *Modernist aesthetic she worked in the offices of the German emigré architect-designers Walter *Gropius and Marcel *Breuer in Cambridge, Massachusetts, in 1940. After further studies and a brief period in a New York architectural practice she joined the Hans G. Knoll Company in

1943, with responsibility for the Planning Unit. She married Hans Knoll in 1946 and they founded Knoll Associates with a showroom in Madison Avenue in New York. She was very much the driving force in design policy with her prestigious contacts such as Breuer, Gropius, *Mies Van Der Rohe, and Eero *Saarinen, whose designs were all produced by the company, as well as textile designs by the Bauhaus-trained German émigré Anni *Albers and others. She gave up her links with the company in 1965.

Knoll, Hans (1914–55) *See* KNOLL ASSOCIATES.

Knoll Associates (established 1938) The origins of this celebrated USA furniture manufacturer and distributor lay in the New York showroom of the Hans G. Knoll Furniture Company established in 1938 by German-born Hans Knoll. Producing furniture by many leading 20th-century designers, it became closely identified with *Modernism and the image of corporate interiors in post-Second World War America. In the second half of the 20th century the company produced many 'classic' designs from the 1920s and 1930s by *Mies Van Der Rohe, Marcel *Breuer, and others.

Born in Stuttgart, Knoll (1914–53) was the son of a furniture maker. After a period in Britain in the second half of the 1930s working with Tom Parker as the Parker-Knoll furniture design partnership, he emigrated to the United States in 1937, establishing a new company with a factory in Pennsylvania. He worked closely with the Scandinavian designer Jens Risom, who produced chairs, tables, and other items for Knoll in 1941. Two years later *Cranbrook trained architect-designer Florence *Knoll joined the company and took on responsibility for the Planning Unit, marrying Hans Knoll in 1946. Together, in the same year, they founded Knoll Associates,

opening a showroom in Madison Avenue in New York. The company became H. G. Knoll International in 1951, then Knoll International in 1955, two years after Hans's death in a car crash in 1953. The Knolls marketed 'classic' designs by leading European Modernists, including Mies Van Der Rohe (under licence) and Marcel Breuer, as well as those of Cranbrook graduates such as Eero *Saarinen and Harry *Bertoia. Such designs were well suited to the progressive ethos of Modernist corporate interiors and furnishings in the post-Second World War period. Florence Knoll ran the company from 1953 to 1965, during which time it expanded considerably. Swiss-born Herbert Matter had been commissioned by Hans Knoll in 1946 to design the company's graphic material, endowing it with a strong Modernist ethos as well as the company's trademark. Taking over from Matter in the mid-1960s, Massimo *Vignelli was charged with the corporate graphic and publicity design, continuing the company's commitment to high standards of design throughout its operations. Over the following decades furniture designs were commissioned from many leading international designers, including Tobia *Scarpa, Gae *Aulenti, Richard Meier, Ettore *Sottsass, Ross Lovegrove, and Frank *Gehry.

Kogei Nyusu (*Industrial Art News*, 1932–74) This influential monthly design periodical was the mouthpiece of the Japanese government's Industrial Arts Institute (IAI) Ministry of International Trade and Industry (MITI). Its immediate antecedent was *Kogei Shido* (*Industrial Art*), the journal established by the IAI's immediate predecessor, the Institute for the Promotion of Industrial Arts of Northern Japan, in 1928. It became highly influential in the post-Second World War period, with important critical

contributions from key figures such as Masaru *Katsumie, Isamu *Kenmochi, and Riki *Watanabe doing much to influence Japanese design thinking and educational outlook.

Koike, Iwataro (1913–92) A highly distinguished Japanese teacher of design, Koike worked from 1942 to 1969 at the Tokyo National University of Fine Arts and Music from which he had graduated in 1935. Subsequently he worked at the Industrial Arts Institute of the Ministry of Commerce and Industry in the late 1930s, gaining further practical design experience in the lacquer industry before taking up teaching at the Tokyo School. One particular group of his students in the early 1950s, comprising Kenji *Ekuan, Shinji Iwasaki, Kenichi Shibata, and Haratsugu Ito, became known as the 'Group Koike', the core of *GK Design, an early Japanese design consultancy. Koike himself participated in GK Design. His pedagogic influence extended to writing, as exemplified by his pioneering 1956 book on *Basic Design: Composition and Formation*. His considerable influence on the Japanese design climate was furthered through his involvement in the *Japan Industrial Designers Association (JIDA), an important pressure group that had been established in 1952 for the professionalization of design in Japan. He was its director in 1957 and again from 1965 to 1966. He was also involved with wider international industrial design promotional initiatives, speaking at the Tokyo World Design Conference in 1960—officially declared Design Year in Japan—and at the *International Council of Societies of Industrial Design (ICSID) conference in Paris in 1963. In 1985 he was awarded the Kuni Industrial Art Award and the Order of the Sacred Treasure by the Japanese government.

Komenda, Erwin (1904–66) Austrian car body designer Komenda worked for Ferdinand *Porsche and was responsible for the appearance of the original *Volkswagen and many Porsche sports car designs from the late 1940s onwards. Komenda began work as a car body designer in 1926 at the Steyrer factories, meeting Ferdinand Porsche when the latter became a technical director there in 1929. In the same year Komenda took up the post of chief designer of body styling at Daimler-Benz where he remained until 1931, when he moved to Porsche's Stuttgart car body construction department as chief engineer in charge. He worked closely with Josef Mickl on the Auto Union and Cisitalia Grand Prix racing cars. He also worked on the body design of the Volkswagen, drawing upon contemporary interest in aerodynamics, though it did not go into production until after the Second World War. In essence, Komenda's design was in production for four decades. In the late 1940s Ferdinand Porsche and Komenda worked on the design of the first Porsche sports car, the *Type 356* of 1949. He worked on a number of other models including the *550 Spyder*, his last contribution being the Porsche *911*.

Kompan (established 1970) This Swedish manufacturer of outdoor playground equipment for children has become widely known for its simply constructed, brightly coloured products that have set international standards for safety and design quality. Immediately recognizable for its child-friendly scale, amongst the first products of the company were the *M100* animals on springs, introduced in 1970. Later designs included the *Legeby* playground system of 1982. Many Kompan products have achieved an almost iconic significance in children's play equipment

and in 1994 the company was awarded the European Design Prize.

Korea Institute of Design Promotion (KIDP, established 1970) Originally entitled the Korea Design Packaging Centre, KIDP's underlying aims were to stimulate Korea's export trade through the promotion of better standards of design in Korean products and to improve the quality of design in daily life. In addition to cooperating with local and national government across a wide range of design activities, the Institute fostered design development in the business and industrial sectors. KIDP has also been responsible for the organization of the Korea Industrial Design Exhibition (first mounted in 1966) which has become the country's most important design exhibition. In common with many other design promotional organizations in the industrialized world the Institute launched its own design award scheme in 1985—the 'Good Design' or *GD Mark. Underlining key features of the Institute's mission, the GD Mark provided an additional means of drawing well-designed products to the attention of the consuming public and of further emphasizing to manufacturing industry the economic significance of better standards of design at home and abroad. At the turn of the century another awards scheme was set in place: Korea Millennium Products (KMP). From 1999 KMP status was awarded for innovative, well-designed, and technologically sophisticated products. By this time Korean design developments had accelerated: in 1998 a Comprehensive Plan for Promoting Industrial Design was established, followed by the 1st Korea Industrial Design Convention in 1999, the significance of which was emphasized by the attendance there of the president of Korea. The Institute was also active in the international arena, hosting major industrial design conferences. These included the *ICOGRADA Millennium Congress, *Oullim 2000 Seoul* (organized jointly by ICOGRADA, KIDP, the Visual Information Design Association of Korea, and the Korean Society for Experimentation in Contemporary Design) and the *ICSID 2001 Seoul Congress, *Exploring Emerging Design Paradigm, Oullim*. In 2001 the Korea Design Centre was constructed and included a Design Innovation Centre and Exhibition Hall, as well as other facilities to promote a greater understanding of design and design culture.

See also DESIGN AWARDS.

Kosta Boda (established 1741) For much of its early life this famous Swedish glassmaking company's production centred on drinking glasses, chandeliers, and window panes. However, in the late 19th century a more concerted design policy emerged with the employment of designers such as Alf Wallander and Gunnar Wennenberg, resulting in the production of more fashionable, *Art Nouveau-inspired products. As with many other design-conscious Swedish industries, Kosta was strongly influenced in 1917 by the *Svenska Slöjdföreningen's call for the employment of artists in manufacture, taking on Edvin Ollers and others as a result. In the 1920s and 1930s there was a *Modernist character to much of Kosta's output, although the company was somewhat overshadowed by *Orrefors, despite the appointment of Elis Bergh as artistic director from 1929 to 1950. The arrival in 1950 of Vicke Lindstrand, who had worked at Orrefors in the 1930s, did much to reinvigorate Kosta's fortunes. Other designers associated with Kosta since then include Bertil Vallien, Ulrica Hydman-Vallien, and Ann Wählström. Kosta is internationally recognized as a glassmaking concern of high quality. After a number of mergers and takeovers, including one by Orrefors

in 1990, the company came under the control of Royal Copenhagen in 1998.

Kosugi, Jiro (1915–81) One of Japan's leading industrial designers, Kosugi graduated in industrial arts from the Tokyo School of Fine Arts before working at the *Industrial Arts Institute (IAI) in 1944. After the Second World War he worked as an independent designer, his designs including a series of three-wheeled trucks for the Toyo Kogyo Company (now Mazda) in Hiroshima on which he worked from 1948 to 1960. Highly practical and relatively cheap to purchase these designs proved highly popular. In 1952, Kosugi was a founder member of the pioneering *Japan Industrial Designers Association (JIDA) and, in the following year, won a special award in the *Mainichi Design Prize competition for his prototype design for the Janome Sewing Machine Company in Tokyo.

Kramer, Ferdinand (1898–1986) A *Modernist German architect and designer of furniture and fitments, Kramer's reputation mainly derived from the work that he carried out on the *Neue Frankfurt* (the New Frankfurt) project under the leadership of Municipal Architect Ernst May. He had studied architecture in Munich immediately after the First World War, followed by a brief spell at the Weimar *Bauhaus. He contributed a number of designs to the *Deutscher Werkbund's 1924 exhibition entitled *Form ohne Ornament* (*Form without Ornament*) that was committed to the rejection of historical ornament, as well as the individualism of Expressionism. In 1925 he joined the municipal architecture at Frankfurt where, in addition to working on a number of housing projects, he also designed standardized related furniture and household equipment, including an efficient coal-burning stove, lighting, and door handles. Other designs that he produced during these years included the 1927 *Kramerstuhl* (*Kramer Chair*) and the 1929 combined wardrobe and linen chest, both manufactured by *Thonet. Family concerns forced him to emigrate to the USA in 1938, returning to Frankfurt in 1952.

Kramer, Piet (1881–1961) *See* AMSTERDAM SCHOOL.

Kuramata, Shiro (1934–91) An internationally recognized Japanese furniture and interior designer, Kuramata studied woodwork in Tokyo Polytechnic High School before finding employment in the Teikoku Kizai furniture factory in 1953. He then studied interior design at the Kuwasawa Design School in Tokyo in 1956, prior to working for San-Ai department store in 1957 where he designed showcase and window displays. After freelancing for the Matsuya department store in 1964 he set up his own design studio in Tokyo in 1965 and soon established a reputation as a furniture designer of originality. A comparatively early design was his soft, experimental, and anti-functionalist 'S' curved *Furniture in Irregular Forms: Side 2 Chest of Drawers* in lacquered wood of 1970. He also used industrial materials in his work, particularly steel mesh, as in his almost transparent, seemingly lightweight, and evocatively poetic *How High the Moon* armchair for *Vitra in 1986. His painstaking eye for detail, precision, and craftsmanship reflect very Japanese characteristics. Other materials with which he experimented included glass, acrylic (including the *Miss Blanche* chair of 1988) and aluminium (including the tinted *Laputa* aluminium and tinted glass washbasin of 1991). Kuramata also became widely known as an innovative interior designer, with a series of experimental designs for clubs and boutiques, including those for fashion designer Issey *Miyake in New York (in the Bergdorf Goodman

department store, New York, 1984), Tokyo (in the Seibu department store Shibuya, 1987), and Paris. He worked in an idiom in tune with the language of the international avant-garde, producing designs for the Italian *Memphis group from 1981 to 1983. His awards included the *Mainichi Design Prize in 1972 and the French government's Ordre des Arts et des Lettres in 1990.

Lad Lada Lalique, René Landor, Walter
Lane, Danny Larsen, Jack Lenor Larsson,
Larsson, Carl Laura Ashley Lauren, Ralph
Leerdam Lego Lethaby, William Richard
Levi Strauss & Co. Levitt, William Le Witt
Liberty & Co. lifestyle Lissitsky, El Loewy
logotype Loos, Adolf Louis Poulsen & Co
Lubalin, Herb Lunning Prize Lurcat, André
Lustig, Alvin Lad Lada Lalique, René La
Landor Associates Lany Larsen, J
Larsson, Karin, and Larsson, Carl Laura A
Ralph Le Corbusier Leerdam Lego Leth
Richard Letraset Levi Strauss & Co. Levi
Witt, Jan Le Witt-Him Liberty & Co. lifest
Loewy, Raymond logotype Loos, Adolf L
Co. Louis Vuitton Lubalin, Herb Lunning
urcat, Jean Lustig, Alvin Lad La
Walter Landor Associates Lane, I
Jack Lenor Larsson, Karin, and Larsson, C
Lauren, Ralph Le Corbusier Leerdam Le
William Richard Letraset Levi Strauss & I
itt, Jan Le Witt-Him Liberty & Co. lif
Raymond logotype Loos, Adolf L
Vuitton Lubalin, Herb Lunning
at a Lustig, Alvin Lad La
or Associates Lane, I
Karin, and Larsson, C
n Le Corbusier Leerdam Le
ichard Letraset Levi Strauss & I
lan Le Witt-Him Liberty & Co. lif
Ray Loos, Adolf L
Herb Lunning
vin Lad La
es Lane, I
arsson, C
dam Le
ouss & I
& Co. lif
Loos, Adolf L
lin. Herb Lunning
Lad La
or, Walter La Lane, I
or Larsson, Karin, and Larsson, C
Corbusier Leerdam Le
etraset Levi Strauss & I
Le Witt, J itt-Him Liberty & Co. lif
Loewy, Raymond logotype Loos, Adolf L
Co. Louis Vuitton Lubalin, Herb Lunning
André Lurcat, Jean Lustig, Alvin Lad La
Landor, Walter Landor Associates Lane, I
Jack Lenor Larsson, Karin, and Larsson, C
Lauren, Ralph Le Corbusier Leerdam Le
William Richard Letraset Levi Strauss & I

Lad (established 1926) Lad brought together artists and designers from the Warsaw Academy of Fine Arts. Many members of its organizing committee were associated with the Cracow School (*see* CRACOW WORKSHOPS). Supported by the Polish State and financed by the National Economic Bank, its members were involved in many areas of design including interiors, furniture, textiles, kilims, carpets, pottery, and metalwork. There was a major showing of its work at the 1929 Poznań Universal National Exhibition where the group was responsible for the design of ten rooms. Its aesthetic roots were firmly grounded in folk art traditions and its characteristic modernizing vernacular style was seen as highly appropriate for an exhibition that celebrated ten years of Polish independence. Although embracing new technologies and a commitment to a modern lifestyle their work was in clear opposition to the austere functionalism of the *Praesens group (also founded in 1926) that, in part due to the internationalizing *Modernist vocabulary that it embraced, rarely enjoyed official state support. Conversely, Lad was commissioned to design the interiors of a number of Polish embassies including those in London, Paris, and Berlin. However, as the 1930s unfolded, the group attracted increasing criticism as bourgeois and backward-looking.

Lada (established 1966) This Russian automobile manufacturing company has been one of the best known outside Eastern Europe since commencing car production. Those models that have been exported to the West have generally been characterized by basic levels of technology and conventional styling. However, in parallel with other fields of design practice Lada designers have explored more imaginative design ideas and possibilities through prototypes that have had neither the finance nor consumer markets to make them realities. Following a governmental decree in 1966 construction was begun on the VAZ works, a new automotive factory, and within two years 100,000 cars were constructed. The best-selling model in Russia for more than three decades was the *Zhiguli*, a Russian version of the *Fiat 124. Introduced in 1970 it was very much a 'people's car', produced with a range of engine sizes and models, but more attractive on account of price than innovative design or performance. Other models were worked on but never put into production, including the *Cheburashka* hatchback of 1971, which revealed many similarities to the *Honda N-600. Early in Lada's life it also produced a Sports-Utility off-road vehicle, the *Niva*, the chief designer for which was Valery Semushkine with the overall project managed by Vladimir Solov'eva. Prototypes dated from the early 1970s with the first version put into production in 1976. A number of modifications were made over succeeding decades, particularly in the 1990s. In 1984 Lada introduced the *Samara*, its first front-wheel drive car, and achieved modest sales in western Europe. Three years later the company launched the *Oka-1111* city car in collaboration with Fiat. The engine apart, there were a number of similarities with the Fiat *Cinquecento*. However, it

never achieved significant success as it proved too small and basic even for the Russian domestic market. Its planned replacement, the *Karat*, was seen in prototype at the Geneva Motor Show in 2000. At this time the company experimented with other progressive ideas for urban transportation including electric vehicles and microcars such as the *Gnom* or *Elfi*.

Lalique, René (1860–1945) Lalique was a dominant and influential figure in the art of glassmaking in France, establishing an international reputation through such major showcases for his work as the Lalique Pavilion at the *Paris Exposition des Arts Décoratifs et Industriels 1925 where he also exhibited furniture at the Sèvres Pavilion. He also worked as a textile, goldsmith, and jewellery designer, doing much to revolutionize the latter through his use of colourful gemstones and other materials less expensive than traditional diamonds such as ivory and translucent enamels. After taking up an apprenticeship with the Parisian jeweller Louis Aucoc in 1876, whilst at the same time taking evening classes at the École des Arts Décoratifs, Lalique moved to London in 1878. He remained there for two years before returning to Paris to practise as a jeweller in his own right. During the 1880s he established a reputation for innovative jewellery design, exhibited in the Vever and Boucheron jewellery displays at the Paris Exposition Universelle of 1889. The 1890s saw the further consolidation of his reputation, winning Second Prize in the *Union Centrale des Arts Décoratifs 1893 competition for the design of a drinking vessel and also designing stage jewellery for the fashionable actress Sarah Bernhardt. His displays at the *Paris Exposition Universelle of 1900 attracted particularly favourable notice, as was also the case at a number of other international exhibitions such as

the St Louis World's Fair in the USA in 1904. In the following year he opened his first retail outlet in central Paris. Amongst his more significant commissions in the years leading up to the First World War were those from the parfumier François Coty for the creation of perfume bottles in 1908 and the design of Coty's Fifth Avenue boutique in New York in 1911. He also established Cristal Lalique in 1909. After the First World War he worked on the interior design of a number of prestigious ocean liners including that of the *Paris* (1921) and the *Normandie* (1935), as well the interiors of luxury coaches for the Compagnie des Wagons-Lits. The Lalique Pavilion at the Exposition des Arts Décoratifs et Industriels of 1925 and its large fountain attracted particular notice, as did his interior designs for the Sèvres Pavilion. Lalique continued to receive prestigious commissions in later years including the main doors of the salon of Prince Asaka Yasuhiko's Palace in Tokyo in 1932.

Landor, Walter (1913–95) Walter Landor was a leading corporate identity and brand design specialist, his most celebrated clients including *Coca-Cola, Fuji Films, *Levi-Strauss, Philip Morris, Twentieth Century Limited, and the World Wildlife Fund. Born in Munich in 1913 he moved to London in 1931 to complete his studies at Goldsmiths College of Art. In 1935 he was a founding member of Industrial Design Partnership, one of Britain's first industrial design consultancies, in the following year becoming the youngest Fellow of the Royal Society of Arts. In 1939 he moved to the USA, establishing Landor Associates with his wife Josephine in San Francisco in 1941. The firm established a reputation for packaging design and the creation and coordination of corporate identity. For Landor, the creation of corporate identity

involved consumer research, business analysis, and strategic planning, an outlook that established the firm as a leading international consultancy with seventeen offices worldwide by the late 1980s, offering a wide range of design services, including corporate identity and environmental design. In addition to the clients listed above the company's identity designs included those of a number of airlines, including Alitalia, British Airways, Thai International, and Singapore Airlines. Reflecting his status as a major American design consultant whose work had a significant impact on everyday visual experience, in 1994 the Smithsonian's National Museum of American History in Washington established the Walter Landor Collections of Design Records and Packaging.

Landor Associates (established 1941) *See* LANDOR, WALTER.

Lane, Danny (1955–) American-born Danny Lane emerged as a leading force in British furniture design circles in the 1980s and has been widely recognized for his often dramatic designs in metal and glass. In common with the output of a number of other progressive artists and designers in Britain at the time Lane's work crossed the boundaries between the fine arts, crafts, and design. His reputation, which grew considerably in the 1980s and 1990s, was fully consolidated in 1994 by a major commission from the *Victoria and Albert Museum to install a stacked glass balustrade in its new Glass Gallery. It attracted considerable media attention and drew his work to the attention of a far wider audience and Lane went on to win many major commissions in the United States, Europe, India, and the Far East. At the age of 20 he had moved from the USA to Britain to take up an apprenticeship with stained glass artist Patrick Reyntiens and also attended the Byam Shaw

School of Art from 1975 to 1977. He then studied painting at the Central School of Art and Design (*see* CENTRAL SCHOOL OF ARTS AND CRAFTS), from where he graduated in 1980. After setting up a studio in the East End of London in the following year, in 1983 he launched the Glassworks company in Camden Lock, London, and, with his fellow workers, began to produce a series of glass furniture pieces. From the mid-1980s he exhibited some of these at furniture designer Ron *Arad's One-Off showroom in Covent Garden, London, and also worked on a number of interior commissions including a steel and glass bar for the Moscow Bar, London, in 1986. This characteristic combination of materials was also seen in his celebrated *Etruscan Chair* of 1986, its variegated edges and spindly legs seemingly reminiscent of an archaeological discovery. Such works reflected the development of Lane's skills in working with steel through collaborating with blacksmiths and other metal designers. His reputation began to grow internationally with a number of exhibitions, including London, Paris, and Milan where he designed furniture for the Italian manufacturer Fiam. In the early 1990s he concentrated on large-scale sculptural work, moving to a large studio in West London to make this more practicable. This resulted in a range of sculptural commissions in Europe, India, Asia, and the Far East including outdoor water sculptures in Delhi (1997), glass fountains in Shanghai (1998), a water fountain in Istanbul (1998), and *Reeling Walls* for the 20th Century Art Fair in New York (1999). He also designed a 20-ton glass water sculpture in Hong Kong and glass furniture and interior design work for the ITN company in central London.

Larsen, Jack Lenor (1927–) A leading figure in American textile design in the

second half of the 20th century, Larsen's influence was considerable, with many offices, showrooms, and manufacturing centres across the world, consultancy for the US State Department in the Far East, and recognition at international venues such as the *Milan Triennale, where he was awarded a Gold Medal in 1964. One of his major achievements was to incorporate the 'feel' of hand-woven textiles in mass-produced fabrics. His design involvement extended across a wide range of media, including carpets, tableware, and furniture. He studied architecture and furniture at the University of Seattle, also studying at the University of Southern California and the *Cranbrook Academy of Art, where he graduated with a Master of Fine Arts degree in 1951. After moving to New York he founded Jack Lenor Larsen Incorporated in 1953, his detailed knowledge of industrial weaving techniques (gained from Marianne Strengell, head of Weaving at Cranbrook as well as his Master's thesis on designing for mass production) gave him an important edge in designing for industry. Three years later he established the Larsen Design Studio, with a considerable expansion of his business in the 1960s and 1970s with interests in Europe and the Far East including a takeover in 1972 of Thaibok Fabriks Ltd., an American firm established in Bangkok in the 1940s. In 1973 he established a carpet division and leather division, followed by a furniture division in 1976. Larsen Textiles was bought by Cowtan and Tout (the American subsidiary of Colefax and Fowler) and continued the company's characteristic technical innovation and investment in design excellence with Larsen himself acting as a consultant designer. He played many important design roles including those of design director and US Commissioner for the XIII Milan Triennale of 1964 and president of the American Crafts Coun-

cil (1981–9). He has also held a number of educational posts and has been curator of many exhibitions including *Wall Hangings* (1968–9) and *Wall Hangings—the New Classicism* (1977) at the *Museum of Modern Art, New York, and *Interlacing: The Elemental Fabric* (1986) at the Textile Museum, Washington, DC. His own work has featured in many exhibitions including a retrospective (1979–80) at the Musée des Arts Décoratifs in Paris. Larsen has also written extensively on textiles including *A Weaver's Memoir* (1998).

Larsson, Carl (1853–1919) and **Larsson, Karin** (1859–1928) A prolific Swedish book illustrator, printmaker, and painter, Carl Larsson's visual imagery did much to establish a widespread idea of a Swedish domestic design and lifestyle, notions that were, almost a century later, marketed by *IKEA and recreated photographically in its catalogues. Of particular significance were his widely disseminated images of his own idyllic family life in the picturesque village of Sundborn where he lived with his wife Karin, also an artist, and eight children. In fact these portrayals of an idyllic Swedish lifestyle proved sufficiently attractive to Larsson's contemporaries for them to visit the village as tourists, although not in the numbers of the early 21st century when about 60,000 visitors a year were attracted to the Larsson house. Carl studied at the Academy of Fine Arts in Stockholm from 1866 to 1876, commencing a prolific career as a book illustrator in 1875. Karen also studied at the Academy of Fine Arts from 1877 to 1882, marrying Carl in 1883. After a brief period in Paris the Larssons returned to Sweden in 1885, Carl taking up an art teaching post in Gothenburg. In 1888 the Larssons were given the cottage *Lilla Hyttnäs* in Sundborn by Karin's father. Karen spent a great deal of time homemaking, designing

furniture, weaving colourful textiles, working on embroideries that drew on folk traditions and natural forms, as well as making clothes for her and her children. After the death of their parents the surviving children established the Carl and Karin Larsson Family Association in order to preserve their parents' home just as it was. As such it has become a significant heritage site, representing an essentially Swedish way of life.

Laura Ashley *See* ASHLEY, LAURA.

Lauren, Ralph (1939–) The Ralph Lauren label is widely known in the world of fashionable clothing, including Ralph Lauren/Polo, Lauren for Men, and Lauren for Women. That he successfully extended his repertoire to include home furnishings enabled the Lauren name to become a leading exemplar of *Lifestyle branding in the late 20th and early 21st centuries. After a period pursuing a business studies course in Manhattan, New York, Lauren became a salesman and worked for the tie-manufacturing firm of A. Rivetz & Co. Having gained experience in tie designing whilst at Rivetz Lauren set up his own business, Polo Fashions, in 1968. He placed a considerable emphasis on packaging and presentation and developed a range of smart shirts and suits that appealed to professional males. He then developed his ranges for women, moving into home furnishings—from bed linen to furniture—in the 1980s.

Le Corbusier (1887–1965) *See* CORBUSIER, LE.

Leerdam (established 1878) This Dutch glass manufacturing company was founded by C. A. Jeekel and commenced production in 1878, becoming NV Glasfabriek Leerdam in 1891. In the first decades the products were mainstream in their design, drawing heavily on the past for inspiration. From 1912 the general manager was P. M. Cochius, a firm believer in corporate social and community responsibilities. He also believed in the production of aesthetically satisfying products that respected the materials from which they were fashioned, Accordingly, he commissioned designers such as the architect K. P. C. De Bazel, who produced a distinctive twenty-piece service of pressed glass. Another noted designer for the company at this time was C. De Lorm, who first worked for the company in 1917, designing a number of simple and elegant drinking glasses including the *Normaal* range. Other well-known designers for the company included the architect-designer H. P. Berlage who designed for the company in the early 1920s, though his breakfast and dinnerware designs were technically problematic to manufacture. Cochius' design outlook was reflected in his involvement in the establishment of the *Nederlandische Bond voor Kunst in Industrie (BKI) in 1924. Among the many designers commissioned in the 1920s and 1930s was Frank Lloyd *Wright. A. D. Copier was the only full-time designer working for the company during these years and produced a number of practical drinking glasses articulated by restrained ornamentation and the use of colour. One of his most enduring services was the *Gilde* range, which became the company's best-selling design. He continued to be the company's leading designer of table glass after the end of the Second World War, including the sapphire blue *Primula* breakfast set of *c.*1948. He was also responsible for the Glass School that had been established in Leerdam in 1940, the first of its type in Holland ensuring the continuity of high-quality designers in the company in the competitive post-war market place. The products were seen as *'Good Design'. Floris Meydam, who had become Copier's assistant in 1935, produced a number of distinctive and sometimes expensive designs after

the Second World War, having been made head of the design department in 1947. These included the *Tulp* (*Tulip*) service (1952), the *Anima* sherry set (1953), the *Milano* sherry set (1954), and the *Anjou* service (1968). Automation came to Leerdam in the late 1950s and Meydam also designed mass-produced glasses for the Hema supermarket chain. Other designers associated with Leerdam glass from the 1960s onwards include G. J. Thomassen, Willem Heesen, L. J. F. Linssen, and Bruno Ninaber van Eyban.

See also STICHTING GOED WONEN.

Lego (established 1932) Deriving from the Danish words 'leg' (to play) and 'godt' (good) Lego's brightly coloured interconnecting plastic bricks and creative play systems have become widely celebrated worldwide and it has been calculated that, by the early 21st century, almost 200 billion pieces of Lego had been sold. The origins of this highly successful enterprise lay in a workshop for the production of wooden toys and ladders established by Ole Kirk Christiansen in 1932 in Billund, Denmark. The company has grown subsequently to become Europe's largest toy manufacturer. It has associated theme-parks (Legoland) opening in Denmark in 1968 and near Windsor, England, in 1994, the production of CD ROMs for 'virtual' Lego building, the introduction of programmable, interactive electronic bricks in 1998, as well as clothing and other merchandise bearing the Lego name.

The name Lego was adopted as early as 1934 although the company did not take up the manufacture of plastic toys until 1947 when it purchased injection-moulding machinery. Ole Kirk Christiansen's son Gotfred invented and patented the classic design for the famous and highly versatile modular interlocking brick with studs that was introduced in 1958, although the *Lego System* had been introduced four years earlier. The pos-

sibilities for inventive play were soon recognized as export markets for Lego developed rapidly from the late 1950s. In 1969, *Duplo*—a larger, more easily manipulated form of Lego—was introduced for younger children, a process of constant innovation and development that, on the one hand, included the introduction of the sophisticated *Technics* system in 1977 and the programmable *RCX* brick in 1998 (building on collaboration with the Massachusetts Institute of Technology in the USA) and, on the other, Lego figures in 1974 and a toddlers' version of the brick system entitled *Primo* in 1995. New directions for encouraging children's imaginative play have been further stimulated through the development of several hundred themed sets, ranging from the more traditional notions of electric train sets fashioned from Lego bricks, through to others that feature haunted castles, space exploration, and robotics. The Lego idea has been sustained further through the theme-parks in Denmark and Britain, which feature reproductions of towns and environments constructed from Lego blocks drawn from a variety of countries and cultures.

Leica (established 1869) *See* BARNACK, OSCAR.

Lethaby, William Richard (1857–1931) The architect, writer, and educator Lethaby was born in Devon and, after studying at the local art school, entered the offices of local architect Alexander Lauder, and later those of Derby architect Richard Waite. Having won the Soane Medallion (1879) and the Pugin Studentship (1991) at the Royal Institute of British Architects (RIBA), he joined the office of *arts and crafts architect Richard Shaw. He soon became a member of the Society for the Protection of Ancient Buildings, coming into contact with the leading arts and crafts figures, William *Morris and

Philip *Webb. He was a founder of the *Art Workers' Guild in 1884 and the *Arts and Crafts Exhibition Society in 1889, setting up in independent practice in 1889. He designed furniture, including a number of designs for Kenton & Co. and cast-iron goods for the Coalbrookdale Company. However, he was best known as an educator, critic, and writer rather than a practising designer or architect. In 1894 he was appointed as an inspector for the Technical Education Board of London County Council, becoming joint director of the newly established *Central School of Arts and Crafts, London, in 1896. He became principal between 1900 and 1912, bringing in a number of professional designers, such as Edward *Johnston, to teach there. He was made Professor of Design and Ornament at the *Royal College of Art in 1901, and was an active member of the *Design and Industries Association, founded in 1915. A highly articulate and informed writer, his books include *Architecture, Mysticism and Myth* (1892), *Medieval Art* (1904), *Londinium, Architecture and the Crafts* (1923), and *Home and Country Crafts* (1923). He also wrote many articles for journals including the RIBA *Journal*, *The Builder*, and *Archaeologia*.

Letraset (established 1959) The Letraset company was established in London in 1959, introducing its instant dry transfer lettering in 1960. This proved highly attractive to graphic artists and designers, revolutionizing graphic design practice through the quick and easy process of applying well-designed letters to flat surfaces. Since then the range of Letraset typefaces has expanded dramatically in both transfer and digital formats. In the 1970s a number of leading designers were employed in the design of new typefaces, a process further developed in the following decade with the introduction of Letragraphica Premier and the acquisition of the International Type-

face Corporation in 1987. In the 1990s the company expanded its digital range with the introduction of the Fontek Display Typeface Library.

Levi Strauss & Co. (established 1853) Founded in San Francisco in the mid-19th century, Levi's have been seen as one of the most powerful and evocative American brands in the international market place. This outlook has been bolstered by such factors as the Smithsonian Institution's absorption of Levi's products into its permanent collection in 1964 and Levi Strauss & Co.'s (LS&C) adoption as the official outfitter for the US Olympics in Los Angeles twenty years later. Ten years later *Fortune*, the American business magazine, also named Levi Strauss & Co. as the most admired clothing company. Sustained by effective marketing strategies over a long period of time LS&C has secured a historical niche as an original maker of strong, denim working clothes, first patented in 1873. By the early 20th century they were marketed as being 'positively superior to any made in the United States', 'sewed with the strongest thread', and 'original riveted clothing'. The company's highest profile product, the *501* jeans, was first named in the 1890s. The company's visual identity—the 'two horses' motif—also gave off an aura of rugged, specifically American, practicality. It incorporated two cowboys driving horses in opposite directions, a pair of jeans being stretched between them as a means of demonstrating the strength of material, thread, and rivets. Since 1928, when Levi's first registered its trademark, the brand has also been successfully identified with America's Wild West heritage and, like *Coca-Cola or Marlboro cigarettes, has become an internationally recognized symbol of core American values. During the 1930s such a portrayal was a strong element of corporate

advertising, echoed in the cowboy heroes in Hollywood films. *Lady Levi's* were introduced in 1935 and were sold alongside *501s*, rodeo shirts, and other Western wear. In 1912 the company had also launched its *Koverella* one-piece playsuit for children, sold nationally from 1920 when a new LS&C factory was established in Indiana. After the Second World War the company maintained the international exposure that it had gained as far back as 1915 when it received an award for its jeans at the Panama Pacific International Exposition in San Francisco in 1915. At the Brussels International Exposition of 1958 (Expo '58) Levi's jeans were exhibited in the American Pavilion, as they were in the following year at the American Fashion Industries' Presentation in Moscow. However, there was a diversification of outlook with the introduction of the *Lighter Blues* and *Denim Family* sports range in 1954. There was also some identification with rock 'n roll, with Jefferson Airplane and Paul Revere and the Raiders making radio commercials for Levi's in 1967 and the introduction of bell-bottom jeans in 1969. During this period LS&C's penetration of export markets was bolstered by the establishment of Levi's Europe in 1962 and Levi Strauss Japan in 1971. A number of other company brands were introduced, including Dockers, first appearing in 1986. A decade later, in 1996, the company explicitly marketed its own history with the international introduction of Levi's Vintage Clothing for the reproduction of earlier items drawn from the company archives. This sense of historical significance was further bolstered by the celebrations of the 130th anniversary of the company's patent for blue jeans in 2003.

Levitt, William (1907–94) Bringing the techniques of mass production to the construction industry William Levitt was the creator of the highly successful Levittown concept of large-scale suburban developments that realized for so many middle-class consumers the 'American Dream' of home ownership away from the oppressive environment of the city. Levitt & Sons were the most significant developers of American suburbia after the Second World War, erecting 17,500 houses in Long Island, between 1947 and 1951, before undertaking further Levittown initiatives in New Jersey, Pennsylvania, and Bowie, near Washington, DC. As Levitt advertising portrayed it in 1946, the Levittown house owner's home was 'the Model T equivalent of the rose-covered cottage—or Cape Coddage, as someone once called it. It is meant to look like the Little House of Ones Own that was the subsidiary of the American Dream long before Charlie Chaplin put it into "Modern Times".' However, not all Americans were enamoured with the 'Dream', the folk singer Pete Seeger later satirizing Levittown in his song *Little Boxes*, or houses, that were 'all made out of ticky tacky, and they all look just the same' (as they did on their uniform plots of 60 foot by 100 foot (18 × 30 m)). On a more seriously critical front the feminist Betty *Friedan looked at the negative impact of suburbia for women in her celebrated text *The Feminine Mystique* of 1963.

Levittown homes were affordable and were well equipped with all of the desirable aspects of contemporary aspirations: 12 foot by 16 foot living rooms with picture windows and a built-in Admiral television; a cooker, a washing machine, a refrigerator, and storage systems in the contemporary kitchen; the standard provision of two bedrooms with the prospect of further accommodation in the loft. The houses could be purchased for $7,900 dollars with war veterans able to take out a mortgage with no

deposit for $58 over a 30-year period. Others could secure their homes with a deposit of 5 per cent or rent with an option to buy. Not only were these houses constructed efficiently on site to keep down costs (at the rate of 37 houses per day), but they were also subject to communal rules: no changes in the external colour of houses; no fences in the front gardens; no washing to be hung out; all lawns to be mown on a weekly basis or the owners would be charged for the task to be executed by Levitt-employed gardeners.

Levittowns were associated with the aspirations of 'the average American', a notion followed through in Herbert Gans's two-year study of life in the Levittown in Willingboro, New Jersey, the results of which were published in his 1967 book *Levittowners*. William Levitt sold up his interests in the company for $92 million in 1968.

Le Witt, Jan (1907–91) *See* LE WITT-HIM.

Le Witt-Him (established 1933) This distinctive graphic design partnership, widely recognized for its witty and original contributions to graphic propaganda and advertising in Britain in the 1940s, was formed by two Polish-born graphic designers, Jan Le Witt (1907–91) and George Him (1900–82). After establishing a partnership in Warsaw in 1933 they emigrated to London in 1937. They worked for a number of British state organizations including the Ministry of Information and the Post Office. Their work was distinctive and widely recognized for the wit and invention evident in their designs for books, posters, and the famous mechanical Guinness Clock in the Battersea Pleasure Gardens at the *Festival of Britain of 1951. Although the partnership came to an end in 1954 when Le Witt abandoned graphic design in favour of fine art Him continued to work in the field and was widely known for his amusing advertise-

ments for the drinks manufacturer Schweppes. He was made a *Royal Designer for Industry in 1977.

Liberty & Co. (established 1875) Liberty & Co. of Regent Street, London, has been a well-known name in fashionable retailing for more than 125 years, with a particularly distinguished place in the history of design in the later 19th and early 20th centuries. Of particular note was its role in relation to the *Aesthetic Movement and *Art Nouveau, often known as Stile Liberty in Italy. Arthur Lazenby Liberty (1843–1917), the firm's founder, became involved with the world of London retailing at the firm of Farmer & Rogers' Regent Street emporium in 1862, the year in which London's second major international exhibition was held in South Kensington. A prominent feature of this exhibition was the display of Japanese art and design, both attracting considerable critical comment and exerting a powerful influence on designers, architects, and artists. Farmer & Rogers purchased a number of oriental artefacts from the exhibition, putting them on sale in its Oriental Warehouse, in which Liberty was given a managerial role in 1864. Capitalizing on the rapidly growing interest in such exotic goods in artistic circles, Liberty opened his own shop in Regent Street opposite Farmer & Rogers, importing decorative artefacts, silks, and wallpapers from India, Indochina, Persia, as well as Japan and other countries. A Furnishing and Decorative Studio was set up in 1883, reflecting fashionable interest in 'art industries' and the Aesthetic Movement. The costume department, established under the direction of E. W. *Godwin in 1884, also promoted fashionable dress and sought to challenge the pre-eminence of Paris. Liberty's exhibited aesthetic clothing at the 1889 Exposition Universelle in Paris, opening 'Maison

Liberty' for the sale of clothes and fabrics in the centre of the city in the following year. It proved successful and lasted until 1932 when unfavourable trade tariffs were introduced. In the later 19th century Liberty's commissioned many other leading designers associated with the *Arts and Crafts Movement including C. F. A. *Voysey, Hugh *Baillie Scott, Lindsay Butterfield, and Arthur Silver for work across a wide range of media. In the early years of the 20th century the company established its own range of silverware designs under the name Liberty & Co. (Cymric) Ltd., soon followed by its Tudric pewter range. Celtic decorative motifs were an important source of inspiration for designers such as Archibald Knox and Rex Silver, although they remained anonymous and their work marketed under the Liberty name.

After the First World War, Liberty's was forced to rebuild its Regent Street premises with two buildings designed by Edwin T. Hall & Son, one in Renaissance style, the other in Tudor. The latter was built in 1924 when the Tudor style was emerging as a popular expression of British imperial heritage. Although Liberty's had commissioned printed textiles for several decades, this sector of the company's activities expanded considerably in the 1920s and 1930s with a proliferation of small-scale floral prints which became known as Liberty Prints. To cater for such growing consumer demands a wholesale company was formed in 1939, Liberty of London Prints. After the Second World War the company continued to promote both traditional and fashionable contemporary design across its departments, selling work by such celebrated designers as Gio *Ponti, Robin *Day, Lucienne *Day, Arne *Jacobsen, and Paolo *Venini. In 1973 Liberty's took over *Metz & Co., a famous Dutch retailer that had for many years also sold Liberty & Co. products. The artistic and cultural significance of the firm was acknowledged by the holding of an important Liberty Exhibition at the *Victoria and Albert Museum in 1975. Reinforcing the long-standing historical ties with Japan, Liberty's established links with the Seibu Department Stores in Japan in 1988. In the early 21st century the Liberty name is still synonymous with both contemporary fashions and heritage, with retail outlets in Windsor and London's Heathrow Airport in addition to the main store in central London.

Lifestyle Associated closely with particular ways of living promoted through advertising and *branding, the word 'lifestyle' has been used increasingly widely in a design context from the 1960s onwards although the term had originally been coined in the late 1920s by the psychologist Alfred Adler to denote the ways in which childhood personality traits marked out future behaviour.

Lissitsky, El (Lazar Markovich Lissitsky, 1890–1941) The Russian *Constructivist typographer, graphic designer, architect, painter, photographer, and theorist El Lissitsky was influential in the dissemination of *Modernism both through his work and theoretical writings. He studied architecture and engineering under Joseph Maria *Olbrich and others at the Technical School at Darmstadt between 1909 and 1914, visiting Paris, the hub of avant-garde artistic activity, in 1911. He moved back to Russia to practise architecture in 1914, but also worked in the fine arts and illustration, underlining notions of his concept of the 'artist-engineer'. In 1919, following an invitation from Chagall, he taught at the art school in Vitebsk and came under the influence of the Suprematist painter Kasimir Malevich, who became head of the school (retitled Unovis: 'New Art'). Strongly

committed to the Russian Revolution, which had commenced in 1917, Lissitsky designed a striking Soviet propagandist poster *Beat the Whites with the Red Wedge* in 1919, using abstract forms to telling effect, an approach taken further in his children's books *Of Two Squares* of 1920. In the same period he also worked on the design and layouts for Mayakovsky's poetry, and a book entitled *For Reading Out Loud* of 1923, one of his most sophisticated typographic achievements. He was also involved in set design as for the electro-mechanical ballet *Victory over the Sun* of 1920. In 1921 he began teaching architecture at the progressive state art and design school *Vkhutemas in Moscow, alongside Vladimir *Tatlin and Alexander *Rodchenko, and in the following year began publishing the journal *Veshch* (*Object*). He had produced his first 'Proun' artwork in 1919, later designing 'Proun Rooms' for exhibition in Berlin (1923) and Hanover (1927). The term 'Proun' derived from a contraction of the words 'Pro' and 'Unovis', meaning 'For the New Art', and represented a dynamic union between architecture and Suprematist painting, creating a sense of movement in interior space. In these years he also forged a number of important relationships with European avant-garde artists and designers associated with Dada, De *Stijl, and the *Bauhaus, meeting Kurt Schwitters and László *Moholy-Nagy in 1922 and Hans Arp and Mart Stam in 1924. In the later 1920s he undertook a number of important exhibition designs including the Soviet Pavilion at the 1928 International Press Exhibition at Cologne. He also undertook commercial commissions such as publicity for Pelikan ink. In the 1930s much of his energy was devoted to photography and teaching.

Loewy, Raymond (1893–1986) One of the most publicity conscious and product-

ive of the American industrial designers who became feted as celebrities in the inter-war years, Raymond Loewy did much to define the profession for subsequent generations. His consultancy was responsible for the design of almost every conceivable product type, from cigarette packs to streamlined steam trains and from dinnerware to dishwashers. Loewy did much to build up the mythology of the industrial designer as having the capacity single-handedly to transform all aspects of everyday life. This was seen in the 1934 design exhibition at the Metropolitan Museum in New York, where he displayed a somewhat spartan, yet elegant, streamlined mock-up of his design office complete with stylish desktop drawing board, fashionable up-lighter, and tubular steel furniture. With only enough room for a single designer to work in, it belied the fact that industrial design consultancies employed a range of specialists who did much to bring the designer's ideas to readiness for mass production. This outlook was more graphically conveyed in the celebrated cover for *Time* magazine of October 1949. It featured Loewy set against a backdrop of products including an automobile, refrigerator, cooker, aeroplane, ocean liner, armchair, and fountain pen, as if he had designed them all single-handedly rather than working together with more than 150 employees. He also had a considerable eye for publicity photographs, appearing next to, standing on, sitting in, or using Loewy-designed products. His 1951 autobiography *Never Leave Well Enough Alone* did little to dispel his self-created myth.

Born in Paris, he studied engineering from 1910 to 1914 but received his degree in 1918, having interrupted his studies for army service in the First World War. Emigrating to New York in 1919 he found employment as a window-display designer for Macy's as well as graphic work for Saks

Fifth Avenue, and fashion illustration for *Vogue*, *Harper's Bazaar*, and *Vanity Fair*. Having established his own industrial design consultancy, Raymond Loewy Associates, in 1929, one of his first commissions was the redesign of the Gestetner duplicating machine (1929). Using a clay model to explore ideas for its form and appearance, he transformed an uncoordinated piece of office machinery into an elegant, efficient looking, modern product. As he became more successful Loewy was able to open a product, transport, and packaging design consultancy in Fifth Avenue, New York. Notable among his early commissions were the *Coldspot* refrigerator designs for the Sears Roebuck & Co. mail order firm for whom he began work in 1932. The most celebrated of these was marketed from 1935 and featured new materials and ideas such as aluminium shelving, storage baskets, a water cooler, and vegetable freshener, all contained within a styled, modern streamlined form. Loewy also worked in many fields of transportation design, his first major commission being the *Hupmobile* (1934) for the Hupp Motor Company. Loewy began his association with the Studebaker company in 1938 when the 1938 Studebaker was named the 'Best Looking Car of the Year' by the American Federation of Arts. After the Second World War Loewy worked briefly with automobile stylist Virgil *Exner at Studebaker. Loewy's post-war designs for the company included the *Champion* (1947), the *Starliner* (1953), and the fibreglass bodied *Avanti* (1961). The critical success of the 1953 Studebaker range was such that it was even feted on the cover of *Time* magazine. Loewy also designed for railways including the 1937 *S-1* locomotive for the Pennsylvania Railroad Company. It was displayed at the *New York World's Fair of 1939, where visitors could also view his *Rocketport of the Future*. From 1935 he was

also consultant designer to the Greyhound Coach Corporation, producing designs for the streamlined *Silversides* motor coach (1940) and its 1954 replacement, the sleek, comfortable *Scenicruiser*. He even worked for NASA from 1967 to 1972, including the interior of Skylab. Other important companies that Loewy worked for included *Coca-Cola, Lucky Strike, *Rosenthal, Shell, and Exxon. After the Second World War Loewy's consultancy expanded, with offices in New York, Chicago, South Bend, Los Angeles, and London. Loewy also set up the Compagnie d'Esthétique Industrielle in Paris in 1952.

Logotype More commonly known as logos, logotypes are generally the visually distinctive arrangements of lettering whereby companies and organizations are readily recognized by clients, consumers, and the general public. They may be closely linked to the *branding of products, be an integral part of *corporate identity schemes, or may relate to trademarks, another means of ready identification.

Loos, Adolf (1870–1933) A highly influential figure in the development of *Modernism, architect and designer Loos was perhaps most widely known for his celebrated and influential text *Ornament und Vebrechen* (*Ornament and Crime*) of 1908. His design work included bentwood furniture for *Thonet and a set of simple, cleanly articulated drinking glasses and jug for the Lobmeyr company (1931). Identified by Nikolaus *Pevsner as one of the 'Pioneers of Modern Design', Loos was a prolific writer on architecture and design opposed to the widespread embellishment of architecture at the turn of the century. In sympathy with the earlier writings of Gottfried *Semper, Loos was influenced by what he saw as qualities of simplicity in British and American design and engineering,

although in his own architectural and design work there were also clear affinities with the clarity of form of neoclassicism. Although born in Brno (in what is now the Czech Republic) and trained in Dresden, much of Loos's professional life was spent in Vienna. He was the chief architect for housing in Vienna from 1920 to 1922, the year in which he submitted an entry to the Chicago Tribune Building Competition in the form of a massive Doric column. His theoretical links with Modernism were underlined by the republication of *Ornament und Vebrechen* in Le *Corbusier's periodical *L'Esprit nouveau* in 1920.

Louis Poulsen & Co. (established 1911) The origins of this leading Danish lighting manufacturer lay in wine importing in the last quarter of the 19th century, although the company soon moved into industrial electrical equipment with the development of the electricity generating industry in Denmark in the 1890s. After other shifts of emphasis in the early 1900s the company was renamed Louis Poulsen & Co. in 1911. After the First World War it increasingly focused on electrical goods and, in 1924, employed architect Poul *Henningsen to design lighting. These included the *PH* lamps (1927) which were placed in the international gaze through their adoption at the *Deutscher Werkbund's Weissenhof Siedlungen exhibition of *Modernist housing in Stuttgart in 1927. By the 1930s the company's products were sold in several European companies. After the Second World War the company manufactured designs by Arne *Jacobsen (the *Visor* desk lamp, 1957), Verner *Panton (the *Pantella* floor lamp, 1970), *King-Miranda Associati (the *Borealis* lamp, 1996), and others.

Louis Vuitton (established 1854) A leading manufacturer of high-quality travel goods founded in Paris, Louis Vuitton has become a truly global brand associated with luxury travel, the LV monogram immediately conveying an aura of status, sophistication, and style. The roots of this success lay in a number of landmark products, commencing with Vuitton's grey *Trianon* canvas trunk (1854). The stylish *LV Monogram* canvas (1896) and the soft *Steamer Bag* (1901) prefigured the opening of the Louis Vuitton building on the Champs-Elysées in Paris, the largest travel goods store in the world. The famous *Keepall Bag*, often seen as a forerunner of the duffel bag, was launched in 1924 and was followed by similar products. In the last quarter of the 20th century Louis Vuitton developed as a truly global brand: the first LV stores opened in Tokyo and Osaka in Japan in 1978, in South Korea in 1984, in China (1992), in Marrakesh (2000), in Moscow (2003), and New Delhi (2003). Louis Vuitton had also become part of the LVMH conglomerate that owned Moët champagne, Hennessey cognac, and the Lacroix and Givenchy fashion labels. By the late 20th century the LV label was applied to a wide range of expensive products, other than travel goods per se. These included watches, silk scarves, pens (such as those designed by Anouska Hempel in 1997), and ready-to-wear clothing and footwear (initiated in 1998). Frenchman Marc Sadler became the company's artistic director in 1998, marking the start of a number of fresh initiatives and collaborations with designers, illustrators, and artists.

Lubalin, Herb (1918–82) A prominent American typographic designer working across many graphic fields including posters, advertising, signage, postage stamp, typeface, and editorial design, Lubalin was recognized as an innovator and iconoclast, particularly with the advent of phototypesetting in the 1960s. This allowed him considerable licence to play with

words, images, and scale on the page. After studying at the Cooper Union in New York (where the Lubalin Archive is now held) from which he graduated in 1939, he worked as a freelance graphic designer and typographer before taking on the role of art director for a number of agencies including Sudler & Hennessey (from 1945). In 1964 he established his own consultancy, Herb Lubalin Inc. (from 1981, with Seymour *Chwast and Alan Peckolick, becoming Pushpin, Lubalin, Peckolick Associates Inc.). In 1970, together with Aaron Burns and Ed Rondaler, he founded the International Typeface Corporation, with the aim of licensing original typefaces as a means of ensuring royalties for their designers. His own typefaces included Avant-garde Gothic (1970, with Tom Carnase), Lubalin Graph (1974), and Serif Gothic (1974, with Tony DiSpigna). For some years he had also played a key design role in a number of magazines including *Eros* (1962) and *Avant Garde* (1968) and in 1973 founded, designed, and edited the influential international typographic journal *U&lc* (the title representing a shorthand for 'Upper and lower case typography'). His work was internationally recognized through his many designs for publication as well as numerous exhibitions and awards, including the American Institute of Graphic Arts (AIGA) medal in 1981.

Lunning Prize (1951–72) This prestigious prize was initiated in December 1951 by Frederik Lunning, Danish-born businessman and owner of the Georg Jensen Inc. store on 5th Avenue, New York. This successful showcase for Danish porcelain and glass had been established in 1924 but, with the outbreak of the Second World War, supplies were cut off. After the war the store's manager Kaj Dessau was sent by Lunning to source fresh merchandise in Scandi-

navia. Deeply impressed by the quality of work he saw, Dessau suggested the establishment of an award scheme for young Scandinavian designers. As a consequence Lunning initiated a biennial prize with $5,000 being awarded to desingers under 36 years of age whose careers would benefit from study abroad. The jury comprised representation by the leading design organizations in Sweden, Denmark, Norway, and Finland, as well as Lunning's nominees. Each award winner was to have an exhibition in Lunning's New York store at which the Prize would be presented. There was also a secondary reason for the initiation of the scheme—the promotion of Scandinavian design and increased markets for its products. The first prizewinners were Hans *Wegner and Tapio *Wirkkala, other early recipients including Jens *Quistgard, Timo *Sarpaneva, and Nanna *Ditzel. The significance of the winners over the twenty years of the Prize is a testament to its contemporary and historical significance.

Luterma (established 1883) This well-known Estonian plywood furniture company was founded in 1883 and by the turn of the century had become the largest plywood and furniture manufacturer in Russia. Luterma (the A. M. Luther Mechanical Woodworking Factory) was renowned for its high quality plywood, which was used for the manufacture of suitcases and pails as well as furniture. The company's early furniture types included office and railway furniture as well as domestic designs. In 1908 Luterma established a sister company in London, the Venesta Plywood Company (the name Venesta deriving from Veneer and Estonia), its international outlook being supported by the establishment of branch offices in many European countries including Germany, Sweden, France, and Italy. By 1914 much of its output reflected

a straightforward functionalism although there were occasional examples of striking innovation as in the sculptural, flowing forms of a screen of 1908 (Model no. 1138) anticipating developments in Finland by Alvar *Aalto and *Artek. With the closure of Russian markets after the First World War, Luterma played an important economic and social role in the production of furniture, a significant amount of which was geared towards utilitarian, everyday types. Prior to the First World War Luterma had boasted one of the largest furniture departments in the Baltic Countries, producing folding chairs and tables for the British market alongside domestic, public, and office furniture for Baltic markets. With the considerable expansion and industrialisation of Tallin arose the need for production of a new furniture range that would be suitable for the rapid growth in the provision of rationally planned apartments and housing designed to cater for the expanding working class. Luterma had begun to develop its interest in this sector through mounting a competition in 1919 for well-designed inexpensive wooden furniture for small flats. Alongside such initiatives Luterma converted its Tallin warehouse into a modern showroom for an extensive display of domestic and office furniture. In the mid 1930s the company promoted a 'Furniture for Everyone' initiative supported by the Ministry of Economics, producing flexible modern designs using standardized forms with interchangeable modular units that could be combined in different ways. Such designs embraced the principles of *Modernism and empathy with the *existenzminimum* ('living in a minimum space') design aesthetic that had been explored elsewhere in avant-garde circles in Europe—in Vienna, Warsaw, Frankfurt, Stuttgart, and other cities involved in progressive large-scale housing programmes. In Britain, Jack *Pritchard who worked for the Venesta Plywood Company, Luterma's sister company, was involved with the architect Wells *Coates in the design of the 'minimum flats' at Lawn Road, Hampstead (1932), and the *Isokon plywood furniture designed by Walter *Gropius and Marcel *Breuer. Luterma's similarly adventurous, but less high-profile, policy continued until 1940 when Estonia was annexed by the Soviet Union.

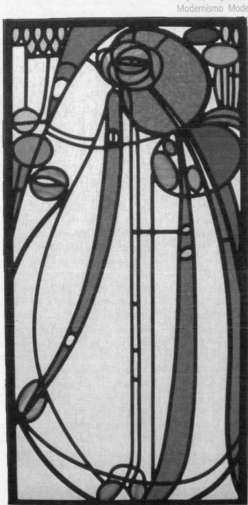

McAllister, Wayne (1907–2000) McAllister was one of the leading designers of American roadside architecture in the 1940s and 1950s, his lively and visually rich contributions to the genre providing populist inspiration to *Postmodernist architects and designers such as Robert *Venturi, author of *Learning from Las Vegas* (1973). Born in San Diego, California, he left high school early to take up architecture with the American Building Co. Although he had no formal architectural training he was commissioned to design the Agua Caliente resort hotel and Tijuana Casino in Mexico at the age of 20. Built in the Spanish Colonial Revival style, McAllister absorbed some influence from *Art Deco through the muralist Anthony Heinsbergen, who was working at Agua Caliente and who had visited the *Paris Exposition des Arts Décoratifs et Industriels in 1925. McAllister went on to design many buildings that catered for the increasingly automobile-oriented culture of California in the inter-war years with a number of 24-hour drive-ins and restaurants, such as the Cinegrill supper club in Hollywood. In addition to a number of restaurants for the Kentucky Fried Chicken and Pig 'n' Whistle chains he also designed for Bob's Big Boy. One of his most celebrated contributions for the latter was the drive-in diner in Riverside Drive, Los Angeles, in 1949. With its glass, neon lighting, mosaics, and terrazzo tiling and contrasting flat surfaces, it is often seen as transitional between 1940s *Moderne and 1950s Californian Coffee Shop style. The third Bob's Big Boy to be built, it had characteristic attention-seeking graphic pink and white neon signage applied to a slab-like tower rising up above the main body of the glass-fronted restaurant. One of comparatively few McAllister buildings to survive, it was made a California State Point of Historical Interest in 1993. Also with a striking tower, integrated with the main building, was the Sands club (1952) on the Las Vegas Strip. The 56 foot (17m) high tower, complete with neon signage including a 35 foot high capital 'S', was a striking symbol that could be easily seen from passing automobiles. Other Las Vegas buildings by McAllister included the theme hotel El Rancho (1941). He gave up his prolific architectural practice in the late 1950s.

McDonald's (established 1948) McDonald's, like *Coca-Cola, Marlboro, and *Levi-Strauss, has become a highly prominent global brand symbolically associated with notions of an American consumer democracy and way of life. The distinctive 'Golden Arches' motif can be seen in about 120 countries, the 30,000th McDonald's restaurant opening in 2001. The origins of the company lay in the 1948 plans of Richard and Maurice McDonald to apply *Fordist principles to the fast food business, concentrating on the production of a limited range of items, speedy service, and reduced labour costs. The two other key ingredients lay in a distinctive visual identity for the restaurants and the establishment of an effective franchising system. There is some debate about the origins of the striking 'Golden Arches' motif, with many histories accrediting its invention to the architect Stanley Meston, who was commissioned

by McDonald's to design a number of their early franchised buildings. However, there is some evidence to suggest that it was Richard McDonald, highly sceptical of the architectural and design professions, who first sketched out the 'Golden Arches' and the colour scheme and assigned them to Meston for realization. The first franchised McDonald's restaurant with the distinctive 'Golden Arch' was designed by architect Stanley Meston and built in Downey, California, in 1953. Restored in 1997 and reopened with a museum and gift shop on site, it was deemed eligible for listing on the National Register of Historic Places. Often considered to be the first visually characteristic McDonald's restaurant was that constructed two years later in Des Plaines, Illinois, also designed by Meston, owned by the McDonald's franchise agent Ray Kroc. The growth of the company was rapid: by 1957 there were 37 McDonald's restaurants, by 1959 over 100, a figure that had doubled in 1960. The definitive McDonald's logo was created in 1968 by the Arcy Agency, based on the 'Golden Arches' of the buildings. The first McDonald's outside the USA was established in Canada in 1967, the beginnings of an international trend that has established major markets in the United Kingdom, France, Germany, Japan, Australia, and Canada. The first McDonald's restaurant in Japan opened in Ginza, Tokyo, in 1971, and the number had grown to more than 2,400 by the early 21st century, making Japan the largest McDonald's market outside the USA. The first McDonald's restaurant on the African continent opened in Morocco in 1992 and in the Middle East in the following year. The first outlet in China was opened in 1992, with more than 80 in Beijing alone by the early 21st century. By the turn of the century eight out of the ten busiest McDonald's restaurants were outside the USA, the busiest being located on Pushkin Square, Moscow, serving 43,000 customers per day. Today, outlets can be found in airports (the first was in Changi Airport, Singapore, in 1981), educational institutions, museums, hospitals, and sports stadiums. However, although McDonald's has attempted to give many of its international outlets an indigenous, local identity through the menu and identification with community causes, the distinctive 'Golden Arches' did not always meet with acclaim. In Beijing, China, they were seen as part of an undesirable clutter of signage in the urban environment. In 2002 the city government ordered McDonald's to remove more than 30 'Golden Arches' as it sought to give the city a visual 'makeover' in the run-up to hosting the 2008 Olympic Games.

Macintosh *See* APPLE MACINTOSH.

Mackintosh, Charles Rennie (1868–1928) Scottish designer and architect Mackintosh was a leading British exponent of *Art Nouveau. Through exposure in magazines such as the *Studio, participation in exhibitions such as the Vienna Secession, and featuring in Hermann *Muthesius' (1904–95) influential book *Das Englische Haus* he also proved to be an influential figure in European design. In addition to the design of a number of striking buildings, he also worked in a wide range of design fields including graphics, interiors, furniture, cutlery and tableware, textiles, carpets, metalwork, stained glass, and jewellery.

After an apprenticeship in architectural offices in Glasgow from 1884 to 1889 he began working in architectural practice and developed an interest in Scottish architectural precedents. By the early 1890s his interests also embraced late *arts and crafts architecture and design as well as the flowing forms associated with Symbolist work seen in the pages of *Studio*. In this period he attended evening classes at

Glasgow School of Art (1885–9) and began to work very closely with fellow students H. J. Macnair and sisters Margaret and Frances Macdonald, the group becoming known collectively as the 'Glasgow Four'. Their work was characterized by curvilinear, flowing forms derived from Celtic art in posters, furniture, and metalwork and attracted considerable critical attention. In 1897 he won the competition for the new Glasgow School of Art which was built between 1897 and 1899, designing furniture, fittings and fitments, and architectural details that became hallmarks of his style. Other important commissions included tearoom interiors and furniture for Mrs Cranston in Glasgow, the first of which (in Argyle Street) also dated from 1897, with the rest following over succeeding years. His influence in Europe was strengthened by exposure in continental arts journals such as *Decorative Kunst* and *Ver sacrum* and participation in the 1900 Vienna Secession and 1902 Turin Exhibitions, for which he designed the Scottish Sections to considerable critical acclaim. In 1902 he also designed a music room for Fritz Warndorfer, a major financier of the *Wiener Werkstätte*, which were founded in the following year. Another widely renowned Mackintosh building was his 1903 Hill House in Helensburgh, near Glasgow, a synthesis of architecture and furniture commissioned by the publisher W. W. Blackie. After moving to London in 1913 he undertook design work for W. J. Bassett Lowke, also redesigning a terraced house for him in 78 Derngate, Northampton (1913–16). This was well known for its rectilinear furniture and fitments, as well as having close affinities with the more geometric side of Wiener Werkstätte design and marking a clear shift from the more flowing, organic forms of his earlier work. It is also sometimes seen as an antecedent of *Art Deco.

Many of these ideas were also followed through in a house named *New Ways*, a later commission for Bassett Lowke. From 1923 to 1927 he lived in France, largely concentrating on painting.

Mackmurdo, Arthur Heygate (1851–1942) The British architect and designer Mackmurdo was apprenticed to the architect T. Chatfield Clarke prior to moving into the offices of the Gothic architect James Brooks in 1873. Two years later Mackmurdo established his own architectural practice in central London but, despite becoming an Associate of the Royal Institute of British Architects in 1882, his output was limited in the 24 years in which he practised in the field. Deeply interested in social reform he was heavily influenced by the writings of John *Ruskin and became far more widely recognized for his involvement in design, especially the foundation of the Century Guild in 1882. The latter comprised a group of craftsmen who worked on the production of artistic goods including furniture and metalwork, as well as wallpaper and textile design. The almost fashionable notion of a guild revival that looked back fondly to the Middle Ages was also warmly embraced by a number of leading figures associated with the *arts and crafts in Britain. These included Ruskin (founder of St George's Guild in 1874) and C. R. *Ashbee (a leading figure in the formation of the Guild of Handicraft in 1888). The Century Guild's philosophy was expressed in its periodical *The Hobby Horse*, the first issue of which was published in April 1884. Many design historians have linked Mackmurdo's work with English *Art Nouveau, seeing the origins of the latter in the flowing, organic forms of the frontispiece for his book on *Wren's City Churches* (1883) and design of a chair which displayed similar forms in the patterning of its back. Although the output

of the Guild was not prolific and it lasted for only six years, its influence was profound as a result of the participation of its members in many public exhibitions. From 1906, when he retired from architectural practice, Mackmurdo devoted his energies to social and economic reform.

McKnight Kauffer, E. *See* KAUFFER, E. MCKNIGHT.

McLuhan, Marshall (1911–80) An important and influential writer on the impact of the mass media on popular culture, the Canadian academic Marshall McCluhan published a number of important texts including *The Mechanical Bride: Folklore of Industrial Man* (1951), *The Gutenberg Galaxy: The Making of Typographic Man* (1962), *Understanding Media: The Extensions of Man* (1964), and *The Medium is the Message* (1967). He considered that in a technologically sophisticated age of mass communication in which everybody could experience events at the time that they were happening, the world had become like a 'global village'. He wrote in *Explorations in Communication* in 1960 that 'postliterate man's electronic media contract the world to a village or tribe where everything happens to everyone at the same time'. He also predicted that printed information would cease to be significant in an electronic age. Although this did not prove to be the case his writings were influential in the 1960s and 1970s.

Magistretti, Ludovico (Vico) (1920–) One of Italy's most important furniture designers in the second half of the 20th century, Magistretti graduated from Milan Polytechnic in 1945. He worked for a number of well-known companies including *Cassina, *Artemide, and *Rosenthal. After a period in his father's architectural practice he set up on his own as an architect

and designer. In common with many other architects experiencing a shortage of commissions in the *ricostruzione* period following the end of the Second World War Magistretti turned his hand to furniture, interior, and product design. One of the pioneers of stylish plastic furniture design, his elegant designs for Artemide included the *Selene* stacking chair, designed in 1961 and produced in a variety of bright colours from 1966 onwards, and the *Gaudi* chair (1979). Other designs for Artemide included the spherical *Eclipse* table lamp (1966) and circular *Mania* wall lamp (1969). He also designed the *Model 115* chair (1964) for Cassina, a painted wooden framed chair with rush seating that acknowledged vernacular precedents. Other designs for the company included the *Maralunga* (1979) and *Sinbad* chairs (1981), the latter a sculptural concept inspired by a traditional horse blanket, thrown over a metal frame. Other companies that commissioned work from Magistretti included O-Luce, De Padova, and Rosenthal Studio-Haus. He was awarded the *Compasso d'Oro in 1967 and 1979 and taught at the *Royal College of Art.

Mail order Mail order shopping originated in the United States with the launch of the Montgomery Ward catalogue in 1872. This innovation had commenced with single-sheet listings of goods but soon evolved into illustrated books containing all kinds of equipment for everyday life, from furniture, furnishings, and clothing to tools, agricultural equipment, and even prefabricated buildings. Another pioneering company in the field was the Chicago-based R. W. Sears firm that launched its services in 1891, soon joining with Roebuck to form *Sears Roebuck & Co. The fact that both Sears Roebuck and Montgomery Ward were based in Chicago was significant as the city was at the hub of the extensive

American railway system, enabling the transfer of goods from source of production to rural communities throughout the United States. In parallel, the American postal system, which had undergone extensive modernization before the First World War, enabled orders to be placed easily and efficiently. Mail order catalogues were often known as 'wish books', providing insights into American life at different periods. Such publications also provided immigrant settlers with a means of viewing the 'American way of life'.

Mail order catalogues also emerged as significant marketing tools in Europe in the late 19th century, as in Germany with Alfred Stukenbruk's mail order company, which had become a significant enterprise by 1914. In France the *3 (Trois) Suisses, established in 1932 also enjoyed spectacular growth in the succeeding decades, issuing more than 6 million catalogues by the mid-1990s. Throughout the 20th century many companies across the world, such as *IKEA and *Habitat, adopted mail order as an everyday part of retailing enterprise. By the 1970s and 1980s such catalogues became as much lifestyle guides as marketing tools, although in the 1990s, with the rapid growth of Personal Computer ownership and internet access, e-commerce and online shopping emerged as increasingly powerful competitors.

Mainichi Design Prize (established 1952) Originally under the title of the New Japan Design Competition, the Mainichi Design Prize was founded in 1952 with sponsorship from the *Mainichi Shimbun* newspaper. It proved a key catalyst for the promotion of Japanese industrial design and was awarded to many of the post-Second World War Japanese designers of significance. These have included industrial designer Hozumi Akita (1962), graphic designers Mitsuo Katsui (1964 and 1994) and Ikko *Tanaka (1854, 1966, and 1973), furniture designer Shiro *Kuramata (1972), and Issey Miyake, who received the Mainichi Design Prize in 1977, the first time it was awarded to a fashion designer (he also received the Mainichi Fashion Prize in 1993). Others wining the award included furniture designer Tishiyuki Kita (1985), interior designer Masayuki Kurokawa (1986), interior, furniture, and lighting designer Shigeru *Uchida (1987), furniture designer Motomi Kawakami (1991), and digital graphic designer John Maeda (2002).

Maldonado, Tomás (1921–) Argentinian-born Maldonado, painter, industrial designer, and theorist, is known for his considerable influence on design thinking and practice in the second half of the 20th century. His reputation was established during his years at the Hochschule für Gestaltung (HfG) at *Ulm where his influence was increasingly felt following his appointment in 1954. Maldonado believed in a systematic, scientific, and theoretical underpinning of the design process and played a key role in moving the curriculum away from its *Bauhaus-inspired beginnings towards an approach that was felt to be more appropriate to deal with the complexities of post-Second World War living. He was also opposed to the rhetoric of American styling. Maldonado's new curriculum was introduced in 1958 and, from 1964 to 1966, Maldonado became the institution's rector. Maldonado's subsequent extensive academic involvements included the Lethaby Lectureship at the *Royal College of Art in London in 1965, Visiting Senior Fellow (1966-7) of the Council of Humanities and Chair of the 'Class of 1913' (1967-70) at the School of Architecture at Princeton University, and a professorship in environmental planning (1976–

84) in the School of Philosophy and Letters at the University of Bologna. In 1984 he transferred his professorship in environmental planning to the Faculty of Architecture at Milan Polytechnic where, from 1993, he coordinated the doctoral research programme in industrial design and, in the following year, established the first Italian degree course in industrial design. Maldonado's own practice was wide ranging and included the design of medical apparatus, office equipment, and precision instruments, as well as aspects of the urban environment. His consultancies included the Italian retailing group, *Rinascente-Upim. Maldonado was also active in the wider public dissemination of his ideas. At the 1958 Brussels World Fair he was a key speaker in the international debate on design and new industrial perspectives where he delineated the evolution of this new profession and the role of industrial design and society. He was particularly interested in promoting a scientific approach to design, an outlook embodied in an essay of 1960 on which he collaborated with another highly significant design thinker at the HfG at Ulm, Giu *Bonsiepe. Entitled 'Science and Design' the essay contained many ideas that he later followed through in *Design, Nature and Revolution* (1972). He has published widely on architecture, design, and informatics including *La speranza progettuale* (1970), *Avantguardia e razionalità* (1974), *Il fututro dellu modernita* (1987), *Reale e virtuale* (1992), and *Critica della ragione informatica* (1997). He also edited a leading Italian design periodical, *Casabella* (1978–81). He has received substantial peer recognition including, in 1968, the award of the Design Medal by the Society of Industrial Artists and Designers (SIAD, *see* CHARTERED SOCIETY OF DESIGNERS). From 1966 to 1969 he served as president of the Executive Committee of *ICSID.

Mallet-Stevens, Robert (1886–1945) A leading French architect, designer, and writer connected with progressive design in the interwar years, Mallet-Stevens studied at the École Spéciale d'Architecture in Paris from 1903 to 1906. An important influence was the Palais Stoclet (1905–11) in Brussels, designed by Josef *Hoffmann for Mallet-Stevens's uncle. Such an outlook was evident in the geometric underpinning of Mallet-Stevens's designs for the Écorcheville house (1914), his 1917 drawings for city buildings, and the 32 plates of city buildings in his publication of *Une Cité Moderne* (1922). Mallet-Stevens also participated in the 1925 *Paris Exposition des Arts Décoratifs et Industriels, for which he designed the Pavilion of the French Embassy. His commission for the Noailles Villa (1923–6) at Hyères, for which he also designed furniture, revealed the influence of De *Stijl. During the 1920s Mallet-Stevens designed a number of film set designs including those for Marcel l'Herbier's *L'Inhumaine* (1923–4) and *Le Vertige* (1926). For the former, he was responsible for the exterior architectural sets including the De Stijl-influenced engineer's villa. Other designers involved included René *Lalique and Jean *Puiforcat who designed objects, Fernand Léger who was involved with the engineer's workshop, and Paul Poiret who contributed a number of the costumes. Mallet-Stevens also designed for Man Ray's film set for *Les Mysteres du Château du Dé* (1928), the latter based on the Noailles Villa. He carried out many other commissions for houses, the most significant being the complex of five private villas in the Rue Mallet-Stevens at Auteuil built between 1926 and 1927. It included his own house and practice, with stained glass by Louis Barillet and metalwork by Jean *Prouvé, who had also carried out metalwork for shop front designs for Mallet-Stevens.

Barillet also worked on decorative glass for Mallet-Stevens's *La Semaine à Paris* newspaper offices of 1928–9. Some of the detailing of the houses in the Rue Mallet-Stevens, particularly the sweeping horizontal lines and sweeping curves of the detail at ground level shares visual characteristics with elements of *Streamlining in the United States. Mallet-Stevens was a founding member and president of the progressive *Union des Artistes Modernes founded in 1929.

Mantelet, Jean (1900–91) *See* MOULINEX.

Marimekko (established 1951) Marimekko, one of the best-known Finnish textile companies, was founded in Helsinki in 1951 by Armi and Viljö Ratia as the fashionable and creative arm of its parent company Printex, also established by them two years earlier. At Printex Armi Ratia set out to produce bold, experimental printed cotton textiles but after this failed to capture the public imagination she established Marimekko. The aim of this new enterprise was to show the public ways in which printed textiles could provide exciting and colourful highlights in domestic interiors and clothing. Vuokko *Nurmesniemi was appointed as chief designer from 1953 to 1960 and soon developed a distinctive 'look' in her bright and colourful clothing designs. Marimekko held its first fashion show in Stockholm in 1956 and gained further recognition with the display of its products at the Brussels World Fair of 1958. The company's designs were first imported to the USA in 1959 and a dramatic breakthrough in publicity and sales was made when fashion icon and American First Lady Jackie Kennedy purchased a number of Marimekko dresses. Far more casual in style than prevailing Parisian fashions their widespread appeal was considerable in a period when attitudes to dress were increasingly relaxed.

During the 1960s the company expanded globally and was widely known for its casual, often unisex clothing aimed at a young, independent clientele immersed in the values of *Pop. Typical of such designs were the bold, colourful geometric textile patterns by the painter Maija Isola which also reflected an awareness of American contemporary fine art practice. In addition to textiles and clothing the company also produced a wide range of other goods, including glassware and paper goods. In the later 1970s the company experienced some economic difficulties and was later taken over in 1985 by the Amer Group, a Finnish company. In the late 20th century the company's international appeal was considerable, with the production of wallpapers, furnishing textiles, bags, tableware, and other domestic products. In 2002 the company collaborated with Turku TV on the production of brightly patterned casings for televisions, making them items of interior decoration rather than anonymous pieces of technological equipment.

Marinetti, Filippo Tommaso (1876–1944) *See* FUTURISM.

Mariscal, Javier (1950–) Born in Valencia, Javier Mariscal is one of the most widely recognized Spanish designers of the late 20th century, coming to international attention with his 1988 graphic creation of the dog *Cobi*, selected as the official mascot for the Barcelona Olympics of 1992. He also worked in many other fields, including interiors, fashion, textiles, and lighting. Having studied philosophy in Valencia from 1967 to 1970, he moved to Barcelona in 1971. Hugely inspired by the city, he has been based there ever since and is recognized as one of the city's most prominent designers.

Mariscal enrolled at the Elisava School of Design, where he studied from 1971 to

1973, during which time he launched an underground comic *El rollo enmascarado*, building on the experience of his first comic, *Señor del Caballito*, which he had published in Valencia in 1969. In 1977 Mariscal organized the *Gran Hotel* exposition in the Mec-Mec Gallery, a show that comprised an installation representing an imaginary 1950s hotel with a reception, bar, lounge, bedroom, bathroom, radios, televisions, and furniture as the context for the exhibition of drawings, comics, posters, sculptures, and videos.

He also worked in several other fields of design including furniture and interiors. The latter included the Merbeyé Bar in Barcelona on which he collaborated with Fernando Amat, the owner of the Barcelona design store *Vinçon. Working with Fernando Salas Mariscal also designed the Duplex de Valencia Bar (1980) for which, with Pepe Cortes, he also produced the *Duplex* barstool. He collaborated with the architect Alfredo Arribas in the design of the Gambrinus Restaurant in Barcelona, recognizable by the giant prawn mounted on the structure and further distinguished by the octopus identity symbol printed on the cutlery, tableware, menus, and signage. In 1981 Mariscal had been invited by Amat to put together a furniture show that was seen by Ettore *Sottsass in Barcelona. This led to an invitation to participate in the first *Memphis show in Milan, also in 1981, for which, with Pepe Cortes, he designed the *Milan Trolley*. In the late 1980s Mariscal established the Estudio Mariscal with a small design team. The practice's extensive client list has included *Akaba, *Alessi, *Renault, *Rosenthal, Seita, Smart, *Swatch, and Vogue. In 1995 Mariscal won the international competition for the mascot of the Hanover 2000 Universal Exhibition. Known as *Twipsy* it was widely adopted for corporate publicity and merchandising and

further developed by Muviscal, the audio-visual division of Estudio Mariscal, as an animated series of 30-minute stories. In the late 1990s Mariscal also scripted and directed a multi-disciplinary show, *Colours*, a personal vision of the history of the universe related through the play of colours. In addition to working for international clients Mariscal has also taught in art schools and universities worldwide.

Mathsson, Bruno (1907–88) Mathsson was a notable Swedish architect and designer, renowned for his laminated bentwood furniture. He came from a cabinetmaking background and was apprentice in the family workshop from 1923 to 1931 and began designing his own furniture. He became interested in the *Modernist aesthetic, bolstered by the functional ethos that pervaded the 1930 Stockholm Exhibition. His early laminated furniture included the *Working Chair* of 1934 (renamed *Eva* in 1978), which was designed to accommodate the human body comfortably by means of a contoured bentwood frame with webbing in cloth or leather. It was shown with other of his designs in a one-person show at the Röhsska Museum in Gothenburg in 1936. His work had a strongly organic feel and makes an interesting contrast to the bentwood furniture designs of Alvar *Aalto in Finland and *Breuer's experiments in laminated plywood for the *Isokon Furniture Company in Britain. Although Matthsson's furniture was favourably reviewed by the critics, manufacturers were less enthusiastic, resulting in its production by the family business, Firma Karl Mathsson. Mathsson furniture was also exhibited at the 1937 Paris International Exhibition and the *New York World's Fair of 1939. Other notable furniture designs from the first half of his career included the *Pernilla*

lounge chair and footstool of 1944, essentially an armed version of the earlier *Working Chair* design, again using an elegantly contoured frame with webbed body support. He visited the USA in 1948 and 1949 and for a number of years focused his attention on architectural designs for modern houses with large plate-glass windows. He took over management of the family furniture-making company in 1957, a time when his designs attracted considerable international interest, epitomizing what became known as *'Swedish Modern'. From the early 1960s he worked with the Danish mathematician inventor Piet Hein on the elegant steel-framed *Superellipsis* table of 1964, produced by *Fritz Hansen. In 1966 he designed the *Jetson* office chair of 1966, which was produced by Dux Industrier (which later took over the Mathsson firm in 1978). Later designs included computer workstations in the 1980s when he also established the Mathsson Foundation for the Support of Scandinavian Designers (1983).

Matsushita (established 1918) One of the largest manufacturers of electrical consumer products in the world this Japanese multinational company has a number of brand names in its corporate portfolio including National (established in 1927), Panasonic (first used in 1955), Technics (first used in 1964), and Quasar (established 1974), a brand name specific to North American markets. The dynamic driving force behind the company for more than half a century was its founder Konosuke Matsushita, who established a business devoted to the manufacture of plugs and sockets in 1918. Early electrical products included bullet-shaped bicycle lamps (1923) and the *Super Iron* (1927), the first product to carry the National brand identity and which was mass produced at the rate of 100,000 per year. The product range expanded in the early 1930s to include radios, an early best-seller being the *R-48* four-tube radio of 1932. In the following year Matsushita introduced a Divisional System into the company, with three separate divisions devoted to different and distinct aspects of the company's activities. After the Second World War Konosuke Matsushita allied his company policies to those of national recovery. Building on efforts to develop Western markets in the 1930s, he visited the USA in 1951 to study American business methods. On his return to Japan he established a small industrial design department, reputed to be the first in Japan, growing to more than 50 members of staff by the end of the decade. The forging of links with *Philips in the Netherlands in 1952 further enhanced the company's profile, as did the establishment of the Matsushita Electric Corporation of America in 1959. The company's manufacture of domestic appliances such as fridges, rice cookers, and vacuum cleaners grew rapidly as the decade evolved, Japan's remarkable economic growth leading to a boom in their consumption. Typifying this trend, the National *MC-1000C* plastic vacuum cleaner of 1965 was lighter than its metal counterparts and had attachments for a variety of tasks. Very popular in Japan, selling 630,000 over the two years in which it was in production, the appliance also met approval on aesthetic grounds in its receipt of a *G-Mark award in 1966. The design of audio-visual products was not left behind and the National *DX-350* radio designed by Zenichi Mano, winner of the Mainichi Industrial Design Competition in 1953, was an early attempt to marry a contemporary industrial product with a Japanese design identity by reference to the traditional architectural designs. More obvious in this respect was the 1964 *Asuka SE 200* stereo radiogram,

characterized by the sweeping horizontal lines and subtle proportions of its wooden casing. By this time Konusuke Matsushita himself had become widely known as a highly successful entrepreneur, appearing on the cover of *Time* magazine in February 1952 and featuring in *Life* magazine in September 1964. Konosuke, Matsushita's president until 1961, chairman of the board until 1973, and adviser until his death in 1988, also wrote several books including the international best-seller *Japan at the Brink* (1974) and *Not for Bread Alone: A Business Ethic, A Management Ethic* (1984). Product diversity and innovations such as a thin radio in 1977 and a paper-thin battery in 1979 helped maintain the company's competitive edge. Design still remained a significant ingredient as in the soft lines and asymmetrical form of the *Piedra* portable colour television of 1987 aimed at affluent metropolitan singles and which earned a G-Mark Award in 1988. Other Matsushita product lines of the 1990s included computer notebooks, portable phones, and DVD players. As well as raising its profile through the acquisition of MCA, owner of Universal Studios, in 1990 the company also established a number of academic chairs at leading universities. These included Matsushita professorships at the Massachusetts Institute of Technology (1975), the Harvard Business School (1981), Stanford University (1985), and the Watson School at Pennsylvania University (1991).

Mattel (established 1945) Harold Matson and Elliot Handler founded Mattel in the USA in 1945. Initially producing picture frames and doll's house furniture the company soon moved into toys. Sustained growth in sales followed sustained advertising on the Mickey Mouse Club television show in 1955. In 1959 the company launched the *Barbie fashion doll, inspired by Ruth Handler's daughter's interest in cut-out adult paper dolls. For decades Barbie proved a global best-seller and was owned by young girls across the generations. In the 1960s the company created a number of successful products, including Hot Wheels miniature vehicles (1968) which proved to be an enduring success amongst boys—by 1998 the Hot Wheels had sold its two-billionth car. During the 1970s the company moved into electronics, including hand-held games, but by the late 1980s the company decided to concentrate on its core brands such as Barbie and Hot Wheels. In 1988 the company entered into an agreement with the Walt Disney Company to produce toys based on characters drawn from its movies and television programmes, a position which was built on with the acquisition of Fischer-Price (established 1930), makers of imaginative early learning toys. Many other marques were acquired during the 1990s, including Matchbox cars and View-Master following Mattel's 1997 merger with Tyco Toys. In 1999 Ferrari gave Mattel the rights to produce toys and accessories, followed in 2000 with the granting to Mattel of the worldwide licence for the production of toys based on the characters of *Harry Potter* (created by J. K. Rowling).

Maurer, Ingo (1932–) Widely known for his experimental and highly individual lighting designs Maurer's innovations were influenced by avant-garde practices in the fine arts, from *Pop to conceptual art. His work has attracted considerable attention on account of its originality, whether in the form of outsized light bulbs, winged light bulbs that interact with people, or lighting designs incorporating holograms. After completing his studies in typography and graphic design in Switzerland and Germany in 1958 he lived in the United States for a number of years, working for such

companies as Kayser Aluminum and *IBM. After returning to Germany he designed his notorious *Bulb* lighting fixture for the *Herman Miller showroom in Munich in 1966. Containing a small bulb within a larger bulb the design attracted considerable attention and led to the establishment of Design M, his own design practice in Munich specializing in lighting design. Maurer explored the poetic meanings of form and materials, whether in the manipulation of industrial materials such as wire mesh, the aesthetic potential of technological innovations such as low-halogen lighting systems, and individualism of craft materials such as transparent rice paper or bird feathers. His highly flexible *YaYa Ho* low-voltage halogen lighting system of 1984 has proved highly influential and was used as an installation in the *Lumières je pense à vous* exhibition at the *Pompidou Centre, Paris, in 1985. There have been many subsequent exhibitions of his work including *Design à la Ville Medici* in Rome in 1986, *Licht Licht* at the Stedelijk, Amsterdam, in 1993, and *Ingo Maurer: passió per la llum* at the Santa Mònica Museum, Barcelona, in 2001. He has also shown at the *Museum of Modern Art, New York, in 1998, where his work is extensively represented in the permanent collection, and the Philadelphia Museum of Art in 2002 to 2003, the latter including an installation in a period room. Installations have been an important facet of Maurer's creative output, including his work on the Japanese fashion designer Issey Miyake's installation at La Villette in 1999, as well as 'urban scenography' that incorporates larger-scale architectural settings. He has received many design awards including the Chevalier des Arts et des Lettres in 1986 from the French Minister of Culture, Designer of the Year 1997 from the German design magazine *Architektur & Wohnen*, Design Prize 1999 from the City of Munich,

and the Lucky Strike Designer Award 2000 from the Raymond *Loewy Foundation.

Mayakovsky, Vladimir (1893–1930) A leading Russian graphic designer, painter, writer, poet, and critic of the early 20th century, Mayakovsky was closely involved with the artistic avant-garde in Moscow, including the Russian Futurists and the Constructivists, He designed many propaganda posters and wrote poems and plays in support of the Russian Revolutionary cause. Whilst studying at the Moscow School of Painting, Sculpture, and Architecture from 1911 to 1914 he met the Burlyuk brothers around whom Russian Futurism was centred. After working on a series of Cubo-Futurist paintings in 1914 he began to design simple anti-German and anti-Turkish war propaganda posters, combining rudimentary images with rhyming script. A keen supporter of the Russian Revolution of 1917 Mayakovsky played a key role in the dissemination of Bolshevik propaganda through his film scripts, plays, and posters. He declared that the 'streets are our brushes, the squares our palettes', a statement carried through in his designs for street decorations, propaganda trains, and architecture. From 1919 Mayakovsky worked for Rosta (the Russian telegraph agency), producing a large number of stencilled posters whose readily understood, cartoon-like images visually informed an often illiterate public about the successes of the Red Army or various government campaigns such as the health programme. The format of sequenced images and texts is thought to have derived from folk art, notably the 'lubok', a traditional popular, woodblock-printed, almost comic-like literature. Such posters were highly visible through their display in empty shop windows, unoccupied business premises, telegraph offices, railway stations, and

elsewhere. After the end of the Civil War in 1921, Mayakovsky became the leader of the Moscow LEF (Left Front of the Arts) and editor of its journal, *LEF*. The latter was a mouthpiece for the Productivists—those Constructivists who believed that fine artists should apply their talents to the design and production of everyday goods. Under Lenin's New Economic Policy (NEP) Mayakovsky worked closely with Alexander *Rodchenko on the design of advertisements of all kinds, from newspapers to billboards. With the rise of totalitarianism under Stalin from the later 1920s Mayakovsky's work was seen increasingly as elitist and out of touch with the masses.

Meccano (established 1901) Frank *Hornby of Liverpool, England, patented this internationally celebrated metal construction educational toy in 1901 under the name *Mechanics Made Easy*. Early sets were quite expensive and made of tinplate, consisting of perforated strips and plates that could be bolted together with nuts and bolts, a range that soon expanded to include brass gears, wheels, and axles. In due course the Meccano system was able to build bridges, cranes, military tanks, carousels, and countless other mechanical products that built on Edwardian children's fascination with construction and engineering feats. The educational toy's remarkable popularity was reflected in the establishment of a new factory in Liverpool in 1907 and, in the following year, its name was changed to 'Meccano', a title that was to become virtually a household name when the product was at its height of popularity. It was soon exported to many parts of the British Empire, in many ways symbolic of the influential developmental role that Britain sought to play in such countries as Canada, Australia, and India. In 1914 the company again moved to new premises in Liverpool

and continued in production there until 1980. Further inspirations for use of the product were disseminated through the *Meccano Magazine*, commencing publication as a single sheet in 1916 but becoming a fully-fledged magazine with many pages and full-colour covers in the 1920s, a period in which many adult model makers also began to show a keen interest in Meccano. The product became more visually attractive from 1926 when the sets were produced in burgundy red, dark green, and brass finishes in addition to the customary nickel plate finish, a colour range that was further again changed in 1934 when dark blue and gold components were introduced. During the Second World War the Meccano Factory was devoted to war-related production, not resuming full production until 1950. After the war sets were again produced in red, green, and brass although, from 1964, silver, yellow, and black components were introduced with further colour changes in 1970 and 1978. However, this period also saw many challenges in the constructional toy field and Meccano found it difficult to reposition itself in a world of more sophisticated alternative products, including the increasingly ubiquitous *Lego, as well as the allure of television with its increasing range of children's programmes. In November 1979 the Meccano company went into receivership and the factory was demolished in the following year. However, Meccano Ltd. was purchased by its former French subsidiary (established in 1912) and relaunched by Meccano SA, based in Calais, France. The company bought the rights to the American *Erector constructional toy in the late 1980s, but Meccano SA was itself purchased by the Japanese company Nikko Toys in 2000.

Mellor, David (1930–) Widely known as a cutlery and metalware designer,

manufacturer, and retailer, David Mellor was elected as a *Royal Designer for Industry in 1962. Bridging the gap between industrial design and the crafts he later became director of the Crafts Council (1982). Born in Sheffield, the centre of the British cutlery industry, he studied at Sheffield College of Art (1946–8) before going on to the *Royal College of Art (RCA, 1950–3) where he was in one of the first cohorts of the new M.Des. degree that included nine months in industry. He also studied at the British School in Rome (1953–4). In the early 1950s many of the RCA graduates featured in exhibitions outside the RCA; Mellor featured in a student exhibition at *Liberty's in 1952, reported in *Design* magazine. Early design successes included the *Pride* silver cutlery (1954), *Pride* silver teaset (1958), and *Symbol* cutlery (1961), all manufactured by Walker and Hall. He received one of the first *Design Centre Awards in 1957 for the first, another in 1959 for the second, and a third for the *Symbol* cutlery and flatware in 1962. He was also given a Design Centre Award for his *Embassy* silver teapot (1962) for the Ministry of Public Works. Many of these elegant designs were in line with the principles of *'Good Design' espoused by the Council of Industrial Design (*See* DESIGN COUNCIL) and also reflected some of the ideals of post-Second World War Scandinavian design that were admired by many of Mellor's generation. He also worked on larger-scale engineering products such as the design of a gear-measuring machine (1965) for J. Goulder and a range of street furniture designs that included a letterbox (1966) for the Post Office, and a bus shelter (1957) and traffic lights (1969) for the Ministry of Transport. His reputation was such that he was chosen as one of four representatives of British industrial design in an international exhibition at the Stedelijk Museum, Amsterdam, in 1968. However, it is with cutlery that he has become most widely known and in the late 1960s he opened the first of a number of Davis Mellor shops in London and elsewhere selling cutlery and kitchenware. He established a cutlery workshop in Sheffield in the mid-1970s, moving into a purpose-built modern factory in Hathersage, Derbyshire, in the late 1980s. Named the Round Building, the factory was designed by Sir Michael Hopkins and has won a number of architectural awards. He was awarded an Honorary Doctorate by the Royal College of Art in 2000 and was made a CBE in 2001.

Memphis (1981–8) This avant-garde group of international designers was launched in Milan in 1981 with the backing of Renzo Brugola (a cabinetmaker), Ernesto Gismondi (founder of *Artemide), Mario and Brunella Godani (furniture showroom owners), and Fausto Celati (an Italian industrialist). Its leading creative persona was Ettore *Sottsass Jr., who had left *Studio Alchimia after differences of opinion with Alessandro *Mendini. With Barbara Radice as art director, he worked with a large number of internationally significant architects and designers who contributed to the large range of furniture, products, metalware, textiles, and interiors that the group created during the 1980s. These designers included Andrea *Branzi, Michele *De Lucchi, Nathalie Du Pasquier, Michael *Graves, Hans *Hollein, Arata Isozaki, Issey *Miyake, Peter Shire, George Sowden, Javier *Mariscal, and Matteo *Thun.

The stylistic characteristics of Memphis designs included bright colours, combinations of patterns and texture which derived from both 'high' and popular cultural sources, and the use of striking juxtapositions of cheap and expensive materials and finishes. Although Sottsass dubbed the work of the group as the 'New International

Style' Memphis shared with the earlier *Anti-Design and *Radical Design movement in Italy a deep-rooted dissatisfaction with the prevalent market-led preoccupation with elegance and *'Good Design' associated with *Modernism and its *International Style legacy. Memphis's strikingly decorative and brightly coloured design alternatives were in direct opposition to the bare minimalism of many later modernist products, whether the sleek *Braun *KM3 Kitchen Machine* of 1957, Eliot *Noyes's *Selectric* typewriter for *IBM of 1961 or the platonic, sensuous, sculptural lines of Gio *Ponti's sanitary ware for Ideal Standard of 1954. Unlike the polemical didacticism of many Italian avant-garde groups of the 1960s and 1970s, Memphis provided a positive creative alternative to those adopted in contemporary manufacturing norms and reinvigorated the design outlook in many countries.

A gathering of designers organized by Sottsass in December 1980 provided the impetus for the group. The name of the group is said to have derived from the Bob Dylan song 'Stuck Inside of Mobile with the Memphis Blues Again', which was playing during the evening. The ways in which popular and 'high' cultural references could be evocatively combined in the same way as cheap and expensive materials might be seen as echoes of the group's dual referencing of Memphis as the capital of ancient Egypt and home of rhythm and blues in contemporary USA. Memphis met again in February 1981 to consider their collective design proposals which drew on styles as diverse as *Art Deco, *Pop, and *Kitsch. The first Memphis exhibition was shown at the Arc '74 Gallery in Milan in September and comprised a wide range of products that had been produced in small quantities by sympathetic manufacturers. The display included furniture, lighting, clocks, and ceramics that, in addition to the semiotic and cultural references mentioned above, often used decorative laminates that flew in the face of conventional 'good taste' on account of their origins in the mass-produced furniture of everyday bar counters and tables and suburban kitchens.

Although the group was wound up by Sottsass in 1988 Memphis has been highly influential in the fields of graphic design, textiles, and furnishing fabrics, carpets, product design, and interiors. Its very fashionability, seen in countless imitations from TV game show set designs to gift wrapping paper, had diminished its original reinvigorating role and rendered it almost as commonplace as the everyday sources from which some of its patterns had been drawn. Its accessibility had been stimulated by the widespread media and design press interest engendered by the group's work when exhibited in leading museums and galleries throughout Europe, Scandinavia, North America, Japan, and elsewhere during the 1980s. Taking its place in many key permanent collections the outlook has been absorbed into the design status quo. Nonetheless, even following Sottsass's departure, there were several later flourishes of the outlook including the foundation of Metamemphis in 1989 and Memphis Extra in 1991.

Mendini, Alessandro (1931–) Mendini played an important role in Italian avant-garde design of the 1970s and 1980s, particularly in association with the Milan-based *Studio Alchimia established in 1976. He was prominent in the dissemination of design theory and practice as editor in chief of *Casabella* (1971–6), founder and director of *Modo* (1977–81), and editor of *Domus* (1979–85). Furthermore, his written polemics such as *Architettura Addio* (1981) and *Il progetto infelice* (1983) have underlined his

importance in progressive Italian design in the last three decades of the 20th century. He has organized design exhibitions and seminars around the world and his design work is represented in leading museums and collections, including the *Museum of Modern Art, New York.

Prior to joining the architectural practice of *Nizzoli Associates, where he remained as a partner until 1970 designing buildings and products, Mendini had graduated with a diploma in architecture from Milan Polytechnic in 1959. Associated with the *Anti-Design and *Radical Design movements, by the early 1970s he was involved with experimental work both for the furniture manufacturer *Cassina and as a founder of Global Tools. His work for Alchimia included the *Proust* armchair (1978), the *Kandissi* sofa (1979), *The Banal Object* exhibit at the Venice Biennale (1980), and his series of *Infinite Furniture* (1981) on which he collaborated with many other designers over a period of years. He also designed for the progressive Milan-based *Memphis group in the early 1980s as well as for manufacturers such as *Alessi. For the latter he organized the limited edition *Tea and Coffee Piazza* sets which were commissioned from eleven leading *Postmodernist architects and designers and launched simultaneously in galleries in New York and Milan in 1983. His designs for Alessi have included the *Anna G* corkscrew (1994) and the *Chocolate* calculator (2000). Other important manufacturing clients have included *Philips, *Swatch, *Venini, and *Zanotta. He has also acted as an artistic and brand identity consultant to many others. In 1989, with his brother Francesco, he established the Atelier Mendini, which was awarded architectural commissions including the Groeningen Museum in Holland (1988–94) and a memorial tower in Hiroshima, Japan (1989).

Mendini was awarded the *Compasso d'Oro for his contribution to design in 1979, received the title of Chevalier des Arts et des Lettres in France, was recognized by the Architectural League of New York, and served on the advisory board for the *Domus Academy in Milan.

Mercedes-Benz (established 1926) Perhaps the most famous name associated with German automobile manufacture, both on account of its historic origins in the pioneering days of automobile design and of its long association with innovation, quality, and style, the origins of the company lay in the 1880s' pioneering work of Carl Benz, who is often credited with the invention of the motor car. The Mercedes name was first introduced for a sports car in 1901 and, in 1926, the Benz and Daimler companies merged. In the following year the famous Mercedes *S* sports car was introduced, followed by the *SS* (*Super Sport*) and *SSK* (*Super Sport Kurz*, designed by Ferdinand *Porsche) models in 1928, all of which did much to establish the company's standing as a manufacturer of luxury cars, a position enhanced further by the introduction of the *500K*, designed by Friedrich Geiger in 1936. The company's global reputation developed with the introduction of the highly successful *Silver Arrow* racing cars in 1934, winning a number of Grand Prix world championships before the Second World War. In the post-war years one of the most famous models was the low-slung *300 SL* of 1954 with its upward opening 'wing' doors designed by Geiger. From the late 1950s Geiger worked closely with Béla Barény from the company's development department and Italian Bruno *Sacco, who had joined Mercedes Benz in 1958. Key models included the *220 S Coupé* of 1961 by Karl Wilfert and the *230 SL* sports car by Barény of 1963. Sacco became increasingly influen-

tial in the 1970s, working on the *S-Class* model series launched in 1972. He took over as head of styling from Geiger in 1975, becoming chief designer in 1987 until Peter Pfeiffer succeeded him in 1999. In 1987 the Advanced Design Department had been established as a means of sharpening the company's design policy and identity of model ranges such as the *E-Class* that had been launched in 1982. In the 1990s the company sought to capture a new, younger affluent urban market keen to access the Mercedes-Benz marque with the launch of its distinctive super-mini *A-Series* launched in 1997. Even more radical was the diminutive two-seater *Smart* town car, a collaboration between Daimler-Benz (Mercedes' parent company) and the *Swatch watch manufacturers SMH, launched in 1998.

Metz & Co. (established *c.*1800) This retail company is well known for its enlightened design policy and close working relationship with designers. Additionally, for about 50 years, commencing shortly before the First World War, Metz & Co. also manufactured a number of products for sale in their store. Although the firm's roots can be traced back to Samuel Metz's 18th-century Amsterdam fabric shop, it was not until *c.* 1900 that a marked shift of policy was initiated. This was engendered by the arrival of a new owner/director Joseph De Leeuw who, in 1902, gained the agency rights to sell goods from the celebrated London department store, *Liberty & Co. These were characterized by an *arts and crafts philosophy and included textiles and the applied arts, a range increased after the First World War by French, Austrian, and Dutch goods. In 1918 Metz went into furniture production, commissioning Paul Bromberg to design furniture and offer advice on interior design, a post taken over by furniture de-

signer W. Penaat in 1924. Metz was also active in textile design, commissioning a number of foreign designers, including Sonia *Delaunay. By the early 1930s Metz products took on a markedly *Modernist flavour, enthusiastically supported by De Leeuw who had become a member of the *Nederlandische Bond voor Kunst in Industrie (BKI). He commissioned avant-garde furniture from the De *Stijl architect-designer Gerrit *Rietveld and carpets by his fellow De Stijl member, the painter Bart Van Der Leck, both of whom he had met. In 1933 Rietveld was commissioned to design a Modernist cupola on the roof of the predominantly 19th-century store, making an ideal showroom for Modernist designs that were seen to advantage in the strong light that permeated the heavily glazed structure. He also designed a new store-front in 1938. In fact, Rietveld's *Zig-Zag* chair (1934) and *Crate* chair (1935) were manufactured exclusively for Metz & Co., the company showing its extensive awareness of international developments by being the first company in Holland to market designs by Alvar *Aalto. It also organized exhibitions, including one in 1932 devoted to tubular steel furniture with pieces by *Mies Van Der Rohe and Marcel *Breuer. Other modern furniture was commissioned from J. J. P. Oud, Mart Stam, and Djo Bourgeois. After the Second World War the company continued to market well-designed goods such as those produced by De *Ploeg. In 1973 Metz was taken over by Liberty & Co., whose goods had been marketed by them just over 70 years earlier.

Mies Van Der Rohe, Ludwig (1886–1969) German architect and designer Mies Van Der Rohe was a leading figure of the *Modern Movement whose work became well known in Europe and the United States. Many of his works, such as the *MR*

Chair (1927), the *Tughendat Chair* (1929), and the *Barcelona Chair* (1929), have subsequently become icons of 20th-century design. His minimalist interiors, manipulation of space and light, and expansive use of glass provided the perfect settings against which his aesthetically refined, and often expensive, furniture designs could be set.

After working as a draughtsman in an Aachen stucco decoration workshop from 1899 to 1903 he served as an apprentice in furniture designer Bruno Paul's workshop from 1904 to 1907, whilst also studying at the School of Arts & Crafts in Munich. From 1908 to 1911 he worked in the architectural offices of Peter *Behrens (like Le *Corbusier and *Gropius), before setting up as an independent architect. After the end of the First World War his enthusiasm for avant-garde ideas was reflected in his membership of the Novembergruppe and early designs for glass skyscrapers. In the mid-1920s he designed laminated wood furniture for his own Berlin apartment, registering a patent for a tubular steel cantilever chair in 1927. Building upon the innovative exploration of tubular steel chairs by fellow German designer Marcel *Breuer and the Dutch architect-designer Mart Stam, Mies's *MR* chair was a sophisticated and elegant aesthetic response to earlier, slightly more prosaic uses of the cantilever in contemporary furniture. Echoing the minimalist aesthetic of many of his architectural interiors the chair was first manufactured by the Joseph Müller Metal Company, although the hand-based modes of production inevitably made it expensive. Mies worked closely with Lilly *Reich on this and other furniture designs, as well as on the *Deutscher Werkbund's 1927 Weissenhof Housing Exhibition at Stuttgart, for which he was the organizer (and also the Werkbund's vice-president). He also gained commissions for wealthy clients such as the Tughendat House in Brno in the Czech Re-

public (1928). Another notable Modernist design was his German Pavilion at the Barcelona International Exhibition of 1929, the location giving its name to Mies's famous *Barcelona Chair*, itself complementing the clearly articulated geometric planes of the interior. However, like the *MR* the *Barcelona Chair* was expensive to make, having the necessity for labour-intensive welding on the central 'X' joints. Mies was appointed as director of the *Bauhaus from 1930 to 1933 before it was closed by the Nazis in Berlin. Many of his furniture designs were displayed at the Werkbund Exhibition in Paris in 1930 and at the Berlin Building Exhibition of the following year. Also in 1931 manufacture of his furniture was taken over by the Bamberg Metal workshops in Berlin, although there was a marked move away from what was essentially a craft-based mode of production when the production of his *MR* chairs was taken over by *Thonet in 1932. Following his collaboration with Lilly Reich at the 1937 *Paris International Exhibition he emigrated to the United States in the following year, establishing an architectural practice in Chicago. Amongst his most celebrated works in the USA were the Farnsworth House (1945–50), the Lake Shore Drive Apartments in Chicago (1951–8), and the Seagram Building in New York (1954–8). From 1948 onwards a number of his furniture designs were produced (in slightly modified form) by *Knoll Associates, New York, and remain classics in the 21st century.

Milan Triennali (established 1930) These important Italian exhibitions of progressive design had their origins in the Biennali of the Decorative and Applied Arts that began in 1923 at Monza. However, their character soon changed from a regional showcase to an exhibition with international standing, particularly after becoming triennial in 1930. In that year the Triennale not only

showed the work of innovative young *Rationalist designers Figini and Pollini in the *Electric House* but also work from abroad. This included contributions from the Berlin Werkbund and the Dessau *Bauhaus, as well as furniture by *Mies Van Der Rohe and electrical products by *AEG and *Siemens. In 1933 the 5th Triennale moved to the newly built Palazzo d'Arte by Giovanni Muzio in Milan. As well as an exhibition devoted to the Futurist visionary architect Antonio Sant'Elia, the prototype of the Breda *ETR 200* electric express train designed by Giuseppe Pagano and Gio *Ponti was exhibited as were photographs of *Ciam architectural design by Le *Corbusier, *Gropius, and *Mies Van Der Rohe. Amongst the Italian designs at the 6th Triennale of 1936 was a *Modernist dwelling by Gio Ponti and the Salone della Vittoria by Edouardo Persico, Marcello *Nizzoli, and others where an acknowledgement of the classicism of Mussolini's 'Roma Secunda' sat uneasily with the avant-garde leanings of Rationalism. Amongst progressive work from abroad was glass design by the Finnish designer Aino *Aalto, who won a Gold Medal, as well as the birchwood Modernist furniture of her husband Alvar. The 1940 Triennale came to a premature end with Italy's involvement in the Second World War. After the war the Triennali resumed in 1947, an exhibition largely devoted to housing and reconstruction: including contributions by Ettore *Sottsass, Vico *Magistretti, and others. At the 1951 Triennale attention was devoted to 'The Form of the Useful' in a display organized by Ludovico Bellgoioso and Enrico Peressutti. Such a focus on industrial aesthetics gave rise to feelings that gathered strength in the 1950s, namely that the social and economic dimensions of design were underplayed at the expense of the quest for style. Nonetheless, much experimentation was evident in the exploration of the aesthetic possibilities of foam rubber furniture, organic form, and the 'rediscovery' of craft traditions as a stimulus to innovative work in a number of fields. Designers such as Franco *Albini, Achille and Piergiacomo *Castiglione, Carlo *Mollino, and Marco *Zanuso did much to suggest the high profile of Italian design in the following decades. Also prominent was the work of Tapio *Wirkkala, who designed the critically acclaimed Finnish display. Indeed, Scandinavian design generally featured significantly in the shows of the 1950s. During that and the following decade the Triennali of the 1950s and 1960s continued to elicit critical attention and often fierce debate until 1968 when the 14th Triennale was brought to an early end by student demonstrators. This manifestation of the volatility of political and social events in many ways echoed the increasingly fragile complexities of the Italian design world. Thereafter the Triennali ceased to play such a central role in design research, rhetoric, and relevance.

Minale Tattersfield (established 1964) A multidisciplinary design agency with studios in London, Paris, and Brisbane the Minale Tattersfield partnership is perhaps best known for the design of *logos, including those for Harrods (1967), the FA Premier League (1992), and the Sydney Olympic Games (1993). It has also worked in many other spheres including architecture and public spaces, as with its designs for the Hammersmith Underground Station for London Transport (1989), BP petrol stations (early 1990s), furniture designed for *Zanotta, and packaging, such as that for Johnnie Walker whisky (1978) and San Pellegrino mineral water (1999). Marcello Minale (1936–2001) and Brian Tattersfield (1938–) formed their partnership in London in 1964, both having worked for

the advertising agency Young & Rubican, Minale as a designer and Tattersfield as an art director. Minale had trained in Naples and had spent some time in Scandinavia whilst Tattersfield trained as a graphic designer at the *Royal College of Art from 1959 to 1962. Minale and Tattersfield were joined by other partners over the years, including Alex Maranzano in 1968 and Nohbuoko Ohtani in the late 1980s, growing from a small scale operation in the first decades of their existence to a larger international agency in the 1980s.

Mitchell, William (Bill) (1912–) As the successor to Harley *Earl as the head of styling and vice-president at *General Motors, Bill Mitchell was a highly influential automobile stylist over a 40-year career at the company. After studying at the Carnegie Institute of Technology and the Art Students League in New York he worked as an illustrator and layout artist for the Barron Collier advertising agency. Mitchell's work came to the attention of Harley Earl, in charge of styling at General Motors, who employed him in 1935. In 1936 he was made head of design at Cadillac where his designs included the classic *Series 60 Special*. After the Second World War Mitchell was, in some quarters, credited with the design of the tail fins of the 1948 Cadillac. This marked the beginning of a trend towards increasingly soaring tail fins that continued until the late 1950s. In 1958, as vice-president and head of styling, Mitchell soon dampened the ardour for the styling extravagances and visual metaphors for the conspicuous consumption of 1950s USA in favour of a more restrained aesthetic. Amongst the striking designs produced under his leadership were the 1963 Buick *Riviera* and Corvette *Stingray*, the 1966 Oldsmobile *Tornado* and the 1967 *Eldorado*.

See also EARL, HARLEY.

Miyake, Issey (1935–) Japanese fashion designer Miyake has been a major figure in stretching the definition of clothing design through his probing and imaginative explorations of the relationship between the body and its coverings, drawing on the possibilities of traditional Japanese forms and natural weaves, well man-made materials and contemporary attitudes blended with a first-hand knowledge of Western couture and culture. For Miyake 'anything can be clothing', whether oil-soaked paper traditionally used for umbrellas, high-tech synthetic materials or even rattan. Decorative effects in Miyake clothing ranged from the exploration of traditional tie-dyeing of traditional fabrics made with ramie fibre on the one hand or the rich surface interest generated by a heat-set pleating machine on the other. Miyake was also an important figurehead in the international recognition of Japanese designers in the West, following on from fashion designers Hanae Mori and Kenzo before him, although his name is the most widely known. After graduating in graphic design from Tama Art University in Tokyo in 1964, Miyake moved to Paris in the following year. He studied fashion design at the school of the Chambre Syndicale de la Haute Couture, before working for Guy Laroche from 1966 to 1967 and Hubert de Givenchy in 1968. He moved to New York in the following year and worked with Geoffrey Beene before returning to Tokyo once more in 1970. After opening the Miyake Design Studio (MDS) in the same year, he established Miyake International Inc. in 1971 and showed his first collection in Tokyo and New York. His first Paris collection followed in 1973 and he went on to establish design companies in Paris in 1979 and the United States in 1982. Over three decades he has produced innovative fabric designs, both natural and syn-

thetic, assisted by Makiko Minagawa, who had been employed at the newly established Miyake Design Studio following her graduation from art school in Kyoto in 1970. Other collaborations have included that with the choreographer William Forsythe and the Frankfurt Ballet in 1988. By the early 21st century the Miyake name was associated with a diversity of products ranging from luggage and home furnishings to bicycles. Miyake has won countless awards including the *Mainichi Fashion Grand Prize (1984, 1989, and 1993), the Council of American Fashion Designers' International Award (1984), the Award for the Best Collection presented by a Foreign Designer at Les Oscars 1985 de la Mode in Paris and the Asahi Prize in 1991. His work has also featured extensively in numerous publications and international exhibitions since the 1970s. One of the most significant that brought him to international prominence was the *Bodyworks* exhibition that was shown in Tokyo, Los Angeles, San Francisco, and London between 1983 and 1985.

Modern Movement *See* MODERNISM.

Moderne *See* box on this page.

Modernism *See* box on pp. 285–289.

Modernisme *See* MODERNISMO.

MODERNE

This term was used to describe a style associated with the ways in which the rather opulent, handcrafted characteristics of *Art Deco in Europe were blended with the more progressive trends associated with *Modernism: the use of new materials such as chrome and plastics, the manipulation of abstract forms and a recognition of dynamics of contemporary life, whether through the use of streamlined forms inherited from transport and applied to furniture, domestic appliances, or even buildings. This was often seen in the context of entertainment as in certain aspects of cinema design in Britain, particularly that known as the 'Odeon Style'. In the United States it was evidenced in the work of Donald Deskey, as in his contributions to Radio City Music Hall in New York, as well as many others associated with the *American Union of Decorative Artists and Craftsmen (AUDAC) who reconciled certain progressive traits in European design with the commercial realities of the United States.

MODERNISM

(1920–1960s) Modernism, also known as the Modern Movement, marked a conscious break with the past and has been one of the dominant expressions of design practice, production, and theory in the 20th century. It is generally characterized visually by the use of modern materials such as tubular steel and glass, the manipulation of abstract forms, space and light, and a restrained palette, dominated by white, off-white, grey, and black. Following on from the well-known phrase 'Ornament and Crime' coined by Adolf *Loos as the title of an article of 1908, later echoed by Le *Corbusier in his assertion that 'trash is always abundantly decorated', was the notion that the surfaces were generally plain. When decoration was used it was restrained and attuned to the abstract aesthetic principles of the artistic avant-garde such as

those associated with De *Stijl or *Constructivism. Also closely associated with Modernism was the maxim 'form follows function' although in reality this was often more symbolic than the case in reality, a visual metaphor for the *Zeitgeist* or spirit of the age. Nonetheless Modernism found forms of material expression alongside exciting, new, and rapidly evolving forms of transport and communication, fresh modes of production and materials coupled to technological and scientific change, alongside a contemporary lifestyle powered by electricity.

The roots of Modernism lie in the design reform movement of the 19th century and were nurtured in Germany in the years leading up to the First World War. The Modernist legacy is considerable in terms of design (whether furniture, tableware, textiles, lighting, advertising, and typography or other everyday things), architecture (whether public or private housing, cinemas, office blocks, and corporate headquarters), or writings (theories, manifestos, books, periodicals, and criticism). This has done much to cement Modernism firmly into the mainstream history of design. Furthermore, it is also heavily represented in numerous museums around the world that have centred their design collections drawn from the later 19th century through to the last quarter of the 20th century around the Modernist aesthetic and its immediate antecedents. This focused collecting policy has generally been at the expense of the representation of many other aspects of design consumed by the majority in the same period. Typifying such an outlook has been the *Museum of Modern Art in New York, established in 1929. The curatorial inclinations of Philip *Johnson, Eliot *Noyes, and Edgar Kaufmann Jr. dominated its collecting policy for several decades. A further significant reason for the prominence of Modernism in accounts of design in the 1920s and, more particularly, the 1930s has been the fact that it was underpinned by social utopian ideals and identified with radical avant-garde tendencies opposed to the repressive political and aesthetic agendas of totalitarian regimes that dominated in Germany, Russia, and Italy. In general, official architecture and design practice under Adolf Hitler and Josef Stalin favoured an authoritarian, stripped down neoclassical style, leading many progressive designers in Germany in particular to emigrate in the face of restricted professional opportunities and increasing political and social oppression. In dictator Benito Mussolini's Fascist Italy, the position was slightly more ambivalent during the 1920s but the Modernist aspirations of those associated with Italian *Rationalism found little official patronage in the interwar years. To many eyes in 1930s Britain Modernism was also felt to reflect 'Bolshevik' tendencies and was out of tune with the more historically inclined stylistic rhetoric of British imperialism (*see* BRITISH EMPIRE EXHIBITION), an outlook that oriented Britain away from continental Europe towards the dominions and colonies of Empire. Known also as the *International Style from the late 1920s onwards, a later phase of Modernism was also, by its very definition and aspiration, opposed to the strongly nationalistic tendencies in many countries in the turbulent political and economic climate of the 1930s. Less affected by the political turmoil in the rest of Europe were Holland and Scandinavia where Modernism found considerable opportunities for further development and dissemination. After the Second World War the International Style was taken up by many major multinational

companies for the architecture, interiors, furniture, and furnishings and equipment of their offices and showrooms, thus promoting themselves through their emphatically modern identity as efficient, up-to-date, and internationally significant organizations in a global economy. In the eyes of some, Modernism's earlier associations with social democratic ideals had been transmuted in its later manifestations to support capitalist ends. Used widely in design and architecture in the 1950s and 1960s, such stylistic traits also attracted increasing criticism from a younger generation of designers, architects, and critics who felt that an abstract design vocabulary that had evolved in the early decades of the 20th century was no longer relevant in an era of rapid and dynamic change, of television and radically developing media and communication systems, and of swiftly developing opportunities for mass travel and the direct experience of other cultures. Such trends found expression in the increasingly rich and vibrant vocabulary of *Postmodernism, echoed in the increasingly ephemeral lifestyle enjoyed by those in the industrial world with greater levels of disposable income. Ideas about what was called *'Good Design' in the 1950s and 1960s were formally linked to the Modernist aesthetic but without the social utopian underpinning promoted by many of the first generation of Modernists in the interwar years. In Britain such objects were approved by the state-funded Council of Industrial Design (*see* DESIGN COUNCIL) and seen in opposition to the elaborate styling and obsolescence inherent in American design that was becoming attractive to British consumers, whilst in the United States, at the Museum of Modern Art in New York, they were also seen as exemplars of European restraint.

A key text that has played an important role in defining Modernism has been Nikolaus *Pevsner's widely read book, first published as *Pioneers of the Modern Movement* (1936). It has subsequently undergone substantial revisions (including a major one supported by the Museum of Modern Art, New York, in 1949) and numerous reprints under the title of *Pioneers of Modern Design: From William Morris to Walter Gropius*. Pevsner provides an account of the ways in which John *Ruskin, William *Morris, and exponents of the *Arts and Crafts Movement fought against what they saw as the morally decadent and materialistic indulgence in historical ornamentation, inappropriate use of materials, and 'dishonest' modes of construction widely prevalent in Victorian design. This period was seen as a prelude to the clean, abstract, machine-made forms of 20th-century Modernism seen in the work of members of the *Deutscher Werkbund and the teachers and students at the *Bauhaus. Unlike the stylistic historicism of Victorian design, Modernism was felt to reflect the *Zeitgeist*. Its first phase emerged in the late 19th and early 20th centuries when arts and crafts principles of 'honesty of construction', 'truth to materials', and rejection of historical encyclopaedism were reconciled with the mass-production potential of the machine and blended with the embrace of new materials, technologies, and abstract forms. Important in such considerations, the main thrust of which moved from Britain to Germany, aided by the writings and outlook of Hermann *Muthesius. He had worked as architectural attaché to the German Embassy in London in 1896, gaining a first-hand knowledge of progressive design thinking in Britain at the time. After returning to Germany in 1903, he was given major responsibilities for art and design education

and influenced the appointment to key institutional posts of major figures such as Peter *Behrens before taking up the Chair of Applied Arts at Berlin Commercial University in 1907. Muthesius was also a key figure in the establishment of the *Deutscher Werkbund (DWB), founded in Munich in 1907 with the aim of improving the quality and design of German consumer products. There were considerable differences of opinion between those such as Henry van der *Velde who believed in the primacy of individual artistic expression and supporters of Muthesius who favoured the use of standardized forms allied to quality production as a means of achieving economic success. The DWB and its celebrated large-scale exhibition in Cologne in 1914 attracted the attention of designers throughout Europe including members of the *Swedish Society of Industrial Design and some of those associated with the foundation of the *Design and Industries Association in Britain in 1915. Another important German exemplar of the exploration of new materials and abstract forms in its modernizing products, buildings, interiors, and corporate identity in the years leading up to the First World War was the large electricity generating and manufacturing company, *AEG, whose design policy was coordinated by Peter Behrens.

Despite the massive disruption of the First World War certain aspects of avant-garde activity continued during the 1914–18 period, most notably the work of the De Stijl group in Holland, founded by Theo Van *Doesburg in 1917. In Germany many of the progressive ideas at the core of Modernism were developed at the German Bauhaus, founded in Weimar in 1919 under the directorship of Walter *Gropius. This radical and influential institution brought together art, craft, and design, allied to architecture, and was influenced strongly in the early 1920s by the ideas of De Stijl and Russian Constructivism. Many of those associated with it were major defining figures of Modernism including Marcel *Breuer, Herbert *Bayer, Ludwig *Mies Van Der Rohe, László *Moholy-Nagy, Wilhelm *Wagenfeld, Anni and Josef *Albers, Marianne *Brandt, and Gunta *Stölzl. By the mid-1920s the DWB began to reassert an influence on contemporary design debates, whether through exhibitions such as *Form ohne Ornament (Form without Ornament)* in 1924 or the recommencement of publication of its propagandist magazine *Die Forme*. Modernism in Germany was also taken up in the mid-1920s by municipal authorities such as that in Frankfurt that instituted a large-scale housing programme under the City Architect Ernst May, developed ergonomic kitchen designs under Greta Schütte-Lihotsky, and promoted many aspects of a Modernist lifestyle in its magazine *Das Neue Frankfurt*. Similar developments could be found in many other European cities such as Rotterdam in Holland and Warsaw in Poland, as well as the large-scale *Die Wohnung (The Dwelling)* exhibition organized by the DWB in Stuttgart in 1927 where a number of buildings by leading Modernists were shown. These included designs by Le Corbusier from France, Mart Stam, and J. J. P. Oud from Holland, Gropius and Mies Van Der Rohe from Germany, and Victor Bourgeois from Belgium, all of which contained furniture and fittings that were characterized by a lightweight Modernist aesthetic very different from the heavy, often intrusive forms of traditional furniture. This collective manifestation reflected the increasingly international orientation of the movement,

a dimension that attracted increasing antagonism on the part of conservative manufacturers, designers, architects, and critics who saw the style as un-Germanic and portrayed its designers and manufacturers as Bolsheviks, Jews, and other foreigners. In France, the Modernist cause had been effectively prosecuted by Le Corbusier, sustained by his theoretical writings such as *Vers une architecture* (1923) and *L'Art decoratif d'aujourd'hui* (1925) and promoted in full public view in his uncompromising Pavillon de L'Esprit Nouveau at the *Paris Exposition des Arts Décoratifs et Industriels of 1925. His stand against the prevailing decorative ethos of the luxurious pavilions elsewhere on the site was followed through in the establishment of the *Union des Artistes Modernes (UAM) in 1928. This was the same year in which another important organization that furthered the international impact of Modernism was founded: the *Congrès Internationaux d'Architecture Moderne (CIAM). In Sweden the Modernist debate was very much to the fore at the *Stockholm Exhibition of 1930, following which a more humanizing dimension was seen with the emergence of what became known as *Swedish Modern with its partiality for natural materials seen in the work of Bruno *Mathsson and Josef *Frank and articles promoted, manufactured, and sold by *Svenskt Tenn in Stockholm. Other Scandinavian examples may be seen in the work of Alvar and Aino *Aalto in Finland or Kaare *Klint in Denmark. Modernism was also evident in both the graphic and rug design work of Edward McKnight *Kauffer that was characterized by the interplay of flat, geometric forms similar to those explored by Marion *Dorn, Serge *Chermayeff and drawing on the pioneering work of Gunta Stölzl, Anni *Albers, and others at the Dessau Bauhaus in the late 1920s and early 1930s.

There were also several ways in which aspects of Modernism could be seen in certain outputs of the later phases of *Art Deco, such as the use of flat, abstract shapes, geometrically conceived forms and modern materials in much American design work of the later 1920s and 1930s including some of the furniture of Paul *Frankl, Donald *Deskey, and Gilbert *Rohde. American *Streamlining also exhibited a number of modernizing tendencies, also blending new materials with clean, often organically inspired, forms that also drew on abstract decorative motifs symbolizing speed. In fact many dimensions of Modernist design endured throughout the rest of the 20th century, whether manifest in Charles *Jencks's notions of Late Modernism or even incorporation as playful or ironic quotation in *Postmodernism.

MODERNISMO

Sometimes also referred to as Modernisme, this term has no connection with mainstream *Modernism but refers to the *Art Nouveau movement in Catalan Spain. It is most commonly associated with leading architect designers Antoni *Gaudí, Louis Domenech i Montaner, and Josep Puig i Cadalfach whose dramatic, often highly colourful, decorative designs may be seen in many key buildings and developments in Barcelona and elsewhere in the region.

Modernismo *See* box on p. 289.

Moggridge, Bill (1943–) One of Britain's leading product designers and innovators in the later 20th century, Moggridge was a co-founder of IDEO, one of the foremost design consultancies in the world, Offering expertise in the fields of user-centred products, services, and environments the company has about 350 employees located in eleven offices around the world and drawn from across a wide range of specialisms: industrial design, ergonomics, mechanical and electrical engineers, interaction design, and model making. IDEO is associated with innovative, technologically sophisticated, and elegant design. Moggridge graduated from the Central School of Art and Design in London (*see* CENTRAL SCHOOL OF ARTS AND CRAFTS) in 1966 before working as a designer in the United States for three years. On his return to Britain he established his own consultancy, Moggridge Associates, in London in 1969 with a focus on product design and development. Business expanded during the 1970s leading to the opening of a second office in San Francisco in 1979. Amongst his well-known designs in this period of his career were the first laptop computer for Grid (1982) and a computer mouse for Microsoft (1988), and he was increasingly concerned with user interface—or interactive—design. In 1991 he joined with David Kelley and Mike Nuttall to form IDEO, the company establishing a worldwide reputation for the strategic use of design in innovation. IDEO Tokyo was established in 1994. Moggridge has played an important role in the dissemination of good practice in professional design and has been involved in education. He was made a Senior Fellow at the *Royal College of Art (RCA) in 1992 and an Honorary Fellow of the London Institute in 1998. He has taught at a number of leading institutions including the London Business School and the RCA in London, and Stanford University in the United States. In 1988 he was elected as a *Royal Designer for Industry and IDEO received the Design Group of the Year Award from the Design Zentrum in Essen in 1996, one of numerous accolades since the consultancy's inception.

Moholy-Nagy, László (1895–1946) Hungarian-born Moholy-Nagy is recognized for the key role that he played in 20th-century design education, first at the *Bauhaus in Germany and later at the 'New Bauhaus' and *Institute of Design, Chicago, where he promoted the values of European *Modernism. His artistic activity covered many fields including the fine arts, design, film, and photography. Initially, his professional aspirations lay in the law but his studies were interrupted by the First World War in which he was seriously wounded whilst a serving officer in the Hungarian army in 1917. Whilst convalescing he resumed earlier interests in practical art, becoming aware of the activities of the German Expressionists, De *Stijl and the Russian avant-garde. From 1919 to 1920 he lived in Vienna and, in the following year, met the Russian *Constructivist designer El *Lissitsky and the De Stijl artist, designer, and writer Theo Van *Doesburg in Düsseldorf. During a period in Berlin (1921–2) he became involved with experimental photography, fine art, and debates with many leading avant-garde artists and writers about the relevance of a machine aesthetic. Despite the lack of a background in design he was appointed as head of the metal workshops at the Weimar Bauhaus by Walter Gropius in 1923, and also made a distinctive contribution—together with Josef *Albers—to the institution's Foundation Course (*Vorkurs*) on which he replaced Johannes *Itten. Moholy-Nagy described

the aims of the *Vorkurs* in his *Von Material zu Architektur* of 1929, one of a series of books issued by the Bauhaus. Importantly, he played an important role in conveying the intellectual underpinning of the Bauhaus as co-editor with Walter Gropius of this series of Bauhaus Books (*Bauhausbücher*), fourteen of which were published between 1925 and 1930. With the exception of two volumes Moholy-Nagy designed the typographic layout of all of the volumes, as well as a number of the cover designs. In addition to *Von Material zu Architektur* he also wrote *Malerei, Photographie, Film* in 1925. In the same year Moholy-Nagy moved to Dessau with the Bauhaus, leaving the institution in 1928. He moved to Berlin, where, in addition to his work as a typographer, he became interested in film, exhibition, and stage design. He left Germany in the difficult political climate of the early 1930s, travelling to Amsterdam in 1934. He moved to London in 1935, where he was involved in publicity design for the *Isokon Furniture Company, which also employed his former director at the Bauhaus, Walter *Gropius, as Controller of Design. Other work included publicity for Imperial Airways and London Transport and design work for the *Architectural Review*. In 1937, encouraged by Gropius, he emigrated to the United States, where he directed the 'New Bauhaus: American School of Design' or, in a later reconstituted form, the Institute of Design in Chicago from then until his death in 1946. Other design work in the United States included work for the *Container Corporation of America and *Fortune* magazine, and the *Parker 51* pen in 1941.

Mollino, Carlo (1905–73) A leading figure in Italian design in the middle decades of the 20th century, Mollino worked in a number of fields, including architecture, furniture, and interior design as well as

aeroplane and racing car design. He originally trained as an architect at the Architectural School of Turin, gaining a diploma in 1931, after which he worked for five years with his engineer father.

Amongst early notable achievements was the award of first prize in the 1934 competition for the House of Fascism in Voghera. Although committed to the pursuit of a contemporary design idiom he preferred organic forms rather than the rectilinear forms often associated with the *International Style and its Italian variant, *Rationalism. He looked instead to sources such as the flowing lines of *Art Nouveau, *Futurism, and contemporary Surrealism, several characteristics of which inspired the furniture designs that he began working on from 1937. In the 1940s and 1950s he designed apartments and furnishing in Turin, including the Casa Minola (1944) and the Casa Orengo (1949). In his furniture he experimented with the expressive possibilities of bent plywood, exploring organic, sculptural forms. This was shared with a number of other designers in the 1940s, including Charles and Ray *Eames and Eero *Saarinen in the USA whose work had been published in *Domus* magazine. In Italy there had also been interest in organic form as a more humanizing alternative to the standardized austerity of Rationalism, as evidenced in Bruno Zevi's book *Verso un architettura organico* (1945) and the founding in the previous year in Rome of the Association for Organic Architecture. One of Mollino's best-known designs in this genre was his *Arabesco* table (1950), with an eloquently sculptural bent plywood base and glass top shaped in the form of a woman's torso. He also attracted attention with his exhibits at the X *Milan Triennale of 1951 and his project for a Carpenter's House at the following Triennale in 1954. However, in the mid-1950s Mollino largely

turned away from furniture towards the design of aeroplanes and racing cars, although he maintained an interest in education. From 1952 he taught in the Faculty of Architecture at Turin, becoming Head of Faculty ten years later, although he was to gain a reputation amongst students for missing many of his classes. In the 1980s his work underwent a re-evaluation, *Zanotta reissuing his *Fenis* chair (1962) in 1985 and the Pompidou Centre in Paris dedicating an exhibition to his work in 1989: *L'Étrange Univers de l'Architecte Carlo Mollino*.

MOMA *See* MUSEUM OF MODERN ART, NEW YORK.

Monza Biennale (1923–30) *See* MILAN TRIENNALE.

Morison, Stanley Arthur (1889–1967) Most widely known for his considerable writings on the history and practice of typography, Stanley Morison also played an important professional role in the field with several important consultancies. These included his work (1922–7 and 1947–59) for the Monotype Corporation, as well as his role as advisor to several influential publishers including the Cambridge University Press and *The Times* newspaper, the redesign of which he oversaw in 1931–2. This included his classic, clearly articulated, and extremely legible design of the Times New Roman typeface. Morison had no formal design training but gained his knowledge from early experience in the printing and publishing world, beginning with the *Imprint* journal which he joined in 1915. After the First World War he worked for the Pelican Press, commencing in 1919, later joining the celebrated, yet essentially conservative, periodical the *Fleuron*, which he edited from 1926 to 1930. His typefaces for the Monotype Corporation were widely admired and included a number of revivals

such as Garamond (1922), Baskerville (1923), and Fournier (1924), also commissioning from Eric Gill typefaces such as Perpetua (1925) and Gill Sans (1928). He was also responsible for book design and production at Gollancz between 1928 and 1938. Morison's own books included *The Craft of Printing* (1921), *Four Centuries of Printing* (1924), *The Typographic Arts, Past Present and Future* (1944), and *Printing the Times since 1785* (1953).

Morris, William (1834–96) A leading figure in 19th-century British art and design practice and ideology, as well as a socialist, reformer, writer, and poet, Morris was also the founder of the Society for the Protection of Ancient Buildings in 1877. He is most commonly associated with the *Arts and Crafts Movement which his theories and practice did much to sustain. Morris firmly believed in the idea of bringing together once more the designer and maker as a means of endowing the production of domestic and ecclesiastical goods with the 'joy of making', a process which had been eroded in the 19th century by the increasing use of the division of labour in industrial production. The latter was often seen as alienating, dehumanizing, and oppressive, a by-product of the relentless industrialization which dominated urban life in 19th-century Britain. Conversely, the Middle Ages, with its high levels of craftsmanship, respect for materials, and belief in spiritual fulfilment, was often held up by writers and theorists such as A. W. G. Pugin, John *Ruskin, and Morris as a source of inspiration for the contemporary production of artefacts. However, Morris's commitment to craft-based, labour-intensive production generally rendered the resulting products affordable only for a wealthy clientele rather than the general public indicated by his socialist leanings.

Morris was educated at Marlborough School (1848–51) and Exeter College, Oxford University (1853–5), where he became friends with Edward Burne-Jones, who later went on to become a leading British artist and designer. Whilst up at Oxford Morris decided to become an architect, leading him to become a pupil of the leading Gothic Revival architect George Edmund Street in 1856. He soon made friends with Philip *Webb, who was working in Street's Oxford practice at the time. However, Morris left Oxford for London at the end of the year, setting up a studio with Burne-Jones in Red Lion Square and becoming involved in many aspects of drawing, painting, and designing. In 1857, in the manner of artists of the early Renaissance he was involved with a group of artists (including the Pre-Raphaelite painter Dante Gabriel Rossetti and Burne-Jones) in painting the walls and ceiling of the Debating Hall of the Oxford Union in a decorative medieval scheme in tempera. Following his marriage in 1859 he was heavily involved with setting up a new home, designed in close collaboration with Philip Webb. Situated in Kent, the Red House (so called on account of the red brick from which it was constructed) drew on *Vernacular traditions. It provided Morris with an early opportunity to explore the idea of furnishing and decorating a home with artefacts that embraced high levels of craftsmanship and aesthetic sensibility. This process provided an important impetus for the establishment in 1861 of the manufacturing and decorating firm of Morris, Marshall, Faulkner & Co. (which also included as partners Rossetti, Webb, Burne-Jones, and Ford Madox Brown) in Red Lion Square, London. Geared to both ecclesiastical and domestic furnishing and decoration, the firm's output included furniture, stained glass, wallpaper, textiles, tapestries, carpets, and jewellery. Having exhibited at the 1862 International Exhibition in London, attracting favourable critical notice, the firm soon built up its business with commissions including the decorative Green Dining Room at the Victoria and Albert Museum (1866). Morris himself produced a number of wallpaper patterns in the mid-1860s, drawing on natural motifs as a source of inspiration rather than the general Victorian predilection for historical motifs or heavy, imposing patterns. However, despite a number of significant commissions and sales the firm of Morris, Marshall, Faulkner & Co. was dissolved for a number of reasons in the mid-1870s, with Morris himself taking charge of Morris & Co. from 1875. At that, further reflecting his interest in earlier periods and practices as sources of inspiration for contemporary production, Morris became involved in experimenting with vegetable dyes for cottons, silks, and wools at the works of Thomas Wardle in Leek, Staffordshire. These natural dyes were a far remove from the strong aniline dyes that had tended to dominate the Victorian market place. Wardle produced a number of Morris's textile designs, including *Honeysuckle* (1875), before Morris established his own print factory at Merton Abbey in 1881. There a number of other Morris textile designs, including *Anemone* and *Daffodil*, were printed and a number of carpets woven. From the 1870s Morris had also been engaged in illumination and he took this interest a stage further in an effort to revive the art of printing, establishing the Kelmscott Press in Hammersmith, London, in 1891. He designed three typefaces, ornamental letters, and borders and also oversaw the printing and production of a wide range of books that included his own writings and reprints of an extensive range of English classics including the Kelmscott *Chaucer* (1896).

Morris was also an eloquent poet and writer and was prolific and varied in his output which developed from the 1850s onwards with volumes such as *The Defence of Guenevere and Other Poems* (1858), *Earthly Paradise* (1868–90), *The House of the Wolfings* (1889), and *News from Nowhere* (1891). The socialist principles which underlay much of his thinking about design was very much reflected in his political activities, which were at their most acute in the 1880s. Morris joined the radical working-class Democratic Federation in 1883, supporting the organization with money as well as vigorous campaigning. Subsequently he played a leading role in the Socialist League, one of the Federation's offshoots, founded in 1884, producing many pamphlets, bankrolling its *Commonweal* magazine and addressing meetings in industrial cities throughout Britain. However, towards the end of the decade the League's membership began to fall away and the organization was taken over by anarchists, leading to Morris's withdrawal in 1890.

However, although Morris was in many ways resistant to mass manufacture and the detrimental effects of relentless industrialization, a significant number of his designs were put into mass production. For instance, he designed wallpapers that were produced by Jeffrey & Co. and carpet designs that were manufactured by Wilton, Kidderminster, and other major companies. Furthermore, the historian Nikolaus *Pevsner in his 1936 text *Pioneers of the Modern Movement* saw Morris as a seminal figure (or 'pioneer') in the development of *Modernism. Pevsner believed that Morris's commitment to honest craftsmanship and truth to materials blended with socialist principles signposted the way for designers associated with the *Deutscher Werkbund and the *Bauhaus to reconcile such principles with liberating possibilities of new materials and mass-production technology. Such an outlook was seen as realistic in the social utopian drive to bring about the possibility of better standards of design for the majority.

Morris & Co. (1861–1940) This important firm, closely associated with William *Morris and the *Arts and Crafts Movement, was established in Red Lion Square, London, in 1861, moving to larger premises in 1865. Originally founded as Morris, Marshall, Faulkner & Co., its partners also included the Pre-Raphaelite artist Dante Gabriel Rossetti, painter-designer Ford Madox Brown, architect-designer Philip Webb, and artist-designer Edward Burne-Jones. The company was involved with the production of a wide range of ecclesiastical and domestic designs, including stained glass, mural decoration, metalwork, jewellery, and furniture, and was closely associated with the outlook of the Arts and Crafts. After winning two awards for designs for textiles, stained glass, and furniture shown in the Medieval Court at the London International Exhibition of 1862, the firm was busy with orders for Gothic Revival churches, as well as commissions for public and private interiors. The former included St Michael and All Angels in Brighton, the latter the Green Dining Room at the *Victoria and Albert (then South Kensington) Museum (1866) and the Armoury Rooms at St James's Palace (1866–7). Later interior commissions included decorations at Alecco Ionides' house at 1, Holland Park, London (1881–8) and Standen Manor (mid-1890s). Designs for wallpapers commenced from the mid-1860s, including William Morris's *Daisy* and *Trellis* patterns, furniture, embroideries, stained glass, and tiles from 1862 (*see also* DE MORGAN, WILLIAM), printed textiles from the late 1860s, woven textiles, linoleums, and carpets from the mid-1870s

and tapestries from 1881. Many of the firm's products looked to traditional precedents that embodied high levels of craftsmanship together with a respect for materials and honesty of construction. This was evidenced in the famous rush-seated Sussex Settle introduced in the 1860s, drawing inspiration from rural *Vernacular models. However, although many of the earlier products were made by the partners, close associates, or the company's workmen, a number of the company's designs were produced by Morris, who was a wealthy man and did much to ensure the financial viability of the firm, of which he took sole charge after it became Morris & Co. in 1875. A central London, Oxford Street showroom was opened in 1877, drawing the firm's products to the attention of a wider, more fashionable audience, an initiative that was echoed in Manchester in the following decade. The firm's designs were also seen abroad at overseas exhibitions and reviewed in architecture and design journals in Britain and overseas. However, after Morris's death in 1896 and the renaming of the firm as Morris & Co., Decorators Limited in 1905, the company's output looked increasingly to historical revivals, marking the beginning of a decline which eventually led to its closure in 1940.

Morrison, Jasper (1959–) British designer Jasper Morrison has become highly influential in industrial design of the later 20th and 21st centuries. His clients have included *Alessi, *Vitra, *FSB (Franz Schneider Brakel), *Rosenthal, and Rowenta and his work widely experienced, whether through collaborating with Swiss architects Herzog & de Meuron in the furnishing of public spaces with his designs at Tate Modern, London, in 2000 or a digital installation at the *Design Museum, London, in 2001.

Morrison studied design at Kingston Polytechnic (now University) followed by a Masters degree at the *Royal College of Art. He graduated from the latter in 1985, having already been commissioned by furniture companies such as Sheridan Coakley Productions (SCP) and featured in the design press. In the following year he established the Office for Design in London, gradually building up a series of commissions from a range of companies including the Italian company Capellini and the Swiss company Vitra. Morrison's work was also exhibited overseas as at the *Documenta 8* exhibition at Kassel, Germany, in 1987 and a room setting—including plywood chairs, chaise longue, and tables—at the *Design Werkstadt* exhibition in Berlin in the following year. *Domus*, the Italian design magazine, also profiled his work in May 1988, including the *Rug of Many Bosoms* (1985) and the *Thinking Man's Chair* (1986) for Capellini. He also worked for the Italian lighting manufacturer *Flos, Magis (including the *Bottle Rack* (1994) and one-piece injection-moulded plastic *Air Chair* (1999)), Alessi (including the *Tin Family* kitchen containers (1998) and *Sim* salad utensils (1998)) and Rosenthal (the *Noon* dinnerware service of 1997). His work also took on a more obviously industrial edge in consultancy work for the Hanover transport authority, Üstra, for whom he designed bus stops (for the Busstops Art Project in which *Sottsass, *Gehry, and others were also involved) and trams between 1994 and 2000. This was also seen in his ergonomic stainless steel door handles (Model *FSB 1166*) for the FSB company in Brakel in the late 1990s and his work on the design of a wide range of household appliances for the French manufacturer Rowenta in 2003. However, in 2000 he also worked with local craftsmen on a limited edition ceramic project commissioned for a French provincial museum,

causing a certain amount of criticism in the crafts world on account of the rather 'industrialized' aesthetic of the resulting wares. In these years his work also featured prominently in the furniture fairs in Italy and Germany and in 2000 he was named Designer of the Year at the Paris Design Fair. In the following year his work was shown at the Design Museum, London, and in 2002 he opened a studio in Paris. There have been several books devoted to his work including one written by himself, *Everything but the Walls* (2002). He was elected a *Royal Designer for Industry in 2001.

Moser, Koloman (1868–1918) Austrian designer Kolomon Moser was a founder member of the influential *Wiener Werkstätte in 1903, with fellow designer and architect Josef *Hoffmann and industrialist Fritz Warndorfer. After studying painting at the Academy in Vienna between 1888 and 1892 when he moved to the School of Applied Arts to study design. His early work exhibited many of the qualities of *Art Nouveau and in 1897 he was a founding member of the Vienna Secession, contributing stained glass and other decorative designs for Joseph Maria *Olbrich's Secession Building of 1898. In 1900 he was responsible for the organization of the Secession contribution to the Austrian Pavilion at the 1900 *Paris Exposition Universelle. From its foundation in 1903 until his departure in 1907, he designed many items for the Wiener Werkstätte including furniture, jewellery, and metalwork, many of which were characterized by a sense of decorative rectilinearity. Other designs included a postage stamp for the Jubilee of the Emperor Franz Josef.

Moskovitch (established 1930) This Russian automobile brand has been one of a limited number to have had some visibility abroad, although generally its models have been characterized by the use of outmoded technologies and styling. In 1930 its manufacturer, the AZLK (Avtobiliny Zavod Imeni Leninskogo Komsomola) car plant, was established and is one of the oldest Russian factories in the field. During the 1930s the AZLK underwent several changes of name and after the Second World War was called the MZMA (Small Car Moscow Factory), which produced the first cars with the Moskovitch brand name. This *400/420* range was based on a pre-war Opel *Kadett*, although it boasted four doors as a more utilitarian, people-oriented design. It remained in production until 1956, but like other Moskovitch models—such as the *402* with three-speed gearbox of 1956—had outdated technology. By the 1960s Moskovitch was the only Russian automobile brand with an export penetration of note, including models such as the *408* that came out in various models including the *Tourist* coupé. During this and succeeding decades the Moskovitch design team worked on a number of protoypes, including off-road vehicles in the 1960s through to MPVs (Multi-Purpose Vehicles) in the 1990s. Nonetheless, for production models the company still drew on lines established elsewhere such as the 1986 *2141* front-wheel drive that looked to the Simca *1308*, 'Car of the Year' of 1976. The export version was named the *Aleko*. In the 1990s Moskovitch tried to update its image with the production of a luxury car, the *Ivan Kalita*, powered by a Renault engine. However, it was only produced in a very limited edition and was beyond the reach of almost all Russians. By the early twenty-first century AZLK was producing under licence a number of cars from the Renault range, including the *19* and the *Clio*. Looking towards Renault precedents such as the pioneering *Espace* the company also attempted to develop a more contemporary image through working on an MPV.

Motoramas (1949–61) General Motors staged eight Motoramas between 1949 and 1961 attracting a total of 12 million visitors. Planned as extravagant shows to promote new lines of automobiles to both public and media, they were initiated at a time when demand for new models was high and manufacturing industry able to meet it for the first time since the end of the War. The first show took place in 1949 in Boston and New York, attracting almost 592,000 people at the two venues to view the elaborate displays complete with glamorous human models and a singing group, the Motorhythms. In the following year the Motorama was staged in New York only, attracting 320,000 visitors in a week. The third GM Motorama was held in the Waldorf Astoria Hotel in New York City in 1953 and was the first to feature Dream Cars or Cars of the Future. GM used these displays to gauge public reactions to future styling possibilities and performance features. Perhaps the most striking car on show was the *Glass-Reinforced Plastic Chevrolet *Corvette* sports car, although other models using this new material also attracted considerable attention. The Dream Car concept had originated with Harley *Earl's futuristic Buick Y *Job* of 1937. The 1954 GM Motorama was also held at the Waldorf Astoria, with an orchestra and singers providing a musical accompaniment to the six shows daily. The whole presentation was media tour de force, involving fashion models, film show, and a Broadway cast as a complement to the six Dream Cars that were shown on raised turntables with the *XP 21 Firebird* experimental gas turbine car as the main focus. A similar sense of theatrical extravagance pervaded the 1956 GM Motorama that was previewed by Bob Hope for CBS Television. The Highway of Tomorrow displayed there featured the futuristic *Firebird II*, alongside five other Dream Cars, which contrasted strongly with the 26 production models on display. The final Motoramas of 1959 and 1961 relied more straightforwardly on production cars and elaborate settings to capture the public imagination, with the *Firebird III* gas-turbine automobile the only Dream Car on display in 1959.

Mouille, Serge (1923–88) A leading French lighting designer in the decades immediately following the Second World War, Mouille graduated with a diploma in silversmithery from the École des Arts Décoratifs in Paris in 1941. Four years later he took up a teaching post there, also opening his own studio where he worked on lighting design alongside the design of a range of metal products. From the early 1950s he devoted himself exclusively to lighting design, including the *Cocotte* (1950), *Osil* (1953), and *Flamme* (1954) lights. From the late 1950s he began to experiment with neon tubing, leading to a series of floor lamps including the *Colonnes* series of 1962. He achieved official recognition for his work through the receipt of a number of awards including the Charles Plumet Prize for design in 1955 and a Diploma of Honour at the international Brussels Expo in 1958.

Moulinex (established 1932) This leading French domestic appliance company was founded as the Moulin-Légumes Company by Jean Mantelet in 1932, the year in which he designed his first manual 'moulin à légumes' (vegetable shredder). In 1955 the brand name Moulinex was registered followed by the development of an increasingly diverse range of household appliances. These ranged from coffee-grinders to kitchen robots, such as the *Charlotte* (1958) and the *Marie* (1961), vacuum cleaners (1963–), electric coffeemakers (1971–), microwaves (1979–), irons (1981–), and hairdryers. From 1962 the company launched the slogan 'Moulinex

libère la femme' ('Moulinex liberates women') and continued to promote itself in this vein in succeeding decades, earning the award of 'Marque du Siècle' ('Brand of the Century') in 1997. The designer most closely associated with the company's products was Jean-Louis Barrault, who had originally worked with Raymond *Loewy's Compagnie d'Esthétique Industrielle (CEI) in Paris. After working on a freelance basis from the early 1960s he assumed responsibility for the corporate identity of the company's products in 1987. Having been floated on the French Stock Exchange in 1969, Moulinex took over the British company Swan Housewares in 1988 and the German manufacturer Krups in 1991, becoming a limited company in 1994. By the year 2000 the company was marketing its products in over 170 countries worldwide, selling more than 45 million products a year. In 2001 it was acquired by the SEB (Société d'Emboutissage de Bourgogne) a conglomerate that had also acquired domestic equipment manufacturers Tefal and Rowenta in the 1970s.

Moulton, Alex (1920–) Most widely known for his distinctive, small-wheeled Moulton bicycle of 1962, Moulton was an inventive British designer and engineer. Having studied engineering at the University of Cambridge on either side of a period in the research department of British Aerospace during the Second World War, he went to work in the family rubber business. He worked with Alec *Issigonis on the rubber suspension for the Austin *Mini* (1959), an idea that was carried through for the suspension of his Moulton *Standard* cycle of 1960. For a while this distinctive new form of bicycle caught the public imagination, with figures such as the architectural and design critic Reyner *Banham seen riding around London on his Moulton

and celebrating its revolutionary features. He even wrote a eulogistic essay, 'A Grid on Two Farthings', for the *New Statesman* magazine in October 1960 where he claimed that 'bicycle thinking can never be the same again, and there can be no more nonsense about permanent and definitive forms'. The Raleigh bicycle manufacturing firm purchased the Moulton bicycle patent and produced the *Mark 3*. However, when the company was looking to capture a larger share of the children's bicycle market, its consultant designers Ogle Associates came up with the idea of the *Chopper*. Production energies were expended on the latter at the expense of the Moulton. Moulton later produced the steel *AM GT* (1983) and *New Series* in 1998.

Mucha, Alphonse (1860–1939) Czechoslovakian born graphic designer and illustrator Mucha is widely known for his *Art Nouveau posters in the 1890s and early 1900s, particularly those portraying the actress Sarah Bernhardt. Major clients also included Job cigarette papers (1898) and the champagne house of Moët & Chandon (1899). Flowing lines and two-dimensional organic forms characterized much of his work, the term 'le style Mucha' becoming almost synonymous with Art Nouveau. He worked across the full range of graphic media, including illustration, packaging, and postage stamp design, as well as involvement in the fields of jewellery and textile design. After commencing his career in theatre set painting he studied in Munich (1884–7) and in Paris from 1888, where he experienced the striking poster designs of Eugène Grasset and Jules Chéret, including the latter's renderings of Sarah Bernhardt in *La biche aux bois* and Loie Fuller dancing at the Folies Bergère. Mucha's own first poster of Bernhardt was produced in 1894 when

she was appearing in *Gismonda*, leading to a six-year contract with the actress. Mucha's reputation, widely disseminated through reproduction in the periodicals press, was further enhanced by a travelling exhibition of his posters, originating in Paris in 1897 before travelling to Prague, Brussels, Munich, London, and New York. In 1897 he opened his own design school in which he taught until 1904 during which time he was commissioned to design the Bosnia-Herzegovina Pavilion at the 1900 *Paris Exposition Universelle where he also exhibited scent bottles, jewellery, and carpet design. The jewellery was commissioned by Georges Fouquet, whose shop in the Rue Royale in Paris Mucha designed as a total unified entity, including furniture, lighting, and stained glass. After a period in which he travelled in Europe and the United States Mucha returned to Czechoslovakia in 1910 and worked on a series of murals depicting Slav history. He also designed postage stamps celebrating Czechoslovakia's freedom in 1918.

Müller-Munk, Peter (1904–67) One of the second generation of American industrial designers, German-born Müller-Munk was an important figure in the development of industrial design, design consultancy, and the professionalization of design in the United States in the post Second World War period. As he declared in the late 1940s he was committed to the idea of making the design process 'a management philosophy' rather than being restricted to the design of products, an outlook consolidated through his involvement with design practice, education, and national and international professional organizations. Having graduated in the humanities in Berlin, Müller-Munk trained as a silversmith before emigrating to New York in 1926. He worked there as a silver designer for the well-known

firm of Tiffany & Co. before opening his own studio in 1929. His design reputation was steadily enhanced by the inclusion of his work in a number of significant exhibitions including the International Exposition of Art in Industry (1928) at Macy's and *Contemporary American Design* (1928) at the Metropolitan Museum of Art, New York. In 1930 Müller-Munk moved into product design, an area of expertise that was to become an increasingly important part of his professional identity. His metalware designs were typified by high aesthetic standards and craftsmanship, as seen in the elegantly *streamlined chrome-plated brass *Normandie* jug designed in 1935 for Revere Copper and Brass Incorporated, the latter a leading American giftware company that placed a high premium on design. In the same year he collaborated with Donald Dohner and Robert Lepper in the inauguration of the first American degree programme in industrial design at Pittsburgh-Carnegie Institute of Technology, marking an involvement with pedagogy alongside professional practice. In 1944 he formed Peter Müller-Munk Associates (PMMA), a design consultancy specializing in industrial design. Important clients included Westinghouse and Texaco. Müller-Munk was also significantly involved in the promotion of the industrial design profession, both in the United States and internationally, through a committed involvement in important organizations. These included the Society of Industrial Designers (SID, *see* INDUSTRIAL DESIGNERS SOCIETY OF AMERICA) and the *International Council of Societies of Industrial Design (ICSID), serving as president of the former in 1954–5 and as a founding member and inaugural president of the latter from 1957 to 1959. By the time of his death in 1967 PMMA had grown significantly in size and disciplinary expertise, employing 40 staff and providing specialist

expertise in product, transportation, and exhibition design. The company later went on to work in communication and environmental design.

Munari, Bruno (1907–98) In his early work as a fine artist Munari was influenced by the dynamism of *Futurism of which he was a leading exponent in Milan from the late 1920s until the mid-1930s. However, in 1933 he had his first exhibition of *Macchine Inutili* ('Useless Machines') which, through their very definition, showed themselves to be closer to Surrealism than Futurism. Like Futurists such as Fortunato Depero, he was interested in the theatre, puppets, and toys, a focus that led him increasingly away from the fine arts to design. After the Second World War he began contributing to the design magazine *Domus*, designed displays for La *Rinascente department store, and was associated with the activities of *ADI (the Italian Association of Industrial Designers), serving on the jury of the *Compasso d'Oro design competition. He also worked for the *Danese company, for whom he designed the *Cube Ashtray* (1957) and a number of children's toys and games, and for Olivetti, for whom he organized an exhibition of kinetic art (1967). In common with a number of other avant-garde Italian designers of the 1960s and 1970s he explored the concept of flexible living units, including the Blocco Abitabile (1968) and Abitacolo (1970). He wrote many texts on visual perception, communication, and the significance of art and design for children.

Munich Vereinigte Werkstätten für Kunst im Handwerk (established 1897) Like a number of other design initiatives in the late 19th century, the Vereinigte Werkstätten für Kunst im Handwerk (United Workshops for Art in Craft) was established in Munich in order to gain greater recognition for the applied arts. In this particular instance the formation of organization stemmed from a concerted campaign for the inclusion of the applied arts in the international Munich Glaspalast Exhibition of 1897. However, although the Munich Vereinigte Werkstätten was based on the *Arts and Crafts Movement idea of a community of craftsmen producing aesthetically charged everyday objects, its aim was not that the artists themselves should carry out the work, but rather to make available a range of technical expertises to bring their ideas to fruition under their control. Under the leadership of the artist Franz August Otto Krueger the Werkstätten became a successful commercial enterprise with its own workshops and showrooms. Key designers associated with the group included Hermann *Obrist, Richard *Riemerschmid, Bruno *Paul, and Peter *Behrens. The Vereinigte Werkstätten exhibited four rooms at the 1899 German Art Exhibition in Dresden, including Riemerschmid's designs of a *Room for a Music Lover*, but found a more prominent stage in the German Pavilion at the *Paris Exposition Universelle of 1900 including Riemerschmid's *Room for an Art Lover*, Bruno Paul's *Hunting Room*, and a *Smoking Room* by Bernhard Pankok. The Vereinigte Werkstätten soon became a commercial enterprise, employing more than 50 in the production of goods carrying its name.

Murray, Keith (1892–1981) New Zealand born Murray was trained as an architect although he is perhaps most widely known for his restrained, poetic, yet functional ceramic designs for *Josiah Wedgwood in the 1930s, his unaffected glassware for Stevens & Williams, and enduringly classic forms for silverware for Mappin & Webb. He first came to England with his parents in 1906, later training as an architect at the Architectural Association

after the First World War. Given the meagre opportunities that were open to architects in the economically difficult years of the early 1920s, Murray turned to design as an alternative means of aesthetic expression. He was impressed by the elegance and grace of Scandinavian and Czechoslovakian glass, which he had seen at the 1925 *Paris Exposition des Arts Décoratifs et Industriels and began experimenting in the medium. The 1931 the Exhibition of Swedish Art in London afforded further opportunities to experience such work at first hand. In 1932 Murray was employed by the Staffordshire glassmaking firm of Stevens & Williams, producing designs that attracted considerable critical attention and praise. From 1933 he was employed at Wedgwood where his elegant designs showed affinities with *Modernism. Murray's designs were included in many of the pro-modernizing design exhibitions of the 1930s such as the landmark *British Industrial Art in Relation to the Home* at Dorland Hall, London, in 1933. His work was also represented at the *Milan Triennale of 1933, the *British Art in Industry* exhibition at the Royal Academy in 1935, and in the British contribution to the 1937 *Paris Exposition des Arts et Techniques dans la Vie Moderne. In 1936 Murray was elected as one of the first Designers for Industry by the Royal Society of Arts (*see* ROYAL DESIGNERS FOR INDUSTRY). In the late 1930s Murray turned to architecture, designing the new Wedgwood factory at Barlaston.

Museum of Modern Art, New York

(established 1929) The Museum of Modern Art (MOMA) in New York houses one of the world's leading collections of modern art and is centred on six curatorial departments: Architecture and Design, Drawings, Film and Media, Painting and Sculpture, Photography, and Prints and Illustrated Books. Over the first decade of its existence MOMA grew

in size, moving three times before occupying a new, strikingly *Modernist building in Manhattan designed by Philip L. Goodwin and Edward Durrell Stone. This opened to the public in 1939 but was further expanded in the 1950s and 1960s to plans by architect Philip Johnson, including the Abby Aldrich Rockefeller Sculpture Garden. In 1984 the architect Cesar Pelli's designs included a new west wing and considerable renovation, leading to a further significant expansion of the gallery space and facilities. In the early 21st century MOMA embarked on a momentous building programme that sought to almost double its space, establish a new Education and Research Center, and provide expanded premises for its Library and Archives. MOMA's central Manhattan site was closed in 2002 to enable the new scheme to be completed by 2005, the museum's collections and exhibitions being made available to the public by opening a new museum (MOMA QNS) in a redesigned and renovated factory building in Long Island City in Queen's.

Originally founded in 1929 with the explicit intention of providing a contemporary alternative to the more traditional collections generally found in American museums and galleries, MOMA's first director was Alfred H. Barr Jr. Part of the original mission was 'to encourage and develop the study of the modern arts and the application of such arts to manufacture and public life'. In pursuit of this aim the Department of Architecture and Industrial Art was established in 1932. The original ethos of this department reflected the tenets of Modernism as exemplified in the work of the European avant-garde, particularly those architects and designers associated with the *Bauhaus in Germany. In 1934, the year in which the Design Collection was formally inaugurated, the first firmly design-oriented show was the

Machine Art exhibition, curated by the architectural modernist Philip Johnson. Many industrial products, ranging from laboratory glassware to industrial insulators, were displayed as aesthetic objects and reflected the Modernist penchant for clean, machine-produced forms, characterized by a lack of decoration and a firm embrace of the 'spirit of the age'. For much of MOMA's early existence a strong sense of moral didacticism pervaded its collecting and exhibiting outlook. Supporting ideas of 'truth to materials' and 'honesty of construction' that had emerged in the outlook of early design reformers such as Augustus Welby Pugin, John *Ruskin, and William *Morris were reconciled to the symbolic embrace of 20th-century materials and mass production technologies. Such an outlook was underlined in the design exhibitions put on by MOMA during the 1930s and favoured the work of the European avant-garde rather than the more ephemeral, streamlined outlook of many everyday American products. This was implicitly echoed in the publication in 1949, by MOMA, of the second, enlarged, and more lavishly illustrated, edition of Nikolaus *Pevsner's *Pioneers of Modern Design: From William Morris to Walter Gropius*. Eliot *Noyes, a well-known industrial designer, had become Director of Industrial Design at MOMA from 1940 to 1942 and 1945 to 1946,

In 1941 he organized the *Organic Design in Home Furnishing* competition in which Charles *Eames, assisted by his wife Ray and in collaboration with Eero *Saarinen, won two prizes, one for a moulded plywood chair and the other for modular design. After Suzanne Wasson-Tucker's brief tenure as director of the Department of Industrial Design at MOMA, the post was taken up by Edgar Kaufmann Jr. The latter mounted a series of *'Good Design' exhibitions from 1950 to 1955, organized in conjunction with the Merchandise Mart, Chicago, and wrote a number of morally charged texts such as *What is Modern Design?* (1950). In this Kaufmann attacked what he saw as the materially excessive and over-indulgent styling of many contemporary American products compared to the clean lines of many of their European counterparts. Typifying these were the Olivetti products and graphic design seen in the *Olivetti: Design in Industry* exhibition of 1953 described in MOMA publicity as symbolizing 'all the visual aspects of an industry, unified under a single high standard of taste'. Over succeeding decades there were growing critiques of what was increasingly seen as the restricted language of Modernism, an outlook sustained by the emergence of *Pop, *Radical Design in Italy, and a growing recognition of pluralism and diversity as realities of everyday life. MOMA's design collecting and exhibiting policies were also undermined by the lecture series delivered by Robert *Venturi that culminated in the publication of his *Complexity and Contradiction in Modern Architecture* (1966). Design policy was further shifted by the Argentinean Emilio *Ambasz, Curator of Design from 1970 to 1975, who organized the landmark exhibition on *Italy: The New Domestic Landscape* in 1972. This showcase for Italian avant-garde design thinking explored the idea of objects as part of a total environment—rather than individual, stand-alone aesthetically self-conscious products. Since then MOMA's design collection has grown to more than 3,000 objects across a wide range of media, including furniture, industrial design, textiles, and a visually diverse collection of graphic design totalling more than 4,000 outputs including typography and posters.

Muthesius, Hermann (1861–1927)

Muthesius was an important link between

the *Arts and Crafts Movement in Britain and progressive design circles in early 20th-century Germany. He had been appointed as architectural attaché to the German Embassy in London in 1896 and came into contact with a number of leading British designers such as Charles Rennie *Mackintosh and Walter Crane. He researched widely into British architecture and design, publishing many articles on the British arts and crafts in the periodical *Dekorative Kunst*, his studies culminating in the three-volumed *Das englische Haus* (1904–5). After returning to Germany in 1903 he was entrusted with the responsibility for art and design education at the Prussian Ministry of Trade and Industry. He was appointed as the first chair of the Applied Arts at Berlin Commercial University in 1907 and sought to promote better standards of design in German industry through greater stress on quality, modernity, and aesthetic excellence. He was also a founder member of the *Deutscher Werkbund (DWB) in 1907 and continued to promote a radical agenda for design reform. He was committed to the adoption of standardized forms that were compatible with economic, modern mass-production techniques although this position was heavily opposed by fellow DWB member Henry van de *Velde who believed that individual artistic creativity was being stifled at the expense of economic, industrial, and political interests. This debate about standardization came to the fore at the Werkbund exhibition in Cologne in 1914. At around this time, like a number of other designers associated with the DWB, he was commissioned to design interiors for German transatlantic liners. During the First World War Muthesius took on a more overtly nationalist stance, arguing that due to Germany's enforced freedom from dependency on foreign influences there was greater opportunity for commitment to a modern German style. He continued to work for the Ministry of Trade and Industry until 1926. Shortly before he died in 1927 he was critical of the DWB's Weissenhof housing exhibition in Stuttgart, seeing it as driven by formalist rather than functionalist principles.

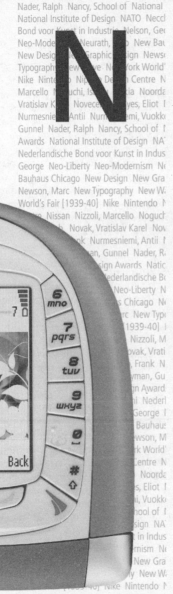

Nader, Ralph Nancy, School of National
National Institute of Design NATO Necc
Bond voor Kunst in Industrie Nelson, Geo
Neo-Moderi Neurath, bo New Bau
New Design Graphic Design News
Typography New ave New York World'
Nike Ninten do Nip De gn Centre N
Marcello N uchi, Is kia Noorda
Vratislav K Novece yes, Eliot I
Nurmesnie Antii Nurme emi, Vuokko
Gunnel Nader, Ralph Nancy, School of I
Awards National Institute of Design NA
Nederlandische Bond voor Kunst in Indus
George Neo-Liberty Neo-Modernism No
Bauhaus Chicago New Design New Gra
Newson, Marc New Typography New W.
World's Fair [1939-40] Nike Nintendo N
e Nissan Nizzoli, Marcello Noguch
b. Novak, Vratislav Karel Nov
k Nurmesniemi, Antii N
an, Gunnel Nader, R.
sign Awards Natic
ederlandische Bo
Neo-Liberty N
Chicago N
rc New Typo
[1939-40] I
Nizzoli, M
ovak, Vrati
, Frank N
yman, Gu
gn Award
ni Nederl
George I
Bauhau:
wson, M
rk World'
Centre N
Noorda
s, Eliot I
i, Vuokk
hool of I
sign NA
in Indus
rnism No
New Gra
y New W.
40) Nike Nintendo N
Centre Nissan Nizzoli, Marcello Noguch
Noorda, Bob, Novak, Vratislav Karel Nov
Eliot Nuovo, Frank Nurmesniemi, Antii N
Vuokko nylon Nyman, Gunnel Nader, R.
School of National Design Awards Natic

Nader, Ralph (1934–) Widely recognized for his indictment of the American automobile industry in his book *Unsafe at Any Speed* (1965), Nader is often seen as an important catalyst in the consumers' rights movement in the United States, playing an influential role in the Consumer Product Safety Commission, the Environmental Protection Agency, and other consumer protection bodies. After graduating in 1955 in government and economics at Princeton University, he studied at Harvard Law School, graduating in 1958. It was at the latter that he first became interested in automobile safety. *Unsafe at Any Speed* was largely directed against *General Motors, particularly the *Corvair* car, which had a record of flipping over. He was also highly critical of the excessive styling of many radiator grilles and the high degree of potential harm that pedestrians might incur if hit. He estimated that styling at General Motors accounted for about $700 per automobile whereas safety accounted for about 23 cents. Nader became something of a public champion when it was discovered that General Motors had hired private detectives to undermine his credibility. The company was forced to apologize before a televised Senate Committee. Nader's campaign resulted in changes to the law, including the National Traffic and Motor Safety Act. A number of themes underpin Nader's subsequent campaigns, including the promotion of consumer cooperatives as a means of gaining greater consumer autonomy in the market place, the devising of means of bringing about government accountability, and more humane business practices.

Nancy, School of (established 1901) Early 20th-century *Art Nouveau was given a fillip by the establishment of the Provincial Alliance of Art Industries (Alliance Provinciale des Industries d'Art), also known as the School of Nancy (L'École de Nancy). Part of a wider drive to dissolve the divide between the 'major' arts of painting and sculpture and the 'minor' decorative arts, the School of Nancy was established by Émile *Gallé in 1901, principally supported by designers Louis Majorelle, Victor Prouvé, and the glassmaking Daum brothers, August and Jean-Antonin. They aimed to enhance the artistic content of industrially produced articles through the intervention of the craftsman, building on the legacy of the writings of John *Ruskin and William *Morris in Britain. With Gallé as president and Majorelle as vice-president, the School of Nancy mounted an exhibition furthering its ideas in Paris in 1901. Following Gallé's death in 1904, Prouvé became president. The views of the group were often promoted in the periodical *Art et industrie* (1909–14) under the editorship of G. Grouthière-Vernolle.

National Design Awards (established 1997) Inaugurated in 1997 by the *Cooper-Hewitt Museum, America's National Design Museum, the National Design Awards sought to recognize excellence and innovation in design over a period of time. Organized annually they are awarded in response to the opinions of more than 600 architects, designers, writers, teachers, and others

from across the United States who are involved in a wide variety of activities associated with design.

National Institute of Design (NID, established 1961) The establishment of the National Institute of Design in Ahmadabad was the outcome of the Indian government and the Ford Foundation's sponsorship of a three-month visit to India by designers Charles and Ray *Eames. Their brief related to the establishment of a design training programme to support small-scale industry and reverse a deterioration in the quality of consumer goods made in India. The Eameses decided to examine the role of Indian design from a number of perspectives including architecture, anthropology, communications, economics, history, physics, psychology, and sociology. As a result it was proposed to set up an institute of design, research, and consultancy linked to the Ministry of Commerce and Industry. It was recommended that the first intake of the Institute should be about twelve, with an Institute staff of about a dozen with a number of visiting Indian experts drawn from government, design practice, and other such constituencies. The significance of the Eameses' report for the foundation of NID was recognized by the institution's inauguration in 1987–8 of the 'Charles Eames Award'.

The NID went on to play a key role in many national design initiatives, setting up a range of courses and liasing with a number of official bodies and design organizations. Early work included documentation on the crafts, a programme initiated in 1970–1 with the publication of *Rural Craftsmen and their Work*. This was followed by other schemes including the Rural University project, the establishment of training programmes for craftsmen, and the documentation of handloom and handicrafts in a number of key centres including Assam, Meghalaya, and Manipur. Acting also as a design consultancy NID was also frequently involved with practical design projects and external commissions including a number of corporate identity design schemes, including that for the Delhi Transport Corporation (1974–5) and the symbols for Indian Telephone Industries (1978–9), Hindustan Lever Limited (1979–80), and the Calcutta Metro (1983–4). Extending the level and range of its specialist activities NID established a chair in Design Research in 1989. Many links were forged with other art and design educational institutions in India and overseas, including British art and design higher education institutions as discussed with Baroness Blackstone, British Minister of State for Education and Employment, on her visit to NID in early 2001. NID won many awards for its services to design including, in 1977–8 the *ICSID-Philips Award, the first International Award for Design in Developing Countries. In 1985–6 NID also won the Worldesign Award for outstanding achievements in Industrial Design and the Sir Misha Black Memorial Award in recognition of its contribution to design education.

NATO (Narrative Architecture Today) *See* COATES, NIGEL.

Necchi (established 1919) This Italian sewing machine manufacturer was founded in Pavia and produced a number of innovative sewing machines in the 1920s and 1930s that increased the speed and variety of stitching for domestic consumers. After the Second World War the company paid greater attention to industrial design, commissioning Marcello *Nizzoli to produce a number of elegant machines including the *Supernova BU* and *Mirella* sewing machines of 1953 and 1957, both of which

NEO-LIBERTY

From the late 1950s this term was applied to a particular strand of Italian design that looked to *Art Nouveau (known in Italy as Stile Liberty) as a source of inspiration that offered a marked alternative to the rectilinear, clean-formed dictates of *Modernism that had begun to dominate the design landscape of the 1950s. Further undermining the values of the 'machine age' aesthetic of modern design, the term Neo-Liberty also embraced the 'look', if not the reality, of craft-produced furniture. Examples of the style include Achille and Piergiacomo *Castiglione's *Sanluca* chair (1960) for *Gavina and Giotto Stoppino, Vittorio Gregotti, and Lodovico Meneghetti's curvilinear bentwood *Cavour* chair (1960) for SIM. The term was also later used in Spain.

See also LIBERTY & CO.

were awarded the *Compasso d'Oro. In 1964 the firm diversified its range, commissioning Richard *Sapper and Marco *Zanuso to design a knife sharpener. Other well-known designers who worked for Necchi included Giorgetto *Giugaro who designed the *Logica* sewing machine in 1982.

Nederlandische Bond voor Kunst in Industrie (BKI: Dutch Association for Art in Industry, established 1924) The BKI was established in 1924 in collaboration with the newly established (1921) Instituut voor Bond voor Sieren Nijverheidskunst (ISK, Institute of Decorative and Industrial Art). Although associated with progressive Dutch companies such as the Amsterdam-based *Metz & Co. and Rotterdam-based NV Gispen Fabrik voor Metaalbewerking (*see* W. GISPEN & CO.), it failed to have more than a modest impact on design in mass production as it was often felt in such quarters to be somewhat elitist and aesthetically preoccupied rather than fully committed to modern manufacturing technologies. One of the BKI's principal means of promoting its ideals was the medium of exhibitions, the most significant of which was the Dutch Industries Fair at Utrecht although, perhaps significantly, the BKI did not ex-

hibit in that forum until 1936. After the Second World War the BKI continued to participate in exhibitions but in 1951 was merged with the Stichting Industriële Vormgeving (SIV, Industrial Design Foundation, established 1949) to form the Instituut Industriële Vormgeving (IIV, Institute of Industrial Design). In 1951 this organization had the affiliation of 50 companies, which may have played a role emphasizing the vicissitudes of commercial life rather than the more ethereal economic potential of aesthetically sensitized products. In 1954 the IIV became the Instituut Industriele *voor* Vormgeving (IIV, Institute *for* Industrial Design), had 140 affiliates, and was given an enhanced government subsidy. However, during the 1960s the government asked an increasing number of questions about the efficacy of the organization, with further currency given to the idea that if it was important to industry then it should be financed by industry rather than be dependent on state subsidy. Such funding uncertainties had a significant effect on the *Centrum Industriële Vormgeving (CIV, Centre for Industrial Design) in Amsterdam, which the IIV had a hand in establishing in 1962. The IIV lasted until 1976 when government subsidies ceased.

NEO-MODERNISM

This Italian design movement emerged as a counter to the increasingly loose definitions associated with *Postmodernism. As the word *'Modernism' in its title implied there were some ideological links with the attachment to a functional aesthetic and rejection of past styles by the international avant-garde of the 1920s and 1930s. However, Neo-Modernists acknowledged the significance of an *individual* aesthetic as a 'functional' dimension of design, together with their acceptance of a pluralist outlook rather than the search for universal solutions associated with the Modernist cause.

Nelson, George (1907–87) Nelson became a leading figure in post-Second World War American design, architecture, and criticism. The foundations were laid in place when he graduated in architecture at Yale University in 1931, following this with studies in the American Academy in Rome between 1932 and 1934. This European experience led to a series of articles on European *Modernism in the periodical *Pencil Points*, followed by work in an editorial capacity at the progressive and influential *Architectural Forum* (1935–44) and the establishment of his architectural practice in 1936. His progressive outlook was underlined by his book *Tomorrow's House* (1945), co-authored with the designer Henry Wright. Also key to his emergence as a leading figure was his 1946 appointment as design director to the *Herman Miller Furniture Company, for whom he commissioned designs from Charles *Eames and Alexander *Girard. He also designed a number of items of furniture himself, including the *Basic Storage Unit*, which originated from a concept that he had evolved with Henry Wright in 1944—the *Storage Wall*, essentially a room divider with storage units. In addition to lighting, textiles, and interiors, other designs for Herman Miller included the striking *Marshmallow Sofa* (1956), the *Sling Sofa* (1964), the *Action Office* (1964), and *Executive Office* (1971). For the

Herman Miller Clock Company Nelson's designs included the *Ball Clock* (1950) with its contemporary molecular hour marks, and the *Spider Web Clock* (1954), which also made references to progressive 20th-century sculpture. In 1947, with George Chadwick, he had founded his own industrial design consultancy, designing a wide range of interior and exhibition displays including the American National Pavilion at the Moscow International Fair of 1959 (*see* EAMES, CHARLES). In addition to works already cited, Nelson wrote *Problems of Design* (1957) and *How to See* (1977).

Neo-Liberty *See* box on p. 308.

Neo-Modernism *See* box on this page.

Neurath, Otto (1882–1945) *See* ISOTYPE.

New Bauhaus Chicago (1937–8) *See* INSTITUTE OF DESIGN.

New Design *See* box on p. 310.

New Graphic Design (1958–68) Published in Zurich this periodical was founded by members of the Swiss School of Graphic Design, also known as the International Typographic Style, and did much to promote its inherent design values including a reliance on a typographic grid system, left-hand margin settings contrasting with a ragged right hand, sans serif typefaces, and a commitment to a clear, rational aesthetic.

n

NEW DESIGN

This term was widely used in the 1980s to denote a radical alternative to the legacy of the homogeneity of *Fordism and functionalist aesthetic of the *International Style. This notion was closely associated with the outlook of the Italian avant-garde, seen in the writings and exhibitions of Andrea *Branzi, most notably his book *The Hot House: Italian New Wave Design* (1984) and his *Centre Georges Pompidou, Paris, exhibition *European Capitals of the New Design* (1991) in which he looked at the work of the avant-garde in Milan, Barcelona, and elsewhere. It shares many of the preoccupations with form, ornament, and meaning associated with *Postmodernism although Ettore *Sottsass, a key figure in Italian design debates, believed that the latter was American, academic, and restricted in its cultural references. Similar tendencies have been associated with 'The New Graphics' and 'New Wave Design'.

See also SWISS STYLE.

In addition to the English language *New Graphic Design* was published in German as *Neue Grafik* and French as *Graphisme actuel*.

Newson, Marc (1963–) Born in Sydney, Australia, Marc Newson emerged as one of that country's leading designers of the late 20th and early 21st centuries. Labelled by some critics as the 'new *Starck' he has worked across a wide range of disciplines including furniture, interiors, lighting, domestic appliance, and transporation design, and has been commissioned by many major clients including *Alessi, *B&B Italia, *Flos, *Ford, Ideal Standard, Idée, *Nike, *Tefal, Shiseido, and Qantas. His work also features in many of the world's leading design collections including those of the *Museum of Modern Art, New York, the *Vitra Design Museum in Weil am Rhein, the Musée Nationale d'Art Moderne at the *Centre Georges Pompidou, Paris, the *Design Museum, London, and the *Powerhouse, Sydney.

Having travelled widely in Europe and Asia in his teens, Newson returned to Sydney, where he studied jewellery and fine arts at the Sydney College of the Arts, absorbing a wide range of overseas influences from design magazines as a stimulus for furniture design. Rather than any specialist design training, such sources provided major stimuli for his early design work. In 1984 he was awarded a grant by the Australian Crafts Council, culminating in an exhibition in Sydney two years later in which his organic, aluminium-surfaced *Lockheed Lounge* chaise longue featured prominently, catching the imagination of the international design press, where it was widely featured. Other furniture prototypes followed before he moved to Tokyo where he settled from 1987 to 1991 with design ideas such as the *Embryo Chair* (1988) and *Wicker Chair* (1990) being put into production by Idée, a company owned by a Japanese entrepreneur, Teruo Kurosaki. Newson's work was exhibited at the Milan Furniture Fair and led to commissions from the Flos lighting and Cappellini furniture companies before moving on to Paris, where he set up a studio in 1991. It was during the 1990s that he designed a number of interiors including restaurants for Coast (1995) in London, Komed (1996) in Cologne, and a recording studio in Tokyo. Newson moved to London in 1997, establishing a new studio, Marc Newson Ltd., with the ambition of working on larger-scale projects.

He developed an increasing number of products for mass production, working closely with Benjamin De Haan, a computer specialist who became his business partner. In addition to glassware for *Iittala and furniture for Magis and *B&B Italia, Newson worked on a small-scale *021C* concept car for Ford (launched at the Tokyo Motor Show in 1999, and shown at the Detroit Motor Show in 2000), bicycles for the Danish Biomega company, aircraft interiors and seating for the Australian airline Qantas, and the Dessault Falcon *900B* private jct. Other commissions have included relighting the Sydney Opera House for the 2000 Sydney Olympic Games and uniforms for the Australian Olympic Team to be worn in Athens in 2004. Newson's work has been exhibited in a number of major venues including retrospectives in the Powerhouse, Sydney, in 2001–2 and the Groninger Museum in Holland in 2004. Books devoted to Newson's work have been published by Alice Rawsthorne (1999) and Conway Lloyd Morgan (2003).

New Typography *See* TSCHICHOLD, JAN.

New Wave *See* SWISS STYLE.

New York World's Fair (NYWF, 1939–40) In many ways this major international exhibition typified the global economic, commercial, and corporate power and influence wielded by the United States of America by the time of the Second World War. Many of that country's leading companies, such as *General Motors, *Ford, *Chrysler, Kodak, and Westinghouse, contributed major buildings and exhibitions on the Flushing Meadow site and generally sought to portray themselves as major contributors to a utopian future world in which they played a key role in satisfying consumer desires and needs. Typical of this outlook was the representation of an im-

agined world of 1960 in the highly popular *Futurama* display in the General Motors Pavilion by Norman *Bel Geddes or the vision of a futuristic *Democracity* by the industrial designer Henry *Dreyfuss in the Perisphere at the centre of the exhibition site. In some ways it may be seen as a full-blooded expression of the aims that had underpinned the *Chicago Century of Progress Exposition of 1933–4, planned as a testament to a technologically and scientifically progressive America in which major corporations played a key role in the period of recovery following the Wall Street Crash of 1929. However, the NYWF was distinctly more forward looking than other international exhibitions held in the United States in the same decade: the California-Pacific International Exposition at San Diego (1935–6) and the Golden Gate International Exposition in San Francisco designed to celebrate the building of the Golden Gate and Oakland Bay bridges in the city (1939). Fittingly the NYWF came at the end of a decade that had seen the brief rise of the Technocratic Party, the popularization of the medium of science fiction, and emergence of comic strip heroes such as Flash Gordon, Buck Rogers, and Superman.

The NYWF provided a fitting material response to its chosen major theme of 'Building the World of Tomorrow with the Tools of Today'. It took three years to plan and build prior to its opening in April 1939 and the participation of 60 countries, the majority of American states, and numerous powerful companies underlined its international, political, and economic significance, as did the enormous 1,216-acre (492-hectare) site and 300 buildings. The striking and highly visible centrepieces of the exhibition were the Trylon and Perisphere, both of which became widely recognized symbols of the Fair. The soaring, needle-like 700-foot (212-metre) Trylon tower, symbolizing aspir-

ation, and the adjacent Perisphere (the largest ever man-made globe), symbolizing the significance of the world, dominated the site and featured in much of the NYWF publicity, related ephemera, souvenirs, and merchandise. These included Remington *Cadet* typewriters, Bissell carpet sweepers, radios, silverware, and commemorative plates by *Tiffany & Co., numerous fabric designs, postage stamps, comics, magazines, and posters, including Joseph Binder's award-winning design for the NYWF poster competition of 1938. The Perisphere contained Dreyfuss's utopian vision of *Democracity*, a vast panorama of a planned metropolitan environment of 2039 that could be viewed from above by spectators who travelled round the exhibit on revolving balconies, as if in an aircraft, at the rate of 8,000 per day.

The NYWF was planned around several major zones, one of the most significant of which was the Transportation Zone, which included buildings housing the Chrysler, Ford, General Motors, and Firestone exhibitions as well as the Aviation Building, the Marine Transportation Building, the Railroads Building (with industrial designer Raymond *Loewy acting as consulting designer for the Railroads exhibits). The rapidly changing world of modern railways, a rapidly increasing network of passenger aircraft flights, luxury ocean liners, and road transportation was one which had captured the public imagination. The Chrysler Building, whose displays were coordinated by Donald *Deskey, included the Transportation Zone's Focal Exhibit of the History of Transportation as well as a Rocketport of the Future. The latter, coordinated by Loewy, was a *son et lumière* display portraying future passenger flights by rocket between the United States and London. The General Motors Buildings housed the Norman Bel Geddes-designed *Highways and Horizons* exhibit, the most popular of the

entire Fair. Up to 28,000 visitors a day were taken around Bel Geddes's portrayal of an envisaged world of 1960 by means of a moving 'travelator' on which they were seated, as if in a low-flying aircraft. From this vantage point they were able to view a vast panoramic landscape in which experimental farming, hydro-electric power plants, leisure resorts, and dramatically futuristic cityscape were all linked by a multi-lane motorway system. The visitor experience culminated in arrival at a full-scale street intersection of the future where visitors could see contemporary production models of General Motors automobiles (Buick, Cadillac, Chevrolet, LaSalle, Oldsmobile, and Pontiac), buses, and commercial vehicles. Similarly, in the Ford Exposition, visitors experienced the 'Road of Tomorrow', a spiral ramp at the centre of the Ford Building, upon which they could test-drive contemporary Ford, Mercury, and Lincoln automobiles as well as marvel at the 'Ford Cycle of Production' display by Walter Dorwin *Teague.

Also very much in keeping with the NYWF vision of the 'World of Tomorrow' was the Communications and Business Systems Zone, the pavilions of which included those of the Radio Corporation of America and the American Telephone and Telegraph Company with interior displays by Henry Dreyfuss. The former housed a highly popular television exhibit where the public could see in operation this new broadcasting medium, which had been inaugurated in New York on the day of the Fair's opening. Also significant in sustaining corporate and consumers' optimistic visions of the future were many of the exhibits in the Production and Distribution Zone, also highly favoured by visitors who were intrinsically interested in technological and commercial innovation. Typifying such an outlook was the Eastman Kodak Company

Building with interiors designed by Teague and Stowe Myers, where a growing public appetite for snapshot photography and increasingly affordable home movie making was catered for in the varied displays. The Westinghouse Building, at the front of which was positioned the science fiction-like *Singing Tower of Light*, contained a crowd-drawing proto-robot, Elektro, that performed a number of elementary tasks such as talking and counting, accompanied by his robotic dog, Sparko. In the NYWF 1940 season the Westinghouse display included the 'Battle of the Centuries', a staged washing-up competition between Mrs Drudge and Mrs Modern, the former cleaning by hand, the latter with the aid of an electrical dishwasher. Also in the Production and Distribution Zone were the General Electric, Du Pont, and Consolidated Edison Buildings, the latter containing a massive diorama of 'The City of Light'. In a dramatic *son et lumière* performance it portrayed the many varied ways in which the city of New York consumed electricity over a 24-hour period.

The Government Zone contained a number of more traditional style buildings as seen in the Court of the States (of America) in which the historicizing Pennsylvania Building, a replica of Independence Hall in Philadelphia, played an important role. Other buildings reflected aesthetically the stylistic roots of colonial American architecture, visible manifestations of the imperial legacy of France, Spain, and Britain. Many national overseas pavilions and displays also played a major part at the NYWF and included contributions by Britain, France, Italy, the USSR, Belgium, Holland, Japan, Finland, Norway, Sweden, Poland, Czechoslovakia, Argentina, and Brazil.

In essence, the NYWF can be seen as an expression of a commitment to technological progress, eagerly endorsed by many major American corporations that sought to promote in the public's eyes a futuristic utopian era where corporate enterprise was seen to play a beneficial role for society as a whole. Such companies often employed the services of the emerging generation of American industrial designers to act as mediators between the worlds of production and consumption by giving substance to persuasive visions of the future where economic prosperity and technological innovation were portrayed as the necessary underpinnings of vastly improved social and material living conditions. However, such an outlook has also been seen as the means by which powerful American corporations were able to create consumer demand for fresh models, test out future styling possibilities, and familiarize the public with new models. Almost a decade earlier this had been referred to as the process of 'consumer engineering'. After the Second World War such corporate commitment to the unremitting stimulation of increased patterns of consumption gave rise to the populist, yet powerful, critiques of writers such as Vance *Packard and the more trenchant critiques of leftist economists such as J. K. Galbraith in his seminal 1957 text *The Affluent Society*.

Nike (established 1972) This highly successful sports goods and accessories company had its origins in the 1950s with two friends at the University of Oregon in the USA, Bowerman and Knight, the former developing athletic shoe design and the latter going on to study for an MBA at Stanford University. Knight pursued the idea that attractively priced, well-designed, and efficiently marketed Japanese shoes could make inroads into the German domination of the US market. As a result a partnership was established with the Japanese athletic shoe manufacturer Onitsuka Tiger and, in

1962, Bowerman and Knight's company Blue Ribbon Sports (BRS) was established as the sole distributor of Tiger shoes. Following a period of real growth BRS began manufacturing its own shoes in 1971 and opened its first retail outlet in Santa Monica, California. BRS broke with Onitsuka Tiger in 1972, renaming itself Nike (after the Greek goddess of Victory). The new company was launched at the US trials for the 1972 Olympic Games and by 1980 the company went public having captured 50 per cent of the US athletic shoe market. In the 1980s Nike International was formed to cater for a growing overseas market that by 2001 covered more than 100 countries. Underpinning the company's success were a number of innovative business strategies as well as technological innovations such as the introduction of Nike-Air cushioning. In the 1990s the company continued to expand, developing its clothing and accessory lines and purchasing Canstar Sports Inc. the world's largest manufacturer of hockey equipment. In 2001 the company launched the first of its women only, *NIKEgoddess* stores in Los Angeles. These stores were planned as interactive with female consumers providing feedback on the style, design, and performance of Nike products.

Nintendo (established 1889) The Nintendo Company had its roots in the manufacture of Japanese playing cards in Kyoto in the late 19th century. One hundred years later it was the world's leading force in interactive entertainment systems and software. Nintendo has sold more than 1 billion video games, producing and marketing home-centred video-game systems such as Nintendo *64* and *Game Boy*. Although the company has established a prominent position in the field, the company remained as a manufacturer and distributor of playing cards before the Second World War. How-

ever, having begun mass production of plastic cards in the 1950s, it extended its product range to include children's cards featuring Walt Disney characters. This move into a new sector of the consumer market place was highly significant in the company's future spectacular growth. Significantly, in 1963 the company changed its name from the Nintendo Playing Card Co. to Nintendo Co. Ltd. and commenced the manufacture of games. By the mid-1970s these were becoming increasingly sophisticated having incorporated the potential of electronics technology, video-recording, and microprocessors, innovations nurtured through a close working relationship with Mitsubishi Electric. This cooperation resulted in home-use and coin-operated games using microcomputers, the latter involving the launch of the highly successful game *Donkey Kong* (1981). Also important in marketing terms was the establishment of a US subsidiary in 1980, which became Nintendo of America Inc. based in Seattle. The 1980s saw dramatic developments with the marketing of the American version of the Family Entertainment System and the *Super Mario Bros* and *Legend of Zelda* games in 1985 and 1987 respectively. Economically of high importance to the company was the *Game Boy* that became the most popular hand-held computer gaming system in the world, its characteristics of portability, miniaturization, and entertainment appealing to both children and adults. Through skilful marketing, the rapid expansion of games titles, and developments in chip technology the company's success continued to grow, reinforced by the launch of the 16-bit Super Nintendo Entertainment System in 1991. The 64-bit Nintendo was launched in Japan in 1996, with more than half a million games sold on the first day alone; the American launch sold out its entire shipment of 350,000 in three days.

Nippon Design Centre (established 1960) Later becoming one of the largest design production companies in Japan, the Nippon Design Centre was founded in Tokyo through a collaboration of eight investor companies including Nikon, Toshiba, and *Toyota, all of which had an interest in the development of advertising design in Japan. This was a period when a number of Japanese manufacturing companies had already invested in the establishment of industrial design departments and there was the further recognition of the further potential economic benefits that might accrue from higher standards of design in advertising. It brought together the highly influential post-war graphic designers Yusaka *Kamekura (co-founder, working at the Centre until 1962), Ryuichi Yamashiro (co-founder, working there until 1973), and Hiromu Hara (co-founder and president in 1969). Other important designers at the Centre included Ikko Tanaka (from 1960 to 1963), Kazumasa Nagai (from 1960 onwards, including presidency from 1975 to 1986), and Tadanori Yokoo (from 1960 to 1964). Other eminent designers working at the company included Makoto Saito (from 1976 to 1981).

Nissan (established 1911) Masujiro Hahimoto, a graduate of the Tokyo Institute of Technology, was a major figure in the evolution of the Japanese automobile, commencing manufacture at a time when there were less than 300 cars registered in Tokyo. In 1902 he travelled to the USA as a government trainee studying the technology for manufacturing car engines. He established the Kaishiinsha Automobile Factory in Tokyo in order to repair, import, and assemble of foreign cars alongside the manufacture of Japanese cars. The company's first small passenger car was the *Dat* ('Hare', 1914), followed by the *Dat31*

(1915) and *Dat41* (1916). In 1918 the company began the manufacture of military vehicles but later faced some financial difficulties and merged with Jitsuya Jidosha Seizo in Osaka, becoming Dat Jidosha Seizo. The 1920s was an uncomfortable period for the Japanese automobile industry since *General Motors and *Ford had commenced large-scale automobile production of *Model Ts* and Chevrolets in Yokohama and Osaka in 1925 and 1927 respectively, each producing around 10,000 cars per annum. Dat Jidosha Seizo produced Datsuns ('sons of Dat') from 1931 though the company was taken over in 1933 (the year in which Hishimoto retired), changing its name to Nissan in the following year. Datsuns were manufactured at the company's sophisticated Yokohama factory and further technological developments in mass-production techniques were developed through linking up with the Graham-Paige Company in the USA. In 1936 the Automobile Manufacturing Industry Law was passed, leading ultimately to the closure of foreign automobile manufacturers in Japan and paving the way for domestic automobile production on a significant scale. The Nissan *Model 70* saloon of 1937 was derived from the Graham *80 Crusader* of 1936. Like a number of other automobile manufacturers such as Isuzu, after the Second World War Nissan developed links with a foreign manufacturer, in this case with Austin of Britain, and from 1953 began production of the *A40*. Its comfort was far greater than most contemporary Japanese cars and so it proved popular. In 1955 the Datsun *Model 110* was launched in 1955, winning the 2nd *Mainichi Design Award in 1956 for its novel design, manoeuvrability, and levels of interior comfort. During this fiercely competitive period Nissan products also gained a reputation for reliabilty. The *Type 310*, or first generation *Bluebird*, passenger saloon

was launched in 1959, followed by the *Fairlady Model SP310*, a sportscar, in 1953. The Datsun *Sunny* was launched in 1966, the same year as the *Toyota *Corolla*, and was aimed at the mass market. The name 'Sunny was voted for by the public, 8.5 million of whom participated in the naming competition. By the end of 1966 it was selling at a monthly rate of 10,000. Since the 1960s Nissan has achieved worldwide sales and has extended its design research and manufacturing facilities in the United States and Europe.

Nizzoli, Marcello (1887–1969) Most widely known for his designs for office equipment manufacturer *Olivetti, Nizzoli was an important figure in Italian design from the 1920s through to the 1960s. He worked in a number of fields including industrial design, graphic design, and architecture. After graduating in 1913 in architecture, painting, and decoration from the Academy of Fine Arts in Parma he exhibited paintings and embroideries at the *Nuove tendenze* exhibition of 1914. After the war his work in applied arts attracted attention at the 1923 exhibition of decorative arts in Monza, leading to a variety of commissions. From the mid-1920s he became involved with poster design for Bitter and Campari. From the early 1930s he worked with Eduardo Persico on a number of exhibitions and showrooms, including the Parker Showroon in Milan of 1934. In 1938 he was taken on by Adriano Olivetti to work in the company's advertising department. He soon became involved in product design, his first design being the *MC 4S Summa* calculating machine of 1940, produced in collaboration with an engineer Natale Capellaro, with whom he worked on other calculators including the *Divisumma 14* of 1948. In the years immediately following the Second World War Nizzoli

found his true *métier* with classic designs such as the sculptural, clean-formed *Lexicon 80* office typewriter (1948, for which he also designed a poster in 1949), the elegant *Lettera 22* portable (1950), and the *Divisumma 24* calculator (1956). He also designed elegant products with an organic aesthetic for other companies such as *Necchi, for whom he designed the *Supernova BU* and *Mirella* sewing machines of 1953 and 1957, both of which were awarded the *Compasso d'Oro in 1954 and 1957 respectively. Other commissions included cigarette lighters for Ronson (1959) and a cooker and petrol pump for Agip (1960). He was involved with the design of a number of office buildings and housing developments for Olivetti. Amongst many other prizes for his design he was awarded an honorary degree in architecture by Milan Polytechnic in 1966. Many of his products for Olivetti are included in the permanent collection of the *Museum of Modern Art, New York.

Noguchi, Isamu (1904–88) A leading American sculptor strongly influenced by Japanese tradition, Noguchi was also widely known for his furniture for the *Herman Miller Furniture Company and lighting for *Knoll Associates. He was brought up in both countries and studied at the Leonardo da Vinci Art School in New York in 1924 before going to Paris to study under the sculptor Constantin Brancusi in Paris. In the early 1930s he travelled to China and Japan, where he studied many aspects of oriental arts and crafts. In 1935 he designed sets for the choreographer Martha Graham's ballet *Frontier*, working on further sets for Martha Graham productions in the 1940s. Noguchi's first furniture designs in rosewood and glass were for A. Conger Goodyear, the president of the *Museum of Modern Art, New York, in 1939. Following in the spirit of his sculptures

earlier in the 1930s, these were biomorphic in character. His furniture for Herman Miller included a glass-topped coffee table (designed *c*.1940), a rocking stool (*c*.1953), and a *Formica-topped dining table using cast iron and steel rods to support its top (*c*.1953). Noguchi also produced an aluminium table for Alcoa in 1957. From the mid-1940s he produced a series of table lamps for Knoll that took on something of the qualities of Japanese lanterns with simple translucent 'shades' wrapped around simple geometric frames. Following a visit to Japan in 1951 he also began to explore the aesthetic possibilities of folding paper lanterns that were first produced under the name of *Akari* in the early 1960s.

Nokia (established 1865) The roots of this internationally renowned Finnish telecommunications company lay in a number of earlier companies, two of which were established in what became the town of Nokia. The first, established in 1865, manufactured paper and built up an international client base in Russia, Britain, France, and China. It was followed by the Finnish Rubber Works, founded in 1898, whose products were sold under the Nokia brand name in the 1920s. The third, the Finnish Cable Works, was established in 1912 and grew rapidly in tandem with the growth of electricity. All three companies were eventually merged in 1967 as the Nokia Group which, by the early 21st century, employed 24,000 in Finland alone.

Nokia's involvement with telecommunications commenced in the 1960s when, in the competitive national context, it began to invest in research and innovation. By the 1980s the company had emerged as a significant international player, being Europe's third largest television manufacturer as well as a major Scandinavian information technology company. In the recessionary years of the 1990s the company focused on its telecommunications and mobile phone divisions, a strategic aspect of corporate policy following the appointment of Jorma Ollila as chief executive in 1992. Nokia's television and cable interests were sold in 1995 and 1996. Innovation has played a key role in Nokia's success, building on its electronics expertise and the development of semiconductor technology in the 1960s. The company was also quick to move into digital (Pulse Code Modulation: PCM) transmission systems and, following the Swedish example, mobile networks for car phones. The Nordic countries collaborated in the establishment of a common mobile network, the Nordic Mobile Telephony (NMT) system in 1981, the world's first multinational cellular network. It was this breakthrough that facilitated the rapid expansion of the mobile telephone. Nokia remained at the forefront of such developments and, in 1991, the company supplied the standardized Global System for Mobile Communications (GSM) to nine other European countries, expanding globally over ensuing years.

A key figure in the company's design thinking was chief designer and vice-president Frank *Nuovo, who joined the company in the 1990s. His design projects have included the Nokia *232*, *2110*, *2120*, *3110*, *6110*, *8810*, *7110*, and *9110* mobile phones. The design of Nokia products proved attractive to consumers, with a premium on functions, size, and aesthetics. Many industry standard features such as large graphic displays, personalized ring tones, and coloured covers were pioneered by the company, the headquarters of which were housed in a glass-panelled building designed by Finnish architect Pekka Helin and interior designer Iris Hulm, completed in 1997. Nokia first introduced its coloured covers for cellular phones in 1992, following up such thinking with richly patterned and textured casings.

NOVECENTO

This Italian movement originated in the 1920s and was characterized by a modernizing, stripped-down Neoclassical style inspired by the geometric decorative tendencies in the work of the *Wiener Werkstätte and certain aspects of *Art Deco in France. The Novecento group was founded in 1926 and included Gio *Ponti, Emilio Lancia, and Pietro Chiesa. With its stylistic and spiritual links with the architectural forms of Ancient Rome the Novecento style found favour in many buildings in Fascist Italy under its dictator Mussolini, the essentially 'Italian' characteristics of the style being more compatible with the ambitions of the regime than the more 'international' qualities inherent in the more progressive forms of *Rationalist architecture and design. Through architect-designers such as Ponti Novecento's influence was also felt in the decorative arts and crafts including ceramics manufactured by Richard-Ginori.

The idea of mobile phone as fashion accessory was taken to greater extremes with the launch of new ranges of coloured covers for the Nokia *8210* fashion phone at the Nokia Design Gala during Paris Fashion Week in 2000, a corporate involvement initiated in 1999. The phone covers were shown in the context of wearable fashion accessories designed by Nokia Young Designers. Like many other successful companies involved in the manufacture of 'lifestyle' products, Nokia sought a variety of ways to endow its products with cultural resonance. In 1998, for example, the company had launched the Nokia *252 Art Edition* mobile phone for exclusive sales in the Museum Shop of the Solomon R. Guggenheim Museum. By the early 21st century Nokia had become the world's leading supplier of mobile phones and telephone networks and was listed on the Frankfurt, Helsinki, London, New York, Paris, and Stockholm stock exhanges with a global turnover of almost 20 billion euros.

Noorda, Bob (1927–) Noorda is widely known as a graphic, exhibition, product, and environmental designer, having practised in his native Holland, Indonesia,

Italy, and elsewhere. He trained at the Amsterdam Institute of Design between 1944 and 1947. After a spell as a freelance designer in Amsterdam he moved to Milan in 1952, where he won commissions from a number of major clients including *Alfa Romeo, *Philips, and Pirelli, becoming art director for the latter in 1961. He was also a consultant to the retail chain La *Rinascente from 1963 to 1964. In 1965, with Lella and Massimo *Vignelli, Ornella Noorda, and Ralph Eckerstrom, he founded Unimark International, an important design consultancy that soon became a global organization with offices throughout the world. His most notable commissions include the signage for the Milan Subway (in collaboration with Franco *Albini), Franca Helg, and Antonio Piva, the success resulting in further similar commission for subways in New York and São Paolo. He won *Compasso d'Oro awards for the Milan Subway (1964), for the Lombardy regional logo (1979), and the global image of Fusital (1984). He is a member of AGI (*Alliance Graphique Internationale) and has been a member of *ADI (Associazione per il Disegno Industriale) since 1961.

Novecento *See* box on p. 318.

Noyes, Eliot (1910–77) The American in-
dustrial designer Noyes studied architec-
ture at Harvard University from 1928 to
1932, followed by attendance at the Gradu-
ate School of Design from 1932 to 1935 and
again from 1937 to 1938. Developing an af-
finity for a European aesthetic, in 1939 he
worked for the German *Modernists Walter
*Gropius and Marcel *Breuer, whom he had
encountered at Harvard, before becoming
Curator of Industrial Design at the
*Museum of Modern Art (MOMA), New
York, from 1940 to 1942 and 1945 to 1946.
At MOMA he curated the *Organic Design in
Home Furnishings* exhibition (1941–2) in
which Charles *Eames and Eero *Saarinen
came to attention, following on the Modern-
ist drive that had dominated the museum's
exhibitions in the 1930s. After becoming
design director at Norman *Bel Geddes's
design office in 1946, he started his own
design consultancy in the following year.
Having worked previously as a consultant
to the company, in 1956 he became design
director at *IBM, where he brought in the
graphic designer Paul *Rand to create the
company's corporate identity and commis-
sioned Eames to work on IBM exhibitions
and films, and Breuer to design buildings.
He was influenced by the corporate design
policy of the Italian office equipment com-
pany *Olivetti and endowed IBM buildings,
interiors, products, and publicity with a
modern, efficient, and technologically so-
phisticated look. Amongst Noyes's best-
known designs for the IBM was the clean-
formed, almost sculptural *Selectric* golfball
typewriter (1961). He also worked on corpor-
ate identity design for Westinghouse (1960–
76), and as design consultant to Mobil
(1964–77), the Cummins Engine Company
(1953–77) and Pan Am (1969–72). His influ-
ence on design thinking was also felt

through his presidency of the Aspen *Inter-
national Design Conferences that com-
menced in 1951. He also wrote a number of
articles on design for the magazine *Consumer
Union Reports*, the public mouthpiece of the
*Consumers' Union, which was an import-
ant pressure group for educated consumers.

Nuovo, Frank (1961–) Perhaps most
widely known for his post as vice-president
and chief designer for the *Nokia telecom-
munications company, Frank Nuovo
trained at the Art Center College of Design
in Pasadena, California, where his studies
included product and automotive design as
well as graphics and communications
design. In the 1980s he worked for Design-
works USA/BMW, an international design
consultancy led by Charles Pelly. Nuovo's
projects for Designworks included furni-
ture, medical instrument, and electronics
design, as well as the design directorship
of Nokia products. Nuovo joined Nokia in
the 1990s where his design projects have
included the Nokia *232, 2110, 2120, 3110,
6110, 8810, 7110,* and *9110* mobile phones.
He also became the creative director and
designer of the Vertu communications com-
pany, a Nokia offshoot. Nuovo's profes-
sional and design-related experience also
encompassed membership of the *Indus-
trial Designers Society of America and the
Business Board of the National Museum of
Modern Art. He has also had a significant
involvement in design education, including
teaching at the University of Industrial Arts
in Helsinki, Domus Academy in Milan,
and the Art Center College of Design in
Pasadena.

Nurmesniemi, Antii (1927–) A leading
Finnish product and interior designer
whose prolific output did much to shape
the visual appearance of everyday life
in Finland in the second half of the 20th
century, as well as to establish Finnish

design in the international arena. Nurmesniemi trained at the Institute of Industrial Arts at Helsinki before entering into an architectural practice from 1951 to 1956. In 1953 he married Vuokko *Nurmesniemi, a leading textile designer for *Marimekko, and, following the establishment of his design studio in Helsinki in 1956, he and his wife exhibited together at the *Artek Gallery in the following year. Antii showed brightly coloured enamelled coffeepots for Wärtsila and plastic lamps for Artek, attracting wider international attention at the 1960 *Milan Triennale with his elegant yet functional *Triennial Chair*. His reputation was further enhanced by winning the prestigious *Lunning Prize in 1959 and a Gran Premio at the Milan Triennale of 1964 for his laminated beech *Sauna Stool*, first designed for the Palace Hotel, Helsinki, in 1952. He continued to design furniture in the 1970s and 1980s, decades in which he was also involved with carriage design for the Helsinki Metro (1968–77), interiors for the Finnish cruise ship *Finnjet* (1976–8), the *Slim* phone for Fujitsu in Japan (1984), and furniture for *Cassina in Italy (1985). His work was widely recognized through awards, including the medal of the *Society of Industrial Artists and Designers (1981), an honorary *Royal Designer for Industry (1986), and the *Japan Design Foundation Prize (1991). He was also the president of the Finnish Designers' Association (1977–82) and served on the Board of the *International Council of Societies of Industrial Design from 1979 including a term as its president between 1989 and 1992.

Nurmesniemi, Vuokko (1930–) A Finnish textile, dress, ceramic, and glass designer of considerable importance Vuokko Nurmesniemi (née Eskolin) initially trained at the Institute of Industrial Arts at Helsinki from 1948 to 1952 before working at the *Arabia factory from 1952 to 1953. In the same year she married the product and interior designer Antii *Nurmesniemi and began working as chief designer for the textile and clothing enterprise *Marimekko, the creative offshoot of the Printex textile company. Her textiles were characterized by large patterns and bold colours and she also designed casual clothing for men as well as women and was soon recognized as Finland's leading fashion designer. In 1964 she established her own company under the name Vuokko, concentrating on furnishing textiles and ready-to-wear designs. She won a number of awards including a Gran Premio for glass design at the *Milan Triennale of 1957, the *Lunning Prize (1964), the Finnish National Prize for Design (1969), and the Prize of the *Japan Design Foundation (1991). She was elected as an Honorary *Royal Designer for Industry (1988).

Nylon Otherwise known as polyamide, nylon is widely used in textiles, carpets, brushes, and, in moulded form, in a variety of products from curtain tracks to engineering components. The first commercial nylon was manufactured in the United States by the Du Pont Company, the result of over ten years of research and development. First used in toothbrushes it was soon used in the manufacture of stockings (1939), selling more than 64 million pairs in the first year of production. It was also exhibited at the Du Pont Pavilion at the *New York World's Fair of 1939. After the Second World War it became increasingly widely used in textiles, carpets, and clothing. In the 1960s nylon was used in the manufacture of synthetic turf, first marketed as *Astroturf* in the USA.

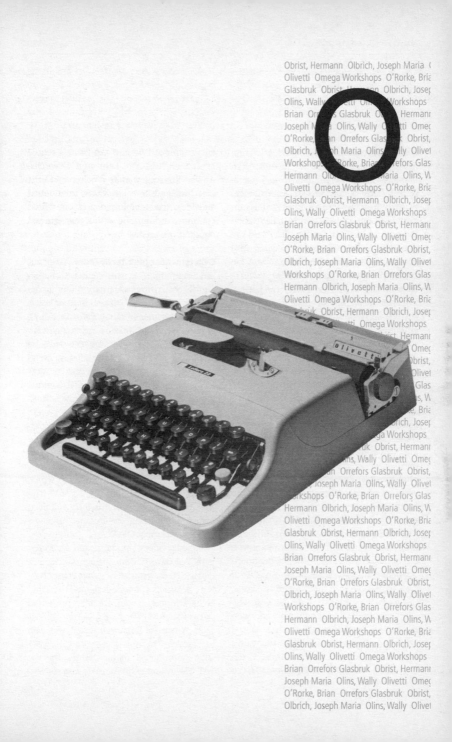

Obrist, Hermann Olbrich, Joseph Maria (
Olivetti Omega Workshops O'Rorke, Bria
Glasbruk Obrist, Hermann Olbrich, Jose
Olins, Wally Olivetti Omega Workshops
Brian Orrefors Glasbruk Obrist, Hermann
Joseph Maria Olins, Wally Olivetti Omeç
O'Rorke, Brian Orrefors Glas ruk Obrist,
Olbrich, Joseph Maria Olins, Wally Olivet
Workshops O'Rorke, Brian Orrefors Glas
Hermann Olbrich, Joseph Maria Olins, W
Olivetti Omega Workshops O'Rorke, Bria
Glasbruk Obrist, Hermann Olbrich, Jose
Olins, Wally Olivetti Omega Workshops
Brian Orrefors Glasbruk Obrist, Hermann
Joseph Maria Olins, Wally Olivetti Omeç
O'Rorke, Brian Orrefors Glasbruk Obrist,
Olbrich, Joseph Maria Olins, Wally Olivet
Workshops O'Rorke, Brian Orrefors Glas
Hermann Olbrich, Joseph Maria Olins, W
Olivetti Omega Workshops O'Rorke, Bria
Obrist, Hermann Olbrich, Jose
Olivetti Omega Workshops
Obrist, Hermann
Omeç
Obrist,
Olivet
Glas
s, W
Bria
rich, Jose
ga Workshops
uk Obrist, Hermann
ns, Wally Olivetti Omeç
an Orrefors Glasbruk Obrist,
Joseph Maria Olins, Wally Olivet
rkshops O'Rorke, Brian Orrefors Glas
Hermann Olbrich, Joseph Maria Olins, W
Olivetti Omega Workshops O'Rorke, Bria
Glasbruk Obrist, Hermann Olbrich, Jose
Olins, Wally Olivetti Omega Workshops
Brian Orrefors Glasbruk Obrist, Hermann
Joseph Maria Olins, Wally Olivetti Omeç
O'Rorke, Brian Orrefors Glasbruk Obrist,
Olbrich, Joseph Maria Olins, Wally Olivet
Workshops O'Rorke, Brian Orrefors Glas
Hermann Olbrich, Joseph Maria Olins, W
Olivetti Omega Workshops O'Rorke, Bria
Glasbruk Obrist, Hermann Olbrich, Jose
Olins, Wally Olivetti Omega Workshops
Brian Orrefors Glasbruk Obrist, Hermann
Joseph Maria Olins, Wally Olivetti Omeç
O'Rorke, Brian Orrefors Glasbruk Obrist,
Olbrich, Joseph Maria Olins, Wally Olivet

Obrist, Hermann (1862–1927) A leading figure in the evolution of *Jugendstil in Munich, Obrist was influenced in his creative outlook by the *Arts and Crafts Movement, which he had encountered when visiting Britain in 1897. Obrist had studied the natural sciences at Heidelberg and applied arts at Kalsruhe before setting up a tapestry workshop in Florence in 1892. He moved his workshop to Munich two years later and, 1895, was featured in the periodical *Pan. He attracted particular critical attention in 1896 when he exhibited 35 embroideries that showed the ways in which natural forms were reinterpreted in a more abstract fashion. Bringing together his interests in the natural sciences and the applied arts, his famous dramatic 'Alpenveilchen' (Alpine Violet) tapestry, with its flowing organic 'Whiplash' rendering of the plant, has become almost a visual trademark of the Jugendstil. Such work influenced August *Endell, especially the latter's external decoration on the Elvira photographic studio (1897–8). Together with Richard *Riemerschmid, Bruno *Paul, and others, Obrist was one of the founding members of the influential *Munich Vereinigte Werkstätten für Kunst im Handwerk (United Workshops for Art in Handcraft) in 1897 and worked in ceramics, tapestry, embroidery, and metalwork. As a crafts collective with their own workshops, the workshops sought to design aesthetic everyday objects and soon put their organization on a commercial footing. Obrist exhibited furniture in Riemerschmid's *Room for an Art Lover* at the 1900 *Paris Exposition. He went on to influence the

curriculum of Wilhelm Debschitz's school of applied arts, the Lehr und Versuchs-Atelier für Angewandte und Freie Kunst (Teaching and Research Studio for Applied and Free Art), established in 1903. Obrist continued as a prolific writer, teacher, and design propagandist.

Olbrich, Joseph Maria (1867–1908) An important figure in the Vienna Secession and the *Darmstadt Artists' Colony at the turn of the century, Olbrich was an architect and designer in many fields including graphic design, wallpapers, interiors, furniture, and lighting. From 1894 to 1896 he worked in the office of the Viennese architect Otto Wagner, where he met another leading figure in the applied arts in Vienna, Josef *Hoffmann. Olbrich, Wagner, Hoffmann, Koloman *Moser, and others were involved in the foundation of the progressive Vienna Secession in 1897, Olbrich also designing the decorative Secession Building in Vienna in 1898, as well as the poster for the second Secession exhibition, in which his wallpapers were also included. Furniture and interior commissions followed before 1899 when he became involved with the Darmstadt Artists' Colony and designed houses, studios, and galleries. Whilst at Darmstadt he influenced the outlook of the progressive designer Peter *Behrens. In 1900 Olbrich designed the Gold Medal-winning room that represented Darmstadt at the *Paris Exposition Universelle, where his Viennese Room was also included in the Austrian section. In 1901 Olbrich produced many designs for the 1901 Darmstadt exhibition. He also showed

a suite of three rooms at the Turin exhibition of 1902 and a further series of rooms at the St Louis Exposition of 1904, winning the Grand Prix and a Gold Medal. He worked for a number of companies including the Rheinische Glashütten, the Metallwarenfabrik Gerhardi Cie, Hueck, and Oscar Winter, for whom he designed modern stoves. He was also involved in designing interiors for the North German Lloyd company's ocean liner, the *Kronprinzessin Cäcilie*, inaugurated in 1907.

Olins, Wally (1930–) *See* WOLFF OLINS.

Olivetti (established 1908) For much of its history the Olivetti company has embraced the highest aesthetic standards throughout its corporate activities: architecture, interiors, advertising, graphics, corporate identity, as well as its manufactured products—office and computing equipment and office furniture. It has also played a prominent part in the sponsorship of major exhibitions, has been the subject of an exhibition at the *Museum of Modern Art, New York, and developed an enlightened corporate social welfare policy. In 1974 the success of the company's corporate identity policy was recognized by the American Institute of Architects. It awarded Olivetti its Industrial Arts Medal 'for a history of excellence in communicating its image through product design, corporate communications, architecturally distinguished manufacturing and merchandising facilities, and sponsorship of numerous social, educational, recreational, and cultural programmes for both its employees and the public at large'.

The company was founded by Camillo Olivetti in Ivrea in northern Italy in 1908, commencing production with his *M1* typewriter in 1910. However, it was not until the 1920s that the company began to modernize its business and production methods, following an extended visit to the United States in 1925 by Camillo's son, Adriano. The latter was to play a key role in developing a coherent corporate identity policy, commencing with the establishment of an advertising office in 1928. Following Adriano's appointment as general manager in 1933, a number of leading architects and designers were brought in to develop the *Modernist aesthetic that was to pervade all of the company's activities. These ranged from advertising and publicity to the design of office equipment, factory buildings, and housing for its employees. Amongst this first wave of notable designers employed to project the progressive face of Olivetti was the Swiss-born *Bauhaus graduate Alexander ('Xanti') Schawinsky, who was involved with graphic and product design for Olivetti from 1933 to 1936. He was joined by Marcello *Nizzoli, a graphic and exhibition designer, who became the company's chief design consultant in 1936, the same year in which the artist and graphic designer Giovanni Pintori joined the company. Both Nizzoli and Pintori worked on architectural, product, and publicity design, the latter field also being one in which the graphic design company Studio Boggeri played a significant shaping role. The *Rationalist architects Luigi Figini and Gino Pollini underlined the progressive image of the company in their design of Olivetti housing and factory buildings in 1939. Products from this period included the *Studio 42* typewriter of 1935 by Schawinsky, Figini, and Pollini and the *MC 4S Summa* calculator of 1940 by Marcello Nizzoli. In the post-Second World War era the company boosted its overseas markets by opening in the United States in 1946, commencing with a sales outlet in New York and further consolidated with the establishment of the Olivetti Corporation of America, also in New York, in 1950. In 1959 Olivetti also acquired a 30 per cent interest

in the Underwood Company in the USA, collaborating in research, development, and production of office equipment. Olivetti's commitment to high-quality design continued to evolve alongside an enlightened social welfare policies for its employees. The rounded, sculptural appearance of Nizzoli's *Lexicon 80* typewriter of 1948 was very much in tune with a widespread contemporary interest in organic form that could be found in other noted Italian designs such as *Pininfarina's *Cisitalia Berlinetta* of 1946 or Gio *Ponti's *La Pavoni* coffee machine of 1949. Similar tendencies could also be seen in the work of Charles *Eames and Eero *Saarinen in the United States, illustrated in *Domus*. Nizzoli's lightweight *Lettera 22* typewriter of 1950 attracted considerable attention and was included in the 1952 Olivetti Exhibition at the Museum of Modern Art in New York. Taking over from Nizzoli, Ettore *Sottsass was appointed as Olivetti's chief design consultant in 1958 and attracted attention for the clearly articulated design of the *Elea 9003*, the company's first mainframe computer. A number of typewriters followed including the *Praxis 48* typewriter of 1964 (with Hans von Klier) and the bright red *Valentine* portable of 1969 (with Perry King, *see* KING-MIRANDA ASSOCIATI). Mario Bellini, another leading figure in Italian design, executed many designs for Olivetti from the 1960s to the 1980s, including the striking orange *Divisumma 18* calculator of 1972 with soft keyboard and the *Praxis 35* typewriter of 1980. Radical designer Michele *De Lucchi, who had been appointed as a design consultant to Olivetti in 1979, became head of the design department in 1992, concentrating on the design of electronic products and computers such as the *Filos 33* notebook of 1993 and the *Echos 20* laptop of 1995. Olivetti was also noted for its office furniture design, prominent examples of which included the *Arcos* office furniture system designed by BBPR in 1960, the innovative *Synthesis 45* system of the 1970s by Ettore Sottsass and the *Ephesos* system of 1992 by Antonio *Citterio. As well as through the commissioning of buildings by notable architects, Olivetti pursued its commitment to a coherent, design-rich ethos by commissioning leading companies and designers to fashion its interiors. For example, the BBPR design studio designed the company's offices in New York in 1954, Carlo *Scarpa the Olivetti showroom in Venice in 1957, and Gae *Aulenti the Paris offices in the following decade. From 1969 onwards Olivetti's corporate identity was developed further by the Czech graphic and product designer Hans von Klier, working with Perry King and C. Castelli. During the 1970s, like many other manufacturers, Olivetti experienced financial difficulties but, under the new management of Carlo De Benedetti in 1978, recovered in the following decade with research collaborations with the American company AT&T commencing in 1983. In 1998 the Archivio Storico Olivetti (Olivetti Historical Archive) was opened in Ivrea, providing ample evidence of its corporate commitment to high standards of design, cultural projection, social welfare, and education for much of the 20th century.

Omega Workshops (1913–19) Founded in London by the British critic, painter, and designer, Roger Fry, the Omega Workshops provided a number of fine artists with the opportunity to work in a number of design fields including, furniture, interiors, textiles, carpets, and ceramics. Two leading members of the Bloomsbury Group, Vanessa Bell and Duncan Grant, were Fry's co-directors. Fry had been an important promoter of French avant-garde art in London, and Omega artist-designers showed a famil-

iarity with the work of Matisse, the Fauves, and Cubists in their bold, brightly coloured decorative work. The outlook of the *Wiener Werkstätte was also significant, particularly its interest in the idea of *gesamtkunstwerk* or total work of art and was evident in the Omega Workshops' Post-Impressionism Room for the 1913 *Ideal Home Exhibition and the interior of the Cadena Café in Westbourne Grove, London, in 1914. For the Cadena Café the Omega artist-designers designed the floor rugs, lamps, and murals as well as the waitresses' uniforms. Other designers connected with the group included Wyndham Lewis, William Roberts, and Frederick Etchells. The Omega Workshops' clientele was largely drawn from the fashionable and wealthy but the venture failed soon after the end of the First World War.

O'Rorke, Brian (1901–74) New Zealand born O'Rorke was a well-known *Modernist designer who was trained in architecture at Cambridge University and the Architectural Association, London. His reputation was made as a designer for the Orient Line luxury steamships, particularly the *Orion* liner (1934–5), featured in the pro-Modernist *Architectural Review* in 1935, and the *Orcades* (1937). Working closely with the Orient Line's owner, Kenneth Anderson, who was anxious to give his ocean liners a clean, modern aesthetic, O'Rorke also designed furniture and chairs. Other designers commissioned by Anderson included Edward McKnight *Kauffer and Marion Dorn. O'Rorke was also responsible for many other interiors for aircraft and trains as well as domestic and commercial commissions that included the Berkeley Hotel, London, and the Mayor Gallery, London (1933). The latter was an important promoter of Modernism, showing the work of avant-garde artists, architects, and designers including members of *Unit One. O'Rorke also designed the Royal Observatory, Herstmontceux, built between 1953 and 1958.

Orrefors Glasbruk (established 1898) With roots in ironmaking in the early 18th century, this Swedish company commenced production of bottle glass and cheap tableware in 1898. Today it is widely recognized as one of the best-known representatives of Swedish art industry and epitomizes the tensions between craft ethos and mass-production economies of scale. For much of the 20th century the company was renowned for its technical innovations and decorative aesthetic, producing both everyday household and artistic pieces. Conscious of heritage Orrefors established its own museum in 1957. Although master glassblowers were employed shortly before the First World War it was not until the arrival of two artists—Simon Gate in 1916 and Edvard Hald in 1917—prompted by the Swedish Society for Industrial Design, that the company began to gain an international reputation. Through their exploration of the Expressionist *graal* technique and a combination of *Modernist forms with classical motifs, Gate and Hald's elegant engraved crystal designs increasingly attracted widespread critical acclaim. Having launched a school for craftsmen at the factory in 1924, with six Grand Prix awards Orrefors further consolidated its international reputation at the 1925 *Paris Exposition des Arts Décoratifs et Industriels where many other fields of Swedish design also made a significant impact. The 1930 *Stockholm Exhibition, with its emphasis on *Functionalism, led to a re-evaluation of the company's outlook. Hald became Orrefors's managing director from 1933 to 1944, during which time the innovative *Ariel* technique was introduced. Although such

techniques continued to be explored by designers like Edvin Öhström and Vicke Lindstrand through the 1940s and 1950s there was a general post-war move towards a clean, refined aesthetic. This was typified in the work of Nils Landberg whose *Tulip* glasses were awarded a gold medal at the *Milan Triennale of 1957. The wider cultural and aesthetic shifts of the 1960s were reflected in the dynamic, colourful work of Gunnar *Cyrén, whilst in the 1970s there was a marked shift towards sculptural, non-functional designs as in the output of Eva Englund, whose work proved highly collectable. Furthering such tendencies the company began production of signed, limited edition art glass collections in 1988. In 1990 Orrefors merged with Kosta Boda and was taken over by Royal Copenhagen in 1997.

Packard, Vance Pan Panton, Verner Pap
Paris Exposition des Arts Décoratifs et Ind
Paris Exposition des Arts et Techniques da
[1937] Paris osition erselle [1900
Bruno Paulss Gregor Penguin Bc
Pentagram P and, Cha te Perspex
Peugeot Pevs phenol-forma
photomontag Piaggio Pilditch, James
Playmobil Plc De plywood Poiret, Pa
Corporation ethylene polypropylene
polyurethane polyvinyl chloride Ponti, G
Pop Porsche Porsche Design Studios Po
Pottery Gazette Poulsen Powerhouse Mu
Praesens Premios Nacionales de Diseño
Productivism product semantics Prouvé,
psychedelia Pucci, Emilio Puiforcat, Jean
Punk Push Pin Studio PVC Pyrex Packa
Panton, Verner Papanek, Victor Paris Exp
Décoratifs et Industriels [1925] Paris Exp
Techniques dans la Vie Moderne [1937]
Universelle [1900 only] Paul, Bruno Pau
Penguin Books Pensi, Jorge Pentagram
Perspex Pesce, Gaetano Peugeot Pevsne
 enol-formaldehyde Philips photomon
 James Pininfarina Playmobil Plc
 Polaroid Corporation polyethl
 olythene polyurethane
 i) Pop Porsche Porsc
 ry Gazette Poulsen
 ns Premios Nacic
 ism product ser
 ucci, Emilio Pu
 Pin Studio PV
 Papanek, Vic
 fs et Industrie
 echniques da
 on Universelle [1900
Bruno Paulsson, Gregor PEl Penguin Bc
Pentagram Perriand, Charlotte Perspex
Peugeot Pevsner, Nikolaus phenol-forma
photomontage Piaggio Pilditch, James
Playmobil Ploeg, De plywood Poiret, Pa
Corporation polyethylene polypropylene
polyurethane polyvinyl chloride Ponti, G
Pop Porsche Porsche Design Studios Po
Pottery Gazette Poulsen Powerhouse Mu
Praesens Premios Nacionales de Diseño
Productivism product semantics Prouvé,
psychedelia Pucci, Emilio Puiforcat, Jean
Punk Push Pin Studio PVC Pyrex Packa
Panton, Verner Papanek, Victor Paris Exp
Décoratifs et Industriels [1925] Paris Exp
Techniques dans la Vie Moderne [1937]

Packard, Vance (1914–96) Vance Packard was an American writer who brought many of the more unpalatable consequences of consumerism in the industrialized world to the attention of the public in an accessible manner. Having graduated from Pennsylvania State University in 1936 he followed a journalistic career, working for a number of newspapers and the Associated Press before taking up the editorship of *American* magazine from 1942 to 1946. His widely read book *The Hidden Persuaders* of 1957 was a strident attack on the American advertising industry, in which he drew attention to the ways behavioural psychologists, colour analysts, and others were able to persuade consumers to buy products they often neither wanted nor needed. This was followed by other texts including *The Waste Makers: A Startling Revelation of Planned Obsolescence* (1960), *The Naked Society* (1964), and *The People Shapers* (1977). Packard was very much part of a tradition of criticism of industrialized society which ran from the writings of John Ruskin and William Morris in the 19th century through to Naomi *Klein in the 21st.

Pan (1895–1900) This short-lived journal carried many avant-garde writings, poems, and paintings. The art critic Julius Meier-Graefe, who had done much to secure funding and royal patronage, was its first editor. However, within months of the first issue he was dismissed, marking the internal wrangling with which *Pan* was beset during its brief existence. It carried articles by contemporary and highly influential figures in art and design such as the

designer Henry van de *Velde and the philosopher Nietzsche. After its demise in 1900, *Pan*'s graphic work was purchased by Hamburg Museum alongside other *Art Nouveau materials, including artefacts from the *Paris Exposition of 1900.

Panton, Verner (1926–98) One of the most celebrated designers of modern chairs in the second half of the 20th century, Panton was renowned for his experimentation with materials and form. He also designed interiors, lighting, and textiles as well as experimental housing such as the 1957 Cardboard House and 1960 Spherical House. After training as an architectural engineer at the Odense Technical School (1944–7) he studied at the Royal Danish Academy of Fine Arts in Copenhagen (1947–51), followed by a spell in Arne *Jacobsen's architectural offices between 1950 and 1952. Three years later he set up his own studio (first in Denmark, from 1955 to 1962, briefly in France and then Switzerland, from 1962) and began a series of experimental chairs. His progressive reputation was furthered by his display of the Applied Arts section of the Fredericia Furniture Show of 1958 where furniture was shown hanging from the ceiling of the stand. After a series of striking furniture designs such as the *Cone* chair of 1958, the *Heart* chair of 1959, and the *Wire Cone* chair of 1960 (all for Plus-linje in Copenhagen) he came to international attention with his 1960 elegantly curved, cantilevered stacking *Panton* chair. This was moulded from a single piece of plastic and available in a range of bright colours. It subsequently

became a design icon of the 1960s. Although Dansk Acryl Teknik made the original mould in 1960 a number of technical difficulties prevented the chair being put into production until 1967 when *Vitra manufactured it for *Herman Miller. More than a quarter of a million of these designs were sold. In search for a less constraining environment for design experimentation Panton had moved from Denmark to Switzerland in the early 1960s. He also designed lighting for *Louis Poulson & Company, notably the enamelled, colourful *Flower Pot* series of 1968. He also designed for the Bayer chemical company, who wanted to showcase their materials innovations such as synthetic fibres and foam plastic. He responded with such futuristic and psychedelically tinged environments as *Visona 2* of 1970 at the International Furniture Fair in Cologne. He continued designing for a variety of companies including lighting for the Holmegaard in Norway, furniture for Erik Jørgensen in Denmark and *Cassina in Italy, and carpets and textiles for Unica Vaev in Denmark. Panton received recognition for his work through a number of awards including the International Design Award from the American Institute of Decorators (1963, 1968, and 1981) and the IF prize in Japan in 1992.

Papanek, Victor (1925–99) Papanek came to public attention as a critic of industrial design culture with his 1971 book, *Design for the Real World*, which takes its place within the context of a chain of social and cultural critiques in the second half of the 20th century from Vance *Packard to Naomi *Klein. Although Papanek's book was turned down by twelve publishers prior to publication, it has since been published in more than twenty languages and captured the imagination of generations of design students and others questioning the lack of a sense of social responsibility in the design profession. Nonetheless, the extent to which the text actually influenced the design profession in any significant way is open to question.

Born in Vienna, Papanek emigrated to the USA in 1939. Nine years later he graduated with a diploma in architecture and industrial design at the Cooper Union, New York. He taught at the Ontario College of Art from 1954 to 1959, was a visiting professor at Rhode Island School of Design, and lectured at many other institutions. He established a design consultancy in 1964 with an international clientele including Volvo in Sweden. Having established his critical position with *Design for the Real World: Human Ecology and Social Change*, he went on to write texts such as *Nomadic Furniture* (1974) and *How Things Don't Work* (1977) with James Hennessey. Other texts have included *Design for Human Scale* (1983) and *Viewing the Real World* (1983).

Paris Exposition des Arts Décoratifs et Industriels Modernes (1925) This important exhibition gave the name *Art Deco to a rich vein of decorative design across a wide range of applications, from cinemas to ceramics, textiles to tableware, and graphics to gramaphones. The underlying aim of the landmark 1925 international exhibition in Paris—the centre of the contemporary arts world—was to re-establish French decorative arts, fashion, and luxury goods at the forefront of international developments in the field. There had been increasing concern about the diminishing standing of French work in design and the decorative arts in the years before the First World War, with economic and aesthetic competition from German manufacturers and designers in particular giving increasing cause for comment. During this period there were a number of proposals to mount

an international exhibition as a means of showing French decorative arts to advantage. The first of these was a response to the Exposizione Internationale in Milan in 1906, with a further initiative coming from the *Societé des Artistes Décorateurs in 1911 and voted on by the Chambre des Deputés in the following year. However, the original plans to hold such a display of modern decorative arts that linked art, crafts, and industry in 1915 were postponed in 1914 since it was felt that more time was needed to show French goods and expertise to telling advantage. After the First World War, largely due to economic uncertainties, the proposed exhibition was eventually put back to 1925. In keeping with the promotion of her national interests, supported by the Ministries of Commerce and Fine Arts, French manufacturers, decorative artists, craftsmen, and retailers dominated the 1925 exhibition. The majority of exhibiting nations were European, although Germany was not invited to participate until it was too late for her to make a credible contribution. The United States was another notable absentee, declining on the grounds of having insufficient original designs to exhibit, although the refusal was more likely to have been for economic reasons than any real inability to comply with the exhibition regulations that 'strictly excluded' all copies and imitations of old styles. The ethos of the 1925 Exposition was epitomized by the outlook of leading designer of luxury goods and cabinetmaker Jacques Émile Ruhlmann. The lavish, brightly coloured interiors for his Pavilion of a Wealth Collector contained the work of many leading contemporary French craftsmen, characterized by a use of expensive materials and high-quality decorative motifs. His own furniture designs drew on the traditions of French craftsmanship but were also infused with an unmistakably contemporary feel. Prominent also

was the work of the influential Societé des Artistes Décorateurs (SAD) displayed in the 25 'Reception Rooms and Private Apartments of a French Embassy', supported by the patronage of the Minister of Fine Arts, designed by architect Charles Plumet. Amongst designers whose work was featured prominently in this often exotic setting were Pierre Chareau, Maurice Dufrène, Jean Dunand, Paul Follot, André Groult, René Herbst, and Francis Jourdain. Fashion itself was a major aspect of the exhibition, including the work of leading couturiers such as Lanvin, Jenny, and Worth seen in the Pavillon de l'Élégance. Also of note were the couturier Paul Poiret's popular displays aboard three large barges moored on the Seine, Sonia Delaunay's 'simultaneous' clothing and textiles in the Boutique Simultané on the Pont Alexandre III, and the fashion exhibits in the pavilion of the French fashion magazine *Fémine*. Many of the leading firms associated with luxury goods such as Christofle for goldsmithing and Baccarat and Lalique for glass had prominent displays, the latter with a striking Lalique-designed fountain at the front of its pavilion. Lalique's work was also seen elsewhere in the French displays, including his dining room for Sèvres Porcelain with its walls of inlaid glass mosaic. A more commercial edge was given by the pavilions of the decorative arts studios of Paris's leading department stores—Studium Louvre (under Étienne Kohlmann and Maurice Matet) of the Magazins des Louvres, La Maîtrise (under Maurice Dufrène) of Galeries Lafayette, Pomone (under Paul Follot) of Bon Marché, and Primavera (under René Guilleré) of Grand Magazins du Printemps. The many shops on the *Rue des Boutiques* on the Pont-Alexandre III and the Esplanade des Invalides also played a key role in promoting French design to a more bourgeois audience. Strictly opposed to this spirit of

luxury, handcrafted goods was Le *Corbusier's Pavillon de l'Esprit Nouveau, whose *Modernist, machine age forms were in tune with a vision of design firmly embedded in the 20th century. Embedded within a rational outlook the Pavillon was characterized by a lack of decoration and expensive handicrafts as well as a commitment to modern technologies, new materials, and an industrial aesthetic. Amongst the items of furniture displayed were the spartan forms of standardized *Thonet chairs and Le Corbusier's own designs that incorporated the use of tubular steel. There were also many foreign pavilions built for the 1925 Paris Exposition. Remarkably modern in spirit was the *Constructivist USSR Pavilion designed by Konstantin Melnikov, containing within it avant-garde furniture and settings by Alexander *Rodchenko and others. In the USSR and a number of the national pavilions there were significant displays of indigenous, vernacular, and 'folk' art, albeit infused with a contemporary edge. These included many of the Cracow School-inspired contents of the Polish Pavilion such as the decorative frescoes of peasant festivals by Zofia Stryjenska and the *vernacular-inspired interiors and office chair by Józef Czajkowski's office. Similar tendencies were also apparent in many of the displays and objects of the Czechoslovakian and Austrian Pavilions, the latter including the folk art ethos pervading the painted floral motifs interior of the Salle des Vitrines by Christa Ehrlich. Other significant trends also emerged at the 1925 exhibition, notably more widespread attention to the neoclassically tinged grace and elegance of Scandinavian design. Although the Finnish and Norway contributions were modest, Sweden and Denmark had their own national pavilions as well as displays in the Grand Palais. In particular, Swedish furniture by Gunner Asplund and by Carl

Malmsten for the AB Nordiska Kompaniet, glass by Simon Gate for *Orrefors, and ceramics by Edward Hald and Wilhelm *Kåge for *Gustavsberg attracted favourable critical attention. This interest was taken further with the extensive displays of Swedish design and architecture at the *Stockholm Exhibition of 1930. Italian contributions to the Paris Exhibition reflected two tendencies in Italian design: the gently innovative work of designers such as Gio *Ponti, whose work pointed the way towards the elegance for which Italian design became recognized in the 1930s and 1940s, and the *Futurist inclinations of Fortunato Depero. The British design contribution at Paris was undermined by the lack of interest by British manufactures who saw their markets as being catered for in the British Empire. They tended to avoid the more aesthetically and economically competitive European markets, devoting their energies to the displays at the *British Empire Exhibition at Wembley in 1924 and 1925 when it opened for a second season. However, the influence of the exhibition was considerable and widely felt throughout the industrialized world, sustained by the many visitors and widespread international publicity, critical comment, and even official reports. These included that of a substantial commission appointed by Herbert Hoover, the US Secretary of Commerce, to report back on developments in the European decorative arts and design. In the United States the decorative tendencies seen at 1925 were subsumed into an alternative modernizing aspect of an up-to-date design vocabulary that utilized modern materials, colour, decoration, and the metaphors and symbols of contemporary life.

Paris Exposition des Arts et Techniques dans la Vie Moderne (1937)
The aim of this important international

exhibition was to bring together original artistic and industrial practices, thereby showing the ways in which artistic creativity could impact on all aspects of modern life. The outlook at Paris 1937 had been affected by the political climate in France, following the election of a government of the Popular Front. The emphasis on luxury goods and high craftsmanship, strongly reflected in the outlook of the *Société des Artistes Décorateurs, a significant force at the *Paris Exposition des Arts Décoratifs et Industriels of 1925, was somewhat downplayed in 1937. The more progressive *Union des Artistes Modernes (UAM, established 1929), with its manifesto commitment to *L'Art moderne cadre de la vie contemporaine*, had the ear of the Ministry of Education. As a result, the outlook at Paris 1937 was more attuned to a *Modernist outlook embracing new materials, technologies, and the realities of industrial production. Nonetheless, despite this intended affirmation of the harmonious coexistence of art and technology in everyday life, the exhibition was dominated by the desire of many exhibiting countries to assert their national identity in the politically turbulent atmosphere in the years immediately prior to the outbreak of the Second World War. In particular, the displays inside the two dramatically facing and dominant pavilions of Germany (designed by Albert Speer) and the USSR laid considerable stress on national industrial and technological achievements alongside the heritage of vernacular traditions in the design of the indigenous domestic environment. The Italian Pavilion also sought to promote the benefits of living under Mussolini through one of the largest foreign displays. Popular and folk art was featured in more than 60 pavilions at the 1937 exhibition, although there was a concern on the part of some countries that such work

might be seen to represent them as backward-looking nations. Displays of peasant art—seen as the basis for contemporary national styles—were to be found in the Hungarian, Romanian, Polish, and Portuguese Pavilions. The French colonies also afforded the opportunity for the display of folk arts. Acknowledging the imperial leanings of France was the large section devoted to the colonies with individual buildings including those devoted to Algeria, Corsica, Guadeloupe, Indochina (with its cratfs shops), Madagascar, Martinique, Morocco (with its Moroccan markets), and Tunisia. However, France's commitment to her colonies appeared less vibrant than had been the case at the large-scale Paris International Colonial exhibition of 1931.

The Paris 1937 exhibition was larger than any of its predecessors. In addition to the traditional landmarks of the Paris exhibition site, such as the Eiffel Tower, was a new building by Carlu, Boileau, and Azéma—the Palais de Chaillot—replacing the old Palais du Trocadéro. Also new for the exhibition was the art gallery, Les Musées d'Art Moderne, designed in neoclassical style. French commitment to arts and technology as an expression of contemporary life was embodied in the architecture and the façade of the Pavillon de la Publicité by René Herbst (1891–1982). This was seen as an affirmation of the increasingly significant role that advertising was playing in an increasingly consumerist society. Herbst, a founder member of UAM, had also played an important role in the organization of the 1937 exhibition and also secured for the UAM its own pavilion. Very much a part of the portrayal of modern technologies was the Palais de l'Air with frescoes by Robert Delaunay and Albert Gleizes in the Aeronautical Hall. Also stressing modernity in everyday life were the Palais de la Radio and pavilions devoted to cinema, various

forms of transport, and materials (including plastics and aluminium). There were also large screen demonstrations of *Cinemascope* projected onto a giant screen. Robert *Mallet-Stevens, another prominent UAM member, designed a number of pavilions including those of Electricity (with Pingusson), National Solidarity, Tobacco, Hygiene (with Coulon), and the Coffees of Brazil. Le *Corbusier, whose Pavillon de l'Esprit Nouveau had caused such controversy at the Paris Exposition des Arts Décoratifs et Industriels in 1925, also contributed a Pavillon de Temps Nouveau in 1937. Erected at the eleventh hour it took the form of a blue and white tent.

In addition to the national pavilions already mentioned, a number of pavilions were Modernist in style, including those of Japan (by Junzo Sakakura, a follower of Le Corbusier), Holland, Denmark, Sweden, and Finland. The latter was designed by Alvar *Aalto and contained a comprehensive display of Finnish modern design, including a wide range of Aalto's wooden furniture and glass. However, just as the USSR, German, and Italian Pavilions were strong propagandists for the Fascist cause, the modernist Pavilion of the Spanish Republic by Josep Lluis Sert represented a strong anti-Fascist statement in its stress on art and culture as powerful expressions of a free and democratic county. It contained Picasso's powerful painting of *Guernica*—an indictment of the German bombing of Spain in support of Franco. Britain distanced herself from the more propagandist outlook of a number of countries through the displays in her *moderne* British Pavilion designed by Oliver Hill. The exhibits, selected by the *Council for Art and Industry, had a strong commitment to a British way of life with a considerable emphasis on sporting traditions and 'fair play'. There was an impressive display of equip-

ment for a wide range of sports including tennis, cricket, golf, fishing, and football. The countryside was also a dominant theme, with photo-murals on portraying rural agriculture, village cricket, cathedrals, country houses, and landscapes. There was even a display of a *Weekend House* by Gordon *Russell, although its furnishings were contemporary in style, as were the contents of a number of other displays including a kitchen by Dorothy *Braddell.

Paris Exposition Universelle (1900) The main purpose of the international 1900 Paris exhibition, like a number of its predecessors and successors, was to proclaim French pre-eminence in the decorative arts, in this case *Art Nouveau, which had proliferated internationally in the preceding decade. One of the organizers' main objectives had been to stress the continuity between French cultural achievements of the past and those of the present day. Such a perspective was underlined by the contents of the Pavilion of the *Union Centrale des Arts Décoratifs (UCAD) containing the work of leading French ateliers and designers such as Hector *Guimard, Louis Majorelle, and Émile *Gallé. Another noted Pavilion was that of Samuel *Bing, whose Parisian Gallery, L'Art Nouveau, had given its name to the movement. His six-roomed Pavilion displayed furnishings and decorations by French designers, most notably Georges du Feure, Eugène Gaillard, and Édouard Colonna. Also prominent among the displays were the French manufacturers of decorative arts, including Sèvres Porcelain with designs by Guimard and others, and the Gobelins Tapestryworks. An emphatically modern characteristic of the Exposition was the widespread use of electricity for the fountains of the Château d'Eau and the Pavilion d'Électricité.

Paul, Bruno (1874–1968) An important figure in the transition from the crafts to *Modernism in Germany, Paul studied at the Dresden School of Applied Arts (1886–94) before working at the Munich Academy. He became a furniture and textile designer for the *Munich Vereinigten Werkstätten für Kunst im Handwerk (United Workshops for Art in Craftwork) in 1898, showing interiors at the *Paris 1900 and 1902 Turin Exhibitions. He was also involved in the design of posters and ship interiors, including that of the *Kronprinzessin Cäcilie* in 1907. In the same year he was appointed to the Berlin Künstgewerbemuseum, also becoming a founding member of the *Deutscher Werkbund (DWB) in the same year. He also played an important role in the 1914 DWB exhibition in Cologne, designing a number of public interiors.

Paulsson, Gregor (1890–1977) Paulsson was a key figure in the early 20th-century development of the *Svenska Slöjdföreningen (Swedish Society of Industrial Design) and a powerful advocate of the modernization of Swedish design. An art historian and critic, in 1912 he was living in Berlin, where he became interested in the progressive design ideals of the *Deutscher Werkbund (DWB), which came to widespread critical attention at the DWB Cologne Exhibition of 1914. He became Secretary of the Svenska Slöjdföreningen in 1917 and published his seminal text *Vackrare Vardagsvara* (*More Beautiful Everyday Things*) in 1919. As the Swedish Society of Industrial Design's general director, he became heavily involved with the landmark *Stockholm Exhibition of 1930 seeking to bring together progressive design trends, contemporary technology, and the spirit of social utopianism that characterized much Swedish design of the period.

PEL (Practical Equipment Ltd., established 1931) This British furniture company was known for its tubular steel furniture in the 1930s, reflecting a growing interest in *Modernism on the part of a number of manufacturers, enlightened patrons such as the British Broadcasting Company (BBC), and projects such as Wells *Coates's Embassy Court apartment block (1935) in Brighton and Serge *Chermayeff's De La Warr Pavilion (1935) at Bexhill-on-Sea. The company's origins lay in the activities of steel tube company conglomerate Tube Investments, particularly its Ackles & Pollock subsidiary, which set up a department for the manufacture of tubular steel furniture in 1929. However, stimulated by examples of *Thonet tubular steel furniture designs imported into Britain, Tube Investments established a new company, Practical Equipment Ltd. (soon afterwards contracted to PEL), in 1931 with Oliver *Bernard as consultant designer, a post he held until 1933. An important early tubular steel furniture commission for PEL was for the BBC's Broadcasting House in London (1931–2) and was soon followed by the production of a PEL Catalogue (designed by design writer Noel Carrington) with a full range of designs. The company also exhibited its furniture at the highly popular *Ideal Home Exhibition of 1932 and soon the company's products were in demand from many British avant-garde designers, fashionable hotels such as the Savoy, Claridge's, and the Berkeley, and retailers such as *Heal's and Harrods. PEL also managed to penetrate the mass market with a number of designs, most notably its *RP6* stacking chair, first put into production in 1932. PEL designs were to be found increasingly in schools, hospitals, canteens, and other public spaces. The company survived the Second World War through a number of Admiralty contracts and continued in production afterwards.

Penguin Books (established 1936) Soon after their launch Penguin books were associated with progressive design trends in 1930s Britain and were often photographed in *Modernist interiors or prominently displayed on bookshelves. The company has since become a worldwide publishing success, producing well-designed quality books at affordable prices. The first, distinctively designed, Penguin books appeared in British bookshops in 1935 and within a year had sold more than 3 million copies. Simply and clearly designed by Edward Young, their contents were clearly delineated by the horizontal blocks of colours on the covers with crime demarcated by green, fiction by orange, and blue for biography, and their titles were easily legible through the use of sans serif typefaces. Young also designed the original Penguin symbol. Penguin was established as a separate company in 1936, having been conceived by Allan Lane, a director of The Bodley Head publishers. He had identified a market opportunity in the lack of good quality fiction at affordable prices. Extending the company's range of reading matter, the Pelican imprint was launched to cover contemporary issues in 1937 and included such titles as Anthony Bertram's discursive text *Design* (1938). After the Second World War the Modernist typographic designer Jan *Tschichold was commissioned by Sir Allen Lane to redesign all Penguin Books, resulting in the *Penguin Composition Rules* (1947). After Tschichold's departure in 1949 his role was taken over by Hans *Schleger, underlining the company's commitment to high-quality design in its publications. (Schleger later designed the logo for the Penguin Press hardback initiative of 1967.) Key figures in respect of the pursuit of first-rate design included Abram *Games, consultant designer to Penguin Books from 1956 to 1958, and Germano Facetti, art director at Penguin from 1961

to 1972, who was tasked with establishing a policy for cover designs that made the transition from the typographic-centred traditions of Penguin and Pelican to those with a more contemporary appearance. Amongst the many other high-quality designers associated with Penguin have been David Gentleman, whose contributions included the engravings for the New Penguin Shakespeare, and Alan Aldridge, fiction art director from 1963 to 1967, the year in which he, with George Perry, produced *The Penguin Book of Comics*. There have also been numerous titles whose contents have been concerned with design as much as their visual presence. These included a number of the King Penguin series launched in 1939 under the editorship of Elizabeth Senior and, from 1942, Nikolaus *Pevsner. Their titles included *English Popular Art* by design propagandist Noel Carrington. Notable art and design publishing initiatives included the *Planning, Design and Art* series, launched in 1942, Penguin *Modern Painters*, initiated in 1944, and *The Things We See*, begun in 1947. In 1951 Allen Lane commissioned Pevsner's renowned *Buildings of England* (later extended to include Scotland, Wales, and Ireland), finishing 46 volumes later in 1974 (the series was sold to Yale University Press in 2001). In 1970 Penguin was acquired by Pearson International, the former taking over a variety of book publishing divisions of other large-scale companies including Frederick Warne in 1983, Michael Joseph (1985), Hamish Hamilton (1985), Dorling Kindersley (2000), and the Rough Guides (2002).

Pensi, Jorge (1946–) A versatile Spanish designer who has worked on interior, architectural, and industrial design projects, Pensi is best known for his furniture and lighting. Born in Buenos Aires he commenced his design career in Brazil but,

after travelling to Spain in 1975, became a Spanish citizen. He participated in the Berenguer Group (founded 1977) until 1984, establishing his own practice in the following year. Pensi has worked for many international clients and his best-known works included the *Toledo* chair for Amat, the *Regina* lamp for B. Lux, and the *Artico* and *Duna* collections for *Cassina. He also has designed for *Akaba since 1992, including the *Carma* Table System and the *Pol* seating range. International recognition came in the form of prizes such as the *Nuevo Estilo* award (1994), the Good Industrial Design Award in Holland (1995), and the Product Design Award at the Industrie Forum Hannover in 1997.

See also PREMIOS NACIONALES DE DISEÑO.

Pentagram (established 1972) A leading name in British design consultancy for over three decades, Pentagram has embraced a wide range of services including architectural and exhibition design, graphic and packaging design, product and industrial design, and corporate design. From the outset, founding partners Kenneth *Grange, architect Theo Crosby, and graphic designers Alan Fletcher and Colin Forbes established a protocol whereby each member of the group was able to establish independent relationship with clients in terms of their own individual expertise but also worked collaboratively whenever multidisciplinary projects were commissioned. The consultancy's awareness of the needs of industry soon resulted in its expansion with offices in New York (1978), San Francisco (1988), Austin (1994), and Berlin (2002). Over the years it also underwent an expansion in the number of partners that went on to include the graphic designers Mervyn Kurlansky, John McConnell, and Peter Saville, and industrial designer Daniel Weil. By 2003 Pentagram had nineteen partners. Its

projects have crossed many disciplines and include Kenneth Grange's High Speed Train for British Rail, Alan Fletcher's collaboration with Norman Foster on signage for Stansted Airport, David Hillman's redesign of the *Guardian* newspaper, the logo for the *Victoria and Albert Museum, and Daniel Weil's design for the Swatch Timeship retail outlet in New York. Pentagram has also played an important role in the development of design awareness with its sponsoring of exhibitions, lectures, and other design-related events. Publications have included *Pentagram: The Work of Five Designers* (1972), *Living by Design* (1978), *Ideas on Design* (1986), *Pentagram: The Compendium* (1993), and the more discursive *Pentagram Papers*, which have been published since 1975.

Perriand, Charlotte (1903–99) Perriand's designs are often associated with furniture designed in collaboration with Le *Corbusier and Pierre Jeanneret in the 1920s, but her contribution to design was significantly more profound. She studied interior design at the École de l'Union Centrale des Arts Décoratifs in Paris in the early 1920s and was influenced by the prevalent *Art Deco aesthetic espoused by her teachers Maurice Dufrène and Paul Follot. However, her introduction to Le Corbusier's writings dramatically changed her design perspectives, resulting in her design of a rooftop bar shown at the Salon d'Automne of 1927. The controversy that this engendered drew her to Le Corbusier's attention and she worked with him on furniture designs and fittings. Her practical knowledge of design and materials such as tubular steel helped to bring Le Corbusier's ideas to fruition in designs such as the *Grand Confort* armchair and the *B306* chaise longue. After setting out on her own in 1937 she was invited in 1940 by the Ministry of Commerce and Industry in Japan to advise on

industrial arts and design. In 1941 she organized an important exhibition in Tokyo, *Tradition, Selection and Creation*, in which she showed work inspired by the Japanese arts and crafts. However, soon after the outbreak of war, she went to Indo-China, where she remained until 1946. After the war she again worked with Le Corbusier, designing a prototype kitchen for his Unités d'Habitations. She was also associated with *Formes Utiles, a body concerned with raising standards of design in mass-produced domestic products.

Perspex First developed in the 1930s as polymerized methyl methylacrylate, this durable thermoplastic was first produced commercially under the registered trade name of Perspex by ICI in 1935. Tough, flexible, and translucent it was an alternative to glass and was widely used in the Second World War for aircraft cockpits. Other design uses include transparent rulers, protractors, and recipe holders, transparent furniture, lighting, and jewellery. It is marketed in the United States as Plexiglass and Lucite.

Pesce, Gaetano (1939–) A leading Italian architect, film-maker, and theatre, furniture, lighting, and product designer who reconciled his interests in the fine arts with design in the 1960s, Pesce, like many of his fellow contemporaries associated with *Radical Design, sought design solutions that did not conform to the standardized forms associated with mass manufacture and mass consumption. He continued to play a prominent role in progressive design circles over the following decades, placing greater emphasis on architecture in the 1990s. He trained in architecture and industrial design from 1959 to 1965, during which he opened a studio in Padua and was a founding member of the fine arts-centred Group N. In the late 1960s he at-

tracted attention through innovative designs such as the *Up* armchairs first seen at the 1969 Milan Furniture Fair. Made of polyurethane foam by C&B Italia (*see* B&B ITALIA) and designed for a variety of uses they were compressed under a vacuum and packaged in *PVC. When the packages were opened the chairs sprang up into their intended shape and size. Other notable designs in this anticonventional vein included the *Sit Down* chair (1975) inspired by the ideas of *Pop artist Claes Oldenburg. His work was also included in the seminal 1972 *Italy: The New Domestic Landscape* exhibition curated by Emilio *Ambasz at the *Museum of Modern Art, New York. Other notable designs that have explored layers of meaning have included his melted plastic resin *Samson* and *Delilah* chairs and tables (1980), produced by *Cassina, whose owner had done much to offer Pesce opportunities for experimentation since the 1960s. Pesce has also designed for *Vitra, including the *Green Street Chair* (1987), and *Knoll. His multi- and interdisciplinary work was celebrated in an exhibition at the *Centre Georges Pompidou in Paris in 1996.

Peugeot (established 1896) With a family background in the manufacture of bicycles and a family history in tools and metal goods, Armand Peugeot (1849–1915) founded the Société des Automobiles Peugeot in 1896. However, in design terms Peugeot remained relatively conservative until the decades following the end of the First World War. Henri Thomas, who was head of styling at the company from 1933 to 1960, did much to develop a distinctive character in Peugeot design. One of the first cars that marked out a distinctive style was the aerodynamic six-cylinder *601* of 1964, advertised in the press with a model reclining on the bonnet under the slogan 'I love my Peugeot'. Another

stylistically sophisticated model was the streamlined Peugeot *402*, first shown to popular acclaim at the Paris Motor Show of 1935. Its sweeping aerodynamic styling was reminiscent of developments in the United States, particularly at *Chrysler, and made an even greater impact than the innovative *Citroën *YCV Traction Avant* (front-wheel drive) model first seen the previous year. It also boasted automatic transmission, jointly researched with Gaston Fleischel. In production from 1935 to 1940 (only halted by the Second World War) it enjoyed healthy sales of 150,000, including a considerable number as taxis. After the war the Peugeot *203*, launched at the Paris Motor Show of 1948, was the company's only car on sale between 1949 and 1954. This was followed by the Peugeot *403*, shown at the Motor Show of 1955, which was well received by the public and remained in production for a decade. It fulfilled the brief for the design of an elegant, comfortable, spacious, economical, and fast car and was the first Peugeot that used an outside consultant, the Italian *Pininfarina. An important figure in brokering this relationship between manufacturer and car stylist over the longer term was Paul Bouvot (1922–) who came to Peugot in 1956, having worked on tractor design after the Second World War followed by a spell at Simca (1947–53). Other Peugeot–Pininfarina collaborations nurtured during Bouvot's period as head of the Style Centre (1960– 80) included the *504*, the first French car with curved side windows and fold-down head restraints, selling 3.7 million. The Peugeot *104*, launched in 1972, was the shortest four-door model in Europe and the result of cooperation between Peugeot engineers and the *Renault company whose Renault *5* played an influential role. This cooperation resulted from the formation of the PRV company (Peugeot-Renault-*Volvo), a

Franco-Swedish enterprise in 1971. In 1976 a further merger took place with Peugeot acquiring 90 per cent of Citroën's capital. Between 1980 and 1994, as head of the Style Centre, Gérard Welter continued Bouvot's work in maintaining a productive relationship with Pininfarina. Welter also worked closely with Paul Bracq, who was responsible for the design of Peugeot interiors. Bracq's previous experience had included responsibility for advanced styling at *Mercedes-Benz (1957–67) and *BMW (1974) before joining Peugeot in 1974 as director of interior styling, a post that he retained until 1996. The Peugeot *205*, launched in 1983, was the company's most popular car, designed in a further collaboration between the Peugeot Style Centre under Welter and Pininfarina. The success of this model did a great deal to underpin Peugeot's continued economic viability. Selling in 120 countries it proved to be a huge export success with a total of more than 15.25 million sales by 1999. It was the fourth best-selling French car ever after the Renault *Super 5* and the Citroen *2CV*. Murat Gurnack, a graduate of the *Royal College of Art with a design background at the *Ford Motor Corporation and Mercedes-Benz, was appointed as head of the Style Centre in 1994.

Pevsner, Nikolaus (1902–83) Born in Leipzig, Germany, architectural and design historian Nikolaus Pevsner studied at the Universities of Leipzig, Munich, Berlin, and Frankfurt, gaining his doctorate on Leipzig baroque houses in 1924. In 1926 he joined the Dresden Art Gallery until 1928, when he took up a post at Göttingen University. He developed an interest in English art and architecture, visiting Britain for the first time in 1930. In the face of political upheaval in Germany Pevsner moved to England in 1933, coming into contact with

Philip Sargent Florence of Birmingham University, who suggested that he should investigate contemporary English industrial design. This resulted in his book *An Enquiry into Industrial Art in England* (1937). (At this time he was also a buyer of textiles and glass for Gordon *Russell Ltd.). However, the book with which he has been most associated in terms of design was his 1936 volume on *Pioneers of the Modern Movement: From William Morris to Walter Gropius*. Subsequently it has undergone many reprints, and several editions, and has been translated into many languages. For many decades it has provided a focal point for debates about the nature and practice of design history which, by the later 1970s, moved away from the Pevsnerian emphasis on *Modernism and its origins in the 19th-century design reform movement. His account was largely predicated on the artistic creativity of well-known individuals and a shift away from historicism and 'gratuitous' ornamentation towards an emphatically 20th-century 'Machine Age' outlook. Such an outlook was challenged increasingly by others who placed greater emphasis on the wider social, economic, political, and technological climate in which design is manufactured and used. After a brief period of internment in 1940 the Architectural Press employed Pevsner before, from 1942 to 1945, he became editor of the *Architectural Review*, a periodical which since the late 1920s had been sympathetic to the Modernist cause. From 1942 until his retirement in 1969 he was employed by Birkbeck College, University of London, and was appointed as professor in the History of Art in 1959. Other writings reflecting an interest in design matters included *Visual Pleasures in Everyday Things* (1946), *High Victorian Design* (1951), and *Sources of Modern Art* (1964, republished as *Sources of Modern Architecture and Design* in 1968). Pevsner is perhaps best

known today as an architectural historian, his many publications in this genre including *An Outline of European Architecture* (1942), *The Buildings of England* series (1951 onwards), *Some Architectural Writers of the Nineteenth Century* (1972), and *A History of Building Types* (1976). He held several prestigious posts including the Slade Professorships in Fine Art at Cambridge (1949–55) and Oxford (1968–9) and was also an influential figure on many important committees including the Fine Art Commission, the Historic Buildings Council, and the National Council for Diplomas in Art and Design. He was a founding member of the Victorian Society, taking on the role of chair from 1958 to 1976. Amongst the many awards he received were the CBE (1953) and the Royal Institute of British Architects Royal Gold Medal for architecture. He was knighted in 1969 for 'services to art and architecture'.

Phenol-Formaldehyde (invented 1907) *See* BAKELITE.

Philips (established 1891) This internationally renowned manufacturer of electrical products was founded in Eindhoven in 1891 as a manufacturer of electric bulbs, moving into radio valves in 1918 and diversifying into other radio components in the 1920s. By the late 1920s the firm became involved in the manufacture of consumer products with its first radio receiver of 1927. Working in partnership with the Nederlandsche Seintoestellen Fabriek (NSF), a manufacturer of radio cabinets, Philips became increasingly involved with design. This was particularly evident in terms of publicity, boosted by the appointment of architect Louis Kalff to the Advertising Department in 1925, first as a supervisor and then, in 1928, as the head of a new department of General Advertising. He was responsible for the design of exhibition stands, posters, and publicity as well as the

design of showroom interiors. The company also opened its own design office, although the decisions about product appearance involved a number of departments with Kalff playing a key role in guiding policy as well as producing individual designs. However, despite the involvement of designers of the stature of *Cassandre for posters advertising the company's radios there was no clear policy for shaping a distinctive brand aesthetic before the Second World War. By this time the company's products included radios, gramophones, televisions (introduced to Holland by Philips in 1938) and electric shavers. After the war the company established a reputation for product innovation, including cassette players (first marketed in 1963), video players (first marketed for professionals in 1964), and compact discs (one of the company's joint research initiatives with *Sony that commenced in 1969). Philips established a design group in 1954, followed by the formation in 1960 of its Industrial Design Office under Rein Veersema. In 1969 when Knut Yran took over control of company design policy, instituting a consistent brand identity, the Industrial Design Office modified its name to the Concern Industrial Design Centre (CIDC). In common with other *corporate identity schemes of the period a consistent design policy was delivered by means of a company manual containing firm guidelines for all visual matters. A more global outlook was developed with manufacturing plants in more than 60 countries and a worldwide sales policy. In 1980 corporate design policy matters fell under the leadership of Robert Blaich, the new head of the CIDC, who believed that the both the appearance and function of Philips products gave off something of the ethos of the company. Stefano Marzano took over from Blaich in 1991, instituting a more consumer-centred, mul-

tidisciplinary approach to design known as 'High Design'. The name of the CIDC was changed to Philips Design, a unit that became independent within the Philips group in 1998 but was also able to offer fresh design thinking to external clients.

Photomontage The term derives from the technique of combining or superimposing photographic images culled from different sources in order to create new pictorial ideas and relationships. It was explored in avant-garde circles of the 1920s and 1930s by *Modernist designers such as László *Moholy-Nagy, Herbert *Bayer, and Edward McKnight *Kauffer, as well as in John Heartfield's overtly political critiques of the Nazi regime in Germany.

Piaggio (established 1884) The most famous design associated with this large industrial design company was the *Vespa motor scooter designed by the aeronautical engineer Corradino *D'Ascanio at the end of the Second World War. It was a symbol of the democratic spirit that underpinned certain aspects of design in Italy in the early years of reconstruction. The Piaggio Company was founded by Rinaldo Piaggio (1864–1938) in Genoa and in its early years was involved in the manufacture of ship and railway fittings, automobiles, and later aeronautics. It expanded over the next half-century, opening new factories in Tuscany, and, by the outbreak of the Second World War, was a leading European manufacturer of aeronautics, railways, and steamships. Complementing a series of record-breaking aero engines in the 1930s was the MC2 railway locomotive, one of the company's more innovative designs of the 1930s. On Rinaldo Piaggio's death his two sons Armando (1901–78) and Enrico (1905–65) split the corporate responsibilities between them, with Enrico the moving force behind the launch of the Vespa in

1946. The *Ape* scooter-truck of 1948 embodied similar characteristics of practicality and was a highly economic means of shifting goods in the urban environment, rather similar in spirit to Japanese designer Jiro *Kosugi's three-wheeled trucks designed for the Toyo Kogyo Company (now Mazda) in Hiroshima on which he worked from 1948 onwards. Not as well known as the ubiquitous *Vespa* or the highly successful *Ape* truck was D'Ascanio's design of the *Vespa 400* small car launched in 1957, available in two- or four-seat versions and powered by a 394 cc two-stroke engine. However, only about 30,000 were manufactured. The company's success in two-wheeled motor transport continued with the production of the *Ciao* moped, launched in 1968, based on similar ideas to those of the Honda *Super Cub* of 1958. The Piaggo company history is recorded in the large documentary and audio-visual archives within the Piaggio Museum in Pontedera, opened in 2000. Also on display are many Piaggio products.

Pilditch, James (1929–95) A highly significant figure in post-war British design Pilditch played an important role in promoting the importance of design and the design profession in many aspects of economic and business life. He was a prolific author in this respect, his books including *The Silent Salesman* (1961), *The Business of Product Design* (1966), *Talk about Design* (1976), and *Winning Ways* (1987). He trained as an art historian at the University of Reading before working in journalism in North America in the 1950s. He also learnt about the ways in which design consultancies operated in Toronto and New York, such organizations being considerably more common in North America than in Britain at the time. He returned to London in 1959, founding Package Design Associates, renamed Allied International Designers (AID)

in the following year. It expanded considerably over the next two decades, with offices in London, New York, San Francisco, Singapore, and Tokyo and was floated on the Stock Exchange in 1980. Like a number of other large consultancies it ran into economic difficulties in the later 1980s. Pilditch was also active in many organizations including the Royal Society of Arts, the *Design Council, the National Economic Development Office, and the London Business School.

Pininfarina (established 1930) Established by Battista 'Pinin' Farina in Turin as a car body workshop (probably named Farina) the company established its reputation with cars such as the Lancia *Aprilia Coupé* (1937) with its flowing streamlined form. It came into its own after the Second World War with the *Cisitalia Coupé* (1947) the flowing lines and organic form of which paralleled the work of other contemporary Italian designers. This included Marcello *Nizzoli's *Lexicon 80* typewriter for *Olivetti in 1948 and Gio *Ponti's *La Cornuta* espresso machine for La Pavoni in 1949. Designs such as the *Alfa Romeo *Giulietta Spider* (1956) and the *Ferrari *250 GT* (1960) consolidated Battista's reputation and led to the decision to rename the company Pininfarina in 1961. The company's Institute for Design Research was established in 1966, the year in which the body of the *Fiat *124 Spider* was produced. Although many striking designs were produced for Ferrari (including the *GTB4 Daytona* of 1968 and the *Mythos* of 1989) and other luxury producers such as Rolls-Royce, the company also designed a number of mass-produced models such as the Austin *A40* (1958) in Britain and the *Peugot *504* (1968) in France.

Playmobil (established 1876) Although the roots of this German company lay in

the 19th century when it was established by Andreas Brandstätter, it only moved into plastic products in 1954. Included in its range were toys and leisure products such as hula-hoops (1958). In 1974 the company's head of development, Hans Beck, introduced the Playmobil range of figures of various occupations whose arms and legs could be moved, accessories added. They have proved incredibly popular and well over 1.5 million sets have been sold since their introduction.

Ploeg, De (established 1923) The Dutch Cooperative Production and Consumers' Association De Ploeg (The Plough) was established in 1923 to produce textiles for the home. Within a short period the company gave up manufacture in favour of marketing textiles produced by other manufacturers, although from 1928 these included fabrics made to its own designs, generally characterized by simple patterns that drew on abstract rather than naturalistic motifs. Most of the designers worked on a freelance basis and were sympathetic to the tenets of *Modernism. Amongst the retail outlets that sold the group's products was the Amsterdam department store De *Bijenkorf which sought to promote functionalist products in Holland in the later 1920s and 1930s. However, the Second World War impacted negatively on sales and so it was decided to set up an applied arts subsidiary, t'Spectrum, although the latter became an independent company after the war. In about 1950 De Ploeg recommenced textile production alongside the commissioning of designs from other manufacturers. In 1957 De Ploeg became a limited company. Among the better known De Ploeg designers in later decades was Ulf Moritz, who worked for the company from 1962 to 1969.

Plywood Plywood boards are made of thin layers, or veneers, of wood which are glued together, the grain of each being set at right angles to that of the next in order to give greater strength. Light in weight and capable of being bent into elegant, curvilinear forms it has been in use in furniture making since the 18th century, notable exponents including *Thonet in the 19th century, Alvar *Aalto and Marcel *Breuer before the Second World War and, in the wake of considerable technological innovations in the early 1940s, Charles *Eames, Eero *Saarinen, Robin *Day, and Arne *Jacobsen in the post-war years.

Poiret, Paul (1879–1944) Poiret was a key figure in the French fashion industry of the early decades of the 20th century, particularly his introduction of a strong oriental flavour and rich colours to contemporary clothing. This was inspired by the dramatic settings and costumes for Diaghilev's Ballets Russes by Leon Bakst and others that first took Paris by storm in 1908. Poiret's work was widely disseminated by fashion illustrators through publications such as *Les Robes de Paul Poiret raconté par Paul Iribe* (1908) and *Les Choses de Paul Poiret vues par Georges Lepape* (1911).

After meeting leading couturier and collector Jacques Doucet in 1896 Poiret had moved into dress design, working for Worth before setting up independently in 1904. After meeting Josef *Hoffmann in Vienna in 1910 and seeing the multi-disciplinary outlook and activities of the *Wiener Werkstätte at first hand he established the Atelier Martine in Paris in 1911. Named after his second daughter this school of decorative art was attended by working-class girls with no formal training. They produced bold, colourful patterns for textiles, wallpapers, ceramics, murals, and furniture perhaps partly inspired by the

flower-patterned textiles of the Wiener Werkstätte that themselves drew on folk art. Poiret arranged for the work of the Martines (as the participants in the Atelier were known) to be shown at the Salon d'Automne in 1912, leading him to establish an interior design business under the name of L'Atelier Martine. Advice was offered for the interior decoration of cafés, hotels, offices, and private houses and the venture proved so successful that a London branch was opened in 1924. The Atelier Martine also produced designs for the prestigious luxury liner *Île de France* (1927) on which many leading French designers collaborated. At the *Paris Exposition des Arts Décoratifs et Industriels of 1925 Poiret exhibited three barges moored on the Seine near the entrance entitled *Amours*, *Délices*, and *Orgues* that included hangings by Raoul *Dufy and room settings, furniture, and furnishings by the Atelier Martine. However, as a result of the difficult economic times from the late 1920s Poiret's fashion business went into decline.

Polaroid Corporation (established 1937) The revolutionary 1948 Polaroid *Model 95* was the first camera was to be able to develop its own prints. Launched onto the market in 1948 it was manufactured by the Polaroid Corporation of Cambridge, Massachusetts, and designed by Walter Dorwin *Teague Associates. Teague's relationship with the Polaroid Corporation had been first established in 1939 with the design of a streamlined *Bakelite and aluminium *Executive* desk lamp. The Polaroid Corporation had been built on work in light polarization carried out by Edwin H. Land (1909–91) from the late 1920s onwards. The company's first products had included anti-glare car headlamps, sunglass lenses, and desk lights and, during the Second World War, it developed specialist

techniques for three-dimensional photography. It was also involved with optical aspects of gun sights and binocular lenses. Land began working on the Polaroid photographic system in 1944, building on a German invention of the 1920s, bringing the project to fruition with the *Model 1995* camera, which retailed at $89.95. Many improvements were made, including the Polaroid *Electric Eye 900* camera (1960), once again designed by Teague for Land. Other American design consultancies were used by Land, most notably Henry *Dreyfuss Associates (HDA), who designed the *Automatic 100* camera (1963) utilizing the 'instant' colour film devised by Polaroid. This was followed by the *Model 20 Swinger* aimed at the teenage market, also developed by HDA in 1965. HDA also designed the Polaroid *Pronto* camera (1976) and the *Vision Date +* (1994), which won an IDEA Award in 1994. The Polaroid Corporation also moved into other areas such as fibre optics, video, and computer products.

Polyethylene *See* POLYTHENE.

Polypropylene (invented 1954) Invented by Professor Giulio Natta in Milan, polypropylene was first produced by Montecatini using the trade name *Moplen*. It is a very strong and versatile material and capable of being moulded in a variety of ways: injection moulding, blow moulding, thermoforming, and extrusion. It was widely used in furniture from the 1960s, a prime example of which was Robin *Day's 1963 polypropylene stacking chair for *Hille and Co., the first injection-moulded chair.

Polythene Polythene, the abbreviated name for polyethylene, was first produced commercially in Britain in 1942 and the USA 1943. Low-density polythene came into its own after the Second World War, being widely used for toys, washing up bowls, liquid and food containers, bottles,

furniture, and many other commodities. High-density polythene is stronger and used in industrial containers, pipes, bottles, and furniture. A well-known example of the latter is the children's stacking chair by Marco *Zanuso and Richard *Sapper for *Kartell. Another variety, expanded polythene foam, was first used in the 1940s for lifebuoys and insulation and later, as manufacture became more sophisticated, as a material for packaging tools and precision instruments.

See also TUPPERWARE.

Polyurethane (invented 1937) Invented by Otto Bayer in Germany in 1937 as an early variant of what was to become a highly versatile modern synthetic plastic. However, despite experimentation on a range of applications during the Second World War and the reconstruction period, rigid and flexible polyurethane foam manufacture did not commence until 1955. Highly versatile, being able to be manufactured in varying degrees of hardness or softness, it has been used in many contexts, ranging from upholstery to fabric coatings and paints to packaging crates. Although generally used as an alternative for conventional upholstery in the 1960s and 1970s its expressive qualities were more dramatically explored in a number of products such as those manufactured by the Italian company Gufram. These included a mid-1960s revival of Salvador Dalí's *Mae West Lips* sofa of 1936, the *Sassi* (Stones) seats by Piero Gilardi in 1967, and the *Pratone* (Large Meadow) seat by Gruppo Strum in 1970. The realistic *Sassi* appear hard but are in fact soft and able to be sat upon; the *Pratone* seat is in the form of a large sod of turf with almost 3 foot (1 metre) high blades of grass and provides a flexible surface for lounging. This *Postmodernist outlook was far from the limitations of plastic discussed by

Roland *Barthes in his book *Mythologies* (1957), showing how swiftly the technological developments of a material can transform its aesthetic and cultural possibilities. Rigid polyurethane foam also enjoys a wide range of applications from low-cost shelters to fine art sculptures, but also as a structural material in its own right, as in the *Cumulus* chair by Robin *Day for *Hille.

Polyvinyl chloride *See* PVC.

Ponti, Gio (Giovanni) (1891–1979) One of the most important figures in 20th-century Italian design, Ponti was also an influential writer, teacher, and practising architect. He designed across a wide range of design fields, from interiors to furniture and product design, acknowledging the significance of craft traditions alongside the development of a modern aesthetic in a long and distinguished career. After graduating in architecture from Milan Polytechnic in 1921, he established a design studio in Milan with Emilio Lancia and Mino Foicchi. He exhibited at the Monza Biennale of Decorative Arts in 1923, the year in which he began working as artistic director at the ceramics manufacturer Richard Ginori. The company was awarded the Grand Prix at the 1925 *Paris Exposition des Arts Décoratifs et Industriels. Although a number of Ponti's designs drew on classical precedents, under his direction the company also brought out its first catalogue of *Modern Art Pottery*, reflecting his concern for quality in mass production. During these years he also designed low-cost furniture for La *Rinascente department store and the first of a number of glass designs for Paolo *Venini in Murano in 1928. In 1930 he was appointed as artistic director to the Fontana Arte company, designing a number of modern lights. He also played an important role in the development of the Monza Biennali and ensuing *Milan Triennali that,

POP

The term as used today first emerged in the mid-1950s with reference to popular culture and was explored materially and theoretically by avant-garde designers, architects, artists, writers, and critics such as those associated with the *Independent Group in Britain. Commonly associated with American artists such as Andy Warhol and Claes Oldenburg it first entered widespread usage in connection with design in the 1960s. In this context it encapsulated the contemporary consumerist spirit of a period in which brightly coloured, ephemeral, iconoclastic and fun mass-produced products, fashion, furniture, and interiors were increasingly widely available, particularly in the increasingly influential market sector catering for affluent younger consumers. Fashion designers such as Mary *Quant, John Stephen, Zandra Rhodes, and the lively boutiques of Carnaby Street, London, provided the opportunity for such consumers (male and female) to purchase stylish, mass-produced clothing that embraced such ideals, from miniskirts to Mod suits. Supported by increasingly seductive advertising, television programmes, films, and glossy magazines aimed at this powerful consumer group, Pop seriously undermined the aesthetic characteristics of *Modernism with its emphasis on 'form follows function', *'Truth to Materials', the elimination of unnecessary decoration, and the use of a restrained palette. In connection with this it also ran in opposition to more 'official' notions of *'Good Design', such as those embraced by the Council of Industrial Design (*see* DESIGN COUNCIL) in Britain, the *Museum of Modern Art in New York, the *Compasso d'Oro in Italy and others (*see also* DESIGN AWARDS). Pop was influential in terms of its iconoclastic outlook in relation to style, materials, and modes of manufacture. It impacted upon the *Anti-Design movement of the radical avant-garde in northern Italy as well as a number of the tenets of *Postmodernism that underlay much design thinking of the latter decades of the 20th century.

p

from the early 1930s, provided important national and international arenas for the exhibition of modern design. At the 1933 Triennale Ponti's and Carlo Pagano's interior designs for the Breda electric train *ETR 200* were displayed; in 1936 he exhibited 'A Demonstrative Dwelling'. After the Second World War Ponti's work attracted considerable attention across Europe and the United States, his work being promoted in New York by W. Singer & Sons from 1950. Reflecting wider post-war interest in organic form in design (*see* EAMES, CHARLES; SAARINEN, EERO), he produced a widely admired coffee machine for La Pavoni in 1948 and a number of sculptural sanitary ware

designs for Ideal Standard in 1953. Other celebrated Ponti designs of the 1950s included the *Leggera* (1952) and the *Superleggera* (1957) chairs for *Cassina, both of which reveal the ways in which Ponti married craft traditions to a modern outlook. He also designed furniture for Arflex and *Knoll, flatware for Krupp Italiana and Christofle, lighting for Arredoluce and *Artemide, textiles for Fede Cheti, and glass for *Venini.

He was also a prolific architect of note, with a variety of commissions that spanned houses and housing developments, university and office buildings, government buildings and department stores. His most

significant buildings were perhaps the Montecatini Building in Milan, completed in 1938, for which he also designed interiors, fittings, and fixtures, and the dominant 1956 Pirelli Tower, also in Milan, in conjunction with Arturo Danusso and Pier Luigi Nervi.

However, Ponti was also influential in terms of his extensive critical and theoretical written outputs. The most important of these was undoubtedly the *Domus* magazine, which he founded in 1928. His editorial voice was heard through its pages in many different phases of 20th-century Italian design, his terms of office spanning much of his professional career (1928–41, 1948–79). Whilst away from *Domus* from 1941 to 1947 he edited *Stile*, another magazine that he founded and which reflected his personal ideas and concerns, as well as articles proposing models for living in the reconstruction period. Between 1941 and 1943 he also contributed to the fashion periodical *Bellezza*. He taught at Milan Polytechnic from 1936 to 1961 and won many awards during his career, including the *Compasso d'Oro Grand Prix in 1956.

Pop *See* box on p. 345.

Porsche (established 1948) One of the most evocative names in automobile design the Porsche company was established by Ferdinand Porsche (1875–1951) in Stuttgart, Germany, in 1930. With minimal formal engineering qualifications he entered the field of automobile design in his mid-twenties, patenting an electric motor in 1897 and presenting an electric car at the *Paris Exposition Universelle of 1900. Subsequently he worked with many of the leading German automobile manufacturers including Austro-Daimler in 1906 for which he became a general manager from 1916 to 1922. In the mid-1920s he was appointed as chief engineer at *Mercedes-Benz where designs such as the *SS* (*Super Sport*) and *SSK*

(*Super Sport Kurz*) of 1928 helped consolidate the company's reputations as a manufacturer of stylish and expensive cars. In 1930 he set up his own engineering consultancy inStuttgart and amongst the projects on which he worked were prototypes for economic mass-produced cars for the NSU and Zundapp motor companies. He also made a proposal to the German Ministry of Finance for the production of an economic people's car in 1932. This evolved into the rear-engined *Volkswagen, prototyped in 1935, the distinctive streamlined shape of which was designed by Erwin *Komenda, with whom Porsche developed a productive working relationship. A special factory for mass-producing this car—dubbed the '*Beetle*' by the *New York Times*—was built at Wolfsburg and the car shown to the public in Berlin in 1939. However, the car did not go into mass production until after the end of the Second World War.

The first major post-war initiative was the establishment of the Porsche Company in Gmund in 1948. Of real significance was the *356* sports car, on which Porsche collaborated with his son Ferry and Erwin Komenda, who created the distinctive streamlined fastback shape. It went into production in 1950, the company having relocated to Stuttgart, and soon established a corporate reputation for high-quality production and innovative engineering. The *356* remained in production in various guises for sixteen years, and established a strong reputation in racing and rallying. The next model, the distinctive *911*, was designed by Komenda and Ferdinand 'Butzi' Porsche, the founder's grandson, and attracted considerable critical and public acclaim at the 1963 Frankfurt Motor Show. A classic design, it remained in production for more than three decades. Collaboration with Volkswagen was initiated in 1969, although models such as the *924* (1969) failed to capture the

public imagination. In 1996 the company produced the *Boxter*, designed by Haarm M. Laagay in charge of design from 1989.

Porsche Design Studios (established 1974) After the members of the Porsche family withdrew from the day-to-day running of the *Porsche automobile company, Professor F. A. (Ferdinand 'Butzi') Porsche founded the Porsche Design Studios in Zell-Am-See, Austria, in 1974. In many ways allied to the family's earlier design philosophy embodied in classic automobiles such as the Porsche *356* sports car of 1948 and the *911* of 1963, products designed at the Porsche Design Studios exude an aura of technical sophistication and aesthetic finesse. F. A. Porsche, co-designer with his father Ferry of the *911*, had studied briefly at the Hochschule für Gestaltung at *Ulm prior to entering the motor industry. Unsympathetic to customary corporate approaches to design wherein designers moved from drawings to models, he preferred the more direct 'feel' for outcome that came from starting with models. The resulting clarity of design, where functions were simplified, also manifested itself in the F. A. Porsche designs from the Porsche Design Studios such as the brushed aluminium Siemens *TC 91100* coffee machine of 1998. This technically elegant, minimal design solution used modern materials effectively, an approach endorsed in his designs for leading manufacturers of furniture, lighting, televisions, tobacco pipes, golf clubs, saucepans, domestic appliances, and sunglasses. Such products are expensive, have won design prizes, and have a fashionable cachet in the early 20th century.

Postmodernism *See* box on pp. 348–351.

Pottery Gazette (established 1878) Published in London and originally entitled the *Pottery and Glass Trades Journal* it became the *Pottery Gazette* in the following year. A very useful tool for researching into glass and ceramics history, it was once again retitled in 1970 as *Tableware International*.

Poulsen *See* LOUIS POULSEN & CO.

Powerhouse Museum (established 1988) In common with a number of other major museums the roots of the large-scale Powerhouse Museum in Sydney, Australia, lay in a 19th-century international exhibition—the Sydney International Exhibition of 1879. Many of the exhibits were purchased for the newly created Technological, Industrial and Sanitary Museum, although this was destroyed by fire in 1882. By 1893 the revivified enterprise had been renamed the Technological Museum and boasted a purpose-built permanent building. Over the following decades, whilst the collection grew across a wide range of disciplines from the decorative arts to industrial products, the museum established a reputation as a scientific research centre until in 1945 it became the Museum of Applied Arts and Sciences. New premises were needed for the growing collection, but it was not until 1979 that the government of New South Wales designated a decommissioned power station as its new premises. After an extensive redesign that was able to accommodate large-scale products such as aeroplanes as well as provide lecture theatres, restaurants, and other ingredients of the late 20th-century museum, the Powerhouse opened in March 1988. The museum has hosted many design exhibitions from overseas as well as from Australia itself. In 1992 it aligned itself with contemporary design initiatives when it began a series of annual 'Selections' from well-designed products recognized in the *Australian Design Award competition. In addition to the extensive collections that embrace design and the decorative arts (particularly over the past two centuries),

p

POSTMODERNISM

The term 'Postmodernism' has been applied to many disciplines including architecture, design, literature, communications, music, sociology, and film. In relation to architecture and design, by the late 1950s the visual language of *Modernism was increasingly equated with the tastes of the educated professional classes, the corporate aesthetic of successful multinational companies, and the outlook of an architectural establishment that had taken up a vocabulary derived from radical avant-garde tendencies in the interwar years. Firmly embedded in the contemporary world of television, passenger jet air transportation, foreign travel, and nuclear energy the burgeoning Postmodern *Zeitgeist* (or 'spirit of the age') of the later 1950s and early 1960s was to many—particularly younger architects, designers, and consumers—emphatically different from that of 1920s and 1930s Modernism. The early 1960s was a period in which the ephemeral values of *Pop came of age, its brightly coloured, culturally diverse, and image-rich ethos increasingly at odds with the rational, restrained aesthetic associated with the Modernists' exploration of new materials, manufacturing technologies, and abstract forms in the decades before the Second World War.

Ornament is an important feature of the Postmodernist vocabulary, a characteristic very much opposed by Modernist practitioners and theorists such as Adolf *Loos, whose article on *Ornament and Crime* of 1908 anticipated the antipathy to the decorative arts of leading figures such as Le *Corbusier in the 1920s. In fact the use of ornament in design had engendered fierce critical debate since the middle of the 19th century when many of the heavily decorated and patterned exhibits at the 1851 *Great Exhibition in London attracted the hostile attention of a number of influential critics who saw it as culturally decadent and the physical embodiment of profit-oriented commercialism. The most vociferous 20th-century inheritors of this design reform outlook were closely associated with the shaping of the Modern Movement. Among them was the theorist Herbert *Read, who, in *Art & Industry* (1934), saw it as a sign of decadence and based on the 'same instinct that causes certain people to scribble on lavatory walls, others to scribble on their blotting pads'.

One of the best-known maxims associated with Postmodernist architecture and design is architect, designer, and writer Robert *Venturi's 'less is a bore', an ironic subversion of the Modernist credo 'less is more'. Although the architectural and design historian and author of *Pioneers of Modern Design* Nikolaus *Pevsner had disapproved of what he detected as a growing trend towards 'Postmodern' electicism in an essay of 1961, Venturi did much to begin to define the term more tightly in his landmark book *Complexity and Contradiction in Architecture*, published in 1966. In this—in opposition to the clarity of form and enduring values associated with Modernism—he identified a number of Postmodern characteristics including hybridity, ambiguity, distortedness, inconsistency, and equivocality. Such ideas were further developed in Venturi's 1972 book, *Learning from Las Vegas*, written with fellow architects Denise Scott Brown and Steven Izenour. They advocated the use of a visual language that could be widely understood, drawing on the visual imagery and symbolism of popular

culture seen in the vibrant, often neon-lit, façades of the hotels, casinos, restaurants, and other entertainment buildings in Las Vegas. However, the popular visual language of billboards and façades explored by Venturi in *Learning from Las Vegas* had been a developing trend in business circles in the United States and, to a lesser extent, Western Europe for well over a decade. In business as well as architectural and design theoretical circles there had also been a growing interest in the formulation of a visual syntax that explored the aspirations and desires of consumers through a more sophisticated understanding of the driving forces of popular culture, an outlook that was fiercely attacked by the American writer Vance *Packard in his best-selling book *The Hidden Persuaders* of 1957. Increasing investment in Motivational Research, especially in the United States, further refined understanding of the visual language of advertising and retailing. Leading figures in the field were the social anthropologist Burleigh Gardner of Social Research Inc. and Austrian-born Dr Ernst Dichter, president of the Institute for Motivational Research and author of *The Strategy of Desire* (1960).

Next to Venturi one of the most important figures involved in the definition of Postmodernism in architectural and design circles was the American architect, designer, theorist, historian, and prolific writer Charles *Jencks, whose major books included *The Language of Postmodern Architecture* (1977) and *Postmodern Classicism* (1983). Further definitions of Postmodernism have been explored in the writings of cultural theorists such as Jean Baudrillard and Jean-François Lyotard. The latter proposed in his book *The Post-Modern Condition* (1984) that Postmodernism was a rejection of the universal certainties of the Modernist world in favour of the local and provisional. Further underlining the variety and complexity of the ways in which the term has been utilized was Marxist writer Frederic Jameson's view that Postmodernism was a form of American cultural imperialism and an expression of multinational and consumer capitalism. The emergence of Postmodernism also coincided with the rise of service-based, Post-Industrial economies and the demise of the production-based economies associated with *Fordism. Furthermore, computerized flexible production runs that could respond swiftly to the varied consumer demands of a pluralist society began to replace the large-scale production runs geared to satisfying homogeneous mass markets.

Dissatisfaction with the restrictions of the Modernist approach was also evident in the creative outlook of Italian designers associated with the *Neo-Liberty style of the 1950s. They sought to revive the expressive, organic, forms of *Art Nouveau and showed considerable respect for craft traditions—the antithesis of the standardized, machine-made forms of Modernist design. Prominent in the Neo-Liberty movement was the furniture designer Carlo *Mollino. Also concerned with the possibilities of a richer visual syntax than that of Modernism in their exploration of the semantic possibilities of architecture and design were Italian writers such as the theorist and historian Gillo Dorfles and academic, novelist, historian, and cultural theorist Umberto Eco. Like the French sociologist Roland *Barthes in *Mythologies* (1957), Eco explored the field from the late 1950s onwards, his texts including *A Theory of Semiotics*

(1976). Dorfles's writings included a 1969 edited book of essays entitled *Kitsch: The World of Bad Taste*, its focus on popular culture being intrinsically opposed to the tenets of Modernism and associated ideas of *'Good Design'. During the 1960s Italian avant-garde designers turned their backs on the dictates of mainstream manufacture in favour of experimentation, the publication of manifestos, involvement in research and education, and the mounting of exhibitions. Important amongst these was the 1972 *Italy: The New Domestic Landscape* exhibition at the *Museum of Modern Art, New York, curated by Emilio *Ambasz. Leading figures such as Ettore *Sottsass Jr. and *Anti-Design and *Radical Design groups such as *Archizoom and *Superstudio drew on the iconography of Hollywood films and Pop and were also attracted to alternative lifestyle models such as those of the hippies. Colour, ornament, and decoration, together with *kitsch, irony, and distortion of scale, were all key ingredients in Postmodernism. Following on from this was the work of *Studio Alchimia, established by Alessandro *Mendini in 1976 although its continuing commitment to design polemics rather than an exploration of the creative potential of design as a powerful agent for change in the world of production led Sottsass to form a new group, *Memphis, in 1981. Associated closely with 'New Design', a term widely used in 1980s Italy that referred to design work that broke with international style and functionalism, Memphis in many ways epitomized the spirit of Postmodernism. However, Sottsass believed that the latter was American, academic, and restricted in its cultural references. Memphis embraced many design fields including furniture, textiles, carpets, lighting, clocks, ceramics, and interiors, drew on an eclectic range of sources including kitsch, *Art Deco, and Pop and married cheap and expensive materials, popular and high culture references, thus imaginatively extending the contemporary design syntax.

Postmodernism was intrinsically bound up with notions of fashion and change associated with graphics, clothing, and retail design despite the fact that many of its original theoretical debates were bound up in the concerns of those who sought to open up fresh expressive possibilities in the more durable outputs of architecture. It flourished most vigorously during the 1980s when new markets for the conspicuous consumption of iconic products flourished and designers emerged as artistic celebrities. All of them stimulated, and catered for, the growing consumer demand for household goods endowed with cultural and aesthetic status. One particular, and often comparatively affordable, feature of Postmodern design was its increasing investment in the production of small-scale products for the table and kitchen—dinnerware, glassware, and metalware—a field where contemporary initiatives had for many years been heavily overshadowed by manufacturers' (and many consumers') preoccupation with traditional forms and patterns. Many of these products were closely associated with the preoccupation that many Postmodern designers, particularly the significant number who came from an architectural background, had with contemporary architecture on a vastly reduced scale. Such designs—including salt and pepper grinders, jugs, tea and coffee pots, sugar bowls, plates—were often referred to as items of 'table architecture' or 'microarchitecture'. The first *Swid

Powell collection of porcelain dinnerware, silverware, and glass to embrace such trends was launched in 1984. The architecturally conceived *Tea and Coffee Piazza* project of 1980, coordinated for Alessi by Alessandro Mendini, did much to promote the company's tableware, also described as 'domestic landscape' and set the scene for related Alessi initiatives over succeeding decades.

Like Modernism, Postmodernism is an international language finding expression in much of the industrialized world including Europe, Scandinavia, the Far East— particularly Japan—and Australia. Catering for the new breed of design-conscious consumers keen to purchase affordable status symbols for the domestic environment were widely recognized companies such as *Alessi, *Ajeto, *FSB (Franz Schneider Brakel), *Källemo, *Knoll, *Swatch, Swid-Powell and *WMF (Württembergische Metallwarenfabrik). The heightened media preoccupation with design in the years in which Postmodernism emerged led to considerably increased emphasis on the cult of the designer celebrity. In addition to the designers mentioned earlier, other well-known designers associated with Postmodernism include Andrea *Branzi, Frank *Gehry, Michael *Graves, Hans *Hollein, Toshiyuki Kita, Danny *Lane, Javier *Mariscal, Borek *Sípek, Philippe *Starck, Matteo *Thun, and Stanley *Tigerman.

industry, and technology, the museum has many important designrelated archives. These embrace the records of manufacturing industry, including the Martin Boyd Pottery, and the papers of contemporary Australian designers such as Gordon *Andrews and Douglas Annand.

Prada (established 1913) Prada's origins lay in a Milan boutique selling luggage, leather goods, and accessories, but it was not until 1978 that the company underwent radical change with the takeover of the family firm by Miucci Prada (1950–) and her husband Patrizio Bertelli. The institution of new management methods, a keen sense of design, and the implementation of an effective marketing policy helped to create a fresh, fashion-conscious identity. In 1985 the company introduced black nylon backpacks and tote bags which were originally sought after by the fashion-conscious as antistatus. However, they soon carried Prada's embossed silver triangle brand identity. The company's first ready-to-wear collection was launched in

1989 and was admired for its clean lines and 'elegant minimalism'. Subsequent designs have been characterized by fabric innovations and computer-enhanced patterns. In 1992 Prada launched its cheaper *Miu Miu* line, aiming to capture a more youthful market sector. The company's success in this project was underlined by the inclusion of Drew Barrymore in many *Miu Miu* advertisements in the mid-1990s.

Praesens (established 1926) This Polish avant-garde group was led by the architect-artist Szymon Syrkus, echoing the earlier rejection by *Blok of the nationalist vernacular design outlook of *Cracow designers and architects. Contrasting also with the outlook of the contemporary *Lad group, which was committed to modernizing vernacular traditions, its functionalist aims were aired in the first issue of the magazine *Praesens* (June 1926, published in Polish and French) and were influenced by *Modernist German and De *Stijl architecture and design. From 1928 Praesens was represented at the *Congrès Internationaux

PRODUCT SEMANTICS

This term was commonly used by industrial designers from the 1980s onwards and indicated an increasing preoccupation with gaining an understanding of the ways in which form, decoration, colour, and other visible features of products could communicate additional meaning to consumers and users. The study of product semantics derives from the linguistic analyses of the structuralist Ferdinand de Saussure and the highly influential writings of Roland *Barthes from the 1950s, particularly *Mythologies* (1957). The fact that this was not translated into English until the early 1970s goes some way to explaining why its influence gathered potency in the 1970s and 1980s. Its implications were explored in the context of advertising in Judith Williamson's widely read text *Decoding Advertisements* (1978),

See also SEMIOTICS.

d'Architecture Moderne and a number of its members contributed prototype Modernist furniture, furnishings, and layouts to the Minimum Flat Exhibition in Warsaw in 1930. Such concerns with 'minimum living' using standardized forms, and exploring new materials and technological possibilities, were shared by avant-garde architects and designers throughout Europe.

Premios Nacionales de Diseño (established 1987) These prestigious Spanish awards were established in 1987 by the *Fundació BCD, the Barcelona Centre de Disseny (Barcelona Design Centre) and the Ministry of Industry & Energy. They were seen as a means of promoting Spanish design excellence and innovation at home and abroad. Designers that have received awards include André *Ricard (1987), Enric Satué (1988), Santiago Miranda (1989), Jorge *Pensi (1997), Javier *Mariscal (1999), and Daniel Gil (2000). Award-winning companies have included Disform (1990), *Vinçon (1995), and Santa & Cole (1999).

See also DESIGN AWARDS.

Pritchard, Jack (1899–1992) Design entrepreneur Jack Pritchard was educated at Cambridge University, where he took a degree in engineering and economics in

1922. After a period of employment with Michelin (1922–5) he developed a strong interest in the *Modernist aesthetic whilst working for the Venesta Furnishing Company. He commissioned Le *Corbusier for the design of a company stand at the Building Trades Exhibition at Olympia, London, in 1930. His familiarity with the European avant-garde was consolidated by a visit to the Dessau *Bauhaus in 1931 with architect-designers Serge *Chermayeff and Wells *Coates. Four years later he met the Finnish architect-designer Alvar *Aalto, who showed him and the critic Philip Morton Shand his Paimio Sanatorium and Finmar furniture workshops. Pritchard did much to promote Modernism in Britain, particularly as chairman of the *Design and Industries Association (DIA). In 1933 Pritchard, his wife Molly, and Wells Coates founded the *Isokon Company responsible for overseeing the ambitious Lawn Road Flats project (completed 1934) in Hampstead, North London. The flats were designed by Coates around the concept of 'minimum living' linked to common services, a concept that was being explored internationally by many architects associated with the *CIAM, and were equipped with plywood furniture designed by Isokon.

Among the residents of the Lawn Road Flats were a number of celebrated figures who had fled the difficult political context of Nazi Germany, including former Bauhaus staff members Walter *Gropius, Marcel *Breuer, and László *Moholy-Nagy. Breuer and Gropius designed furniture for Isokon, whilst Moholy-Nagy designed company leaflets. Pritchard also introduced Gropius to Henry Morris, the Chief Education Officer for Cambridge, which led to Gropius' commission for the design of Impington Village College in 1939. After the Second World War Pritchard became director of the Furniture Development Council, retiring in the 1960s.

Productivism *See* CONSTRUCTIVISM.

Product Semantics *See* box on p. 352.

Prouvé, Jean (1901–54) A leading French designer and architect, Prouvé came from a distinguished pedigree in the decorative arts, his father Victor and godfather Émile *Gallé being leading figures of the École de Nancy. Though interested in engineering the First World War interrupted his career plans and he became an ironworker, having taken up an apprenticeship with a blacksmith, followed by work in the Szabo metal workshops. He established his own design workshop in Nancy in 1923, producing wrought iron lamps, balustrades, and other architectural fitments. A significant early commission was for shop-front fittings for the architect Robert *Mallet-Stevens. From an early stage of his career Prouvé was interested in achieving an industrial quality in his furniture designs, often using prefabricated and interchangeable elements as in his metal desk designs for the Compagnie Parisienne d'Électricité in 1926. In 1930 Prouvé was involved in the establishment of the pioneering *Union des Artistes Modernes (UAM), a body of French *Modernists that had become disillusioned with the *Societé des Artistes Décorateurs

(SAD). This was both on account of its perceived conservatism and its perceived pandering to the tastes of an affluent urban cultural élite. In the following year he opened the Ateliers Jean Prouvé, soon establishing a reputation for innovative architectural commissions including prefabricated buildings. In 1944 he opened an experimental factory at Maxéville, near Nancy, specializing in experimental housing design and research into aluminium. In 1945 800 of his prefabricated houses were erected, each able to be erected by three non-specialists in four hours. He also collaborated on furniture design projects with Charlotte *Perriand, Pierre Jeanneret, and Le *Corbusier. In 1954 he left Maxéville for Paris, founding a company for the mass production of his furniture. His great significance was recognized through several awards made for his work, including the Auguste Perret Prize of the International Union of Architects in 1963.

Psion (established 1980) Founded by David Potter, this innovative British company established a reputation for small-scale computers with a particular focus on electronic personal organizers and information systems, replacing the ubiquitous 'designer' fashion Filofax paper-based organizers that became so popular in the 1980s. Psion products were included in the Millennium Products selected by a panel of experts on behalf of the *Design Council to represent the best of British design for the year 2000 promoted abroad by the British Council and the Design Council itself. The company's first electronic product was the *Organizer* (1984) but its reputation was more firmly established with the introduction of its *Palmtop* series, which heralded a very real reduction in size, as the name implied. By the time of the *Palmtop Series 5* (1997) sophisticated miniaturized electronic systems had

PSYCHEDELIA

Originating in San Francisco on the West Coast of the USA psychedelia was closely associated with the hippy movement, 'flower power', and the increasingly widespread use of hallucinatory drugs, initially in the USA in the mid-1960s and soon afterwards in Europe. Such drugs as LSD induced in the taker a quasi-surrealist experience, bringing together bright colours, sounds, and images, and feelings which some sought to echo by means of multimedia shows which included films, slides, and sounds. The American band the Grateful Dead explored such ideas through the words and music of 'acid rock'. In Britain, the band Pink Floyd, also closely linked with psychedelia, played against a backdrop of specially commissioned light shows. Designers also sought to link psychedelic experiences to many things associated with everyday life, applying a vivid vocabulary of swirling, gaudy shapes and colours to a wide variety of surfaces including posters and record covers, clothing, furniture, jewellery, and boutiques. Typifying this genre were poster and record cover designers such as Victor Moscoso, Rick Griffin, and Wes Wilson in the USA and Martin Sharp and Hipgnosis in Britain. Such work, much of which embraced images associated with 'alternative' lifestyle, was often used to decorate the living environments of consumers opposed to the ethics of big business and was influenced by imagery as diverse as *Art Nouveau and Indian art. The illustrated 'underground' magazine *Oz*, launched in London in 1967, was seen as 'subversive' in terms of content by the establishment. *Oz* also took on a radical visual appearance, with print and images superimposed, often in different, contrasting colours, with text laid at angles and visuals deliberately unfocused, a material counterpart to the psychedelic experience. Many self-taught designers applied psychedelic designs to their cars and homes, whereas others applied them to more commercial, though generally small-scale, concerns. These included the exterior of boutiques such as 'Granny Takes a Trip' painted by Nigel Weymouth and Michael English, a partnership known as 'Hapsash and the Coloured Coat' which had been formed in London in 1967. Although the impetus of psychedelic imagery derived from radical ideas associated with the projected creation of an 'alternative' society, within a very short period it was emasculated as a result of the highly commercial appropriation of its originally subcultural ideology by the very business interests that it opposed.

been set in place, including a touch type keyboard, a touch sensitive screen, and communication via mobile phone.

Psychedelia *See* box on this page.

Pucci, Emilio (1914–92) A leading figure in Italian fashion in the 1950s and 1960s, Pucci studied for a year at the University of Milan. In 1935 he travelled to the United States where he also studied, returning to the Uni-

versity of Florence, from which he graduated in 1941. After the war, he gained attention as a fashionable designer of skiwear after being featured modelling his own designs in *Harper's Bazaar* in 1948. This was followed in 1949 with designs for hats, casual trousers, and shirts that further drew him to the attention of an affluent fashion-conscious clientele which reflected his own social background. In 1950 he opened his own cou-

PUNK

The origins of Punk in the mid-1970s lay in the realities of disaffected working-class urban youth with little hope of employment, housing, and a meaningful future. Its visual expression in clothing, as cultural sociologist Dick Hebdige remarked at the time, was 'the sartorial equivalent of swearwords' and was opposed to conventional fashion, with bondage trousers and ripped clothing, often made from unconventional materials such as fake leopard skin or plastic binliners. Hairstyles were unnatural, dyed, and often spiked, with personal decoration in the form of safety pins, body piercing, and dangling chains, heavy high-laced Doc Marten's boots, all of which were associated with forms of social 'deviancy'. At the outset punk graphics were also immediate and required, like punk music, little skill to produce in the conventional sense; they were characterized by the emergence of a range of low-tech fanzines such as *Sniffin Glue*, which began publication in 1976. Crudely designed pages, often with handwritten, graffiti-like insertions and typographic errors, as well as letters torn out from other sources, characterized the style. Such ideas gained wider currency in the Punk music scene with record covers for companies like Factory Records and Stiff Records and the emergence of designers like Jamie *Reid, who designed the controversial sleeve for the Punk band the Sex Pistols' single *God Save the Queen* of 1977, showing the defaced head of Queen Elizabeth II. Entrepreneur Malcolm McClaren and fashion designer Vivienne Westwood generated the Sex Pistols in 1974 in their *Sex* *boutique on the King's Road. Graphic designers such as Reid, Malcolm Garrett, and Peter Saville, all closely associated with Punk music graphics, had all attended art school and, with others such as Neville *Brody, revitalized graphic design through harnessing the vitality and iconoclasm of Punk to graphic skills and an awareness of *Postmodern eclecticism. However, like many radical challenges to conventional lifestyles any threat was removed by the commercialization of the style, as had been the case with hippies and *Psychedelia in the previous decade.

ture house in Florence, increasingly gaining attention for colourful casual clothing. His clothes became highly fashionable on both sides of the Atlantic from the mid-1950s, with the establishment of a shop on Fifth Avenue, New York, and featured in *Vogue*. From 1964 to 1973 he also served as a Member of Parliament for Florence, a period which saw the emergence of a new, less elitist generation of Milan-based Italian designers such as *Armani and Versace. However, in the 1990s there was a revival of interest in Pucci's designs ('Puccimania') exemplified in the Versace Collection of 1991 that derived closely from Pucci's work of the 1960s.

Puiforcat, Jean (1897–1945) Born into a Parisian silversmithing family Puiforcat became a leading designer in the field in France between the two World Wars. After commencing an apprenticeship in the family firm he studied sculpture under Louis Lejeune. He set up as a silversmith in 1922, working in the fashionable *Art Deco style, and showed in Jacques-Émile Ruhlmann's Pavilion of a Rich Collector at the 1925 *Paris Exposition des Arts Décoratifs et Industriels. Committed more to the abstract forms and restraint of *Modernism than the more decorative aesthetic of the applied

arts in France he joined the *Union des Artistes Modernes (UAM) established in 1929. He was interested in mathematics and worked with geometrically inspired forms. An entire pavilion was dedicated to his work at the 1937 *Paris Exposition des Arts et Techniques dans la Vie Moderne. With the rise of Fascism in Europe he settled in Mexico, where he opened a silversmithy in 1942.

Pulos, Arthur J. (1917–93) A distinguished design educator, propagandist, and industrial designer, Arthur Pulos was well known for his writings, his lecturing in developed and developing countries across the world, and his involvement with key organizations such as the *International Council of Societies of Industrial Design (ICSID). Graduating from the Carnegie Institute of Technology in 1939 he went on to study for a Masters of Fine Art at the University of Oregon, completing in 1943. Between 1955 and 1982 he was professor and dean of the Design Department at Syracuse University, also president of Pulos Design Associates (1955–88). His best-known texts on design in the United States are *The American Design Ethic: A History of Industrial Design to 1940* (1983) and *The American Design Adventure: 1940–1975* (1988). His consultancies have been wide-ranging, from advising Colonial Williamsburg in 1953 to acting as a juror for the International Design Awards, Osaka, in 1983 (see JAPAN DESIGN FOUNDATION). In addition to his presidency of ICSID from 1981 to 1983 he was made a Distinguished Designer Fellow of National Endowment (1984), received the 1st World Design Award at the World Design Conference in New York (1988), and the 7th International Design Award from the International Design Festival in Osaka in 1993.

Punk See box on p. 355.

Push Pin Studio (established 1954) See GLASER, MILTON; CHWAST, SEYMOUR.

PVC (polyvinyl chloride) The origins of this material lay in experimentation in the 19th century and in the years immediately before the First World War. But it was not until the interwar years that manufacturing on any significant scale began to be undertaken in Germany and the United States. In 1928 the Carbide and Carbon Chemical Corporation began to manufacture PVC as a rigid plastic under the trade name *Vinylite* and it was used in the pressing of records by RCA-Victor. It was also soon used for many other products including the manufacture of clock cases, ash trays, bowls, light fittings, lampshades, and flooring. The first flexible vinyl plastic produced in the USA was manufactured by the B. F. Goodrich Company in 1931 and taken up by a number of other large companies in the late 1930s. Celebrating the new plastics as a reflection of the modern spirit the Pierce Foundation displayed a whole room furnished and equipped with a variety of PVC products at the *Chicago Century of Progress Exposition in 1933. In the post-Second World War period the uses of PVC were widespread. In addition to the ever-increasing array of packaging products from shampoo sachets to bleach bottles it has been used for shoes, wellington boots, dustbins, road signs, furniture, upholstery, and in the construction of fabrics. PVC is also widely used in building and decorating, from skirting boards to cornices. Amongst the most celebrated designs using the material were the 1967 *Blow Chair* by Scolari, De Pas, D'Urbino, and Lomazzo for *Zanotta, furniture by Quasar Khanh, and dresses and fashion.

Pyrex See CORNING GLASS.

Quant, Mary (1934–) An important figure in British fashion design, Quant studied art and design art Goldsmith's College of Art from 1952 to 1955, during which time she also took evening classes in clothing construction and cutting. In 1955 she opened her first shop *Bazaar* in the King's Road in bohemian Chelsea, London, which was followed up with a second outlet, designed by Terence *Conran in Knightsbridge in 1957. Working closely with Alexander Plunkett Green, whom she had married in 1957, she founded both the Mary Quant Ginger Group (for wholesale clothing design and production) and Mary Quant Limited in 1963. Despite the fact that her merchandise was comparatively expensive, during the 1960s the name Mary Quant became almost synonymous with the internationally recognized concept of 'Swinging London', particularly through the popularization of the miniskirt, a ubiquitous fashion icon of the *Pop era and symbol of new-found sexual freedoms. She also explored the possibilities of new materials, as with her designs for tights for the Nylon Hosiery Company in 1965, and branched out into cosmetics in the following year. Quant was also successful in the United States in the 1960s, designing a clothing and underwear collection for the J. C. Penney Company in 1962, a dress collection for Puritan Clothing, New York, in 1964 and patterns for Butterick Paper Patterns. Since then her work has encompassed many product ranges including berets and hats for Kangol (1967), bed linen and curtains for Dorma (1972), sunglasses for *Polaroid (1977), Axminster Carpets for Templetons (1978), shoes for K Shoes (1982), and clothing for Great Universal Stores (1987). In the late 1990s she opened shops in Paris and New York. Quant has received many awards throughout her career, ranging from 'Woman of the Year' in London in 1963 to the Order of the British Empire in 1966 and election as *Royal Designer for Industry in 1969. She wrote her autobigraphy *Quant by Quant* in 1966 and in 1973 featured in the *Mary Quant's London* exhibition at the London Museum.

Quistgaard, Jens Harald (1919–) Quistgaard was apprenticed at the Georg *Jensen Solvsmedie in Copenhagen, becoming a freelance designer after the Second World War. He worked in a variety of media including wood, metal, glass, stainless steel, and ceramics. His characteristically Danish craft aesthetic brought him to the attention of Ted Nierenberg, the founder of *Dansk International, for whom he worked for 30 years from its establishment in 1954. Quistgaard's work was publicly recognized through winning the *Lunning Prize in 1954, as well as the Scandinavian Award, together with six awards at the *Milan Triennali.

R

Race, Ernest (1913–64) British furniture designer Ernest Race achieved international recognition in the post-Second World War period alongside the emergence of the *Contemporary Style, characterized by his *Antelope* and *Springbok* chairs. His work was generally innovative in its use of materials and fabrication and he was awarded Gold and Silver Medals at the 1954 *Milan Triennale. He trained in interior design at the Bartlett School of Architecture, London University, from 1932 to 1935 before working for the lighting manufacturing company Troughton & Young from 1936 to 1937. Following travel to India he ran a London shop where he sold his own textile designs (woven in India with a strongly indigenous flavour) alongside modern, particularly Swedish, furniture design. In 1945 he formed a partnership with J. W. Noel Jordan to establish Ernest Race Ltd. (with Noel Jordan as the managing director) and commenced his career as a furniture designer. An early design was the *BA3* aluminium chair, which remained in production from 1946 to 1969. His steel rod *Antelope* and *Springbok* chairs, selected by the Council of Industrial Design (*see* DESIGN COUNCIL) for the *Festival of Britain of 1951 attracted particular attention. He also designed the ingenious folding *Neptune* deckchair in plywood for the Orient Line in 1953. Other designs included the *Heron* (1955) and *Flamingo* (1957), combining a lightweight frame with foam rubber to give a contemporary look that fitted well with smaller homes. In 1961 the company changed its name to Race Furniture Ltd., and Race resigned in the following year. He became a consultant designer to the *Isokon Furniture Company in 1963, redesigning Egon Riss's *Isokon Penguin Donkey* and *Bottleship* of the late 1930s in flatpack form. He was elected as a *Royal Designer for Industry in 1963.

Race Furniture Ltd. *See* RACE, ERNEST.

Radical Design *See* box on p. 361.

Rams, Dieter (1932–) The clarity of form and minimalist design vocabulary associated with the German designer Dieter Rams is closely identified with the *Braun company. Many of his designs for domestic appliances and audio equipment feature in the permanent collections of leading museums that collect and promote design, such as the *Museum of Modern Art, New York, which began to collect Braun products in 1958. After studying architecture at the Wiesbaden Academy of Applied Arts from 1947 to 1953 he spent three years as an apprentice cabinetmaker. This was followed by a period in architectural offices until he joined Braun in 1955. The clean, austere appearance associated with a functional aesthetic was epitomized by Rams's and Hans Gugelot's design of the *Phonosuper SK4* radiogram of 1956, sometimes dubbed 'Snow White's Coffin'. At this time he was also involved in furniture development with the designer, physicist, and entrepreneur Otto Zapf (born 1931). He became Braun's design director in 1960 and was responsible for establishing a cleanly stated and distinctive aesthetic for a wide range of products from kitchen appliances to alarm clocks, calculators, lighters, and electric razors. This aesthetic was also in tune with the outlook of the Hochschule für Gestal-

RADICAL DESIGN

This movement emerged in Italy in the 1960s and, like its close counterpart *Anti-Design, was firmly opposed to the tenets of *'Good Design' and style as marketing tools divorced from the social and cultural possibilities inherent in the design process. Centred around avant-garde design groups such as *Archizoom, *Superstudio, *Global Tools, and 9999, the movement expressed its ideas through the publication of manifestos, reviews, and articles, participation in national and international competitions and exhibitions, expository films, research, and teaching. Although ideologically aligned to the broader aims of Anti-Design, those associated with Radical Design were more politically motivated, devoting considerable energy to research into urban architecture, innovation, and the environment. Strongly opposed to the constraints of capitalism, the role of the consumer-user was central to their thinking and reflected their attraction to sociocultural possibilities such as those proposed by alternative lifestyle models like those of the Beat poets and subsequent hippy movement. Many aspects of the Radical Design agenda were displayed at the 1968 Venice Biennale and subsequently at the *Museum of Modern Art, New York, in its *Italy: The New Domestic Landscape* exhibition of 1972, supported by the accompanying publication edited by Emilio *Ambasz, the show's curator. Rather like those of the Italian Futurists 60 years earlier, the ideas of the Radical Designers remained largely in the form of paper projects and printed manifestos rather than fully realized designs, buildings, and environments. Nonetheless, like *Futurism before it, Radical Design exerted a significant influence on subsequent avant-garde design activity and outlook.

tung at *Ulm, a progressive design academy with links to Braun that had been first established in 1954. Other companies with which Rams has been associated include the furniture manufacturer Vitsoe (established 1959), the door handle manufacturer FSB (established 1881), and the lighting producer Tecnolumen (established 1980). His clearly articulated and austere 606 shelf unit for Vitsoe (1960) remained in production for more than 40 years. He has held a number of academic posts including, from 1981, a professorship in industrial design in Hamburg. In 1987 he became president of the German Rat für Formgebung (Design Council), which for many years had promoted the values associated with ideas of *'Good Design'. By this time many of the design values espoused by Rams were increasingly challenged by the content-rich

visual language associated with *Postmodernism. Dieter Rams has received many international design awards throughout his career.

Rand, Paul (1914–96) One of the most influential graphic designers of the 20th century, Paul Rand's contribution to the visual environment has been striking on many fronts. This contribution was apparent in his instantly recognizable *corporate identity designs for *IBM, Westinghouse, and other large multinational corporations, his teaching at Yale University, and his writings such as *Design, Form and Chaos*. He was born in New York, studying at the Pratt Institute (1929–32), the Parsons School of Design (1932–3), and at the Art Students League (1933–4). Having established his own office in 1935, two years later he became art

director of *Esquire-Coronet* and *Apparel Arts* magazines, followed by *Direction* in 1938. His interest in European avant-garde design (including De *Stijl, *Constructivism, and work at the *Bauhaus), blended with his immersion in contemporary American visual culture, did much to bring about a very distinct form of advertising art in the late 1930s. He showed a willingness to use a full palette of techniques, such as typography, painting, collage, photography, and montage, combining them in an original way with his penchant for visual symbols to produce a rich and distinctive visual language. In 1941 he became advertising director at the well-known William H. Weintraub Agency in New York, working at the centre of a creative team producing advertisements that combined type and image in a striking pictorial manner. In the mid-1950s he became a freelance graphic design consultant to many leading American corporations. He played a highly influential role in the development of corporate identity design and *logotypes which, in addition to those for IBM, the Cummins Engine Company, and Westinghouse (corporations where he worked closely with Eliot *Noyes), included work for *Apple, ABC Television, and the United Parcel Service. In addition to the professional influence exerted by his work from the late 1930s onwards his teaching at the Pratt Institute, the Cooper Union, and, from 1956 to 1992, the Yale School of Architecture did much to influence new generations of graphic designers. He also wrote several books and many articles on graphic design and his 1946 text *Thoughts on Design* made a lasting impact on the profession. Another insight to his work, influences, and beliefs was his 1985 book *Paul Rand: A Designer's Art*, which also included a number of reprinted essays spanning 40 years of his career. However, towards the end of his life he was also highly critical of many aspects of contemporary graphic design practice, as seen in his text *Design, Form and Chaos* (1994). During his career he won many design awards including Gold Medals from the American Institute of Graphic Arts (AIGA) and the Art Directors Club of New York, being elected to the latter's Hall of Fame in 1972. He was also a member of the Alliance Graphique Internationale (AGI).

Rasch Brothers (established 1897) Founded by brothers Emil and Hugo Rasch, this German wallpaper manufacturing concern has been closely identified with the German *Bauhaus following manufacture of its designs in 1930. After the Second World War the company retained its progressive edge with the marketing of artistic wallpapers by designers such as Lucienne *Day, Salvador Dalí, Shinkichi Tajiri, and Bruno Munari. In 1992 the company's *Zeitwande* (Timewalls) collection of wallpapers was issued, including designs by Ron *Arad, Ettore *Sotssass, Alessandro *Mendini, Borek *Sípek, and Matteo *Thun. The company also had a textile manufacturing business and specialized in the publication of art books and catalogues.

Rat für Formgebung (established 1953) Following a parliamentary recommendation of 1951 the Rat für Formgebung (German Design Council) was established in 1953 as a non-profit-making national body for design promotion in Germany. Like its predecessor in Britain, the Council of Industrial Design (established in 1944, *see* DESIGN COUNCIL), the German Design Council had a role to play in national reconstruction after the Second World War. The *Deutscher Werkbund, a powerful German design promotional body in the first three decades of the 20th century, supported this initiative. The 1951 parliamentary mandate for the

RATIONALISM

An Italian movement in tune with the progressive tenets of *Modernism in the 1920s and 1930s, Rationalism initially centred on the activities of Gruppo Sette, an architectural group founded in 1926, the members of which included Luigi Figini, Gino Pollini, and Giuseppe *Terragni. Their designs were characterized by the manipulation of clean, abstract forms harnessed to new materials and the potential of contemporary technologies. They hoped that their progressive aesthetic might become the official style in Mussolini's Fascist Italy although, in part, their commitment to an international rather than national outlook may have led to the failure of such aspirations. As a result the Rationalists won few major public commissions, although a number of privately funded works attracted favourable critical attention. These ranged from work on a modest scale such as Figini, Pollini, and Luciano Baldessari's Craja Bar (1930) and Eduardo Persico and Marcello *Nizzoli's Parker shop (1934) in Milan to the clean steel and glass factory (1937) for *Olivetti at Ivrea by Figini and Pollini. The opportunities for significant exposure of Rationalist work was largely restricted to the pages of progressive architectural and design magazines such as *Domus and *Casabella and the displays at the *Milan Triennali where such *Functionalist designs as those of Franco *Albini's *Room for a Man* were shown at the 1936 Triennale. Despite the political difficulties of pursuing an international avant-garde aesthetic, there were instances where Rationalist work was commissioned in the cause of Fascism, most notably Terragni's House of Fascism (1933–6) in Como.

Design Council included the mission 'to promote all efforts deemed appropriate to achieve the optimum design for German products, both in the consumer's interest and in order to secure the competitive advantages of the products of industry and the craft trades in West Germany'. Accordingly, the Council sought to influence German industry, business, educational, and cultural institutions and organizations and the public in their understanding of the social, economic, and cultural benefits of design. Again like its British counterpart it established a photographic library of exemplars of well-designed, mainly German, products in the 1950s and now consists of over 40,000 photographs and 10,000 slides. Furthermore, in the 1960s, it established a library for the dissemination of design knowledge and information. It purchased books on all aspects of design, from visual communication to architecture, and has holdings of more than 300 international design periodicals. In 1988 a video archive was established and, in 1992, the German Design Council published a *Design Report* that provided an overview of about 800 design and design-related organizations in the Federal German Republic. Located in Frankfurt since 1987 the Council has been part of the Ministry of Trade, organizing conferences, symposia, and exhibitions. It is also responsible for the German Award for Product Design awarded biannually since the early 1990s (originally established in 1969 as the Gute Form (Good Form) Awards, the first of which was awarded to Otl *Aicher for his Lufthansa Airlines corporate identity design).

Rationalism *See* box on this page.

Raymor (1941–1980s) Also known as Richards Morgenthau & Co., the New York-based company Raymor was a well-known American distributor of modern domestic products, evolving from Russell *Wright Accessories, with which the company's founder, Irving Richards, had been linked since 1935. The company's range included designs by Gilbert Rohde, Donald *Deskey, Walter Dorwin *Teague, Ray and Charles *Eames, George *Nelson, and Eva *Zeisel. In the post-Second World War period Raymor also imported modern Scandinavian and Italian designs, including work by Arne *Jacobsen, Tapio *Wirkkala, Hans *Wegner, and Ettore *Sottsass, the latter designing a wide range of ceramics in the late 1950s. From 1947, when the Richards Morgenthau side of the business was formed, the company also manufactured lighting, ceramics, and glass in its own factory in New Jersey, many items being designed by Irving Richards himself. Although known both as Raymor and Richards Morgenthau & Co., the former was more closely identified with design and imports, the latter with sales.

Read, Herbert (1895–1968) After a brief spell as a bank clerk the British writer, critic, and poet Herbert Read studied at Leeds University before serving in the army in the First World War. He became an important figure in the promotion of *Modernism in Britain, developing friendships with key figures such as the poet T. S. Eliot, the sculptors Henry Moore and Barbara Hepworth, and the painter Ben Nicholson. After working in the Treasury from 1819 to 1922 he developed his interests in the visual arts through employment as an Assistant Keeper at the *Victoria and Albert Museum from 1922 to 1931. This impetus was furthered through his appointment to the Watson Gordon Professorship of Fine Art at the University of Edinburgh from 1931 to 1933, followed by a period of six years as editor of and contributor to the *Burlington Magazine*. Amongst the most important texts promoting Modernism published in Britain was Read's *Art & Industry: The Principles of Industrial Design* (1934), the layout of which was designed by former *Bauhaus tutor Herbert *Bayer. In this seminal text, the designer was portrayed as an abstract artist working in industry, reconciling facets of design such as materials, form, colour, and proportion with modern mass-production technology. Read felt that the designer should play a central role in modern manufacture, rather than the low-paid, subservient role that generally prevailed. Read was also involved with the avant-garde group of artists and architects who formed *Unit One in London in 1933 and *Circle* (1937), an interdisciplinary survey of international *Constructivist art. In addition to Read, contributors to the latter included *Breuer, Le *Corbusier, *Gropius, *Moholy-Nagy, and Mondrian and subjects covered ranged from art and architecture, biotechnics, and choreography to engineering and typography. He was also a leading figure in the mounting of the controversial Surrealist Exhibition at the New Burlington Galleries, London, in 1936. During the Second World War Read was a director of the *Design Research Unit, established in 1943, which was to emerge as a significant consultancy in the post-war period. With Roland Penrose, in 1948 he founded the Institute of Contemporary Arts in London which, amongst other things, provided a focal point for the *Independent Group in the early 1950s. He was knighted in 1953. Amongst his other writings relating to the visual arts were *Art Now* (1933), *Art & Society* (1937), *Education through Art* (1943), *Modern Painting* (1959), and *Modern Sculpture* (1964).

Reeves, Ruth (1892–1966) After attending the Pratt Institute, Brooklyn (1910–11), the textile designer and artist Reeves won a scholarship to the Art Students League in New York in 1913. She was attracted by the artistic allure of Europe and travelled to Paris in 1920, where she studied with Fernand Léger. After returning to the United States in 1927 her designs showed a strong influence of French developments in the arts. In textile designs such as *Manhattan*, printed by W. & J. Sloane (1930), her knowledge of Cubist forms blended with the modern iconography of New York, including skyscrapers, smoking factory chimneys, a speeding locomotive, an ocean liner, an aeroplane, and a telephone switchboard.

Reich, Lily (1885–1947) Reich's early career centred upon the design of textiles and women's clothing, working at the *Wiener Werkstätte with Josef *Hoffmann from 1908 to 1911. In the following year in Berlin she met one of the driving forces of the *Deutscher Werkbund (DWB, established 1907), Hermann *Muthesius, and his wife Anne. She was involved with this progressive group in a number of ways, including the organization of a fashion show in Berlin in 1915 as means of promoting well-designed German clothes. However, despite favourable critical and press attention this policy was soon discarded. In 1920 she became the first DWB woman member and established her own fashion and interior design studio in Berlin, followed by a similar venture in Frankfurt from 1924 to 1926. She also worked for the Werkbund as an exhibition organizer and was involved in the 1921 DWB exhibition of German arts and crafts that toured in the United States, commencing at the Museum of Art in Newark, New Jersey. The show contained 1,600 objects, with Reich working with Otto Baur and Richard L. F. Schulz on their selection and organization. In the mid-1920s she became acquainted with the influential German architect and designer *Mies Van Der Rohe and was closely associated with him from 1927 to 1938, although she continued to manage his affairs after he left Germany until her death in 1947. They cooperated closely on a number of projects, whether interiors, furniture, or exhibitions for the DWB. These included the *MR* cantilever chair of 1927 first manufactured by the Joseph Müller Metal Company and the *Brno* chair of 1929–30. She also worked with him on aspects of the DWB's Weissenhof Housing Exhibition in Stuttgart, for which he was the organizer (as well as the DWB's vice-president). In 1932 she directed the Weaving Workshops at the *Bauhaus in Dessau whilst Mies was the institution's director and she also collaborated with Mies at the 1937 Paris Exposition Universelle before he emigrated to the USA in the following year. She continued to manage his interests in Germany, saving the 4,000 drawings and documents from his Berlin Office now in the Mies Archives at the Museum of Modern Art (MOMA), New York. At the end of the Second World War she was involved in a meeting to revive the DWB and once more established her architecture and design practice alongside a teaching career in Berlin. The first major exhibition devoted to Lily Reich was shown at MOMA in 1996.

Reich, Tibor (1916–96) Hungarian born Reich was an innovative woven and printed textile, ceramic, and graphic designer who also contributed designs for *G-Plan, Gordon *Russell, and Ercol furniture. In the 1930s he studied textile design in Vienna, where he was influenced by the legacy of the *Wiener Werkstätte and the *Bauhaus. With the rise of Nazism in Europe Reich emigrated to Britain and studied at the textile department at Leeds

University in the later 1930s. After graduating he worked for the Tootal textile manufacturing company, going on to establish his own textile firm, Tibor Limited (1945–1978) near Stratford on Avon. He first worked on woven, textured textiles, moving into printed textiles in the 1950s. His brightly coloured designs made an impact on home furnishing of the period. Reich also designed a textile for Princess Elizabeth's wedding (selected by the Commonwealth of Wool Growers), as well as a series of commissions for the British Royal family, including curtain textiles for Windsor Castle and upholstery textiles for the Royal Yacht *Britannia*. Other significant commissions included a range of textiles for the Shakespeare Memorial Theatre in Stratford to mark the *Festival of Britain in 1951, and tapestries for Coventry Cathedral and Manchester University. Tibor Textiles opened a London showroom in the 1960s, further promoting his designs in the domestic, office, and contract sectors. His fabric designs were used for a wide variety of clients including Lotus Cars, the supersonic airliner Concorde, cruise liners, and halls of residence in the new universities of the 1960s. He was also awarded a *Design Centre Award for his photographically based *Flamingo* printed textile in 1957, the Award's inaugural year, and the Textile Institute's Design Medal in 1973. Reich also designed in other media including *Tigo*, a black and white pottery range for Denby, carpets for a number of companies including Wilton, greetings cards, and first day covers.

Renault (established 1899) The Renault Brothers Marcel and Fernand founded this leading French automobile company in 1899. The early cars, designed by their brother Louis, began winning road races from 1899 onwards, the resultant publicity

developing a demand for the company's cars. Renault soon developed a sales network and, in 1905, moved from the craft to industrial production of cars in order to cope with large orders for taxis in Paris and New York. By the outbreak of the First World War the company employed about 5,000. However, the hiatus of the First World War led to a shift in the balance of power in the global production of cars. France was overtaken by the United States as the leading producer: the impact of the *Ford philosophy, backed by the introduction of its moving assembly line and accessible prices without the interruption of war saw a significant shift. Both Renault and *Citroën sought to learn from American methods, with Citroën leading the way. In the 1920s Renault diversified into the production of buses, commercial vehicles, and tractors. The company also built a large factory at Billancourt near Paris in order, like Ford at his Baton Rouge complex in Michigan in the USA, to control as many aspects of car production—from raw materials to component parts—within a single company. Assembly lines were introduced at Renault and the factory completed in 1937. Renault automobile designs followed fairly conventional lines until the later 1920s when external consultants Hibbard & Darrin were brought in for the *Reinastella* range of 1928. In common with other manufacturers in Europe and the United States, streamlined forms also made their impact on the Renault range in the 1930s, as seen in the *Viva Grand Sport* of 1934 designed by Marcel Riffart. Three years later Renault launched its first attempt at a people's car, the streamlined *Juvaquatre*, affordable and with hydraulic brakes. Nonetheless, technological imperative rather than style generally informed the outlook of Renault's body design department, directed by Roger Barthaud. The Second World War proved a difficult time for the

RETRO

This term was first employed in France in the early 1970s as an abbreviation of the term 'rétrograde' ('rétro') and was used to look back to past styles and fashions in a nostalgic way. It has entered common currency in the context of marketing past styles whether in terms of music, dress, furniture, appliances, architecture, or car styling. For example, in 1974, the whole of the Selfridge's store window display in Oxford Street, London, was devoted to products and ephemera associated with the period in which the Paramount film, *The Great Gatsby*, was set, including *Art Deco motifs, cocktails, and correspondent shoes. Such contemporary Deco 'retro' inclinations of the time were also evident in the *Biba emporium in Kensington, with its glamorous Rainbow Room and other references to the glamour of the 1930s. Since then the term has been used almost indiscriminately as a marketing tool, but has also been seen in a more considered way in designs such as the reinterpretation of the *Volkswagen *Beetle* car design by J. Meys in 1998.

company as it was closely associated with the occupying Germans and, as a result, was nationalized in 1945. In 1946 Renault launched its *4CV*, a symbol of mass motoring in France, with the popular *Dauphine* following a decade later, with the rather box-like, functional Renault 4 of 1961 providing a design response to the Suez crisis. During the 1950s Renault had begun working with the Italian automobile body design company *Ghia and also set up a centre for styling. In charge of this from 1960 to 1963 was Philippe Charbonneaux, who came from a design background that included *General Motors. Gaston Juchet, who had arrived at Renault in 1958, was in charge of styling from 1963 to 1975 and worked with a distinguished team of designers including Michel Boué (1936–71), the designer of the highly successful, stylish yet practical *R5* (1972–92), and Robert Opron, designer of the *R14*. As had been the case in the late 1950s, links with Italian designers and stylists such as Ital Design were maintained and fostered. Opron, who had arrived at Renault with a background at Simca and Citroën, took charge of the Style Centre from 1975 to 1984 and was ably assisted by Gaston Juchet (applied style) and

Jacques Nocher (advanced styling). Opron also extended the range of design consultants used by the company, linking with figures such as Terence *Conran and Mario Bellini. Models at this time included the Renault 25 (1985) and the Renault *Espace* (1984). The design of the latter was innovative, shifting ideas of family motoring away from the conventional format of a four-seater towards a more convivial, flexible, and relaxing configuration. After Opron left for *Fiat in 1984, Juchet again took charge of styling for another three years until the arrival of Patrick Le Quément, who became director of industrial design in 1988. Models introduced at this time included the *Clio* (1991), the *Twingo* (1992), and the *Scenic* (1991) which, in parallel with the earlier *Espace*, initiated mini-MPV (multi-purpose vehicle) design thinking. In 1992, Le Quément, whose design credentials had been established previously at Simca and Ford, received the Grand Prix National de la Création Industrielle (established 1985), awarded by the Minister of Culture.

Retro *See* box on this page.

Revere Copper and Brass Inc. (established 1929) With roots going back as far as 1801 and the establishment of the USA's first copper rolling mill, a number of mergers took place in the early 20th century, culminating in the establishment of Revere Copper and Brass Incorporated in 1929. During the following decade the company branched out from its production of goods for the industrial and construction sectors to market giftware aimed at the domestic market, including Peter *Müller-Munk's elegant *Normandie* streamlined chrome-plated jug of 1935. The company was also known for its *Revere Ware* range of cooking utensils first introduced in 1939 and designed by W. Archibald Welden. In 1988 the company was taken over by *Corning Glass Works.

Revue des Arts Décoratifs (1880–1902) This was the magazine of the Union Centrale des Beaux-Arts Appliqués à l'Industrie, succeeding the *Bulletin de l'Union Centrale* of the Musée des Arts Décoratifs in Paris and contained a wide variety of articles on both current and historic design. More than the *Bulletin* it gave positive support to the industrial arts and was an important forum for debates in the applied arts.

Richards Morgenthau & Co. *See* RAYMOR.

Riemerschmid, Richard (1868–1957) Riemerschmid was an important designer in bridging the gap between the underlying principles of the *Arts and Crafts Movement and a commitment to modern design principles in an industralized society as espoused by the *Deutscher Werkbund (of which he was a founder member in 1907 and later, in 1920, a director). He worked for a number of manufacturers in a wide range of media including furniture, ceramics, metalware, glass, carpets, and linoleum and his mature designs were generally char-

acterized by simple forms and a respect for materials. After designing his own house in 1895 he went on two years later to become one of the founders of the arts and crafts-inspired *Munich Vereinigten Werkstätten für Kunst im Handwerk (United Workshops for Art in Craftwork), for which he designed furniture and interiors. Although the earlier phases of his career revealed influences from *Art Nouveau, this had waned by the late 1890s as evidenced by the clarity and restraint of his designs for a *Music Room* shown at the German Art Exhibition in Dresden in 1999. He also exhibited a *Room for an Art Lover* at the *Paris Exposition of 1900 and a *Room for the Rector of an Academy of Art* at the St Louis Exhibition of 1904. He went on to design machine-made furniture, including furniture and interiors for ships such as the light cruiser *SMS Danzig* in 1905. However, it should be remembered that such machine-made designs still required a significant involvement of hand finishing and assembly. Riemerschmid also showed machine-made furniture at the Dresdener Werkstätten in 1905, with further significant contributions to a number of other exhibitions including the Salon d'Automne in Paris in 1910 and the Deutscher Werkbund in Cologne in 1914, for which he designed a living room. From 1912 to 1924 he was director of the Munich School of Applied Arts and from 1926 to 1931 head of the Industrial School in Cologne.

Rietveld, Gerrit (1888–1964) A leading exponent of the De *Stijl movement, Dutch architect and designer Rietveld is most widely known for his *Red and Blue Chair* of 1918 and the remarkable Schröder House, Utrecht, of 1924, the latter a complete visual embodiment of the De Stijl-built environment. Originally trained as a cabinetmaker in his father's workshop from 1899 to 1906, followed by a period as

a draughtsman for a jeweller, he began his own cabinetmaking business in Utrecht in 1911 and studied architecture under P. J. Klaarhamer. He joined the De Stijl group in 1919 after his *Red and Blue Chair* had featured in the periodical *De Stijl*. Reduced to basic geometric elements showing the influence of Frank Lloyd *Wright and the *arts and crafts and rendered in primary colours that owed much to the aesthetic philosophy of the Dutch painter Piet Mondrian, the chair subsequently became a 20th-century design icon. It was later reissued by *Cassina, who had bought up all the rights to Rietveld's designs in 1971. He also set up an independent architectural practice in 1919.

Rietveld was a prominent member of the avant-garde in the 1920s and was in contact with leading designers of the period, including the Russian *Constructivist El *Lissitsky. Underlining such progressive links was his inclusion in the 1923 Weimar *Bauhaus exhibition where his *Berlin* chair and an innovative lighting design in Walter *Gropius' office were shown. He was also a founding member of the CIAM (*Congrès Internationaux d'Architecture Moderne) in 1928 and was included in the *Museum of Modern Art, New York, *Recent European Architecture* show of 1931. His 1924 Schröder House in Utrecht, a design solution arrived at in conjunction with his client Truus Schröder-Schräder, was perhaps his most complete realization of the De Stijl philosophy with an integration of architectural form, interior design, furniture, and fittings. In the previous year *Metz & Co., the Amsterdam department store, issued the mass-produced version of his 1927 *Beugel Stool* in moulded plywood. This was followed up in 1934 with his 'z-shaped' *Zig-Zag* chair and, in 1935, a home assembly *Crate* chair made from packing case wood, an economic design that incurred strong

criticism from the furniture trade. In the same year he also designed an upholstered armchair. In the 1940s and 1950s he continued to produce experimental furniture designs using metal and plywood, a number of his plywood designs being influenced by the work of Charles and Ray *Eames. In the latter years of his career he devoted increasing attention to architecture, establishing a partnership with J. Van Dillen and J. Van Tricht in 1961.

Rinascente, La (established 1918) This Milanese department store was established after the First World War and has done much to promote higher standards of Italian design. The Italian poet Gabriele D'Annunzio conceived its name, La Rinascente (Rebirth), one that had a particular resonance in the 1930s when the company also did much to promote the domestic consumption of Italian products in the drive towards national self-sufficiency (autarchy) under Mussolini. After the Second World War, La Rinascente redoubled its efforts to influence Italian consumer taste by commissioning leading designers such as Gio *Ponti and Franco *Albini to design aesthetic mass-produced goods. Max Huber designed the company's corporate logo in 1950, a period when Swiss designer Albe Steiner also worked on La Rinascente graphics between 1950 and 1954. Also passing through the company en route to wider recognition were many other subsequently famous designers. These included fashion designer Giorgio *Armani, who was a buyer for the company from 1957 to 1964, and both Bruno *Munari and Tomás *Maldonado, who were employed as window display artists. The company participated in important forums for design debate, such as the IX *Milan Triennale of 1951 where La Rinascente's contribution was orchestrated by Carlo Pagano. Pagano also

initiated the *Aesthetics of the Product* shows in the store's Furniture Department in which domestic appliances, lighting, textiles, clothing, and other products selected by Alberto Rosselli and Albe Steiner were displayed. In 1954 Aldo Borletti took such *'Good Design' shows one stage further by initiating the *Compasso d'Oro awards as a means of encouraging better standards of design in Italian manufacture. Other designers involved with La Rinascente included Roberto Sambonet, who was a design consultant to the company from 1960, and Bob *Noorda, a consultant to the company from 1963 to 1964.

Risom, Jens (1916–) Danish-born Risom established himself as a designer of Scandinavian Modern style furniture and textiles in the United States, where he settled in 1939. Amongst his early designs in the United States were those for *Knoll, the first of which was a side chair with a cedar frame and seat and back of woven webbing. It was produced originally in 1943 and later modified when wartime restrictions on the use of particular materials were lifted. In 1946 Jens Risom Design was established, one of a small number of firms in the USA that specialized in modern furniture. The company also established a reputation for office furniture design. It was taken over by Dictaphone in 1970, Risom remaining as chief executive until 1973.

Rodchenko, Alexander (1891–1956) A leading avant-garde designer of the Russian Revolutionary period, Rodchenko was widely known for his *Constructivist work across a variety of creative fields including posters, packaging, photography, textiles, furniture, products, and stage sets. After studying at the School of Fine Arts in Kazan from 1911 to 1914, Rodchenko moved to Moscow, where he studied graphic design at the Stroganoff School of Applied Art. In 1915 he met fellow Russian Vladimir *Tatlin, who had been involved with the Parisian avant-garde, reinforcing his growing interest in Cubism and *Futurism, trends that were far removed from the conservatism curriculum of the Strogonoff School. Amongst Rodchenko's first product designs were a series of metal lamps designed for the Café Pittoresk in Moscow in 1917, working alongside Tatlin and others who were also involved in other aspects of the Café's interior design. Much of Rodchenko's design work was devoted to promoting the revolutionary cause, including a kiosk in 1919 for the sale and distribution of newspapers and other political propaganda. He also designed a large number of posters promoting state enterprises between 1923 and 1925 in collaboration with the poet Vladimir Mayakovsky. Throughout the 1920s he was a prolific graphic designer, working on political, commercial, and film posters, as chief designer and contributor to the journal *LEF* (1923–5) and its successor *Novy LEF* (1927–8)—both edited by Mayakovsky—as well as packaging and book covers. His use of *photomontage, striking typographic layouts, and flat, coloured geometric elements resulted in many memorable designs. He also designed simple, functional geometric wooden furniture and shelving for the Workers' Club in the Soviet Pavilion at the 1925 *Paris Exposition des Arts Décoratifs et Industriels. The philosophy that underpinned this display was in many ways a counterpart to the functional workers' clothing he had designed in 1920. Rodchenko was a member of Inhuk (the Institute of Artistic Culture) which had been established in 1920 by the painter Wassily Kandinsky. In the following year, with his wife Varvara *Stepanova and others, he reorganized Inhuk to promote Productivism—the mass production of in-

dustrial and applied art (*see* CONSTRUCTIV-ISM)—and wrote the Productivist Manifesto. He was also involved in design education, playing a significant role at the *Vkhutemas (Higher State Artistic and Technical Work-shops) in Moscow from 1920 to 1930. He also worked on costume and set design, including those for *The Bed Bug* by Mayakovsky (1929). During the 1930s he increasingly devoted his attention to pho-tography and book and periodical design, often in conjunction with his wife. Their collaborations included 'The White Sea Canal' issue of the periodical *USSR in Con-structivism* (1933), the book *Film in the USSR* (1936), and the photo-album *First Cavalry* (1937).

Rohde, Gilbert (1894–1944) Rohde was one of the first generation of American in-dustrial designers, establishing his reputa-tion in the 1920s and 1930s. Although most widely recognized for furniture design, Rohde also designed lighting, radios, and other products and was an articulate writer on design matters. Born into a cabinet-maker's family, he trained at the Arts Stu-dents League and the Grand Central Galler-ies in New York. After working as a freelance political cartoonist and illustrator for advertising, fashion design, and inter-iors, he went on to work for leading New York stores such as R. H. Macy and W. & J. Sloane in the early 1920s. His design out-look changed following a visit to Europe in 1926 where he experienced *Art Deco and *Modernism at first hand in France and Germany. As a result he began designing furniture that acknowledged both Deco and Modernist traits, using bakelite and chrome, fashionable materials of the time, and in 1927–8 designed interiors for the Avedon fashion stores. His furniture designs became increasingly widely known, especially his 1930 bentwood chair for the

Heywood-Wakefield Company, which sold widely (and was taken up by other com-panies) in the 1930s. He was subsequently appointed as chief designer for the *Herman Miller Company in 1931, modern-ising the company's aesthetic through a series of his own designs. Other firms for which he designed included *Thonet. He also designed appliances for General Elec-tric in the 1930s and was profiled in an article in the trade periodical *Modern Plastics* entitled 'Planning Ahead with Gilbert Rohde' in mid-1935. His designs were also widely seen at the growing number of ex-hibitions devoted to design. Such shows in-cluded the 1932 *Design for the Machine* exhibit at the Philadelphia Museum of Art, the 1934 *Machine Art* exhibit at the *Museum of Modern Art, New York, and the *Contemporary Industrial Art* exhibit at the Metropolitan Museum, New York, also held in 1934. Rohde designs were also seen at the *Chicago Century of Progress Expos-ition of 1933–4 and the New Work World's Fair (NYWF) of 1939–40. The former con-tained examples of Rohde's bedroom furni-ture for Herman Miller whilst the latter included Rohde's displays in the Petroleum Industry Exhibit and the Focal Exhibit in the Community Interests Zone. However, the Focal Exhibit was changed for the 1940 season. Rohde also had some involvement in design education, having been appointed director of the Design Laboratory in New York. This federally-funded design school was supported by a grant from the Works Progress Administration with a number of well-known industrial designers on its Board, including Henry *Dreyfuss and Walter Dorwin *Teague. However, after a year government funding ceased, soon leading to the institution's closure. He was also head of industrial design at the New York University School of Architecture from 1939–43. Rohde was a member of the

*American Union of Decorative Artists and Craftsmen (AUDAC).

Rörstrands Porslinfabrik (established 1726) Founded in 1726 in the Rörstrands Castle in Stockholm, the company produced blue and white faience until the 1780s when it expanded to produce cream coloured earthenware. This was its staple until the company was incorporated as Rörstrand Aktiebolag in 1867 when stoneware, majolica, and porcelain were added to its product range. By the late 19th century the company had won international recognition, a position further enhanced by the appointment of Alf Wallander who had been employed to design new ranges for the 1987 Exhibition of Art and Industry in Stockholm. Employed as art director in the following year he introduced *Art Nouveau and delicately painted floral motifs to the company's range. The year 1917 signalled another shift in outlook with the appointment of Edvard Hald as a designer in the earthenware division, resulting in a more expressionist outlook. In 1926 the Rörstrand factory moved to Gothenburg, where it came under the aegis of the Finnish company *Arabia, itself formally created and controlled by Rörstrand until the previous decade. The 1930 *Stockholm Exhibition saw the launch of Louise Adelberg's *Swedish Grace* porcelain service, which remained in production for decades. Gunnar Nyland became art director in 1931 and in the following year the company took over the Lidköpings Porslinfabrik, where the whole Rörstrand operation moved in 1939. After the war the elongated, elegant stoneware vases of Nyland and Carl-Harry Stalhone attracted critical attention, with many other designs being characterized by the application of abstract geometric decorative motifs. In the 1950s there were a number of successes, including Hertha Bengtson's *Koka* and Marianne Westman's *Mon Amie* services. Much of the company's development in this period was due to Fredrik Wehjte who was managing director from 1932 to 1964 and built up links with the Swedish Society for Industrial Design and a number of museums. In 1964 the company was taken over by Upsala Ekeby AB and a process of rationalization was begun. Nonetheless, in the 1960s the company responded to wider cultural and aesthetic change in work such as Inger Persson's 1968 *Pop* range. After a number of other shifts of ownership *Gustavsberg and Rörstrand were merged in 1988 by their controlling company Arabia to become Rörstrand-Gustavsberg AB.

Rosenthal Porzellan (established 1879) Philipp Rosenthal founded this highly successful German porcelain manufacturing company at Erkersreuth in 1879. In its early years the business thrived on decorating blanks bought in from outside companies and soon moved to Selb where a new factory was built, commencing production in 1891. After gaining an award at the Paris Exposition International of 1900, Rosenthal achieved further prominence in the early years of the 20th century through its *Art Nouveau tableware, such as the *Darmstadt* (1905) and *Donatello* (1907) services, as well as figurines of contemporary subjects. In order to develop further such initiatives an Art Department was established in 1910. In common with much of German industry, Rosenthal's production was seriously disrupted by the First World War and the ensuing shortages of materials but, as the 1920s progressed the company expanded and moved its head offices to Berlin. With the exception of Wilhelm *Wagenfeld's *Daphne* dinnerware of 1937 much of the production followed the prevailing trends in German decorative arts in

the interwar years. The Second World War and its aftermath was problematic for the company but from the 1950s it began to expand both markets and production capacity, including the establishment of a glassworks department in 1950, the start of cutlery production in 1958 and diversification into furniture. Also in 1958 Rosenthal established a Design Studio in Selb in order to centralize product development activities. In 1960 Rosenthal opened the first of a series of 'Studio Houses' to market the company's products alongside those of other factories and studio potters approved by the firm's design advisory panel. In the early 1950s the company began its policy of commissioning leading international figures including Raymond *Loewy (who designed the *Continental* dinnerware range in 1952), Wagenfeld, and Tapio *Wirkkala (who designed the Finlandia service in 1954–7). This outlook, a useful strategy for expanding overseas markets, was consolidated in succeeding decades with commissions from Walter *Gropius and artists such as Henry Moore, Nicki de Saint-Phalle, Victor Vasarely, and Jasper *Morrison, who designed the *Noon* porcelain dinnerware service in 1997. Throughout its life the company has undergone many corporate reorganizations, many precipitated by a series of takeovers and movement into the fields of furniture and glass, as well as the establishment of business links with companies such as Gianni Versace in Milan in 1992. In 1997 Waterford Wedgwood acquired a controlling interest in the Rosenthal Group.

Royal College of Art (RCA, established 1837) The RCA is one of the most illustrious art and design educational institutions in Britain and has a long and distinguished history. Its beginnings were as the Government School of Design, established in 1837 as a response to the British failure to compete effectively with a growing number of countries in the design of manufactured goods. In 1853 the School became the National Art Training School and moved to South Kensington, training new teachers and providing a focus for national art education. A leading force in this enterprise was Henry *Cole (1808–82), who had played an important role in setting up the *Great Exhibition in London in 1851. Notable amongst early teachers at the Government School were Owen *Jones and Gottfried *Semper and design played a significant role in the curriculum. In 1896 the School was renamed the Royal College of Art and soon underwent a number of further changes with the appointment of Walter *Crane as principal in 1898. In 1901 the RCA organized itself into schools of painting, sculpture, design, and architecture. After the First World War the RCA was noted for its aesthetic input into many fields, including British sculpture that was influenced by students such as Henry Moore and Barbara Hepworth. Influential design tutors included the artist Paul Nash and in 1936 the government-appointed Hambledon Committee recommended that the RCA again be reorganized in order to raise the profile of design in the curriculum with the consequent suggestion that it be redesignated as the Royal College of Design. Almost exactly a century later than the government committees that had resulted in the establishment of the Government School of Design and a national network of art and design schools, similar concerns about the ability of Britain to compete with other countries in terms of design came once more to the fore in the 1930s. After the Second World War the RCA was reorganized under a new principal, Robin Darwin, who took up the post in 1948 and placed greater emphasis on product design

and specialist design provision including graphics and fashion. In 1959 a new School of Industrial Design (Engineering) was established under Misha *Black, who in turn instituted a Research Unit within it under L. Bruce *Archer, a visiting professor at the Hochschule für Gestaltung at *Ulm and a director of the company Scientists and Technologies Engineering Partnership. After a series of successful, externally funded projects, the Research Unit became a department in its own right, the Department of Design Research, and Archer was promoted to a professorship in 1967. In the same year the RCA was granted a Royal Charter which conferred on it independent university status and the ability to confer its own degrees, singling it out from most of the rest of British art and design higher education which was controlled by a centralized system of diploma and degree conferment until the late 1980s. From 1984 when Jocelyn Stevens became rector a further programme of development and expansion was undertaken, culminating in the opening in 1992 of the Stevens Building in 1992, the 25th anniversary of the College's gaining of the Royal Charter. However, during Stevens's rectorship the Department of Design Research was closed in 1987. Christopher Frayling became rector in 1996, a role he held alongside that of the chairmanship of the *Design Council in the early 21st century. Over its lifetime the RCA has had a distinguished list of alumni and staff, many of whom are internationally renowned and influential designers.

Royal Designers for Industry (established 1936) Established in 1936 by the Royal Society of Arts as a select body of designers, the Royal Designers for Industry initiative was one of a number of initiatives in the interwar years to raise the status of the industrial design profession in Britain and was an award given to individuals who had demonstrated 'sustained excellence in aesthetic and efficient design for industry'. In 1938 the Faculty of Royal Designers for Industry (RDI) was formed as the association of RDIs committed to excellence in industrial design and was representative of a wide range of professional design activity in Britain, from engineering design to graphics, and fashion to product design. Most leading British designers have been elected to the Faculty by its membership, the total of which is now limited to 200 at any one time. Members have included the following: Robin *Day (elected 1959), Lucienne *Day (elected 1962), Mary *Quant (elected 1964), Kenneth *Grange (elected 1969), Perry King (elected 1990, *see* KING-MIRANDA ASSOCIATI), Eva *Jiricná (elected 1991), and Jasper *Morrison (elected 2001). Designers from outside Britain can also be awarded the status of Honorary Royal Designer for Industry.

Rubik's Cube (1974–) Erno Rubik, a lecturer in the Department of Interior Design at the Academy of Applied Arts and Crafts, evolved the first prototype of the Cube in Budapest in 1974. Fascinated by the theoretical possibilities of geometrical form, Rubik grounded such ideas in his teaching where he encouraged students to express their ideas in the practical construction of forms that were capable of manipulation. In many ways Rubik's Cube also lies in the tradition of earlier puzzles concerned with the manipulation of form, such as the ancient Chinese Tangram or Solomon W. Golumb's Pentomino. However, Rubik's Cube differed from these and other antecedents both on account of its three-dimensionality, its greater complexity, and the fact that throughout its many transformations it remained as a single,

self-contained unit. This was due to its unique interior mechanism. After field testing the Cube on his students and friends, he discovered that their desire to manipulate the Cube so that all elements of each of its surfaces were in the same colour was addictive. A Hungarian manufacturing company, Polytechnika took up its production and the first commercial versions were marketed in 1977. However, given the prevailing market conditions in a Communist country, it was not until it was shown at the Nuremberg Toy Fair of 1979 that the Cube's full commercial potential was seen and developed, aided by articles in the British press and in *Scientific American*. After a further sustained bout of marketing at toy fairs on both sides of the Atlantic in early 1980, it became almost impossible to satisfy rampant consumer demand with orders exceeding 5 million. In addition to production in Hungary manufacture was taken up in Hong Kong, Brazil, Taiwan, and Costa Rica. Having won toy awards in several European countries it also won design recognition through exhibition at the *Museum of Modern Art, New York, in 1981, winning linguistic recognition through inclusion in the *Oxford English Dictionary* in 1982. It is likely that sales of the Cube, and its copies, have exceeded 200 million.

Ruskin, John, (1819–1900) One of the most significant writers on art, architecture, design, and society in Britain in the 19th century, Ruskin exerted a powerful influence on the *Arts and Crafts Movement in Britain and abroad. Important shaping forces were Ruskin's major writings on architecture, *The Seven Lamps of Architecture* (1949) and *The Stones of Venice* (1851–3), texts that informed the thinking of William *Morris and others. Ruskin had attributed the decline of Venice to her indulgence in the material values of the High Renaissance rather than the moral propriety of the Gothic period with its celebration of the joy of making. In may ways this was a metaphor for what he saw as the decline in moral values of a materially indulgent Victorian society when compared to those of the Middle Ages. He was also committed to socialist principles and his antipathy to machine-made ornament, allied to his belief in nature as a source of inspiration for design rather than the prevalent Victorian penchant for historic encyclopaedism, provided another undercurrent of the Arts and Crafts Movement. He founded the Guild of Saint George in 1874, its precepts being outlined in a series of open letters published as *Fors Clavigera: Letters to the Workmen and Labourers of Great Britain* (1870–4). The Guild was in many ways a prototype for the idea of a group of craftsmen living and working together. The idea influenced, amongst others, William Morris and C. R. *Ashbee, whose Guild of Handicraft founded in 1888 in the East End of London moved to the rural utopia of the Chipping Campden Cotswolds in the early 20th century.

Russell, Gordon (1892–1980) Russell was a leading figure in design and craft circles, involved with state design policy in connection with the *Utility scheme of the 1940s and the Council of Industrial Design (*see* DESIGN COUNCIL) on which he served as director from 1947 to 1960. For much of his life Russell was closely identified with the Cotswolds, attending the Grammar School in Chipping Camden where C. R. *Ashbee had established his Guild of Handicraft. From an early age he worked in his father's furniture repair shop and, after serving with distinction as a soldier in the trenches in the First World War, commenced a career in furniture design. Heavily influenced by the tenets of the *Arts and Crafts

Movement, much of his early work was geared to hand production. Russell furniture was exhibited at the Wembley *British Empire Exhibition in London (1924) and at the 1925 *Paris Exposition des Arts Décoratifs et Industriels where he was awarded a Gold and two Silver Medals. Russell Workshops Ltd. was established in 1927, becoming Gordon Russell Ltd. in 1929. His outlook became increasingly oriented towards mechanization and quantity production, particularly through the manufacture of radio cabinets (often designed by his brother R. D. Russell) for radio manufacturers Frank Murphy and E. J. Power. Russell was also active in the *Design and Industries Association, an organization that was in tune with Russell's commitment to producing well-designed furniture in quantity at attractive prices without sacrificing quality. The company had showrooms in Broadway in Gloucestershire and in London and its designs were also sold through selected retailers, including those of the Good Furniture Group of the late 1930s. Russell's links with *Modernism in Britain were further consolidated by the appointment during the 1930s of Nikolaus *Pevsner as buyer of textiles and glass for the company. During the Second World War Russell became a member of the Board of Trade's Utility Committee (from 1942) and chairman of the Board's Design Panel (from 1943). As a campaigner for better standards of design in British industry with an intimate knowledge of the field he was appointed as a member of the Council of Industrial Design (established 1944, *see* DESIGN COUNCIL), becoming its second director from 1947 to 1959. He was knighted in 1955 and received many honours for his services to design, including the Albert Medal of the Royal Society of Arts (1962), election as a *Royal Designer for Industry, and a number honorary doctorates. He was also the first Fellow of the Society of Industrial Artists and Designers (*see* CHARTERED SOCIETY OF DESIGNERS), president of the Design and Industries Association, and master of the *Art Workers' Guild. He was also the first chairman of the Crafts Council of Great Britain, showing that despite his deep professional involvement with the promotion of industrial design in the 1940s and 1950s he was still sensitive to the arts and crafts philosophy that had influenced him earlier in life. Russell was a writer on many aspects of design and furniture, including the revealing *Designer's Trade: Autobiography of Gordon Russell* (1968).

Saab Saarinen, Eero Saarinen, Eliel Sac
Saint Laurent, Yves Salon des Arts Ména
Salvador, Pascual S net, Roberto sa
Sapper, Richar arfatti, Gino Sason, Six
and Tobia Sc Carlo Schleger, Hans
Schütte-Lihots garete Scott, Dougl
& Co. semiotics Se Gottfried Seym
Shaker design Sharp Co ration Siemer
Borek Skoda Smith, P ociété des Ar
Society of Ind s Society of Ind
Designers Society of Industrial Designers
Sony Corporation Sottsass, Ettore, Jr. Sol
Spencer, Herbert Starck, Philippe Stenbe
Georgy Stepanova, Varvara Stichting Go
Stickl ustav Stijl, De Stile industria !
Exhi on [1930] Stölzl, Gunta streamlir
St o Alchimia Suetin, Nikolai Sullivan,
nska Slö[j]dföreningen Svenskt Tenn
Modern Swedish Society of Industrial De
Swiss Style Saab Saarinen, Eero Saarine
Bruno Saint Laurent, Yves Salon des Art:
Salvador, Pascual Sambonet, Roberto sa
Sapper, Richard Sarfatti, Gino Sason, Six
and Tobia Scarpa Schleger, Hans
Schütte-Liho margarete Scott, Dougl
& Co tics Semper, Gottfried Seym
design Sharp Corporation Siemer
orek Skoda Smith, Paul Société des Ar
Society of Industrial Artists Society of Ind
Designers Society of Industrial Designers
Sony Corporation Sottsass, Ettore, Jr. Sol
Spencer, Herbert Starck, Philippe Stenbe
Georgy Stepanova, Varvara Stichting Go
Stickley, Gustav Stijl, De Stile industria !
Exhibition [1930] Stölzl, Gunta streamlir
n, Nikolai Sullivan,
Svenska Slö[j]dföreningen Svenskt Tenn
Modern Swedish Society of Industrial De
Swiss Style Saab Saarinen, Eero Saarine
Bruno Laurent, Yves Salon des Art:
Salva scual Sambonet, Roberto sa
chard Sarfatti, Gino Sason, Six
ia Scarpa, Carlo Schleger, Hans
Schütte-Lihotsky, Margarete Scott, Dougl
& Co. semiotics Semper, Gottfried Seym
Shaker design Sharp Corporation Siemer
Borek Skoda Smith, Paul Société des Ar
Society of Industrial Artists Society of Ind
Designers Society of Industrial Designers
Sony Corporation Sottsass, Ettore, Jr. Sol
Spencer, Herbert Starck, Philippe Stenbe
Georgy Stepanova, Varvara Stichting Go
Stickley, Gustav Stijl, De Stile industria !

Saab (established 1937) Supported by private capital and the Swedish government, Saab (Svenska Aeroplan Aktiebolaget) was founded in 1937 as a military aircraft manufacturer. After the Second World War the company moved into automobile production, developing a 'small car' project from 1945 with the aid of Sixten *Sason, a first-generation Swedish industrial designer. Working closely with company engineer Gunnar Ljungström this evolved into the Saab 92 automobile that went into production in 1949. Many critics have commented on the analogy between the Saab 92's sleek, aerodynamic form and aeronautical design, a styling characteristic that was retained until the launch of the more angular Saab 99 in 1968. In 1969 the company merged with the truck manufacturer Scania and Björn Envall, Sason's assistant, became design director. The company was again taken over by *General Motors in 1989, the year in which the Giorgetto *Giugaro-styled *Model 9000* car (commissioned in 1984) was launched. In the early 1990s the company reverted to a more fluid, Sason-like, immediately recognizable Saab shape with the *Model 900*.

Saarinen, Eero (1910–64) Well known for his influential sculptural furniture designs and innovative use of materials in the 1940s and 1950s, architect-designer Saarinen had emigrated from Finland to the United States in 1923 with his weaver mother Loja and architect-designer father Eliel. His interest in sculpture had been supported by study at the Académie of La Grande Chaumière in Paris in the early 1930s, but he soon changed direction, taking up architecture at Yale University, from where he graduated in 1934. He had been involved with furniture design between 1929 and 1933, when he had worked on wooden furniture for Kingswood School for Girls and also at the *Cranbrook Academy of Art. He also collaborated on furniture designs with Norman *Bel Geddes in 1934. In the same year he had won a travel scholarship to Europe and spent a period in Finland, returning to teach at Cranbrook from 1939 to 1942 alongside Harry *Bertoia and Charles *Eames, both early graduates of the Academy. With the latter Saarinen won First Prize for moulded plywood seating in the 1940 *Organic Design in Home Furnishings* Competition at the *Museum of Modern Art, New York. Saarinen and Eames also produced modular, or unit, furniture for this competition. Saarinen had become acquainted with Florence Schust (later *Knoll) a student at both the Kingswood School and Cranbrook Academy. Through her *Knoll Associates commissioned Eero for a number of subsequently celebrated designs, including a bent plywood chair (1946), the organic fibreglass and tubular steel *Womb Chair* (designed in 1946 and manufactured from 1948) and the fibreglass and plastic coated cast aluminium *Tulip Chair* (manufactured from 1956). The latter was a truly organic design, the 'flower-like' seat 'growing' out of a single 'stem' in place of the conventional four legs and gave rise to a related range of side chairs and tables. Saarinen had set up in architectural practice with his father in 1937 (a collaboration which lasted until the latter's death in

1950). Saarinen was widely recognized for a number of architectural commissions, most notably the sweeping forms of the TWA Terminal at Kennedy Airport (1956–62) and the auditorium and chapel at the Massachussets Institute of Technology (1953–6).

Saarinen, Eliel (1873–1950) A highly influential Finnish architect and designer who had a significant impact on many modern American architects and designers through his influence at the *Cranbrook Academy of Art. He had studied fine art and architecture at the University of Helsinki and came to attention with his designs for the National Romantic-style Finnish Pavilion at the *Paris Exposition Universelle of 1900, the Finnish National Museum in Helsinki, and Helsinki Railway Station (1906). His early furniture showed some influence of the late *Arts and Crafts Movement in Britain and he absorbed other ideas from meeting leading international designers such as Peter *Behrens and participation in the *Deutscher Werkbund exhibition in Cologne in 1914. He won second prize in the Chicago Tribune Tower Competition in 1922 (the winner was Frank Lloyd *Wright) and emigrated to the United States in 1923 with his wife Loja, a weaver, and son Eero. After a brief spell teaching architecture at the University of Michigan he was involved with the wealthy newspaper proprietor George C. Booth in the foundation of the craft-oriented Cranbrook Academy of Art in 1925. Both Eliel and Loja Saarinen were heavily involved with designing buildings, furniture, and furnishing textiles for the new institution. Eliel also showed his work in major exhibitions such as those devoted to *Architecture and Industrial Art* at the Metropolitan Museum of Art in New York, where he showed a dining room in 1929 and, with his wife Loja, *A Room for a Lady* in 1934. In

1932 he became president of the Cranbrook Academy and was influential in bringing a new generation of designers to teach there. They included his son Eero, Charles *Eames, and Harry *Bertoia.

Sacco, Bruno (1933–) Bruno Sacco has been a major influence on the design policy at *Mercedez-Benz for more than 30 years. He studied mechanical engineering at the Turin Technical University but, unable to find work in the Italian automobile industry, went to Germany, where he took up employment as a stylist in the Daimler-Benz Styling Department at Sindelfingen, near Stuttgart, in 1958. He worked alongside Friedrich Geiger, Bélena Barény, and the head of the Styling Department, Karl Wilfert, and was involved with the *230 SL* coupé (1963), the *600* limousine (1964), and a series of *C-111* experimental cars before becoming the head of the bodywork and ergonomics departments in 1970. Four years later he was made chief engineer and, in 1975, the head of the Daimler-Benz Styling Department at Sindelfingen. Designs with which he was closely associated included the *S-Class* series from the early 1970s onwards, the *SEC* coupé of 1981, the *E-Class* series, commencing in 1982, the *C-Class* of 1993, and the *SLK* sports car of 1993.

Saint Laurent, Yves (1936–) French fashion designer Yves Saint Laurent is closely associated with the 'Swinging Sixties', an outlook embodied in his 'see through' blouses of 1968 and his incorporation of 'street style' into fashion goods. He studied at the school of the Chambre Syndicale de la Haute Couture and, after winning first prize in an International Wool Secretariat Competition for a cocktail dress in 1954, went to work for *Dior on the recommendation of the editor of French *Vogue*. He became head designer at Dior in 1957,

producing six collections before he was replaced in 1960, when he undertook military service. He started his own couture house two years later, going on to launch *Y*, his first perfume for women (1964), the Rive Gauche boutiques for women (1966), and menswear (1974). He also brought his design expertise to bear on other fields, styling the actress Catherine Deneuve for the Luis Bunuel film *Belle du jour*, a fashion-film star relationship that gained recognition for Saint Laurent with an 'Oscar' award from *Harper's Bazaar*. He established a reputation for his ready-to-wear designs over succeeding decades but stopped putting on major fashion shows for his ready-to-wear collections in 1996, the same year in which he marked a first amongst couturiers by transmitting his couture show live on the internet. His prominent place in French national culture was underlined by being chosen to stage a large-scale fashion entertainment in the Stade du France on the occasion of the World Cup in 1998. Furthermore, not only did he and his fashion output receive considerable coverage in the fashion press, but his work was also seen internationally in many exhibitions. These included the *Yves Saint Laurent: 25 Years of Design* exhibition (1983) of his major designs at the Metropolitan Museum of Art, New York, a retrospective exhibition of his work from 1958 to 1985 in Beijing (1985), with further retrospectives at the Musée des Arts de la Mode in Paris (1986, also shown in Moscow), Tokyo (1990), and elsewhere. Throughout his career Saint Laurent has received many awards, including the International Award from the Council of the Fashion Designers of America (1982), receiving a Lifetime Achievement Award from the same body in 1999. In 1985 he was awarded the Chevalier of the Legion d'Honneur by the president of France, François Mitterand.

Sakashita, Kiyoshi (1933–) An important figure in post-Second World War Japanese industrial design, Sakashita has been closely associated with the *Sharp Corporation, a leading manufacturer of electrical appliances and office equipment. His role as corporate director and general manager of the company's Design Centre in Osaka has been significant in Sharp's success, particularly the introduction of 'lifestyle' products, notions of 'human touch', and the implementation of a consistent 'house style' across a wide range of the company's products. Having studied industrial design at Tokyo University (1953–7) he joined Sharp as a staff designer and moved through a number of roles including Domestic Appliances Manager (1960–63), Research and Marketing Manager (1963–6), Corporate Design Manager (from 1973), Corporate Director (from 1981), and Corporate Adviser (from 1995). The Design Department at Sharp was initiated in 1957, the year in which Sakashita joined the company. Within 30 years the Design Centre at Osaka had grown to 200 designers producing about 2,000 new models a year. Throughout his career at Sharp he supervized many innovative products, particularly in the sphere of audio-visual equipment. He has also played an important role in the consolidation of the Japanese design profession as a Board member of the *Japan Industrial Designers' Association (JIDA, from 1975) and of the Japan Package Design Association (from 1979). He was also an advisor to the *Japan Industrial Design Promotion Organisation (from 1980) and the *Japan Design Foundation (from 1981).

Salon des Arts Ménagers (established 1923) This institution, which sought to provide the French with information about all aspects of domestic management, furnishing, and decoration, began life in 1923 as

the 'Salon des Appareils Ménagers' in the Champ de Mars in Paris. This first exhibition, largely devoted to domestic appliances, attracted over 100,000, but the Salon moved to the Grand Palais in 1926, when it was renamed the 'Salon des Arts Ménagers'. A key figure was Jules-Louis Breton, Under-Secretary of State for Inventions during the First World War. In 1923 the Institut d'Organisation Ménagère (Institute for Household Management) was founded by Paulette Bernège, also an important mover in the establishment of the Ligue d'Organisation Ménagère (League for Household Management). Both Breton and Bernège were important in educating the public in this sphere of domestic life. By the 1930s, in addition to the display of domestic appliances the shows included furniture and furnishings, as well as the work of members of the *Union des Artistes Modernes (UAM). By 1939 the Salon attracted over 600,000 visitors, a figure that reached 1,400,000 in 1955. However, over succeeding decades consumers became increasingly sophisticated and marketing and retailing systems underwent significant changes. In 1983 the Salons ceased as public events.

Salvador Pascual (1951–) A Spanish designer working in interior, industrial, and furniture design, Salvador studied industrial design at the Massana School in Barcelona, from which he graduated in 1974. He opened his own studio in Barcelona in 1990, working with leading Spanish companies, including *Akaba (since 1990). His most widely known designs include the *Galilea* lamp for Carpyen and the *Capa* chair for Jacinto Urban. He has also taught industrial design in Spain and beyond.

Sambonet, Roberto (1924–95) Sambonet's stylish Italian designs were informed by his keen interest in fine art, despite his training in architecture in Milan, where he graduated in 1945. Friends with Finnish designer Alvar *Aalto and collaborator with Pier Maria Bardi in Brazil, his commitment to design was consolidated with the establishment of his own company, Sambonet, in 1956. He earned a reputation for domestic products such as the stainless steel *Centre Line* kitchenware (1965), *Empilage* glassware (1971) for Baccarat, and ceramics for Richard Ginori. He also designed packaging for goods designed for the Sambonet company, as well as graphics for a number of other companies including the Milan-based department store La *Rinascente (for which he was appointed consultant in 1960), automobile manufacturer *Alfa Romeo and the periodical *Zodiac* (for which he was art director from 1956). He was awarded many design prizes including the Grand Prix at the *Milan Triennale of 1960, the *Domus* Prize in 1962, and the *Compasso d'Oro in 1956, 1970, and 1979.

Sans serif This term refers to typography whose letterforms do not have serifs, or terminal strokes at the top and bottom of the main strokes.

Sapper, Richard (1932–) German-born Sapper has been a major force in Italian industrial design circles since the late 1950s. His design work has embraced the full range of industrial products, from lighting and audio-visual equipment to furniture and kitchenware and from digital watches and business equipment to cars and bicycles. After graduating in engineering design at Munich University in 1955 he went to work in the design department of *Mercedes-Benz from 1956 to 1958 when he moved to Italy, where his engineering background added a new dimension to design thinking. He worked in Gio *Ponti's studio before moving on to the department store La *Rinascente, for which he designed

the *Transmaster* radio (1959) during his period at the company (1959–61). From the late 1950s to 1977 he also worked very closely with Marco *Zanuso, including designs for the *Doney 14* (1962) and *Algol* television sets (1964) for *Brionvega, the colourful *K 1340* polyethylene children's chair for *Kartell (1964), and the *Grillo* telephone for *Siemens (1965). He worked for many other large companies including the *Fiat automobile company, for whom he was a consultant from 1970 to 1976, as well as designing for *Knoll (including the 1979 *Sapperchair*) and *IBM (including the 1992 *Thinkpad* laptop and the 1998 *9514* LCD monitor). He has also designed a number of design icons including the *Tizio* desk lamp for *Artemide in 1972 and the *9091* kettle for *Alessi (1983) with its haunting whistle. Sapper has also been involved with many exhibitions as designer, participant, and subject. In 1968 he organized an exhibition on advanced technologies at the *Milan Triennale and, in 1972, participated in the landmark exhibition on *Italy: The New Domestic Landscape* curated by Emilio *Ambasz at the *Museum of Modern Art, New York. In 1993 the same museum, an arbiter of international taste-making, devoted a solo show to his work. Sapper also played a role in design education, teaching at the Hochschule für Angewandte Kunst in Vienna from 1985 and at the Stuttgart Academy of Art from 1986 to 1998. Since 1960 he has also received the prestigious *Compasso d'Oro design award nine times.

Sarfatti, Gino *See* ARTELUCE.

Sarpaneva, Timo (1926–) A leading Finnish glass and textile designer in the second half of the 20th century exemplifying the best of Scandinavian craft traditions, Sarpaneva also worked in the fields of sculpture, ceramic, product, and exhibition design. Originally trained in graphic design at the Institute of Industrial Art in Helsinki (where Tapio *Wirkkala, a contemporary internationally renowned Finnish glass designer had also trained), he graduated in 1948. Sarpaneva worked on exhibition design, window display, and graphic design for the A. Ahlstrom company before he was employed in publicity and exhibition design for the *Iittala glassworks in 1950, having won second prize in a competition sponsored by the company in 1949. Among his most enduring designs at this time was his famous logo for Iittala, a lower case 'i' contained in a red circle. His first major glass designs were the *Hiidenkirnu* (*Devil's Head*) series, commencing in 1950–51, the flowing organic, sculptural forms having qualities in common with the aesthetic of contemporary designers working in other fields, such as Charles and Ray *Eames and Eero *Saarinen in the United States and Gio *Ponti in Italy. Working in close collaboration with the glass blowers at Iittala he went on to produce the highly sculptural series of *Orchid* vases, commencing in 1953. Given the accolade of 'The Most Beautiful Design Object of the Year' by the American magazine *House Beautiful* in 1954 it and other glass products designed by Sarpaneva attracted additional international recognition by gaining a Grand Prix at the X *Milan Triennale of 1954. In the later 1950s he went on to produce the commercially successful *I-line series* of watercolour paintings on everyday glassware, so bringing his designs for glasses, bottles, and plates into the financial reach of many more consumers than his highly expensive sculptural pieces. These utilitarian designs were also recognised at the XI Milan Triennale of 1957, resulting in the award of another Grand Prix. He also gained a Grand Prix for exhibition architecture at the same Triennale, where he had been responsible for the design of the

Finnish section. In the 1960s he was inspired by the wooden moulds that glassblowers threw away after use, which gave rise to heavily textured one-off glass sculptures and the development of innovative techniques seen in his *Festivo* series. Later sculptural glass designs for Iittala by Sarpaneva included the *Claritas* range in the 1980s and the *Marcel* range in the 1990s. During these years he was also working in other design media, including textiles, ceramics, and cast iron. Having exhibited an embroidered tea cosy at the 1951 Triennale, in 1955 Sarpaneva moved into textile design, working on woven fabrics for the Porin Puuvilla company for whom he acted as design consultant until 1966. He also designed textiles for the Kinnasand company in Sweden (1964–72) and rya rugs for the Villayhtyma company in Helsinki (1960–72). Just as he had done in other media, Sarpaneva looked to innovate in textiles, working with a new computerised printing process in 1968 when working on his *Ambiente* textiles for the Finlayson–Forssa company in 1968. He also explored the possibilities of cast-iron cookware for W. Rosenlew & Co. in 1960, gaining a silver medal in the Milan Triennale of 1960. In addition to cookware for Rosenlew he also designed steel dishes and jugs for Opa. He also worked in ceramics and metal, designing the *Suomi* tableware range and stainless steel flatware for *Rosenthal in 1974, designs for which he received the Italian President's Gold Medal at Faenza in the same year. In addition to his many awards at the Milan Triennali, Sarpaneva also won the *Lunning Prize in 1956 and ID (International Design) Award of the American Institute of Industrial Designers three times, commencing in 1963. In 1995 the Finnish State purchased Sarpaneva's collection, depositing more than 400 items of glass, porcelain, metal, wood, and textiles

in the Museum of Decorative Arts in Helsinki. He received many awards throughout his career including election as an Honorary *Royal Designer for Industry by the Royal Society of Arts, London in 1963 and honorary membership of the Finnish Association of Designers in 1981. He also received honorary doctorates from the *Royal College of Art, London (1967) and the University of Art and Design, Helsinki (1993), and received the Academico di Honor from the Academy of Design at the University of Mexico City (1985).

Sason, Sixten (1912–67) A pioneer of Swedish product design in the 1940s, Sason originally trained as a fine artist, subsequently finding work as an illustrator. After working as a draughtsman in the engineering department of a motorcycle manufacturer, his career trajectory inclined in the direction of engineering and industrial design. In the post-Second World War era he established his own design office, Sixten Sason AB, which was inspired by American models. As a result he began to attract industrial design commissions from companies such as *Saab, for which his designs included the aerodynamic Saab 92 automobile, produced in collaboration with engineer Gunnar Ljungström, in production from the late 1940s. Other early commissions were earned from *Electrolux (vacuum cleaners and other domestic appliances) and *Hasselblad (the 1600F camera, 1948). For many years Sason was chief designer for Saab and did much to enhance the company's international reputation with the Saab 99 which was launched soon after his death.

Scarpa, Afra (1937–) and **Tobia** (1935–) Italian architect-designers Afra and Tobia Scarpa, fellow architecture graduates in Venice, collaborated on many designs that have subsequently become

'classics', produced by a variety of leading international manufacturers of furniture and lighting. Both were influenced by Tobia's father Carlo *Scarpa, particularly his interest in the technical properties and aesthetic possibilities of materials, an outlook that Tobia shared through his own work for the Venini glassworks in the late 1950s. In 1959 he designed the *Nibei* table for *Gavina, a prominent company for whom both worked subsequently on many commissions. Other leading enterprises for whom the couple worked included *Cassina, their *Soriana* armchair of 1968 being awarded a *Compasso d'Oro in 1970. They also worked on commissions for *Flos, such as Tobia's *Biagio* table lamp and numerous joint designs including the *Papillona* halogen lamp (1977) and *Pierrot* desk lamp (1990). They also worked on many designs for *B&B Italia, including the *Poligon* table (1984) and *Artona* chair (1985) and for furniture manufacturer Poggi and office furniture manufacturer Unifor.

Scarpa, Carlo (1906–78) Perhaps most widely known as a leading Italian furniture designer and architect of the post-Second World War era, influenced by Le *Corbusier and Frank Lloyd *Wright, whom he met in Venice in 1951, Scarpa was also a glass and furniture designer of note. His architectural commissions included showrooms for *Olivetti in Venice in 1957 and *Gavina in Bologna in 1961 and he also played a noteworthy role in his series of installations for the Venice Biennale, from 1942 (a Paul Klee retrospective) through to 1972. After graduating from the Accademia di Belle Arti in Venice in 1926, Scarpa had designed several buildings in an academic manner before falling under the influence of the *International Style. He also worked for a number of Venetian glassmaking firms, working closely with Paolo *Venini, and

experimented with the technical properties, and imaginative possibilities, of glass. He was awarded a Diploma of Honour at the *Milan Triennale in 1934. Amongst his best-known contributions to this field were his *Tessuto* and *Battuto* series of 1940. Scarpa also established a reputation for furniture design, particularly through his association with Dino Gavina, who helped put his designs into production in the 1960s and early 1970s. These included the *Doge* and *Valmarana* tables of 1969 and 1972 manufactured by Simon International. Italian furniture manufacturer Bernini put other Scarpa designs into production, including the *Zibaldone* shelving unit (1974).

Schleger, Hans (1898–1970) Well known for his post-Second World War corporate identity schemes for leading British companies such as ICI, Macfisheries, the British Sugar Corporation, Finmar Furniture Ltd., Fisons Pest Control, and the John Lewis Partnership, German-born Schleger established a reputation for his graphic work from the 1920s onwards. After studying fine arts at the Kunstgewerbeschule in Berlin (1918–21) he worked as a set designer and publicist for the Hagenbeck Film Company in the same city before leaving for New York in 1924. He set up his own agency in Madison Avenue under the name 'Zeró' (the pseudonym he used to sign his graphic work), introducing a number of the principles of graphic *Modernism to the USA in his newspaper and magazine advertisements. During the 1920s his work was published on both sides of the Atlantic. He returned to Berlin in 1929, working as an art director in the German offices of a leading British advertising agency, W. S. Crawford. In 1932, in the difficult political climate in Germany, Schleger emigrated to England (and was naturalized in 1938). Edward McKnight *Kauffer, a leading London-based graphic

designer, helped to promote his work through an exhibition at Lund Humphries, a leading art publisher, in 1934. His reputation was enhanced by his posters for BP Ethyl Petrol (1934) and Shell (1938), the latter a strikingly Surrealistic design. He also worked for London Transport, designing posters as well as bus stop graphics (1935) adapted from the signage of Edward *Johnston. During the Second World War he designed many striking posters for government propaganda, the General Post Office, and London Transport. After the War Schleger, like fellow German immigrant F. H. K. *Henrion, played an important role in establishing corporate identity design in Britain. His well-known trademark and symbol designs include those for the *Design Centre, London (1956), the British Sugar Corporation (1961), the John Lewis Partnership (1964), and the Penguin Press (1965). From 1951 to 1952 he was a consultant to the Mather and Crowther advertising agency, setting up his own consultancy, Hans Schleger and Associates in 1954.

He was a member of the *Alliance Graphique Internationale (AGI) and the Society of Industrial Artists and Designers (SIAD, *see* CHARTERED SOCIETY OF DESIGNERS) and was elected as a *Royal Designer for Industry in 1959.

Schreiber, Gaby (*c*.1916–1991) A leading British industrial and interior designer, Austrian-born Schreiber (née Wolff) initially gained recognition for her work in plastics begun during the Second World War, branching out into kitchen design and catering equipment in the post-war years. She established her own design consultancy, Gaby Schreiber & Associates in 1943 and, through the recruitment of a team of disciplinary design specialists, developed the potential to deal with all kinds of commissions right across the design spectrum, from product to engineering design, and from architecture and interiors to graphic design. She worked for many prestigious clients including British European Airways, the British Overseas Airways Corporation, Cunard, Hawker Siddeley Aviation, and Marks & Spencer and served on a number of prominent competition juries, including the *Design Awards scheme run by the Council of Industrial Design (COID, *see* DESIGN COUNCIL).

She arrived in Britain shortly before the Second World War, having trained in art, stage, and interior design in Vienna, Florence, Berlin, and Paris. After showing at the *Britain Can Make It exhibition of 1946 her work was increasingly in demand, particularly from the 1950s onwards, when she undertook a range of aircraft interiors for Boeing (1957–63) and work for Cunard including the *Cunarder* and *QE2* ocean liners. She also designed many interiors for leading department stores, retailing outlets, and businesses. In addition to managing Gaby Schreiber & Associates, by the 1960s she also headed a trading company, Convel Ltd., and Convel Design International, a design consultancy based in Brussels. Schreiber was prominent in a number of national and international organizations, most of which had only a modest proportion of women members. These included the COID, on which she served between 1960 and 1962, and the Society of Industrial Artists and Designers (SIAD, *see* CHARTERED SOCIETY OF DESIGNERS), of which she was a Fellow. She was also a Council Member of the *International Council of Societies of Industrial Design (ICSID), serving as the UK delegate at the General Assembly of 1961. Her work is represented in many major international design collections including those of the *Victoria and Albert Museum

and the *Museum of Modern Art, New York.

Schütte-Lihotsky, Margarete (1897–2000) Austrian architect-designer Schütte-Lihotsky played an important role in the design of efficient, economical, and pleasant living environments for working women. She is perhaps best known for her design of the 'Frankfurt Kitchen', an important contribution to scientific management in the home. She was the first woman to study architecture at the High School for the Applied Arts in Vienna and worked under Oskar Strnad, a Viennese architect specializing in working-class housing. In 1920 she was awarded a prize for a drawing of an allotment design, thereby bringing herself to the attention of Adolf *Loos, Josef *Frank, and others involved in Viennese public housing. Influential on her outlook were the principles of *Taylorism, a scientific approach to efficiency in the workplace pioneered by Frederick Winslow Taylor in the late 19th century documented in his book *Principles of Scientific Management* (1911). Also important to European designers concerned with domestic efficiency were the writings of the American Christine Frederick, whose *Scientific Management in the Home* (1915) was translated into German in 1922. Ernst May, the City Architect of Frankfurt, a muncipality overtly committed to the promotion of *Modernist architecture and design, invited Schütte-Lihotsky to bring together architects, manufacturers, and housewives to assist in the design of well-planned, easily managed homes. Schütte-Lihotsky (like Frederick and Lillian *Gilbreth in the United States) realized that the principles of Taylorism could be applied usefully to the domestic environment, particularly the kitchen. She measured the times taken for kitchen-based tasks with a stopwatch and, armed with her findings and inspired by railway and ship galleys, designed a small efficient kitchen in which activities were logically linked. The resulting designs included built-in cupboards and storage units and beechwood work surfaces. The latter were easy to keep clean; other surfaces not used for food preparation were painted blue to deter flies. The culinary tasks of the housewives were aided further by the provision of a swivel-top stool from which they could easily reach food storage, chopping board, and the kitchen sink. Psychological considerations were also taken into account and mothers were able to watch over their children in the living area whilst working in the kitchen. Construction costs were minimized through factory prefabrication and over 10,000 'Frankfurt kitchens' were installed in Viennese housing schemes in the 1920s. After the success of the Frankfurt kitchens Schütte-Lihotsky joined a team of Austrians and Germans in the design of towns in the Soviet Union. However, in 1938 when the Germans marched into Austria Schütte-Lihotsky joined the Communist Party and protested against the Nazis. This resulted in her arrest by the Gestapo and imprisonment in Bavaria until the end of the Second World War. In 1988 she was awarded both the Vienna City Prize for Architecture and the Austrian Honorary Medal for Science and Art. The importance and quality of her work was celebrated in the 1993 exhibition at the Museum of Applied Arts in Vienna devoted to her life and career. Fittingly, near the end of her life, in 1998 she oversaw a project for a housing estate in Vienna designed by women for women.

Scott, Douglas (1913–90) After studying at the Department of Metal Studies at the *Central School of Arts and Crafts (1926–9), Scott worked for lighting design companies

in Birmingham and London. In 1936 he joined the newly established London offices of Raymond *Loewy Associates, thus becoming one of the first professional British industrial designers.

Among the company's principal clients were Allied Iron founders (for whom Scott redesigned the Aga cooker), *Electrolux, the General Electric Company (GEC), and Rootes, the motor manufacturers. During the Second World War Scott worked in the engine department of the aircraft manufacturers *De Havilland where he learnt a great deal about materials and production engineering. Scott then took on a variety of freelance commissions, including luxury luggage for Papworth Industries (1947), coach design for London Transport (1946–8) and radio cabinet and selector systems for Rediffusion (1946–7). In 1949 he joined Fred Ashford to establish the design consultancy Scott-Ashford Associates.

Important in this period was his work for London Transport (LT), including designs for the luxury Regent Type Coach (RTC). He was also heavily involved with prototype work for the celebrated double-decker Routemaster bus (1952–4) which went into production in 1959 and remained in service for more than 30 years. In 1955 he split from Fred Ashford to establish Douglas Scott Associates (1955–76). Commissions included work for British Sound Recorders (tape recorders), the General Post Office (stamp-vending machines, pay-phones, and clocks), Prestige (kitchenware), Ideal-Standard (sanitary ware), Marconi (broadcasting equipment and mobile outside studio), and English Electric (electrical motor housings and computer control systems). One of his most celebrated designs was the practical, best-selling *Roma* washbasin for Ideal-Standard (in production from 1964). Scott also made an important contribution to design education, establishing the indus-

trial design curriculum at the Central School of Arts and Crafts, London. He was Visiting Professor at the Universidad Nacional Autonoma de Mexico (UNAM) in 1970, where he became a full-time Professor of Industrial Design from 1976. He received three *Design Council Awards and the Instituto Mexicano de Commercio Exterior's Gold Medal for Design (1973). His work is represented in the permanent collection of the *Museum of Modern Art, New York. He was made a *Royal Designer for Industry (RDI) in 1974, and received the Design Medal of the *Society of Industrial Artists and Designers (1983). He was awarded the *Japan Design Foundation's second International Design Award in Osaka (1985).

Sears Roebuck & Co. (established 1893) The origins of the company lay in the activities of Richard Sears, an agent of the Minneapolis and St Louis railway station in Minnesota, USA, who began trading watches up and down the line. After moving to Chicago in 1887 he employed Alvah Roebuck, forming Sears Roebuck & Co. in 1893. They began to compete with expensive rural stores by selling an increasing variety of goods via mail order and railway delivery. By the mid-1890s the catalogues were substantial (over 500 pages) offering a wide range of goods, from furniture, glassware, and ceramics to musical instruments, women's clothing, and farm wagons. The company grew rapidly and built a 40-acre (16-hectare) mail order plant and office building in Chicago in 1906, followed by a mail order plant in Dallas, Texas, in 1912. With the growth of chain stores, Sears moved into retailing in 1925, moving from a single outlet to more than 300 by 1929, with retail sales exceeding those of mail order in 1931. Sears Roebuck also occasionally commissioned designers to improve the design of

S

SEMIOTICS

Concerned with the study of systems of 'signs' in language, literature, and the material world, in terms of design semiotics is closely associated with the writings of Roland *Barthes, particularly his collected writings on popular culture and consumerism, *Mythologies* of 1957. Known also as semiology in France, it is the linguistic aspect of the philosophy of structuralism first developed by Ferdinand de Saussure (1857–1913) and the cultural anthropological writings of Claude Lévi-Strauss and provides a means of understanding the signs and symbols of modern, commercial life. In Barthes's *Mythologies* his exploration of the meanings of a variety of objects in everyday life ranged from wrestling and striptease to advertisements, photography, and automobiles.

their goods as, for example, the industrial designer Raymond *Loewy, who was employed by the company from 1932 to design a new refrigerator. This resulted in the stylish, streamlined *Coldspot* refrigerator of 1935, which proved to be a market success. After the Second World War expansion continued with the formation of Simpsons-Sears Limited in Canada in 1953 (now Sears Canada Inc.) and the opening of sales offices and stores in other countries. The company's continued success was symbolized in the construction of its new headquarters in Chicago, the 110-storey Sears Tower that opened in 1973 as the world's tallest building. In the 1980s and 1990s the company underwent considerable corporate restructuring which included the closure of its least profitable department stores as well as its catalogue distribution operations in 1993. However, in the late 1990s Sears was still a very substantial retail company with more than 800 department stores nationwide, more than 1,300 other Sears stores, and the Sears Shop at Home Service.

Semiotics *See* box on this page.

Semper, Gottfried (1803–79) A German architect and theorist, Semper exerted a wide influence on design thinking and education in Victorian Britain, whether

through his part in the organization of the *Great Exhibition, London, of 1851, the establishment of the South Kensington Museum (the future *Victoria and Albert Museum), his involvement in pedagogy, or his writings. His influence has also been closely identified with the formative period of *Modernism in Germany in the late 19th and early 20th centuries. Having studied law and mathematics, Semper went on to train as an architect in Munich in 1825. During the 1830s he travelled in Europe, where he began to form his ideas about ornament and architecture, having a particular affinity with the Italian Renaissance. He took up an architectural teaching post in Dresden in 1934 and gained widespread recognition for his design of the Dresden Opera House (1838–41). He also designed porcelain for the Meissen factory (1835–48). Having been involved in the 1848 Revolution, Semper was forced to leave Germany for Paris, before moving in 1850 to London, where he became involved with the Henry *Cole circle and the design of a number of sections of the Great Exhibition. He went on to teach metalwork and furniture design at the Government Schools of Design in London. Subsequently, in 1855, Semper moved to Switzerland where he retained a professorship at Zurich Polytech-

nic until 1871, when he moved to Vienna and then Italy. His ideas were conveyed through his writings, in which he devoted considerable attention to design and the applied arts. His major texts included *Wissenschaft, Industrie and Kunst* (*Science, Industry and Art*, 1853) and *Der Stil* (1861–3). Amongst Semper's most far-reaching ideas were those concerned with the notion of 'types'—seen as the essence of objects in relation to their function and form. Such ideas (like those of *Viollet-le-Duc in France) were taken up in progressive design circles in Germany in the later 19th and early 20th centuries, when there was considerable debate about the notion of a 'machine aesthetic'. He was also concerned with the premiss that materials provided the basis for creativity.

Seymour Powell (established 1984) This prominent British product design partnership was founded by advertising designer Richard Seymour and industrial designer Dick Powell and subsequently established a sound reputation for the innovative and forward-looking design of many products for leading British and overseas manufacturers. Much of their work is not for public consumption as it is geared to developing future strategies for companies and brands, often several years from the present day. Amongst such clients is the *Renault automobile company, for whom Seymour Powell produced advanced interior concepts for more than a decade. Amongst the best-known products designed in their London studio have been the seminal *Freeline*, the world's first cordless kettle (1986) for *Tefal, the BSA Bantam motor cycle (1994), the *Baby G* watches for Casio (1996), sports cameras for Minolta (1998), and a bagless vacuum cleaner for Rowenta (2001) developed from the air intakes of desert helicopters. Other significant clients have

included *BMW, *Nokia, Clairol, ICI, Ideal Standard, Panasonic, *Yamaha, and *Ford's Premier Automobile Division, showing Seymour Powell's *F350 Concept Super Truck* (2001) at the Detroit Motor Show of 2002. They have also won several design awards including a *Design Week* Award (1990), a D&AD Silver Award (1991), and a BBC Design Award (1994). Both partners have also been actively involved in promotion of design and the design profession with a wide range of inputs in design and business circles, design journalism, and broadcasting. Seymour and Powell have attracted wider public attention through their television work, most notably programmes such as the six-part *Better by Design Series* (2000, produced by Channel 4 TV in conjunction with the *Design Council), which focused on the advantages that could accrue from a fresh appraisal of everyday products such as kitchen bins, shopping trolleys, and razors. One such case study concept, the *Bio-form* bra for Charnos, became a best-seller in the lead up to Christmas 2000. Richard Seymour also became president of the D&AD Association in 1998, delivering a Presidential Lecture on 'The Road to Hell' in 2001.

Sezessionstil Known as Sezessionstil, the stylistic characteristics of the avant-garde designers associated with the *Vienna Secession (established in 1897) originally drew on the flowing, organic forms of *Art Nouveau and Symbolist Art. Later, after absorbing the influence of the designs of Charles Rennie *Mackintosh and other members of the Glasgow School who exhibited at the Secession Exhibition of 1900, designers associated with the Secession went on to adopt the flatter, more structured geometric motifs and patterns that were to become the hallmarks of the early Vienna Secession and *Wiener Werkstätte. The major artists and designers associated with Sezessionstil were the

SHAKER DESIGN

The clean, well-proportioned forms of Shaker furniture and artefacts were opposed to the material values of the ornamentation that generally prevailed in 19th-century industrialized culture. Some historians have suggested that the graceful elegance of Shaker goods influenced the outlook of Scandinavian designers, who went on to explore the aesthetic potential of natural materials and forms. The origins of the Shaker communities lay in 18th-century America, where religious principles lay at the core of their way of life, underpinned by a very simple puritanical philosophy. This was effectively translated into the Shakers' physical environment and their furniture, furnishings, and equipment were imbued with qualities of simplicity and restraint. They eschewed conventional ideas of beauty that were closely linked to ornament and decoration in favour of simple forms and harmonious proportions seen equally in clothes pegs, hat boxes, and dining tables. The Shakers only began to produce on a more significant scale after the needs of their community had been met, making furniture and other domestic artefacts in New Lebanon from 1849 to 1949. They had a small display at the Centennial Exhibition in Philadelphia in 1976.

painter Gustav Klimt, and designer-architects Josef *Hoffmann, Kolomon *Moser and Josef Maria *Olbrich. There was a common commitment to the idea of an aesthetic unification of design, architecture, and the decorative arts, typified by the architecture, interiors, and decoration of the 1989 Vienna Secession building itself, designed by Olbrich, and the *Ver sacrum* room at the first Secession Exhibition (1898), designed by Hoffmann. Many of the characteristics of Sezessionstil graphic design can be charted by reference to the Secession periodical, *Ver sacrum* (1898–1903), its own artistic unity evident in the stylistic coherence of all aspects of its appearance, including advertisements.

Shaker Design *See* box on this page.

Sharp Corporation (established 1912) One of the largest Japanese manufacturers of domestic appliances, audio-visual products, and office equipment in the early 21st century, Sharp was originally established as the Hayakawa Metal Works in Tokyo in 1912. In its early years the business centred on the manufacture of a mechanical pencil, the Ever-Sharp Pencil, invented by the company's founder Tojuki Hayakawa. It sold well in Europe and the United States as well as Japan. Following the 1923 earthquake the company relocated to Osaka and moved into radio technology and the production of crystal radio sets with the advent of Japanese radio broadcasting in 1925. Hayakawa was seen as at the forefront of this new technology in Japan. From 1931 onwards the company expanded into South East Asia, first in Hong Kong and then in other countries including China, where a manufacturing plant was established in 1934. After a difficult period following the Second World War Hayakawa moved into television production in 1953 when TV broadcasting began in Japan, although the company had been researching in this field for more than twenty years. Television sales were boosted considerably by the broadcast of the wedding ceremony of the Crown Prince and Michiko Shoda in 1959. During the decade the company diversified into domestic appliance manufacture (especially

refrigerators and washing machines), establishing its design department in 1957. Research and development were also important ingredients in commercial success, as seen in breakthrough products such as the Compet *C5-10A* calculator of 1964, the world's first all-transistor-diode electronic calculator. Though extremely bulky by today's standards it attracted considerable interest and resulted in fierce competition in the office equipment market place. In 1970, as it diversified into the business equipment field, the company changed its name to the Sharp Corporation. In the same year it established its Advanced Development and Planning Centre. Continually at the forefront of technological innovation its products utilized liquid crystal displays (LCD) from 1973 and became increasingly compact. In 1978 the company introduced its 'new lifestyle' product strategy, seeking to cater for consumer demand for greater colour ranges, diverse product forms, and innovative features. This idea was taken further in the mid-1980s with the establishment of the Creative Lifestyle Focus Centre, which concentrated on 'lifestyle software' as much as on 'hardware'. In the late 1970s the company introduced its first PC (personal computer), in 1980 its first fax machine, and, in 1987, its first LCD television. In 1992 Sharp introduced its innovative and prize-winning *ViewCam* video camera and recorder with LCD monitor and viewfinder. In 1999 such innovations were taken further with the *Internet View-Cam*, launched simultaneously in Japan, the USA and Europe, and the *RE-M21o* microwave oven able to download recipes from the internet. Similar consumer innovations continued into the 21st century with the launch of the sophisticated *AQUOS* LCD colour television designed by Toshiyuki Kita. Much of Sharp's success in the second half of the 20th century was due to the

design leadership of Kiyoshi *Sakashita, who joined the company as a staff designer in 1957, rising to the position of corporate design manager (from 1973), corporate director (from 1981), and corporate adviser (from 1995). The recognition of the importance of design at Board level has also been an important ingredient in corporate success.

Siemens (established 1847) This leading German domestic appliance, computer, and communications manufacturer was founded in 1847 and, in the later 19th century, was involved in the production of telegraph and generating equipment. Like fellow German company *AEG, Siemens became involved with electrical appliance design and manufacture in the early 20th century, developing in tandem with the increasingly rapid and widespread growth of electricity consumption. Although the company manufactured a wide range of appliances in the 1920s and 1930s including the *Protos* vacuum cleaner (1927), the *Protos* washing machine, and the *FeApp 37* telephone (1937), it did not establish a design department until 1937. After the Second World War key designers for the company included Norbert Schlagheck (working for Siemens from 1954 to 1967) and Herbert H. Schultes, who became the company's chief designer in 1984. Schultes effected a significant change of corporate design policy with the establishment in 1997 of a sizeable independent design company, Design & Messe, that specialized in design innovation and worked for other companies as well as Siemens. (From 1964 both Schlagheck and Schultes had collaborated in their own celebrated design consultancy, Schlagheck & Shultes, renamed Schlagheck Design in 1991.) Additionally, mirroring earlier industrial collaborations with AEG and Bosch in the later 1960s, 30 years later Siemens collaborated with external agencies for the

design of a number of its products including the *S29* mobile telephone (Schlagheck Design, 1998) and the *TC 91100* coffee machine (Ferdinand Porsche).

Sindy (1963–) Pedigree Toys launched Sindy ('The doll you love to dress') in Britain in 1963 and, like *Barbie, her glamorous counterpart in the USA, she proved an instant sales success as Britain's first fashion doll. Sindy reflected the burgeoning consumerist aspirations of young girls and looked to sought-after possessions of the rapidly growing teenage markets of the 1960s and 1970s. As a gender stereotype, in succeeding years Sindy was given a range of new outfits and accessories. These included a car (1964), nurse's and bridesmaid's outfits (1965), and an air hostess outfit (1967), but it was not until 1968 that Sindy acquired 'real' eyelashes, side-parted hair (available in several colours), and a twisting waist. Like Barbie, she also acquired a boyfriend, in this case Paul (1965)—probably named after Beatle Paul McCartney. With the 1970s she gained her characteristic centre parting as well as a house with Scenesetter furniture, and a number of new roles including Trendy Girl Sindy (1971), Top Pop Sindy (1972), Active Cindy (1975) with fifteen movable joints, and Sweet Dreams Sindy (1979). The 1980s were equally active with a new range of roles as well as a short hairstyle (1982) in tune with the popularity of Princess Diana. Additionally, in 1985, the Emanuels (designers of Princess Diana's wedding dress) designed a range of new outfits for Sindy. In 1986 Pedigree Toys were declared bankrupt and the Sindy name was sold to the American toy company Hasbro.

Sípek, Borek (1949–) Sípek studied furniture design at the School of Applied Arts, Prague, architecture at the Academy of Fine Arts, Hamburg, philosophy at the University of Stuttgart, and later took a doctorate in architecture at the University of Delft. His practical, philosophical, and theoretical background was significant in establishing him as an important and original *Postmodernist designer.

Like many others he left Czechoslovakia in 1968 and has subsequently worked for a number of international clients, including furniture designs for *Driade in Italy, Leitner in Austria, Gallery Néotu in France, and *Vitra in Switzerland. He has also become well known for idiosyncratic interiors and adventurous tableware designs as well as imaginative work in glass, including work in Murano, Venice, and for Novy Bor and Ajeto in the Czech Republic. Amongst many major commissions are the Karl Lagerfeld boutique in Paris, the Opera House in Kyoto, and the façade of the Komatsu department store in Tokyo. In 1992, as architect for Prague Castle, he was commissioned to design the interior of the president's study, the new art gallery, and other projects. Having taught design theory at the University of Essen between 1979 and 1983, he settled in Amsterdam and established the Alterego firm with designer David Palterer. From 1986 Sípek designed for the Steltman Gallery, Amsterdam, a collection of more than 100 limited edition designs, including furniture, lighting, and vases. In 1990 he was made head of the Studio of Architecture and Design at the Academy of Arts, Architecture, and Design in Prague where his originality and experience made a significant impact. In 1998 he was appointed as Professor of Design at the University of Applied Arts in Vienna. He has exhibited widely, including solo shows at the Musée des Arts Décoratifs, Lyon (1987), the Stedelijk, Amsterdam (1990), the Vitra Design Museum, Switzerland (1992), the Denver Art Gallery, USA (1996), and the National Museum, Prague (1998).

S

Skoda (established 1895) The roots of this famous Czech automobile manufacturer lay in the bicycle manufacturing business established by Vaclav Klement and Vaclav Laurin in Mlada Boleslav near Prague. Within four years the company began the manufacture of motorcycles, moving into motor car production with the *Voiturette A* in 1905. In 1925 Klement and Laurin merged with the Skoda Company, a manufacturer of engines and industrial products, and soon established a reputation for the manufacture of luxury limousines such as the 1929 Skoda *860* and the technologically sophisticated *Superb* designed in 1934 and in production until 1949. During the Second World War Skoda centred its activities on the production of military transport and, in 1946, was nationalized and given a monopoly on passenger car production including the 1946 *Tudor* range. In the 1950s and 1960s the company manufactured a number of celebrated models such as the *Spartak* and the *Estelle*, followed by a period of difficulty in the face of stiff European competition until the introduction of the *Favorit* in 1988. With the softening of relations with the West, and the corporate goal of developing new markets, the company became a member of the *Volkswagen group (incorporating *Audi and SEAT) in 1991. The *Felicia* was launched in 1994 followed by the Octavia, produced in a new assembly plant in 1996. A new Design Centre was established in Mlada Boleslav in 1999 and the image of Skoda, previously often seen as a manufacturer of cheap, fairly basic models, was altered with the launch of the award-winning *Fabia* in the UK in 2000. This was followed by the launch of a more luxurious version of the *Octavia* in 2001 and another new model, the *Superb* (named after its successful 1930s predecessor), characterized by a spacious interior, comfort, and technological sophistication.

Smith, Paul (1946–) Paul Smith has established a reputation for aligning British male fashion traditions with a progressive outlook in the marketing of clothes and promotion of a contemporary British *lifestyle. His well-made clothes have captured the imagination of consumers internationally through the opening up of shops and franchises in New York (1987), Hong Kong (1990), Paris, and elsewhere. By the mid-1990s about two-thirds of sales were for export, with more than 162 Paul Smith outlets in Japan, where he is feted as one of Britain's foremost designers. Smith opened his first clothing shop in Nottingham, England, in 1970, rapidly building up his business through a combination of classic tailoring and traditional materials alongside a flair for rethinking the ways in which such elements could be reinterpreted in fashionable ways. Important in the company's success has been Pauline Denyer, a *Royal College of Art fashion graduate and co-owner of the company whom Smith first met in 1969. In 1976 Smith showed his first men's collection in Paris, his growing success leading to the opening of his shop in Covent Garden, London, in 1979. In 1983 he participated in the *English Designer Menswear Collection* show in Paris. By the early 1990s, after establishing that about 15 per cent of Paul Smith clothes were bought by women, a women's collection was introduced in 1993, an addition to his earlier diversification into children's clothing in 1990. Also in 1993, Smith took over the firm of R. Newbould (established 1885), which had specialized in workers' clothing, and adapted many of its lines for his own collections. The 1990s also saw the launch of Paul Smith eyeglasses, watches, and other accessories, as well as the mounting in 1995 of a solo exhibition, *True Brit*, at the *Design Museum, London, designed by Tom *Dixon. Reviewing his design contribution

over the previous 25 years, it was the first time that the museum had devoted an entire show to an individual fashion designer.

Société des Artistes Décorateurs
(SAD, established 1901) The establishment of the Société des Artistes Décorateurs in 1901 reflected the growing importance of this new profession in France. This stemmed from a series of government-funded initiatives undertaken in the French schools of the fine and applied arts in order to enhance the status of—and training in—the applied arts. These sought to counter significant developments in other countries that increasingly recognized the economic significance of design education. As well as the overhaul of existing French schools of the fine and applied arts, in the closing decades of the 19th century new institutions were also created. These included the national schools of decorative arts at Limoges and Nice (both opening in 1881), the national school of applied arts at Bourges (also opening in the same year), and the École des Arts Appliqués in Saint-Étienne (commencing in 1889). Amongst the new breed of Parisian institutions were the École Boullée (opened in 1886), and the École Estienne (opened in 1889). The SAD was modelled on the Société des Artistes Français, of which its first president, Guillaume Dubufe, was a member. From the outset SAD was committed to the promotion of high-quality French craftsmanship, cabinetmaking, and satisfying the taste of an affluent urban elite. In addition to exhibiting the decorative arts in other contexts the Société set up its exhibitions from 1904. In the years leading up to 1910 the Société experienced some difficulties with falling membership and, in 1910 itself, a visible threat from the display of German applied arts at the Salon d'Automne in Paris. Such work was characterized by modernizing forms, bold colours, and aesthetic unity, making a significant impact on critics and French decorative artists. The economic significance of Germany's increased market share in the field was an added anxiety for the French, strengthening moves in the years leading up to the First World War to mount an international exhibition where French traditions of craftsmanship and quality in luxury goods would be re-established. After a number of postponements the proposed *Paris Exposition des Arts Décoratifs et Industriels eventually took place in 1925. Despite misgivings amongst the membership of SAD about the terms 'modern' and 'industrial' in the title of the 1925 Paris Exposition, its showing was impressive. Although SAD played a less central role than had been anticipated, its exhibit was subsidized by the state and took the form of a French Embassy with an impressive display of interiors designed by artistes-décorateurs of the calibre of Maurice Dufrène, Paul Follot, Pierre Chareau, René Herbst, and André Groult. Despite considerable debate about the relationship between art and industry the Société's long-standing commitment to the luxury end of the market resulted in considerable tensions between its more conservative members and others more sympathetic to modern design principles. This led to the establishment in 1929 of the ideologically opposed *Union des Artistes Modernes, a body committed to design production and consumption that firmly embraced new materials, manufacturing technologies, and the realities of modern life. Acknowledging the significance of modern design, in 1930 SAD invited the *Deutscher Werkbund (DWB) to exhibit in Paris. Amongst the DWB designers on show were Walter *Gropius, Marcel *Breuer, Herbert *Bayer, and László Moholy-Nagy. Although the SAD continued

after the Second World War its position never regained the vitality and sense of purpose of its earlier years.

Society of Industrial Artists *See* CHARTERED SOCIETY OF DESIGNERS.

Society of Industrial Artists and Designers *See* CHARTERED SOCIETY OF DESIGNERS.

Society of Industrial Designers *See* INDUSTRIAL DESIGNERS SOCIETY OF AMERICA.

Soloviev, Yuri (1920–) One of the leading figures in Russian design in the second half of the 20th century, Soloviev worked in many fields including furniture, interior, industrial, and transport design. Director of the government-sponsored USSR Research Institute of Industrial Design, VNIITE (1962–87), and a prominent figure in ICSID (*International Council of Societies of Industrial Design), Soloviev was also a founding member and the first president of the Society of Soviet Designers (established 1987). He studied design in Moscow (1938–43) before going on to work as a designer in a number of state-funded enterprises including the Architecture and Art Bureau (of which he was the first director) in the Ministry of Transport Industry (1946–56), the Central Design Bureau in the Ministry of Shipbuilding (1956–9), and the State Commission for Science and Technology (1959–62). His role within the Ministry of Transport Industry was important since the USSR's transportation infrastructure had been badly affected by the war. His design work included design of railway carriages, urban transport, and passenger ships. He became the founding director of VNIITE from 1962 to 1987, having been charged in 1959 with expanding design activity in the USSR. He had consulted with leading internal figures in contemporary design, most significantly Paul Reilly, director of the Council of Industrial Design (*see* DESIGN COUNCIL) in Britain and the American industrial designer, Raymond *Loewy. The COID provided the model of a state-funded organization charged with the promotion of improving standards of design in industry, albeit in a democratic consumer society, whilst Loewy's consultancy demonstrated the significance of design in business with offices in New York, Chicago, South Bend, Los Angeles, and London. VNIITE grew in size and significance with branch offices across Russia and began to establish international relationships through the organization of exhibitions and seminars. Its research and development policies were also influential in East Germany. Perhaps most important in terms of external relations was the link with ICSID, of which VNIITE became an institutional member in 1969, with Soloviev becoming a vice-president in the same year. After organizing ICSID's 1975 biannual congress in Moscow on the theme of *Man, Design and Society*, he served as president of ICSID from 1977 to 1980. In addition to his role in design education and professional organizations Soloviev also disseminated his ideas widely through his editorship from 1964 onwards of the *Tekniecheskaya Estetika* (*Technical Aesthetic*) VNIITE design journal, as well as the publication of many books and articles and conference addresses. His importance was recognized in the receipt of many design awards including the fourth Osaka International Design Award (1989), the International World Design Prize (1988), the *Japan Design Foundation's International Design Award (1989), and the Sir Misha Black Medal for Distinguished Services to Design (2001).

Sony Corporation (established 1946) The Sony trademark is globally recognized as a symbol of high standards of design and

a diverse and often innovative range of audio-visual products personified by the ubiquitous *Walkman* launched in 1979. The company was founded in 1946 by Masaru Ibuka, an electronics engineer, and Akio Morita, a physicist, under the title of Tokyo Telecommunications Engineering, soon establishing a reputation for the production of electrical components. Its first product of note was the first commercial Japanese *G Type* tape recorder of 1950, although it was limited to the recording of speech. This innovative outlook was maintained through the manufacture under licence of the first Japanese transistor in 1954 and the marketing of its first transistor radio in 1955. The small, clean-lined, and simple design of this *TR-55* radio was the company's first export, encouraging the development of pocket-sized models in succeeding years such as the highly popular *TR-610* of 1958. The *TR-55* was the first company product to use the Sony logo, a corporate branding feature that was further developed by Yasuko Kuroki and further revised in 1973. By the late 1950s Japanese product design was seen in a far more positive light than it had been before the war when it had been felt by many to be overly dependent on Western precedents. In 1959 the advertising slogan 'Sony—A Worldwide Brand Born in Japan' carried some real conviction. Miniaturization was an important facet of many contemporary Japanese products and was also visible in the lightweight Sony *8-301* portable television of 1959, its clean rounded, attractive appearance earning a Gold Medal at the *Milan Triennale of 1960. This interest in miniaturization continued with the launch of the globally successful *Walkman* in 1979, the *Watchman* miniature television in 1982, and the *Discman*, a small CD player, in 1985. In the decades following the Second World War Sony, like a number of other progressive Japanese companies in the same period, appòinted its first full-time designer (1954), establishing its design department under Norio Ohga in 1961 with seventeen members of staff. The company's exponential commitment to design may be evidenced in its employment of about 120 designers in the Sony Design Centre in the mid-1980s. Research and development was another important ingredient in Sony's success, supported by slogans such as 'Research Makes the Difference' initiated in the late 1950s. Other noted Sony products have included the *Profeel* (meaning 'professional feel') television in 1981, the Compact Disc player (a joint venture with CBS, *Philips, and Deutsche Grammaphon) in 1982, and the palmtop computer of 1990. Other ventures included the purchase of CBS Records in 1988 and Columbia Picture Entertainment in the following year. Sony has managed to stay at the forefront in design terms through such initiatives as its formation of a Strategic Design Group able to propose a range of possible design futures directly to the company's president. Such visibility of design issues at executive boardroom level is an important ingredient of success in the market place.

Sottsass, Ettore, Jr. (1917–) Although Sottsass worked for major manufacturers such as the office equipment company *Olivetti, the domestic equipment company *Alessi, the furniture companies *Knoll and *Artemide, and the glass company *Venini, he was at the forefront of avant-garde design practice in Italy for most of the second half of the 20th century. His rejection of *Modernism in the 1950s was followed by involvement with the *Anti-Design movement of the 1960s and 1970s, with *Studio Alchimia from the late 1970s, and *Memphis during the 1980s. He also formed Sottsass Associates in 1980, thus

consolidating his role as an important ful-
crum for design discourse throughout the
whole period. Sottsass's work has been ex-
hibited at major venues around the world
for three decades and features prominently
in the contemporary design collections of
all major museums.

From origins in Innsbruck the family
moved to Turin in 1928. Growing up with
an architect as father Sottsass became inter-
ested in the creative arts from an early age.
After travelling to Paris in 1936 he went on
to study architecture at Turin Polytechnic,
graduating in 1939. In 1947 he established
an architectural and design office in Milan
and worked alongside other key figures in
post-war Italian design, Marco *Zanuso and
Vico *Magistretti, on interiors and furniture
for municipal housing. Over succeeding
years he became increasingly involved
with design debates, particularly through
the *Milan Triennali. From 1955 he moved
into product design, a position furthered by
a visit to the United States in the following
year. His experience was deepened by
working in the design studio of George
*Nelson in New York, a location that
afforded him the opportunity to experience
a highly developed consumer society in
which mass culture played a prominent
role. He also saw the power of scale and
colour of the American Abstract Expres-
sionist artists (and, on a later visit in the
early 1960s, the work of American *Pop
artists). In 1957, back in Italy, he began
working for Olivetti as a consultant
designer working on a range of products
including the large-scale *Elea 9000* computer
(1959), the *Praxis 48* typewriter (1963), and
the brightly coloured *Valentine* portable
typewriter (1969). This period marked an
interest in design for the workplace that
resulted in a number of innovative design
solutions such as the *Synthesis 45* office fur-
niture. However, during this period, Sott-

sass also travelled to India in 1961 and
experienced a spiritual dimension to life,
far removed from the materialism that he
had experienced in the USA and Europe.
This resulted in a series of ceramic pro-
jects—including the series *Ceramics of Dark-
ness* (1963) and *Ceramics to Shiva* (1964)—that
added to the wealth of cultural meaning
and symbolism that was to characterize
much of his work. From the mid-1960s he
worked for Poltronova, designing experi-
mental furniture that drew on many refer-
ences to popular culture such as Disney's
Mickey Mouse. During the 1960s his out-
look was firmly opposed to notions of
*'Good Design' and made him a leading
figure in the Anti-Design movement. In
1972 he participated in the *Italy: The New
Domestic Landscape* exhibition at the
*Museum of Modern Art, New York,
curated by Emilio *Ambasz, showing
designs for a flexible living space compris-
ing a series of movable modules. In 1973 he
was a co-founder of *Global Tools, an ex-
perimental laboratory for architecture and
design that sowed the seeds for Studio
Alchimia, itself a highly influential avant-
garde design group committed to research
and discourse, with which Sottsass was as-
sociated from 1979. However, Sottsass was
more committed to developing new rela-
tionships with industry than Alchimia's im-
plicit commitment to polemic through
exhibition, manifesto, and limited editions
and became a founder of the Memphis
group in Milan in 1981. They believed that
any possibilities to realize the propositions
of the *Radical Design counterculture had
disappeared with the economic crises of the
later 1970s. Sottsass's work for Memphis
ran completely counter to conventional
notions of 'form follows function' and ex-
plored new possibilities of colour, decor-
ation, meaning, and metaphor in furniture
and product design that did not conform to

tradition or precedent. These vibrant prototypes proved highly influential in international design circles and represented what has been termed 'Nuovo Design' (New Design) and, more generally, *Postmodernism. Typifying this phase of his work was the free-standing *Carlton* sideboard.

In 1980 Sottsass Associates was formed with Matteo *Thun, Marco *Zanini, and Aldo Cibic, for which Sottsass worked on both architectural and design projects. These included work for large industrial companies such as *Brionvega (television sets) and Mandelli (machine tools), interior designs for Esprit retail outlets, the Alessi shop in Milan and the Zibibbo bar in Fukuoka, Japan (1989), and architectural commissions such as the Wolf House (1987–9) in the United States and the Contemporary Furniture Museum in Ravenna (1992–4). Other designers working at Sottsass Associates have included Johanna Grawunder, Mike Ryan, Marco Susani, James Irvine, and Christopher Redfern.

Sottsass Associates *See* SOTTSASS, ETTORE, JR.

Spencer, Herbert (1924–2002) A highly influential British communication and typographic designer, Spencer disseminated his ideas through his work, his commitment to design education, his involvement with the pioneering magazine *Typographica* and the *Penrose Annual*, and highly perceptive writings in the field.

Born in London Spencer became interested in printing as a child, an interest that was further developed as an RAF cartographer during the Second World War. Having joined the London Typographic Designers in 1946 he embarked on a career in design. He built up a design and consultancy business from 1948, with a client list that was to include the Post Office, British

Railways, Shell, and the Tate Gallery. From the late 1940s onwards he travelled in Europe, meeting many influential figures such as Max *Bill and Piet Zwart who enhanced the breadth of his design thinking and knowledge. Over many years he disseminated in Britain his familiarity with European typographic innovation.

Spencer exerted considerable influence through a commitment to publishing and writing. He had a close relationship with the Lund Humphries company who began publishing the *Typographica* journal, which he founded in 1949, editing it until it ceased in 1967. It embraced avant-garde ideas from typography to photography, its own format often taking on fresh ideas. From 1964 to 1973 he also edited the highly respected print-focused *Penrose Annual* (1895–1982), also published by Lund Humphries. Furthermore, Spencer wrote a number of books that have proved influential in the profession, including *Design in Business Printing* (1952), *The Visible Word* (1966), and *Pioneers of Modern Typography* (1969). His national and international reputation was reflected by his role as Master of the Faculty of RDI (*Royal Designers for Industry) from 1979 to 1981 and International President of AGI (*Alliance Graphique Internationale) from 1971 to 1974.

For three decades he played an important role in graphic design education, influencing several generations of students. From 1949 to 1955 he taught typography at the *Central School of Arts and Crafts in London, and in 1966 was appointed Senior Research Fellow in the Print Research Unit at the *Royal College of Art and was made Professor of Graphic Arts at the RCA from 1978 to 1985.

Starbucks (established 1971) This American chain of coffee houses, with its distinctive *logo, has become a recognized

brand in countless major towns and cities throughout the world, with innumerable smaller outlets located in bookshops, hotels, airports, stations, and sports and leisure centres. Based on the concept of a comfortable living room combined with coffee shop, the brand has also developed its commercial potential to embrace a wide range of other products, whether closely related—such as own-brand coffee-beans, biscuits, and ice cream—or more generic *lifestyle commodities such as music. The company's distinctive logo was designed by Seattle-based Heckler Associates in 1971 and underwent three changes between then and its more definitive 1990 version. Although based on the image of a mythical siren, due to the company founders' interest in the sea, the increasingly simplified image has made a global impact. The first Japanese Starbucks outlets opened in 1996 and, by the early 21st century, had outlets in more than 30 countries including China. The expansion in Japan was dramatic, opening its first store in the Ginza district of Tokyo in August 1996 and its 400th in Okinawa in 2002. The success of the Starbucks lifestyle concept, accompanied by rapid growth and high levels of profitability, has been such that it has also given rise to a number of imitators. The first Starbucks location opened in the United States, in Pike Place, Seattle in 1971 and the company expanded globally with a brand recognition that has been compared to the longer standing, brand-distinctive *McDonald's fast-food empire. However, in its early years the company's activities were mainly concerned with the marketing of coffee to expresso bars and restaurants and it was not until 1983, when its marketing director Howard Schultz travelled to Italy, that the idea of developing a coffee bar culture began to take off. Starbuck's achievements have been such that, in 2003, it was considered by *Fortune*, the leading American business magazine, to be one of its ten most admired companies. However, like many other American global brands, it also attracted criticism but sought to counter this through its profiling of progressive employment practices, including the offer of share options to part-time staff, and a commitment to ecological and environmentally-friendly policies.

Starck, Philippe (1949–) One of the most widely known of artist-designer 'names' in the later 20th and early 21st centuries, Starck is one of France's most fêted designers who has worked across a wide range of media. His work epitomizes the intersection of art and design, its often fanciful qualities attracting both critical approbation and criticism, particularly in such commissions as pasta for Panzani (1987). His clients have included many leading international companies with a commitment to extending the visual syntax of design in Europe, the United States, and the Far East. These have included *Alessi, *Cassina, *Driade, *Flos, and *Vitra. After attending the École Nissim de Camondo in Paris in the 1960s he established a company for the production of inflatable products in 1968. In the following decade he designed a series of nightclubs, establishing the Starck Product Company in 1979. Starck's celebrity status owed much to the design policies of the French State, following the establishment of the VIA (Valorisation pour l'Innovation dans l'Ameublement) in 1980 under the Ministry of Industry and its involvement with designers such as Martin Szekely, Garouste and Bonetti, and Starck himself. He designed a suite of rooms for President Mitterand at the Élysée Palace in Paris in 1982, a commission that led to considerable media attention. His interest in interior design continued during the rest

of the decade with commissions in Japan, Spain, and France, the latter including the Café Costes in Paris in 1984 with a three-legged chair that was put into production by the Italian furniture manufacturer Driade. He also designed a number of hotel interiors, such as those of the Royalton (1988) and Paramount (1990) hotels for the entrepreneur Ian Schrager, and was also involved with the design of the Groningen Museum (1991) in the Netherlands.

His collaboration with Driade commenced in 1985 and, in addition to the *Costes Chair*, included the *Ubik* range (1985) and the *Lord Yo* chair (1994). Another significant collaboration with Italian manufacturing industry was with Alessi, commencing in 1986, and incorporated such iconic products as the *Hot Bertaa* kettle and *Juicy Salif* lemon squeezer (1990). Much of his work was highly individualistic, with strong artistic leanings. On occasion his work was literally experimental, as in his competition design of a plastic bottle for the mineral water company Vittel in 1986. On other occasions he paid homage to the fine arts, typified by his celebrated toothbrush (1990) for Fluocaril, a brand name of Goupil Laboratories, its sinuous form paying homage to the work of the sculptor Brancusi. Reference to other fields of creativity embraced film, acknowledging the work of a fashionable director in his design of the *Wim Wenders* stool (1992) for Vitra. Lighting designs ranged from the intimate to the large scale, such as the playful *Miss Sissi* table lamps (1991) and *Romeo Babe* pendant light (1996) for Flos and distinctive street lamps (1992) for Decaux. Industrial designs have also, since 1990, culminated in audio-visual products for Thomson such as the *Rock 'n Role* CD player, the *Lux Lux* television, and the *Perso* mobile phone, as well as the *Moto 6.5* motorcycle for Aprilia. Amongst other notable commissions were an imaginary house for

Les *3 (Trois) Suisses and the *Good Goods* catalogue for La Radoute in which, in 1998, he presented over 200 product ideas.

Starck's work has been the subject of numerous articles and books ranging from those in professional and critical journals to glossy fashion magazines and coffee table books. He has also been recognized officially through the mounting of a one-man show of his work at the *Museum of Modern Art, New York, in 1993, and at the *Pompidou Centre in Paris in 2003. He was also the first recipient of the Harvard Excellence in Design Award in 1987.

Stenberg, Vladimir (1899–1982) and **Georgy** (1900–33) Widely known for their striking theatre designs, film posters, and street festivals of the 1920s, the Russian *Constructivist Stenberg brothers originally trained from 1912 to 1917 at the Strogonov School of Painting, Sculpture and Architecture and the Free State Art Studios (1917–20). Founder members of the Society of Young Artists they were involved with the production of propaganda posters and street art in support of the Russian Revolution of 1917. They joined Inhuk (the Institute of Artistic Culture) in 1920 and were members of the Constructivist group, influenced by the outlook of Vladimir *Tatlin and Alexander *Rodchenko. In 1922 the Stenbergs exhibited more than 30 experimental works exploring new possibilities of architectural and spatial structures at the Café Poetov in Moscow. From 1915 onwards they had also been involved in theatre design and, from 1922 to 1931, designed many sets and costumes for Alexander Tairov's Karmerny Theatre, visiting Paris with the Theatre in 1923. In the 1920s they produced more than 300 film poster designs and worked as graphic designers on magazines such as *Stroitel'stvo Moskvy* (*The Construction of Moscow*). Their

film poster designs were almost as striking a means of communication as Soviet cinema itself, combining photomontage, graphic forms and images, and often vibrant colours in a highly original way—in marked contrast to the black and white films they advertised. These included Eisenstein's *Battleship Potemkin* (1925) and *October* (1927). However, with the rise of Stalinist totalitarianism from the late 1920s such progressive designs were increasingly constrained. Working together on the large-scale designs of official festivals in the urban environment, the Stenbergs were also involved with many other branches of design including those relating to railway and underground carriages, public seating, fountains, and lighting. After Georgy's death in 1933, Vladimir continued to work alone, later collaborating on works with his sister and, after the Second World War, his son.

Stepanova, Varvara (1894–1958) A leading Russian *Constructivist artist, graphic, and costume and set designer Stepanova was best known for her textile and clothing designs and, like her husband Alexander *Rodchenko and Vladimir *Tatlin, became committed to utilitarian designs geared to social needs and economic mass production. After studying at the School of Fine Arts in Kazan from 1910 to 1911 she moved to Moscow where she studied at the Stroganoff School of Applied Art from 1913 to 1914. After working with avant-garde abstract forms she was, from 1920, an active member of Inhuk (the Institute of Artistic Culture) which had been established in 1920. In the following year, with her husband Rodchenko and others, she became involved with Productivism—the mass production of industrial and applied art (*see* CONSTRUCTIVISM). She designed utilitarian workers' clothing, strongly coloured, geometrically patterned sportswear, and theatre costumes and sets, such as that for

The Death of Tarelkin produced by Meyerhold in Moscow in 1922. She also taught at the Moscow *Vkhutemas and, in the mid-1920s, produced many designs for mass-produced cotton textiles often characterized by flat, coloured abstract patterns. In the same period she contributed to a number of avant-garde periodicals such as *LEF* (1923–5) and *Novy LEF* (1927) and increasingly devoted her attention to book and periodical design, often in conjunction with her husband Rodchenko, with whom she collaborated closely on photographic albums in the 1930s. After the Second World War she worked on the periodical the *Soviet Woman* (1945–6).

Stichting Goed Wonen (Good Living Foundation, established 1948) This Dutch foundation was set up to promote well-designed domestic goods and, like many other contemporary *'Good Design' initiatives (*see* DESIGN COUNCIL), its idealistic agenda of bringing together manufacturers, retailers, consumers, and designers failed to capture widespread support. Among the more energetic individuals involved in its affairs included Mart Stam, Johan Niegeman, and Hein Salomonson. In order to make its goals more accessible it established a periodical, *Goed Wonen*, and also—in common with other contemporary organizations concerned with the promotion of modern design (*see* DESIGN COUNCIL; MUSEUM OF MODERN ART, NEW YORK)—presented awards for selected modern products. Early award winners included Gispen lamps and *Leerdam glass. In common with many other design promotional organizations Goed Wonen also promoted its ideas through the furnishing and equipping of show houses. Goed Wonen was also involved in furniture manufacture. Although it attracted real public interest at a time when goods were in short supply, the idea

of 'Good Design' began to take on connotations of elitism and didacticism. As a result, the 'Good Living' (Goed Wonen) title was abbreviated to 'Living' (Wonen).

Stickley, Gustav, (1858–1942) Stickley was a significant American furniture designer who was heavily influenced by the *Arts and Crafts Movement, which he had experienced at first hand, having travelled to England early in his career. He was an important designer of what became known as 'Mission Furniture' His many brothers were also involved with furniture manufacture including Charles, whose Stickley-Brandt Furniture Company was in business from 1884 to 1919, Leopold and George, who ran the L. and J. G. Stickley Company, and George and Albert, who ran Stickley Brothers from from 1891 to 1907. Although originally trained as a stonemason Gustav himself began his own furniture business after more than a decade in furniture making, establishing his own company in 1898. His first rather austere range, *New Furniture*, was launched at the Grand Rapids Furniture Show of 1900. From 1901 Gustav's company was renamed Craftsman with an accompanying magazine of the same title, edited by Irene Sargent of Syracuse University, which sought to promote his arts and crafts ideals. From 1903 he worked closely with designer Harvey Ellis who became editor of the *Craftsman* and enjoyed considerable success and sales. As a result the company moved to New York in 1905 and licensed manufacturing franchises across the United States. However, in the face of strong competition from many imitators as well as his own business expansion, his company went bankrupt in 1915 and, in the following year, his factory was purchased by his brothers Leopold and George and continued in business as the Stickley Manufacturing Company.

Stijl *See* box on p. 403.

Stile Industria (1954–63) This Italian periodical was published at a time when Italian industrial design was beginning to establish an international reputation. Edited by designer, architect, and theorist Alberto Rossell, its aim was to open up a dialogue between design and industry and stimulate debate around the aesthetics and technologies appropriate for contemporary design. It folded in the particularly difficult political and economic climate in Italy in the early 1960s.

Stockholm Exhibition (1930) The 1930 Stockholm Exhibition was organized by the *Svenska Slöjdföreningen (Swedish Society of Industrial Design) as a means of promoting a *Swedish Modern aesthetic, a reflection of the influence in progressive design circles of the social utopian ideals promoted by the *Deutscher Werkbund in Germany in the mid-1920s. The Society's aim was also to promote to an international audience the achievements of Swedish design that had been gaining increasing critical admiration at exhibitions in the 1920s. These included the 1923 Gothenburg Exhibition and the *Exposition des Arts Décoratifs et Industriels in Paris in 1925, as well as smaller-scale exhibits such as a special exhibition of Swedish design at the Metropolitan Museum in New York in 1927.

At the 1930 Stockholm Exhibition advertising played a prominent role, being seen to epitomize the dynamism of modern life and the forging of links between design, manufacturing industry, and marketing. The neon-lit 260 foot (80 metres) tall 'Social Democrat' advertising tower provided a focal point of the exhibition. Topped by the Sigurd Lewerentz exhibition symbol, an abstract motif of a pair of delta wings in flight that symbolized the exhibition's orientation towards the future, the tower could be seen for miles. Gregor *Paulsson,

STIJL, DE

(established 1917) This avant-garde movement originated in neutral Holland during the First World War and became influential internationally in the 1920s. Founded by painter, designer, and writer Theo Van *Doesburg in 1917 alongside a magazine of the same title, the De Stijl group consisted of architects, designers, and artists whose early aesthetic outlook built on that of the Dutch painter Piet Mondrian who had, in turn, been influenced by the ideas of the Cubist artists in Paris in the years immediately leading up to the First World War. Also influential on the group's early approach was the Dutch architect and designer H. P. Berlage who had looked to the ways in which the American architect and designer Frank Lloyd *Wright had manipulated space and form in the early years of the 20th century. De Stijl design was characterized by a vocabulary that reflected a harmonius balance between verticals and horizontals, was elemental in its reliance on abstract forms and restricted palette of the primary colours of red, yellow, and blue, together with black and white, and was symbolically attuned to the methods of modern mass-production technology. The best-known designers of the group included Gerrit *Rietveld, whose furniture, architecture, and interiors—notably his striking Schröder House in Utrecht of 1924—were the physical embodiment of the style; Bart van der Leck worked in a range of design media, including textiles; the Hungarian Vilmos Huiszár designed the first cover for the *De Stijl* magazine and was also involved with interiors and textiles; and Piet Zwart who was a typographer, advertising, and industrial designer. Theo Van Doesburg himself worked in a variety of media including architecture, interiors, furnishings, and graphics, and introduced the ideas of De Stijl to many of those connected with the *Bauhaus whilst living in Weimar from 1921 to 1923. Walter *Gropius, the Bauhaus director at the time, revealed a keen interest in the aesthetic in the lighting design for his office in 1923. The considerable interest in De Stijl principles was further evidenced by Van Doesburg's design for the Bauhaus Book number 6, published in 1925. Links were also established between De Stijl and the *Constructivist designers El *Lissitsky and László *Moholy-Nagy in Berlin, with a special issue of *De Stijl* in September 1922 devoted to Lissitsky's work and Elementarism. This period, which also saw exhibitions of De Stijl architecture at Léonce Rosenberg's Galerie L'Effort Moderne, marked the international phase of the movement and was also marked by the resignation from the group of Mondrian in 1925. Some of Van Doesburg's most striking designs were for the restaurant-nightclub the Café Aubette in Strasbourg, for which he designed the interiors and furnishings for ten rooms in 1926. Perhaps the most striking of these was the Cinema-Dance Hall, which embraced rectilinear planes of flat colour set within a dynamic 45-degree angle from the walls and ceilings.

S

who had become the Svenska Slöjdföreningen's director in 1917, was the 1930 exhibition's general director with Gunnar Asplund overseeing the architecture, much of it characterized by lightness and transparency, standardized elements, and clarity of construction. Summarizing the progressive spirit of the exhibition Paulsson commented that 'the fundamental changes which have taken place in the technical and

social structure of our society are in process of creating a zeitgeist, philosophy of life, or whatever we like to call it, which objective observers regards as different from that of the previous era'. Notions of social reform were implicit in the modern forms and interior furnishings and equipment of the flats and housing on display, as well as in the schools and hospitals exhibits. Involved in the design of many of the interiors were *Modernists such as Uno Ahrens, Gustaf Clason, Erik Friberger, and Sven Markelius. The concept of *Existenzminimum* (living in the minimum space) was one of the key themes shared with avant-garde designers in Germany (*see* SCHÜTTE-LIHOTSKY, MARGARETE), Holland, Scandinavia, Eastern Europe, and Britain (*see* COATES, WELLS), and members of *CIAM. Exemplifying the prevailing functionalist aesthetic at Stockholm were products such as tubular steel chairs, Wilhelm *Kåge's austere 1930 *Pyro* oven-to-tableware manufactured by *Gustavsberg and Alvar Andersen's utilitarian modular furniture manufactured by the Tenants Furniture Company. Numerous examples of modern lighting could be seen in the Lighting Hall where products manufactured by *Orrefors, Böhlmarks, and others were on display. Transportation, another rapidly evolving dimension of 20th-century life, also played an important role at the exhibition with attention being paid to cars, buses, trains, and aeroplanes.

There were positive contemporary responses to the Stockholm Exhibition, not least from the British critic Philip Morton Shand who wrote in the *Architectural Review* that Sweden had 'prima facie, the ideal equipment for gauging both the potentialities and limitations of the machine, and the machine aesthetic, in a degree which no other country can claim . . . The new machine architecture is not the herald of world Bolshevism. It is destined to be imbued with wholesome Nordic sanity.' However, the exhibition also aroused fierce controversy, not least in Sweden itself where many viewed the new style as rather stark, austere, and lacking in human values. The traditional values and craft aesthetic embraced by many designers, especially those in the Swedish ceramics and glass industries, were generally more sympathetically received. Indeed, such was the volume of opposition that Gregor Paulsson, Gunnar Asplund, Sven Markelius, Ekil Sundahl, and others decided to publish a defence of the ideals of the exhibition in 1931. Entitled *Acceptera* ('Accepting') and designed with a modern typeface and clean layout, the authors argued that a new way of life, new materials, and modern technological advances required new approaches to living. However, as the 1930s unfolded a somewhat less austere, yet contemporary, style evolved. Known as Swedish Modern, it more readily embraced natural materials such as wood (as opposed to tubular steel) and was associated with designers such as Bruno *Mathsson and Josef *Frank and the textiles, furniture, lighting, and other products marketed by the Swedish store *Svenskt Tenn.

Stölzl, Gunta (1897–1983) Weaver and textile designer Stözl was both a graduate and member of staff at the German *Bauhaus. Having studied decorative arts at the School of Applied Arts in Munich from 1914 to 1916, she went on to study at the Bauhaus from 1919 to 1925, before becoming technical director of the Bauhaus weaving workshops. After being put in charge of the latter in 1927, she resigned from the Bauhaus in 1931 and established a weaving business in Zurich, which she ran until 1967. In 1932 she became a member of the Swiss Werkbund.

STREAMLINING

Most often associated with the aerodynamic forms of many products in the United States in the 1930s, streamlining reflected popular interest in speed records on land, sea, and in the air. However, although such forms were often equated with fast-moving objects, such as the Douglas *DC-3* airliner of 1933, the Burlington *Zephyr* and Union Pacific *M10,000* railway locomotives (see CHICAGO CENTURY OF PROGRESS EXPOSITION), and the *Chrysler *Airflow* car (1933), they were also used to provide a symbolic link with technological progress through the appropriation of aerodynamic forms in static objects. These ranged from the flowing lines of Kem *Weber's *Airline* chair (1934) and the rounded forms of Walter Dorwin *Teague's *Bantam* enamelled metal camera (1936) for Eastman Kodak to the sculptural dynamism Raymond *Loewy's *Coldspot* refrigerator (1935) for *Sears Roebuck & Co. and Peter *Müller-Munk's chrome-plated brass steamer funnel-like *Normandie* jug (1931). Such forms became the basis for countless vacuum cleaners, toasters, radios, fountain pens, and items of furniture. Indeed, many objects took on a number of explicit styling features that came to symbolize speed. 'Speed whiskers'—thin horizontal strips, often of chrome, applied to the surface of objects—could be seen running in parallel lines on bona fide transportation designs such as Loewy's *Silversides* motor coach (1940) for Greyhound and his *S-1* railway locomotive (1935) for the Pennsylvannia Railroad. Nonetheless they were applied to countless static situations, ranging from the entrance to the McGraw-Hill Building by Raymond Hood and J. André Fouilhoux in New York to the ubiquitous roadside diners and the domestic, as in the streamlined earthenware refrigerator jug (1940) by J. Paulin Thorley for the Westinghouse Electric Co. The public appetite for the symbolism of speed and contemporaneity had been whetted by the almost science fiction-like renderings of the technological utopianism of industrial designer Norman *Bel Geddes in his book *Horizons* (1932), as well as science fiction itself which in the same period saw the creation of Flash Gordon, Buck Rogers, and Superman. It was also a dynamic feature of the *New York World's Fair of 1939–40. Although a streamlined aesthetic made some impact in European products, it was most apparent in transportation developments with the design of new locomotives by engineers such as Nigel *Gresley and also in a number of cars such as the Burney Streamliner in Britain, the Tatra in Czechoslovakia, and *Porsche's designs for the 'Volkswagen' in Germany. Its impact was greater in the 1950s when the appeal of American products symbolizing the rapidly changing world of technology became more alluring with increased levels of affluence.

Streamlining *See* box on this page.

Studio (1893–1988) Published in London and devoted to the fine and applied arts, *Studio* magazine was founded in 1893 by Charles Holme, an artistically well-connected businessman who lived in Wil-liam *Morris's Red House. With an international readership it did much to promote British design abroad, particularly in the late 19th and early 20th centuries when many illustrated articles on the graphic artist Aubrey *Beardsley, architect-designers Charles Rennie *Mackintosh, Charles

Annesley *Voysey, and others appeared. Similarly, it did much to introduce its British readers to *Art Nouveau and a wide range of other European developments surveyed in articles and notices. Its first editor was C. Lewis Hind, although he was soon replaced by the influential and effective Gleeson White. So successful was the magazine in its early years that an American version, entitled *International Studio*, was launched in 1897, a series of Special Issues produced from 1898 until 1939, and, from 1907 until the 1980s (with some adjustments of title), *The Studio Yearbooks of Decorative Art* provided useful surveys of international design and interiors. The First World War seriously affected the magazine's readership and, under the editorship of Geoffrey Holme (son of the founder), a generally conservative line was pursued in the interwar years. In the 1960s the magazine was retitled *Studio International* and devoted itself to modern art.

Studio Alchimia (established 1976) Founded by Alessandro and Adriana Guerriero and Bruno and Giorgio Gregori in 1976, this Milan-based avant-garde experimental design group worked outside the constraints of mass production and the dictates of manufacturers, evolving from the *Anti-Design experimentation of Italian radical design groups of the 1960s such as *Archizoom and *Superstudio. The pivotal figures of the group were Alessandro *Mendini and Ettore *Sottsass Jr., both of whom were opposed to the dogma of elegance and 'good taste' so evident in much mainstream Italian design of the 1950s and 1960s. Other key designers associated with Studio Alchimia included Andrea *Branzi, Michele *De Lucchi, and Matteo *Thun. The group's exhibitions included *Bauhaus I* and *Bauhaus II*, the latter shown at the *Milan Triennale of 1979, and *The Banal Object* exhibited at the

Venice Biennale of 1980. The Bauhaus exhibitions included commonplace motifs drawn from the 1950s, drawing together strands of design, culture, and everyday life in the belief that the ordinary can provide the impetus for creativity. The *Banal Object* comprised a collection of everyday products such as irons, carpet sweepers, lights, and shoes, the banality of which was accentuated by the addition of dramatic decorative features. Mendini was commited to the idea of design as expressing a polemical or didactic position rather than providing a set of propositions for the reinvigoration of design as a positive instrument of social and cultural change. It was this latter outlook that was to be taken up by *Memphis for much of the 1980s. The group was awarded the *Compasso d'Oro in 1981 for design research.

Suetin, Nikolai (1897–1954) Russian artist and industrial and graphic designer Suetin was, for the first half of his professional career, closely associated with the abstract, avant-garde forms of Suprematist painting that had emerged in the years immediately preceding the Russian Revolution of 1917. Suetin had studied at the Institute of Art at Vitebsk between 1918 and 1922, joining the progressive Unovis group in 1919. Founded by fine artist Kasimir Malevich, Unovis sought to forge an alliance between fine art and utilitarian products, tendencies that were also reflected in the debates of Russian *Constructivism. Suetin went on to work with Malevich on Suprematist architectural projects and also applied Suprematist principles to his ceramic decorations for the State (Lomonosov) Porcelain Factory in Leningrad. He exhibited a Suprematist tea service at the *Paris Exposition des Arts Décoratifs et Industriels in 1925 but by 1932, when he became chief designer at the Porcelain Factory, his work reflected

the more traditional forms of decoration that were in keeping with the totalitarian Stalinist regime.

Sullivan, Louis (1856–1924) Widely known for his dictum 'form follows function' the American architect Sullivan's major contribution to design thinking in the United States and Europe was his integration of ornament with underlying structures rather than simply applied to the surface as was the case in the work of many Victorian architects and designers. He had commenced his architectural training at the Massachusetts Institute of Technology (MIT) in 1872, the first architecture school in the United States, before becoming a pupil of Philadelphia architect Frank Furness. In 1874 he studied briefly at the École des Beaux-Arts in Paris before returning to the United States in the following year. In 1881 he became a partner in the architectural firm of Adler and Sullivan (until 1895), concentrating on design and Dankmar Adler on engineering. The firm produced a number of skyscraper buildings in the period of rebuilding Chicago after the Chicago Fire of 1871, including the Auditorium Building (1886-9) the Stock Exchange Building (1893-4), and the Schlesinger Meyer Department Store (1899-1904, now Carson, Pirie & Scott). Other notable works included Wainwright Building in St Louis (1890-1) and the Guaranty Building in Buffalso (1894-5). Important in the transmission of Sullivan's ideas on ornament was Frank Lloyd *Wright who was a member of the firm between 1888 and 1893. Sullivan's aesthetic ideas were contained in his writings, including *Kindergarten Chats* (1901-2) and his *Autobiography* (1922-3).

Superstudio (1966–78) This avant-garde architecture and design group was closely associated with the *Radical Design movement in Italy. Founded in Florence in December 1966 by Adolfo Natalini and Cristiano Toraldo di Francia, its members rejected the traditional relationship between designer and manufacturer whereby the former was subservient to, and thus constrained by, the dictates of the latter. Like *Archizoom, also founded in Florence in 1966, Superstudio sought to explore utopian ideas for living rather than be confined by the strictures of functionalism. Its philosophy was characterized by the *Monumento Continuo* of 1968 in which expansive future living environments were conceived as being objectless and free from the pressures of consumerism. The main outlets for Superstudio's ideas were exhibitions, catalogues, international competitions, seminars, and lectures, the most significant stage perhaps being the *Italy: The New Domestic Landscape* (1972), curated by Emilio *Ambasz at the *Museum of Modern Art, New York. Superstudio was a member of the *Global Tools initiative (1973-5) and participated in a number of exhibitions including the *Milan Triennali and the *Sottsass and Superstudio: Mindscapes* exhibition that toured the United States in from 1973 to 1975. Members of Superstudio were also active in promoting their ideas through teaching and research in university departments in Florence and elsewhere.

Svenska Slöjdföreningen (Swedish Society of Industrial Design, established 1845) Founded in Stockholm, this campaigning body for improving standards of design in Swedish industry alongside public education in the aesthetics of the domestic environment is one of the longest-standing in the world. With increased levels of migration from the countryside to the cities in the late 19th and early 20th centuries the Society's original mission was re-evaluated, and it took on a stronger social dimension with a commitment to raising standards of

design in everyday life. Such tendencies were reflected in Ellen Key's 1899 book *Skönhet för Alla* (*Beauty for All*) that argued for economic everyday design. Many of those associated with the Society ensured the continuity of such thinking in Sweden, as was seen in Gregor *Paulsson's influential publication *Vackrare Vardagsvara* (*More Beautiful Everyday Things*) of 1919. Paulsson, an art historian and critic who was to become the Society's director in 1917, had lived in Berlin in 1912 and developed links with the *Deutscher Werkbund, which had been established in 1907 to forge close links between design and industry in Germany. Unlike many other European countries Sweden was not involved in the First World War and so relationships between design and industry continued to develop uninterrupted, driven on by the efforts of the Society's secretary Erik Wettergren. An important design landmark in this period was the 1917 *Hemutställningen* (*Home*) exhibition put on by the Society in the Liljevalchs Gallery in Stockholm. It consisted of 23 interiors that derived from a competition for the design of furnishings, fittings, and equipment of one- and two-bedroomed flats for working-class and middle-class consumers. Key figures emerged at this exhibition, including the craft-oriented furniture and textile designer Carl Malmsten and architect and furniture designer Gunnar Asplund, who exhibited a kitchen-living room. The latter, although it had a strong crafts influence in the simple forms of its furniture, was also symbolically attuned to the possibilities of economic, larger-scale production.

This more progressive functional aesthetic was to become an increasingly important aspect of the Society's propaganda and influence during the 1920s as seen in its collaboration with AB Svenska Möbelfabrikerna, one of the largest furniture manufac-

turers in Sweden. Swedish 'grace and elegance' in design was increasingly recognized in international circles, particularly in the Swedish showing at the 1925 *Paris Exposition des Arts Décoratifs et Industriels, but the Society's next major initiative was a significant involvement in the functionalist 1930 *Stockholm Exhibition. Inspired by the Deutscher Werkbund's 1927 Weissenhof housing exhibition in Stuttgart, the Stockholm exhibition was an unambiguous promotion of modern design and 20th-century living: advertising, transport and communications, and the urban environment were all central to the display. Housing, interiors, furnishings, and equipment design was on view alongside schools and hospitals. This Swedish commitment to *funkis* (functionalism) was too austere for large sectors of the public who did not warm to the abandonment of ornament and decoration as important features in design; nor did they warm to tubular steel furniture in place of the more familiar use of wood. Prominent among such critical voices (in many ways parallel to the situation at the Weissenhof Exhibition) was that of the generally conservative furniture industry, which warned that undecorated standardized forms would lead to job losses and that investment in innovation would lead to price increases. Nonetheless, the idea of a softer 'Swedish Modern' design remained a positive strand of 1930s design with positive showings at the 1937 *Paris Exposition and the 1939 *New York World's Fair. After the war the influence of the Svenska Slöjdföreningen was less marked, although Paulsson's ideas continued to be promoted by Ake Stavenow, Sven-Erik Skawonius, and Arthur Hald. Another Paulsson disciple, the Society's director Ake H. Huldt, was the manager for the *H55* exhibition held at Helsingborg where over a million visitors saw a large-

scale exhibition of modern housing and furniture.

Swedish Modern's blend of functionalism and humanism was particularly influential internationally in the fields of furniture, ceramics, glass, and metalware. However, during the 1960s the emphasis of the Society shifted away from the art industries towards environmental and other concerns that questioned the design status quo, resulting in a fall in membership. This was also affected by the establishment of a number of other professional associations such as the Föreningen Svenska Industridesigner (Society of Swedish Industrial Designers), founded in 1957 and the Föreningen Sveriges Konsthantsverkare och Industriformgivare (KIF—the Association of Swedish Art Craftsmen and Industrial Designers), founded in 1961. In 1964 the Svenska Slöjdföreningen established a Design Centre in Malmö, a permanent exhibition of contemporary domestic design and, in the 1970s, was renamed Föreningen Svensk Form (the Swedish Society of Crafts and Design). In the 1980s, it again sought to reassert itself through the opening of the Design Centre in Stockholm in 1985. Its mouthpiece for almost a century has been the design periodical *Form*, founded in 1905, with a remit that embraces the crafts and design. The society has offices in Stockholm with library and exhibition facilities.

Svenskt Tenn (established 1924) This celebrated Swedish design company and store was launched in Stockholm in 1924 by designer and entrepreneur Estrid *Ericson and pewter designer Nils Fougstedt and, through its long-standing success in the export market, did much to promote Scandinavian design abroad. In 1925 the company featured successfully at the 1925 *Paris Exposition des Arts Décoratifs et Industriels where Ericson was awarded a Gold Medal for her designs in pewter. This was followed up by further successes in the USA, beginning in 1927 with an exhibition of Swedish design at the Metropolitan Museum of Art, New York, that also toured to Chicago and Detroit. In the same year the New York Wanamaker department store began to sell Svenskt Tenn products. In 1930 Svenskt Tenn extended its interests to the manufacture of furniture and rugs by progressive designers such as Uno Åhren and, in the following year, the company's products were also represented at the critically acclaimed 1931 exhibition of Swedish Design at Dorland Hall, London. Josef *Frank, who was appointed as artistic director to Svenskt Tenn in 1933, was also instrumental in the dissemination of a distinctive modern aesthetic as his many designs for furniture, textiles, lighting, and other domestic products were marketed by the store. These were less stark in appearance than many of the rather austere *Modernist designs on show at the *Stockholm Exhibition of 1930. Further recognition of the company's designs was aided by its showings as part of the Swedish contributions to the *Paris Exposition des Arts et Techniques dans la Vie Moderne 1937, the *New York World's Fair of 1939–40, and the Golden Gate International Exposition in San Francisco of 1939. As well as its commitment to contemporary design, the company also looked to its roots in the *Arts and Crafts Movement by putting on an exhibition devoted to William *Morris in 1938. The working relationship between Ericson and Frank prospered until the latter's death in 1967. The company continued its success after the Second World War, receiving further recognition through exhibitions such as *Josef Frank: 20 Years at Svenskt Tenn* at the National Museum in Stockholm in 1952 and a memorial exhibition of Frank's work in the same venue in 1968.

SWEDISH MODERN

This term first became current in the 1930s when modern Swedish design was becoming increasingly well known in Europe and the United States. However, it was at its height in the 1950s and was characterized by many of the qualities of *Modernism blended with natural materials such as wood and a Scandinavian respect for craftsmanship. The 'beauty for all' philosophy that had provided the title of Ellen Key's book *Skönheit för Alla* of 1899 was the backbone of modern Swedish design, sustained by Gregor *Paulsson's in his 1919 publication *Vackrare Vardagsvara* (*More Beautiful Everyday Things*) and was promoted by the *Svenska Slöjdföreningen (Swedish Society of Industrial Design) for most of the 20th century. Like its counterpart in Denmark (*Danish Modern) attributes of the Swedish Modern style included the use of light-coloured woods, organic shapes, and colour schemes with a predominance of white offset by accents of colour in textiles, rugs, and ceramics. Closely associated with the promotion of the Swedish Modern were the products of Josef *Frank and *Svenskt Tenn seen at international exhibitions of the 1930s, most notably the *New York World's Fair of 1939–40.

Seven years later Ericson sold the business to the Kjell and Märta Beijer Foundation, though she continued to design energetically, also remaining as Svenskt Tenn's managing director until 1978. Since then Svenskt Tenn has continued to promote the best in contemporary design, showcasing the work of younger designers through exhibitions as well as marketing other lines in keeping with the *Swedish Modern aesthetic.

Swatch (established 1985) This internationally renowned company was named after amalgamation of the words 'Swiss' and 'watch'. It emerged from a severe crisis in the Swiss watchmaking industry in the 1970s brought about by the worldwide availability of cheap Japanese electronic watches. This rather depressing picture began to change in the wake of the launch of the *Delirium*, the world's thinnest electronic watch, in 1979 and the formation of SMH (Swiss Corporation for Microelectronic and Watchmaking Industries). Following the merger and reorganization of two watch companies in the early 1980s by Nicolas G. Hayek, a number of the strategies that he set in place led to the re-emergence of the Swiss watch industry as world leader by 1984. The Hayek Company had been founded in 1963 and developed a reputation for technological innovation, strategic planning, and a wide range of expertise in several other fields. Hayek was the co-founder of the Swatch Group, becoming its chief executive officer and chairman of the board of directors in 1986. In addition to Swatch itself, the brand names of the Swatch Group include Omega, Tissot, Pierre Balmain, Calvin Klein, Flik Flak, Rado, and Longines.

The first Swatch watch was high quality, attractively priced, and launched in 1983. It was also slim-line, plastic, precision engineered, and manufactured using highly innovative and automated technologies. Impossible to repair but cheap enough to replace without fuss, by the early 21st century it had achieved sales of 200 million, making it the best-selling watch ever. Each Swatch watch has the same mechanism

SWISS STYLE

Also known as the International Typographic Style, the Swiss Style was an extension of *Bauhaus principles developed mainly in Zurich and Basle in the period leading up to the Second World War. Key figures in the evolution of the Style included Ernst Keller, Theo Ballmer, Max *Bill, and Max Huber, all of whom were familiar with the avant-garde ideals of De *Stijl, *Constructivism, and the New Typography (*see* TSCHICHOLD, JAN) of the interwar years. The rational characteristics of the Style were its use of *sans serif typography (especially the Helvetica and Univers typefaces), text set in narrow columns with a rigid left-hand margin and unjustified right. This austere, geometrically conceived, and rational outlook was further defined by its use of photography rather than hand-drawn illustrations. Swiss neutrality during the war had allowed these design principles to develop uninterrupted and it became increasingly adopted in design-conscious circles internationally in the 1950s, 1960s, and 1970s. Its influence was widely disseminated through the Swiss-based journal *New Graphic Design* (1958–65), edited by Josef Müller-Brockmann, Hans Neuburg, Carlos Vivarelli, and Richarde Lohse, and its layout was consonant with the design principles that its contributors espoused, a visual embodiment of the corporate aesthetic of many multinationals in the United States. This came under attack from a new generation of typographers identified with New Wave Design (*see* NEW DESIGN) who sought to counter the rigidity of the Swiss Style with a more expressive, intuitive style linked to the tenets of *Postmodernism. These included Wolfgang Weingart in Basle, April Greimann in the United States, Neville *Brody in Britain, Studio Dumbar in Holland, and Javier *Mariscal in Spain.

rendering the product capable of differentiation through the design of its face and strap. From the late 1980s onwards the Swatch became a fashion accessory, the Swatch Design Lab in Milan producing more than 70 designs per year, often using celebrated designers such as Alessandro *Mendini and Matteo *Thun. Swatch has also diversified into other model ranges including the *Automatic* (the first wristwatch alarm), the *Beep* (the first wristwatch pager), the *Solar* (light powered), and the *Musicall* (musical alarm). Swatch was also the official timekeeper for the Sydney Olympic Games of 2000.

Furthermore, in addition to a number of honorary doctorates from leading European universities, in 1995 the German Chancellor Helmut Kohl appointed Hayek to his Council for Research, Technology, and Innovation, the only foreigner among seventeen members. Similarly, in the following year, the French government nominated him as president of the Groupe de Réflexion, an innovation council devoted to future French economic strategies.

Swedish Society of Industrial Design *See* SVENSKA SLÖJDFÖRENINGEN.

Swedish Modern *See* box on p. 410.

Swid Powell (established 1982) Well known for its promotion of fashionable ceramics, silverware, and glass by leading international, generally *Postmodernist, architect-designers the New York-based Swid Powell company was founded by Nan Swid and Addie Powell, both of whom had a

background in contemporary furniture. They had worked for *Knoll International, a firm well known for its production of *Modernist classics, Swid as a director of product development, Powell as vice-president of sales. Amongst the nine architects involved in preliminary discussions were former Modernist Philip *Johnson, Stanley *Tigerman, and Richard Meier, all of whom were enthusiastic about designing for a wider public than those able to commission buildings by fashionable designers. In 1984 the first Swid Powell collection of porcelain dinnerware, silverware, and glass was launched, proving highly commercial in design-conscious retail outlets. Those designing for Swid Powell included many of the celebrity 'names' associated with international design, such as Arata Isosaki, Ettore Sottsass, Zaha Hadid, George Sowden, Robert *Venturi, and Michael *Graves.

The diversity of references, historical and populist, found in Postmodernism is exemplified in work for Swid Powell. Richard Meier's decorative detailing drew on his familiarity with the early 20th-century work of the *Wiener Werkstätte and Charles Rennie *Mackintosh. Robert and Trix Haussman, on the other hand, referenced the ears of Walt Disney's Mickey Mouse in the grinding mechanisms of their Swid Powell pepper grinder. Michael Graves was also keen to explore colour symbolism in his work for the company. In his *Little Dripper* drip-filter coffee pot (1986), for example, the terracotta glazed base represented heat and the colour of coffee and the blue wavy lines signified water. The company continued to develop its fashionable profile in the late 20th century.

Swiss Style *See* box on p. 411.

S

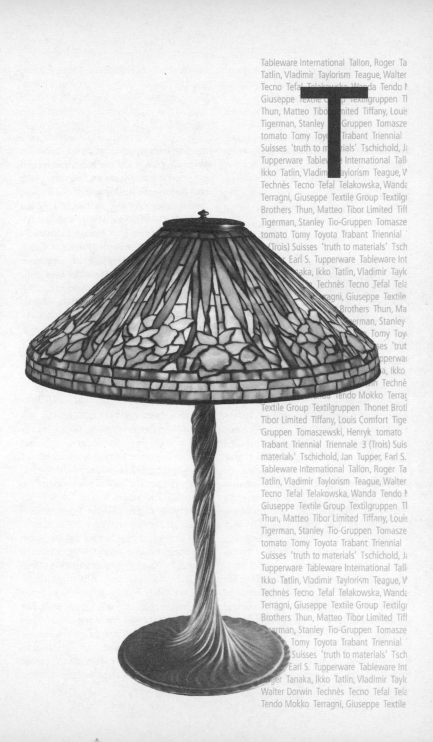

Tableware International Tallon, Roger Ta
Tatlin, Vladimir Taylorism Teague, Walter
Tecno Tefal Telakowska Wanda Tendo M
Giuseppe Textile Group Textilgruppen Th
Thun, Matteo Tibor Limited Tiffany, Louis
Tigerman, Stanley **T** Gruppen Tomasze
tomato Tomy Toyota Trabant Triennial
Suisses 'truth to materials' Tschichold, Ja
Tupperware Tableware International Tall
Ikko Tatlin, Vladimir Taylorism Teague, W
Technès Tecno Tefal Telakowska, Wanda
Terragni, Giuseppe Textile Group Textilgr
Brothers Thun, Matteo Tibor Limited Tiff
Tigerman, Stanley Tio-Gruppen Tomasze
tomato Tomy Toyota Trabant Triennial
(Trois) Suisses 'truth to materials' Tsch
Earl S. Tupperware Tableware Int
aka, Ikko Tatlin, Vladimir Tayl
Technès Tecno Tefal Tela
ragni, Giuseppe Textile
Brothers Thun, Ma
erman, Stanley
Tomy Toy
ses 'trut
pperwa
a, Ikko
Technè
Tendo Mokko Terrag
Textile Group Textilgruppen Thonet Broth
Tibor Limited Tiffany, Louis Comfort Tige
Gruppen Tomaszewski, Henryk tomato
Trabant Triennial Triennale 3 (Trois) Suis
materials' Tschichold, Jan Tupper, Earl S.
Tableware International Tallon, Roger Ta
Tatlin, Vladimir Taylorism Teague, Walter
Tecno Tefal Telakowska, Wanda Tendo M
Giuseppe Textile Group Textilgruppen Th
Thun, Matteo Tibor Limited Tiffany, Louis
Tigerman, Stanley Tio-Gruppen Tomasze
tomato Tomy Toyota Trabant Triennial
Suisses 'truth to materials' Tschichold, Ja
Tupperware Tableware International Tall
Ikko Tatlin, Vladimir Taylorism Teague, W
Technès Tecno Tefal Telakowska, Wanda
Terragni, Giuseppe Textile Group Textilgr
Brothers Thun, Matteo Tibor Limited Tiff
erman, Stanley Tio-Gruppen Tomasze
Tomy Toyota Trabant Triennial
Suisses 'truth to materials' Tsch
Earl S. Tupperware Tableware Int
ger Tanaka, Ikko Tatlin, Vladimir Taylc
Walter Dorwin Technès Tecno Tefal Tela
Tendo Mokko Terragni, Giuseppe Textile

Tableware International *See* POTTERY GAZETTE.

Tallon, Roger (1929–) Tallon was a leading figure in French industrial design in the second half of the 20th century. Having studied engineering in Paris he joined Studio Avas from 1951 to 1953 when he joined the Technes design consultancy, which had been established by Jacques *Vienot. From 1963 he taught at the École Nationale Supérieure des Arts Décoratifs in Paris, establishing the Department of Design with Jaques Dumond. The creative side of his thinking was underlined by close links with the fine arts, especially the Nouveaux Réalistes. He gained widespread recognition for his transportation design; in 1967 he began a long period of collaboration with French National Railways (SNCF), modernizing their trains. His most important outcomes in this sphere included his designs for the high-speed TVG trains. These culminated in his designs for carriage interiors, exteriors, and the visual identity for the whole TGV network. In the early 1990s he became the design director of the TGV *Eurostar* rail project which was financed by Britain, France, and Belgium. He founded the multidisciplinary consultancy Design Programmes in 1973, ten years later joining Pierre Paulin and Michel Schreiber's ADSA+Partners, followed in turn by involvement in Euro RSCG Design, established in 1994. Tallon has been a prolific designer across a wide range of products, from ski boots to cameras, from machine tools to furniture. His designs have included the *Taon* motorbike (1955),

the ergonomic Gallic machine lathe for Mondiale (1957), the sleek, black-screened *P111* portable television for Téléavia (1963), and *Zombie* café seating (1967). Tallon also received many awards, including a *Milan Triennale Gold Medal (1954) and the national Grand Prix for Création Industrielle (1985). He also represented French design at the inaugural exhibition of the *Centre de Création Industrielle entitled *Qu'est ce que le design?* Other prestigious exhibitions of his work included the *Roger Tallon, Designer Industriel* (*Industrial Designer*) show at the National Museum of Science and Technology, Ottawa (1984) and the retrospective *Roger Tallon: Itinéraires d'un designer industriel* organized by the CCI at the Pompidou Centre (*see* CENTRE GEORGES POMPIDOU) in 1993.

Tanaka, Ikko (1930–2002) A leading Japanese designer of posters, books, exhibitions, and corporate identity schemes Tanaka has often been considered one of the founding fathers of graphic design in Japan. His prolific output has included the *logotype and medals for the Tokyo Olympics (1964), displays for the Japanese Government Pavilion at Expo '70 in Osaka, corporate identity schemes for the Seibu department stores, Tokyo (1978), exhibition layouts for the *Japan Style* exhibition (1980) at the *Victoria and Albert Museum, London, and murals at the New International Airport at Narita (1992). Even late in his career he was producing a wide range of graphic material, including 38 posters for the New National Theatre in Tokyo since its opening in 1996. His work also included collaborations with many leading Japanese

fashion designers including Hanae Mori, Kenzo Takada, and Issey *Miyake.

After graduating from the City College of Fine Arts in Kyoto in 1950, Tanaka began his career as textile designer for a local firm, Kanebo Ltd. (1950–2). He then moved into graphic design, first for the Sankei Press (1952–7) and then the Nippon Design Centre in Tokyo (1960–3). He was founder and director of the Tanaka Design Atelier in Tokyo (1963–76) and of the Ikko Tanaka Design Studio from 1976. His career has been marked by an extensive series of art directorships for a wide variety of clients and projects ranging from environmental city planning to films and from exposition and event design to corporate histories. He has received many awards including the *Mainichi Design Award (1954, 1966, and 1973), the Tokyo Art Directors Club Medal (fourteen times between 1957 and 1985) and the Purple Ribbon Award from the Emperor of Japan (1995). He has been a member of the *Alliance Graphique Internationale, the Tokyo Art Directors Club, and the *Japan Graphic Designers Association.

Tatlin, Vladimir (1885–1953) A central figure in the development of Russian *Constructivism, artist, designer, and theorist Tatlin was born into a family with an engineer father and poet mother. He studied at the Moscow School of Painting, Sculpture, and Architecture from 1902 to 1903 before moving on to the School of Fine Arts at Penza from 1905 to 1910, when he returned to Moscow. Over succeeding years he became increasingly involved with the Russian artistic avant-garde and its growing interest in *Futurism and Cubism. He was acquainted with the latter at first hand in Paris in 1913 and soon began experimenting in three-dimensional abstract reliefs, some of which were shown in the Futurist Exhibition in Petrograd in 1915. In 1917 this interest in materials and form evolved further in a commission for the interior decoration of the Café Pittoresque, a bohemian avant-garde Moscow theatre-cabaret, on which he worked alongside *Rodchenko and Yakulov in the construction of a dynamic environment of abstract forms in wood, metal, and cardboard. A leading artistic figure in the post-Revolutionary period, he became involved in Soviet propaganda, a highly significant project being the gigantic *Monument to the Third International*, commissioned in 1919. It was intended to be a massively tall, dynamic spiral structure, built in glass and iron, with core elements revolving at different speeds (annually, monthly, and weekly). Each had distinct functions, such as conference halls, meeting rooms, and information centre that, combined with new forms, technologies, and materials, symbolized the utopian aspirations of the immediate post-Revolution years. Revolutionary messages were to be projected into the sky and the news and propaganda broadcast by radio and loudspeakers. Although the project never materialized beyond scale models, its use of industrial materials and contemporary technologies revealed the utilitarian ethos that increasingly characterized Tatlin's work. This was evidenced in his 1920 *Programme of the Productivist Group* and his 1920s designs for practical and ergonomically designed workers' clothing, ceramics, metalware, and furniture. He taught industrial design at the *Vkhutemas in Moscow from 1927 to 1931 but, following its liquidation in 1931, together with a marked change in the political and aesthetic climate, returned to practise in the fine arts.

Taylorism *See* box on p. 416.

Teague, Walter Dorwin (1883–1960) A leading luminary of the new breed of industrial designer that emerged in the United

TAYLORISM

Like *Fordism, Taylorism emerged as an important concept in the quest for industrial efficiency in the United States in the early 20th century and proved influential in the rest of the industrialized world in for the next 50 years. First applied as a means of achieving efficiency on the factory floor, it was devised by Frederick Winslow Taylor through his analysis of the organization and sequencing of work operations by means of a series of 'time and motion' studies. These ideas were laid out in his book *Principles of Scientific Management* of 1911 and have impacted on several aspects of design such as labour-saving kitchens and more ergonomic domestic appliances. These included the writings of fellow American Christine Frederick who published *Scientific Management in the Home* in 1915 and the analyses of domestic efficiency by Lillian *Gilbreth, who examined the notion of the kitchen as a site of industrial production for the Brooklyn Gas Company in 1930. Similar ideas were also explored in Frankfurt, Germany, by Grete *Schütte-Lihotsky in her 1924 designs for the Frankfurt kitchen which was utilized in mass housing.

States in the interwar years, Teague designed for many major American corporations during his long and distinguished career. From 1903 to 1907 he studied at the Art Students League in New York, specializing in typography and lithography. After a brief spell in a publicity agency, he went on to work from 1908 to 1911 in the art department of Calkins and Holden, a leading New York advertising agency, before setting up as a freelance typographic and advertising designer. By the mid-1920s he had expanded his services to include packaging and industrial design. However, it was not until after 1926 when he visited Europe and experienced at first hand the work of Le *Corbusier and other avant-garde designers that he began working in an unambiguously modern manner. One of Teague's most important commissions at this time was for the redesign of the *Box Brownie* for Eastman Kodak (1927), a company with which he enjoyed a good working relationship over many years. He also designed the plastic *Baby Brownie* (1933) and streamlined Kodak *Bantam* (1936) cameras. Teague's many clients included

Steuben Glass, for whom he designed glass tableware and decorative objects. Transport design was a particular strength of the Teague consultancy's output, with automobiles for Marmon, streamlined petrol stations for Texaco, coaches for the New Haven Railroad Company, and, from 1944 onwards, offices and airline interiors for the Boeing Company. These included the Boeing *707* and *747* jetliners. Teague also designed a number of displays for the Ford Motor Company including those at the *Chicago Century of Progress Exposition of 1933 and the *New York World's Fair (NYWF) of 1939–40. Indeed he played a seminal role at the NYWF, having chaired its Board of Design from 1936 in addition to designing the Ford Motor Company Pavilion, as well as work for several other leading corporations including Du Pont, Kodak Eastman, Consolidated Edison, and US Steel. His early thinking on design was contained in his book *Design This Day: The Technique of Order in the Machine Age* (1940). His position as a major figure in the industrial design profession was recognized in 1944, when he became the first president of the Society of

Industrial Designers (*see* INDUSTRIAL DE-
SIGNERS SOCIETY OF AMERICA). His reputa-
tion was also sufficient to be recognized in
Europe, being made an honorary *Royal
Designer for Industry in 1951, the year in
which the consultancy became known as
Walter Dorwin Teague Associates.

Technès (established 1949) *See* VIENOT,
JACQUES.

Tecno (established 1953) This innovative
Italian furniture firm, founded by Osvaldo
and Fulgenzio Borsani, had its origins in the
family furniture-making concern, the Atel-
ier di Varedo, established 26 years earlier.
Using Osvaldo's designs Tecno soon estab-
lished a reputation for innovative design,
particularly in the use of metal frames and
polyfoam upholstery. This was boosted by
participation in the *Milan Triennale of
1954 where visitors could see the flexible
D70 divan-bed. This was followed by the
highly versatile *P40* lounge chair, which
could be adjusted to a variety of seating
and reclining positions from chaise longue
to upright, which was seen at the 1957 Tri-
ennale. From the 1960s the company com-
missioned work from other designers and
groups including Carlo De Carli, whose
armchair was awarded the Gran Premio at
the 1960 Triennale, Gio *Ponti, and
Norman Foster Associates (the *Nomos* office
furniture range, 1986). In addition to indi-
vidually commissioned work the company
expanded its output to include large-scale
contract work.

Tefal (established 1956) This well-known
brand name evolved from the application of
a non-stick surface (PolyTetraFluorEthy-
lene, better known under its registered
name Teflon) to metal by Marc Grégoire, a
French engineer in 1954. The Tefal com-
pany was formed two years later and was
soon closely associated with the advertising
slogan 'La Poêle Tefal, la poêle qui n'attache

vraimant pas' ('The Tefal saucepan, the
saucepan pan that really doesn't stick'). A
1961 photo of American fashion icon Jackie
Kennedy with a Tefal pan in her hand
prompted a considerable boost to the com-
pany's sales, to such an extent that by 1968
Tefal had become the leading company for
French kitchen products and was bought by
SEB (Société d'Emboutissage de Bourgogne).
In 1974 the Tefal brand diversified its prod-
uct range, showing a sandwich toaster and
gas-lighter at the *Salon des Arts Ménagers
in Paris 1974. In 1982 it launched its *Sprin-
kettle* (an electric jug kettle) onto the English
market, weighing scales for both people
and kitchens in 1985, and a range of child
products (Tefal Baby Home) such as baby
intercom and weighing scales in the 1990s.
Tefal sought to innovate over the decades
and in 2000 introduced the Thermospot,
the first heat indicator built into the bottom
of a non-stick pan.

Telakowska, Wanda (1905–86) *See*
INSTYTUT WZORNICTWA PRZEMYSLOWEGO.

Tendo Mokko (established 1940) From its
beginnings as a woodworkers' cooperative
it began manufacturing munitions boxes
and, in conjunction with the *Industrial
Arts Institute (IAI), plywood decoy aircraft.
In 1947 it became involved with the manu-
facture of occupation housing and, from the
early 1950s, furniture for the domestic
market. Early examples of the moulded ply-
wood furniture on which it was to establish
its reputation were seen in the Takashi-
maya department store in Tokyo. Other ply-
wood furniture included seating by
architect Kenzo Tange for the Shizuoka Pre-
fectural Sports Arena, the *Butterfly* stool
(1956 by Sori *Yanagi), a moulded stool
(1960) by Reiko Tanabe, and a low-level
chair (1960) by Daisaku Choh that was
shown at the *Milan Triennale in the same
year. Although such Japanese designers

drew on forms drawn from indigenous sources, they were also aware of the forms of plywood experiments in the United States and Scandinavia but also drew on an awareness of the aesthetic elegance of contemporary Italian design. Many designers were also attracted to design for the company by its design competition, mounted between 1960 and 1967, and the payment of royalties. Tendo Mokko itself was awarded the prestigious *Mainichi Design Prize in 1964 for its contribution to Japanese furniture production in a period when the company enjoyed commissions for the furniture for many new buildings. Its manufacture of furniture by leading designers continued in succeeding decades, as with Arata Isozaki's black stained wood and polyurethane-upholstered *Marilyn* chair, first designed in 1972 and manufactured by the company from 1981. In keeping with the emerging ethos of *Postmodernism, Isozaki combined historical references to high backed chairs by Charles Rennie *Mackintosh with the glamorous curvilinear form of film star Marilyn Monroe. In the 1980s the company produced furniture for government offices, libraries, museums, and hotels but also attracted exciting new ideas from architects and designers entering the company's biennial competition.

Terragni, Giuseppe (1904–43) An architect and designer, Terragni studied at the Technical School in Como and Milan Polytechnic. In 1926 he was a founder member of the Milan-based Gruppo Sette (Group 7) which embraced the ideals of *Modernism. The Italian variant of this international movement was known as *Rationalism and put forward its aims in a series of articles published in *La rassegna italiana* between December 1927 and May 1927, the year in which Terragni opened his architectural practice. His work was shown at the *Deutscher Werkbund's landmark 1927 Weissenhof Siedlungen exhibition in Stuttgart and at the inaugural 1928 Rational Architecture exhibition in Rome. He is perhaps best known for buildings in Como such as the 'Novocomum' apartment block (1926–8), the Sant'Elia School, and the Casa del Fascio (House of Fascism, 1932–6). The modern exteriors were complemented by his designs for fittings and furniture, the latter often using tubular steel.

Textile Group (Textilgruppen, established 1973) About 40 designers and craftspeople founded this Swedish association in order to establish direct links with consumers through their showroom and shop in Stockholm. Each member was involved with the running and promotion of the shop and its products, having an opportunity to exhibit their work during the year. Slides of members' work were also available for viewing. Members paid an annual fee and a set commission on work sold that was reinvested in the business. Many contacts were made with manufacturers and interior designers and their work has been exhibited throughout Scandinavia, Europe, and the United States.

Textilgruppen *See* TEXTILE GROUP.

Thonet Brothers (established 1843) The roots of this celebrated furniture manufacturing company lay in Michael Thonet's (1796–1881) cabinetmaking business established in 1819 in Boppard am Rhein. From about 1830 he began experimenting with the possibilities of harnessing the steaming processes used in boat building for the fabrication of bentwood furniture, moving to Vienna in 1842 where he was granted a patent for his ideas. In 1849 he established a factory that expanded rapidly over the following years with the mass production of bentwood furniture and, in 1853, he

made his three sons partners in the firm. 1851 was an important year for Thonet. Not only did he gain a significant order for the celebrated Daum Café, for which he designed the *No. 4* chair, but he also exhibited at the *Great Exhibition of 1851 in London where he was awarded a bronze medal. In 1858 Thonet produced the classic, round-seated *No. 14* chair that went on to achieve sales figures of several million by the early 20th century. The *No. 14* was also the precursor of *flatpack furniture in the post-Second World War period, being composed of six basic components that could be transported economically from factory to retail outlet and then assembled straightforwardly and with a minimum of skill. Thonet furniture gained further recognition through its adoption as clean, undecorated, efficient pieces of design by *Modernist designers such as Le *Corbusier, who showed examples (*No. 9* and *No. 209* chairs) in his Pavillon de L'Esprit Nouveau at the *Paris Exposition des Arts Décoratifs et Industriels. By the early 20th century the company had established a number of factories and among its more celebrated designers were the Austrians Adolf *Loos, Josef *Hoffmann, and Otto *Wagner. In the 1920s the company had also begun to manufacture furniture in tubular steel in Germany and Austria, working with designers such as Marcel *Breuer, Le Corbusier, Ludwig *Mies Van Der Rohe, Charlotte *Perriand, and Mart Stam. In 1935 the company moved its entire tubular steel furniture manufacture to Frankenberg. Thonet also opened a showroom in London in 1929 and, after a slightly hesitant start, Thonet furniture took on a fashionable edge and could be found in such venues as Oliver *Bernard's Strand Palace Hotel, London, in 1930, and the restaurant of the Capitol Cinema, Epsom (1930). After the Second World War Thonet

rebuilt its manufacturing plants, continuing to commission designs from significant designers and receiving recognition for its significance as an important dimension of the Modernist outlook through the mounting of a Thonet exhibition by the *Museum of Modern Art, New York, in 1953. Notable designs have included the plywood, cantilevered *S-Chair* (1968) by Verner *Panton, the wood and cane *737 Chair* (1993), and the *S900 Chair* by Norman Foster (1999).

Thun, Matteo (1952–) Thun emerged as a leading Italian industrial designer in the last two decades of the 20th century, working as a consultant to several larger multinationals eager to explore the developing markets of younger 'lifestyle' oriented consumers interested in *Postmodern products. These have included *Arzberg, Flos, Fiorrucci, *Rosenthal, *Swatch, *Villeroy & Boch, and *WMF (Württembergische Metallwarenfabrik). Following his graduation in architecture in Florence in 1975, Thun became intimately involved with the course of Italian avant-garde design, particularly through his involvement with the *Memphis group and *Sottsass Associates from 1981 to 1984, the year in which he opened his own design studio in Milan. His many designs have included *Le Petit Café* service for Arzberg (1987), *Pao* floor and table lamps for Arteluce (1993), and bicycles for Gruppo, a leading Italian specialist manufacturer in the field. He also designed the *Tavola* tableware range of 1987 and *Punk-oriented *Hommage à Madonna* cutlery of 1985–6 for WMF, a leading German cutlery and domestic hardware manufacturer.

Tibor Limited *See* REICH, TIBOR.

Tiffany, Louis Comfort (1848–1943) American decorative artist and designer

Tiffany was widely known for his colourful *Art Nouveau glassware which proved both influential and fashionable on both sides of the Atlantic. He worked in a wide range of fields including textiles, wallpaper, ceramics, jewellery, interiors, and lighting. Tiffany was born into an artistic background, the son of Charles Tiffany, founder of Tiffany Jewelry and Silversmiths in New York. He was strongly influenced by the writings of John *Ruskin and William *Morris and visited Europe for the first time in 1865. He studied painting in both the United States and France, later founding the Society of American Artists with John La Farge, a painter and designer of stained glass, in 1877. From this period Tiffany took an increasing interest in the decorative arts, establishing his own successful interior decorating company, Louis C. Tiffany & Associated Artists, in 1878. The company was awarded a number of highly prestigious commissions, including a number of rooms at the presidential White House in Washington, DC, in 1882 to 1883. Tiffany also established a reputation for the design of textiles, wallpapers, and other surface patterns and developed expertise in decorative glass. In 1885 he founded the Tiffany Glass Company at Corona, Long Island, where he gained a reputation for the brightly coloured, delicate, and decorative *Favrile* glass for which his firm became widely celebrated, especially its lampshades, which often embraced the naturalistically derived sources of Art Nouveau. Tiffany visited the 1889 Paris International Exhibition, where he met the celebrated entrepreneur and promoter of Art Nouveau, Samuel *Bing, later to become his exclusive European distributor and promoter. He also exhibited successfully at the *Chicago World's Columbian Exhibition of 1893. Tiffany was awarded a Grand Prix at the *Paris Exposition Universelle 1900 and at the Turin International Exhibition of Modern Decorative Art of 1902, the year in which he became artistic director of the family firm.

Tigerman, Stanley (1930–) One of a generation of influential American architects in the second half of the 20th century who explored the expressive possibilities of bright colours, pattern, and symbolism as key features of the design process, Tigerman also played an important role in architectural education, having held visiting architectural professorial chairs at a number of leading university architectural schools including Yale and Harvard. In common with many of his contemporaries he worked for a number of manufacturers of fashionable domestic products such as *Alessi and *Swid Powell. He studied at the Massachusetts Institute of Technology (MIT) from 1948 to 1949, and the Institute of Design at Chicago from 1949 to 1950, completing his architectural studies at Master's level at Yale University in 1961. After working as an architectural draughtsman he was a designer for a number of practices including Skidmore, Owings & Merrill (1957–9) before establishing Stanley Tigerman & Associates in 1964. Amongst his well-known buildings are the Illinois Regional Library for the Blind and Physically Handicapped in Chicago (1982), the Momochi Residential Complex in Fukuoka, Japan (1991) and the *Herman Miller Complex in Sacramento, California (1991). Tigerman also worked in several fields of design including ceramics, furniture, and metalware. An important association was with the New York-based Swid Powell company, which began to explore the possibilities of bringing together leading progressive architects to design porcelain, silverware, and glass products for the aesthetically conscious affluent urban home. Tigerman

contributed to the first range of Swid Powell products in 1984 and with Margaret Mc-Curry (of Tigerman McCurry Architects) also designed porcelain teasets for the company, including the *Teaside* seven-piece crockery set (1985), which drew on the vernacular agricultural architecture of the Midwest for its inspiration (in some ways paralleling ideas explored by Robert *Venturi in his Italianate *Village* teaset for Swid Powell of 1984), and the decorative *Sunshine* and historically informed *Pompeii* plates of 1985 and 1986. He also explored the decorative potential of *ColorCore, a new material in a wide range of colours developed by *Formica International Limited in the 1980s. Alongside other celebrated architect designers such as Frank *Gehry and Venturi he participated in the celebrated ColorCore *Surface and Ornament* design competition (1983) and its follow-up, *Material Evidence*, the latter opening in the Renwick Gallery, Washington, before touring the United States. Exemplifying Tigerman's design outlook was his *Tête-à-tête* double easy chair (1985) in ColorCore. Decoratively striped in the fashion of deckchairs, this easy chair also explored the expressive potential of sculptural form and the ability of the new material to support a dramatic cantilever. Tigerman's commissions to design for the Italian housewares manufacturer Alessi included his contribution to the company's *Tea and Coffee Piazza* series of 1983. His five-piece silver tea and coffee set reflected the eclecticism of *Postmodernism with *trompe-l'œil* fingers serving as tray handles. In 1994 Tigerman co-founded Archeworks, a socially oriented design research institute and school of which he was director. Throughout his career he has enjoyed considerable peer recognition, representing the United States at the Venice Biennali of 1976 and 1980, and receiving numerous awards from national institutions and

organizations, including five National Honor Awards from the (AIA) American Institute of Architects, a body of which he was a Fellow. His work has also been comprehensively represented in a number of exhibitions including the Art Institute of Chicago show entitled *Stanley Tigerman: Recent Works* (1990). In addition to the important role that Tigerman has played in American architectural education, he has also curated a number of exhibitions and written several architectural books—historical and contemporary, theoretical and relating to his own practice.

Tio-Gruppen (Group of Ten, established 1970) Reflecting a resurgence of interest in the handicrafts, the TIO-Gruppen collective was formed by Gunila Axén, Britt-Marie Christofferson, Carl Johan De Geer, Susanne Grundell, Lotta Hagerman, Birgitta Hahn, Ingela Hakansson, Tom Hedqvist, Tage Muler, and Inez Svensson. Mainly from backgrounds in the textile industry, its members sought greater freedom of opportunity to promote their own creative ideas. They opened a permanent showroom/shop in Stockholm and have also exhibited printed textiles in Paris, New York, and elsewhere, as well as winning a number of state commissions for the decoration of Swedish government agencies. Their work is often characterized by large-scale, brightly coloured patterns.

Tomaszewski, Henryk (1914–) A leading Polish poster designer whose work did much to provide a sense of cultural identity in Poland in the decades following the end of the Second World War, Tomaszewski was the major driving force behind the international recognition of Polish poster art to which he contributed with his characteristically simple, witty, and distinctive style. He studied at Warsaw Academy of Fine Arts from 1934 to 1939,

becoming a freelance graphic designer in the years immediately following the end of the Second World War. He then became the head of poster design at Warsaw Academy of Fine Art in 1951, a professor of graphic design from 1955, his work in posters, book illustration, and stage design proving highly influential. He was a prizewinner at the São Paolo Poster Biennale in 1963 and a frequent winner at the Warsaw Poster Biennale, established in 1964. He was a member of AGI (*Alliance Graphique Internationale) and elected as an Honorary *Royal Designer for Industry in 1975.

tomato (established 1991) This design group was founded in 1991 by Steve Baker, Dirk van Dooren, Karl Hyde, Rick Smith, Simon Taylor, John Warwicker, and Graham Wood. Tomato sees itself more as a media and arts collective rather than a design consultancy per se, often working on commercial projects in order to fund personal initiatives. Working in a wide range of media including graphic design, film-making, and music has built up an international reputation for creative excellence. Its corporate clients have included *Nike, *Coca-Cola, *Levi's, Microsoft, and Kodak. It has also acted as a consultant to the British government initiatives relating to the 'creative industries' in the later 1990s, extending its work in the cultural sector to design a multimedia identity for the Moderna Museet, Stockholm. As with many other design groups it has published its own history and discourse in the self-authored book, *process: a tomato project* (1996), which sold widely around the world. This was further consolidated in the very popular exhibition mounted at the Neue Sammlung Museum in Munich in the following year entitled *process: a tomato project, munich*. In 1998 *tomato interactive* was founded, followed by the establishment of *tomato new york* in October 2000.

Tomy (established 1924) Eiichiro Tomiyama founded this leading metal toy company in Tokyo in 1924. However, it was not until after the Second World War that the company began to be recognized outside Japan when, in the early 1950s, it was involved with both the manufacture and export of large metal toys. In 1963 the company's manufacturing wing became the Tomy Kyogo Company and its sales wing the Tomy Company, with a global network being established in the following decade. In 1980 a research laboratory was opened for the design of toys for children with physical disabilities and visual impairments. The company currently has subsidiaries in the United Kingdom, the United States, Hong Kong, and Thailand.

Toyota (established 1933) Kichiro Toyoda, mechanical engineering graduate of Tokyo Imperial University, founded this leading Japanese automobile manufacturing company in Nagoya in 1933 within the Toyoda Loom Works Ltd. Like Masujiro Hahimoto at *Nissan, he was a key figure in the development of the Japanese automobile industry. After the production of the *Model A1* prototype, the *G1* truck, and the *Model AA* saloon the enterprise was formally incorporated in 1937 as the Toyota Motor Company. The Automobile Manufacturing Industry Law had been passed in the previous year, forcing both *General Motors and *Ford, which had commenced large-scale automobile production of *Model T*s and Chevrolets in Yokohama and Osaka in 1925 and 1927 respectively, out of the Japanese market place. This paved the way for both Toyota and Nissan to embark upon full-scale automobile production. The 1936 *AA* saloon was Toyota's first passenger car. Marketed as a 'streamlined car', it bore a

striking resemblance to the 1934 Chrysler *Airflow*, a model admired by Kichiro Toyoda. However, the *AAs* were mainly used as taxis and government vehicles. The Second World War disrupted automobile production, which was not resumed until 1947, when a limited number of units was allowed. Toyota produced its small *Model SA* passenger saloon in 1947, nicknamed 'Toyopet' by the public. However, in 1955 the company began manufacturer of the Toyopet *Crown Model R8* in 1955, the first entirely Japanese-made passenger car for family use. Both durable and comfortable, the *Crown* boosted the morale of the Japanese automobile industry, coinciding with the launch of operations at the company's Motomachi factory, Japan's first large-scale passenger car production plant. However, although it helped establish a domestic appetite for Japanese cars it was still also comparatively expensive (several times the average salary) and its performance was not on a par with international standards. It was exported to the United States in 1957. The Toyopet *Crown De Luxe Type RS31* was launched in 1960 and was also exported to the USA. In the following year the company launched the *Publica* (now *Corolla*) range of cars, available through *Publica* dealerships. Three years later the Toyopet *Corona RT40* was launched and was successful in both domestic and foreign markets, reaching international standards of comfort and performance. The Toyota *Corolla* launched in 1966, the same years as the Datsun *Sunny*, was the company's most successful model and did much to make motoring an aspect of everyday Japanese life. Within four years more than a million *Corollas* had been sold. The 1960s saw an international expansion of the company, with the establishment of manufacturing plants in Asia, South Africa, and Portugal, an outlook that gathered momentum in the following decades. Toyota also established a series of Research and Development Centres around the world, placing it advantageously to trade in the major market places of Europe, North America, and Japan. These included the company's Tokyo Design Centre (1990) and Tokyo Design Research Lab (1996). In 1988 the company established its luxury Lexus mark followed, in 1989, by a new brand mark for Toyota. The latter consisted of three ellipses, two of them crossing in the centre to represent the letter 't' with the third ellipse representing 'the spirit of understanding in design'. Having established its Toyota Hybrid System for powering vehicles in 1997 the company was committed to the development and marketing of hybrid-powered cars such as the *Coaster* hybrid electric vehicle (1997) and the Toyota *Prius* (1997). The latter was selected as the 2004 'North American Car of the Year' and *Motor Trend*'s 'Car of the Year' on account of its exceptional value and superiority in its class. In October 1999 Toyota manufactured its 100 millionth vehicle in Japan and, in June 2002, its 10 millionth vehicle produced in North America. By the early 21st century Toyota was the third largest automobile manufacturer in the world, and the largest in Japan, producing 5.5 million cars a year.

Trabant (first manufactured 1955) The box-like *Trabant* car was a potent symbol of East German values in the years immediately following the fall of the Berlin Wall in 1989 and was celebrated on the record (rather than CD) cover of *Achtung Baby* by the Irish pop band U2. After the end of the Second World War when Germany was divided, many existing factories were taken over by the Soviets. Amongst them was the Hoch Factory in Zwickau, a manufacturer of luxury cars. However, the first

two models were mass produced under the IFA brand—the *F8* and the *F9*, two-stroke cars based on pre-war DKW (Das Kleine Wunder—The Small Wonder) projects. The factory's former luxury car expertise was not entirely discarded, as there was also limited production of the Sachsenring *P-240* and a car for presidential parades, the Repraesentant *P-240*. The *F8* was a classic East German family car, with the *F9* an updated version. In 1953 the latter was transferred from Zwickau to Eisenach where Wartburg cars were later produced. Not long after this the Swickau brand name was changed to AWZ and the AWZ *P70* launched in 1955. This established what were to become the hallmarks of the Trabant: a *fibreglass body and a two-cylinder, two-stroke engine. First seen at the Leipzig Fair in 1955 it provided cheap, basic family transport powered by a small engine and was in production until 1959, reaching sales of around 30,000. The *P50* was initiated in 1957, building on the AWZ *P70* idea, and was the first car to carry the Trabant name. The meaning of the word 'Trabant' included notions of 'servant' or 'comrade', ideas which were literally realized in the archetypal *P601* launched in 1964. The latter was the model that became famous, remaining in production for almost 30 years with comparatively few modifications. Its fibreglass bodywork had a simple box-like appearance, a visual metaphor for the basic technology that underpinned it. More powerful than its *P50* predecessor it was available in saloon and cabriolet versions as well as a *Kombi* station wagon. A jeep-like model, the *Kubelwagon*, was developed for the army and another version, the *Tramp*, for civilian use. As was the case in other industrial contexts in the Eastern bloc, designers at the AWZ factory had many ideas for other models that were never realized for economic reasons. These included a prototype for an updated 'people's car', the Trabant *603* with a Wankel engine; further unrealized attempts to update the Trabant took place in 1979 and 1982 with the *P610* powered by an 1100 cc engine. However, following the fall of the Berlin Wall the place of the previously ubiquitous yet basic Trabant, a powerful icon of the former East Germany, was challenged by the widespread availability and attraction of cheap, but style-conscious and symbolically 'democratic', second-hand Western alternatives such as the *Volkswagen *Golf*. The competitive nature of the market place rang the death knell for the Trabant, leading to the closure of the Swickau factory for car production.

Triennial *See* ZAGREB TRIENNIAL.

Triennale *See* MILAN TRIENNALI.

3 (Trois) Suisses (established 1932) Xavier Toulemende founded this French mail order company in 1932 and it rapidly expanded in the years leading up to the outbreak of the Second World War. Equally remarkable was the dramatic increase in the circulation of its catalogue, the first of which was launched in 1949. By the mid-1990s more than 6 million copies were issued. From the late 1970s onwards well-known contemporary designers such as Agnès B, Guy Paulin, and Issey *Miyake were commissioned to work on the company's lines. Furniture and product design by eminent designers such as Gae *Aulenti and Philippe *Starck featured in 3 Suisses catalogues from the mid-1980s onwards.

'Trutle to Materials' *See* box on p. 425.

Tschichold, Jan (1902–74) German-born Tschichold was a leading designer of books and typography as well as the author of such internationally influential *Modernist texts such as *Die neue Typographie* (*The*

'TRUTH TO MATERIALS'

This phrase was closely associated with the *Arts and Crafts Movement, reflecting the concern of Pugin, William *Morris, and others to reject the historical virtuosity and elaborate, showy ornamentation of much Victorian design and architecture. Such decorative devices were admired for their own sake and often disguised the natural properties of the materials from which they were made. Arts and crafts practitioners advocated honesty of construction and truth to materials, an outlook that was later to become important to many progressive designers in the early 20th century, including many of those associated with the *Deutscher Werkbund and *Modern Movement in the 1920s and 1930s.

New Typography) of 1928 and Typographische Gestaltung (Typographic Design) of 1935. He was trained at the Academy of Graphic Arts and Book Design in Leipzig from 1919 to 1922 before working as a freelance designer. Influenced by the principles of Russian *Constructivism and the designs of El *Lissitsky he also attended the *Bauhaus exhibition at Weimar in 1923 where he encountered other progressive ideas. He was appointed to the staff of the Meisterschule für Deutschlands Buchdrucker (Master School for German Printers) in Munich in 1925. The outlook embraced by his Die neue Typographie, with its emphasis on sans serif typefaces and an aesthetic that embraced 20th-century technologies, proved influential but politically difficult in the increasingly turbulent climate of the early 1930s. This led to his arrest by the Nazis in March 1933, following which he was able to flee to Basle, Switzerland, to pursue a career in book design. His major text, Typographische Gestaltung, was published in 1935, the year in which he had an exhibition of his work at the publishers Lund Humphries. In this period he revised his earlier enthusiasm for the new typography, associating its starkness with the totalitarian outlook of the Nazis. After the Second World War he was commissioned by Allen Lane to redesign all Penguin Books and worked in London from 1946 to 1949, establishing a distinctive house style and an output that involved over 500 titles that utilized a number of sans serif typefaces and symmetrical layouts. He returned to Switzerland in 1949 and was involved in practice, education, and writing. He began designing type in the 1920s, early designs including Transits (1930) and Saskia (1932), with his most celebrated design Sabon (1964–6) coming late in a distinguished career. Tschichold's international recognition was considerable: he was awarded the Gold Medal of the American Institute of Graphic Arts (AIGA, established 1914) in 1954, and the Gutenberg Prize in East Germany in 1965, the same year in which he was elected as an Honorary *Royal Designer for Industry in London.

Tupper, Earl S. (1907–83) See TUPPER-WARE.

Tupperware (1946–) Tupperware food containers have become almost synonymous with everyday life in the kitchens of the Western industrialized world, their sales methods inspiring the proliferation of suburban parties for a wide range of products from cosmetics and jewellery to underwear and erotica. Tupperware was the brainchild of Earl S. Tupper, a chemist at Du Pont company in Massachussets in the United States who, in 1942, proposed to the company

management his ideas for the production of polyethylene (*see* POLYTHENE) household containers. In 1945 he founded Tupper Plastics and, in the following year, launched the Tupperware range of soft plastic, airtight food containers that prolonged the life of their contents. Colourful and inexpensive they were soon widely purchased in the United States and used for the storage of foods and liquids, both in the home and for leisure activities such as picnics and barbecues. Tupperware has also been widely associated with Tupperware parties, a sales concept that was introduced by the company in 1951 on the advice of Brownie Wise, a sales representative. The products were no longer available in retail outlets and travelling saleswomen organized parties in people's homes, generating tremendous sales to consumers who were able to familiarize themselves with the products and be instructed on their uses in the comfort of a domestic setting. Such an approach proved highly successful and was also practised in Britain where Tupperware was first distributed in 1960, although Tupper had himself sold his company in 1958 for $9 million.

Uchida, Shigeru Ulm, Hochschule für Ges
Umeda, Masanori Union Centrale des Ar
Union des Artistes Modernes Unit One U
Utility Design Uchida, Shig Ulm, Hoch
Gestaltung meda, Masa Union Cer
Décoratifs on des Artis Modernes
Josef Utili esign Uchid higeru Uln
Gestaltung meda, Masa Union Cer
Décoratifs des Ar Modernes
Urban, Josef Uchida, Shig
Hochschule für Gestaltung Umeda, Masa
Centrale des Arts Décoratifs Union des A
Unit One Urban, Josef Utility Design Uc
Ulm, Hochschule für Gestaltung Umeda,
Union Centrale des Arts Décoratifs Union

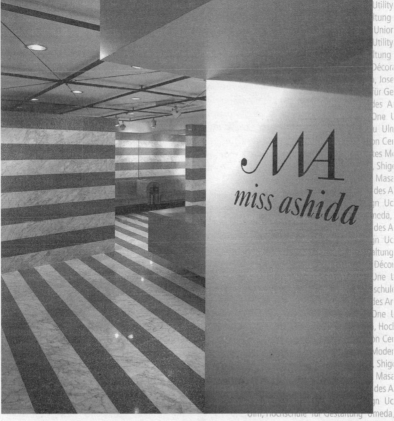

Utility
ltung
Union
Utility
ltung
Décor
, Jose
für Ge
des A
One l
u Uln
on Cer
tes M
Shig
Masa
des A
n Uc
neda,
des A
n Uc
altung
Déco
One l
schul
des Ar
One l
, Hoc
on Cer
Moder
Shig
Masa
des A
n Uc

Uchida, Shigeru (1943–) A noted Japanese interior, lighting, and furniture designer, Uchida worked for a number of significant clients including *Alessi, Acerbis, and the fashion designers Issey Miyake and Yohji Yamamoto. After graduating from the Kuwasawa Design School in Tokyo, he set up his own design practice in 1970. He attracted attention through his interior designs for the retail outlets of Miyake (1976–82) and Yamamoto (1983–6), changing the name of his practice to Studio 80 in 1981. He has won many important commissions including the interior of the Japanese Government Pavilion at Expo '85 at Tskuba. He has taught in many institutions including Tokyo University of Art and Design (1974–8), Parsons School of Design, New York (1986), and *Domus Academy (1992). In 1987 he was awarded the *Mainichi Design Prize.

Ulm, Hochschule für Gestaltung (HfG, 1951–68) This innovative West German academy was closely associated with a more scientific, rational, and efficient approach to design after the Second World War. It moved decisively away from the customary reliance on established notions of the supremacy of the creative individual designer towards an approach to design that was concerned with problem solving and the utilization of multidisciplinary expertise. The HfG at Ulm exerted a considerable international impact on design education and practice.

In the new era of democracy and reconstruction in post-war West Germany, Inge Scholl, whose brother and sister had been executed by the Nazis in 1943, sought to resurrect the idea of an international school of design. This vision had been inspired by the *Bauhaus, founded by Walter *Gropius in Weimar Germany in 1919, an institution that had been closed on ideological grounds by the repressive Nazi regime in 1933. Somewhat ironically, almost 40 years later, the HfG at Ulm was also brought to a premature end on account of political pressures and problems of funding.

Funding for the new academy of design at Ulm derived from a foundation established by Scholl in 1950, together with financial support from the US government, German federal and regional government, and the business sector. It formally commenced in 1953 under the leadership of the architect and designer Max *Bill and lived up to its initial conception as a new Bauhaus through the employment of former Bauhaus teachers as visiting tutors. These included Josef *Albers, Johannes *Itten, and *Mies Van Der Rohe. Bill was commissioned to design new buildings for the school that were officially opened in 1955. However, within a short period, younger members of staff at Ulm increasingly questioned the relevance of a curriculum closely linked to what they saw as outmoded ideas of creativity represented by the established Bauhaus approach. They felt that the real needs of contemporary designers were to be answered by a more systematic, scientific, and theoretically grounded approach to design, rather than being dependent on a continued emphasis on studio and workshop centred work. The study of sociology, anthropology, and cultural history, to-

gether with a grounding in mathematical, statistical, and analytical methods, were increasingly seen as significant elements of the curriculum. Bill resigned as rector in 1956 and from the school in 1957, prompted by the increasing influence of the Argentinian Tomás *Maldonado, who had been appointed by him in 1954. Following Bill's resignation the school was then managed by a rectoral board until 1962, when Otl *Aicher was given sole charge. During these years Maldonado was a mainspring in theoretical debates and later became rector himself from 1964 to 1966. Another key figure in promoting an intrinsically methodological approach to design was Giu *Bonsiepe, an Ulm graduate in 1959 and then teacher from 1960 to 1968. An important vehicle for transmitting the ideology of the HfG to a wider international audience was its periodical, *Ulm*, published between 1958 and 1959 and from 1962 to 1968. The institution also influenced design approaches elsewhere through visiting academics such as L. Bruce *Archer, an important figure in the *Design Methods movement and Research Fellow at the *Royal College of Art, who wrote *Systematic Method for Designers* in 1965. There were also links with the industrial sector, notably *Braun, the West German electrical appliances firm, for which the HfG's head of industrial design, Hans *Gugelot, designed a number of products. Other notable design projects executed by members of the school included the corporate identity scheme for Lufthansa, the West German national airline, overseen by Otl Aicher and Hans Roericht in 1962–3. However, the institution underwent a series of crises in the 1960s that emanated from its radical design agenda, the politics of the German educational system, and a funding crisis. Faced with a difficult and unwelcome ultimatum by regional government, staff

and students decided to close the HfG in 1968.

Umeda, Masanori (1941–) Although he trained in Japan, graduating from the Kuwasama Design School in Tokyo in 1962, Umeda established a reputation in the West, particularly through his contributions to the Milan-based avant-garde design group *Memphis in the 1980s. He had begun his career in Italy in 1967 when he worked in Achille *Castiglione's architecture and design studio for two years. In 1970 he became a consultant designer for the Italian office equipment manufacturer *Olivetti, working on products, furniture, and interiors. In 1981 he (like his compatriots Shiro *Kuramata and Arata Isozaki) began contributing to *Memphis. His designs included the *Ginza Robot* cabinet (1982), combining references to the fashionable shopping district in central Tokyo with a widely recognizable feature of Japanese popular culture, a creative juxtaposition of contrasting elements that characterized much of the Memphis output. He also designed for the idiosyncratic and imaginative Italian furniture manufacturer Edra Mazzei (established 1987), including the *Rose* (1990) and *Getsuen* (1990) chairs. He also worked in Japan, opening a Tokyo office, U-Metadesign, in 1986 and worked on industrial and environmental projects.

Union Centrale des Arts Décoratifs (UCAD, established 1882) UCAD was founded in 1882 from the amalgamation of the Societé du Musée des Arts Décoratifs and the Union Centrale des Beaux-Arts Appliqués à l'Industrie with the aim of promoting 'in France an artistic culture that seeeks to marry beauty and utility'. A non-profit organization, the impetus for its establishment came from the desire of manufacturers to forge closer links between art, industry, and culture. UCAD's initial aims,

many of which have remained throughout its existence, were to develop collections of art and design, to undertake cultural initiatives, and to provide training in art and design. However, for much of its existence the organization attracted criticism for its frequent perceived inability to live up to one of its stated ambitions—to improve standards design for the majority as well as the better off. In its early years it organized exhibitions including *L'Art de la femme* of 1892 that focused on textiles and other fields of design and the decorative arts with which women were generally associated, acknowledging women's importance in matters of taste, especially with regard to the home. In 1899 UCAD organized a competition to stimulate originality and aesthetic quality in the decorative arts. Designs for furniture, interiors, everyday objects, clothing, and jewellery were solicited for inclusion in the large-scale *Paris Exposition Universelle of 1900. UCAD's Pavilion at the 1900 exhibition revealed something of its aesthetic predilections through its contents that included the work of leading French ateliers and designers such as Hector *Guimard, Louis Majorelle, and Émile *Gallé. Similar tendencies were also seen in UCAD's Pavillion at the St Louis International Exhibition in the United States. A significant step forward was made by the organization with the opening of its museum in 1905 with many galleries, a large library and document collection, and dedicated exhibition space. It was located in the Rohan wing of the Louvre in Paris, subsequently moving to the Rue de Rivoli. In the period immediately preceding the outbreak of the First World War common with other design organizations in Europe at the time, UCAD committed itself to campaigning for well-designed, affordable practical products and stimulating the national economy through the mass

production of truly modern design. However, despite hosting exhibitions such as the first exhibition by the UAM (*Union des Artistes Modernes) in 1930, *L'Art moderne cadre de la vie contemporaine*, its outlook moved towards one that was less progressive and often historicising. After the Second World War it mounted a number of exhibitions such as French fashion (1945), *La Siège français du Moyen Âge à nos jours* (1947), and *Les Ateliers du goût* (1948) on the theme of art education. However, a change of direction was discernible with the appointment of François Mathey, later chief curator from 1966 to 1985. Not only was the work of individual major artists and designers displayed but also of more contemporary themes such as *Formes scandinaves* (1958) and *Formes industrielles* (1964), one of the first dedicated to the industrial design in France. This growing emphasis on contemporary issues, largely articulated through Mathey's energies, led to the establishment of the *Centre de Création Industrielle (CCI) in 1969. In 1978 UCAD established the Musée de l'Affiche, later reconstituted as the Musée du Publicitée that opened in 1999 with collections covering all aspects of the field, ranging from posters and press advertising through to film, television, and radio commercials. Also under the UCAD umbrella is the Musée de la Mode et du Textile, and the schools of the Centre des Arts, du Livre, et de l'Encadrement.

Union des Artistes Modernes (UAM, 1929–58) The UAM was founded in May 1929 by an influential group of committed *Modernist designers who had become disillusioned with the conservatism of the *Société des Artistes Décorateurs (SAD), from whom they split. SAD was largely geared to the expensive tastes of an affluent urban cultural elite, an outlook evident in the majority of lavish decorative displays seen at the

UNIT ONE

(established 1933) The designer, artist, and teacher Paul Nash founded this British avant-garde group of architects and fine artists to promote *Modernism in art and architecture in England. The leading members of the group included Henry Moore, Barbara Hepworth, and Ben Nicholson, as well as the architects Wells *Coates and Colin Lucas. In 1934 their work was exhibited at the Mayor Gallery in London and published in a book edited by the writer, historian, and theorist Herbert *Read. According to Nash members of the group were linked by 'the expression of a truly contemporary spirit which is recognised as peculiarly of today'. The *Unit One* book published by Cassell (1934) and *Circle* (1937) were important elements in the promotion of Modernism in Britain in the years leading up to the Second World War. Originally the plans for Unit One had included design, as well as fine arts and architecture, but this was later abandoned.

1925 *Paris Exposition des Arts Décoratifs et Industriels. Members of the UAM included Robert *Mallet-Stevens, Charlotte *Perriand, Le *Corbusier, Jean *Puiforcat, Franz Jourdain, René Herbst, Pierre Chareau, and Louis Sognot. The group's first exhibition, *L'Art moderne cadre de la vie contemporaine*, was held at the Musée des Arts Décoratifs, Paris, in 1930. In addition to the distinguished list of French Modernist participants, it also included the work of foreign designers such as Eileen *Gray, Bart Van Der Leck, and Gerrit *Rietveld. In 1934 UAM issued its first manifesto entitled *Pour l'art moderne cadre de la vie* as a strategic counter to the attacks being made against the Modernist avant-garde. It also played an important role in the 1937 *Paris Exposition with its emphasis on sciences and techniques. After the Second World War the UAM re-established itself with the 1949 exhibition entitled *Formes utiles, objets de notre temps*. In 1950 *Formes Utiles became an organization in its own right, mounting an annual exhibition. UAM was wound up in 1958.

Unit One *See* box on this page.

Urban, Josef (1872–1933) Viennese born Urban was an architect, interior designer,

and illustrator and one of many progressive European designers and architects who emigrated to the USA in the early decades of the 20th century. From 1906 to 1908, whilst in Vienna, he was president of the Hagenbund (Artists' Association) from 1906 to 1908 and designed a number of buildings and interiors, including (with H. Lefler) the restaurant in the Vienna Town Hall (Rathauskeller). From 1911 he worked in the USA, where he was involved in the design of theatre interiors, film decor, set, and costumes. From 1922 he was the director of the New York branch of the *Wiener Werkstätte. His work was seen in a number of exhibitions, such as the 1923 New York Art-in-Trades Club show at the Waldorf-Astoria Hotel where his Viennese Werkstätte-influenced dining room stood out amongst the many other rooms that were executed in a variety of historicist styles. As a leading progressive designer Urban was later invited to contribute one of the room settings in the 1927 *Contemporary American Design: The Architect and the Industrial Arts* exhibition at the Metropolitan Museum of Art in New York. This show was one of a number put on by the Metropolitan to promote new directions in the decorative

u

UTILITY DESIGN (1942–52)

The Utility Design programme was established under the Board of Trade during the early years of the Second World War both as a means of concentrating centres of production and as a means of restricting wastage of materials through the imposition of strict guidelines for the production of furniture and other goods. Although the first formal steps to limit the supply of such goods were initiated in 1941, the Utility Scheme itself was not launched until the following year following the establishment of the Advisory Committee on Utility Furniture in 1942 that aimed to establish products 'of good, sound construction in simple but agreeable designs for sale at reasonable prices'. In many ways their rather stark, undecorated aesthetic was a legacy of the British *Arts and Crafts Movement and offered British design reform campaigners an opportunity to put their beliefs into practice. Similar qualities were also to be found in ceramic design, clothing, and textile design. In fact, the Utility Advisory Committee consisted of many key voices in design debates in Britain in the interwar years, including Charles Tennyson, vice-chair of the *Council for Art and Industry (CAI), Elizabeth Denby, a leading figure in the CAI's *Working Class Home Report* of 1937, and a later director of the Board of Trade-funded *Council of Industrial Design, Gordon *Russell. In the autumn of 1942 the first furniture range was exhibited to the public in a series of room settings that also included Utility influenced ceramics and examples of Utility utensils. The Utility Furniture Catalogue was launched in January 1943 and a Design Panel established under Gordon Russell six months later. Membership included the textile designer Enid Marx, who produced a wide range of furnishing fabrics under the scheme, typified by small-scale patterns and repeats that were in line with minimal wastage. Clothing was also subjected to restriction during the war years and leading designers belonging to the Incorporated Society of London Fashion designers (including Hardy Amies, Norman Hartnell, and Worth) submitted designs that were economical with materials and a number put into mass production. One of the key aspects of the Utility programme had been that goods within its ambit had been exempt from purchase tax from 1942 onwards. After the end of the war there was increasing pressure from consumers and manufacturers to persuade the Board of Trade to widen the range of design options available to consumers. The 1946 *Britain Can Make It* exhibition, organized by the Council of Industrial Design, stimulated public debate on fresh design possibilities in the post-war period and consumer desires were also spurred on in the fashion world by the extravagance of Christian Dior's 'New Look' in 1947. From 1948 the Board of Trade eased its directive that Utility furniture be manufactured to standard designs, allowing a much broader range of specifications. As a result, the Utility Mark could no longer be seen to be a means of indicating guaranteed standards and 'value for money' or safeguard for the consumer, a fact acknowledged in the 1952 Douglas Report reviewing Utility and Purchase Tax where a need was identified 'for effective advice to enable [consumers] to distinguish between cheapness that is good value and cheapness that is bad economy'. The Utility Scheme formally came to an end in the same year

arts and design in the wake of the 1925 *Paris Exposition des Arts Décoratifs et Industriels and attracted many visitors over the nine months that it was open. Urban's work was widely illustrated in contemporary design magazines and he also played a prominent role at the *Chicago Century of Progress Exposition of 1933 where he was coordinator of the colour schemes for the exhibition buildings. This gave rise to the popular description of the exhibition site as 'Rainbow City', a marked contrast to the 'White City' label of its predecessor the *Chicago World's Columbian Exhibition of 1893.

Utility Design *See* box on p. 432.

V

Van Doren, Harold L. VANK Veblen, Thor
van de Venini, Paolo Venturi, Robert ver
sacrum Vespa Victoria and Albert Museu
Vigano, Vittorio Vignelli, Lella and Massi
Bo[s]ch Viollet-Le-Duc, Eugène-Emmanu
Vitra Design Museum Vkhutemas VNIITE
Volvo Voysey, Charles Frances Annesley
Harold L. VANK Veblen, Thorsten Velde,
Venini, Paolo Venturi, Robert vernacular
Vespa Victoria and Albert Museum Vien
Vigano, Vittorio Vignelli, Lella and Massi
and Bo[s]ch Viollet-Le-Duc, Eugène-Emm
Vitra Vitra Design Museum Vkhutemas
Volkswagen Volvo Voysey, Charles Franc
Doren, Harold L. VANK Veblen, Thorsten
de Venini, Paolo Venturi, Robert vernac
Vespa Victoria and Albert Museum Vien
Vigano, Vittorio Vignelli, Lella and Massi
ugène-Emmanu
temas VNIITE
Annesley
Velde,
nacular
Vespa ria and bert Museum Vien
Vigano, Vittorio Vignelli, Lella and Massi
and Bo[s]ch Viollet-Le-Duc, Eugène-Emm
Vitra Vitra Design Museum Vkhutemas
Volkswagen Volvo Voysey, Charles Franc
Doren, Harold L. VANK Veblen, Thorsten
de Venini, Paolo Venturi, Robert vernac
a Victoria and Albert Museum Vien
o, Vittorio Vignelli, Lella and Massi
Viollet-Le-Duc, Eugène-Emmanu
Museum Vkhutemas VNIITE
harles Frances Annesley
blen, Thorsten Velde,
Robert vernacular
ert Museum Vien
elli, Lella and Massi
et-Le-Duc, Eugène-Emm
esign Museum Vkhutemas
kswagen Volvo Voysey, Charles Franc
Van Doren, Harold L. VANK Veblen, Thor
van de Venini, Paolo Venturi, Robert ver
sacrum Vespa Victoria and Albert Museu
Vigano, Vittorio Vignelli, Lella and Massi
Bo[s]ch Viollet-Le-Duc, Eugène-Emmanu
Vitra Design Museum Vkhutemas VNIITE
Volvo Voysey, Charles Frances Annesley
Harold L. VANK Veblen, Thorsten Velde,
Venini, Paolo Venturi, Robert vernacular
Vespa Victoria and Albert Museum Vien
Vigano, Vittorio Vignelli, Lella and Massi

Van Doren, Harold L. (1895–1957) One of the first generation of American industrial designers Van Doren began working in the field in the 1930s. His early visual outlook was informed by a training in art history, studying at the École de Louvre in Paris, lecturing in the Louvre Museum, and translating important texts by Ambroise Vollard on Cézanne and Renoir. He held the post of assistant director at the Institute of Art in Minneapolis from 1927 until 1930 when he established a design consultancy with John Gordon Rideout in Toledo, Ohio. An early collaborative product was their plastic-cased *Air King* radio of 1933, the stepped-back form of which echoed the lines of contemporary skyscrapers. In the same year Harold Van Doren & Associates replaced their earlier partnership. Van Doren and Rideout worked on a number of designs for children's play equipment for the American National Company in the mid-1930s, comprising the streamlined *Skippy Airflow* pedal car, tricycle, and scooter. Other Van Doren clients included the Toledo Scale Co., the Ex-Cell-O Aircraft and Machine Tool Co., and Philco. In 1944 Van Doren's company underwent a further name change, becoming Van Doren, Nowland & Schladermundt in 1944. Van Doren was also an interesting writer, publishing *Industrial Design: A Practical Guide* (1940). In it he argued for teamwork in design, recommending that each consultancy should include a designer, an engineer, a technical specialist, and others with a knowledge of manufacturing, production processes, retailing, and distribution. Furthermore, Van Doren sought to imbue contemporary debates about the newly emerging industrial design profession with a note of caution, pointing out that the majority of American manufacturers neither saw the advantages of industrial design as a business tool nor the need for the implementation of longer-term design strategies.

VANK (Nederlandsche Vereeniging voor Ambachts en Nijveheidskunst, 1904–42) VANK (the Netherlands Association for Crafts and Industrial Art) was established in 1904 in order to give better representation to those working in craft and design. The main objective was to promote the development of the crafts and 'industrial art' alongside the interests of its maker-designers. However, ideological cracks soon appeared in the association's bringing together of craft-based and industrial interests. VANK's philosophy was promoted through its magazine *De Jonge Kunst* (*The New Art*) and, like the *Deutscher Werkbund, a series of Yearbooks published, with state support, between 1919 and 1931. It also promoted design through mounting its own exhibitions at the Stedelijk Museum in Amsterdam, both before the First World War and in the 1930s, and representation at industrial exhibitions. It also did much to influence the design content of Dutch displays at international exhibitions. Like its British counterpart, the *Design and Industries Association, VANK was characterized by confusion about the extent to which it fully embraced modern manufacturing processes and the exploration of new materials and abstract forms. Although closer relationships with industry

emerged in the 1930s, the VANK came to an end in 1942.

Veblen, Thorsten (1857–1929) Celebrated for his use of the term 'conspicuous consumption' in his book *The Theory of the Leisure Class* (1899), an early sociological analysis of the concept of popular taste, Veblen was an American sociologist and social commentator. He described the 'leisure classes' as the owners of commercial enterprises and as 'predators' with 'conspicuous consumption' seen to characterize the competition for status that increasingly infused American society. Something of the flavour of Veblen's investigation may be seen from the chapter headings of his 1899 text. They include: Pecuniary Emulation; Conspicuous Leisure; Conspicuous Consumption; Pecuniary Canons of Taste; and Dress as an Expression of the Pecuniary Culture. His text was frequently reprinted throughout the 20th century on both sides of the Atlantic and has often been cited by design historians and others examining issues of consumption in everyday life. Educated at Carleton College, Minnesota, and John Hopkins and Yale Universities (gaining a Ph.D. in philosophy at the latter in 1884), he taught political economy at the University of Chicago (1906–9) and at the University of Missouri (1911–18) and was a staff member of the New School for Social Research in New York (1919–26). Veblen's other publications included *The Theory of Business Enterprise* (1904), *The Instinct of Workmanship* (1914), and *The Place of Science in Modern Civilisation* (1919), although they never attracted attention comparable to that of *The Theory of the Leisure Class*.

Velde, Henry van de (1863–1957) A leading architect, designer, theorist, and educator in the late 19th and early 20th centuries, Belgian-born Henry van de Velde was an influential figure in progres-sive circles. Although he first practised as a painter in Paris in the Post-Impressionist and Symbolist styles, in 1892 he abandoned painting to concentrate on architecture and design, fields in which he was strongly influenced by the writings of British design reformers John Ruskin and William *Morris. His early design work was in the *Art Nouveau style across a wide range of media including graphics, interiors, furniture, wallpapers, textiles, ceramics, and metalware, reflecting a belief in the idea of *Gesamtkunstwerk* (total work of art). Such an outlook was epitomized in the arts and crafts-influenced Villa Bloemenwerf in Uccle in Belgium, which he built for his family in 1895, his designs embracing all aspects of the project, even to the extent of clothing for his wife. Van de Velde's work soon became increasingly widely known, earning commissions for work in fashionable Parisian circles, including that of the art dealer Samuel *Bing. He also came into contact with Julius Meier-Graefe, proprietor of the gallery La Maison Moderne and co-editor of the periodical *Dekorative Kunst*, the first issue of which was dedicated to van de Velde. After moving to Berlin in 1900, he was invited two years later to establish a new School of Applied Arts in Weimar, constructed between 1904 and 1911 and a predecessor of the *Bauhaus. He was a founding member of the *Deutscher Werkbund (DWB) in 1907 and subscribed to its mission of improving standards of design in German industry. However, van de Velde's commitment to the concept of individual artistic creativity was in distinct opposition to the more radical beliefs of fellow DWB member Hermann *Muthesius, who sought to promote standardization as a key to the production of modern, economic quality design, their differences coming to a head in the 'Standardization Debate' at the 1914 DWB

V

exhibition in Cologne for which van de Velde designed a theatre. On the outbreak of war in 1914 he resigned his post at the Weimar School of Applied Arts, moving to Switzerland in 1917 and then to Holland in 1920 where he carried out a number of commissions for the Kröller-Mullers, including the Kröler-Muller Museum at Otterloo (1936–8). In 1926 he had returned to Belgium where he held a number of educational posts. His later design projects included the interior design of the steamer *Prince Baudouin* (1934–6).

Venesta Plywood Company *See* LUTERMA; PRITCHARD, JACK; ISOKON; COATES, WELLS.

Venini Company (1921–97) The Venini Company, established in Venice by Paolo Venini (1895–1959) in 1921 and incorporated in 1924, soon became one of Italy's leading glass manufacturers through its employment of modern designers keen to explore the aesthetic potential of the material. Paolo had given up a legal career to purchase the Murano glassworks owned by Giacomo Cappelani. Even by the time of the 1923 Monza Biennale (*see* MILAN TRIENNALE) the new company began to attract favourable critical attention, consolidated further by the award of a Grand Prix at the *Paris Exposition des Arts Décoratifs et Industriels, 1925. Early collaborators with Venini included Gio *Ponti and Carlo *Scarpa. The latter became artistic director in 1932, combining aspects of traditional glassmaking with a modern vision in his *Tessuti* vases. After the Second World War the factory remained a leader in the field, despite the death of Paolo Venini in 1959. Massimo *Vignelli, then an architecture student at the University of Venice, began designing for the company from 1953, producing a series of hanging and table lamps (such as the *Fungo*, 1955). Amongst Ponti's post-war

designs the *Morandiane* series of bottles (1956). Tobia *Scarpa began working for the company in the late 1950s, American studio glass artist Dale Chihuly and Tapio *Wirkkala in the 1960s, and Gae *Aulenti in the 1990s. In 1997 the Venini company was acquired by Royal Copenhagen Ltd., along with Swedish glass manufacturer *Orrefors *Kosta Boda and became part of Royal Scandinavia Ltd.

Venturi, Robert (1925–) One of the most influential figures in American *Postmodernist architectural and design theory, practice, and education, Venturi is often remembered for his substitution of the *Modernist adage 'less is more' with the phrase 'less is a bore'. Venturi's work draws on a wide and eclectic miscellany of styles ranging from the historical to the forms of contemporary popular culture. This ranged from his blend of traditional and modern in his mother's house in Pennsylvania (1961–4), the creative exploration and reinterpretation of the Gothic, Sheraton, Chippendale, and *Art Deco styles for his series of chairs for *Knoll Associates (1978–84), or the blend of traditional Japanese architectural features and an iconography of the commercial contemporary streetscape in his design for the Hotel Mielmonte Nikko Kirifuri in Nikko, Japan (1992–7). At the outset of his career Venturi studied architecture at Princeton University, graduating in 1947 and completing his Master's thesis there in 1950. He went on to work as a Prize Fellow at the American Academy in Rome from 1954 to 1956 where he experienced at first hand the emotional and expressive language of Baroque and Mannerism. After his return to the United States he worked in the architectural offices of Eero *Saarinen, Louis I. Khan, and Oscar Stonorov and taught architectural theory in the School of Architecture at the University

VERNACULAR

This term has been widely used to describe everyday design, the simple, generally undecorated forms of which have strong associations with traditional craft-making skills. Vernacular forms, their functional qualities having evolved over decades or even centuries, have often been seen as the inspiration for *Arts & Crafts furniture designers such as William *Morris and the 'Sussex Settle' in Britain, Gustav *Stickley and his 'Mission Furniture' in the United States, or Richard *Riemerschmid in Germany. Nikolaus *Pevsner argued in his celebrated *Pioneers of the Modern Movement: From William Morris to Walter Gropius* (1936) that there was a clear link between the Arts and Crafts philosophy (with its emphasis on qualities such as honesty of construction and appropriate use of materials) and the *Modern Movement in which a number of its aesthetic implications were reconciled with machine production. Others, in texts such as *The Roots of Modern Design: The Functional Tradition in the Nineteenth Century* (1970) by Herwin Shaefer, Pevsner's assistant on the *Museum of Modern Art, New York sponsored revised edition of *Pioneers* (1949), have argued for recognition of a more direct link between vernacular forms and *Modernism.

of Pennsylvania, where he met Denise Scott Brown. She was a fellow teacher and he went on to marry her in 1967, becoming her business partner in 1969. His first book, entitled *Complexity and Contradiction in Architecture*, proved highly influential. The *Museum of Modern Art in New York, where he first delivered its ideas as lectures, published it in 1966. In it he argued for an architecture that promoted elements that were 'hybrid rather than "pure", compromising rather than "clear", distorted rather than straightforward' and reflected the complexities of the urban environment. His second book *Learning from Las Vegas* of 1972, co-authored with Denise Scott Brown and Stephen Izenour, drew attention to the vitality of the commercial vernacular of the city street and the importance of the symbol and mass culture for contemporary architecture. Such ideas may be related to contemporary avant-garde design interests in *Pop and *Kitsch evidenced in the contemporary work of *Anti-Design designers in Italy. A further collection of essays by Venturi, entitled *A View from the Campidoglio: Selected Essays, 1953–1984*, was published in 1984. His interest in Michelangelo's designs for the Piazza del Campidoglio in Rome had surfaced in his *Campidoglio Tray* of the early 1980s for the Italian housewares manufacturer *Alessi (1983). Venturi also worked in ceramics with designs for the fashionable *Swid Powell company, including his patterned *Grandmother* four-piece porcelain crockery set of 1984 and four-piece *Village* tea and coffee set of the following year. The latter drew on the design of a peasant's cottage for the sugar bowl, the Pantheon in Rome for the teapot, a Tuscan tower for the coffee pot, and a Renaissance palazzo for the milk jug, revealing aspects of the stylistic and cultural eclecticism that pervaded his work. For more than 30 years the firm of Venturi, Scott Brown and Associates (VSBA) has been prolific in its architectural output including the Eclectic House Series (1977), the Sainsbury Wing extension of the National Gallery, London (1985–91), and the Art Museum in Seattle (1988–91). The firm's work was celebrated in a comprehensive exhibition entitled *Out*

of the Ordinary: The Architecture and Design of Robert Venturi, Denise Scott Brown and Associates held at the Carnegie Museum of Art in late 2002 and early 2003. It included architectural photographs, drawings, and models as well as examples of textiles, furniture, and the decorative arts. Venturi has lectured at many of the leading institutions in the United States including Yale, Harvard, Princeton, and UCLA and, in 1991, was awarded the Pritzker Architecture Prize.

Vernacular See box on p. 439.

Ver sacrum (1898–1903) This short-lived but highly significant periodical, influenced by the German magazine *Pan, was both a graphic showpiece and the principal mouthpiece of the Viennese Secession. It contained illustrations by the leading Viennese artist Gustav Klimt as well as illustrating the work of other key figures such as Josef *Hoffmann, Koloman *Moser, Joseph *Olbrich, and theatre designer Alfred Roller. Its written contributions were also often by distinguished literary figures such as Rilke, Maeterlinck, and Verhaeren and even advertisements were striking realizations of the Secessionist style.

Vespa (established 1946) Sometimes likened to the *Ford Model T automobile (1908–27), which sold 15 million units in its lifetime, the Italian Vespa motor scooter designed by Corradino *D'Ascanio and manufactured by *Piaggio since 1946 has been the best-selling two-wheeler, with more Vespas than Model Ts having been sold by the end of the 20th century: more than 3.5 million by 1965; more than 10 million by 1988; and more than 15 million by 1996, the year of the Vespa's 50th anniversary. In terms of public visibility and capturing the public imagination, the Vespa has also featured in countless films spanning several generations, including Roman Holiday (in

which it was ridden by Gregory Peck and Audrey Hepburn), Vincente Minnelli's An American in Paris, Federico Fellini's La dolce vita, Franc Roddam's Quadrophenia, George Lucas's American Graffiti, and Jay Roach's Austin Powers. The Vespa scooter (named after the wasp whose buzzing it imitates) proved to be a stylish, affordable means of transportation in the reconstruction period of the later 1940s, epitomizing the democratic spirit that infused the outlook of many designers in the years immediately after the end of the war. Able to be ridden by men and women alike, easy to operate, with three-speed gears operated from the handlebar, a pedal-operated rear brake, and a stylish body casing to protect riders from dirt, the final form evolved from D'Ascanio's 1945 Paperino and MP6 prototypes and was launched in April 1946. It proved immensely popular throughout Europe, having sold 100,000 units by 1952 with Vespa Club membership standing at over 50,000. It was marketed widely in the United States, being imported by the Cushman scooter company from 1961 and also by *Sears Roebuck & Co. who sold it through their stores and *mail order catalogues. It was also produced under licence in several European countries, such as Germany where production by Hoffman-Werle began in 1950, as well as in India where it was manufactured by Bajaj and in Taiwan by PGO. All kinds of variations, models, and new features were introduced over succeeding generations including the 1976 Primavera 125-ET3, the first Vespa with electronic ignition, and the 1989 Sfera with its plastic body.

Victoria and Albert Museum (V&A) The V&A is one of the world's leading repositories of the decorative arts and design and was a source of inspiration for the establishment of applied arts museums conceived along similar lines in Vienna (1864),

Berlin (1867), Oslo (1876), Copenhagen (1890), and elsewhere The V&A's origins lay in the design reform activities that were initiated in Britain in the two decades leading up to the *Great Exhibition of 1851 in London. Of particular note was the 1835 Select Committee on *The Arts and their Connection with Manufacturers*, which was charged with investigation of 'the means of extending a knowledge of the Arts & Design among the people (especially the manufacturing population)'. Reporting in the following year it reflected the growing belief that one means of achieving this would be to establish a collection of well-designed manufactured goods. It was anticipated it would educate students, industrialists, and artisans in matters of taste and thus help to stem the flow of foreign design imports to Britain, a growing cause of economic concern in political circles. Following the Great Exhibition Henry *Cole, a dominant figure in Victorian art and design educational policy and head of the Department of Practical Art in 1852, established a Museum of Manufactures. Known subsequently as the Museum of Ornamental Art, it had at its core a collection of objects purchased from the Great Exhibition with a government grant. It took on a strong moral slant with a gallery devoted to the display of 'Examples of False Principles in Decoration', an approach that could be likened to the portrayal of Victorian industry by A.W. Pugin in his celebrated book of 1836, *Contrasts*. In 1857 the museum was relocated to a site in South Kensington purchased with some of the profits of the Great Exhibition and housed in what were dubbed the 'Brompton Boilers'. This was followed in 1860 by the recommendation of a Select Committee of the House of Commons to construct a more permanent building, designed by Francis Fowke. A number of distinguished designers and design com-

panies contributed to the design of the new building's interior, and included Owen *Jones (the decorations of the Indian and Oriental Galleries), *Morris & Co. (the Green Dining Room, 1866) and Sir Edward Poynter (the Grill Room). In 1882 the library was built and, in 1899, a new building designed by Aston Webb was commenced. The foundation stone was laid by Queen Victoria and the museum renamed the Victoria and Albert Museum. Although an important bequest of *Art Nouveau furniture from the 1900 *Paris Exposition was exhibited in 1901, by the First World War the museum's original policy of purchasing contemporary designs as exemplars for educating those involved in manufacturing industry had largely ceased, with modern items largely resulting from gifts. Although in the following decades there were some instances of exhibiting and acquiring contemporary design as, for example, following the failure of the British Institute of Industrial Art's Gallery in nearby Knightsbridge in the 1920s, there was little commitment to the original mission of showing modern design. However, the V&A's Circulation Department collected 20th-century design for much of the century, until the museum's then director, Roy Strong, closed it in 1977. This department organized small travelling exhibitions to art schools and, after the Second World War, put on a series of more substantial shows such as the *Victorian and Edwardian Decorative Arts* of 1952 and the *Modern Chairs* exhibition at the Whitechapel Gallery, London, of 1970. From the mid-1970s the V&A once more began to collect 20th-century artefacts and, in 1981, established the *Boilerhouse, run by the Conran Foundation as a major showcase for contemporary design until 1987, when it moved with its director to the new *Design Museum near Tower Bridge. In 1983 the V&A had established a

British Art & Design 1900–1960 Gallery and in 1992, complementing the museum's re-invigorated 20th-century and contemporary design acquisitions policy, a new Twentieth-Century Gallery. A number of other galleries have been redesigned and new displays such as the British Galleries set in place. The museum's explicit acknowledgement of the importance of contemporary design was underlined by the holding of a competition to house a new V&A building in 1995–6. Polish-born architect Deniel Liebeskind won it with a seven-storey high glass and tiled proposal known as the Spiral Project.

Vienna Secession (1897–1905) In design terms the Vienna Secession was the most significant of a number of Secession groups established in the 1890s in Germany and Austria that were set up in opposition to the traditional outlook of the official academies, including those of Munich launched in 1892 and Berlin in 1899. Founded by a progressive group of younger Austrian artists, the Vienna Secession was formed in 1897 in opposition to the exclusion of foreign artists from exhibitions of the Viennese Academy. Led by the artist Gustav Klimt, its first President, members of the group included the designer and architect Josef *Hoffmann, Kolomon *Moser and Josef Maria *Olbrich. Olbrich designed the decorative Secession Building in Vienna (1898), with Moser contributing stained glass and other decorative work in the interior. Hoffmann designed the Ver sacrum room at the first Vienna Secession exhibition in 1898, *Ver sacrum being the title of the periodical closely associated with the group.

See also SEZESSIONSTIL.

Vienot, Jacques (1893–1959) The highly influential French industrial designer and theorist Jacques Vienot established the com-pany Décore Installe Meuble (DIM) in 1929 and, in the following year founded Porza, an international association that sought to promote the ideas of the *Modern Movement. In 1933 he became the manager of Printemps, a leading Parisian department store. His significance in French design and decorative arts circles was such that he was made responsible for the Fêtes section at the 1937 *Paris Exposition. However, following the Second World War he became a leading figure in the promotion of industrial design in France. After travelling to the United States and Britain to see at first hand good practice in the emerging industrial design profession, with the help of Jean Parthenay he established the design consultancy Bureau Technès in 1948. Vienot was much influenced by the methods of leading American designer Raymond *Loewy. Following this was his establishment of the Institut d'Esthétique Industrielle in 1951, with the aim of improving the aesthetic and technical standards of French industrial products. The latter was to some extent influenced by the ideals of the British Council of Industrial Design (see DESIGN COUNCIL) which had been founded in 1944 with a principal aim of improving aesthetic standards in manufacturing industry. Also in 1951, with the financial support of the French Ministry of Commerce and Industry, the Institut d'Esthétique Industrielle launched the journal Esthétique industrielle which was to become the leading mouthpiece in France for design debate and news. In 1953, following pressure from Vienot, the Ministry of Commerce and Industry established *Design Award Beauté France (later Beauté Industrie), the year in which Roger *Tallon joined Bureau Technès and became an increasingly influential figure in French industrial design. Having established the Centre Supérieur d'Esthétique in 1954 at the School of Applied Arts,

Paris, he initiated the first industrial design course in France two years later.

Vigano, Vittorio (1919–) The work of this Italian architect and product designer proved influential in the decades immediately following the Second World War. He participated in the important post-war exhibition of furniture and interiors organized by the Riunione Italiana Mostre per l'Arredamento in 1946. Many of the ideals of the democratic left were embraced in this exhibition of well-designed, practical, and affordable domestic furnishings. He also worked for the BBPR architecture and design studio, for Gio *Ponti, and for Gino Sarfatti's lighting manufacturing company *Arteluce, an important fulcrum for emerging industrial design talent.

Vignelli, Lella (1931–) and **Massimo** (1931–) Vignelli Associates was founded in New York in 1971 by Italian-born designers Lella and Massimo Vignelli and offered a range of consultancy services including corporate and visual communication design, and industrial and furniture design. Both had graduated in architecture, she studying in Venice and he at Milan and Venice before going on to concentrate on design from 1956 onwards, having been involved in the formation of *ADI (Associazione per il Disegno Industriale), the major Italian professional design organization, in the same year. In 1960 the Vignellis established an industrial and graphic design studio in Milan. They moved to the United States in 1965, forming the corporate design consultancy Unimark with Bob Noorda and Ralph Eckerstrom. Some of the Vignellis' best-known designs from this period involved aspects of identity for a number of major clients including *Knoll International, for whom they undertook a comprehensive review of all aspects of their visual presence (commencing 1966), American Airlines, for whom they designed the logo (1967), and the sign systems and map for the New York Subway (commencing 1966). As Vignelli Associates, their designs continued to embrace corporate identity design alongside exhibition, furniture, product, and publication design. Amongst their more significant commissions in this later phase of their career have been the corporate identities for leading New York Department store Bloomingdale's (1972), for the automobile and motorcycle manufacturers Lancia (1978) and Ducati (1992) and the signage system for the Guggenheim Museum in Bilbao (1997). Their furniture designs included the *Handkerchief* chair for Knoll (1982), the *Serenissimo* table (1985) for Italian manufacturer Acerbis, and the *Magic* coffee table (1990) for its lower-priced Morphos label. Other Vignelli designs have also included retail layouts for *Artemide, jewellery for Cleto Munari, and glassware for *Venini and Steuben. Their work was recognized by the *Compasso d'Oro awards in 1964 and 1988, the receipt of a gold medal from the AIGA (American Institute of Graphic Arts, established 1914) in 1983 and has been appraised in Emilio Ambasz's book of essays *Design: Vignelli* (1980), first published by the Commune di Milan, and republished by Rizzol in 1981 and 1990.

Villeroy & Boch (established 1836) With roots that go back to François Boch's ceramic business, founded in 1748, and Nicolas Villeroy's earthenware factory, founded in 1791, Villeroy & Boch was established in 1836 and is now one of the leading pottery companies in Germany. By the 1880s the firm was producing high-quality bone china, floor tiles, and architectural ceramics, moving into large-scale production of sanitary ware by the turn of the century. At this time the company rarely pioneered in design terms, although it produced

quality work that embraced contemporary aesthetic trends, such as *Art Nouveau. During a period of readjustment after the First World War the company devoted resources to technical development. Something of the *Modernist spirit of the *Bauhaus was reflected in Villeroy & Boch's products with the employment in 1932 of Hermann *Gretsch, who designed the *Freia* service. After the Second World War the company maintained its reputation as a design-conscious company, commissioning designers such as Luigi *Colani and Paloma Picasso. She began her relationship with the company in 1987 with the development of a series of tiles, followed by tableware, cutlery, and glass. In the same year Villeroy & Boch became a public limited company. In 1989, after the purchase of the Dutch company Ucosan, Villeroy & Boch diversified into plastic baths and showertrays, expanding further into bathroom furniture after 1991 when it bought into an Austrian company, Das Bad. In 1990 Villeroy & Boch began trading on the Stock Exchange, purchasing significant shareholdings in other companies over the next decade. These included the Hungarian ceramic sanitary ware and tile manufacturer Alfoldi Porcelángyár (1992), the Romanian sanitary ware and tile manufacturer Mondial SA (1996), the Italian ceramic group Ceramica Ligure (1997), and *Gustavsberg (2000).

Viollet-Le-Duc, Eugène-Emmanuel (1814–1989) An influential French architect, designer, and theorist, Viollet-Le-Duc was highly influential on a number of progressive architects and designers such as Hector *Guimard, Antoni *Gaudí, René *Lalique, and Frank Lloyd *Wright, transmitting his outlook through a series of important texts, especially his two-volume *Entretiens sur l'architecture* (*Architectural Dis-*

cussions, 1863–72). After an early career that included the teaching of drawing, the design of ornaments, and travels in France and Italy, he took up the post of architectural auditor for the Council of Civilian Buildings in 1938, after which he became increasingly involved in the restoration of Gothic buildings including Notre Dame in Paris (commencing 1842). In 1849 he was appointed to improve standards of design in the state manufactories of Sèvres, Gobelins, and Beauvais and, in 1853, was commissioned for the design of the furniture and fittings of a railway train for Napoleon III. Several other commissions followed over succeeding decades, though it was through his writings rather than his designs (with strong medieval leanings) that his influence was felt. These included his ten-volume *Dictionnaire raisonné de l'architecture* (1858–68), the six-volume *Dictionnaire du mobilier français* (1863–72), and *Entretiens sur l'architecture*. The latter contained his ideas on iron construction, the relationship between form and decoration, and the role of new materials, all of which, together with the plates, can be seen to have been influential on a number of practitioners of *Art Nouveau at the turn of the century.

Vinçon (established 1934) The origins of this famous Barcelona retailing company can be traced to a retail business founded in 1934. In the following year Jacinto Arnat was employed as a salesman, the first of several generations of the family to become involved with the company. In 1941, under the name Regalos Hugh Vinçon, the business moved to its present location in the Paseo de Grazia, Barcelona. The Arnat family bought the business in 1957 but it was not until after 1967, when the company began marketing contemporary household products to boost profits, that Vinçon began to attract significant attention. The basic

concept was to convey the attractive allure of a walk-in shop window. In 1972 America Sanchez, one of many well-known graphic designers associated with the company, established the company logo. Designers such as George Hardie and Javier *Mariscal have undertaken a range of high-profile graphic initiatives and the company's carrier bags have subsequently become collectors' items. The company has won many design awards, including the Laus Award for continuous excellence in graphic design (1993), the *Premio Nacionale de Diseño (1995), and the Frankfurter Swilling European Prize for the best shop in Barcelona (1999). Vinçon has retail outlets in Barcelona and Madrid and has developed an online facility, VinçoNet.

Vitra (established 1950) In the closing decades of the 20th century Vitra became widely known as a fashionable manufacturer of furniture, commissioning experimental designs from a range of designers including Ron *Arad, Frank *Gehry, Shiro *Kuramata, Alessandro *Mendini, Ettore *Sottsass, Borek *Sípek, and Philippe *Starck, in addition to its own exciting Design Museum building by Frank *Gehry. The company's origins lay in Willi Fehlbaum's shop-fitting business, established in Switzerland in 1934. The Vitra furniture manufacturing company in Weil am Rhein in Germany was established for the production of office furniture by Willi's son Rolf in 1950. Made under licence from the *Herman Miller Company early products that set out Vitra's corporate design ambitions encompassed furniture designed by Charles and Ray *Eames (including the *Lounge Chair*, 1956), George *Nelson (including the *Marshmallow Sofa*, 1957), and, a little later, Verner *Panton (the *Panton Chair*, 1967). In the 1970s Vitra's growing reputation for high-quality design and a visually dynamic corporate identity was further enhanced by Rolf Felbaum, who had been made chief executive in 1977. He commissioned company buildings by highly innovative designers, including factory buildings by British architect Nicholas Grimshaw (1981) and Italian Antonio Citterio (1992), a conference building by Japanese architect Tadao Ando (1992), and the world-famous *Vitra Design Museum by Frank Gehry, completed in 1989. Amongst the best-known chairs commissioned by the company under its experimental Vitra Editions initiative, launched in the 1980s, have been Kuramata's *How High the Moon* armchair in nickel-plated steel mesh (1986), Sípek's *Ota Otanek* chair (1988), Philippe Starck's *Louix XX* stacking chair (1992), and Frank Gehry's *Grandpa Chair* (reissued in 1993). Amongst the many prizes awarded to Vitra was the Lucky Strike Design Award given to Rolf Fehlbaum in 1994.

Vitra Design Museum (opened 1989) The striking Vitra Design Museum in Weil am Rhein in Germany was commissioned by Frank *Gehry (whose furniture was also manufactured by the company), opening to the public in 1989. It has one of the most comprehensive collections of chairs in the world and also mounts periodic exhibitions that, together with the museum building, have also helped to promote the company as one with a rich visual design identity and sense of heritage. One of the main reasons underlying the museum's creation was the desire of Rolf Fehlbaum, Vitra's chief executive since 1977, to document and explain the history of the furniture industry. The museum's first director was Alexander von Vegesack, a design historian, collector, and exhibition designer who had been involved in establishing the *Thonet Museum in Boppard in 1986. In the same year Von Vegesack first met Fehlbaum and became

involved with the systematic development of the Vitra collection that spans the history of chairs from the mid-19th century to the present by means of mainstream design historical movements and key designers. In addition to the art-based presentation of exhibitions such as *Floating Shapes* devoted to the sculptural qualities of bentwood furniture, Von Vegesack has also overseen the organization of many Vitra touring exhibitions such as its *100 Masterpieces*, devoted to exemplars of chair design through the ages.

Vkhutemas (established 1920) This Russian progressive art and design institution, the Higher State Artistic and Technical Workshops, was established in Moscow in 1920, bringing together art, architecture, and design education. One of its fundamental aims was to ally itself to those aspects of Russian *Constructivism that sought to forge a positive relationship between art and industry as a means of bringing about social and cultural change. This would be effected by the training of a new breed of 'artist-productivists'. The range of the institution's Faculties was expanded in 1922 to include Architecture, Design, Textiles, Ceramics, Metalwork, Woodwork, and Graphics. The Woodwork and Metalwork Faculties were brought together in 1926 and began to produce furniture and products informed by the Constructivist ethos, influenced by Vladimir *Tatlin, who became its director. The institution's aim was to provide a focus for research and experimentation, particularly in art and design with all students having to follow core courses in Space, Volume, Colour, and Graphics. The institution's staff members for design and graphics included Alexander *Rodchenko, his wife Varvara *Stepanova, El *Lissitsky, Gustav *Klutsis, and Vladimir *Mayakovsky. The architecture staff included Alexandre Vesnin and Konstantin Melnikov. In the late 1920s the Vkhutemas was reorganized with a breaking up of the faculties into separate institutions.

VNIITE (USSR Research Institute of Industrial Design, established 1962) In the light of criticism on several fronts, including the *Isvestia* newspaper, which pointed to the poor design of consumer goods, the Soviet government established the VNIITE in Moscow in April 1962. Yuri *Soloviev, a key figure in Soviet design in the second half of the 20th century with experience of design promotion at government level, was appointed as director, a post he maintained until 1987, during which period he played a powerful guiding role. The Institute's Moscow headquarters was divided into nine key divisions. Six of these (design theory, socio-economic research, product testing, ergonomics, decorative materials and finishes, and information and documentation) sought to provide research findings and information to designers working throughout the USSR. The other three (interiors and transport, machine tools, and graphics and packaging) were devoted to major important design projects. VNIITE grew in size and significance and, within five years of its establishment, employed a total of more than 3,000 staff including those in the regional offices in nine industrial centres, including Leningrad, Kharkov, Minsk, Kiev, and Tblisi. In these early years there were also design offices (with staff of 50 to 200) attached to major industries, as well as about 200 groups of between two and fifteen designers working in individual factories. This was part of a wider Soviet governmental concern to improve design standards, further demonstrated by a ruling requiring Soviet manufacturers to use trademarks on their products. Nonetheless, the redesign of non-essential goods had a low priority in an economy geared to

satisfying the needs of the military and heavy industry. It was difficult to embrace the ideas of everyday product obsolescence common in Western industrialized economies when it was possible to build objects for a longer life. However, an improvement in the design of some capital goods and consumer goods was discernible to critics, albeit reliant on European and US precedents. This perhaps owed something to Soloviev's invitations to Russia to the American industrial designer Raymond *Loewy and the director of the British Council of Industrial Design (see DESIGN COUNCIL), Paul Reilly, as part of his official drive to improve Russian design before VNIITE was established. His friendship with Reilly resulted in an exhibition at VNIITE entitled *The Role of the Industrial Designer in Britain.* Organized by the Council and the British Central Office of Information it was visited by many Russian Ministers and key sectors of the public. This initiative was followed in 1966 by an Anglo-Soviet cultural agreement that saw an exchange of designers arranged through the Council, with V. M. Munipov, B. V. Shekov, and M. V. Feodorov travelling to Britain and Frank Height, John Reid, and Edward Pullee reciprocating in the USSR. From 1964, under Soloviev's editorship, VNIITE published its *Tekniecheskaya Estetika* (*Technical Aesthetic*) design journal with its information supplement on *Industrial Design Abroad.* By the mid-1970s the USSR was planning a closer integration with the economies of Eastern European countries and attention was focused on design in East Germany and Czechoslovakia in particular, countries where VNIITE's research and development policies were influential However, perhaps most important in terms of external relations was the link with *ICSID, of which VNIITE became an institutional member in 1969, with Soloviev becoming a vice-president in the same year. After or-

ganizing ICSID's 1975 biannual congress in Moscow on the theme of *Man, Design and Society*, he served as president of ICSID from 1977 to 1980.

Volkswagen (established 1938) This international company is known worldwide for its production of the *Beetle*, sustained by a series of films featuring the car as the central 'character' that commenced with *The Love Bug* (1973) and revived in a new *Beetle* design in 1998 by J. Meys. Volkswagen's origins lay in Ferdinand *Porsche's designs for small cars in the early 1930s, the most significant of which was his design for a 'people's car'—the *KdF-Wagen*—for the Reichsverband des Automobilindustrie (State Union of the Automobile Industry). Its engineering qualities included a rear-mounted air-cooled engine. The distinctive 'streamlined' shape of the car owed something to precedent, particularly in the USA, and was designed by Austrian car bodywork designer Erwin *Komenda. Although the first models came off the production line at Wolfsburg in 1938 the car was not put into mass production on a large scale until after the Second World War, during which Volkswagen manufactured over 100,000 military vehicles. Volkswagen automobile production began in earnest under the British in Germany in 1945, with exports commencing in 1949, the year in which the company returned to German control. Economic and durable, the car sold well in both Europe and the United States, in the latter providing a striking alternative to the large, petrol-hungry cars produced by *General Motors, *Ford, and *Chrysler.

Other significant designs in this early period included the two-seater *Karmann Ghia Coupé* (1955; see KARMANN, WILHELM) and the *Transporter* and *Microbus* (1956). The latter was to become associated with the 'hippy' movement and others opposed

V

to commercial values associated with the fashionable style values of the annual model change. Despite being Germany's largest automobile producer the company underwent a difficult period until the 1974 launch of the hatchbacked VW *Golf*, designed by Giorgetto *Giugaro in tune with practical needs of the urban consumer, and which underwent many model updates and changes. Other models by Giugiaro included the *Passat* estate car (1973) and *Scirocco* sports car (1974). The VW *Polo* (1975) was styled by the Italian car body company *Bertone. In 1998 the VW *Lupo*, another neatly styled, economical car, was launched. Now a leading manufacturing force with subsidiaries in North and South America, Volkswagen has taken over many other companies over the past 50 years including *Audi (1965) and NSU (1969) in Germany, SEAT (1982) in Spain, *Skoda (1990) in the Czech Republic, and Rolls-Royce (1998) in Britain. High-quality design has been an important ingredient of the company's international success.

Volvo (established 1924) Assar Gabrielsson and Gustaf Larson in Gothenburg founded this well-known Swedish manufacturer in 1924, with the first Volvo car—an open-topped four-cylinder model—produced in 1927. Their aim was to build cars fabricated from high-quality Swedish steel that were more suited to the extremes of the Scandinavian climate than their competitors imported from the United States. In 1928 Volvo began exporting and also set up its first subsidiary in Finland. In its early years the company survived largely on the sale of its trucks, buses, and taxis. However, in the 1930s the strong contemporary influence of streamlining made itself felt and style became increasingly important in the advertising, selling, and purchase of cars. This was particularly marked in the *PV36*

Carioca of 1936, the design of which had involved American collaboration and was in some ways reminiscent of the *Chrysler *Airflow* of 1934. It also had independent front-wheel suspension and an all-steel body. The *PV51* of 1936 proved to be popular as well as inexpensive, although the first genuine 'people's car' produced by Volvo, the *PV60*, did not go into production until 1946. Safety, which was to be an extremely significant aspect of Volvo corporate policy as well as consumer appeal in the decades following the end of the Second World War, emerged as a key aspect of Volvo's outlook during the 1930s. In the 1950s Volvo cars began to capture new markets, as with the versatile and utilitarian *Duett* van and estate car of 1953, which proved highly attractive to businessmen and craftsworkers on account of its load-carrying capacity. The *Duett* of 1953 van and estate car very popular with business and crafts works for practicality and load-carrying capacity. The *P1200* (later *120*) *Amazon* also made a considerable impact, particularly on account of the flowing lines of its modern style, its appeal confirmed with the release of the estate version of 1962. Designed by Jan Wilsgaard, a dominant figure in Volvo design for more than 40 years, it was on sale for fourteen years from 1957, with sales of more than 667,000. The stylish *P1800* sports car also injected some verve and *joie de vivre* into the company's products. Shown at the Brussels Motor Show of 1960 and building on a design idea of Wilsgaard and Helmer Patterson with styling initiated by the Italian body-styling company *Ghia but completed by its associate company Frua, it was later driven by Roger Moore in the dashing title role of *The Saint* television series, based on the novels of Leslie Charteris. It remained in production until 1967. With disc brakes and collapsible steering wheel provided as standard, the

Volvo *144* was launched in 1966 and was voted 'Car of the Year' and 'the safest car in the world'. Although rather box-like the car sold well with sales of over half a million. For some years the square, rather functional look dominated and Volvo as a brand was associated with high levels of passenger comfort and safety. For many people this design went hand in glove with the ethos of the Swedish welfare state rather than the highly commercial styling associated with the majority of cars, particularly in the United States. In the 1950s Volvo had hired its first designer, Jan Wilsgaard, later head of styling from 1981 to 1991. He was succeeded by Peter Horsbury, under whose regime there was a much greater tendency towards flowing soft lines and curves, as in the 1996 *S/V40* range developed jointly with Mitsubishi. The elegant Volvo *S80* of 1998 commanded huge sales across the world and was able to compete with luxury *BMW and *Mercedes models. In 1971 the PRV company (*Peugeot-*Renault-Volvo), a Franco-Swedish enterprise, was formed, a partnership that ultimately failed, and in 1999 Volvo was bought by *Ford.

Voysey, Charles Francis Annesley (1857–1941) A highly versatile architect and multi-disciplined designer, Voysey was an important link between the later phases of the *Arts and Crafts Movement in Britain and progressive design thinking in Europe in the early 20th century. Originally working in the architectural office of J. P. Seddon in 1874, he set up his own architectural practice in 1882. However, friendship with A. H. *Mackmurdo stimulated his appetite for design and in addition to wallpapers for Jeffrey & Co. and textiles for Alexander Morton & Co., he extended his design vocabulary to include metalwork, lighting, tableware, and cutlery.

V

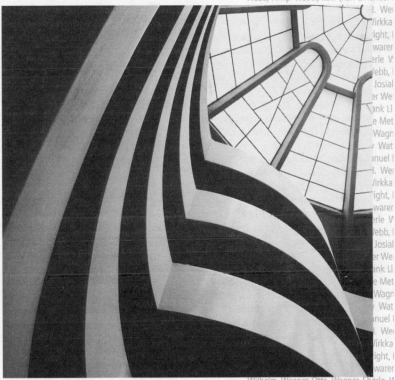

Wagenfeld, Wilhelm (1900–90) Well known as a *Bauhaus designer, Wagenfeld has become widely celebrated as a leading German product designer specializing in everyday products in metal and glass in the interwar and post-Second World War periods. After an apprenticeship in the Koch & Bergfeld silverware factory and studies at the Zeichenakedemie from 1919 to 1922 Wagenfeld became a student at the Bauhaus in Weimar from 1923, becoming a pupil of László *Moholy-Nagy in the metal workshop where he worked with Marianne *Brandt. Amongst his designs at this stage was the *WG 24* 'Bauhaus' desk lamp (with the collaboration of K. J. Juncker) of 1924, with its distinctive functional aesthetic. He became head of the department after the Bauhaus moved to Dessau in 1926. Although many Bauhaus staff and former students emigrated for political and ethical reasons Wagenfeld remained in Germany throughout the 1930s and Second World War years. During the politically turbulent 1930s he taught at the Berlin Staatliche Kunsthochschule from 1931 to 1935. In 1930 he designed a series of functional ovenproof glass casserole dishes for Jenaer Glass (Schott & Gen), a well-known German glass manufacturer that had developed heat resistant glass in the late 19th century. He also designed (in collaboration with Ladislav Sutner) an elegant glass tea service for Jenaer in 1932 (reissued in 1997 as part of the design heritage drive of many leading *Modernist design manufacturers). In 1935 he was made design director at the Lausitzer Glassworks, for whom he designed the celebrated modular and neatly stacking *Kubus* glass storage containers of 1938. After the Second World War he designed for many well-known German manufacturers including *WMF (Württembergische Metallwarenfabrik), *Rosenthal, and *Braun. For WMF his designs included the ubiquitous *Max and Moritz* salt and pepper shakers of 1953, for Rosenthal his *Gloriana* dinnerware also of 1953, and for Braun the *Combi* radio-gramophone of 1955. He established his own design consultancy in Stuttgart in 1954. Amongst the many prizes he received were the Grand Prix at the *Milan Triennale of 1957 and the *Gute Form* (*Good Form*) prize organized by the *Rat für Formgebung in 1969 and 1982. A museum devoted to his work has been established in Bremen, Germany, and many of his designs are held in the collections of major museums including the *Victoria and Albert Museum, London, and the *Museum of Modern Art, New York.

Wagner, Otto (1841–1918) Architect Otto Wagner was a leading figure in the Vienna Secession. After studying architecture at the Technical High School in Vienna (1857–60) and the Vienna Academy (1861–3) for many years he worked in a range of historical styles until he joined the Secession. The latter had been founded in 1898 as a focus for opposition to the prevalent academicism of the fine arts establishment, which also believed in the superiority of painting and sculpture over the applied arts. Supporting the idea of the unity of the arts common to many avant-garde designers, architects, and artists at the turn of the century, Wagner's work took

on a more functional appearance. This was particularly apparent in the Post Office Savings Bank building in Vienna (1904–6), the furniture for which was manufactured by *Thonet and was characterized by a simplicity of form. His role as an influential figure in the development of modern architecture and design was consolidated in his 1896 book *Moderne Architektur* which stressed the need for function, practical construction, and new materials. His position as head of architecture at the Vienna Academy in 1894 was also important in this respect, having taught Josef *Hoffmann and other young avant-garde figures. Both Hoffmann and Joseph *Olbrich also worked in Wagner's architectural office in the mid-1890s.

Wagner, Sherle (1917–97) Widely renowned as a designer of extravagant and glamorous bathrooms, Sherle Wagner grew up in New York, studying architecture in the 1930s. In 1945, with his wife Rose, he opened a shop in 1945 which sold bedroom and bathroom fittings. Through his vision as a designer he was soon able to capitalize on the absence of design which catered for the luxury end of the bathroom market, one that in the post-war years was generally characterized by functional, economical, mass-produced products. Beginning with a 24-carat gold-plated dolphin spout, Wagner moved on to the design of hand-painted basins, semi-precious stone embellished taps, gold-plated lavatory seats, carved marble fittings, and lighting. As a result, he built up an affluent New York client base which soon spread to the West Coast and, rather later, Europe. Initially, his designs were produced by European craftsworkers although later he set up production capacity in the United States. By the 1950s the business had expanded considerably, with the employment of sales

representatives and the advertising of his bathroom fittings and fixtures in fashionable magazines as a means of bringing his products to the attention of interior decorators and architects. His clients included Frank Sinatra, President Kennedy, King Hassan of Morocco, and the Saudi Arabian millionaire Adnan Khashoggi. In the 1960s and 1970s clients ranged from the extremely wealthy to the middle classes, although in the following decade the luxury bathroom market place became considerably more competitive. In 1989 the company was sold to Masco.

Walker, George W. (1896–1993) The status of this leading American car designer at the *Ford Motor Corporation after the Second World War was confirmed by his appearance on the cover of *Time* magazine in 1957, like the famous American industrial designer Raymond *Loewy eight years earlier. Responsible for such significant models as the 1949 Ford and the classic 1955 Ford *Thunderbird*, Walker was made a company vice-president and director of styling in 1955. His significance at Ford could be compared with Virgil *Exner's at *Chrysler or even Harley *Earl's at *General Motors. Walker had attended the Cleveland School of Art and the Otis Art Institute of the Parsons School of Design before embarking on a career as an art director in Cleveland. He then moved to Detroit, establishing an independent design consultancy for which, amongst a wide range of industrial products such as radios and refrigerators, he designed a number of details that were sold to Henry *Ford in the early 1930s. However, his relationship with the Ford Motor Corporation did not develop seriously until after the Second World War, when he was invited to comment on the company's proposed designs for the 1949 Ford. He felt that they were uncommercial

and put his own proposals forward a few months later. Walker is generally credited as the mainspring behind the styling of the 1949 Ford, a model that is widely acknowledged as one that had a significant positive effect on the Ford profile and profitability. He also headed the team that designed the 1950 Lincoln, the 1951 Mercury, and the 1952 Ford with its characteristic circular rear lights. Inspired by the European sports cars that he had seen at the 1953 Paris Auto Show of 1953 he produced the classic Ford *Thunderbird* in 1955. His design team at this time included Elwood Engel (later moving to the Chrysler Corporation as head of design from 1961 to 1974), Joseph Oros, and George Bordinat. Walker retired from Ford in 1961 although his contribution to design was far wider than automobiles, his Detroit design consultancy also working on more than 3,000 designs, including watches, washing machines, radios, refrigerator, and alarm clocks.

Waring & Gillow (established 1727) The roots of this furniture-making and retailing company are located in the 18th century when the Gillows firm was founded (in 1727) in Lancaster by Robert Gillows, a joiner. In order to market its products London showrooms and a warehouse were established, and a distinguished clientele built up. During the 19th century, although producing furniture in a variety of historical styles, the firm also commissioned furniture from well-known contemporary designers, including T. E. Collcutt and B. J. Talbert. In 1897 Gillows was absorbed by Collinson and Lock, soon afterwards being amalgamated with S. J. Waring & Son to become Waring & Gillow.

In the early years of the 20th century the new company catered for a wealthy clientele through the kind of furniture seen in the Chinese Lacquer and Neo-Georgian

room settings at the *British Empire Exhibition of 1924. From the later 1920s the company assumed a more progressive edge through its embrace of a more contemporary European aesthetic. This was brought about largely by the Russian emigré architect and designer, Serge *Chermayeff who, after marrying into the controlling family, was appointed director of the firm's Modern Art Studios. He collaborated with the French designer Paul Follot to mount a large-scale exhibition of *Modern Art in Decoration and Furnishing* in the London showrooms in 1928. It found particular favour in an editorial in the *Architectural Review* and, from this time until the outbreak of the Second World War, Waring & Gillow became recognized for its promotion of modern furniture design and interior decoration.

In the post-war years the furniture trade became increasingly competitive with the advent of retailing concerns such as *Habitat and the later proliferation of out-of-town warehouse outlets. In the light of such competition Waring & Gillow's position in the market place became increasingly problematic until its eventual demise in 1997.

Watanabe, Riki (1911–) An influential figure in the emergence of Japanese industrial design in the post-Second World War years, Watanabe played a key role in professional practice, education, and promotion. He was a member of staff on the government-funded *Industrial Arts Institute from 1936. From 1940 he also taught at the Tokyo College of Industrial Arts from which he had graduated some years earlier. After the Second World War he founded his own design studio in 1949, renamed Q Designers in 1955. An early design of significance was his *Rope* chair of 1952, a low-cost item of furniture that struck a balance between Japanese traditions (low-level seating and

natural materials) and a contemporary aesthetic. He was also a founding member of the *Japan Industrial Designers Association (JIDA) in 1952 and, with other pioneering contemporaries (including Masaru *Katsumie, Isamu *Kenmochi, Yusaku *Kamekura, and Sori *Yanagi) was also involved in the formation in 1953 of the International Design Committee. (This later became the Good Design Committee (1959) and then the Japan Design Committee (1963).) This body sought to encourage links with overseas design organizations alongside participation in conferences and exhibitions. An original, though unsuccessful, objective of the Committee had been to0 enable Japanese participation in the *Milan Triennale of 1954. However, at the 1957 Triennale Watanabe was awarded a Gold Medal, showing his *Torii* stool. Manufactured by the Yamakawa Rattan Company, the stool (like his earlier *Rope* chair) reconciled traditional forms (from the *torii* entrance gates at Shinto shrines) and techniques with a contemporary aesthetic. In his bench made by *Tendo Mokko in 1960s, Watanabe explored a similar design solution that drew on forms derived from Shinto architecture, the Japanese penchant for natural materials, and a crisp, undecorated appearance that was also visually in tune with the later manifestations of the *International Style. In 1956 he had been one of thirteen Japanese designers invited by the International Cooperation Administration (affiliated to the US Department of Commerce) to study industrial design in the USA, visiting design consultancies, art and design colleges, and manufacturers over a two-month period, including the General Motors Technical Center and a mock-up by Walter Dorwin *Teague Associates of the interior of a Boeing 707 airliner. In addition to his Gold Medal at the 1957 Milan Triennale, Watanabe was awarded the *Mainichi

Design Prize in 1967, the order of the Rising Sun in 1984, and the Kunii Industrial Art Award in 1992.

Webb, Philip (1831–1915) A leading figure in the British *Arts and Crafts Movement, Webb was an architect and designer in many fields including furniture, interiors, glass, silver, jewellery, stained glass, and lettering. In addition to playing a central role in progressive design circles in the latter half of the 19th century he was admired by a contemporary analyst of the British Arts and Crafts, the German writer, educator, and design theorist, Hermann *Muthesius. After early training in architecture, including a period commencing in 1854 under the Gothic Revivalist George Street in Oxford, Webb was drawn to the writings of John *Ruskin, a major source of inspiration for arts and crafts thinking. He also met William *Morris, a fellow member of Street's office, and became a close friend for life. After a trip to France with Morris in 1858 he established his own architectural practice. In the following year he designed Morris's new home, the Red House in Bexley Heath, drawing on English *Vernacular traditions encountered when working for Street. Again looking to the vernacular, he also designed furniture for the Red House. In 1861 Webb joined the newly founded firm of Morris, Marshall, Faulkner & Co. (*see* MORRIS & CO.) going on to design a sideboard, bedstead, and a washstand for the company's showing at the International Exhibition in London in the following year. He also designed a number of interiors, including the Green Room at the *Victoria and Albert Museum in 1967, the same year in which he was made consulting manager of the Morris firm. Among Webb's more important architectural designs was Standon (1891), a substantial country house in East Sussex. He had continued to design

W

furniture since the 1850s, often for his own houses and was well known to many arts and crafts designers as a friend and adviser. He retired in 1900.

Weber, Kem (Karl Emanuel Martin) (1889–1963) Weber was an important figure in the dissemination of modern design in the USA in the interwar years. Born in Berlin he was apprenticed to a cabinetmaker in Potsdam in 1904 before studying at the Berlin School of Applied Arts from 1908 to 1912 where he worked under Bruno *Paul. Rather than taking up the offer of a job with Paul *Poiret in Paris in 1914 he chose to work on the German Section for the Panama-Pacific Exposition in San Francisco of 1915, the outbreak of war forcing him to remain in the United States. In the 1920s he became increasingly influential in the promotion of contemporary European ideas in America, working as artistic director for Barker Brothers Furniture Company in Los Angeles, designing furniture, interiors, and packaging. Having become a US citizen in 1924, he subsequently opened an office and studio in Hollywood in 1927. The most important designer promoting European *Modernism on the West Coast of America, he was also the West Coast representative of the *American Union of Decorative Artists and Craftsmen (AUDAC), exhibiting at its New York Exhibitions of 1930 and 1931. In 1933–4 he also designed film sets for Paramount and tubular steel furniture, as well as his knockdown streamlined *Airline* lounger seat which, although it was ordered by many stores, was never put into mass production. He also worked on a series of streamlined designs, including clocks for Lawson Time Inc. After the Second World War he concentrated on architectural projects rather than industrial design.

Wedgwood, Josiah *See* JOSIAH WEDGWOOD & SONS.

Wegner, Hans J. (1914–) After an early career as a cabinetmaker Wegner trained at the Institute of Technology in Copenhagen in 1936, transferring to the city's School of Arts and Crafts to study furniture in the following year. From 1938 he worked as an assistant to architect-designer Arne *Jacobsen and Eric Møller, before launching his own design practice in 1943. It was in the late 1940s that Wegner began to establish his reputation as a designer-maker with a series of wooden chairs for the Copenhagen furniture manufacturer *Fritz Hansen that reworked traditional designs in a modern idiom. Typifying this were the *Chinese* armchair (1945), drawing on 16th- and 17th-century precedents, the *Peacock* chair, a contemporary reinterpretation of the Windsor chair first seen at the Copenhagen Cabinetmakers' Guild exhibition of 1947, and the *Round* chair (1949) which looked to earlier designs by Danish furniture maker Kaare *Klint. Wegner's reputation as one of the emerging figures of the *'Danish Modern' movement was reflected in his being awarded the first *Lunning Prize in 1951. He lectured at the Copenhagen School of Arts and Crafts from 1948 until 1953 and, in addition to furniture design, has also worked in wallpaper, metalware, and lighting. In 1957, at the XI *Milan Triennale, he was awarded the Grand Prix.

Wendingen (1918–31) Under the editorship of Theo van der Wijdeveld, in its early years this Dutch magazine was an important propagandist for the designer-architects of the *Amsterdam School, particularly Michel De Klerk, to whom it dedicated three issues as a memorial following his death in 1923. However, it was not until the early 1920s that the periodical assumed any real international significance through its links with Erich Mendelssohn and Berlin Expressionism, later followed by an issue

on Eileen *Gray (1924) and a double-issue devoted to the work of Frank Lloyd *Wright in 1925. The layout of the magazine underwent a number of changes, reflecting a move away from the more decorative aesthetic ideas of the Amsterdam School towards the more rectilinear and austere qualities of the international phase of De *Stijl in its later years before folding in 1931.

W. Gispen & Co. (established 1916) This metalworking firm was founded by Willem Gispen (1890–1981) in Rotterdam in 1916 and was involved in the production of ornamental metalwork for architects. From 1919 the company diversified into furniture and other domestic artefacts which were sold in Gispen's shop *Het Gulden Vlies* (The Golden Fleece) together with the work of other designers. He became increasingly interested in modern design and, in the 1920s, moved away from individual one-off designs towards the serial production of modern functionalist lights sold under the trade name of *Giso*, first registered in 1927. He also began to manufacture modern tubular steel furniture from 1929, by which time his company was employing about 100. This had been given extra impetus by large commission for the striking *Modernist Van Nelle factory in Rotterdam, designed by L. C. Van Der Vlugt. In the 1930s the company went on to produce a wide range of steel plate furniture. Gispen had been a founder-member of the Rotterdam group of avant-garde architects and designers, Opbouw and was concerned to present a concerted Modernist corporate identity for his company, complementing the contemporary lighting and furniture ranges with up-to-date publicity materials and printed ephemera. To this end he employed Jan Kammen from 1928 to 1934 and Paul Schuitema in 1930.

Wiener Werkstätte (1903–32) Josef *Hoffmann and Koloman *Moser, financially backed by the wealthy industrialist Fritz Wärndorfer, founded the Wiener Werkstätte (Vienna Workshops) in June 1903. Inspired by the outlook of William *Morris, John *Ruskin and C. R. *Ashbee's Guild of Handicraft that had been founded in England in 1888, the Austrian roots of the Wiener Werkstätte lay in the late 19th-century Secessionist movement. Its ideals were promoted in the periodical *Ver sacrum* and the Secession Exhibitions (which in 1900 included work by C. R. *Mackintosh and Ashbee that impressed through its simplicity of form). Vigorously opposed to the intrinsically conservative outlook of the art establishment the Secession also embraced the applied arts. Wiener Werkstätte products included metalwork, glass, ceramics, furniture, wallpaper, graphics, dress, and jewellery and, in the early years, were characterized by geometric motifs and abstract patterns. Typifying this was the distinctively rectilinear Werkstätte *logotype thought to have been designed by Koloman Moser in 1903. Superficially, such qualities might be seen to parallel the standardized forms of contemporary German design in its search to find modern product types that were aesthetically compatible with 20th-century manufacturing technology. However, although the Werkstätte employed more than 100 workers by 1905, its largely handcrafted products were inevitably expensive and remained the preserve of a wealthy clientele, despite the original intentions of its founders who had sought to produce good, simple designs for the home. Other designers involved with the earlier years of the Werkstätte included Carl Czeschka, Otto Prütscher, Berthold Löffler, and Michael Powolny. By about 1915 there was a shift away from the rectilinear abstraction favoured by Moser and

Hoffmann towards a more florid, curvilinear, and marketable style influenced by Dagobert Peche, who directed the Werkstätte from 1910 to 1923. After the First World War, perhaps reflecting the traditional percentages of women training and working in the applied arts, many women also designed for the Werkstätte. Typifying this trend was Vally Wieselthier, who designed textiles, glass, wallpaper and ceramics, winning gold and silver medals at the 1925 Paris Exposition des Arts Décoratifs et Industriels. Although new retailing outlets were opened, including one on Fifth Avenue, New York, the Werkstätte were disbanded in 1932 in the difficult economic climate which followed the Wall Street Crash of 1929.

Wirkkala, Tapio (1913–85) Acknowledged internationally as one of Finland's leading designers Wirkkala was originally trained as a sculptor in Helsinki from 1933 to 1936. However, although the Second World War interrupted his early career as a sculptor and graphic designer in 1946 he won a glass competition run by the *Iittala company, the same year in which he also won a competition to design banknotes for the Bank of Finland. He attracted particular attention at the IX *Milan Triennale in 1951 where he gained three Grand Prix, a success that he followed up in the X Triennale of 1954, where he again won three Grand Prix, and the XII Triennale of 1960 where he was awarded a Grand Prix and a Gold Medal. His reputation was also established in Scandinavia where (with Hans *Wagner) he had been awarded the first *Lunning Prize for design in 1951. During the 1950s he became widely recognized for his organic, flowing designs in glass and ceramics, characteristics which had been signalled with his *Kantarelli* vase series of the 1940s and 1950s. In 1954 he went to the United States, where he

worked with Raymond *Loewy Associates in New York, studying American methods of mass production. The diversity of his design activity extended across many fields, including lighting and cutlery. From 1956 until his death he worked for the German ceramics company *Rosenthal, also designing for the *Venini glass company from the late 1950s onwards.

WMF (Württembergische Metallwarenfabrik, established 1853) The origins of the metalware manufacturing WMF company lay in the formation in 1853 of the firm Metallwarenfabrik Straub & Schweizer. Most early designs for the company looked to past historical styles although early recognition of the quality of its products included the award of a Gold Medal at the 1862 International Exhibition in London. The company showroom, established in Berlin in 1868, was its first retailing outlet and marked the beginnings of a rapid development in scale. By 1880, when the company merged with Ritter & Co. to form the Württembergische Metallwarenfabrik, the company employed about 200 and had a range of nearly 1,000 products, many of them electroplated. In the late 19th century the company was also involved in architectural decoration, ornaments for the home and replicas of works of art and archaeology, including the reproduction of Lorenzo Ghiberti's famous early Italian Renaissance doors from the Baptistry at Florence, now on show at the company's headquarters in Geislingen. In 1883 the company established a crystal and glass studio.

In the 20th century the company continued to expand at home and abroad, with subsidiaries in Britain, Poland, and Austria. Design was an important ingredient in the company's success, whether in terms of *Art Nouveau styling or *Art Deco. Art Nouveau designs for the company were

generally produced in the company's design studio, under the direction of Albert Mayer between 1895 and 1915, although work was also commissioned from Peter *Behrens and Hans Peter. There were opportunities for artist-designers to experiment as an alternative to mass production, not least through the establishment of WMF's Contemporary Decorative Products Department (NKA) under the direction of Hugo Debachin (1925). Catering for a design-conscious clientele, NKA commissioned work from a number of leading designers including Richard *Riemerschmid. The NKA also oversaw innovations in glassware design, particularly coloured glass including the *Ikora*, *Myra*, and *Lavaluna* brand names. In 1927 WMF gained the rights from Krupp to use Cromargan, a registered name for stainless steel, launching its Cromargan cookware range at the 1927 Leipzig Trade Fair, followed later by Cromargan cutlery. The Contemporary Decorative Products Department (NKA) was enhanced be the addition of a ceramics workshop in the mid-1930s.

The rupture of the Second World War caused considerable difficulties in the early reconstruction period and brought about the closure of the NKA (Contemporary Products Department) but, by the early 1950s, the company was again flourishing. Many WMF designs by Wilhelm *Wagenfeld stem from these years, well known amongst them being the highly popular *Max and Moritz* salt and pepper pots. Such designs reflected the influence of Scandinavian design as well as German *Modernism in the company's cutlery and tableware design. Typifying the work of this period were Kurt Mayer's organic *Stockholm* cutlery designs. Over the following decades there was increasing development in international markets and, in 1977, WMF's computer-controlled Warehouse and Distribution Centre was launched, an initiative which, by the later 1990s, allowed retail outlets to order directly from the factory and review stock and orders. In 1985 the *Galleria* range of domestic products was launched, including silverplated and stainless steel tableware, glassware, ceramics, and culinary equipment, much of it *Postmodern in appearance. Collaborating designers have included Matteo *Thun, Pierre Cardin, Garouste & Bonetti (*Volute* cutlery), Dieter Sieger (including coffee machines, kitchen knives), Mario Vivaldi (*Esprit*, *Moda*, and *Solo* cutlery) and Maiko *Hasuike (*Topstar* stacking cookware range and *Zeno* cafetière). Amongst the company's more widely celebrated cutlery products of the last decades have been Thun's black and gold *Hommage à Madonna*, *Candy*, and *Fantasia* ranges, together with Hasuike's *Grand Gourmet* all-metal kitchen knives.

Wolff Olins (established 1965) A leading British design consultancy for almost four decades with particular prominence in the fields of *corporate identity and branding, Wolff Olins has offices in London, Madrid, Lisbon, New York, San Francisco, and Tokyo. It is part of the Omnicom Group. Founded by Michael Wolff and Wally Olins in London, the latter in particular has done much to define publicly the discipline of corporate identity design and has published several books on the field. In these texts he made it clear that successful corporate identity work is about much more than *logotypes and visual imagery, rather embracing a wider and deeper understanding of individual corporate business practices, patterns of behaviour, and aspirations. The consultancy's identity strategy clients have included the Q8 oil company (1984), British Telecom (BT, 1984), Orange telecommunications (1994), *Honda, *Renault, the Heathrow Express train (1998), the

*Victoria and Albert Museum and the Tate Gallery (1998 onwards). Wolff Olins's clients are drawn from many fields including automotive manufacture, business and financial services, consumer goods and services, the cultural industries, education healthcare, manufacturing industry, information technology and media, and transportation. Wolff Olins's programme of brand management of BT typified the consultancy's approach to corporate identity, bringing about changes to BT's culture and its relationship with the public it serves. Such an approach has been carried through in most aspects of the company's work including the Portuguese Tourist Board, the 2004 Athens Olympic Committee, the South West Development Agency, the North Staffordshire Design Initiative (2003), and the World Gold Council. The kind of impact that Wolff Olins's identity work can generate is exemplified by its work for the Tate Gallery that began in 1998 with the aim of developing a new brand that would bring together its collections, three existing sites, and a fourth site that would open in 2000. This resulted in the 'Tate' brand and the four galleries: Tate Britain, Tate Modern, Tate Liverpool, and Tate St Ives. The newly branded Tate had 7.5 million visitors in its first year 2000–01, an increase of 3.5 million on the previous year.

Wright, Frank Lloyd (1867–1959) Widely celebrated as one of the most influential American architects of the 20th century, Wright also played an important role as a furniture designer and design theorist. After studying engineering at the University of Wisconsin (1885–7) in 1888 he joined the architectural office of Louis *Sullivan, an influential figure in the development of *Modernism in architecture and design. In 1893 Wright established his own practice and began to evolve his principles of organic architecture in a series of low, horizontal, asymmetrically planned houses. Commissioned between the 1890s and early 1900s they became known as the Prairie School style on account of their influence on many of Wright's American contemporaries working in the Midwest. In 1897 Wright became a founder member of the Chicago Arts and Crafts Society, reflecting an outlook which influenced many of his early furniture and interior designs although, unlike many associated with the *arts and crafts, he was more unequivocally committed to ideas of machine production. This was particularly evident in the rectilinear metal office furniture for his Larkin Company Administration Building (1904) in Buffalo, New York. The painted metal desks and swivelling chairs were conceived as integral both to the aesthetic and function of the building as whole. In 1909 he went to Europe, where he was influenced by first-hand experience of Viennese and other avant-garde European design which he had for the most part previously encountered in published form. This was perhaps reflected in his abstract rectilinear stained glass designs for the Avery Coonley Playhouse (1912) and the lighter, more geometric forms of his furniture for the Little House in Wayzata, Minnesota (1913). However, Wright's influence was also felt in Europe, as in the work of Hendrik Berlage and Gerrit *Rietveld. The ways in which he sought to unify designs from building to detail was evident in his Imperial Hotel, Tokyo (1915–22), where he designed everything from furniture to tableware. A different aesthetic, though still essentially organic, approach was evident rather later in his career, as at the Johnson Administration Building in Racine, Wisconsin (1936–9), for which he designed painted aluminium and steel furniture that embraced, like its

architectural surroundings, something of the quality of contemporary streamlined forms. In 1955 Wright sought to capture new, essentially middle-class, markets with his *Taliesin Line* furniture (named after his homes in Arizona and Wisconsin) for the Heritage Henredon Company of North Carolina. Similarly, in the same year, a *Taliesin Line* series of thirteen Wright textiles and four wallpapers was manufactured in a variety of colours by the New York firm F. Schumacher & Co. Elizabeth Gordon, editor of *House Beautiful*, has been credited with the idea for the scheme when preparing an issue of the magazine devoted to Wright's work. However, the *Taliesin* range failed to sell in large quantities. Nonetheless, Wright's influence on 20th-century design and architecture was profound, both in terms of practical work and his many writings.

Wright, Russell (1904–76) From the 1930s onwards Wright was both a leading promoter of a *Modernist aesthetic in the United States and advocate of a more informal way of living. He studied at the Cincinnati Academy of Art in 1921, followed by a brief period at the Art Students League in New York, then Princeton University to study law. After leaving early, he became involved in theatre design in 1924 but, following his marriage in 1927, he moved into mainstream design. Early projects included a range of spun aluminium household items that were successfully promoted in department stores and trade shows. He exhibited at the Metropolitan Museum of Art's annual exhibition of Contemporary American Industrial Art of 1934, the attention bringing him a number of commissions. These included radios and instruments for the *Wurlitzer Company (1932), products in chromium-plated brass for the Chase Brass Company (1930s–1944), and

furniture for the Heywood-Wakefield Company and the Conant Ball Company (the *Modern Living* and *Blonde Modern* ranges of 1935 and 1936). In 1935, in association with his wife and businessman-designer Irving Richards, he established Russell Wright Associates. An early company success was the *American Modern* dinnerware, designed in 1937 and manufactured by the Steubenville Pottery Company from 1939 to 1959, one of the best-selling services ever put into production. Wright's design for informal 'modern living' was organic yet functional and shared qualities with Scandinavian work of the period. Wright remained keen to promote an American version of Modernism, hoping to further this ideal through the launch of a modern homes furnishing scheme entitled the *American Way*. Seeking to demonstrate the vitality of American design, whether craft or mass produced, he selected work by leading American artists, craftsmen, designers, and manufacturers, and his travels took him across the USA to source items for the scheme. Chosen products were displayed as model room ensembles in department stores across America in order to suggest to consumers the ways in which they might combine products and further a particular 'lifestyle'. Despite a promising start the scheme was abandoned in 1942, beset with difficulties of supply and quality control. Wright's better-known design ranges after the Second World War included the *Casual China* range, manufactured by the Iroquois China Company (from 1946), the *Residential* plastic dinnerware manufactured by Northern Industrial Chemical (1953), and the colourful school furniture manufactured by the Schwayder Corporation (1955).

Wurlitzer (established late 1800s) Celebrated for its classic jukebox designs of the

1930s and 1940s this American company began life in the closing years of the 19th century as a manufacturer of pianos. It soon moved into the production of coin-slot record players and, as film-going became increasingly popular, cinema organs. After the 1929 Wall Street Crash, Wurlitzer diversified into jukeboxes and refrigerators, producing its first jukebox in 1934 (the ten-selection *Model-P10*) and appointing Paul *Fuller as its chief designer in 1935. It soon became the leading company in the field, despite strong competition from Seeburg, AMI, and Rock-Ola. During the thirteen years that Fuller remained with the company Wurlitzer designs were characterized by their adoption of theatrical lighting effects (such as those generated by 'bubble tubes', colour filters, and polarized film), coloured plastics, and chromium detailing. Amongst the classic models of these years were the *312* (1936), the arch-topped *750 Peacock* (1941), and the highly popular *1015* (1946). The latter was the most commercially successful jukebox ever, selling more than 56,000 units in the first eighteen months after its launch. Its key visual design characteristics provided the basis for new models in the heritage and nostalgia-rich 1980s, including the *One More Time* CD jukebox, the internal workings of which were computerized rather than the much older gramophone technology of the pre-Second World War 'golden age' of jukebox production. By the 1960s jukeboxes were no longer fashionable, leading to the company ceasing production in the USA, although its German subsidiary has continued to manufacture them.

Württembergische Metallwarenfabrik *See* WMF.

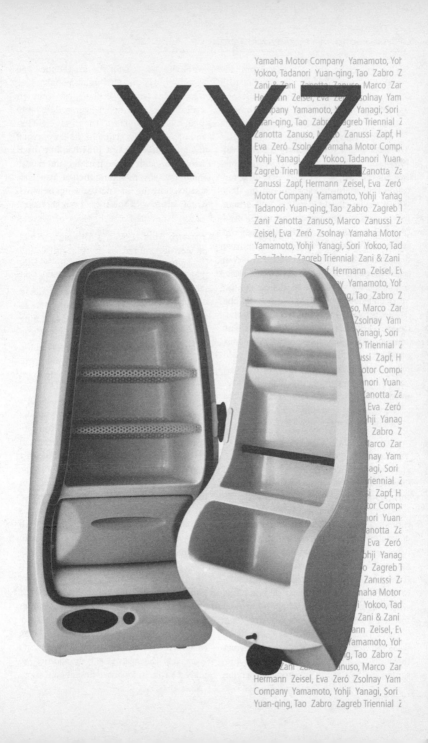

XYZ

Yamaha Motor Company Yamamoto, Yo
Yokoo, Tadanori Yuan-qing, Tao Zabro Z
Zani & Zani Zanotta Zanuso Marco
Hermann Zeisel, Eva Zeró Zsolnay Yam
Company Yamamoto, Yohji Yanagi, Sori
Yuan-qing, Tao Zabro Zagreb Triennial Z
Zanotta Zanuso, Marco Zanussi Zapf, H
Eva Zeró Zsolnay Yamaha Motor Compa
Yohji Yanagi, Sori Yokoo, Tadanori Yuan
Zagreb Trien Zanotta Za
Zanussi Zapf, Hermann Zeisel, Eva Zeró
Motor Company Yamamoto, Yohji Yanag
Tadanori Yuan-qing, Tao Zabro Zagreb T
Zani Zanotta Zanuso, Marco Zanussi Z
Zeisel, Eva Zeró Zsolnay Yamaha Motor
Yamamoto, Yohji Yanagi, Sori Yokoo, Tad
Tao Zabro Zagreb Triennial Zani & Zani
 f Hermann Zeisel, Ev
 y Yamamoto, Yoh
 ng, Tao Zabro Z
 so, Marco Zar
 Zsolnay Yam
 Yanagi, Sori
 o Triennial Z
 ussi Zapf, H
 otor Compa
 nori Yuan
 Zanotta Za
 Eva Zeró
 ohji Yanag
 Zabro Z
 Marco Zar
 lnay Yam
 agi, Sori
 riennial Z
 si Zapf, H
 tor Compa
 nori Yuan
 anotta Za
 Eva Zeró
 ohji Yanag
 o Zagreb T
 Zanussi Z
 aha Motor
 Yokoo, Tad
 Zani & Zani
 ann Zeisel, Ev
 amamoto, Yoh
 g, Tao Zabro Z
 anuso, Marco Zar
Hermann Zeisel, Eva Zeró Zsolnay Yam
Company Yamamoto, Yohji Yanagi, Sori
Yuan-qing, Tao Zabro Zagreb Triennial Z

Yamaha Motor Company (established 1955) The company was established in the wake of the Yamaha Corporation's diversification into motorcycle production in 1954 with a model closely based on the German DKW design. Presaging the company's future design success in the field was the compact Yamaha 250cc YD-1 motorcycle designed by Shinji Iwasaki and *GK Industrial Design Associates with design characteristics that were not so dependent on European design precedents. By 1962 the company was exporting 12,000 motorcycles, rising to 87,000 in 1964. The company also developed other specialist products, including powerboats, outboard motors, automobile engines, industrial machinery, and snowmobiles and has factories in more than 45 countries. Today it is the second largest manufacturer of motorcycles in the world.

Yamamoto, Yohji (1943–) Yamamoto clothing is often characterized by its use of washed, unironed fabrics, loose uncluttered forms, and dark colours. Its occasional combinations of Japanese and Western, traditional and contemporary references is characteristic of *Postmodernist bricolage. After graduating in law from Keio University in Tokyo in 1966 Yamamoto studied for three years at the Fashion Culture Institute. In 1969 he won the Endo design prize, which took him to Paris where he worked for two years in the couture industry. Once back in Tokyo he established Y's ready-to-wear for women in 1972; Y's ready-to-wear for men was launched in 1977. He presented his first Yohji Yamamoto collection

in Paris in 1981 and in 1984 his first Yohji Yamamoto pour Homme collection. Yohji Yamamoto+Noir was launched in 1995 and its clothing, as the name suggests, is largely black with splashes of bright colour.

Yanagi, Sori (1915–) Although he had previously trained as a fine artist and worked in an architectural studio, Yanagi went on to study industrial design in 1947. In 1952 he opened his own design studio in Tokyo, the Yanagi Design Institute, and attracted attention with his award-winning record player radio design for Nihon-Columbia. This was a prizewinner at the first *Mainichi Industrial Design Competition of 1952. As one of the first generation of Japanese industrial designers he continued to attract attention for designs in a wide range of media, from furniture to domestic products. He explored the combination of Japanese and Western traditions in his elegant plywood and metal butterfly stool (1956) and the possibilities of modern materials blended with elegant forms as in his stainless steel and *Bakelite water jug for the Uehan Shoji Company (1958). His reputation was further underlined with the award of a Gold Medal at the *Milan Triennale of 1957 and a prestigious *G-Mark Prize in 1958 for his aluminium *Speed* kettle for Nikkei. He played an important role in the consolidation of the emerging design profession as a founder member of Japan Industrial Designers Association in 1952, also writing widely on design including his book *Sori Yanagi's Works and Philosophy* (1983). In addition he played a role in Japanese design education,

teaching at the Women's Art College, Tokyo (1953–4), and the Kanazawa University of Arts and Crafts. Later in life, in 1977, he became director of the Japan Folk Crafts Museum in Tokyo.

Yokoo, Tadanori (1936–) Japanese graphic designer, art director, and fine artist Yokoo has become internationally recognized for his striking designs for posters, record covers, postage stamps, and illustrations. After an early interest and involvement in manga comics he joined the Japanese graphic design group *Non* in 1957, entering the *Nippon Design Centre in 1960. He promoted a design outlook that was in marked opposition to the rather ascetic *Modernist aesthetic that had been favoured by many designers in the 1950s, exploring the strident and colourful imagery of Western popular culture and combining it with Japanese sources and sensitivity. He became an important figure in Japanese *Pop in the 1960s and established two graphic design studios, Studio Illfill (1964–5) and The End Studio (1968–71). In 1967 fifteen of his posters were included in the permanent collection of the *Museum of Modern Art in New York. In the same year he was also featured in *Life* magazine and was commissioned to design a banner and poster for the MOMA *Word and Image* exhibition. In the 1970s his reputation grew further with one-man shows at MOMA (1972) and the Stedelijk, Amsterdam (1974). He also designed the Textile Pavilion for Expo '70 in Osaka and collaborated with the fashion designer Issey *Miyake on printed textiles such as the *Paradise* and *Paradise Lost* images for the latter's Spring-Summer Collection of 1977. He also designed interiors such as that for the Arabian restaurant at the Tapei Ritz Hotel in 1979. His clients have been wide-ranging and have included department stores such as Sibu, Matsuya, and Takashimaya as well as industrial corporations such as Toshiba and Seiko for whom he designed six watches in 1998. Since the 1980s Yokoo has been very active in the fine arts arena.

Yuan-qing, Tao (1893–1929) An influential figure in 20th-century Chinese graphic design, Shanghai designer Tao Yuan-qing drew heavily on traditional motifs drawn from a wide range of indigenous Chinese historic sources. His work of the 1920s included the book *Token of Depression* (1924) and *Wandering* (1929), a collaboration with the writer Lu Xun (1883–1936) that began with the cover for *Depressed Symbol* (1924). Lu Xun did much in the 1920s and 1930s to promote Chinese graphic design and was knowledgeable about Western art and design, especially the work of the German Expressionists. A blend of the Western and the indigenous was apparent in Tao Yuanqing's flat, almost primitively conceived designs for book covers and magazines, characterized by the limited colour range and wood-block like forms for his 1926 cover for *Hometown*, edited by Lu Xun and published in Beijing.

y

Zabro (established 1983) *See* ZANOTTA.

Zagreb Triennial (Zagrebacki Trienale, 1955–9) The Zagreb Triennal exhibitions of the 1955s reflected the utopian ambitions of Croatian designers whose progressive ideas generally failed to capture social or commercial enthusiasm. This was also the case in the wider design climate in Eastern Europe in the decades following the end of the Second World War when state manufacturers, planned economies, and market monopolies were key drivers of the economy. Such a climate was evidenced in Croatia at the beginning of the decade by the failure of the Academy of Applied Arts (Academija za Primijenjenu Umjetnost, 1950–4) to realize its functionalist and multidisciplinary agenda in a brief existence cut short by political intervention. The first Zagreb Triennial of 1955, organized by Vjenceslav Richter, reflected something of the approach embraced by the Academy of Applied Arts, brining together a wide range of design disciplines, including both the applied arts and industrial design, alongside the fine arts. Its displays endorsed a commitment to design for modern life. However, the design prototypes that were on display remained statements of intent rather than products that were to be put into mass production. The difficulties facing progressive design were reflected in the fact that the second—and last—Zagreb Triennial was held in 1959, four years after the first and was similarly unable to convince manufacturers or society of the relevance of modern design. In the 1960s the Triennial was reformulated as the Zagreb Salon (Zagrenabacki Salon).

Zani & Zani (established 1936) A leading Italian manufacturer of kitchen utensils and tableware, Serafino Zani founded the company under the Zani name in 1936. Building on craft traditions in cutlery making the firm extended its repertoire to include flatware and other tableware in 1960, subsequently establishing a reputation for elegant designs in stainless steel, a medium in which it began to specialize in the late 1970s. Amongst well-known designers commissioned by the company have been Tapio *Wirkkala, Bruno *Munari (*TMT* ice bucket, 1954), Lino Sabattini, Enzo Mari (*Smith & Smith* kitchen product range, 1987), and Gaetano *Pesce (the dramatic *Vesuvio* cafetiere, 1993).

Zanotta (established 1954) One of the leading furniture manufacturers in Italy since the Second World War, Aurelio Zanotta's company began to establish a reputation for modern design in the late 1950s. By the middle of the following decade it began a policy of commissioning avantgarde furniture from designers such as Gae *Aulenti, Achille and Piergiacomo *Castiglione, Ettore *Sottsass, and Alessandro *Mendini. An early innovative design was the *Blow Chair* seen at the *Eurodomus 3* exhibition in Turin in 1967. Designed by Jonathan De Pas, Donato D'Urbino, Paolo Lomazzi, and Carla Scolari, this inflatable chair reflected the interest of experimental designers in the informality of *Pop, which had made such an impact at the 1964 Venice Biennale. The highly successful 1968 *Sacco* beanbag, designed by Piero Gatti, Cesare Pollini, and Franco Teodoro, was even

more casual in intent. Zanotta also manufactured avant-garde designs from earlier periods including the *Mezzadro* tractor seat (1970), originally designed by the Castiglione brothers in 1957, and the *Larianna* tubular steel chair by Giuseppe *Terragni (1982), originally designed for the Casa del Fascio in Como in 1936. Other celebrated designs have included the *Gaetano* glass table (1973) by Gae Aulenti, the coatstand (1974) by De Pas, D'Urbino, and Lomazzi, the *Tonietta* chair (1986) and *Novecento* cabinet (1994) by Enzo Mari. In 1983 Zanotta established an experimental division under the direction of Alessandro *Mendini and Alessandro Guerriero for the production of furniture. Amongst the work produced by Zabro were the *Dorifora* chair (1984) by Mendini and the *Families of Objects for Domestic Animals* furniture (1986) by Andrea *Branzi.

Zanuso, Marco (1916–) The eminent Italian architect and designer Zanuso was a leading figure in 20th-century Italian industrial design, both in terms of practice and theory. Born in Milan, he studied architecture at the Polytechnic (1935–9) and set up an architectural office after the Second World War. He also served as co-editor of *Domus* magazine (1946–7) and editor of *Casabella* magazine (1947–9), during which time he began working as an industrial designer. This included the design of a tubular metal chair for the 1948 Low Cost Furniture Competition (*see* DAY, ROBIN) at the *Museum of Modern Art, New York. In 1950 he was commissioned for experimental furniture designs using foam rubber newly developed by the Pirelli Company, underlining his career-long interest in the relationship between form and technology. The successful outcome of this work led to the formation of the Arflex Company as a subsidiary of Pirelli, with Zanuso assigned the key design role. His 1951 designs for Arflex included the foam-rubber upholstered *Lady* armchair, the *Bridge* folding chair, the *St Moritz* recliner, and a terrace furnished with foam rubber furniture shown at the IX *Milan Triennale. Later Arflex designs by Zanuso included the *Martingala* armchair (1953) and *Sleep-o-matic* sofabed (1954). From 1958 to 1977 Zanuso enjoyed a productive working relationship with Richard *Sapper, resulting in a number of 'classic' elegant designs. These included several products for the *Brionvega company, most notably a series of radios and televisions, including the *Doney 14* (1962) and the *Black 201* (1969) models, and the *K 1340* polyethylene chair for *Kartell (1964). Other designs by Zanuso himself included the 1100 *Superautomatico* sewing machine for Borletti (1956) and the ABS plastic *Grillo* telephone for *Siemens.

Zanuso's significance has been widely acknowledged through the many prizes that his work has received over the years since 1948, including Gold Medals at six and the Gran Premio at three Milan Triennali, as well as five *Compasso d'Oro awards. His work is also represented in the collection of the Museum of Modern Art in New York. He was also a founding member of Associazione per il Disegno Industriale (*ADI), the professional body for Italian designers and a member of CIAM (*Congrès Internationaux d'Architecture Moderne) from 1956 to 1958. He also taught at Milan Polytechnic until 1986.

Zanussi (established 1916) The Zanussi domestic appliance manufacturing company became well known in the late 20th century for its 'designer' range of products, including Roberto Pezzetta's *Wizard* range of refrigerators, complete with pyramidal top and miniature flagpole (1986), and his bulbous, colourful *Oz* refrigerator (in production from 1998). After modest beginnings as a

Z

domestic appliance repair shop the company moved into appliance production. However, it was not until the 1950s that it became recognized as a design-conscious manufacturer, bolstered considerably by the involvement of industrial designer Gino Valle, who from 1954 until the 1970s worked on a number of the company's products, including the *202* washing machine of 1957 and the *170 TS* refrigerator of 1958. He worked closely with Gastone Zanello, head of the design department from 1958 to 1981, being succeeded by Pezzetta in 1982. Other designers important to the design profile of the company included *Ulm graduate Andries van Onck, who acted as consultant between 1976 and 1989. The company merged with *Electrolux in 1984.

Zapf, Hermann (1918–) This eminent German graphic designer, typographer, calligrapher, and book designer was a major international figure and widely recognized as an educator and thinker of significance. He was also a member of the *Alliance Graphique Internationale (AGI) and the American Institute of Graphic Arts (AIGA) and was elected as a *Royal Designer for Industry in 1985. His early graphic interests lay in calligraphy and the work of Rudolf Koch and Edward *Johnston, although he was to become widely known for his contribution to type, working as type director of the Sempel Foundry in Frankfurt from 1947 to 1956, graphic consultant to the Megenthaler Linotype Company in Brooklyn, New York, from 1957 to 1974, and vice-president of Design Processing International in New York from 1977 to 1986. His best-known typefaces included *Palatino* (1950), *Optima* (1958), *ITC Zapf International* (1977), and *ITC Zapf Chancery* (1979), the latter two for the International Typeface Corporation. Other major foundries for which he worked in-

cluded Linotype and Berthold. He was a prolific author, his books including *Manuale Typographicum* (volume i, 1954, volume ii, 1968), *Typographische Variationen* (1963), and *Herman Zapf and his Design Philosophy* (1987).

Zeisel, Eva (1906–) After an early career in Europe Hungarian born Eva Zeisel emigrated to the United States in 1938 and became one of the most celebrated designers of 20th century tableware. Her early pottery designs were influenced by Hungarian folk art as well more fashionable *Wiener Werkstätte trends. After a period designing teasets for the Kispester Pottery in Budapest, she produced designs for a number of other European manufacturers, including the Schramberger Majolika Fabrik (1928–30) and Christian Karstens Kommerz (1930–2) in Germany. Her design outlook in Germany displayed knowledge of contemporary modernist trends epitomized by the progressive outlook of the *Deutscher Werkbund and the *Bauhaus, both of which favoured clean, undecorated geometric forms. In 1932 Zeisel left for the USSR and worked in the Lomonosov State Porcelain Factory until 1934 and Dulevo Porcelain Factory (1934–6) and became art director of the China and Glass Industry of the Russian Republic. After her arrival in the USA in 1938 she taught at the Pratt Institute of Art, Brooklyn, and the Rhode Island School of Design. She soon attracted particular critical attention with her designs in 1942–3 for her *Museum* dinnerware designs, resulting from a collaboration between Castleton China and the *Museum of Modern Art (MOMA) in New York. Its clean shapes and elegant forms of reflected the best of European *Modernism between the wars. However, the range was unable to be put into mass production until 1946 when it was launched in a special exhibition at MOMA. Amongst other early cer-

amic designs in America was the less formal and biomorphic *Town and Country* dinnerware (1945) for Red Wing Pottery, in tune with much immediate post-war organic design by designers such as Russell *Wright, Isamu *Noguchi, and Charles and Ray *Eames. Her designs for *Tomorrows's Classic* (1949–50), later manufactured by Hall China, proved a commercial success. Zeisel also designed in other media, ranging from metal cookware for General Mills to a chromium-plated portable chair, the prototype of which was designed in the late 1940s. However, it was never put into mass production, despite being shown to critical acclaim at the *Milan Triennale of 1964. During her career many companies including *Sears Roebuck in the United States, *Rosenthal in Germany, Mancioli in Italy, Noritake in Japan, and *Zsolnay in Hungary commissioned Zeisel for designs in different media. In 1983 she received a grant from the USA's National Endowment for the Arts and returned to Hungary and, in the following year a retrospective of her work entitled *Eva Zeisel: Designer for Industry* began to tour internationally.

Zeró *See* SCHLEGER, HANS.

Zsolnay (established 1862) This Hungarian ceramics manufacturing company was established by Ignar Zsolnay in Pécs, factory management passing to his brother Vilmos

in 1865. Rapidly growing in scale and international reputation until the First World War, the company produced traditional domestic pottery as well as decorative wares influenced by Turkish and Persian models. From the end of the 19th century the company manufactured designs in *Art Nouveau and Hungarian Secessionist styles. Designers, such as József Rippl-Rónai, whose Zsolnay designs included the celebrated Art Nouveau *Andrássy* tableware, and architects, such as the Hungarian Secessionist Ödön Lechner and the Austrian Secessionists Joseph *Olbrich and Otto *Wagner, produced designs for architectural ceramics that helped to enhance the company's reputation worldwide. Furthermore, in an experimental studio run by Vinace Wartha between 1893 and 1910, a series of iridescent glazes were developed, the most significant of these being used for *Eosin* ware, which was exhibited in Vienna at the turn of the century and was internationally in demand. Although the company went into decline after the First World War it has remained in production to the present day. However, many of its designs were essentially retrospective, as for example with the *Baroqueservice* no. 9355, which went into production after the Second World War, selling between 50,000 and 60,000 sets every year for decades. From the 1980s Eva *Zeisel designed for the company.

Bibliography

This is intended only as a brief introductory guide to background reading for design in the period surveyed in this dictionary of design and is framed around books rather than articles. It should not be seen as definitive but embraces books with a spectrum of approaches, ranging from the art historical through to texts that embrace the social, economic, political, technological, and other viewpoints important to our understanding of design, its conception, production, and consumption. For the most part texts have been selected for their relative accessibility and recent publication dates. Books devoted to individual designers, firms, and consultancies have also been avoided for reasons of space and the fact that references to a very large number of these are included in many of the texts listed below. Although there has been an attempt to include references that embrace a wide geographical and cultural spread the book-based literature that is generally available unfortunately fails to cover the histories of design that obtain in many parts of the globe.

The bibliography is organized around the following headings:

General Introductory Texts

Design Atlas
 American Design
 Asian and Far Eastern Design
 Australasian Design
 Austrian Design
 British Design
 Central and Eastern European Design
 French Design
 German Design
 Irish Design
 Italian Design
 Netherlands and Belgian Design
 Scandinavian Design
 Spanish Design

Major Design Movements
Aesthetic Movement
Art Nouveau
Arts and Crafts
Modernism
Postmodernism

Other Design Topics
Corporate and Retail Design
Critical Voices
The Design Profession
Gender and Design
Green Design

General Introductory Texts

ALBRECHT, DONALD, et al., *Design Culture Now: National Design Triennial* (New York: Princeton Architectural Press, 2000).

ALDERSLEY-WILLIAMS, HUGH, *World Design: Nationalism and Globalism in Design* (New York: Rizzoli, 1989).

ALLWOOD, JOHN, *The Great Exhibitions* (London: Studio Vista, 1977).

AYNSLEY, JEREMY, *A Century of Graphic Design: Design Pioneers of the Twentieth Century* (London: Mitchell Beazley, 2001).

BOWE, NICOLA GORDON, *Art and the National Dream: The Search for Vernacular Expression in Turn-of-the-Century Design* (Dublin: Irish Academic Press, 1993).

BOWLBY, RACHEL, *Carried Away: The Invention of Modern Shopping* (London: Faber & Faber, 2000).

BRETT, DAVID, *On Decoration* (Cambridge: Lutterworth Press, 1992).

BURKHARDT, L., and BRANZI, ANDREA, *Neues Europäisches Design* (Berlin: Ernst & Sohn, 1991).

CENTRE GEORGES POMPIDOU, *Les Années 50* (Paris: Centre Georges Pompidou, 1988).

CHANT, COLIN, *Science, Technology and Everyday Life* (Milton Keynes: Open University, 1989).

DORFLES, GILLO (ed.), *Kitsch: The World of Bad Taste* (London: Studio Vista, 1969).

DURANT, STUART, *Ornament: A Survey of Decoration since 1830* (London: Macdonald, 1986).

FORTY, ADRIAN, *Objects of Desire: Design and Society 1750–1980* (London: Thames & Hudson, 1986).

GIEDION, SIEGFRIED, *Mechanisation Takes Command: A Contribution towards Anonymous Design* (New York: Norton, 1969).

HAYWARD GALLERY, *Art and Power: Europe under the Dictators 1930–1945* (London: Hayward Gallery, 1995).

HEISINGER, K., *Design since 1945* (London: Thames & Hudson, 1983).

HELLER, STEPHEN, and BALANCE, GEORGETTE (eds.), *Graphic Design History* (New York: Allworth Press, 2003).

HESKETT, JOHN, *Toothpicks & Logos: Design in Everyday Life* (Oxford: Oxford University Press, 2002).

—— *Industrial Design* (London: Thames & Hudson, 1980).

JULIER, GUY, *The Culture of Design* (London: Sage, 2000).

KAPLAN, WENDY (ed.), *Designing Modernity: The Arts of Reform and Persuasion 1885–1945* (London: Thames & Hudson, 1995).

KATZ, SILVIA, *Plastics: Common Objects, Classic Designs* (New York: Abrams, 1984).

KIRKHAM, PAT (ed.), *The Gendered Object* (Manchester: Manchester University Press, 1996).

LAURENT, STÉPHANE, *Chronologie du design* (Paris: Flammarion, 1999).

MANZINI, EZIO, *The Materials of Invention* (Milan: Arcadia, 1986).

MYERS, KATHY, *Understains: The Sense of Seduction of Advertising* (London: Commedia, 1986).

NOBLET, JOCELYN DE (ed.), *Design: Reflections of a Century* (Paris: Flammarion/APCI, 1993).

PILE, JOHN, *A History of Interior Design* (New York: John Wiley, 2000).

RUDOE, JUDY, *Decorative Arts 1850–1950* (London: British Museum, 1991).

SHAEFER, HERWIN, *The Roots of Modern Design: Functional Design in the Nineteenth Century* (London: Studio Vista, 1970).

WILK, CHRISTOPHER, *Bentwood and Metal Furniture 1850–1946* (New York: Abrams, 1982).

WINSTON, BRIAN, *Media, Technology and Society: A History from the Telegraph to the Internet* (London: Routledge, 1998).

WOODHAM, JONATHAN M., *Twentieth Century Design* (Oxford: Oxford University Press, 1997).

—— *Twentieth Century Ornament* (London: Studio Vista, 1990).

Design Atlas

American Design

ALLEN, JAMES SLOAN, *The Romance of Commerce and Culture: Capitalism, Modernism and the Chicago-Aspen Crusade for Cultural Reform* (Chicago: University of Chicago Press, 1983).

BACHELOR, RAY, *Henry Ford, Mass Production, Modernism & Design* (Manchester: Manchester University Press, 1994).

BEL GEDDES, NORMAN, *Horizons* (1932; New York: Dover, 1977).

BUSH, DONALD, *The Streamlined Decade* (New York: Braziller, 1968).

CLARK, ROBERT JUDSON (ed.), *The Arts and Crafts Movement in America 1876–1916* (Princeton: Princeton University Press, 1972).

——, et al., *Design in America: The Cranbrook Vision 1925–1950* (New York: Harry Abrams, 1984).

CLARKE, ALISON, *Tupperware: The Promise of Plastic in 1950s America* (Washington: Smithsonian Institution, 1999).

DARLING, SHARON, *Chicago Furniture: Art, Craft and Industry 1833–1933* (New York: Norton/Chicago Historical Society, 1984).

DAVIES, KAREN, *At Home in Manhattan: Modern Decorative Arts, 1925 to the Depression* (New Haven: Yale University Art Gallery, 1983).

EWEN, S., *All Consuming Images: The Politics of Style in Contemporary USA* (New York: Basic, 1988).

FINDLING, J. E., *Chicago's Great World Fairs* (Manchester: Manchester University Press, 1995).

GANS, HERBERT, *The Levittowners: Ways of Life and Politics in a New Suburban Community* (London: Allen Lane, 1967).

HEIMANN, J., and GEORGES, R., *California Crazy: Roadside Vernacular Architecture* (San Francisco: Chronicle, 1980).

HESS, A., *Google: Fifties Coffee Shop Architecture* (San Francisco: Chronicle, 1985).

HINE, THOMAS, *Populuxe* (New York: Alfred A. Knopf, 1986).

HOUNDSHELL, D. A., *From the American System to Mass-Production 1800–1932* (Baltimore: Johns Hopkins University Press, 1984).

KAPLAN, WENDY, *'The Art that is Life': The Arts & Crafts Movement in America* (Boston: Museum of Fine Arts, 1987).

KIRKHAM, PAT (ed.), *Women Designers in the USA 1900–2000: Diversity and Difference* (New Haven: Yale University Press, 2000).

MARCHAND, ROLAND, *Advertising the American Dream: Making Way for Modernity 1920–1940* (Berkeley and Los Angeles: University of California Press, 1986).

MARLING, K. A., *As Seen on TV: The Visual Culture of Everyday Life in the 1950s* (Cambridge, Mass.: Harvard University Press, 1994).

MEIKLE, JEFFREY, *Twentieth Century Limited: Industrial Design in America 1925–1939* (Philadelphia: Temple University Press, 1979).

—— *American Plastic: A Cultural History* (Piscataway, New Jersey: Rutgers University Press, 1997).

MUSEUM OF MODERN ART, *The Museum of Modern Art at Mid Century at Home and Abroad* (New York: Abrams, 1994).

PHILLIPS, L., *High Styles: Twentieth Century American Design* (New York: Whitney Museum, 1985).

PULOS, ARTHUR J., *American Design Ethic: A History of Design to 1940* (Cambridge, Mass.: MIT, 1983).

—— *The American Design Adventure 1940–1975* (Cambridge, Mass.: MIT, 1988).

RILEY, NOEL, and BAYER, PATRICIA, *The Elements of Design: The Development of Design and Stylistic Elements from the Renaissance to the Postmodern Era* (London: Mitchell Beazley, 2003).

RYDELL, ROBERT W., *All the World's a Fair: Visions of Empire at American International Exhibitions 1876–1916* (Chicago: University of Chicago Press, 1984).

SMITH, TERRY, *The Making of the Modern: Industry, Art and Design in America* (Chicago: University of Chicago Press, reissue 1994).

WILSON, RICHARD GUY, et al., *The Machine Age in America 1918–41* (New York: Abrams, 1986).

WRIGHT, GWENDOLYN, *Building the Dream: A Social History of Housing in America* (New York: Pantheon, 1981).

WURZ, R., *The New York World's Fair 1939–40* (New York: Dover, 1977).

ZIM, LARRY, et al., *The World of Tomorrow: The New York World's Fair* (New York: Harper & Row, 1988).

Asian and Far Eastern Design

ANDREWS, JULIA F., and SHEN, KUIYI, *A Century in Crisis: Modernity and Tradition in the Art of Twentieth Century China* (New York: Guggenheim Museum, 1968).

HIESINGER, KATHRYN B., and FISCHER, FELICE, *Japanese Design: A Survey since 1950* (New York: Abrams/Philadelphia Museum of Art, 1995).

SPARKE, PENNY, *Japanese Design* (London: Michael Joseph, 1987).

TOBIN, JOSEPH J., *Re-Made in Japan: Everyday Life and Consumer Taste in a Changing Society* (New Haven: Yale University Press, 1992).

WILKINSON, ENDYMION, *Japan versus Europe* (Harmondsworth: Penguin, 1983).

Australasian Design

BOGLE, MICHAEL, *Design in Australia 1880–1970* (Sydney: Craftsman House, 1998).

COCHRANE, GRACE, *The Crafts Movement in Australia: A History* (Sydney University of New South Wales Press, 1992).

FRY, ANTHONY H., *Design History Australia: A Source Text in Methods and Resources* (Sydney: Hale & Ironmonger, 1988).

MENZ, CHRISTOPHER, *Australian Decorative Arts: 1820s–1990s* (Adelaide: Art Gallery of South Australia, 1990).

THOMSON, HAMISH, *Paste Up: A Century of New Zealand Poster Art* (Auckland: Random House, 2003).

Austrian Design

GRAVAGNUOLO, B., *Adolf Loos: Theory and Works* (London: Art Data, 1995).

KALLIR, JANE, *Viennese Design and the Wiener Werkstätte* (London: Thames & Hudson, 1986).

SCHWEIGER, W. J., *Wiener Werkstätte: Design in Vienna 1903–1932* (London: Thames & Hudson, 1984).

VOLKER, ANGELA, and PICHLER, RUPERT, *Textiles of the Wiener Werkstätte 1910–1932* (London: Thames & Hudson, 1994).

WILK, CHRISTOPHER, *Thonet: 150 Years of Furniture* (London: Barron's, 1980).

British Design

BANHAM, MARY, and HILLIER, BEVIS, *Tonic to the Nation* (London: Thames & Hudson, 1976).

BRITISH COUNCIL, *Lost & Found: Critical Voices in New British Design* (Basle: Birkhäuser, 1999).

HARVEY, CHARLES, and PRESS, JON, *William Morris: Design & Enterprise in Victorian Britain* (Manchester: Manchester University Press, 1991).

HAYWARD GALLERY, *Thirties: British Art and Design before the War* (London: Arts Council, 1980).

HUYGEN, FRÉDÉRIQUE, *British Design: Image and Identity* (London: Thames & Hudson, 1989).

MACCARTHY, FIONA, *A History of British Design 1830–1979* (London: Allen & Unwin, 1979).

MACKENZIE, JOHN, *Propaganda and Empire: The Manipulation of Public Opinion* (Manchester: Manchester University Press, 1985).

WHITELEY, NIGEL, *Design for Society* (London: Reaktion, 1993).

—— *Pop Design: From Modernism to Mod* (London: Design Council, 1987).

Central and Eastern European Design

ANIKST, M. (ed.), *Soviet Commercial Design of the Twenties* (London: Alexandria Press/Thames & Hudson, 1987).

BENSON, TIMOTHY O., (ed.), *Central European Avant-Gardes: Exchange and Transformation, 1910–1930* (Cambridge, Mass.: MIT/Los Angeles County Museum of Art, 2002).

——, and FORGACS, EVA (eds.), *Between Worlds: A Sourcebook on the Central European Avant-Gardes, 1920–1930* (Cambridge, Mass.: MIT/Los Angeles County Museum of Art, 2002).

CROWLEY, DAVID, *National Style and Nation-State: Design in Poland from the Vernacular Revival* (Manchester: Manchester University Press, 1992).

ELLIOTT, DAVID, et al., *Art into Production: Soviet Textiles, Fashion and Ceramics 1917–1935* (Oxford: Museum of Modern Art, 1984).

ERNYEY, GYULA, *Made in Hungary: The Best of 150 Years in Industrial Design* (Budapest: Rubil Innovation Foundation, 1993).

GIBIAN, G., and TJALSMA, H. W. (eds.), *Russian Modernism, Cultures and the Avant Garde 1900–1970* (New York: Cornell University, 1988).

HUML, IRENA, *Polska Sztuka Stosowana XX Wieku* (Warsaw: Arcady, 1973).

KETTLES YARD, *Constructivism in Poland 1923–1926* (Cambridge: Kettles Yard, 1986).

LAMAROVA, MILENA, *Ceskoslovensky Design—Stroje a Nastroje* (Prague: Odeon, 1984).

—— *Czech Design 1980–1999* (Prague: Museum of Decorative Arts, 1999).

——, and VEGESACK, ALEXANDER VON (eds.), *Czech Cubism: Architecture, Furniture and Decorative Arts* (New York: Princeton University Press, 1997).

LAVRANTIEV, ALEXANDER N., and NASAROV, YURI V., *Russian Design: Tradition and Experiment 1920–1991* (London: Architectural Design, 1991).

LODDEN, CHRISTINA, *Russian Constructivism* (New Haven: Yale University Press, 1985).

LUBANOV-ROSTOVSKY, N., *Revolutionary Ceramics: Soviet Porcelain 1917–1927* (London: Studio Vista, 1990).

Mucsarnok Design Centre, *Örökség: Tárgy-és Környezelutúra Magyarorszagon 1945–1985/Design and Man-Made Environment 1945–1985* (Budapest: Mucsarnok Design Centre, 1985).

MUSEUM OF MODERN ART, *Devetsil: Czech Avant-Garde Art, Architecture and Design of the 1920s* (Oxford: Museum of Modern Art, 1990).

SLAPETA, V., *Czech Functionalism 1918–1938* (London: Architectural Association, 1987).

VUKIC, FEDJA, *A Century of Croatian Design* (Zagreb: Meander, 1998).

YASINSKAYA, L., *Soviet Textiles of the Revolutionary Period* (London: Thames & Hudson, 1983).

French Design

AMINJOU, C., et al., *L'Art de vivre: Decorative Arts and Design in France 1790–1989* (London: Thames & Hudson, 1989).

BRUNHAMMER, YVONNE, and TISE, SUZANNE, *French Decorative Art: The Société des Artistes Décorateurs* (Paris: Flammarion, 1990).

CENTRE GEORGES POMPIDOU, *Design français 1960–1990* (Paris: APCI/ Centre Georges Pompidou, 1988).

JOUIN, PIERRE, *Une liberté toute neuve: culture de masse et esthétique industrielle dans le France les années 50* (Paris: Klincksiek, 1995).

LAURENT, STÉPHANE, *Les Arts appliqués en France, genèse d'un enseignement 1851–1940* (Paris: CTHS, 1999).

SILVERMAN, DEBORAH, *Art Nouveau in Fin-de-Siècle France* (Berkeley and Los Angeles: University of California Press, 1989).

TROY, NANCY, *Modernism and the Decorative Arts in France: Art Nouveau to Le Corbusier* (London: Yale University Press, 1991).

German Design

AYNSLEY, JEREMY, *Graphic Design in Germany 1890–1940* (Berkeley and Los Angeles: University of California Press, 2000).

BURCKHARDT, LUCIUS, *The Werkbund: Studies in the History and Ideology of the Deutscher Werkbund* (London: Design Council, 1989).

CAMPBELL, JOAN, *The German Werkbund: The Politics of Reform in the Applied Arts* (Princeton: Princeton University Press, 1978).

DROSTE, MAGDALENA, *Bauhaus 1919–1933* (Cologne: Taschen, 1990).

ERLHOFF, MICHAEL (ed.), *Designed in Germany since 1949* (Munich: Prestel, 1990).

FRANCISCONO, M., *Walter Gropius and the Creation of the Bauhaus in Weimar* (Chicago: University of Illinois, 1971).

FUCHS, H., and BURCKHARDT, LUCIUS, *Product-Design-History: German Design from 1820 down to the Present Era* (Stuttgart: Institute for Foreign Cultural Relations, 1985).

HESKETT, JOHN, *Design in Germany 1870–1918* (London: Trefoil, 1986).

HINZ, BERTHOLD, *Art in the Third Reich* (Oxford: Blackwell, 1979).

LINDINGER, H. (ed.), *Ulm Design: The Morality of Objects, Hochschule für Gestaltung* (Berlin: Ernst Sohn, 1990).

NAYLOR, GILLIAN, *The Bauhaus Re-assessed: Sources and Design Theory* (St Neots: Herbert Press, 1985).

SCHÖNBERGER, ANGELA (ed.), *The East German Take-Off: Economy and Design in Transition* (Berlin: Ernst & Sohn, 1994).

SCHWARTZ, FREDERICK, *The Werkbund: Design, Theory and Mass Culture before the First World War* (New Haven: Yale University Press, 1996).

TAYLOR, BRANDON, and WILL, W. VAN DER (eds.), *The Nazification of Art: Art, Design, Music, Architecture and Film in the Third Reich* (Winchester: Winchester Press, 1990).

WELTGE, S. W., *Bauhaus Textiles: Women Artists and the Weaving Workshop* (London: Thames & Hudson, 1991).

WICHMANN, HANS, *Made in Germany: Produktform, Industrial Design 1970* (Munich: Peter Winkler, 1970).

WINGLER, HANS M., *The Bauhaus, Weimar, Dessau* (1962: Cambridge, Mass.: MIT, 1977).

Irish Design

EDEL, T. J., *Imaging an Irish Past: The Celtic Revival 1840–1940* (Chicago: David and Alfred Smart Museum of Art, 1992).

SHEEHY, JEANNE, *The Rediscovery of Ireland's Past: The Celtic Revival, 1830–1930* (London: Thames & Hudson, 1980).

Italian Design

AMBASZ, EMILIO (ed.), *Italy: The New Domestic Landscape* (New York: Museum of Modern Art, 1972).

BRANZI, ANDREA, *The Hot House* (London: Thames & Hudson, 1984).

——, and DE LUCCHI, MICHELE, *Il design italiano negli anni '50* (Milan: IGIS Edizioni, 1981).

COMMUNE DI MILANO, *Annitrenta: arte e cultura in Italia* (Milan: Mazzotta, 1982).

DANESI, SILVIA, and PATTETA, LUCIANO, *1919–1943: rationalisme et architecture en Italie* (Paris: Electa, 1976).

GRASSI, ALFONSO, and PANSERA, ANTY, *Atlante del disegno italiano 1940–1980* (Milan: Fabbri, 1980).

GREGOTTI, VITTORIO, *Il disegno nel prodotta industriale, Italia 1860–1980* (Milan: Electa, 1982).

PANSERA, ANTY, *Storia e cronaca della Triennale* (Milan: Longanesi, 1978).

RADICE, BARBARA, *Memphis: Research, Experiences, Results, Failures and Successes of New Design* (London: Thames & Hudson, 1984).

SARTAGO, P., *Italian Re-evolution: Design in Italian Society in the Eighties* (La Jolla, Calif.: Museum of Contemporary Art, 1986).

SPARKE, PENNY, *Italian Design: 1870 to the Present* (London: Thames & Hudson, 1988).

TISDALL, CAROLINE, and BOZZOLLA, ANGELO, *Futurism* (London: Thames & Hudson, 1977).

Netherlands and Belgian Design

BOYMANS-VAN BEUNINGEN MUSEUM, *Het Nieuwe Bouwen in Rotterdam 1920–1960* (Delft: University of Delft, 1982).

ELIÉNS, TITUS M., GROOT, MARJAN, and LEIDELMEIJER, FRANS, *Avant-garde Design: Dutch Decorative Arts 1880–1940* (London: Philip Wilson, 1997).

OVERY, PAUL, *De Stijl* (London: Thames & Hudson, 1991).

STAAL, G., and WOLTERS, H. (eds.), *Dutch Design 1947–1987 (Holland in Vorm 1945–1987)* (s'-Gravenhage: Stichting Holland in Vorm, 1987).

STEDELIJK MUSEUM, *Het Nieuwe Bouwen: Amsterdam 1920–1980* (Delft: University of Delft, 1982).

—— *Industry and Design in the Netherlands 1850–1950* (Amsterdam: Stedelijk Museum, 1985).

TROY, NANCY, *The De Stijl Environment* (Cambridge, Mass.: MIT, 1983).

WIT, WIM DE (ed.), *The Amsterdam School: Dutch Expressionist Architecture 1915–1930* (London: MIT Press, 1983).

Scandinavian Design

ERICSON, A.-M., and STRITZLER-LEVINE, NINA (eds.), *The Brilliance of Swedish Glass 1918–1939: An Alliance of Art & Industry* (New Haven: Yale University Press, 1996).

KARLSEN, ARNE, and TIEDEMANN, ANKER, *Made in Denmark* (Copenhagen: Jul Giellerup, 1960).

MCFADDEN, DAVID R. (ed.), *Scandinavian Modern Design 1880–1980* (New York: Abrams, 1982).

NATIONAL MUSEUM, *The Lunning Prize* (Stockholm: National Museum, 1986).

OPIE, JENNIFER, *Scandinavia: Ceramics and Glass of the Twentieth Century* (London: Victoria and Albert Museum, 1989).

WICKMAN, KERSTIN, *Orrefors: A Century of Swedish Glassmaking* (Washington: Washington University Press, Orrefors Glasbruk, 1999).

Spanish Design

CAPELLA, JULI, and LARREA, QUIM, *Nuevo diseño español* (Barcelona: Editorial G. Gili, 1991).

COAD, EMMA DENT, *Spanish Architecture & Design* (London: Studio Vista, 1990).

JULIER, GUY, *New Spanish Design* (London: Thames & Hudson, 1991).

PITAARCH, ANTONIO JOSE, and NURIA DE DALMASES, BALANA, *Arte e industria en España 1774-1907* (Barcelona: Blume, 1982).

Major Design Movements

Aesthetic Movement

ASLIN, ELIZABETH, *The Aesthetic Movement: Prelude to Art Nouveau* (London: Ferndale, 1981).

METROPOLITAN MUSEUM, *In Pursuit of Beauty: Americans and the Aesthetic Movement* (New York: Rizzoli/Metropolitan Museum of Art, 1986).

Art Deco

BAYER, PATRICIA, *Art Deco Interiors: Decoration and Design Classics of the 1920s and Thirties* (London: Thames & Hudson, 1998).

BENTON, CHARLOTTE, BENTON, TIM, and WOOD, GHISLAINE (eds.), *Art Deco 1910-1939* (London: Victoria and Albert Publications, 2003).

CERWINSKE, L., *Tropical Deco: The Architecture and Design of Old Miami Beach* (New York: Rizzoli, 1981).

CURL, JAMES STEPHENS, *The Egyptian Revival* (Manchester: Manchester University Press, 1982).

HILLIER, BEVIS, and ESCRITT, STEPHEN, *Art Deco Style* (London: Phaidon, 1997).

Art Nouveau

EADIE, W., *Movements of Modernity: The Case of Glasgow and Art Nouveau* (London: Routledge, 1990).

GALERIE DU CRÉDIT COMMUNAL, *Art nouveau polonais: Bruxelles/Cracovie 1890-1920* (Brussels: Galerie du Crédit Communal, 1990).

GREENHALGH, PAUL (ed.), *Art Nouveau 1890-1914* (London: Victoria and Albert Museum, 2000).

MANDELL, RICHARD D., *Paris 1900: The Great World's Fair* (Toronto: Toronto University Press, 1990).

RICHARDS, J. M., *The Anti-Rationalists: Art Nouveau Architecture and Design* (London: Architectural Press, 1973).

SILVERMAN, DEBORAH, *Art Nouveau in Fin-de-Siècle France: Politics, Psychology and Style* (Berkeley and Los Angeles: University of California Press, 1989).

Arts and Crafts

ANSCOMBE, ISABELLE, *Arts and Crafts in Britain and America* (London: Academy Editions, 1978).

AYRES, WILLIAM (ed.), *A Poor Sort of Heaven, a Good Sort of Earth: The Rose Valley Arts and Crafts Experiment* (Chads Ford: Brandywine Museum, 1983).

BOWE, NICOLA GORDON, and CUMMING, ELIZABETH, *The Arts & Crafts Movement in Dublin and Edinburgh 1885–1925* (Dublin: Irish Academic Press, 1998).

CROWLEY, DAVID, and TAYLOR, LOU (eds.), *The Lost Arts of Europe: The Haslemere Collection of European Peasant Art* (Haslemere: Haslemere Educational Museum, 2000).

CUMMING, ELIZABETH, and KAPLAN, WENDY, *The Arts & Crafts Movement* (London: Thames & Hudson, 1995).

JACOBS, MICHAEL, *The Good and Simple Life: Artists' Colonies in Europe & America* (Oxford: Phaidon, 1995).

NAYLOR, GILLIAN, *The Arts and Crafts Movement: A Study of its Sources, Ideals and Influence on Design Theory* (London: Studio Vista, 1990).

SALMOND, WENDY, *Arts & Crafts in Late Imperial Russia* (Cambridge: Cambridge University Press, 1997).

VOLPE, TOD M., *Treasures of the American Arts & Crafts Movement 1890–1920* (London: Thames & Hudson, 1988).

Modernism

BANHAM, PETER REYNER, *Theory and Design in the First Machine Age* (London: Architectural Press, 1960).

CORBUSIER, LE, *The Decorative Art of Today* (1925), trans. James Dunnett (London: Architectural Press, 1987).

—— *Vers une architecture* (1923), trans. Frederick Etchells (London: Architectural Press, 1927).

EIDELBERG, MARTIN (ed.), *Design 1935–1965: What Modern Was* (New York: Abrams, 1991).

GREENHALGH, PAUL (ed.), *Modernism in Design* (London: Reaktion, 1990).

HITCHCOCK, HENRY RUSSELL, and JOHNSON, PHILIP, *The International Style* (New York: Museum of Modern Art, 1932).

PEVSNER, NIKOLAUS, *Pioneers of Modern Design*, (rev. edn.: Harmondsworth: Penguin, 1988).

SHARP, DENNIS (ed.), *The Rationalists: Theory and Design in the Modern Movement* (London: Architectural Press, 1978).

—— (ed.), *Pel and Tubular Steel Furniture of the Thirties* (London: Architectural Association, 1977).

Postmodernism

ALDERSLEY-WILLIAMS, HUGH, *New American Design: Graphics and Products for a Post Industrial Age* (New York: Rizzoli, 1988).

COLLINS, MICHAEL, *Post-Modern Design* (London: Academy, 1989).

FEATHERSTONE, MIKE, *Consumer Culture and Postmodernism* (London: Sage, 1991).

FISCHER, VOLKER (ed.), *Design Now: Industry or Art?* (Munich: Prestel, 1988).

HARVEY, D., *The Condition of Postmodernity* (Oxford: Oxford University Press, 1991).

JENCKS, CHARLES, *The Language of Post Modern Architecture* (London: Academy, 1977).

—— *What is Post-Modernism?* (London: Academy, 1986).

JENSEN, ROBERT, and CONWAY, PATRICIA, *Ornamentalism and the New Decorativeness in Architecture and Design* (Harmondsworth: Allen Lane, 1983).

WOLFE, TOM, *From Bauhaus to our House* (London: Cape, 1982).

VENTURI, ROBERT, et al., *Learning from Las Vegas* (Cambridge, Mass.: MIT, 1972).

Other Design Topics

Corporate and Retail Design

CROSSICK, G., and JAUMAIN, S. (eds.), *Cathedrals of Consumption: The European Department Store, 1850–1939* (London: Ashgate, 1999).

FABBRI EDITORI, *Fiat 1899–1989: An Industrial Revolution* (London: Science Museum, 1988).

FORDE, G., *Design in the Public Service: The Dutch PTT 1920–1990* (London: Design Museum).

GOLDMAN, R., and PAPSON, S., *Nike Culture: The Sign of the Swoosh* (London: Sage, 1998).

HESKETT, JOHN, *Philips: A Study of the Corporate Management of Design* (London: Trefoil, 1989).

LARRABEE, L., and VIGNELLI, M., *Knoll Design* (New York: Abrams, 1981).

LORENZ, CHRISTOPHER, *The Design Dimension: The New Competitive Weapon for Product Strategy and Product Marketing* (Oxford: Blackwell, 1990).

LURY, G., *Brand Watching: Lifting the Lid on the Phenomenon of Branding* (Dublin: Blackhall, 1998).

MILLER, MICHAEL B., *The Bon Marché: Bourgeois Culture and the Department Store 1869–1920* (Princeton: Princeton University Press, 1981).

OLINS, WALLY, *Corporate Design* (London: Thames & Hudson, 1989).

OLIVER, T., *The Real Coke, the Real Story* (New York: Viking Penguin, 1987).

PAVITT, JANE, *Brand.New* (London: Victoria and Albert Publications, 2000).

PRENDERGRAST, M., *For God, Country and Coca-Cola: The Unauthorized History of the World's Most Popular Soft Drink* (London: Phoenix, 1994).

ROY, N., *The IBM World* (London: Eyre Methuen, 1974).

THACKARA, JOHN, *Winners! How Today's Successful Companies Innovate by Design* (Aldershot: Gower, 1997).

WILLIAMS, GARETH, *Branded?* (London: Victoria and Albert Publications, 2000).

Critical Voices

BURRALL, PAUL, *Green Design* (London: Design Council, 1991).

CARSON, RACHEL, *Silent Spring* (Harmondsworth: Penguin, 1965).

KLEIN, NAOMI, *No Logo* (London: Flamingo, 2000).

MacCarthy, Fiona, *The Simple Life: C. R. Ashbee in the Cotswolds* (London: Lund Humphries, 1981).

Mackenzie, Dorothy, *Green Design: Design for the Environment* (London: Lawrence King, 1997).

Packard, Vance, *The Hidden Persuaders* (London: Longman, 1957).

Papanek, Victor, *Design for the Real World: Human Ecology and Social Change* (1972), rev. ed. (London: Thames & Hudson, 1985).

Pugin, A. W., *Contrasts* (1936), introd. H. R. Hancock, 2nd edn., repr. (Leicester: Leicester University Press, 1969).

Ruskin, John, *The Stones of Venice*, ed. and introd. Jan Morris (London: Faber, 1981).

Schumacher, Ernst F., *Small is Beautiful: A Study of Economics as if People Mattered* (London: Abacus, 1974).

Whiteley, Nigel, *Design for Society* (London: Reaktion, 1993).

The Design Profession

Gorb, Peter (ed.), *London Business School: Design Talks* (London: Design Council, 1988).

Lorenz, Christopher, *The Design Dimension: The New Competitive Weapon for Product Strategy*, rev. and updated edn. (Oxford: Blackwell, 1990).

Lydiate, Liz (ed.), *Professional Practice in Design Consultancy: A Design Business Association Guide* (London: Design Council, 1992).

Gender and Design

Attfield, Judy, and Kirkham, Pat (eds.), *A View from the Interior: Feminism, Women and Design* (1989), rev. edn. (London: Women's Press, 1995).

Cowan, Ruth Schwartz, *More Work for Mother: The Ironies of Household Technology from the Open Hearth to the Microwave* (London: Free Association, 1983).

Design Center Stuttgart, *Frauen im Design: Berufsbilder und Lebenswege seit 1900* (Stuttgart: Design Centres, 1989).

Friedan, Betty, *The Feminine Mystique* (Harmondsworth: Penguin, 1963).

Green, H., *The Light of the Home: An Intimate View of the Lives of Women in Victorian America* (New York: Pantheon, 1983).

MCQUISTON, LIZ, *Women in Design: A Contemporary View* (London: Trefoil, 1988).

ROGERS, M. F., *Barbie Culture* (London: Sage, 1999).

SPARKE, PENNY, *As Long as it's Pink: The Sexual Politics of Taste* (London: Pandora, 1995).

Green Design

BURRALL, PAUL, *Green Design* (London: Design Council, 1991).

MACKENZIE, DOROTHY, *Green Design: Design for the Environment* (London: Lawrence King, 1991).

PAPANEK, VICTOR, *The Green Imperative: Ecology and Ethics in Design and Architecture* (London: Thames & Hudson, 1995).

PAWLEY, MARTIN, *Garbage Housing* (London: Architectural Press, 1975).

PEARCE, D., et al., *Blueprint for a Green Economy* (London: Earthscan Publications, 1969).

Timelines

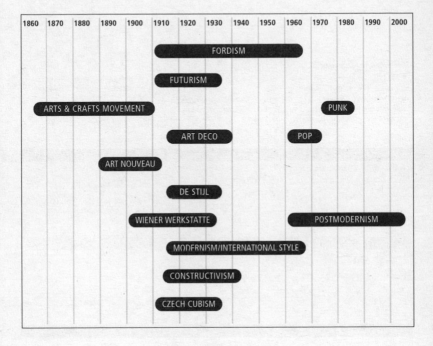

| 1860 | 1870 | 1880 | 1890 | 1900 | 1910 | 1920 | 1930 | 1940 | 1950 | 1960 | 1970 | 1980 | 1990 | 2000 |

FORDISM

FUTURISM

ARTS & CRAFTS MOVEMENT

PUNK

ART DECO

POP

ART NOUVEAU

DE STIJL

WIENER WERKSTATTE

POSTMODERNISM

MODERNISM/INTERNATIONAL STYLE

CONSTRUCTIVISM

CZECH CUBISM

1840 1850

Design Groups and Organisations

■1845 Svenska Slöjdföreningen
(Swedish Society of Industrial
Design)

Companies and Corporations

■1843 Thonet Brothers furniture
manufacturer established, Austria

■1847 Siemens, domestic
appliance and electronic goods
manufacturer established, Germany

■1851 Corning Glass established,
USA

■1853 WMF (Württembergische
Metallwarenfabrik) metalware
manufacturer, Germany

■1853 Levi Strauss & Co, workers
clothing manufacturer, USA

■1854 Louis Vuitton travel goods
manufacturer established, France

Design Landmarks

■1858 Michael Thonet, *No 14*,
bentwood chair

Technology, Processes, and Materials

■1851 Singer sewing machine

Key Exhibitions

■1851 Great Exhibition, London

■1855 Paris Exposition Universelle

Key Publications

■1849 *Journal of Design*, London
(ceased publication 1852)

■1851–23 John Ruskin, *The Stones
of Venice*

■1852 Gottfried Semper,
Wissenschaft, Industrie und Kunst
(Science Industry and Art)

■1856 Owen Jones, *Grammar of
Ornament*

Major World Events

■1854–56 Crimean War

1860 1870

■1864 Union Centrale des
Beaux-Arts Appliqués à l'Industrie

■1870 Abramtsevo Art Colony,
near Moscow
■1879 Finnish Society of Crafts
and Design

■1861 Morris & Co established by
William Morris and others, Britain
■1862 Zsolnay ceramics
manufacturer founded, Hungary
■1865 Nokia communications
company established, Finland

■1873 Arabia ceramics company
established, Finland
■1875 Liberty & Co Ltd, fashionable
retailer, London
■1878 Leerdam glass
manufacturing firm, Netherlands

■1864 William Morris, *Trellis*
wallpaper

■1875 Thomas Edison invents
incandescent lamp
■1876 Alexander Graham Bell
invents the telephone

■1862 London International
Exhibition
■1867 Paris Exposition Universelle

■1873 Vienna Universal Exhibition
■1876 Philadelphia Centennial
Exposition
■1878 Paris Exposition Universelle

■1861 *L'Art pour Tous:
Encyclopédie de l'Art Industriel
et Décoratifs* magazine (ceased
publication 1906)
■1868 Charles Eastlake, *Hints on
Household Taste in Furniture,
Upholstery and Other Detail*

■1869 Catherine and Harriet
Beecher, *The American Women's
Home*

■1872 Eugène Viollet-le-Duc,
Entretiens sur L'Architecture
(1963–72)
■1873 Christopher Dresser, *The
Principles of Decorative Design*

■1861–5 American Civil War
■1865 Abolition of slavery in USA
■1865 Assassination of President
Lincoln, USA
■1866 Foundation of Klu Klux Klan,
USA

■1869 Inauguration of Suez Canal

■1871 Bismarck proclaims the
German Empire
■1875–1885 Franco-Chinese War
■1875 Civil Rights Bill, USA

1870 cont... 1880

Design Groups and Organisations

- 1882 Union Centrale des Artistes Modernes (UCAD), France
- 1884 Art Workers Guild, Britain
- 1885 Hungarian Decorative Arts Society (Magyar Iparmüvévsti Társulat)

- 1888 Arts & Crafts Exhibition Society, Britain

Companies and Corporations

- 1879 Rosenthal ceramics manufacturing, Germany

- 1881 FSB (Franz Schneider Brakel) household goods manufacturer established, Germany
- 1881 Iittala glass manufacturing company established, Finland

- 1883 Allgemeine Elektrizitäts Gesellschaft (General Electric Company), Germany
- 1886 Coca-Cola company founded
- 1887 Arzberg porcelain factory established, Germany

Design Landmarks

Technology, Processes, and Materials

- 1880 W. Von Siemens invents first electric lift
- 1882 First power station in world by Thomas Edison, New York
- 1888 George Eastman, Kodak box camera

Key Exhibitions

- 1889 Exposition Universelle, Paris

Key Publications

- 1880 *Revue des Arts Décoratifs* magazine, France

Major World Events

1890

■**1897** Vienna Secession

■**1897** Munich Vereinigte Werkstätten für Kunst im Handwerk (Munich United Workshops for Art in Craft)

■**1898** Dresdener Werkstätten für Handwerkskunst (Dresden Workshops for Arts & Crafts)

■**1899** Darmstadt Artists' Colony, Germany

■**1888** Nintendo cards and gaming equipment manufacturer established, Japan

■**1888** Philips electrical goods manufacturer established, Netherlands

■**1893** Sears, Roebuck & Co mail order, manufacturing and retailing company, USA

■**1895** Škoda motor manufacturer established, Czechoslovakia

■**1896** Peugot motor company founded, France

■**1897** Rasch Brothers wallpaper manufacturing company established, Germany

■**1898** Orrefors glass manufacturing company established, Sweden

■**1899** Fiat automobile company established, Italy

■**1893** Victor Horta, Tassel House, Brussels in Art Nouveau style

■**1893** Otto Diesel develops prototype diesel engine

■**1893** Chicago World's Columbian Exposition

■**1893** *The Studio* magazine, London

■**1895** *Pan* magazine, Germany

■**1896** *Architectural Revue*, Britain

■**1897** *Art et Décoration* magazine, France

■**1898** *Ver Sacrum* magazine Austria

■**1899** Thorsten Veblen, *Theory of the Leisure Class*

■**1899–1902** Boer War

1900

Design Groups and Organisations

- **1901** Polish Applied Art Society (Towarzystwo Polska Sztuka Stosowana), Cracow
- **1901** Société des Artistes Décorateurs (SAD), France
- **1901** École de Nancy established, France
- **1902** Gödöllő Workshops, Hungary
- **1903** Wiener Werkstätte
- **1904** Vank (Nederlandsche Vereeniging Voorambachtsnijve-heiskunst, Netherlands Association for Crafts and Industrial Art)
- **1905** Artel Cooperative craft and furniture workshops, Prague
- **1907** Deutscher Werkbund
- **1907** Danish Society of Arts and Crafts and Industrial Design
- **1909** Futurist Manifesto launched, Paris

Companies and Corporations

- **Early 1900s** Jacuzzi Company founded, USA
- **1902** Harley Davidson motorcycle company founded, USA
- **1903** Ford Motor Company established, USA
- **1904** Gucci leather goods and fashion accessories company established, Italy
- **1906** Hille furniture company established, Britain
- **1908** Olivetti office equipment founded, Italy
- **1908** General Motors founded, USA
- **1908** Alfa Romeo automobile company founded, Italy
- **1909** Audi motor company founded

Design Landmarks

- **1908** Model T car designed by Henry Ford (in production until 1927)

Technology, Processes, and Materials

- **1900** Bakelite synthetic plastic patented by Leo Baekeland
- **1903** First powered flight by Wright brothers
- **1908** Henry Ford produces first Model T car
- **1909** Louis Blériot flies across the English Channel

Key Exhibitions

- **1900** Paris Exposition Universelle
- **1902** Turin International Exhibition of Modern Decorative Arts
- **1904** St Louis International Exhibition
- **1908** *Daily Mail* Ideal Home Exhibitions launched, London

Key Publications

- **1901–2** Louis Sullivan, *Kindergarten Chats*
- **1904–5** Hermann Muthesius, *Das Englische Haus*
- **1905** *Svenske Slödforinengen Tidskrift* magazine, later called *Form*, Sweden
- **1908** Adolf Loos, *Ornament and Crime*

Major World Events

- **1904** War between Russia and Japan

1910

■1910 Czech Cubism, Prague
■1911 Atelier Martine, producer of decorative arts and design, France
■1912 Cracow Workshops, Poland
■1912 National Alliance of Art and Industry, USA

■1913 Omega Workshops, London
■1915 Design & Industries Association (DIA), London
■1917 De Stijl founded, Netherlands

■1910 Louis Poulsen & Co, lighting manufacturer, established
■1911 Nissan Company established, Japan
■1912 Sharp Corporation, electronics manufacturer, established, Japan

■1913 Formica Company established, USA
■1913 Prada leather and fashion accessories company, Italy
■1915 Ghia car body styling company, Italy

■1916 BMW automobile company founded, Germany
■1916 Gispen metalware company founded, Netherlands
■1916 Zanussi domestic appliance manufacturer founded, Italy

■1915 Alex Samuelson designs iconic Coca-Cola bottle
■1917 Red-Blue armchair designed by Gerrit Rietveld

■1913 Henry Ford launches the moving assembly line

■1914 Deutscher Werkbund Exhibition, Cologne
■1917 *The Home* exhibition, Stockholm

■1911 Frederick Winslow Taylor, *Principles of Scientific Management*
■1915 Christine Frederick, *Principles of Household Management*
■1918 La Rinascente department store founded, Milan

■1918 *Wendingen* periodical, Netherlands

■1914–1918 First World War
■1917 Russian October Revolution commences
■1917 Founding of Communist Party, China

1910 cont... 1920

- ▪1920 Devetsil Group, Prague
- ▪1924 Blok group of Constructivist artists established, Poland
- ▪1924 Nederlandsche Bond voor Kunst in Industrie (BKI, Dutch Association for Art in Industry)

- ▪1924 Svenskt Tenn design company and retailer, Sweden
- ▪1926 Praesens, Poland
- ▪1926 LAD, Warsaw

- ▪1918 Matsushita electrical appliances company founded, Japan
- ▪1919 Citröen motor company established, France

- ▪1921 Braun domestic appliances company founded, Germany
- ▪1921 Alessi metalware company established, Italy
- ▪1923 Herman Miller Company established, USA

- ▪1923 De Ploeg textile producing cooperative established, Netherlands
- ▪1924 IBM (International Business Machines) founded, USA, Sweden
- ▪1924 Tomy toy company founded, Japan

- ▪1925 *Wassily* chair designed by Marcel Breuer
- ▪1928 Jan Tschichold, *Die Neue Typographie*

- ▪1920 First radio broadcasts
- ▪1924 First 35mm camera manufactured
- ▪1925 Chromium commercially available

- ▪1927 Charles Lindbergh flies the *Spirit of St Louis* across the Atlantic

- ▪1923 International Biennale of Decorative Art, Monza, becoming Triennale in 1930
- ▪1923 First Salon des Arts Ménagers, Paris

- ▪1924 *Forme ohne Ornament* (*Form without Ornament*) Exhibition, Stuttgart
- ▪1924–25 British Empire Exhibition, Wembley, London,
- ▪1925 Paris Exposition des Arts Décoratifs Industriels et Modernes

- ▪1920 *L'Esprit Nouveau* magazine
- ▪1923 Le Corbusier, *Vers Un Architecture*
- ▪1925 Le Corbusier, *L'Art Décoratif d'Aujourd'Hui*

- ▪1926 Mercedes-Benz motor company established, Germany
- ▪1926 Edna Meyer, *Der Neue Haushalt*
- ▪1928 *Domus* magazine founded, Italy

- ▪1922 Mussolini takes power, Italy
- ▪1922 Stalin elected General Secretary of Central Committee, USSR
- ▪1928 First Five Year Plan, USSR
- ▪1929 Wall Street Crash, USA

1930

■1926 Djelo Association for
promoting Craft Art (Udruga za
Promicanje Umjetnog Obrta 'Djelo'),
Croatia
■1928 Industrial Arts Institute (IAI),
Japan

■1928 Congrès Internationaux
d'Architecture Moderne (CIAM)
■1928 American Union of
Decorative Artists and Craftsmen
(AUDAC), New York
■1929 Union des Artistes Modernes
(UAM), France

■1930 Society of Industrial Artists
(later Chartered Society of Designers),
Britain
■1934 Council for Art & Industry,
Britain

■1924 Volvo motor manufacturing
company established, Sweden
■1925 Container Corporation of
America founded, USA
■1925 Chrysler Corporation
founded, USA

■1925 Bang & Olufsen audio-visual
company founded, Denmark
■1927 Cassina furniture company
founded, Italy

■1930 Pininfarina automobile
design company founded, Italy
■1932 Lego toy manufacturing
company established, Denmark
■1932 3 Suisses mail order
company founded, France

■1933 Henry Beck's map of the
London Underground
■1934 Kodak Baby Brownie camera,
designed by Walter Dorwin Teague
■1934 *Coldspot* refrigerator for
Sears Roebuck, designed by Raymond
Loewy

■1933 Modern air passenger flight
marked by launch of Douglas DC1
and Boeing 247 aircraft
■1935 IBM markets the first
commercially successful electric
typewriter
■1935 Perspex patented, Britain

■1927 *Die Wohning* (*The Dwelling*)
exhibition at the Weissenhof-
Siedlungen, Stuttgart

■1930 Stockholm Exhibition,
Sweden
■1932 *The International Style*,
Museum of Modern Art, New York

■1928 *Casabella* magazine founded,
Italy
■1928 *Kogei Shido* (*Industrial Art*)
magazine, Japan

■1930 *Fortune* business magazine,
USA
■1930 Moskovitch motor company,
Russia
■1932 Roy Sheldon and Egmont
Arens, *Consumer Engineering:
A New Technique for Prosperity*

■1931 Declaration of Spanish
Republic
■1933 Adolf Hitler becomes
Chancellor, Germany. Start of Third
Reich

1930 cont...

Design Groups and Organisations

Companies and Corporations

■**1933** Canon camera and office equipment company founded, Japan

■**1933** Toyota motor company, Japan

■**1935** Artek furniture company, Finland

■**1936** Arteluce lighting company founded, Italy

■**1936** Zani & Zani utensils and tableware manufacturer, Italy

■**1936** Vinçon design retailing company, Spain

■**1937** Saab aircraft company founded (diversifying into automobile manufacture after the Second World War), Sweden

■**1937** Polaroid Company, manufacturer of lighting and photographic equipment, USA

Design Landmarks

■**1934** Chrysler *Airflow* car

■**1936** Fiat *500* 'Topolino' car, designed by Dante Giocosa

■**1937** Bell Telephone Company introduces Bell 300 telephone designed by Henry Dreyfuss, standard for 40 years

■**1939** Henry Boulanger's Citroën *2CV* car

Technology, Processes, and Materials

■**1936** BBC television broadcasting commences

■**1937** Nylon patented for Du Pont company, USA

■**1937** Polyurethane invented, Germany

Key Exhibitions

■**1933** First International Triennale of Decorative and Modern Industrial Art in Milan, having moved from Monza

■**1933–34** Chicago *Century of Progress*

■**1934** *Machine Art* exhibition, Museum of Modern Art, New York

■**1937** Paris Exposition Internationale des Arts et Techniques dans la Vie Moderne

■**1939–40** New York *World's Fair*

Key Publications

■**1932** *Kogei Nyusu* (Industrial Art News) magazine, Japan

■**1934** Herbert Read, *Art & Industry*

■**1935** *Arcady* periodical, Warsaw

■**1936** Nikolaus Pevsner, *Pioneers of the Modern Movement*

Major World Events

■**1933** Franklin D. Roosevelt launches the New Deal programme, USA

■**1933** Second Five Year Plan, USSR

■**1936** Outbreak of Spanish Civil War

■**1939–1945** Second World War

1940

■**1944** Council of Industrial Design (becomes Design Council 1972), Britain
■**1947** Buiro Nadzoru Estetyki Producji (BNEP, Office for the Supervision of a Aesthetic Production), Poland

■**1948** Stichting Goed Wonen (Good Living Foundation), Netherlands
■**1949** Formes Utiles established, France

■**1938** Volkswagen motor manufacturing company established, Germany

■**1940** Tendo Mokko wooden products and furniture manufacturer established, Japan
■**1943** IKEA founded
■**1945** Brionvega electronics company founded, Italy

■**1945** Jaguar motor manufacturing company established, Britain
■**1946** Sony Corporation founded (as TTK), Japan
■**1946** Arteluce lighting company founded, Italy

■**1941** Raymond Loewy redesign of *Lucky Strike* cigarette packaging
■**1941** Paul Fuller, Wurlitzer 850 jukebox
■**1943** Lego introduced, Denmark

■**1944** Libby-Owens-Ford *Day After Tomorrow* kitchen tour across USA
■**1945** Mass-production of Volkswagen *Beetle* commences
■**1946** Piaggio *Vespa* motor scooter

■**1940** Commercial television launched in USA
■**1942** Polythene manufactured, Britain
■**1945** Atom bomb developed by Robert Oppenheimer and team, USA

■**1945** Microwave oven invented by Percy le Baron Spencer (marketed 1947)
■**Late 1940s** ABS plastics launched
■**1948** Edward Land develops first Polaroid camera, USA

■**1940** Harold Van Doren, *Industrial Design: A Practical Guide*
■**1948** Siegfried Giedion, *Mechanisation Takes Command*
■**1949** *Design* magazine launched, London

■**1948** American Marshall Plan for European post-war recovery
■**1948** Mahatma Gandhi assassinated, India
■**1948** Beginning of Cold War

■**1948** Communist coup d'etat in Czechoslovakia
■**1949** Proclamation of People's Republic of China
■**1949** Establishment of COMECON, an economic alliance between Moscow and Eastern European bloc

1940 cont... 1950

Design Groups and Organisations

- **1950** Instytut Wzornictwa Przemyslowego (IWP, Institute of Industrial Design)
- **1951** Aspen International Design Conferences launched, USA
- **1951** Alliance Graphique Internationale (AGI), Paris

Companies and Corporations

- **1946** Knoll furniture company founded, USA
- **1946** Honda motor company founded, Japan (first known as Honda Technical Research Institute)

- **1947** Kenwood domestic appliance manufacturing company established, Britain
- **1949** Porsche motor company founded, Germany
- **1949** Kartell plastics company founded, Italy

- **1950** Bjorn & Bernadotte (B&B) industrial design consultancy established, Denmark
- **1950** Vitra furniture manufacturing company established, Germany

Design Landmarks

- **1946** Eral S. Tupper launches *Tupperware*
- **1947** Christian Dior launches 'New Look' fashion, Paris
- **1947** First Levittown erected by Levitt & Sons, Long Island, USA

- **1947** Tapio Wirkkala, *Kanttarelli* vase, 1947
- **1948** Olivetti *Lexicon 80* typewriter designed by Marcello Nizzoli

- **1953** First flight of Boeing 707 jet airliner, interiors by Walter Dorwin Teague Associates
- **1953** BIC *Crystal* ballpoint pen
- **1953** First use of McDonalds 'Golden Arch' symbol at restaurant in Downey, California

Technology, Processes, and Materials

- **1948** Transistor invented at Bell laboratories, USA

- **1951** Colour television introduced in the USA
- **1951** Electricity produced by atomic power
- **1954** Polypropylene invented, Italy

Key Exhibitions

Key Publications

- **1951** Raymond Loewy autobiography, *Never Leave Well Enough Alone*
- **1951** *Esthétique Industrial* magazine, France
- **1954** *Stile Industria* magazine, Italy

Major World Events

- **1950–53** Korean War
- **1957** Treaty of Rome marks the beginning of the European Common Market

■1951 Japan Advertising Artists Club (JAAC)

■1951 Insitut d'Esthétique Industrielle, France

■1952 Japan Industrial Designers Association (JIDA)

■1953 Rat für Formgebung (Design Council), Germany

■1953 GK Design consultancy established, Japan

■1954 Push Pin Studios established, New York

■1954 Bureau Technès consultancy, France

■1956 Associazione per il Disegno Industriale (ADI) 1950

■1957 International Council of Industrial Design Societies (ICSID)

■1951 Marimekko textile manufacturing company established, Finland

■1953 Tecno furniture company, Italy

■1954 Zanotta furniture manufacturer founded, Italy

■1955 Yamaha Motor Company established, Japan

■1956 Tefal kitchen products manufacturer established, France

■1959 Artemide furniture company founded, Italy

■1955 Trabant car first manufactured, East Germany

■1955 Disneyland opened USA

■1957 Citroën *DS* car, styled by Flaminio Beroni, launched

■1957 Braun *KM31* food processor, designed by Gerd Alfred Muller

■1958 First IKEA store opened

■1959 First *Barbie* doll by Mattel

■1959 Alec Issigonis' *Mini* car

■1957 Launch of *Sputnik* satellite, USSR

■1958 National Aeronautics and Space Administration (NASA) established, USA

■Late 1950s Development of Computer-Aided Design

■1951 Festival of Britain Exhibition

■1955 Zagreb Triennali established, Croatia

■1958 Expo '58, Brussels

■1955 Henry Dreyfuss, *Designing for People*

■1957 Vance Packard, *The Hidden Persuaders*

■1957 Roland Barthes, *Mythologies*

1950 cont... 1960

Design Groups and Organisations

▪ **1958** Industrial Design Council of Australia (IDCA)
▪ **1958** Industrial Design Institute of Australia (IDIA)

▪ **1960** Nippon Design Centre, Japan
▪ **1962** VNIITE (All-Union Scientific Research Institute for Technical Aesthetic), USSR
▪ **1963** International Council of Graphic Design Associations (ICOGRADA)

▪ **1963** IFI (International Federation of Interior Designers/Architects)
▪ **1963** Kilkenny Design Workshops founded, Ireland
▪ **1965** Industrial Designers Society of America (IDSA)

Companies and Corporations

▪ **1964** Habitat established, London
▪ **1965** Källemo furniture company established, Sweden
▪ **1966** Benetton clothing company established, Italy

▪ **1966** Lada motor company established Russia

Design Landmarks

▪ **1960** Letraset introduced
▪ **1961** IBM *Selectric* 'golfball' electric typewriter
▪ **1964** First Habitat shop, London
▪ **1965** Cricket disposable cigarette lighter

▪ **1967** *Blow Chair* by Scolari, D'Urbino, Lomazzi, and De Pas
▪ **1969** Olivetti *Valentine* typewriter by Ettore Sottsass

Technology, Processes, and Materials

▪ **1961** First manned space flight, USSR
▪ **Mid 1960s** MDF (Medium Density Fibreboard) first appears, USA
▪ **1969** Apollo XI lands on moon

Key Exhibitions

▪ **1967** Expo '67 Montreal

Key Publications

▪ **1960** Reyner Banham, *Theory and Design in the First Machine Age*
▪ **1960** Vance Packard, *The Waste Makers: A Startling Revelation of Planned Obsolescence*
▪ **1961** Berlin Wall erected

▪ **1962** Jane Jacobs, *The Death and Life of Great American Cities*
▪ **1962** Marshall McLuhan, *The Gutenberg Galaxy; The Making of Typographic Man*
▪ **1963** Betty Friedan, *The Feminine Mystique*

Major World Events

▪ **1960** John Kennedy elected as President of the USA
▪ **1961** Erection of the Berlin War
▪ **1961** Cuban missile crisis and confrontation between USSSR and USA

▪ **1963** Assassination of President John Kennedy
▪ **1964** Martin Luther King receives Nobel Peace Prize
▪ **1965** Cultural Revolution or 'revisionism' commenced in China

1970

■**1965** Wolff Olins corporate identity design consultancy, Britain
■**1966** Archizoom and Superstudio avant-garde groups established, Italy
■**1967** Design Research Society, Britain

■**1969** Japan Industrial Design Promotion Organisation (JETRO)
■**1969** Ergonomi Design, design for the disadvantaged consultancy, Sweden
■**1969** Frogdesign consultancy established, Germany

■**1970** Korea Design and Packaging Centre (DKPC, later entitles the Korea Institute of Design Promotion (KIDP)
■**1970** Tio-Gruppen textiles collective and retailing concern, Sweden

■**1972** Nike sports goods company established, USA
■**1974** B&B Italia furniture company founded, Italy
■**1976** Apple Macintosh computer company established, USA

■**1975** BIC disposable plastic razor
■**1979** Sony *Walkman* I

■**1972** IRM develops silicon chip
■**1973** First commercial fax machine

■**1970** Japan World Exhibition, Osaka
■**1972** *Italy: the New Domestic Landscape*, Museum of Modern Art, New York

■**1965** Ralph Nader, *Unsafe at Any Speed*
■**1966** Robert Venturi, *Complexity and Contradiction in Modern Architecture*

■**1971** Victor Papanek, *Design for the Real World*
■**1972** Robert Venturi & Denise Scott Brown, *Learning from Las Vegas*
■**1973** Eugene Schumacher, *Small is Beautiful*

■**1965** US troops involved in Vietnam War
■**1968** Martin Luther King and Robert Kennedy assassinated
■**1968** Student unrest in Paris and elsewhere

■**1965** Soviet repression in Czechoslovakia following 'Prague Spring'

■**1972** Britain, Ireland, and Denmark join the European Community
■**1973** Oil crisis
■**1973** Ceasefire between US and Vietnam

1970 cont...

Design Groups and Organisations

■**1972** Pentagram design consultancy established, Britain

■**1973** Fundació BCD, Barcelona Centre De Disseny (Barcelona Design Centre)

■**1973** Porsche Design Studios, Germany

■**1975** Conseil Supérieur de la Création Esthétique Industrielle, France

■**1976** Studio Alchimia, Milan

■**1977** Danish Design Council, Copenhagen

■**1978** Japan Graphic Designers Association (JAGDA)

■**1979** Taiwan Design Promotion Centre

Companies and Corporations

Design Landmarks

Technology, Processes, and Materials

■**1977** First telephone links with fibre optics

■**1979** Ericsson company develops cellular telephone, Sweden

■**1979** Nuclear accident at Three Mile Island, USA

■**1979** Compact disc developed by Philips and Sony (launched 1983)

Key Exhibitions

Key Publications

Major World Events

■**1975** Death of General Franco, Spanish dictator

■**1977** Communist Party legalized in Spain

■**1978** Unification of North and South Vietnam

■**1979** Fall of the Shah of Iran and establishment of Islamic Republic under spiritual guidance of Ayatollah Khomeini

■**1979** First elections to the European Parliament

1980

1990

- ■1981 Memphis, Milan
- ■1981 Japan Design Foundation, Osaka
- ■1983 Design Institute Australia (IDA)

- ■1984 Seymour Powell design consultancy, Britain
- ■1987 Atika design group, Czechoslovakia

- ■1991 Tomato design consultancy, Britain
- ■1992 International Design Centre Nagoya

- ■1980 Psion electronic goods manufacturer established, Britain
- ■1982 Swid Powell, design company specialising in ceramics, metalware, and glass established
- ■1985 Swatch company established, Switzerland

- ■1986 Akaba furniture company established, Spain

- ■1990 Eidos software company established, Britain

- ■1981 Ettore Sottsass, *Carlton* room divider for Memphis
- ■1983 First Swatch watch
- ■1985 Ron Arad's Concrete Stereo
- ■1986 Dyson *G-Force* vacuum cleaner

- ■1992 Danny Lane, *Etruscan* chair
- ■1998 i-Mac computer

- ■1981 First flight of space shuttle, USA
- ■Early 1980s ColorCore material developed by Formica International, USA
- ■1984 Apple Macintosh computer and mouse launched

- ■1985 Zenith company launches the touch screen

- ■1993 World Wide Web graphic interface for Internet
- ■1996 Launch of DVD (Digital Versatile Disc), Japan

- ■1983 First International Design Festival, Osaka

- ■1992 Seville International Exposition

- ■1984 *Design Issues* periodical launched, USA

- ■1998 Kenji Ekuan, *The Aesthetics of the Japanese Lunchbox*

- ■1980 Iran-Iraq War
- ■1986 Chernobyl nuclear plant disaster, Russia
- ■1986 Spain and Portugal become members of the European Community

- ■1989 Demolition of Berlin Wall and demise of Eastern European communist regimes
- ■1989 President Ceausescu and government overthrown in Romania

- ■1990 Re-unification of Germany
- ■1991 Gulf War
- ■1991 Collapse of communist regime in USSR
- ■1991 End of apartheid in South Africa

1990 cont... 2000

Design Groups and Organisations

Companies and Corporations

Design Landmarks

Technology, Processes, and Materials

Key Exhibitions

■ **2000** Saint-Etienne Design Biennale, France

Key Publications

■ **2000** Naomi Klein, *No Logo: Taking Aim at the Brand Bullies*

Major World Events

■ **1991** Civil War in Yugoslavia

■ **1992** Maastricht Treaty

■ **1994** Civil War in Rwanda

■ **1994** First multiracial elections in South Africa, Nelson Mandela elected President

■ **1999** European monetary union

■ **2003** USA and Britain invade Iraq

Index

Individual designers, writers, theorists, and critics are listed alphabetically. Those whose surnames appear in capital letters have dedicated entries; those whose surnames appear in lower case appear in the consolidated entries of design consultancies, companies, institutions, organizations, and other designers with whom they have worked or been associated.

AALTO, Alvar 2
AALTO, Aino 2
AARNIO, Eerio 3
ADAMOVICH, Mikhail
 Mikhailovich 4
Adelberg, Louis see RÖRSTRANDS
 PORSLINFABRIK
Adler, Dankmar see SULLIVAN, LOUIS
Ahlström, Tom see A&E DESIGN
Ahrens, Uno see STOCKHOLM
 EXHIBITION; SVENSKT TENN
AICHER, Otl 8
ALBERS, Anni 9
ALBERS, Josef 41
ALBINI, Franco 10
Alessi, Carlo see ALESSI
Alger, Jonathan see CHERMAYEFF &
 GEISMAR INC.
Allner, Walter see FORTUNE
Andersen, Alvar see STOCKHOLM
 EXHIBITION
ANDREWS, Gordon 15
Andrews, Mary see ANDREWS,
 GORDON
ARAD, Ron 18
ARCHER, L. Bruce 19
ARMANI, Giorgio 21
Arnat, Jacinto see VINÇON
Arndt, Gertrud see BAUHAUS
Arnold, Dagmar see 'DAMSELS OF
 DESIGN'

ASHBEE, Charles Robert 29
Ashford, Fred see SCOTT, DOUGLAS
ASHLEY, Laura 29
Asplund, Gunnar see CASSINA,
 STOCKHOLM EXHIBITION, SVENSKA
 SLÖJDFÖRENINGEN
Asti, Sergio see KARTELL
Astori, Antonia see DRIADE
AULENTI, Gae 31
Axén, Gunila see TIO-GRUPPEN

B, Agnès see 3 (TROIS) SUISSES
Bäckström, Olof see FISKARS
Bahnsen, Uwe see FORD MOTOR
 COMPANY
BAILLIE SCOTT, Hugh McKay 34
Baillin, Mogens see JENSEN, GEORG
Baker, Steve see TOMATO
Bakst, Léon see ART DECO
BALLA, Giacomo 35
Ballmer, Theo see SWISS STYLE
BALLMER, Walter 35
Bangle, Chris see BMW
BANHAM, Peter Reyner 36
Barassi, Carlo see KARTELL
Bardi, Pier Maria see SAMBONET,
 ROBERTO
Barény, Béla see MERCEDES-BENZ,
 SACCO, BRUNO
Barillet, Louis see MALLET-STEVENS,
 ROBERT

BARMAN, Christian 37
BARNACK, Oscar 38
Barnsley, Sidney see GIMSON, ERNEST
Barrie, Colin see INDUSTRIAL DESIGN
COUNCIL OF AUSTRALIA
BARTHES, Roland 38
Bartolini, Dario see ARCHIZOOM
Bartolini, Lucia see ARCHIZOOM
BASS, Saul 38
Baudrillard, Jean see POSTMODERNISM
Baumann, Hans Theo see ARZBERG
BAYER, Herbert 41
BAYES, Kenneth see DESIGN
RESEARCH UNIT
Bazel, K. P. C. see LEERDAM
BEARDSLEY, Aubrey 42
Beck, Hans see PLAYMOBIL
BECK, Henry C. 42
Beene, Geoffrey see MIYAKE, ISSEY
BEHRENS, Peter 43
BEL GEDDES, Norman 44
Bell, Vanessa see OMEGA WORKSHOPS
Bellefroid, Guillaume see DE SPHINX
Bellgioioso, Ludovico see MILAN
TRIENNALI
Belmonte, Leo see GÖDÖLLÓ
WORKSHOPS
Benda, Jaroslav see ARTEL
COOPERATIVE
Bengtson, Hertha see RÖRSTRANDS
PORSLINFABRIK
Benktzon, Maria see
ERGONOMIDESIGN
BENSON, William Arthur Smith 45
Berlage, H. P. see STIJL, DE; LEERDAM;
WRIGHT, FRANK LLOYD
BERNADOTTE, Sigvard see BJORN &
BERNADOTTE; JENSEN, GEORG
BERNARD, Oliver Percy 46
Bernège, Paulette see SALON DES ARTS
MÉNAGERS
Bertelli, Patrizio see PRADA
BERTOIA, Harry 46
Bertone, Giovanni see BERTONE
Bertone, Nuccio see BERTONE

Bertoni, Flaminio see CITROËN
Bevilacqua, Carlotta de see DANESE
Bich, Marcel see BIC
BILL, Max 48
Binfaré, Francesco see B&B ITALIA
BING, Samuel 49
Biró, László and George see BIRO
BJORN, Acton see BJORN &
BERNADOTTE
Björquist, Karen see GUSTAVSBERG
BLACK, Misha 50
Blaich, Robert see PHILIPS
Blakeslee, Arthur see CITROËN
Boano, Felice Mario see FIAT
Boano, Gian Paolo see FIAT
Bohlin, Jonas see KÄLLEMO
Bonetto, Roberto see CASTELLI
BONSIEPE, Giu 53
Bordinat, George see WALKER,
GEORGE W.
Borletti, Aldo see RINASCENTE, LA
Borsani, Osvaldo and Fulgenzio see
TECNO
Bosio, Lucio see GIUGARO, GIORGETTO
BOUÉ, Michel see RENAULT
BOULANGER, Pierre see CITROËN
Bouvot, Paul see PEUGEOT
Bowyer, Gordon see GRANGE, KENNETH
Bracq, Paul see BMW, PEUGEOT
BRADDELL, Dorothy 54
BRADLEY, William 55
BRANDT, Marianne 56
BRANZI, Andrea 56
Breer, Carl see CHRYSLER
CORPORATION
BREUER, Marcel 58
BRODY, Neville 62
Brownjohn, Robert see CHERMAYEFF
& GEISMAR INC.
Brun, Donald see ALLIANCE
GRAPHIQUE INTERNATIONALE
BUEHRIG, Gordon 63
BUGATTI, Carlo 64
Bühler, Fritz see ALLIANCE GRAPHIQUE
INTERNATIONALE

Bulleid, O. V. S. *see* GRESLEY, NIGEL

Bürck, Paul *see* DARMSTADT ARTISTS'
COLONY

Burns, Aaron *see* LUBALIN, HERB

Burridge, Fred *see* CENTRAL SCHOOL
OF ARTS AND CRAFTS

Burtin, Will *see* FORTUNE

Butler, Nick *see* BIB DESIGN
CONSULTANTS

Capellaro, Natale *see* NIZZOLI,
MARCELLO

Carli, Carlo De *see* TECNO

Carlu, Jean *see* CASSANDRE;
CONTAINER CORPORATION OF
AMERICA; GAMES, ABRAM

CARPAY, Frank 69

Carson, Rachel *see* GREEN DESIGN

CASSANDRE (Adolf Jean-Marie
Mouron) 70

Cassina, Cesare *see* CASSINA

Castelli, Giulio *see* KARTELL

Castelli, Valerio *see* KARTELL

Castelli-Ferrieri, Anna *see* KARTELL

CASTIGLIONE, Achille 71

CASTIGLIONE, Piergiacomo *see*
CASTIGLIONE, ACHILLE

CASTLE, Wendell 72

Cazaubon, Jean *see* CHANEL, GABRIELLE

Chadwick, George *see* NELSON, GEORGE

CHANEL, Gabrielle ('Coco') 75

Chareau, Pierre *see* PARIS EXPOSITION
DES ARTS DÉCORATIFS ET
INDUSTRIELS; SOCIETÉ DES ARTISTES
DÉCORATEURS; UNION DES
ARTISTES MODERNES

Chéret, Jules *see* MUCHA, ALPHONSE

Chermayeff, Ivan *see* CHERMAYEFF &
GEISMAR INC.

CHERMAYEFF, Serge 76

Cherry, Wayne *see* GENERAL
MOTORS

Chiesa, Pietro *see* NOVECENTO

Choh, Daisaku *see* TENDO MOKKO

Christiansen, Gotfred *see* LEGO

Christofferson, Britt-Marie *see* TIO-
GRUPPEN

CHWAST, Seymour 83

CIGANDA, Miguel Ángel 83

Cimbura, Vít *see* ATIKA

CITTERIO, Antonio 85

Clark, Oliver *see* CHRYSLER
CORPORATION

Clason, Gustaf *see* STOCKHOLM
EXHIBITION

CLIFF, Clarice 85

COATES, Nigel 86

COATES, Wells 87

Cobden-Sanderson, T. J. *see*
JOHNSTON, EDWARD

Cochius, P. M. *see* LEERDAM

Cockerell, Douglas *see* CENTRAL
SCHOOL OF ARTS AND CRAFTS

COLANI, Luigi 88

COLE, Henry 88

Colin, Jean *see* ALLIANCE GRAPHIQUE
INTERNATIONALE; CASSANDRE;
GAMES, ABRAM; HENRION, F. H. K.

COLOMBINI, Gino 89

COLOMBO, 'Joe' Cesare 89

Colonna, Édouard *see* BING, SAMUEL;
PARIS EXPOSITION UNIVERSELLE

CONRAN, Terence 92

Copier, A. D. *see* LEERDAM

CORBUSIER, Le 254

Cortes, Pepe *see* MARISCAL, JAVIER

CRANE, Walter 101

Crumb, Robert *see* ALTERNATIVE
DESIGN

CYRÉN, Gunnar 103

Czajkowski, Józef *see* CRACOW
WORKSHOPS; PARIS EXPOSITION DES
ARTS DÉCORATIFS ET INDUSTRIELS

Czeschka, Carl Otto *see* HOFFMANN,
JOSEF; WIENER WERKSTÄTTE

Daems, Pierre *see* DE SPHINX

Danese, Bruno *see* DANESE

Darwin, Robin *see* ROYAL COLLEGE OF
ART

D'ASCANIO, Corradino 108

Dassler, Adolf *see* ADIDAS

Dassler, Rudolf *see* ADIDAS

Daum, August and Jean-Antonin *see* NANCY, SCHOOL OF

Davidson, Walter *see* HARLEY-DAVIDSON

DAY, Lewis Foreman 108

DAY, Lucienne 109

DAY, Robin 109

Debachin, Hugo *see* WMF

De Feure, Georges *see* BING, SAMUEL; PARIS EXPOSITION UNIVERSELLE

DEGANELLO, Paolo 109

De Haan, Benjamin *see* NEWSON, MARC

DE HAVILLAND, Geoffrey 110

DELAUNAY, Sonia 110

De Lorm, C. *see* LEERDAM

DE LUCCHI, Michele 111

DE MAJO, William (Willy) 111

DE MORGAN, William 112

Denyer, Pauline *see* SMITH, PAUL

Depero, Fortunato *see* FUTURISM

DESKEY, Donald 124

Didoni, Ezio *see* ARTELUCE

Dietrich, Ray *see* CHRYSLER CORPORATION

DIOR, Christian 126

DITZEL, Nanna 127

DIXON, Tom 127

Doblin, Jay *see* 'GOOD DESIGN'; INSTITUTE OF DESIGN

DOESBURG, Theo Van 128

Dohner, Donald *see* MÜLLER-MUNK, PETER

Domenech i Montaner, Louis *see* MODERNISMO

Dominioni, Luigi Caccia *see* CASTIGLIONE, ACHILLE

Dooren, Dirk van *see* TOMATO

Dorfles, Gillo *see* POSTMODERNISM

DORN, Marion 129

DRESSER, Christopher 131

DREYFUSS, Henry 132

Dubufe, Guillaume *see* SOCIETÉ DES ARTISTES DÉCORATEURS

Dufrène, Maurice *see* PARIS EXPOSITION DES ARTS DÉCORATIFS ET INDUSTRIELS; PERRIAND, CHARLOTTE; SOCIETÉ DES ARTISTES DÉCORATEURS

DUFY, Raoul 132

Dunand, Jean *see* PARIS EXPOSITION DES ARTS DÉCORATIFS ET INDUSTRIELS

Dutton, Norbert *see* DESIGN RESEARCH UNIT

DYSON, James 133

EAMES, Charles 136

EAMES, Ray Kaiser 137

EARL, Harley 137

EASTLAKE, Charles 138

ECKERSLEY, Tom 138

Eckerstrom, Ralph *see* CONTAINER CORPORATION OF AMERICA; NOORDA, BOB; VIGNELLI; LELLA AND MASSIMO

Eckmann, Otto *see* AEG

Eco, Umberto *see* POSTMODERNISM

Ehrich, Hans *see* A&E DESIGN

Ehrlich, Christa *see* PARIS EXPOSITION DES ARTS DÉCORATIFS ET INDUSTRIELS

Eicher, Fritz *see* BRAUN

Ekholm, Kurt *see* ARABIA

EKUAN, Kenji 139

EMBERTON, Joseph 140

ENDELL, August 141

Engel, Elwood *see* WALKER, GEORGE W.

English, Michael *see* PSYCHEDELIA

Englund, Eva *see* ORREFORS GLASBRUK

ERICSON, Estrid 143

Esherick, Wharton *see* CASTLE, WENDELL

Esslinger, Hartmut *see* APPLE MACINTOSH; FROGDESIGN

Evans, Beresford *see* DESIGN
 RESEARCH UNIT
EXNER, Virgil 143

Facetti, Germano *see* PENGUIN BOOKS
Farina, Battista 'Pinin' *see*
 PININFARINA
Fehlbaum, Rolf *see* VITRA; VITRA
 DESIGN MUSEUM
Feodorov, M. V. *see* VNIITE
Figini, Luigi *see* OLIVETTI
Fleischel, Gaston *see* PEUGEOT
Fletcher, Alan *see* PENTAGRAM
Foicchi, Mino *see* PONTI, GIO
Follot, Paul *see* PARIS EXPOSITION DES
 ARTS DÉCORATIFS ET INDUSTRIELS;
 PERRIAND, CHARLOTTE; SOCIÉTÉ
 DES ARTISTES DÉCORATEURS
Forbes, Colin *see* PENTAGRAM
Ford, Edsel B. *see* FORD, HENRY
FORD, Henry 150
Fougstedt, Nils *see* SVENSKT TENN
Francia, Cristiano Toraldo di *see*
 SUPERSTUDIO
FRANCK, Kaj 154
FRANK, Josef 155
FRANKL, Paul T. 155
Frayling, Christopher *see* ROYAL
 COLLEGE OF ART
Frederick, Christine *see* GILBRETH,
 LILLIAN; SCHÜTTE-LIHOTSKY,
 MARGARETE; TAYLORISM
Friberger, Erik *see* STOCKHOLM
 EXHIBITION
FRIEDAN, Betty 156
Frigeriosa, Emanuela *see*
 CHERMAYEFF & GEISMAR INC.
Fristedt, Sven *see* BORÅS WÄFVERI
FULLER, Paul 157
FULLER, Richard Buckminster
 157–160

Gabrielsson, Assar *see* VOLVO
Gaillard, Eugène *see* BING, SAMUEL;
 PARIS EXPOSITION UNIVERSELLE

GALLÉ, Émile 162
GALLEN-KALLELA, Akseli 162
Galliano, John *see* DIOR, CHRISTIAN
GAMES, Abram 163
Gammelgaard, Niels *see* IKEA
Garamond, Jacques *see* ALLIANCE
 GRAPHIQUE INTERNATIONALE
GARDELLA, Ignazio 164
GARDNER, James 164
Garrett, Malcolm *see* PUNK
Gate, Simon *see* ORREFORS GLASBRUK
GAUDÍ, Antoni 165
GAULTIER, Jean-Paul 166
Geer, Carl Johan De *see* TIO-GRUPPEN
GEHRY, Frank 167
Geiger, Friedrich *see* MERCEDES-BENZ;
 SACCO, BRUNO
Geismar, Tom *see* CHERMAYEFF &
 GEISMAR INC.
Geissbuhler, Steff *see* CHERMAYEFF &
 GEISMAR INC.
Gentleman, David *see* PENGUIN BOOKS
Ghini, Iosa *see* FERRARI
GIACOSA, Dante 169
Gibbons, Cedric *see* ART DECO
GIEDION, Siegfried 170
Gilardi, Piero *see* POLYURETHANE
GILBERT, A. C. 170
Gilbreth, Frank *see* GILBRETH,
 LILLIAN
GILBRETH, Lillian 171
GILL, Eric 171
GIMSON, Ernest 172
GIRARD, Alexander 172
GISMONDI, Ernesto 173
Gispen, Willem *see* W. GISPEN & CO.
GIUGARO, Giorgetto 173
Givenchy, Hubert de *see* MIYAKE,
 ISSEY
GLASER, Milton 174
Gocar, Josef *see* CZECH CUBISM
GODWIN, Edward William
Goertz, A. G. *see* BMW 178
Gomme, Ebenezer *see* G PLAN
GRANGE, Kenneth 180

Grant, Duncan *see* OMEGA WORKSHOPS

Grasset, Eugène *see* MUCHA, ALPHONSE

GRAVES, Michael 180

Grawunder, Johana *see* SOTTSASS, ETTORE, JR.

GRAY, Eileen 181

GRAY, Milner 182

Greenaway, Kate *see* AESTHETIC MOVEMENT

Greenwood, Arthur *see* HEAL & SONS

GREGORIE, Eugene T. (Bob) 186

GREGORY, Oliver 186

GREGOTTI, Vittorio 187

Greimann, April *see* SWISS STYLE

GRESLEY, Nigel 187

GRETSCH, Hermann *see also* ARZBERG

Gricic, Kostatin *see* FLOS

Griffin, Rick *see* PSYCHEDELIA

GROPIUS, Walter 188

Groult, André *see* PARIS EXPOSITION DES ARTS DÉCORATIFS ET INDUSTRIELS; SOCIÉTÉ DES ARTISTES DÉCORATEURS

Grundell, Susanne *see* TIO-GRUPPEN

Gucci, Guccio *see* GUCCI

GUERRIERO, Alessandro 189

GUGELOT, Hans 190

GUIMARD, Hector 190

Gurnack, Murat *see* PEUGEOT

Guyatt, Richard *see* FESTIVAL OF BRITAIN; GAMES, ABRAM

Hadid, Zaha *see* SWID POWELL

Hagerman, Lotta *see* TIO-GRUPPEN

Hahimoto, Masujiro *see* NISSAN

Hahn, Birgitta *see* TIO-GRUPPEN

Hakansson, Ingela *see* TIO-GRUPPEN

Hald, Edvard *see* ORREFORS GLASBRUK; RÖRSTRANDS PORSLINFABRIK

Hara, Hiromu *see* NIPPON DESIGN CENTRE

Harley, William *see* HARLEY-DAVIDSON

Harmand, Michel *see* CITROËN

Hasselblad, Victor *see* HASSELBLAD

HASUIKE, Makio 195

Haussman, Robert and Trix *see* SWID POWELL

Hayakawa, Tojuki *see* SHARP CORPORATION

HEAL, Ambrose 195

Hedqvist, Tom *see* TIO-GRUPPEN

Heesen, Willem *see* LEERDAM

Helg, Franca *see* NOORDA, BOB

Helmetag, Keith *see* CHERMAYEFF & GEISMAR INC.

HENNINGSEN, Poul 197

HENRION, F. H. K. (Frederick Henry Kay) 198

Henrion, Ludlow & Schmidt *see* HENRION, F. H. K.

Herbst, René *see* PARIS EXPOSITION DES ARTS DÉCORATIFS ET INDUSTRIELS; PARIS EXPOSITION DES ARTS ET TECHNIQUES DANS LA VIE MODERNE; SOCIÉTÉ DES ARTISTES DÉCORATEURS; UNION DES ARTISTES MODERNES

HICKS, David 200

HILFIGER, Tommy 201

Hillman, David *see* PENTAGRAM

Him, George *see* LE WITT-HIM

HOFFMANN, Josef 201

Hofman, Vlastislav *see* ARTEL COOPERATIVE; CZECH CUBISM

Hofmeister, Wilhelm *see* BMW

HOLLEIN, Hans 202

Horak, Bohuslav *see* ATIKA

HORNBY, Frank 203

Horsbury, Peter *see* VOLVO

HORTA, Victor 203

Huber, Max *see* SWISS STYLE

Huber, Patriz *see* DARMSTADT ARTISTS' COLONY

Huiszár, Vilmos *see* STIJL, DE

HULANICKI, Barbara 204

Hulm, Iris *see* NOKIA

Hydman-Vallien, Ulrica *see* KOSTA BODA

ILLICH, Ivan 210
IMAGE, Selwyn 210
Innocenti, Ferdinando see INNOCENTI
Irvine, James see SOTTSASS; ETTORE, JR.
Isosaki, Arata see SWID POWELL
ISSIGONIS, Alec 219
Ito, Haratsugu see EKUAN, KENJI;
 KOIKE, IWATARO
ITTEN, Johannes 220
Iwasaki, Shinji see EKUAN; KENJI; GK
 INDUSTRIAL DESIGN ASSOCIATES;
 KOIKE, IWATARO; YAMAHA MOTOR
 COMPANY

JACOBSEN, Arne 222
Jacobsen, Egbert see CONTAINER
 CORPORATION OF AMERICA
Jacuzzi, Roy see JACUZZI COMPANY
Jahn, Helmut see AKABA
Jameson, Frederic see
 POSTMODERNISM
Janák, Pavel see ARTEL COOPERATIVE;
 CZECH CUBISM
Javurek, Jírí see ATIKA
JENCKS, Charles Alexander 226
JENSEN, Georg 227
JENSEN, Jacob 227
Jesenka, Milena see ARTEL
 COOPERATIVE
JIRICNÁ, Eva 228
Johnová, Helena see ARTEL
 COOPERATIVE
Johnson, J. F. see HEAL & SONS
JOHNSON, Philip 228
JOHNSTON, Edward 229
JONES, Owen 229
Jordan, Charles see GENERAL MOTORS
Jourdain, Francis see ART ET
 DÉCORATION; PARIS EXPOSITION
 DES ARTS DÉCORATIFS ET
 INDUSTRIELS; UNION DES ARTISTES
 MODERNES
JUHL, Finn 230
Juhlin, Sven-Eric see
 ERGONOMIDESIGN

KÅGE, Wilhelm 234
Kalff, Louis see PHILIPS
KAMEKURA, Yusaku 234
Kammen, Jan see W. GISPEN & CO.
Kandell, John see KÄLLEMO
Kandinsky, Wassily see BAUHAUS;
 BAYER, HERBERT; BREUER, MARCEL
KARMANN, Wilhelm 235
KATSUMIE, Masaru 237
Katz, Bronek see DESIGN RESEARCH
 UNIT
KAUFFER, Edward McKnight 237
Kaufmann Jr., Edgar see MUSEUM OF
 MODERN ART, NEW YORK
Kavanaugh, Gere see 'DAMSELS OF
 DESIGN'
KAWAKUBO, Rei 238
Keck, George see CHICAGO CENTURY
 OF PROGRESS EXPOSITION
Keller, Ernst see SWISS STYLE
KENMOCHI, Isamu 239
Kenzo see MIYAKE, ISSEY
Key, Ellen see SVENSKA
 SLÖJDFÖRENINGEN
King, Henry see CHRYSLER
 CORPORATION
King, Perry see KING-MIRANDA
 ASSOCIATI
Kira, Alexander see
 ANTHROPOMETRICS
KJAERHOLM, Poul 241
KLEIN, Calvin 242
KLEIN, Naomi 242
Klier, Hans von see OLIVETTI
KLINT, Kaare 243
KLUTSIS, Gustav 243
KNOLL, Florence 243
Knox, Archibald see LIBERTY & CO.
Knoll, Hans see KNOLL ASSOCIATES
Koch, Alexander see DARMSTADT
 ARTISTS' COLONY
KOIKE, Iwataro 245
Kokko, Valto see IITTALA
KOMENDA, Erwin 245
Koppel, Henning see JENSEN, GEORG

Korhonen, Otto see AALTO, ALVAR
Körösfö-Kriesch, Aladár see GÖDÖLLÓ
 WORKSHOPS
KOSUGI, Jiro see also KENMOCHI,
 ISAMU
Králícek, Emil see CZECH CUBISM
KRAMER, Ferdinand 247
Kramer, Piet see AMSTERDAM SCHOOL
Krizman, Tomislav see DJELO
 ASSOCIATION FOR PROMOTING
 CRAFT ART
KURAMATA, Shiro 247
Kurlansky, Mervyn see PENTAGRAM
Kuroki, Yasuko see SONY
 CORPORATION
Kysela, František see ARTEL
 COOPERATIVE; CZECH CUBISM

Lagerfeld, Karl see CHANEL,
 GABRIELLE; SÍPEK, BOREK
LALIQUE, René 251
Lancia, Emilio see NOVECENTO; PONTI,
 GIO
Land, Edwin H. see POLAROID
Landberg, Nils see ORREFORS
 GLASBRUK
LANDOR, Walter 251
Lane, Allen see PENGUIN BOOKS
LANE, Danny 252
Laroche, Guy see MIYAKE, ISSEY
LARSEN, Jack Lenor 252
Larson, Gustaf see VOLVO
LARSSON, Carl 253
LARSSON, Karin 253
Latimer, Clive see HEAL & SONS
LAUREN, Ralph 254
Lechner, Odön see ZSOLNAY
Le Doux, Jean Picart see ALLIANCE
 GRAPHIQUE INTERNATIONALE
Leonni, Leo see FORTUNE
Lepper, Robert see MÜLLER-MUNK,
 PETER
LETHABY, William Richard 255
Lévi-Strauss, Claude see SEMIOTICS
LEVITT, William 257

Lewerentz, Sigurd see STOCKHOLM
 EXHIBITION
Lewis, Wyndham see OMEGA
 WORKSHOPS
LE WITT, Jan see LE WITT-HIM
Lindberg, Stig see GUSTAVSBERG
Lindén, Olavi see FISKARS
Lindstrand, Vicke see ORREFORS
 GLASBRUK
Linssen, L. J. F. see LEERDAM
Lint, J. H. see DE SPHINX
LISSITSKY, El (Lazar Markovich) 259
Lobo, Claude see FORD MOTOR
 COMPANY
LOEWY, Raymond 260
Löffelhardt, Heinrich see ARZBERG
Löffler, Berthold see WIENER
 WERKSTÄTTE
LOOS, Adolf 261
Loupot, Charles see CASSANDRE
Löw, Glen Oliver see CITTERIO,
 ANTONIO
LUBALIN, Herb 262
Luthe, Claus see BMW
Lyotard, Jean-François see
 POSTMODERNISM

MCALLISTER, Wayne 266
McClaren, Malcolm see PUNK
McCleland, Thomas see FORTUNE
McConnell, John see BIBA;
 PENTAGRAM
McCoy, Katherine see CRANBROOK
 ACADEMY OF ART
McCoy, Michael see CRANBROOK
 ACADEMY OF ART
McGrath, Raymond see COATES,
 WELLS; COX & CO.
McHale, John see INDEPENDENT
 GROUP
Machon, Ladislav see CZECH CUBISM
MACKINTOSH, Charles Rennie 267
MACKMURDO, Arthur Heygate 268
MCLUHAN, Marshall 269
MAGISTRETTI, Ludovico (Vico) 269

Majorelle, Louis *see* GALLÉ, ÉMILE;
 NANCY, SCHOOL OF
Makeig-Jones, Daisy *see* JOSIAH
 WEDGWOOD & SONS
MALDONADO, Tomás 270
Malevich, Kasimir *see*
 CONSTRUCTIVISM
MALLET-STEVENS, Robert 271
Malmsten, Carl *see* SVENSKA
 SLÖJDFÖRENINGEN
Mamontov, Savva *see* ABRAMTSEVO
 ART COLONY
Mano, Zenichi *see* MATSUSHITA
Mantelet, Jean *see* MOULINEX
Mantovani, Aldo *see* GIUGARO,
 GIORGETTO
Manzu, Pio *see* FLOS
Mare, André *see* ART DECO
Mari, Enzo *see* DRIADE
Marinetti, Filippo Tommaso *see*
 FUTURISM
MARISCAL, Javier 272
Markelius, Sven *see* STOCKHOLM
 EXHIBITION
Marzano, Stefano *see* PHILIPS
Massey, John *see* CONTAINER
 CORPORATION OF AMERICA
Massoni, Luigi *see* ALESSI
MATHSSON, Bruno 273
Matteo-Trucco, Giovanni *see* FIAT
Matter, Herbert *see* CONTAINER
 CORPORATION OF AMERICA
MAURER, Ingo 275
MAYAKOVSKY, Vladimir 276
Mayer, Albert *see* WMF
Mayer, Kurt *see* WMF
Mazza, Sergio *see* ARTEMIDE;
 GISMONDI, ERNESTO
Meier, Richard *see* SWID POWELL
MELLOR, David 277
Melnikov, Konstantin *see*
 CONSTRUCTIVISM
Mendelsohn, Erich *see* CHERMAYEFF,
 SERGE
MENDINI, Alessandro 279

Meneghetti, Lodovico *see* NELSON,
 GEORGE
Menghi, Roberto *see* KARTELL
Meston, Stanley *see* MCDONALD'S
Meydam, Floris *see* LEERDAM
Micheli, Angelo *see* DE LUCCHI,
 MICHELE
Mickl, Josef *see* KOMENDA, ERWIN
MIES VAN DER ROHE, Ludwig 281
Minagawa, Makiko *see* LAUREN, RALPH
Minale, Marcello *see* MINALE
 TATTERSFIELD
Miranda, Santiago *see* KING-MIRANDA
 ASSOCIATI
MITCHELL, William (Bill) 284
MIYAKE, Issey 284
Mögelin, Else *see* BAUHAUS
MOGGRIDGE, Bill 290
MOHOLY-NAGY, László 290
Møller, Jørgen *see* JENSEN, GEORG
MOLLINO, Carlo 291
Moneo, Rafael *see* AKABA
MORISON, Stanley 292
Moritz, Ulf *see* PLOEG, DE
MORRIS, William 292
MORRISON, Jasper 295
Moscoso, Victor *see* PSYCHEDELIA
MOSER, Koloman 296
MOUILLE, Serge 297
MOULTON, Alex 298
MUCHA, Alphonse 298
Muche, Georg *see* BAUHAUS
Müler, Tage *see* TIO-GRUPPEN
Müller, Gerd Alfred *see* BRAUN
MÜLLER-MUNK, Peter 299
MUNARI, Bruno 300
Munipov, V. M. *see* VNIITE
MURRAY, Keith 300
MUTHESIUS, Hermann 302

NADER, Ralph 306
Nagy, Sándor *see* GÖDÖLLÓ
 WORKSHOPS
Nash, Paul *see* COATES, WELLS
Natalini, Adolfo *see* SUPERSTUDIO

Nava, Paola *see* B&B ITALIA; CITTERIO, ANTONIO
NELSON, George 309
Neurath, Otto *see* ISOTYPE
NEWSON, Marc 310
Nielsen, Harald *see* JENSEN, GEORG
NIZZOLI, Marcello 316
NOGUCHI, Isamu 316
NOORDA, Bob 318
Noorda, Ornella *see* NOORDA, BOB
Nørgaard, Bjorn *see* KÄLLEMO
Novotny, Otakar *see* CZECH CUBISM
Novotny, Petr *see* AJETO
NOYES, Eliot 319
NUOVO, Frank 319
NURMESNIEMI, Antii 319
NURMESNIEMI, Vuokko 320
Nyland, Gunnar *see* RÖRSTRANDS PORSLINFABRIK

OBRIST, Hermann 322
Ohga, Norio *see* SONY CORPORATION
Öhström, Edvin *see* ORREFORS GLASBRUK
OLBRICH, Joseph Maria 322
O'Leary, Howard *see* BUEHRIG, GORDON
Olins, Wally *see* WOLFF OLINS
Ollers, Edvin *see* KOSTA BODA
Olsen, Carl *see* CITROËN
O'RORKE, Brian 325
Oros, Joseph *see* WALKER, GEORG W.
Ozenfant, Amadée *see* LE CORBUSIER; L'ESPRIT NOUVEAU

PACKARD, Vance 328
Pagano, Carlo *see* RINASCENTE, LA
Pallavicino, Cesare *see* INNOCENTI
PANTON, Verner 328
PAPANEK, Victor 329
Parppanen, Mikko *see* IITTALA
Parthenay, Jean *see* CALOR; VIENOT, JACQUES
Patterson, Helmer *see* VOLVO

PAUL, Bruno 334
Paulin, Guy *see* 3 (TROIS) SUISSES
Paulin, Pierre *see* CALOR; TALLON, ROGER
PAULSSON, Gregor 334
Peach, Harry *see* DESIGN AND INDUSTRIES ASSOCIATION
Peckolick, Alan *see* CHWAST, SEYMOUR; LUBALIN, HERB
Pelcl, Jírí *see* ATIKA
Pelly, Charles *see* NUOVO, FRANK
Penaat, W *see* METZ & CO.
PENSI, Jorge 335
Peressutti, Enrico *see* MILAN TRIENNALI
PERRIAND, Charlotte 336
Persson, Inger *see* RÖRSTRANDS PORSLINFABRIK
PESCE, Gaetano 337
Peugeot, Armand *see* PEUGEOT
PEVSNER, Nikolaus 338
Pezzetta, Roberto *see* ZANUSSI
Pfeiffer, Peter *see* MERCEDES-BENZ
Piaggio, Rinaldo *see* PIAGGIO
Picasso, Paloma *see* VILLEROY & BOCH
PILDITCH, James 341
Pilstrup, Henry *see* JENSEN, GEORG
Pintori, Giovanni *see* OLIVETTI
Piretti, Giancarlo *see* CASTELLI
Piva, Antonio *see* NOORDA, BOB
POIRET, Paul 342
Polglase, Van Nest *see* ART DECO
Pollini, Gino *see* OLIVETTI
PONTI, Gio (Giovanni) 344
Popova, Liubov *see* CONSTRUCTIVISM
Porsche, F. A. (Ferdinand 'Butzi') *see* PORSCHE DESIGN STUDIOS
Porsche, Ferdinand *see* PORSCHE
Porsche, Ferry *see* PORSCHE
Portoghesi, Paolo *see* ALESSI
Powell, Addie *see* SWID POWELL
Powell, Alfred and Louise *see* JOSIAH WEDGWOOD & SONS
Powell, Dick *see* SEYMOUR POWELL

Powolny, Michael see WIENER
 WERKSTÄTTE
Prada, Miucci see PRADA
Prampolini, Enrico see FUTURISM
PRITCHARD, Jack 352
Probst, Robert see HERMAN MILLER
 FURNITURE COMPANY
Procopé, Ulla see ARABIA
PROUVÉ, Jean 353
Prouvé, Victor see GALLÉ, ÉMILE;
 NANCY, SCHOOL OF
Prütscher, Otto see WIENER
 WERKSTÄTTE
Przyrembel, Hans see BRANDT,
 MARIANNE
PUCCI, Emilio 354
PUIFORCAT, Jean 355
Puig i Cadalfach, Josep see
 MODERNISMO
PULOS, Arthur J. 356

QUANT, Mary 358
QUISTGARD, Jens Harald 358

RACE, Ernest 360
RAMS, Dieter 360
RAND, Paul 361
Rasch, Emil see RASCH BROTHERS
Rasch, Hugo see RASCH BROTHERS
Rasmussenand, Rudolf see KLINT,
 KAARE
Redfern, Christopher see SOTTSASS,
 ETTORE, JR.
Reid, Jamie see PUNK
Repin, Il'ya see ABRAMTSEVO ART
 COLONY
Rhodes, Zandra see POP
Richter, C. A. see COX & CO.
Richter, Vjenceslav see ZAGREB
 TRIENNIAL
Rideout, John Gorden see VAN DOREN,
 HAROLD L.
RIETVELD, Gerrit 368
Riis, Egon see ISOKON
Rippl-Rónai, József see MOLNÁY

RISOM, Jens 370
RODCHENKO, Alexander 370
Rogers, Ernesto see CASABELLA; DOMUS
Rohde, Gilbert see HERMAN MILLER
 FURNITURE COMPANY
Rohde, Johan see JENSEN, GEORG;
 MODERNISM
Rondaler, Alan see LUBALIN, HERB
Roos, Delmar G. see JEEP
Rossell, Alberto see STILE INDUSTRIA
Rubik, Erno see RUBIK'S CUBE
Ruffins, Reynold see GLASER, MILTON
Ruhlmann, Jacques Émile see ART ET
 DÉCORATION; PARIS EXPOSITION
 DES ARTS DÉCORATIFS ET
 INDUSTRIELS
RUSKIN, John 375
RUSSELL, Gordon 375
Russell, R. D. see RUSSELL, GORDON
Ryan, Mike see SOTTSASS, ETTORE, JR.
Rybicki, Irvin W. see GENERAL MOTORS

SAARINEN, Eero 378
SAARINEN, Eliel 379
SACCO, Bruno 379
Sadler, Marc see ARTELUCE; FLOS;
 LOUIS VUITTON
SAINT LAURENT, Yves 379
Saito, Makoto see NIPPON DESIGN
 CENTRE
SAKASHITA, Kiyoshi 380
Salas, Fernando see MARISCAL, JAVIER
Salomon, Jules see CITROËN
Salomonson, Hein see STICHTING
 GOED WONEN
SALVADOR, Pascual 381
SAMBONET, Roberto 381
Samuelson, Alexander see COCA-COLA
SAPPER, Richard 381
Sarfatti, Gino see ARTELUCE
SARPANEVA, Timb 382
SASON, Sixten 383
Saussure, Ferdinand de see PRODUCT
 SEMANTICS; SEMIOTICS
SCARPA, Afra and Tobia 383

SCARPA, Carlo 384

Schaeffer, Rodolfo see GIACOSA, DANTE

Scharff, Allan see JENSEN, GEORG

Schawinsky, Alexander, 'Xanti' see
OLIVETTI

Schlagheck, Norbert see SIEMENS

SCHLEGER, Hans 384

Schlumbohm, Peter see CORNING
GLASS

Schmidt, Karl see DRESDENER
WERKSTÄTTEN FUR
HANDWERKSKUNST

SCHREIBER, Gaby 385

Schreiber, Michael see TALLON, ROGER

Schreyer, Peter see AUDI

Schuitema, Paul see W. GISPEN & CO.

Schultes, Herbert H. see SIEMENS

SCHÜTTE-LIHOTSKY, Margarete 386

SCOTT, Douglas 386

Sedding, J. D. see ARTS AND CRAFTS
EXHIBITION SOCIETY

SEMPER, Gottfried 388

Semushkine, Valery see LADA

Seymour, Richard see SEYMOUR
POWELL

Shaefer, Herwin see VERNACULAR

Sharp, Martin see PSYCHEDELIA

Shekov, B. V. see VNIITE

Shelton, Gilbert see ALTERNATIVE
DESIGN

Shibata, Kenichi see KOIKE, IWATARO;
EKUAN, KENJI

Silver, Arthur see LIBERTY & CO.

Silver, Nathan see ADHOCISM

Simonsen, Lee see DESKEY, DONALD

Singer, Dieter see ARZBERG

SÍPEK, Borek 392

Skellern, Victor see JOSIAH
WEDGWOOD & SONS

SMITH, Paul 393

Smith, Rick see TOMATO

Smithson, Alison and Peter see IDEAL
HOME EXHIBITIONS; INDEPENDENT
GROUP

Solov'eva, Vladimir see LADA

SOLOVIEV, Yuri 395

Sorel, Edward see GLASER, MILTON

SOTTSASS, Ettore, Jr. 396

Sparre, Louis see GALLEN-KALLELA,
AKSELI

SPENCER, Herbert 398

Stabler, Harold see DESIGN AND
INDUSTRIES ASSOCIATION; HEAL
& SONS

Stalhone, Carl-Harry see RÖRSTRANDS
PORSLINFABRIK

Stam, Mart see STICHTING GOED
WONEN

STARCK, Philippe 399

Steiner, Albe see RINASCENTE, LA

STENBERG, Vladimir and
Georgy 400

STEPANOVA, Varvara 401

Stephen, John see POP

Stevens, Brooks see JEEP

Stockar, Rudolf see ARTEL
COOPERATIVE

Stoppino, Giotto see NELSON, GEORGE

STÖZL, Gunta 404

Stryjenska, Zofia see PARIS
EXPOSITION DES ARTS DÉCORATIFS
ET INDUSTRIELS

Stumpf, Bill see HERMAN MILLER
FURNITURE COMPANY

Sudjic, Deyan see BLUEPRINT

Süe, Louis see ART DECO

SUETIN, Nikolai 406

SULLIVAN, Louis 407

Summerly, Felix see COLE, HENRY

Sumner, Heywood see ARTS AND
CRAFTS EXHIBITION SOCIETY

Sundahl, Ekil see STOCKHOLM
EXHIBITION

Susani, Marco see SOTTSASS,
ETTORE, JR.

Susta, Jaroslav see ATIKA

Sutnar, Ladislav see ARTEL
COOPERATIVE; WAGENFELD,
WILHELM

Svensson, Inez see TIO-GRUPPEN

Swid, Nan see SWID POWELL
Syrkus, Szmon see PRAESENS
Szczuka, Mieczyslaw see BLOK

Tajiri, Shinkich see RASCH BROTHERS
TALLON, Roger 414
Tanabe, Reiko see TENDO MOKKO
TANAKA, Ikko 414
Tange, Kenzo see TENDO MOKKO
Taplin, Millie see JOSIAH WEDGWOOD
 & SONS
TATLIN, Vladimir 415
Tattersfield, Brian see MINALE
 TATTERSFIELD
Taylor, Frederick Winslow see
 TAYLORISM
Taylor, Simon see TOMATO
TEAGUE, Walter Dorwin 415
Teige, Karel see DEVETSIL
Teinitzerová, Marie see ARTEL
 COOPERATIVE
Telakowska, Wanda see INSTYTUT
 WZORNICTWA PRZEMYSLOWEGO
TERRAGNI, Giuseppe 418
Terry, Eli see AMERICAN SYSTEM OF
 MANUFACTURES
Thomas, Henri see PEUGEOT
Thomassen, G. J. see LEERDAM
Thonet, Michael see THONET
 BROTHERS
Thorley, J. Paulin see STREAMLINING
THUN, Matteo 419
TIFFANY, Louis Comfort 419
TIGERMAN, Stanley 420
TOMASZEWSKI, Henryk 421
Tomiyama, Eiichiro see TOMY
Torre, Pierluigi see INNOCENTI
Toscani, Oliviero see BENETTON;
 GUERRIERO, ALESSANDRO
Toyoda, Kichiro see TOYOTA
TSCHICHOLD, Jan 424
Tupper, Earl S. see TUPPERWARE

UCHIDA, Shigeru 428
UMEDA, Masanori 429

URBAN, Josef 431

Valle, Gino see ZANUSSI
Vallien, Bertil see KOSTA BODA
Van Alstyne, Jane see 'DAMSELS OF
 DESIGN'
Van Der Leck, Bart see STIJL, DE; METZ
 & CO.; UNION DES ARTISTES
 MODERNES
VAN DOREN, Harold L. 436
Van Onck, Andries see ZANUSSI
Vasnetsov, Viktor see ABRAMTSEVO
 ART COLONY
Vassos, John see CHICAGO CENTURY
 OF PROGRESS EXPOSITION;
 INDUSTRIAL DESIGNERS SOCIETY
 OF AMERICA
VEBLEN, Thorsten 437
Veersema, Rein see PHILIPS
VELDE, Henry van de 437
Venini, Paolo 438
Vennola, Jorma see IITTALA
VENTURI, Robert 438
VIENOT, Jacques 442
VIGANO, Vittorio 443
VIGNELLI, Lella and Massimo 443
VIOLLET-LE-DUC, Eugéne-
 Emmanuel 444
Vitale, Anselmo see ALESSI
Vodder, Niels see JUHL, FINN
Vodoz, Jacqueline see DANESE
Vondrácek, Otakar see ARTEL
 COOPERATIVE
Von Vegesack, Alexander see VITRA
 DESIGN MUSEUM
VOYSEY, Charles Francis
 Annesley 449
Vrubel, Mikhail see ABRAMTSEVO ART
 COLONY

WAGENFELD, Wilhelm 452
WAGNER, Otto 452
WAGNER, Sherle 453
Wählström, Ann see KOSTA BODA
WALKER, George W. 453

Wallander, Alf *see* KOSTA BODA;
 RÖRSTRANDS PORSLINFABRIK
Ward, John B. *see* CORNING GLASS
Wars, Walter *see* BRIO
Wartha, Vinace *see* ZSOLNAY
Warwicker, John *see* TOMATO
WATANABE, Riki 454
WEBB, Philip 455
WEBER, Kem (Karl Emanuel
 Martin) 456
WEDGWOOD, Josiah *see* JOSIAH
 WEDGWOOD & SONS
WEGNER, Hans J. 456
Wehjte, Fredric *see* RÖRSTRANDS
 PORSLINFABRIK
Weil, Daniel *see* PENTAGRAM
Weingart, Wolfgang *see* SWISS STYLE
Wennerberg, Gunnar *see*
 GUSTAVSBERG; KOSTA BODA
Westman, Marianne *see* RÖRSTRANDS
 PORSLINFABRIK
Westwood, Vivienne *see* PUNK
Weymouth, Nigel *see* PSYCHEDELIA
White, Gleeson *see* STUDIO
Widmer, Jean *see* CENTRE DE
 CRÉATION INDUSTRIELLE
Wieselthier, Vally *see* WIENER
 WERKSTÄTTE
Wijdeveld, Theo van der *see*
 WENDINGEN
Wilfert, Karl *see* MERCEDES-BENZ;
 SACCO, BRUNO

Williamson, Judith *see* PRODUCT
 SEMANTICS
Wilsgaard, Jan *see* VOLVO
Wilson, Wes *see* PSYCHEDELIA
WIRKKALA, Tapio 458
Wolff, Michael *see* WOLFF OLINS
Wood, Graham *see* TOMATO
Woodson, W. E. *see*
 ANTHROPOMETRICS
WRIGHT, Frank Lloyd 460
Wright, Henry *see* NELSON, GEORGE
WRIGHT, Russell 461

YAMAMOTO, Yohji 464
Yamashiro, Ryuichi *see* NIPPON
 DESIGN CENTRE
Yamashita, Kazuma *see* ALESSI
YOKOO, Tadanori 465
Young, Edward *see* PENGUIN BOOKS
Yran, Knut *see* PHILIPS
YUAN-QING, Tao 465

Zanello, Gastone *see* ZANUSSI
Zani, Serafino *see* ZANI & ZANI
ZANUSO, Marco 467
ZAPF, Hermann 468
Zapf, Otto *see* RAMS, DIETER
Zarnowerówna, Teresa *see* BLOK
ZEISEL, Eva 468
Zsolnay, Ignar and Vilmos *see*
 ZSOLNAY
Zwart, Piet *see* STIJL, DE

Oxford Paperback Reference

The Concise Oxford Dictionary of Art & Artists
Ian Chilvers

Based on the highly praised *Oxford Dictionary of Art*, over 2,500 up-to-date entries on painting, sculpture, and the graphic arts.

'the best and most inclusive single volume available, immensely useful and very well written'

Marina Vaizey, *Sunday Times*

The Concise Oxford Dictionary of Art Terms
Michael Clarke

Written by the Director of the National Gallery of Scotland, over 1,800 entries cover periods, styles, materials, techniques, and foreign terms.

A Dictionary of Architecture
James Stevens Curl

Over 5,000 entries and 250 illustrations cover all periods of Western architectural history.

'splendid ... you can't have a more concise, entertaining, and informative guide to the words of architecture'

Architectural Review

'excellent, and amazing value for money ... by far the best thing of its kind'

Professor David Walker

More Art Reference from Oxford

The Grove Dictionary of Art

The 34 volumes of *The Grove Dictionary of Art* provide unrivalled coverage of the visual arts from Asia, Africa, the Americas, Europe, and the Pacific, from prehistory to the present day.

'succeeds in performing the most difficult of balancing acts, satisfying specialists while ... remaining accessible to the general reader'

The Times

The Grove Dictionary of Art – Online
www.groveart.com

This immense cultural resource is now available online. Updated regularly, it includes recent developments in the art world as well as the latest art scholarship.

'a mammoth one-stop site for art-related information'

Antiques Magazine

The Oxford History of Western Art
Edited by Martin Kemp

From Classical Greece to postmodernism, *The Oxford History of Western Art* is an authoritative and stimulating overview of the development of visual culture in the West over the last 2,700 years.

'here is a work that will permanently alter the face of art history ... a hugely ambitious project successfully achieved'

The Times

The Oxford Dictionary of Art
Edited by Ian Chilvers

The Oxford Dictionary of Art is an authoritative guide to the art of the western world, ranging across painting, sculpture, drawing, and the applied arts.

'the best and most inclusive single-volume available'

Marina Vaizey, *Sunday Times*

Oxford Paperback Reference

A Dictionary of Psychology
Andrew M. Colman

Over 10,500 authoritative entries make up the most wide-ranging dictionary of psychology available.

'impressive ... certainly to be recommended'
Times Higher Educational Supplement

'Comprehensive, sound, readable, and up-to-date, this is probably the best single-volume dictionary of its kind.'
Library Journal

A Dictionary of Economics
John Black

Fully up-to-date and jargon-free coverage of economics. Over 2,500 terms on all aspects of economic theory and practice.

A Dictionary of Law

An ideal source of legal terminology for systems based on English law. Over 4,000 clear and concise entries.

'The entries are clearly drafted and succinctly written ... Precision for the professional is combined with a layman's enlightenment.'
Times Literary Supplement

More Social Science titles from OUP

The Globalization of World Politics
John Baylis and Steve Smith

The essential introduction for all students of international relations.

'The best introduction to the subject by far. A classic of its kind.'
Dr David Baker, University of Warwick

Macroeconomics
A European Text
Michael Burda and Charles Wyplosz

'Burda and Wyplosz's best-selling text stands out for the breadth of its coverage, the clarity of its exposition, and the topicality of its examples. Students seeking a comprehensive guide to modern macroeconomics need look no further.'
Charles Bean, Chief Economist, Bank of England

Economics
Richard Lipsey and Alec Chrystal

The classic introduction to economics, revised every few years to include the latest topical issues and examples.

VISIT THE COMPANION WEB SITES FOR THESE CLASSIC TEXTBOOKS AT:

www.oup.com/uk/booksites

Oxford Paperback Reference

The Oxford Dictionary of Dance
Debra Craine and Judith Mackrell

Over 2,500 entries on everything from hip-hop to classical ballet, covering dancers, dance styles, choreographers and composers, techniques, companies, and productions.

'A must-have volume ... impressively thorough'
Margaret Reynolds, *The Times*

Who's Who in Opera
Joyce Bourne

Covering operas, operettas, roles, perfomances, and well-known personalities.

'a generally scrupulous and scholarly book'

Opera

The Concise Oxford Dictionary of Music
Michael Kennedy

The most comprehensive, authoritative, and up-to-date dictionary of music available in paperback.

'clearly the best around ... the dictionary that everyone should have'
Literary Review

OXFORD

Oxford Paperback Reference

The Kings of Queens of Britain
John Cannon and Anne Hargreaves

A detailed, fully-illustrated history ranging from mythical and pre-conquest rulers to the present House of Windsor, featuring regional maps and genealogies.

A Dictionary of Dates
Cyril Leslie Beeching

Births and deaths of the famous, significant and unusual dates in history – this is an entertaining guide to each day of the year.

'a dipper's blissful paradise ... Every single day of the year, plus an index of birthdays and chronologies of scientific developments and world events.'

Observer

A Dictionary of British History
Edited by John Cannon

An invaluable source of information covering the history of Britain over the past two millennia. Over 3,600 entries written by more than 100 specialist contributors.

Review of the parent volume
'the range is impressive ... truly (almost) all of human life is here'

Kenneth Morgan, *Observer*